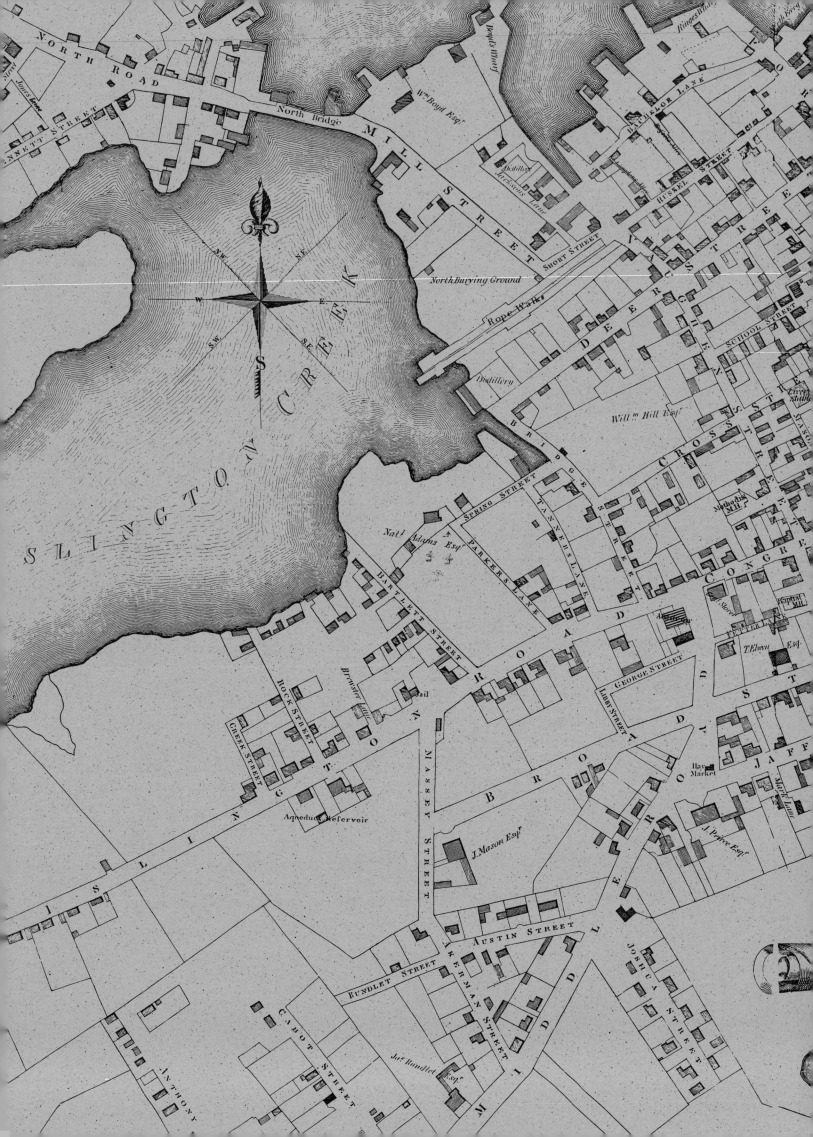

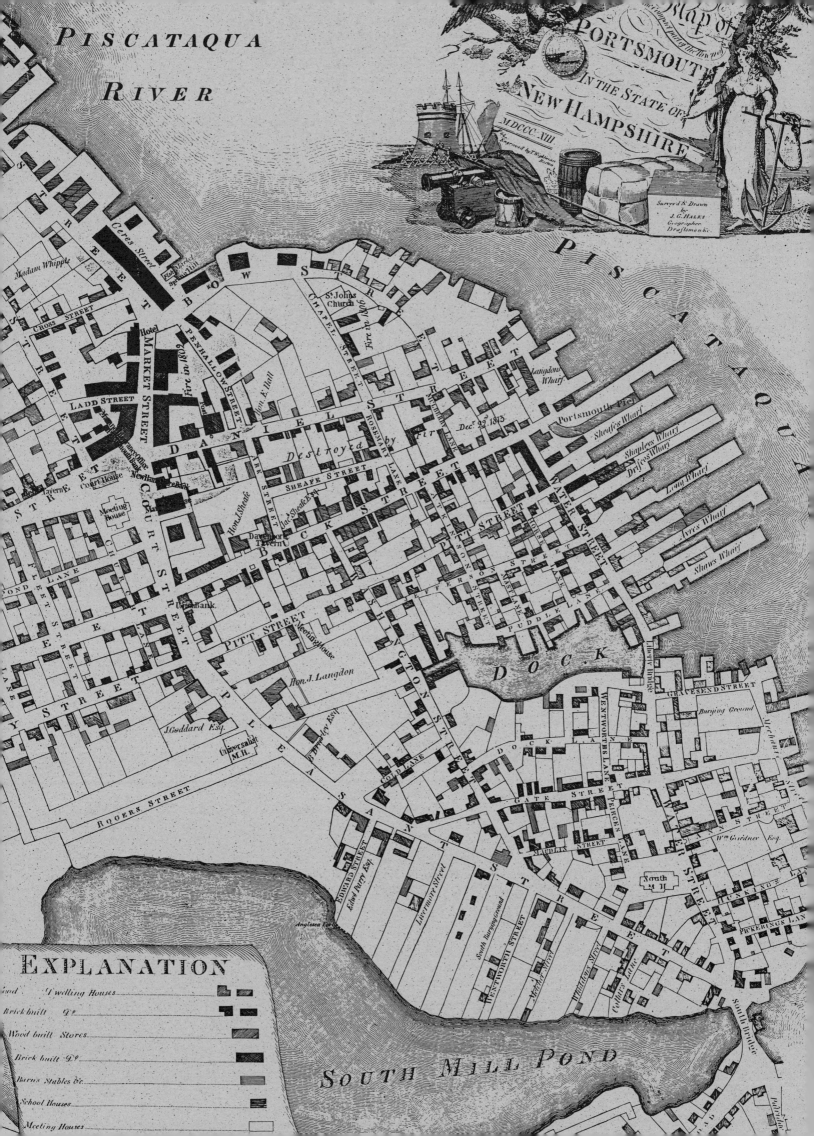

PORTSMOUTH FURNITURE

Masterworks from the

New Hampshire

Seacoast

PORTSMOUTH FURNITURE

Masterworks from the

New Hampshire

Seacoast

Organized and edited by
Brock Jobe

With contributions by
Diane Carlberg Ehrenpreis, James L. Garvin,
Anne Rogers Haley, Brock Jobe, Myrna Kaye,
Johanna McBrien, Kevin Nicholson, Richard C. Nylander,
Elizabeth Redmond, Kevin Shupe, Robert Trent,
Gerald W. R. Ward, and Philip Zea

Photographs by
David Bohl

Published by the
Society for the Preservation of New England Antiquities

Distributed by
University Press of New England

First edition. Printed in the United States of
America.

Distributed by the University Press of New
England, Hanover, New Hampshire 03755

Designed by DeFrancis Studio; edited by Nancy
Curtis and Gerald W. R. Ward

Library of Congress Cataloging-in-Publication
Data
Portsmouth furniture: masterworks from the
New Hampshire seacoast /organized and edited
by Brock Jobe; with contributions by Diane
Carlberg Ehrenpreis...[et al.]; photographs by
David Bohl.—1st ed.
p. cm.
Exhibition catalog.
Includes bibliographical references and index.
ISBN 0-87451-607-2. —
ISBN 0-87451-608-0 (pbk.)
1. Furniture—New Hampshire—Portsmouth—
Exhibitions.
I. Jobe, Brock. II. Ehrenpreis, Diane Carlberg.
NK2438.P67P67 1992
749.2142'6—dc20
LC 92—50296

Assistance in preparation of this publication has
been financed in part from the annual federal
"Historic Preservation fund" matching grant
from the National Park Service of the United
States Department of the Interior to the New
Hampshire Division of Historical Resources /
State Historic Preservation Office. The federal
matching grant provides up to a maximum of
50% of the total cost of the New Hampshire
state historic preservation program and related
subgrants and contracts. However, its contents
and opinions do not necessarily reflect the views
of policies of the Department of the Interior or
the Division of Historical Reources. Regulations
of the U.S. Department of the Interior strictly
prohibit unlawful discrimination in departmen-
tal federally assisted programs on the basis of
race, color, national origin, age, or handicap.
The State of New Hampshire (under RSA 275
and RSA 354-A) prohibits discrimination on
the basis of age, sex, race, creed, color, marital
status, physical or mental handicap or national
origin. Any person who believes that he or she
has been discriminated against in any program,
activity, or facility operated by a recipient of
federal assistance should write to: Director,
Equal Opportunity Program, U.S. Department
of the Interior, P.O. Box 37127, Washington,
D.C. 20013-7127.

ENDLEAVES: *Map of the Compact Part of the
Town of Portsmouth in the State of New
Hampshire,* (detail) 1813. Drawn by J. G. Hales
and engraved by T. Wightman, Boston, Massa-
chusetts, H. 29¾; W. 39½. Courtesy, Library of
Congress, Washington, D.C.

CONTENTS

Acknowledgments

Brock Jobe

I<small>N</small> 1842, A VISITOR to the home of Mrs. Cutts of Portsmouth observed:

> She is one of those ladies who delight in displaying their own eccentricities & tastes and trea-
> sures to all who may have the honor of ten seconds acquaintance with her. She had us all over
> her house before we had been ten minutes in it, showing us old chairs & china sets, and
> couches, pictures & rooms, with complete history of their character as she called it.[1]

Mrs. Cutts was not alone in her pride in Portsmouth's past. Veneration of the
town's ancestors was already underway when, to celebrate New Hampshire's bicen-
tennial in 1823, residents assembled an exhibition of thirty portraits of distin-
guished founding fathers.[2] In 1847, when she had her portrait painted, Mrs.
Alexander Ladd chose to be seated in a century-old Chinese Chippendale armchair,
and in the 1860s, the newspaperman Charles Brewster wrote fondly of chairs made
by his ancestor, John Gaines, in 1728 (*fig. 30; see cat. no. 77*).[3]

 Eighteenth-century Portsmouth was marked by bustling prosperity and ad-
venture, the busy waterfront providing the stage for its merchant princes and strug-
gling entrepreneurs, master seamen and common sailors, ingenious craftsmen and
runaway apprentices. The seaport's success was due in part to its location upon one
of the best natural harbors along the Atlantic coast and to the surrounding stands of
white pine, hemlock, oak, birch, maple, and cherry. Merchants came to dominate
the town, and the lumber industry spawned important crafts of house building,
shipbuilding, and furniture making.

 By the 1820s, the depletion of timber, increasing competition from other sea-
ports, and the lack of a major inland market tightly capped the town's vigorous en-
terprise, and Portsmouth slowly receded into a quiet backwater. Many of its
wealthiest merchants died paupers, their inventories shackled by sizable debt.

 The glory that was Portsmouth's did not die easily in the hearts of its citizens.
In a time of diminished opportunity, the need to identify with federal Portsmouth's
energetic vision and achievement led many of its nineteenth-century citizens to pre-
serve the symbols of the past. To enter Mrs. Cutts's house in the 1840s—or, in-
deed, to visit the homes of any of the other old families in Portsmouth—was to be
initiated into intimate and telling museums. Furnished by family members with a
mixture of eighteenth- and nineteenth-century furniture and other household
items, these homes told the bold tale of the town; each lolling chair, bed, tea table,
secretary, or settee spoke eloquently or roughly about its maker and owner and
added a small element to the rich mosaic of an era. As late as 1930, at least a dozen
Portsmouth houses, such as the Warner, Wendell, Rundlet-May, Peirce, and
Boardman homes, still retained entire collections of early furnishings demonstrating
the pride and aristocratic nature of the town.

 However lovingly preserved and proudly presented the household furnishings
from the past may have been in the nineteenth century, little attention has been

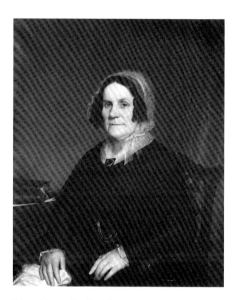

Mrs. Alexander Ladd, *by Albert Gallatin Hoyt
(1809–56), 1847. Oil on canvas, H. 36; W. 29.
Moffatt-Ladd House, Portsmouth, New Hamp-
shire, in care of The National Society of The
Colonial Dames of America in the state of New
Hampshire, on loan from a Ladd descendant,
5. 1978. Mrs. Ladd is seated in an English ro-
coco armchair that probably belonged to John
Wentworth (1737–1820), governor of New
Hampshire from 1767 until 1775 (see cat. no. 81).*

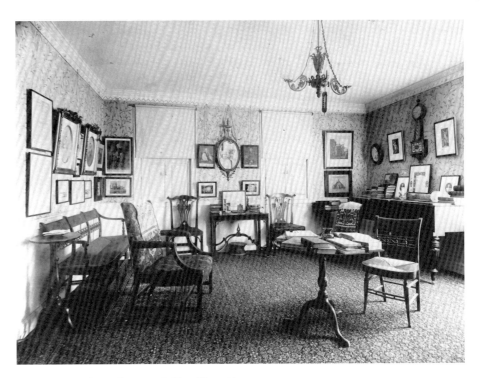

Parlor, Wendell house, Portsmouth, New Hampshire.
Photograph, ca. 1900. Courtesy, Strawbery Banke
Museum, Portsmouth, New Hampshire.

paid to them in the twentieth. To date, only nine articles have appeared on the sub-
ject.[4] The absence of signed furniture and detailed accounts by craftsmen, the over-
shadowing of Portsmouth by Boston, Salem, New York, and Philadelphia as major
furniture-making centers, and the dispersal of household collections after 1930 con-
tributed to the obscurity of Portsmouth furniture.

The discovery of the great wealth of this furniture and subsequent need for
scholarly research came about somewhat by chance. During the summers of 1975–
77, Myrna Kaye and I examined furniture in SPNEA houses in the Portsmouth
area for *New England Furniture: The Colonial Era.* After studying documented
provenances of much of the furniture, we suspected that many objects had been
made there. A quick survey of historic houses in the Portsmouth area, other than
those owned by SPNEA, revealed many items that closely resembled furniture in
SPNEA properties. The resemblance seemed more than coincidence, and the quan-
tity and quality of the objects indicated that Portsmouth furniture offered a fertile
field for further investigation.

I began the project in earnest in the fall of 1988 with four goals: 1) to cata-
logue and photograph as much Portsmouth furniture as possible, 2) to survey docu-
mentary records for information on Portsmouth furniture, 3) to develop a book on
the subject, and 4) to organize a related traveling exhibition.

After securing initial funding for the project, I assembled a team to assist with
research. Field work yielded a rich cache of furniture far larger than anticipated.
Traveling to 230 sites ranging from Portsmouth to Palo Alto, California, we cata-
logued and photographed nearly 1,500 objects. A survey of every major auction
catalogue produced since 1920 and every issue of *Antiques* provided another 500
items attributable to the Portsmouth area. This information forms an extraordinary
pictorial archive available to scholars for future research at SPNEA. One of the ex-
citing discoveries made during the examination of the objects was the high incidence
of branded furniture in Portsmouth during the early nineteenth century. Nearly fifty

names of Portsmouth owners were discovered on branded items (*see appendix B*).

While the field work was underway, three researchers for the project surveyed documents at fifty libraries in the Portsmouth area. Their efforts produced an impressive array of documentary material, which has helped us to understand the furniture industry better and to know more about local patrons and their use of furniture.

Preparation of the exhibition and catalogue was assisted in great part by a planning grant from the National Endowment for the Humanities. The grant enabled us to form a group of consultants, guided by James L. Garvin, Architectural Historian for the State of New Hampshire, Gerald W. R. Ward, formerly Curator of the Strawbery Banke Museum and now Associate Curator, Museum of Fine Arts, Boston, Dr. Laurel Thatcher Ulrich, Professor of History at the University of New Hampshire, and Philip Zea, Curator of Historic Deerfield, Inc., who suggested interpretive themes and an organizational outline for the show. The grant also allowed us to prepare a preliminary design for installation of the exhibition at The Currier Gallery of Art in Manchester, New Hampshire.

From the pictorial archive, I chose 117 objects for the catalogue. The book is more comprehensive than the exhibition, including furniture dating from as early as 1675, and extends beyond a simple cataloguing of the salient characteristics of the objects to tell the story of the development of Portsmouth furniture. Some pieces closely resemble those made elsewhere; others emphasize the originality of individual makers. Both the ornate and the ordinary are represented, though the former predominate. Three essays provide an overview of the historical and architectural scene and the business of making furniture in Portsmouth. The appendices include a checklist of Portsmouth-area craftsmen, which is the most comprehensive list published to date, as well as the checklist of branded furniture.

This project focuses attention for the first time on the furniture of Portsmouth. It reflects four years of full-time work but has been in the planning stage for more than a decade. Its success results from the dedication, enthusiasm, and perseverance of the staffs of SPNEA and other New England museums, consultants, volunteers, interns, collectors, dealers, and funding organizations. In particular, I wish to acknowledge the support of Nancy R. Coolidge, former Director of SPNEA, who recognized the significance of the material our research had uncovered and never wavered in her commitment to the project. Jane C. Nylander, who assumed the position of Director while the book was in its final phases, has been equally energetic in ensuring its completion.

The initial research and planning stages of the project occurred through the hard work of a number of individuals. Johanna McBrien, Research Assistant, provided valuable input during the National Endowment for the Humanities planning period and assisted with most of the field work and documentation survey. In addition, she wrote a substantive essay on furniture making in the nineteenth century. Diane Carlberg Ehrenpreis, Assistant Curator, worked tirelessly on all aspects of the project, contributing research, entries, checklists, bibliography, and editorial assistance for this book. She also provided valuable input on the exhibition, overseeing the installation of a partial replica of a parlor from the Jaffrey house, writing text panels, and leading docent training. David Bohl, SPNEA Staff Photographer, devoted much of the past four years to documenting Portsmouth furniture through his superb photographs, which contribute so much to the lasting value of the book. William Upton, a collector and scholar of New Hampshire furniture, became a key participant in the project, generously sharing his time and expertise on numerous tasks. He assembled files on every piece of Portsmouth furniture pictured in *Antiques,* examined pertinent court records at the New Hampshire State Archives, ar-

ranged for me to see many pieces of Portsmouth furniture in private collections, and was an insightful reader of the catalogue text.

Carolyn Eastman and Kevin Shupe of the Portsmouth Athenaeum, and Johanna McBrien and William Lyman conducted a thorough search of Portsmouth-area libraries, discovering a wealth of information relating to Portsmouth furniture. Kevin Shupe also organized the detailed checklist of Portsmouth craftsmen. Anne Rogers Haley, Myrna Kaye, Richard Nylander, SPNEA Chief Curator, Elizabeth Redmond, Robert Trent, Curator in Charge of Furniture at the Winterthur Museum, and Philip Zea all contributed entries to the book marked by scholarship, expertise, and insight. James Garvin prepared a masterful introductory essay, and Kevin Nicholson kindly agreed to organize the checklist of branded furniture. Nancy Curtis, SPNEA Publications Director, provided wise editing and overall shaping of the catalogue and produced related brochures for the exhibition. Linda Woolford assisted with manuscript editing. I am deeply indebted to Jane and Richard Nylander, who reviewed the entire manuscript and gave me the benefit of their combined expertise on Portsmouth and domestic furnishings. Richard Candee generously shared his research on Portsmouth neighborhoods with us and served as a reader for the catalogue. Gerald W. R. Ward performed a masterful job of copy-editing on a grueling schedule as well as writing fourteen entries for the catalogue. Lorna Condon, Curator of the SPNEA Archives, provided archival material for the project. Johanna Gurland coordinated our fundraising efforts, and Barbara Jobe helped to organize project files.

Individuals, both staff and volunteers, who assisted in the preparation of the exhibition have also worked with enthusiasm and dedication. Tara Hingston Cederholm, Exhibition Administrator, oversaw all registrarial aspects of the exhibition with great diligence and performed many research tasks. Elizabeth Redmond coordinated the administration of both the exhibition and the book during an early phase of their development. At The Currier Gallery of Art, I extend thanks to Marilyn Hoffman, Director, Michael Komanecky, Curator, Susan Leidy, Special Projects Administrator, Timothy Johnson, Registrar and Preparator, and the rest of the staff and installation crew for their effective collaboration on the exhibition's first showing; I am also grateful to the late Robert Doty, former Director of the Currier, for his initial invitation to host the exhibit at The Currier. Judy Downes, of the Museum of Fine Arts, Boston, and Betsy Bailey, of Graphic Graphics and Design, created an installation design that is visually stimulating and interpretively rich. Allan Breed contributed his expertise in making reproductions for the exhibition. Robert Adam and the preservation carpentry students of North Bennet Street School, Boston, are congratulated for their fine craftsmanship in recreating the Jaffrey Parlor. From the SPNEA staff, Ellen Garbarino, Program Coordinator, organized programs in conjunction with the exhibit, and Barbara Levy, former Director of Education, and Martha Pike, Director of Collections and Archives, helped prepare text panels for the show. We are grateful to William Hosley and Linda Ayres from the Wadsworth Atheneum and Barbara Nosanow, Director of the Portland Museum, and Martha Severens, former Portland Museum curator, for their enthusiastic support in arranging for the exhibition to be viewed at their museums.

Dedicated interns and volunteers contributed hundreds of hours researching Portsmouth furniture and preparing material for the book and exhibition. They include: Margaret Clarke, Tom Denenberg, Eleanor deRopp, Victoria Fraser, Jennifer Landry, Susan Snell, Nicholas Steward, Isabel Taube, and Amy Werlin.

Many objects in the exhibition and catalogue benefited from careful conservation by the staff of the SPNEA Conservation Center. Robert Mussey, former SPNEA Furniture Conservator, prepared treatment proposals, with the assistance

of Kevin Green. The following conservators were involved in treating the furniture: David Arnold, Anne Battram, Susan Buck, Joseph Godla, Kevin Green, Gisele Haven, Elizabeth Lahikainen, Karen Mirholm, David Mitchell, Gerald Nadeau, Brian Powell, Georgette Rudes, Marcy Sumner, Christine Thomson, and Joseph Twichell. The staff was assisted by conservation consultants Joan Parcher and William Young. Our thanks to Mervin Richard, Deputy Chief of Conservation, National Gallery of Art, whose expertise on climate control aided us in the installation of the exhibition, and to Bruce Hoadley, University of Massachusetts, for microscopic wood analysis.

The project would not have been possible without access to Portsmouth furniture. I visited 230 sites and was heartened by every owner's generous spirit of cooperation. In particular, I would like to thank Albert, Harold, and Robert Sack, Deanne Levison, and Dean, Bernard, and Frank Levy, who made their extensive files as well as extraordinary knowledge available to me at every turn; Robert and Joseph Lionetti, who allowed me access to the John Walton archive; Bert Denker, head of the Decorative Arts Photographic Collection and the research facilities at the Winterthur Museum; Neville Thompson, Librarian of the Printed Book and Periodical Collection at the Winterthur Museum; Philip Zimmerman, former Chief Curator at the Winterthur Museum; Strawbery Banke Museum staff, especially Greg Colati, Karin Cullity, Rodney Rowland, Carolyn Roy, and Gerald W. R. Ward; Nancy Goss, who generously shared her research on the Moffatt and Ladd families and arranged access to the Moffatt-Ladd House; Sandy Armentrout, SPNEA's Piscataqua regional administrator, who facilitated access to SPNEA's properties; Barbara Myers, who provided us with access to the Old Parsonage in Newington as well as the Wentworth-Gardner House in Portsmouth; Ron Bourgeault, who generously shared his resources and expertise throughout this project; Clark Pearce; Peter Sawyer; Scott Bassett; and Luke Beckerdite, Executive Director of Chipstone Foundation.

The elegant design of this volume is the work of Lisa DeFrancis, Greg Galvan, and Malia Preble of DeFrancis Studio. They have made a long, complex manuscript attractive and comprehensible.

We are indebted to the National Endowment for the Humanities for its initial support in funding this project, to an anonymous benefactor, to William E. Gilmore and Terri C. Beyer, Clipper Affiliates, Durham, New Hampshire, and to Mr. and Mrs. E. G. Nicholson, whose generous gifts enabled the project to move from planning stages into the products of the exhibition and catalogue. The grandeur of this volume results from the special support of the Nicholsons. Their unfailing encouragement has ensured a product of the highest quality. Subsequent solicitations brought in additional gifts and led to the successful completion of the project. We are deeply grateful to all our contributors, whose support has made it possible to focus attention on one of early America's most significant centers of furniture making.

1. Tolles 1984, 4–5.

2. "Two Hundredth Anniversary," 266–69.

3. Brewster 1869, 355.

4. Decatur 1937; Decatur 1938; Comstock 1954; Buckley 1963; Michael 1972; Rice 1974; Michael 1976; Kaye 1978; Jobe 1987.

SUPPORTERS OF THE PROJECT

BENEFACTORS

Anonymous

William E. Gilmore and Terri C. Beyer, Clipper Affiliates, Durham, New Hampshire

Mr. and Mrs. E. G. Nicholson

PATRONS

Anonymous

The Chipstone Foundation

The Chubb Group of Insurance Companies

The Lynch Foundation

The National Endowment for the Humanities

Mr. and Mrs. Joseph P. Pellegrino

SUSTAINERS

Anonymous

Ronald Bourgeault

Elizabeth Carter Fund of the Greater Portsmouth Community Foundation

Chatam, Inc.

New Hampshire Charitable Foundation

Marguerite Riordan

The Sack Foundation

Skinner, Inc.

Barbara Wriston

DONORS

Theodore and Barbara Alfond

Mrs. Ichabod Francis Atwood

William N. Banks Foundation

Mrs. Charles F. Batchelder

The Boston Foundation

Charles E. Buckley

Frank and Irja Cilluffo

William O. DeWitt, Jr.

Dietrich American Foundation

H. Richard Dietrich, Jr.

Eldred Wheeler Company, Inc.

Jameson S. French

Martha and John Hamilton

Mr. and Mrs. Donald E. Hare

William B. Hart and Constance Eaton

The Henley League, Ltd.

Alen Hollomon

Mason J. O. Klinck

Barbara M. Marshall

New Hampshire Humanities Council

C. L. Prickett Antiques

Peter J. Sawyer

Mr. and Mrs. Roger Servison

Joseph Peter Spang

Mr. and Mrs. Frederick Vogel III

William G. Waters

Stanley and Beth Weiss

Sumner and Helen Winebaum

Eric Martin Wunsch

CONTRIBUTORS

Allendale Insurance Foundation

Robert L. and Susan B. Aller

Jo Barher

Mr. and Mrs. John D. Barnard

Roland and Joyce Barnard

Richard J. Bertman

Hollis E. and Trisha A. Brodrick

Christopher E. Bryant

Philip A. and Doris Budrose

Desiree Caldwell and William Armitage

Christie's

Geoffrey E. and Martha Fuller Clark

Rhoda Shaw Clark

Mr. and Mrs. Thomas M. Cole

Mr. and Mrs. Richard D. Conant

Hugh Crean

Miss Irene Crosby

Frederick M. Danzinger

Margot E. Davis

Digital Equipment Corp.

Peter H. Eaton

Berry R. Eitel

Famous Brand Shoes, Inc.

J. Michael Flanigan

Mr. and Mrs. John M. Flentje

Samuel A. Frederick

Mrs. Herbert Gasque

Robert G. Goelet

Vira L. M. H. Goldman

Mr. and Mrs. C. Lane Goss

Lane W. and Nancy D. Goss

John F. and Anne R. Haley, Jr.

Roland B. Hammond, Inc.

George B. Handran

Donald M. Hayes

Mr. and Mrs. Morrison Heckscher

Mr. and Mrs. Warren R. Hedden III

Mr. and Mrs. Gerard C. Hellman, M.D.

Mr. and Mrs. Booth Hemingway

The Henkel Harris Company, Inc.

Mr. and Mrs. Daniel G. Hingston

Mr. and Mrs. Kenneth Hipkins

David L. Hopkins

Mrs. Robert S. Horner

Mr. and Mrs. William White Howells

Jonathan V. and Ann Hubbard

Mr. and Mrs. James Hutchinson

Mrs. Kennett R. Kendall

Leigh Keno American Antiques

Nancy Kollisch, M.D., and
Jeffrey H. Pressman, M.D.

Deanne D. Levison

Bernard and S. Dean Levy, Inc.

Jack L. Lindsey

Michael A. Loeb

Douglas Long

L. V. Mawn Corporation

Mary D. Merrill

George E. and Bette Michael

Ms. Lee Hunt Miller

Mrs. Norman F. Milne, Jr.

Mr. and Mrs. John H. Muller

Mrs. A. M. Murray

Matthew Newman

Charles S. Nichols

Mr. and Mrs. Donald O. Nylander

Mrs. L. Phippen Ogilby

Katharine S. Overlock

Joan D. Pratel

Todd D. Prickett

Mr. and Mrs. William C. Reynolds

Frank Rothstein

Barbara Rowland

Mr. and Mrs. George F. Sawyer

Schumacher

Timothy H. Smith

Sotheby's

Mr. and Mrs. Clinton H. Springer

Mr. Robert Stenger

Mr. David Stockwell

Mrs. Stanley Stone

Mr. and Mrs. Thaxter Swan

Dorell Moulton Tanner

Dr. and Mrs. Irvin Taube

Eulalia C. Tevriz

Ms. E. C. Titus

Brian B. Topping

Laurel Thatcher Ulrich

Richard F. Upton

William W. Upton

Michael J. Valente, Inc.

Mr. and Mrs. S. Thompson Viele

Anna Glen B. Vietor

Walton Antiques, Inc.

Mr. and Mrs. Matthew Weatherbie

David A. Webber

Peter M. and Natalie L. Webster

Kemble Widmer II

Mrs. Elaine Wilde

Sanford S. Witherell

Richard W. Withington, Inc.

Barbara K. Zeisler

"THAT LITTLE WORLD, PORTSMOUTH"

James L. Garvin

FIGURE I.

Piscatway River in New England, *ca. 1660.*
Ink and color wash on vellum, H. 25¼; W. 37¼.
By permission of the British Library, British
Museum, London.

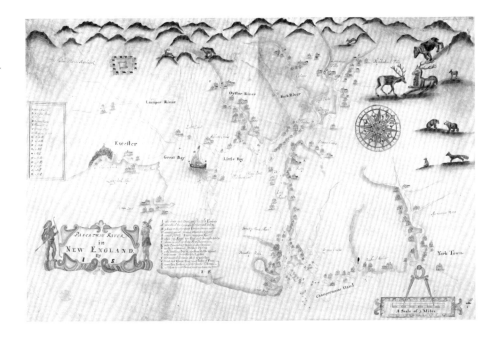

THE FIRST ENGLISH SETTLERS who arrived at Piscataqua in the early 1620s disembarked in a land that would yield most of the necessities of life. The region was marked by a rock-bottomed tidal river with so swift a current that the channel never froze. Upstream, a series of small but navigable streams fed into a broad estuary called Great Bay, offering easy access to extensive forests and giving the promise, in due time, of waterside farms and villages with easy water communication with each other and with the limitless world of the Atlantic. The lands on the east side of this river system were granted by the Council of Plymouth to Sir Ferdinando Gorges, and would be called Maine. The lands to the west were granted to Captain John Mason and others, and would take the name of New Hampshire. From the time of first settlement, the entire region saw itself as one; the British government gave the district the name of Piscataqua after it established a customs jurisdiction here in 1680, and it was under this name that merchants and mariners from around the world knew the port.

The Piscataqua region was lavish in one commodity. Limitless forests overspread the region, often directly accessible from navigable streams that fed Great Bay and the main river. The single forest species of greatest economic and architectural importance was *Pinus strobus*, the eastern white pine. Affording superior masts and spars, white pine quickly became a resource of strategic importance to the Royal Navy.[1] It also remained important through the early nineteenth century as a framing and sheathing material for buildings, and as the preeminent material for ar-

chitectural joiner's work. Several native hardwood species, notably the maples, the birches, and black cherry, were valued as cabinet woods and were being utilized by local joiners early in the eighteenth century.

The sea around the Isles of Shoals, just off the coast, had been famous for rich schools of cod long before Englishmen attempted actual settlement in the 1620s. The first settlers took advantage of the bounty and the reputation of these fishes, establishing a thriving year-round fishery that largely sustained the Piscataqua settlements until the far larger Newfoundland fishing grounds supplanted the Isles of Shoals in the 1670s.[2]

The eventual decline of the local fishery reinforced the focus of the Piscataqua settlers on their most bountiful natural resource. As early as the spring of 1634, Captain John Mason had sent three carpenters to the Piscataqua River with the task of building a water-powered sawmill and a stamping mill for grain. At about the same time, Sir Ferdinando Gorges erected a second sawmill nearby in present-day York, Maine. By the mid-1600s a vigorous lumbering industry developed from these halting beginnings. About 1660, the cartographer "I.S." (probably John Seller from London) produced an elaborate map of Piscataqua (*fig. 1*) intended to show "how Englands strength doth lye / unseen in *Rivers* of the new Plantations." This survey indicates no fewer than fifteen sawmills in operation upon the river system. By 1700 investors had built more than sixty sawmills between Hampton, New Hampshire, and Casco, Maine.[3] Jonathan Bridger, Surveyor-General of the King's Woods between 1705 and 1718, stated that his inquiries revealed at least seventy sawmills within a day's ride of Portsmouth in 1706.[4] The presence of these machines rendered Piscataqua one of the most heavily industrialized regions of colonial North America and established an economic base upon which a mercantile economy slowly took form.

The production of the sawmills of Piscataqua became prodigious. In the year between the summers of 1718 and 1719, the port exported some 915,000 feet of pine boards and 55,000 feet of pine joists.[5] By 1768, Piscataqua's shipment of pine boards had risen to over twelve million board feet. In the five years between the autumns of 1770 and 1775, over a thousand vessels left Piscataqua for the West Indies, southern Europe, and Africa. These ships carried nearly seventy-four million board feet of sawn pine planks and boards, plus almost forty-two million hand-split shingles and some 98,000 clapboards, also made by hand.[6]

With this vast manufacture as a base, the port of Piscataqua began to see the rise of a merchant class, most of whom lived in Portsmouth and contributed to the growth of that town as the metropolis of the region. In a pattern that would be repeated until well after the Revolution, the first of Portsmouth's merchants arose during the 1680s by combining native intelligence, experience as ship masters, alliances with upriver loggers and millmen, and good marriages that concentrated economic power within their own families.[7]

Taking advantage of relative independence from British control, these merchants very early developed trade patterns that would persist until the Revolution, providing Portsmouth with a special trading niche in the Atlantic community. Sometime before 1680, Portsmouth established strong ties with Newfoundland and the southern colonial ports, with the Caribbean, with southern Europe (especially Spain and Portugal), and with Great Britain. Portsmouth shipping would eventually come to dominate the Caribbean trade, carrying some seventy percent of the tonnage arriving in the West Indies.[8]

Throughout most of the seventeenth century, the Piscataqua settlements were under the direct political control of Massachusetts. In 1679, however, Charles II saw fit to establish New Hampshire as a separate province with its own charter. Al-

though New Hampshire continued to share a governor with the larger and more powerful colony to its south for the greater part of its history until 1740, the new province had its own lieutenant-governor, council, and assembly.

The charter gave New Hampshire, and particularly Portsmouth, a mechanism for further controlling and strengthening its own economy. As New Hampshire entered the eighteenth century, this economy was guided by a new generation of young merchants, most of them united by marriage and by common financial interests. By the 1720s, merchant John Wentworth (*fig.* 2) was lieutenant-governor, and his council was made up of fellow merchants who shared his interests and, in several cases, were related to him by marriage.[9] Although the region's economy had been depressed by the dangers and uncertainties accompanying King William's War (1689–97) and Queen Anne's War (1702–13), the period following the Peace of Utrecht in 1713 brought a quick resurgence in shipping. The mercantile and political leaders saw their fortunes prosper through a continuing increase in both import and export traffic, a growth in the population (and hence the internal market) of the province, and a steady strengthening of trade in lumber products and naval stores with Great Britain, Newfoundland, and the Caribbean.[10]

The period of John Wentworth's lieutenant-governorship marked the first expansion of New Hampshire beyond the bounds of its original four towns of Dover, Portsmouth, Exeter, and Hampton. John Wentworth was a natural leader in this enterprise. In 1714, two years after being appointed to the New Hampshire council, Wentworth had joined John Ruck (whose daughter would marry Wentworth's son Benning) and other substantial merchants of Boston in purchasing a seventeenth-century claim for lands near Merrymeeting Bay in Maine. Calling themselves the Company of Pejepscot Proprietors, the merchants employed Robert Temple of Ireland to recruit Irish Presbyterian immigrants to settle the land.[11]

Wentworth saw several advantages in employing the Pejepscot model in New Hampshire. First, as a lumber merchant and as kin to other lumber and mast merchants, Wentworth could profit from opening new territories for masting and sawmilling. Second, by placing settlers on the frontiers, Wentworth could strengthen New Hampshire's territorial claims in a long-contended boundary dispute with Massachusetts. Third, by acquiring empty and almost worthless lands and by inducing settlers to occupy these or nearby lands, Wentworth and his fellow investors could reap profits as the settlers' labors gave value to what had been a wilderness. Wentworth's leadership thus established a clear bond between the traditional seaward-looking interests of the Portsmouth elite and a new landward-looking enterprise on the frontier.

In 1722, the New Hampshire government laid out a line of new townships beyond the original four towns of the province. Beginning with Londonderry (which had already been occupied by a group of Irish Presbyterian settlers) on the southwest, these new townships included Chester, Nottingham, Barrington, and Rochester. Some of these tracts were granted to taxpayers in Dover and Portsmouth, affording families in these old communities room to expand and land to sell; other townships included grantees from Boston or elsewhere in Massachusetts, providing a new source of settlers or investors.

Several of these townships were laid out according to a new type of plan. Dispensing with any semblance of a compact village, the proprietors of towns like Rochester and Barrington laid out their lots in tier after tier of separate farmsteads, each tier separated from adjacent rows of lots by straight "range roads."[12] The idea of gridding new lands appealed to the merchant proprietors, who saw land as a commodity, and also to settlers, most of whom valued the freedom afforded by single large landholdings more than the comfort of living in a compact village.

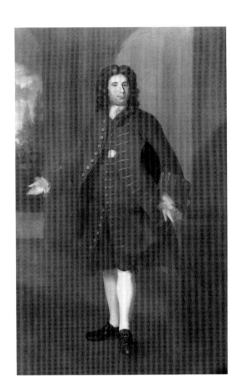

FIGURE 2.

Lieutenant-Governor John Wentworth, *by Joseph Blackburn (1727–92), ca. 1760. Oil on canvas, H. 93½; W. 58 (including frame). New Hampshire Historical Society, Concord, New Hampshire, 1969.30.1.*

No better explanation of Wentworth's strategy for profiting from his frontier landholdings can be found than a letter he wrote in 1729 to former governor Samuel Shute:

> If you could Incourage some families to come over from England to settle your farms, it would do verry well. You will be Oblidged to Support them for four or five years [with] a small house & Barn, Two Oxen, two Cows, twenty bushells Corn & a barrell flesh...the man being oblidg'd to fence in proper fields And to Clear twelve or fifteen Acres of land within the time and then deliver it up, or to agree on a rent for time to come.[13]

Although it might take some years for such investments in land to return real benefit to Portsmouth merchants, the laying out and peopling of new townships would continue to occupy New Hampshire's wealthiest families for several generations.

The period following the end of Queen Anne's War saw more than a resurgence of Piscataqua's shipping and an expansion on the frontiers. From this period dates a house which reveals a sudden advancement of wealth and sophistication in Portsmouth.

In the spring of 1715 and in the following months three joiners sailed from Britain, stayed briefly in Boston, and settled at Piscataqua. Not much is known about two of these men, Hugh Montgomery and Mark Haddon. But the third joiner, John Drew, brought with him an urban experience that would transform Piscataqua architecture, and probably Piscataqua furniture making, within a few years of his arrival. Drew's influence did not end with his death about 1738; his son-in-law, Michael Whidden II, and his grandson, Michael Whidden III, transmitted the high standards of Drew's British training down to the 1780s, to the very eve of the introduction of the newer Adamesque or Federal style.

Soon after arriving at Portsmouth, Drew found employment as master builder of a great brick house for merchant Archibald Macpheadris (*fig. 3*), Lieutenant-Governor Wentworth's son-in-law. In keeping with a tradition that would long persist in the region, Drew acted both as joiner on this job and as superintendent of other tradesmen, surveying or measuring their work to verify their charges to the owner of the new house.

Drew was no ordinary craftsman. His British experience had prepared him well for the versatile role he would play at Piscataqua. His surviving account book reveals that he had engaged in many enterprises at Deptford, near London, where the Royal Dockyards created many opportunities for craftsmen in the early eighteenth century.[14] As might be expected of a joiner in a shipbuilding town, Drew finished the cabins of vessels of many sizes and types, besides doing a multitude of other kinds of ship's work. He frequently worked as a joiner on houses and other buildings. He made furniture, including a billiard table, and also fashioned items as humble as hen coops for ships and coffins. He participated in Deptford's major building project during the first decade of the century, the construction of rows of connected houses along both sides of Union (now Albury) Street on land owned by bricklayer and developer Thomas Lucas.[15] By 1707, Drew owned six houses in Deptford, mortgaging them to raise capital.[16] Drew's versatility and familiarity with the work of several trades would serve him well at Piscataqua.

Drew was a curious and well-educated man who speculated upon many areas of learning. Much of his account book is devoted to notes on "dialing" (the construction of sundials for various latitudes and azimuths), on geometry, on the extraction of square and cube roots, on navigation, and on the proportioning of masts and spars to ships. More significantly, Drew alludes to Palladio's rules for the proportioning of columns in *The Four Books of Architecture*, which reveals his familiarity with the source book of the architectural style that he would introduce into New Hampshire.

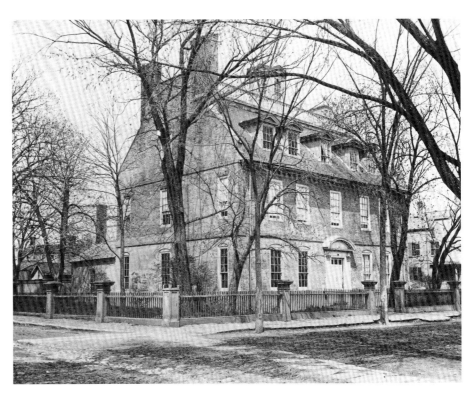

FIGURE 3.

The Macpheadris–Warner House, Portsmouth, New Hampshire, 1716. Photograph by Davis Brothers, ca. 1890. Archives, Society for the Preservation of New England Antiquities, Boston, Massachusetts.

The great brick house that Drew built for Macpheadris reflected in its design and detailing many of the current London fashions then being introduced in the suburb of Deptford by developer Lucas.[17] Drew used his urban experience in planning Macpheadris's house, placing the chimneys against outer walls and employing diagonal fireplaces in the manner of the row houses of Deptford, and setting off the "Great Stairs" of the dwelling behind pilasters and "two double arches" in the fashion of the entries of Deptford houses. Having an unlimited supply of native white pine at his command, Drew was lavish in his joiner's work. The interiors he fashioned for Macpheadris are richly paneled and wainscoted, with panels in several rooms framed and raised above their wall surfaces by bolection moldings, which were probably made with the same planes Drew had used in Deptford to "stick" his 2" and 2½" "pullexsions."

Drew had worked as a painter and as a surveyor of the work of other painters in Deptford. He continued this practice in Portsmouth, charging Macpheadris for 1,233 square yards of painting, which included the graining of the floor-to-ceiling paneling of the west front room of the Macpheadris house. Drew described a different and even more resplendent style of decoration when he told of a ship's cabin he paneled and painted for Captain Joseph Warren in Portsmouth in 1722. This was a "Square State room" with "Sashes and Lockers" and a "hansom beaufait & raised Arched pannels," reminiscent in its joinery of the east parlor of the Macpheadris house. Of this ship's cabin, Drew recounted,

> I was painting of Capt. Warrens great Cabbin and he asked me what Couler I designed to paint it with. I told him I should do all plain & of one Colour & he said that he would have the Moldings done with vermilion the sides or mergents [of the panels] with green & the Collums with blew.[18]

It is fitting that the style of the Renaissance, of Palladio, should have been introduced to Portsmouth by a craftsman who was himself so fully a product of the Renaissance. Drew's example was passed to several apprentices and co-workers, and through them established an extraordinarily high standard of craftsmanship in a community that probably numbered only 3,500 inhabitants in 1740.

Throughout the pre-Revolutionary period, other British-trained craftsmen settled in Portsmouth, adding their training and breadth of experience to the craft traditions of Piscataqua. Such a man was turner (lathe-worker) and joiner John Mills, who served his apprenticeship with turner John Palmer of Bristol between 1708 and 1715. Mills came to Portsmouth around 1725, and was clearly the originator of the distinctive type of balustrade, with its three different baluster patterns, that characterized houses of the region until after the Revolution.[19]

The decades following Drew's construction of the Macpheadris house were a period of consolidation of the new Palladian or Georgian style. A number of Piscataqua merchants built grand houses during these years, but only a few have survived. One of these stands at Kittery Point, Maine, across the river from Portsmouth. This is the large, wooden, gambrel-roofed dwelling of Sir William Pepperrell, merchant and investor in Maine lands. Other grand Piscataqua houses of the period have been demolished, sometimes with hardly a description of their appearance. Among them are the Kittery dwellings of Nathaniel Sparhawk and Andrew Pepperrell, and the Portsmouth houses of Mark Hunking Wentworth, Theodore Atkinson, Nathaniel Meserve, and George Jaffrey.

Jaffrey's house, said to have been built around 1730 on land purchased as early as 1699, was an unusually large, hip-roofed dwelling with two rear wings that created a U-shaped floor plan. Its western front parlor was finished with a paneled fireplace wall with Corinthian pilasters, window seats, and a bold cornice, but its paneling was without the bolection moldings often seen in earlier or contemporary grand houses. By dispensing with these heavy, baroque moldings and by relying instead on carefully proportioned panels and pilasters with carved capitals to articulate its walls, the room offered a prototype of the style of joinery that would predominate at Piscataqua from the mid century. The house did, however, possess at least one intricately carved beaufait or corner cupboard (*cat. no. 4*) of the type introduced and often used by John Drew in the years after 1715; this is the most elaborate example of its type known in Portsmouth.

During these same decades, Portsmouth merchants were intent on enlarging and elaborating their sources of income. The period from 1725 to 1750 witnessed a dramatic mercantile expansion that bore fruit by mid century in a new generation of grand houses, in a notable increase in the display of personal wealth among the oligarchy, and in social stratification which strengthened the status of those few families that had seized wealth earlier in the century.

Portsmouth merchants continued to widen their timber markets, well aware that gluts could occur in any one area and that their continuing prosperity would depend upon having ready buyers in other regions. In addition to the crucial Caribbean market, Piscataqua merchants were able to stimulate a demand for New Hampshire pine, oak, clapboards, shingles, and staves in Newfoundland and northern Europe as well as in their older markets in Great Britain and southern Europe.[20] The trade in masts and spars with the Royal Navy continued to be a mainstay of the regional economy. This commerce was narrowly channeled through an English contractor to one or two Portsmouth agents. After 1743, the contractor was John Thomlinson of London, who also served as New Hampshire's paid agent or lobbyist at court; the local agent was Mark Hunking Wentworth; and the Surveyor of the King's Woods, who oversaw the traffic in naval stores, was Governor

Benning Wentworth, Mark Hunking Wentworth's elder brother.

Piscataqua merchants had long been involved in the Grand Banks fisheries, which had supplanted the local Isles of Shoals industry. These merchants shrewdly developed a new trading niche by becoming middlemen in the transport of New-foundland and Canso fish to markets in the Caribbean and Catholic Europe, and by supplying the markets at the fishing stations with raw materials from New Hamp-shire and with manufactured goods from New England and Britain.[21]

New Hampshire also slowly increased its exports of manufactured goods. Chief among these were the very vessels that carried cargoes to distant ports. Piscataqua ships earned a sound reputation in the Atlantic marketplace, and many captains were instructed to sell vessel as well as cargo if a favorable opportunity pre-sented itself.[22] Piscataqua shipyards showed slow but steady increases in the ton-nages of vessels they built; in the half-century after 1695, New Hampshire-built vessels employed in the overseas carrying trade increased fourfold in number and tenfold in carrying capacity, bringing Piscataqua to the rank of New England's sec-ond or third largest shipbuilding center by the 1740s.[23]

But ships were only the largest of the complex products exported from Piscataqua. Archibald Macpheadris had begun exporting house frames to Lisbon by 1715.[24] The Caribbean became a good market for such frames, and sometimes for the joiner's work to finish them as livable houses. By the period between 1770 and 1775, Piscataqua merchants shipped no fewer than 147 house frames in twenty-eight separate shipments.[25] Small boats, notably the "moses boats" used as tenders for ships in the Caribbean, were also a popular New Hampshire product; some 346 of them, together with 124,000 feet of oars, were sent from Piscataqua between 1770 and 1775. Other well-built but utilitarian New Hampshire products that found a ready overseas market included carts, axes, oxbows, handspikes, treenails, miscellaneous woodenwares, and bricks.[26] The export of furniture, more fully de-scribed in the following essay, also rose from small beginnings in the second decade of the century to extraordinary levels from the 1740s through the 1770s. Limited quantities of native cabinet woods like black birch, regarded as "almost equal to Mahogany," were also sent to England "on tryal for the Cabinet Makers" there.[27]

If the enterprise of New Hampshire lumbermen, mariners, and merchants brought commercial good fortune to the province during the first half of the cen-tury, the diligence of New Hampshire's political leaders multiplied that good for-tune manyfold. Throughout its history, New Hampshire had been constrained in its growth by two ancient land claims. The first claim arose out of the original charter of Massachusetts, given by Charles I in 1629, which established the northern bor-der of that province as lying "three English miles to the northward of the… Merrimack River, or to the northward of any and every point thereof." Because the Merrimack turns almost due north at Pawtucket Falls (now Lowell, Massachusetts), Massachusetts appeared by this language to gain a claim to all territory below present-day Franklin, New Hampshire.

Although New Hampshire generally accepted the Massachusetts interpreta-tion of the provincial boundary throughout the period of Indian troubles early in the eighteenth century, Lieutenant-Governor John Wentworth began to challenge this limitation in the 1720s, as his new township grants quickly filled what little ter-ritory was indisputably New Hampshire's. Driven by an interest in expanding New Hampshire's population and resources, Wentworth inaugurated a patient and com-plex campaign to discredit the Massachusetts interpretation of the border. After Wentworth's death in 1730, his cause was taken up by a growing faction of Ports-mouth merchants who dreamed of unbridled expansion into the interior lands west of the Merrimack River.

This campaign was greatly aided by John Thomlinson, New Hampshire's tireless and well-connected agent at court after 1734. Closely allied with the Piscataqua merchants by a multitude of commercial connections, Thomlinson expended great energy and ingenuity to further New Hampshire's claim for expanded territory. Largely due to his diligence in assembling formidable documentation, and partly because of a long-standing prejudice at court against Massachusetts's traditional independence, the Privy Council decided in 1740 that the border between the two provinces should run three miles north of the Merrimack River only to the point where the river turns north; from a point above Pawtucket Falls, the boundary would run due west "till it meets with his majesty's other governments."[28]

This royal decree exceeded even New Hampshire's most hopeful expectations, giving the province a number of townships already laid out and partly settled under Massachusetts's authority and opening up territories that extended far west of the Connecticut River.

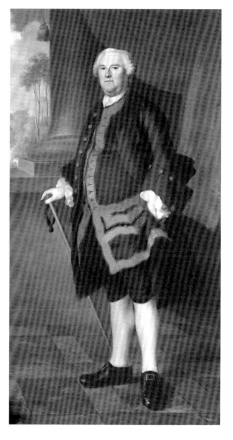

But greater fortune awaited New Hampshire when the British government decided to provide the expanded province with its own full royal governor. Again largely due to John Thomlinson's influence, this post was conferred in 1741 upon Benning Wentworth (*fig. 4*), a son of the late Lieutenant-Governor John and a well-connected merchant who was facing bankruptcy because of the refusal of Spanish authorities to pay large debts they owed him.[29] Within a few months, New Hampshire was transformed from a tiny province of a few townships to a vast territory with vague western limits, and had taken control of its own government. When Wentworth also purchased the Surveyorship of the King's Woods for himself in 1743, the Portsmouth oligarchy, and especially the Wentworth family, matched their already extensive mercantile interests with unparalleled control over the land and raw materials of northern New England.

The second land claim that had clouded New Hampshire's title to its eventual territory derived from the original grant by the Council of Plymouth to Captain John Mason in 1629. Mason's heirs claimed private ownership of all lands in New Hampshire within a great arc having a radius of sixty miles from Portsmouth harbor. This huge tract was officially estimated at 200,000 acres but actually exceeded two million. In 1746, largely thanks to patient negotiations by John Thomlinson, a group of Portsmouth merchants were able to purchase this huge tract for themselves. These men included Benning Wentworth's brother-in-law, Theodore Atkinson; his brothers Mark Hunking and John, Jr.; seven others who were related to the governor by marriage; and Thomlinson himself.

The Masonian Proprietors, as they called themselves, began to grant townships on these lands late in 1748, having already received thirty-one petitions for such grants in various parts of their territory. The proprietors immediately returned to the concept of the "range township" as it had evolved in some of the grants made in the 1720s under Lieutenant-Governor John Wentworth, laying out regularly sized farm lots in rows extending from border to border within each township, and separating these lots by range roads. To encourage settlement, the proprietors generally granted lands free of charge to responsible applicants, reserving to themselves a generous portion of each township to be disposed of later when the efforts of neighboring settlers had increased its value.[30]

As Benning Wentworth watched the successful application of this principle among the Masonian Proprietors, he was naturally eager to emulate their success. Thanks to the generous boundary determination of 1740, Wentworth had vast ungranted territories under his jurisdiction, and his royal instructions of 1741 had encouraged the settlement of townships, each to encompass about 20,000 acres, "on the Frontiers of your Province." Interpreting this phrase in an expansive manner, he

FIGURE 4.

Governor Benning Wentworth, *by Joseph Blackburn (1727–92), 1760. Oil on canvas, H. 93½; W. 58 (including frame). New Hampshire Historical Society, Concord, New Hampshire, 1969.30.2.*

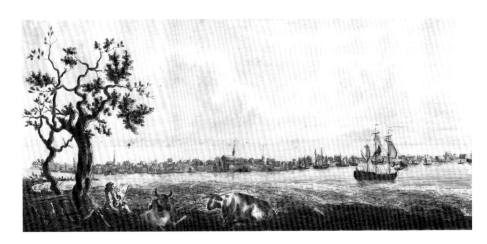

FIGURE 5.

*A View of Portsmouth in New Hampshire
Taken from the East Shore, from* The
Atlantic Neptune, *1778. Colored etching,
H. 25½; W. 11⅞. Peabody and Essex Museum,
Salem, Massachusetts, the Augustus P. Loring
Collection.*

began his program of land grants with the chartering of Bennington in the south-
west corner of present-day Vermont in 1750. In the next four years, Wentworth
made sixteen such grants; by the time he left office in 1767, he had chartered 138
new towns west of the Connecticut River and many more east of the river.[31]

By 1750, then, New Hampshire's merchants had solidified both a trading em-
pire that encompassed virtually every Atlantic market they chose to develop, and a
land empire that included millions of acres. A natural result of these varied enter-
prises was an increase in visible prosperity in Portsmouth during the period before
the Seven Years' War (1756–63), the final French and Indian conflict. Travelers to
the port remarked upon the town's flourishing appearance (*fig. 5*). Writing in 1750,
James Birket commended Portsmouth's location "upon a point that Jetts out into
the river[;] it makes very good Conveniencys for Building wharfs and
warehouses…where Ships of any Burthen may lay and discharge their cargos into
the warehouses w^th out Expence or trouble." Of Portsmouth's dwellings, Birket re-
marked that

> The houses that are of Modern Architecture are large & Exceeding neat[;] this sort is gener-
> ally 3 Story high & well Sashed and Glazed with the best glass[,] the rooms are well plasterd
> and many Wainscoted or hung with painted paper from England[,] the outside Clapboarded
> very neatly and are very warm and Comodious houses…all the houses in town Save two are
> built of wood… [32]

Although Birket found much to admire in the Portsmouth of 1750, greater
buildings would arise during the early 1760s. This was a wartime period, accompa-
nied by a severe contraction of Portsmouth's shipping. But it was also a time of op-
portunity for those in the mast trade, for those well cushioned by the protective
trading network of the merchant oligarchy, and even for those whose well-insured
(some said over-insured) ships were seized by privateers.[33] After some twenty years
of delay, this was the period chosen by the province to construct its long-awaited
state house in Portsmouth.[34]

This was also a golden age among Portsmouth's crafts community. The older
generation of immigrant British craftsmen had died, but their apprentices and de-
scendants now presided over a matured craft tradition that was capable of meeting

all of Portsmouth's building needs. These men included carpenters, joiners, turners, carvers, and painters, and their seaport environment provided them with an opportunity to apply their skills to houses, to ships, and occasionally to items for export.

Portsmouth had a population of only 4,466 by 1767, however, so these craftsmen tended to guard their trades jealously against competition. Early in 1766, the *Boston Evening Post* reported that "A Number of Persons in Piscataqua lately entered the Ships commanded by Captains Long and Clapp, and cut and hack'd the Joyners Work in such a Manner as entirely to ruin the same." It developed that the owners of these vessels had had the temerity to commission out-of-town joiners to finish the cabins in defiance of a broadside that had been posted around the town, warning

> Those that have hitherto imploy'd Country Joyners, not to employ them any more, for such Persons that does may depend on it for a Truth that we Joyners belonging to Town are determined to make a bold Push.[35]

Whatever stresses may have dimmed the prospects of the Portsmouth craft community during the 1760s, some tradesmen achieved respect and enjoyed ample employment. One of the most successful was joiner Michael Whidden III, grandson of British immigrant John Drew. Possessing much of his grandfather's enterprise and versatility, Whidden built a number of houses for himself and others after the mid-1750s. Another was carver Ebenezer Dearing, originally from Kittery. Dearing found steady employment from the merchants and shipbuilders of Piscataqua, fashioning figureheads, trailboards, stern- and taffrails, and other carved embellishments for the many new vessels built in local shipyards during this period. Still another was turner Richard Mills, son of the Bristol immigrant John, who maintained a shop and apprentices in common with his father during the 1760s.

Because these men were one or two generations removed from British training, they depended increasingly upon architectural sourcebooks to guide them in their work. Such books were occasionally available in Portsmouth during the eighteenth century, perhaps beginning with John Drew, who had access to a copy of Palladio. Local carvers and joiners made impressive use of an architectural book during the 1750s, when Governor Benning Wentworth moved from his rented quarters in the former Archibald Macpheadris house to a farm south of town at Little Harbor. There, Wentworth built a wing containing a remarkable mantelpiece (*fig. 6*), copied from William Kent's design of about 1725 for the stone hall at Houghton, in Norfolk. This grand Palladian composition had been published in 1727 in Kent's *The Designs of Inigo Jones (fig. 7)*. It is an imposing composition, with a heavily carved mantelshelf and overmantel panel supported by female terms. The Portsmouth carver (probably Ebenezer Dearing) who executed Wentworth's copy of the mantelpiece rose easily to the challenge, however, using his experience in carving "woman heads" for ships and employing the enriched or carved moldings and floral festoons that would soon become a hallmark of the richer houses in town.

It is impossible to know how Kent's mantelpiece design came to the attention of Governor Wentworth and his carver. Peter Harrison, a gentleman-architect from Newport and Boston and a personal friend of Wentworth, owned a copy of Kent's book. But the same design had been published in a cheaper volume, Edward Hoppus's *The Gentleman's and Builder's Repository* (ca. 1737), and this may have been the book used at the Little Harbor estate. John Thomlinson of London is said to have been a member of William Kent's circle of friends; since the Portsmouth merchants often relied on Thomlinson's familiarity with London fashion to provide them with clothing, household furnishings, and books, Thomlinson himself may therefore have influenced the governor in the choice of this imposing design for a country parlor.

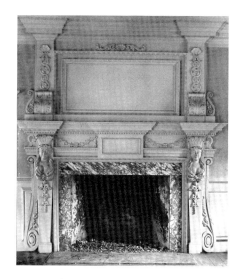

FIGURE 6.

Fireplace surround in the great hall of the Benning Wentworth House, Little Harbor, New Hampshire, 1750. Douglas Armsden photograph, ca. 1965.

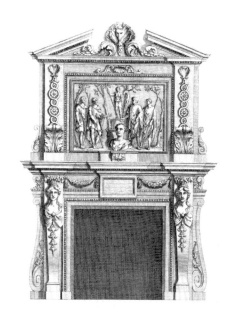

FIGURE 7.

Design for fireplace surround from William Kent, The Designs of Inigo Jones, *1727, plate 64. Courtesy, Printed Book and Periodical Collection, Winterthur Library, Wintherthur Museum, Winterthur, Delaware.*

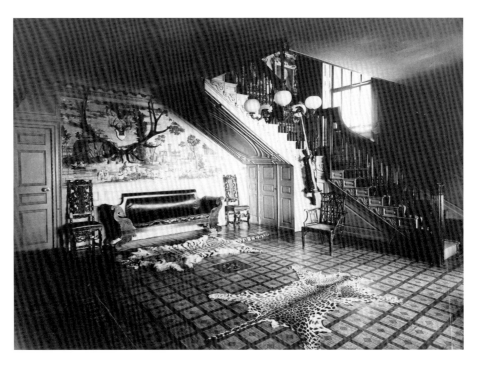

FIGURE 8.

Great hall of the Moffatt-Ladd House, Portsmouth,
New Hampshire, 1763. Photograph, ca. 1890.
Archives, Society for the Preservation of New
England Antiquities, Boston, Massachusetts.

The mantelpiece at Little Harbor was but a sample of the architectural embellishment that Portsmouth craftsmen would create within a decade. Relying on their craft skills and on such sourcebooks as they could obtain, the local craft fraternity fashioned a number of remarkable houses during the 1760s.

Chief among these in size and elaboration was the grand, three-story dwelling built by the merchant John Moffatt for his son Samuel, who had married one of the Mason heirs. The Moffatt house is remarkable not only for its size, but also for the fact that much of its first floor is given over to a grand stairhall (*fig.* 8) similar to, but larger than, one built by turner John Mills about 1760 for his own house.

Completed about 1763, Moffatt's imposing house displayed the skills of Portsmouth's best craftsmen. Michael Whidden III supervised the work from the delivery of the massive frame, through its raising and sheathing, to the installation of the interior and exterior joiner's work. Most if not all the lavish carving of the house was the work of Ebenezer Dearing. The stairway balustrade of the house was evidently the work of Richard Mills, who copied many of its features, on a larger scale, from the staircase in his father's house.

The Moffatt House was far from the only imposing dwelling of its era. At about the same time, Mark Hunking Wentworth constructed a smaller but equally opulent house (*fig.* 9) for his son Thomas, a promising young merchant. The joinery, carved work, and turned balusters of this house nearly duplicate those in the Moffatt dwelling, suggesting the identity of the craftsmen who provided its elegant finish. Yet while the same craftsmen may have completed the two houses, the dwellings have a very different character. While the Moffatt house relies on delicately carved moldings for much of its effect, the Wentworth house is filled with well-proportioned pilasters, which frame its mantelpieces and line its upper entry (*fig.* 10). With their Ionic and composite capitals, these features display a fluent command of Palladian detailing and give the house a strongly classical character.

FIGURE 9.

The Wentworth-Gardner House, Portsmouth,
New Hampshire, 1760. Photograph, ca. 1910.
Patch Collection, Strawbery Banke Museum,
Portsmouth, New Hampshire.

The central hallway or entry, the stairway arch, and the coved second-floor hallway
ceiling of the house pay tribute to design traditions introduced by John Drew forty-
five years earlier.

 Another son of Mark Hunking Wentworth was destined to succeed Benning
Wentworth as governor of New Hampshire in 1767. John Wentworth (*fig.* 11) was
young, Harvard-educated, well-traveled, and possessed of a grand vision of New
Hampshire's destiny. He hurried toward completion many internal improvements
that had been largely neglected by his uncle Benning. Among these were the con-
struction of a harbor lighthouse and the building of a network of roads connecting
the Winnipesaukee region and the upper Connecticut River with Portsmouth.

 But in his zeal for public works, Wentworth did not neglect the social life of
the colonial capital. He quickly became a patron of the new assembly house, built
about 1771 by joiner Michael Whidden III, sponsoring elegant balls to which he
invited both the local elite and visiting naval officers and respectable "strangers." He
encouraged the establishment of a playhouse against the objections of conservative
citizens. The attitude of Wentworth's critics must have closely mirrored that of his
dour Harvard classmate John Adams, who noted in 1770,

> I have avoided Portsmouth and my old Friend the Governor of it…I should have seen
> enough of the Pomps and Vanities and Ceremonies of that little World, Portsmouth If I had
> gone there, but Formalities and Ceremonies are an abomination in my sight.[36]

 The Portsmouth house to which Governor John Wentworth moved in 1767
belonged to his brother-in-law, John Fisher, for whom it had been purchased in
1764 by Mark Hunking Wentworth. Built in 1763 by Henry Appleton, the house is
an imposing, hip-roofed dwelling, which failed to impress the new governor, fresh
from England. Regarding the house as "a Small Hut with little comfortable Apart-
ments," Wentworth proceeded to carry out certain improvements to the dwelling.
Among these may have been the installation of a gray marble fireplace enframement

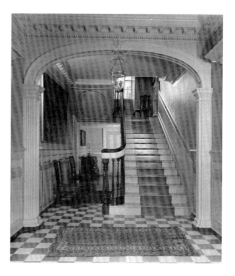

FIGURE 10.

Hall of the Wentworth-Gardner House, 1760.
Portsmouth, New Hampshire. Douglas Armsden
photograph, ca. 1955.

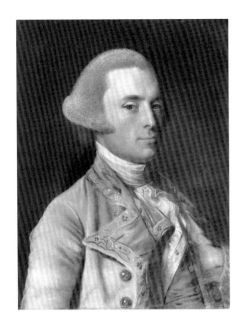

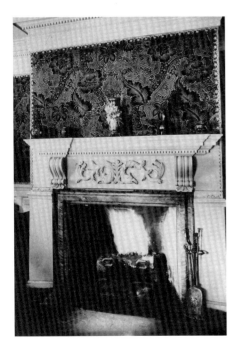

in the parlor, and the hanging of the same room with crimson damask wallpaper with molded papier-mâché borders (*fig.* 12).

Just prior to his appointment, Wentworth had spent some months in Yorkshire, living with his distant relatives, Lord and Lady Rockingham. There, the young Wentworth developed a taste for country living as it had been refined and perfected by the British nobility. It was therefore natural that the last of New Hampshire's royal governors focused his dreams and ambitions on a grand inland estate, which he hoped would inspire some of the Masonian Proprietors to occupy and improve their own landholdings and would one day become the locale of a new capital for New Hampshire.

Wentworth began to build his country seat in 1768 at Wolfeborough, more than forty-five miles from Portsmouth. Although never finished on its interior, Wentworth's grand mansion measured one hundred feet in length by forty in depth, more than twice as large as the grandest Portsmouth house of the period, and was designed with advice from architect Peter Harrison, a family friend. Like Wentworth's rented "Small Hut" in Portsmouth, the Wolfeborough mansion was furnished with marble mantelpieces, imported wallpapers with papier-mâché borders, and well-painted chambers.

The imposing structure was furnished almost to opulence, probably combining English and locally made pieces. In keeping with the English fashion, some of the best furnished rooms were on the second floor; here were found damask window curtains and upholstery, sofas, floor carpets, a billiard table, a sideboard, many mahogany chairs (some having silk-covered seats), looking glasses, pictures, and bedsteads and bedding. The house also contained Wentworth's 550-volume library, which seems to have numbered among its books a copy of James Paine's *Plans, Elevations, and Sections, of Noblemen and Gentlemen's Houses*, a London publication of 1767, which illustrated many of the seats that Wentworth had visited while in Yorkshire and which may have offered the young governor a prototype for his own estate.[37]

Wentworth House in Wolfeborough was intended as an architectural model and as a magnet to draw the attention of Portsmouth merchants toward their interior landholdings. Yet the mansion was destined to be confiscated by the new state government at the outbreak of the Revolution, to stand unfinished in the hands of other owners for forty-five years, and finally to burn accidentally in 1820. Its fate mirrored that of the entire Portsmouth oligarchy as the Revolution devastated a social structure that had evolved for a century or more. The Revolution reduced or swept away old fortunes, compelled intelligent and well-respected men and women to abandon their families and estates, and left a social vacuum that would eventually be filled by younger men and women of native ability but of humbler origins.

Chief among these was John Langdon (*fig.* 13), who began his career in the counting house of merchant Daniel Rindge and then became the master of his own vessels, the *Andromache* and the *Agamemnon*. Langdon soon became a merchant of moderate prosperity in his own right, establishing relationships in the American ports and in London. He also became active in politics as troubles with the royal government developed, establishing himself as a leader among the generation that was ready to rebel against the old order.[38]

Langdon threw himself into the war effort during the Revolution, acting as contractor for the Continental Navy in superintending the construction of the *Raleigh* (1776), the *Ranger* (1777), and the *America* (1782), as well as of several small privateers.[39] He was also captain of his own independent company of soldiers, which was stationed at Portsmouth in 1777, saw service at Saratoga later that year, and campaigned in Rhode Island in 1778.

Many had hoped that the Revolution would stimulate New Hampshire's economy after the lean economic times that had followed the Seven Years' War. Hostilities did, indeed, provide a demand for vessels of war, grain, and livestock, create employment in the form of military service, and even offer great wealth through privateering.[40] But the emission of paper money as a medium of exchange during this period brought with it an inevitable inflation, requiring the imposition of wage and price controls beginning in 1777.[41] The war cost American merchants all the benefits they had enjoyed while trading within the protection of the British Empire, shutting them out of many of the ports once open to them. The result in New Hampshire was a general economic depression, which lasted through the decade of the 1780s.[42]

Foreign visitors to Portsmouth noted a town in decline. The marquis de Chastellux found commodities scarce and prices high in 1782. To Francisco de Miranda, Portsmouth was "quite badly formed and has the saddest appearance one can imagine" in 1784. Writing in 1788, Brissot de Warville gave the worst image of all, seeing "a thin population, many houses in ruins, women and children in rags; every thing announc[ing] decline."[43]

As had been true in the 1760s, however, there were those with the financial resources to take advantage of this depressed period, obtaining materials and labor at favorable rates. The number of substantial Portsmouth houses constructed during the 1780s suggests that this period, like the 1760s, was a good time to build.

John Langdon was one of those who had profited from the war. By 1783, Langdon was prepared to carry out a building project for which he had begun to acquire land as early as 1775. In the spring of 1784, having obtained a "draft" of a house from joiners Daniel Hart and Michael Whidden III, Langdon paid Stratham housewright Henry Wiggin £150 for a large house frame. The proportions of this hip-roofed frame are not greatly different from those of the house that Mark Hunking Wentworth built for his son Thomas more than twenty years earlier. Yet these two houses differ greatly in outward and inward appearance, and this difference may be traced to the architectural sourcebooks that influenced their ornamentation.

Whereas the Thomas Wentworth house was finished under the guidance of a Palladian book, very possibly one of the Batty Langley volumes like *The Builder's Director* or *The Builder's Jewel*, Langdon's house (now owned by SPNEA) shows its reliance on the books of English architect Abraham Swan. During the 1740s, Swan published several books that displayed a type of continental European decoration very different from the classically rigorous Palladian style. The rococo style, with its asymmetrical, almost bizarre ornament, displayed a lightness and frivolity that relieved the severe Palladianism then dominant in English design. British cabinetmakers like Thomas Chippendale embraced the rococo with enthusiasm, and architectural writers like Swan made the style seem less foreign to British sensibilities by applying its fanciful ornamentation over a Palladian framework. Americans welcomed the rococo as well, but generally not until it was old-fashioned in England and completely obsolete in Europe. Swan's *The British Architect* and *A Collection of Designs in Architecture*, the two books that influenced the interior and exterior of Langdon's house, were reprinted in Philadelphia in 1775; John Norman, a Boston publisher, published his edition of *The British Architect* as late as 1794.

The rococo was a carver's style, and it is the carving of Langdon's house that makes it extraordinary (*fig.* 14). This is the work of Ebenezer Dearing, who had embellished the Moffatt house twenty years earlier, and of his son William, then in his mid-twenties. The Dearings took their inspiration from several plates in Swan's *The British Architect* (*fig.* 15), sometimes following their sources with great fidelity and

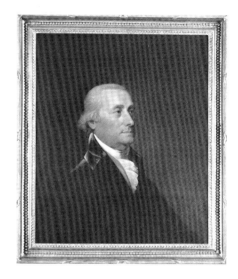

FIGURE 13.

Governor John Langdon, *attributed to Edward Savage (1761–1817), ca. 1790. Oil on canvas, H. 29¼; W. 24½ (sight). Society for the Preservation of New England Antiquities, Boston, Massachusetts, bequest of John Elwyn Stone, 1975.161.*

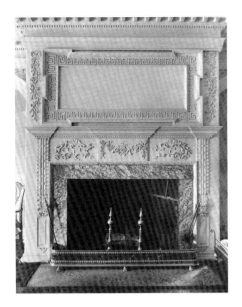

FIGURE 14.

Fireplace surround in the Governor John Langdon House, Portsmouth, New Hampshire, 1783–85. Douglas Armsden photograph, ca. 1950.

FIGURE 15.

Design for fireplace surround from Abraham Swan, The British Architect, *plate 68. Courtesy, Boston Athenaeum, Boston, Massachusetts.*

skill, sometimes departing from them with conscious or unconscious variation, sometimes combining suggestions from several plates, and sometimes abandoning the book altogether. The result is an interior of unparalleled splendor, exceeding even the richness of the Moffatt or Thomas Wentworth houses.

Yet even as John Langdon was completing his house, his older brother Woodbury was building a dwelling of far different character (*fig.* 16). Woodbury Langdon's house was brick, and was by far the most advanced building constructed in Portsmouth in decades. Its impact on the community must have been comparable to that of the Macpheadris house almost seventy years earlier. Like the Macpheadris house, Woodbury Langdon's dwelling symbolized the end of one architectural era and the beginning of another.

Woodbury Langdon's house was the first in New Hampshire to display the characteristics of the architecture of British designer Robert Adam, whose work had received wide patronage in England from the 1760s. Adam possessed a genius for interior design, coupled with great skill in adapting architectural devices from several cultures into a new vocabulary that was dramatically different from the stolid classicism espoused by the Palladian architects of the early 1700s. While Adam's ornamental language was based on classical forms, his ultimate expression was exotic, fanciful, varied, colorful, and eclectic.

Just as many authors had reduced the complex writings and theories of Palladio to the language and needs of the craftsman during the early 1700s, other writers transformed the work of Robert Adam into simple and inexpensive handbooks that were usable to craftsmen who were far removed from the origins of the style. One such author was English writer William Pain. Pain's *The Practical Builder* of 1774 was clearly used by the craftsmen who designed and finished Woodbury Langdon's house; the book provided suggestions for the façade, a prototype for the fan lighted doorway, and details used on the interiors.

Little has survived of Woodbury Langdon's house. Fires and rebuilding have left only one room from the great brick dwelling. But even this remnant shows that the house was far more modern than others built during the 1780s, including John Langdon's house and the nearby Jeremiah Hill (Jacob Wendell) house (*fig.* 17), which looked back to the Palladian and rococo styles. The Woodbury Langdon house foretold the architectural future of Portsmouth.

Before that future could be realized, however, the town had to recover from the depression of the 1780s, and recovery depended upon vision and enterprise. In 1788, New Hampshire became the ninth and deciding state to ratify the federal constitution; Portsmouth merchants, compelled to reconstruct their entire commercial world, looked to the new government to guarantee greater uniformity and regulation of trade and to protect commerce, thereby encouraging entrepreneurial risk.

Portsmouth's citizens, like those of other coastal cities, celebrated the adoption of the constitution with a grand federal procession in which the various trades and handicrafts celebrated their new-found confidence. Among those who took part in the grand parade of June 26, 1788, were farmers, blacksmiths, shipwrights, coopers, ship captains and seamen, housewrights, masons, cabinetmakers, upholsterers, gold- and silversmiths, foreign consuls, merchants, traders, and representatives of all branches of state government. All of these varied participants, according to a writer of the time, "intended to represent that in consequence of this union, commerce, and all the arts dependant on it, would revive and flourish."[44]

As predicted, prosperity did return to Portsmouth during the 1790s. Yet international tensions and regulations made the commercial world a treacherous one, calling for considerable shrewdness and not a little deception on the part of those who were compelled to find new markets outside the British empire, especially in

the Spanish, French, and Dutch West Indies. Shipmaster Keyran Walsh's account of one voyage in 1799 gives some hint of the chameleon-like attributes demanded of a Portsmouth captain during these uncertain times.

Walsh sailed from Boston as master of the ship *America*. Setting course for Tenerife in the Canaries, Walsh sold his cargo and loaded another destined for Vera Cruz. At Tenerife, Walsh was compelled to pay "a Spanish House there doing business…to take out papers purporting that they were the owners of said ship," because "by the laws of Spain, no American vessel could sail from Teneriffe to Vera Cruz, unless…a Spanish Captain was on board." Arriving at Vera Cruz, Walsh found his cargo seized by the governor "on the ground that the inhabitants of the Canary Islands could not by the laws of Spain export to Vera Cruz any merchandize which was not the produce or manufacture of some of the Spanish Dominions." Offering his confiscated cargo as security, Walsh was able to borrow a thousand dollars, which he invested in logwood ballast. Wishing to bring the *America* back to the United States after this short but discouraging voyage, Walsh was told that it was "repugnant to the laws of Spain to clear her out but for some port in the Spanish Dominions." Accordingly, Walsh concluded,

> about the middle of December, I left Vera Cruz bound for Havannah with the intention, after I had there landed my cargo, to make said ship an American bottom, and then proceed to her port of discharge in the United States. On my passage to Havannah I was chased on[to] the shore of Cuba, by the Thunderer, a British Seventy-four gun ship, who afterwards got of[f] the said ship and cargo, and carried the same to Jamaica, where both were condemned as Spanish property.[45]

Despite such a trying existence, Portsmouth merchants were willing to attempt many commercial risks. Their enterprise was repaid; commerce prospered throughout the first years of the new century until the imposition of the Jeffersonian Embargo in 1807.

Portsmouth's spirit of enterprise extended beyond the world of seaborne commerce. Portsmouth merchants funded the construction of the great Piscataqua

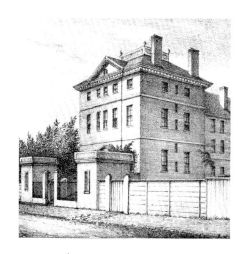

FIGURE 16.

The Woodbury Langdon House, Portsmouth, New Hampshire, 1785. Lithograph by Pendleton's Lithography, Boston, depicting the house when it was a hotel, before 1836. Archives, Society for the Preservation of New England Antiquities, Boston, Massachusetts.

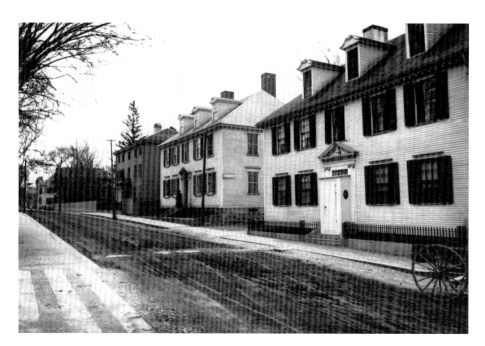

FIGURE 17.

Pleasant Street, Portsmouth, New Hampshire, showing, from right to left, the Wendell, Parry, and Haven houses. Photograph, ca. 1895. Strawbery Banke Museum, Portsmouth, New Hampshire.

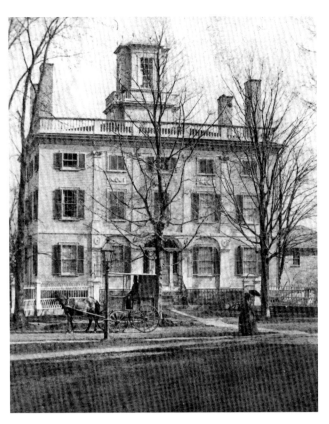

FIGURE 18.

John Peirce House, Portsmouth, New Hampshire, 1799. Photograph,
ca. 1860. Photograph Collection, Portsmouth Athenaeum, Portsmouth,
New Hampshire.

Bridge of 1794; with its massive 244' arch extending from Fox Point in Newington to Goat Island at the outlet of Great Bay, this mighty span was an engineering wonder of its day. Combining their interests with those of Concord, Portsmouth investors helped to build the First New Hampshire Turnpike, which opened an improved link between the Piscataqua Bridge and the Merrimack River after 1796.[46]

The town of Portsmouth enjoyed the fruits of similar civic enterprise. In 1796, a group of Portsmouth merchants combined to enlarge the former Penhallow wharf on the Portsmouth waterfront and to modernize the ancient brick Penhallow house as the New Hampshire Hotel, a "most convenient place, for the Merchant, ship-owner, Captain, Mate and Mariner to meet at." Following its lengthening, the adjacent pier measured 340' in length and held a building containing fourteen stores for local merchants, contributing much to the revival of a moribund waterfront.[47] Beginning in 1798, sections of Portsmouth were supplied with running water from the Portsmouth Aqueduct. In 1800, the town erected a large brick market house, praised by travelers as one of the best in New England, with a public hall on its second floor.

Accompanying this great surge of enterprise was a new sense of style in architecture and furniture. By the 1790s, the Adamesque style in architecture had become familiar to New Englanders through books like Pain's *The Practical Builder*. New England joiner Asher Benjamin published *The Country Builder's Assistant* (1797) and *The American Builder's Companion* (1806). These books suggested American forms of Pain's ornamentation, and illustrated new "Grecian" molding profiles recommended by Robert Adam and based on the subtle curves of ellipses.[48]

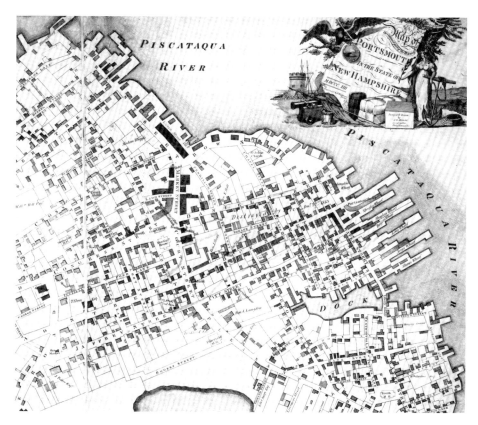

FIGURE 19.

Map of the Compact Part of the Town of Portsmouth in
the State of New Hampshire, *1813. Drawn by J.G. Hales
and engraved by T. Wightman, Boston, Massachusetts, H. 29¾;
W. 39½. Courtesy, Library of Congress, Washington, D. C.*

New England joiners were quick to adopt the fanciful decoration illustrated in the
new books, entering enthusiastically into the use of fret dentils, drilled holes,
gouged flutes, and wooden spools, balls, cables, and lattices to enliven cornices,
mantelpieces, chair rails, and door and window casings.

As Asher Benjamin's books supplanted those of William Pain, the
Adamesque style took on a new form, now called the Federal style, which was
adapted to American materials and craft practices. The first Portsmouth house to
reveal this transformation was the three-story dwelling built for merchant John
Peirce in 1799 (*fig.* 18). Deriving its outward form from several houses designed by
the Boston architect Charles Bulfinch during the 1790s, the Peirce mansion has a
façade articulated by pilasters above an arcaded first story, panels displaying delicate
Adamesque carving, and a fanciful cornice. The interior was equally new; in place
of the customary central entry with a staircase rising along one wall, the Peirce
house has a small front hall with a dramatic spiral staircase ascending in a semicir-
cular niche on one side. A curved settee (*see cat. no.* 93) originally rested at the base
of the stairway.

If the Peirce house was revolutionary in 1799, its vocabulary was quickly
taken up in many houses and public buildings erected within the next few years.
The period just after 1800 saw a virtual transformation of Portsmouth. This was
due in part to extensive building of three-story houses in the vicinity of Haymarket
Square (considered inconveniently remote until John Peirce built his mansion
there), in part to a surprising amount of new construction on formerly vacant lots in
older neighborhoods, and in part to the need to rebuild sections of the town center

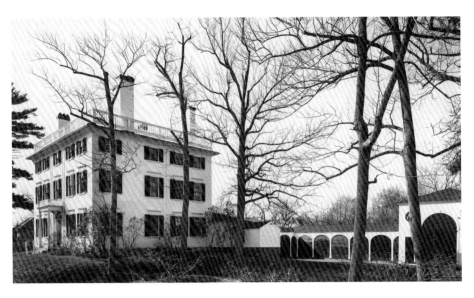

FIGURE 20.

The Rundlet-May House, attributed to Ebenezer
Clifford, Portsmouth, New Hampshire. 1807–08.
Society for the Preservation of New England
Antiquities, Boston, Massachusetts. David Bohl
photograph, 1985.

following fires in 1802 and 1806. Writing to his children in Boston in 1804, Portsmouth merchant John Wendell remarked, "there are immense Buildings going forward and the Town is astonishly altered."[49] Portsmouth's character at this period is portrayed in a detailed map prepared by the English-born cartographer John Groves Hales (*fig.* 19).[50]

Few of the dwellings that followed the Peirce mansion copied its highly articulated exterior; most were content to express the standard, three-story, flat façade so strongly associated with the New England Federal style. Through careful proportioning and the use of fanlighted doorways, delicate porticos, eaves balustrades, and fanciful cornices or window caps, Portsmouth houses of the early 1800s attained dignity and character.

One of the best-documented and most typical of these three-story dwellings is the house built far out on Middle Street by James Rundlet in 1807 and 1808 (now owned by SPNEA; *fig.* 20). Set upon a knoll above the road, backed by spacious flower gardens and a small orchard, and connected to a suite of outbuildings that make it almost an urban farm, the Rundlet house expresses mercantile success, a love of retirement and nature, and a richness in finish and furnishing that show taste without ostentation.

By the early 1800s, the Portsmouth craft community had merged with that of neighboring towns to give the Piscataqua area a regional fraternity of building tradesmen. These men frequently traveled from town to town and project to project, merging their talents and exchanging their craft insights and skills. A leader in this fraternity was the Exeter builder-architect Ebenezer Clifford, who had worked alongside Michael Whidden III and Ebenezer Dearing in finishing the John Langdon mansion in the 1780s and had later designed or built many Exeter-area buildings, including the Phillips Academy of 1794 and the First Parish meetinghouse of 1799.

The Exeter-born merchant Rundlet chose Clifford as his master builder, and the sixty-one-year-old joiner summoned a wide array of talent to help build the

FIGURE 21.

Market Square, Portsmouth, New Hampshire.
Stereograph, ca. 1865. Courtesy, James B. Vickery.

house. The frame was hewn in Newfields and erected in June 1807. During that summer and fall, no fewer than twenty-three joiners, many from the Exeter area, invested some two thousand man-days in bringing the house toward completion. Among them was twenty-one-year-old Jacob Marston, who may have been trained by Clifford and who eventually invested more labor in Rundlet's dwelling than did the master builder himself. Another craftsman on the job was carver William Dearing, with whom Clifford had worked twenty years earlier at Langdon's house; Dearing carved the fireplace in Rundlet's east parlor.[51]

By the time that Rundlet's spacious dwelling stood complete on Middle Street, Portsmouth could boast many craftsmen who were capable of building comparable houses for other merchants, simpler dwellings for workers, and public structures. Among them was Bradbury Johnson, who had worked alongside Clifford in Exeter and found ample employment in Portsmouth after 1800, superintending construction of the Portsmouth Market House and the nearby New Hampshire Bank, and designing the New Hampshire Fire and Marine Insurance Company office, which rose as the focal point of a brick block constructed in Market Square after a devastating fire in 1802 (*fig.* 21). Another was James Nutter, who built Rundlet's front fence but was mainly employed in 1807 as the master joiner of the great brick St. John's Episcopal Church, erected at a cost of $30,000 from plans

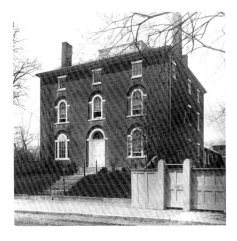

provided by Alexander Parris of Portland, Maine.[52] Like Clifford and Johnson, Nutter was talented as an architect as well as a joiner; in 1809, he provided plans for a new brick academy building in Portsmouth.

Portsmouth had suffered terrible fires in 1802 and 1806. In the last days of 1813, a still greater conflagration engulfed the center of the town.

> The fire seemed a torrent of desolation rushing through the midst of the town, and with hu-
> mility we saw its destructive energies mocking the impotence of man. Not only this place, but
> the whole adjacent country was illuminated with a crimson splendor. The deep and majestic
> river awfully reflected the blazing deluge of ruin, and contributed greatly to heighten the
> grandeur of the scene.[53]

This third fire came at an especially bad time, for mercantile income had been choked by the War of 1812, leaving shipbuilding at the new Navy Yard (*fig.* 22) in Kittery or privateering as the only means by which Portsmouth could hope to derive wealth from the sea. Nevertheless, the town did rebuild slowly after the fire, and it rebuilt in brick rather than wood.

In this final period of architectural enterprise, another young joiner arose as the leading builder-architect. This was Jonathan Folsom, who had served as an apprentice of Ebenezer Clifford and who showed unusual initiative by traveling to Savannah, Georgia, at the conclusion of his training in 1806. Folsom returned to Portsmouth about four years later and began a career as a builder, which was halted only by his premature death in 1825 at the age of forty.[54] Folsom's designs were especially sophisticated, giving Portsmouth a final display of native architecture before the beginning of a long period of commercial and economic stagnation. Folsom can probably be credited with the grand brick dwelling of auctioneer Samuel Larkin, built in 1815 from Larkin's profits in liquidating prizes taken by Portsmouth privateers during the war (*fig.* 23). As one of the most subtle and sophisticated houses built in Portsmouth at any period, the Larkin dwelling stands as an appropriate finale to an era of architectural accomplishment that had begun just a century earlier with the arrival of John Drew.

Following the War of 1812, Portsmouth turned its energies increasingly toward manufactures rather than trade. New Hampshire as a whole devoted an increasing amount of its human energy to the cultivation of the interior. The Merrimack and Connecticut River valleys had become as populous as the seacoast, or more so, by 1800. As New Hampshire's turnpike network began to channel goods from the interior of the state during the early 1800s, it became increasingly clear that most of this traffic, as well as the river commerce of the Merrimack, was to be diverted to Boston rather than through Portsmouth. New Hampshire became less and less dependent upon its seaport, leaving Portsmouth in the quiet possession of the fruits of five generations of skilled craftsmanship.

1. Albion 1926, chapter 6. For the native tree species of the Piscataqua region, see "A Survey of Piscataqua Riv[er] by I.B.," map, ca. 1700, Public Record Office, London, Document No. CO 700/N.Hamps. 7.

2. Barry 1971, 127–28.

3. Candee 1970, 131–49; and Candee 1976, chapter 3.

4. Malone 1964, 57.

5. Ibid., 1964, 153; McKinley 1931, 311; Candee 1976, 150–54.

6. "Port of Piscataqua, Colonial Customs Records, 1770–1775," copy, Portsmouth Athenaeum.

7. Barry 1971, 292–93.

8. Ibid., 1971, 136.

9. *Documents and Papers* 5:1–21; Belknap 1792, 411.

10. Barry 1971, 350–57.

11. Wallace 1984, 141–52.

12. Garvin 1980, 54–55.

13. John Wentworth to Samuel Shute, Feb.19, 1729, Wentworth Papers, folder 1, box 1, New Hampshire Historical Society.

14. John Drew, account book, Strawbery Banke Museum Library.

15. Quiney 1979, 269–80.

16. Drew account book, 141.

17. Quiney 1990, 154.

18. Drew v. Warren, docket 6080, New Hampshire Superior Court Records, State Archives.

19. *Bristol (England) Apprentice Books*, 1705–11; Garvin 1983, 75–76.

20. Van Deventer 1976, 160–61.

21. Van Deventer 1976, 161, 172; McKinley 1931, 354.

22. Charles Wetherell 1991; see especially Introduction (Spring 1991): 12.

23. Van Deventer 1976, 105–6.

24. Jonathan Warner Papers, New Hampshire Historical Society.

25. Piscataqua Customs Records, 1770–75; *Journal of the Society of Architectural Historians* 23 (March 1964): 43–44.

26. Van Deventer 1976, 106.

27. George Boyd to Hugh Pringle, Liverpool, and George Boyd to Lane, Son & Fraser, London, both Jan. 7, 1774, Wetherell 1991, 111.

28. *Documents and Papers* 19:478; for Thomlinson's correspondence regarding the boundary line, see *Documents and Papers* 5:833–65; 6:914–31; 18:149–89; 19:179–676.

29. *Sibley's Harvard Graduates* 6:113–33.

30. Garvin 1980, 63–64.

31. Looney 1968, 12; Belknap 1792, 323–24.

32. Andrews 1916, 8–9.

33. McKinley 1931, 136–44.

34. Garvin 1991, 202–29.

35. *Boston Evening Post*, Jan. 6, 1766.

36. Butterfield 1961, 355.

37. Garvin 1989, 27–38.

38. Mayo 1937, passim.

39. Fischer 1987, 1-35; Saltonstall 1968, 95–104.

40. Daniell 1970, 128–9.

41. Scott 1946, 453–73; Portsmouth Town Records, Sept. 29, 1779.

42. Flanagan 1972, 16–66.

43. Rice 1963, 484–88; Wood 1963, 178–85; Brissot de Warville 1797, 255–56.

44. Adams 1825, 290–94.

45. Docket A-21844, New Hampshire Superior Court Records, State Archives.

46. Chesley 1984; Chesley 1982.

47. *New Hampshire Gazette*, Oct. 22, 1805; Adams 1825, 311–12.

48. Garvin and Garvin 1985, 11–14.

49. John and Dorothy Wendell to an unspecified son and daughter, Aug. 25, 1804, Wendell Collection, folder 2, case 7, Baker Library, Harvard Business School.

50. Meigs 1975, 23–29.

51. Garvin 1983, 443–51.

52. Garvin 1973, 153–75.

53. *Portsmouth Oracle*, Jan. 1, 1814.

54. Garvin 1983, 484–507.

Furniture Making in Eighteenth-Century Portsmouth

Brock Jobe

Situated on the swift and deep Piscataqua River, Portsmouth has a fine port which is always ice-free as far as four or five miles above the town. This was once one of the largest ports for the export of building timber…Everybody here is involved either in trading or in building.
— *J. P. Brissot de Warville, 1788*[1]

The prominence of eighteenth-century Portsmouth stemmed from two principal resources: the sea and the forest. The town's harbor offered an avenue to the world, linking the port to communities along the Atlantic Coast and across the ocean. Immense stands of nearby timber provided a marketable commodity. Towering Piscataqua pines became masts and spars for the British navy, oaks were transformed into house frames or barrel staves, and birches and maples served as the raw materials for tables and chairs. Timber products brought wealth to the town and spawned the related industries of house construction, shipbuilding, and furniture making.

The early houses of Portsmouth have long commanded attention. The most significant are now museums; hundreds of others remain in private hands; and all enhance the historic environment of a town that attracts thousands of visitors each year. Such a rich legacy has prompted careful study, beginning in 1937 with John Mead Howells's *Architectural Heritage of the Piscataqua* and continuing in the scholarly investigations of Richard Candee and James Garvin.[2] The illustrious accomplishments of Piscataqua shipbuilders have elicited similar scrutiny. An impressive array of publications charts the proud products of three centuries: from gundalows to brigantines, from ironclads to nuclear submarines.[3]

In contrast, the furniture of the region has received only the most cursory treatment; surveys of American furniture relegate the town to little more than a footnote, prompting one scholar to note that "cabinetwork of this town [Portsmouth] has always evaded identification, with the result that we know almost nothing about the furniture produced here before 1790."[4]

Consequently, many items made in the area have been ascribed to other communities. A story recounted by a Massachusetts antiques dealer offers a telling illustration. During the 1940s he combed the town in search of furniture. His frequent forays bore impressive results, and he often returned with truckloads of treasures gathered from local families. Yet, during the short drive back to the Boston area, these Portsmouth heirlooms acquired new identities, their origins reassigned to Boston, Salem, Newburyport, or just "North Shore."[5] The attributions enhanced the furniture's sales value, but the connection to Portsmouth was lost and the study of Piscataqua craftsmanship impeded. This publication reverses the century-long process of misattribution. It rediscovers coastal New Hampshire furniture and, in the process, comments upon the skill of its makers and the taste of its purchasers. For the first time, the contributions of Portsmouth-area artisans become an identi-

fiable component within the kaleidoscope of American furniture history. To introduce the subject, this essay surveys three topics: the working environment of eighteenth-century Portsmouth craftsmen, the range of their activities, and the characteristics of their furniture. A succeeding essay examines the trade during the early nineteenth century.

Furniture making arose to serve the immediate needs of settlers. As early as 1657, Edward Clark had begun to make furniture for his neighbors.[6] Over the next two centuries, more than 250 artisans engaged in the production of furniture in the Piscataqua area. The earliest woodworkers succeeded through versatility. Carpenters not only built house frames but also assembled chests and boxes. Joiners outfitted ships and homes with joined paneling as well as joined chests. Turners made banisters for both chairs and staircases. Invariably, these artisans farmed as well. A household garden, a complement of farm animals, and acreage for wheat or barley were essential to survival for even the most accomplished craftsman of the seventeenth century.

The passage of time brought greater specialization of trades and less reliance on farming, especially in the growing urban settlement of Portsmouth. By 1714, a cabinetmaker had begun to work in the town, offering dovetailed "cases of drawers" ornamented with decorative walnut and maple "finenears."[7] Chairmakers and carvers appeared during the 1730s, and the first professional upholsterer had arrived by 1763. Windsor chairmakers and ornamental painters advertised their skills in Portsmouth at the end of the century.[8] Of the specialized trades, only clockmaking was slow to develop. For much of the eighteenth century, wealthy Portsmouth patrons looked to London and Boston for clocks. The first local maker, an English immigrant named Samuel Aris, did not come to town until 1758.[9] In contrast, several nearby communities had supported clockmaking artisans for a decade. To the southwest, in Kingston, blacksmiths Caleb Shaw and Jonathan Blasdel doubled as clockmakers. To the north, in Durham, Thomas Wille had opened a shop by 1757.[10] These isolated artisans served a rural clientele who could not easily obtain stylish timepieces from distant sources.

Whether in urban Portsmouth or rural Kingston, colonial craftsmen worked in close proximity to their homes. In Portsmouth, the location of these residences conformed to the general pattern of settlement, which spread initially along the waterfront and later progressed inland between Islington Creek and the South Mill Pond (*see endpapers*).[11] Samuel Aris and the cabinetmaker Mark Ham worked in buildings on Water Street, opposite Long Wharf. Richard Shortridge kept a shop in one of the front rooms of his impressive Georgian house on Deer Street in the North End. He and his neighbors, the joiners Michael Whidden and Samuel Hart, transformed Deer Street into a modest enclave of craft establishments. In the South End, Robert Harrold, Portsmouth's leading cabinetmaker of the pre-Revolutionary era, had worked in a shop near his home on Gate Street. The venerable joiner Mark Langdon, who practiced his trade for more than half a century, resided next to Harrold.[12] Newly arrived immigrants often sought space in the homes of established workmen. Henery Golden from London announced in 1763 that he "now carries on the Upholster's Business, at the House of Mr. *John Gotham*, near the Swing-Bridge."[13] After moving to Portsmouth in 1734, the Boston cabinetmaker Joseph Davis stayed briefly with John Mills, a turner in the South End.[14] Spread across the Portsmouth townscape, these shops formed a geographical patchwork. Eventually, however, the pattern began to change. By the second decade of the nineteenth century, competing craftsmen concentrated their shops within a business district in the center of the town and took up residence in homes often several blocks away (*see next essay*).

FIGURE 24.

Joiner's Work, *plate 4 in Joseph Moxon's*
Mechanick Exercises, *London (1703).*
Courtesy, Printed Book and Periodical
Collection, The Winterthur Library, Winterthur
Museum, Winterthur, Delaware. The work
bench (A) is fitted with a vice (A.g) and holdfast
(A.d) for securing boards in place while working.
The fore plane (B.1), jointer (B.2), and
smoothing plane (B.4) were used to dress rough
boards. The rabbet plane (B.5) and plow plane
(B.6) cut dadoes and lipped edges (called
rabbets). Chisels (C.1–5) and gouges (C.6) were
used for carving and making mortises. Squares
(D,F) enabled craftsmen to create precise angles.
A marking gauge (G) was essential for laying out
mortises and tenons. The brace and bit (H),
gimlet (I), and auger (K) made holes of various
sizes. The hatchet (L), according to Moxon, was
used "to Hew the Irregularities off such pieces of
Stuff which may be sooner Hewn than Sawn."
Two men used the pit saw (M) to cut boards and
planks along the grain of the log. The whip saw
or crosscut saw (N) cut boards across the grain.
The frame saw or bow saw (O) cut precise
shapes, while the smaller compass saw (E) was
used to cut curved outlines.

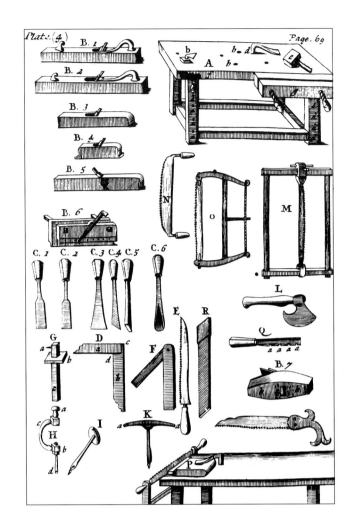

The interiors of these shops were small, crowded spaces cluttered with tools, templates, and unfinished parts. Most shops contained one, two, or three work benches and rarely had more than four employees. The joiner Kingsley James kept a small but well-equipped shop near his home in Exeter during the second quarter of the eighteenth century. He had only a single bench and possessed a standard assortment of joiner's tools nearly matching those depicted in *Mechanick Exercises*, a late seventeenth-century guide to English crafts (*fig.* 24). Yet James performed more than just joinery. His shop goods also included a "feenearing Saw" for cutting veneers, glue pots for warming the hide glue used to bind the veneers to secondary wood, and "6 Wates" for pressing the veneers in place while the glue dried.[15] In rural Exeter, James constructed fashionable veneered case furniture. His Portsmouth counterpart, Richard Shortridge, had a larger, more fully outfitted work space; but it too was small by later, nineteenth-century standards. Shortridge owned "157 Articles of Cabinet makers Tools," "1 Wheel & Laith Compl[t]," "2 Cabinet makers benches," a "Quantity of peices mahogany," and "some unfinish'd Chears bedsted &c &c."[16] The shop probably resembled that of Nathaniel Dominy of Long Island (*fig.* 25), which also contained two benches for making cabinetwork of every description and a large wheel lathe for turning such elements as chair stretchers, columnar shafts for tilt-top tables, and pilasters for the document drawers of desk interiors.

Though artisans made year-round use of their shops, they would readily travel to other sites to perform specific tasks. Joiners constructed the cabins of newly built ships in local shipyards and installed paneling in the homes of their customers. Sometimes, too, special opportunities could lure a craftsman far from home. Samuel

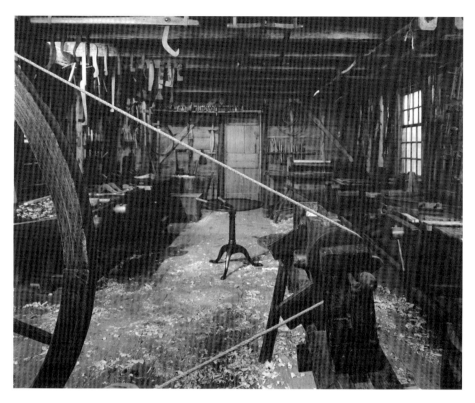

FIGURE 25.

Interior of the Dominy Workshop, as reconstructed at the Winterthur Museum, Winterthur, Delaware, in 1958–59. Courtesy, Winterthur Museum. By 1760, the joiner Nathaniel Dominy III (1714–78) had added this shop to one end of his home in East Hampton, Long Island. The shop continued to serve as a work space for successive generations of Dominys until the early twentieth century.

Sweat, a joiner of Kingston, kept a record of one such experience.[17] In 1772, he was hired to finish the interior of a house for Daniel Curtis in East Harpswell, off the coast of Maine, seventy-five miles away. Sweat's adventure began on September 9, when he and two young workmen, identified only as Mark and John, shipped their tools to Maine and set off on foot. They collected their tool chest six days later and went on to the home of a Mr. Lowell, who had agreed to transport them by boat from the coastal village of Topsham to the island community of Harpswell, ten miles to the south. While waiting for the outgoing tide, the New Hampshire artisans helped bring in three loads of hay for Lowell, hauled a load of boards to his house, and "then boarded his barn a spell." At eleven that evening, Sweat and Lowell borrowed a canoe from a neighbor, picked up his boys and tool chest, "rowed down to Harpswell and got to Curtis' as the daylight appeared."[18]

After breakfast, Sweat and his crew immediately set to work. They boarded and shingled the frame of the house, laid the under-floor, and set the corner boards; afterwards, they made door casings and window sash, then began to install the exterior doors and windows. By September 29, the stairs were under construction and the floor was laid. The next day, they finished the stairs, put up a ceiling, and "cut out the breastwork [panelled wall]" for the front room. They completed the breastwork for the bedroom and made a "mantletree" a day later. By October 5, they had placed panels in the breastwork and pinned the joints. Work on a "buffet" (beaufait or cupboard) for the front room followed. Within a week, they had finished the kitchen and its "dressers," as well as the back room. On October 15, they dismantled their scaffolding, and Mrs. Curtis moved into the house. Finishing touches filled the next five days. As the architectural work came to a close, Sweat turned to

furniture. Earlier in the month he and one of his workmen had "lined out the stuff for a clock case" at the home of a Mr. Purinton. On October 21, Sweat "put the body together and made the glass door and worked out the base molding." The next morning "Mark laid out the boards for the base after breakfast...I put on the base and made the door and smoothed up the whole case." Two days later, on October 24, Sweat "Stained the clock case and polished it and set it up about 3 o'clock. Then received 1£. 7s. 0d." After completing the clock for Purinton, Sweat returned to the Curtises' house, and during his final three days in Harpswell, he "broke" the cornice over the breastwork in the front room and bedroom, finished the chamber floor, and put the latches on the doors, while his workmen "went to work on a bedstead." On October 27, Curtis settled his accounts with Sweat, giving the joiner five guineas and a note of hand valued at £5 lawful money. The crew departed by boat the next day and reached Kingston on October 31, seven weeks after they had left.[19]

Sweat's detailed account offers a vivid portrait of craft life. Sweat worked every day but Sunday. He devoted long hours to his labor, beginning at daybreak and sometimes continuing after dark. Bad weather had little effect on his schedule, since he worked mostly indoors. Illness or accidents could have slowed his progress, but fortunately neither was a significant factor. Sweat notes only one mishap, which did not take the craftsman completely by surprise: "This night I dreamed I saw a man stick a broad ax into a man's head. The next day, being the 23 [of October], I cut my finger and bled considerable at my nose."[20] Within the eighteenth-century world of Sweat and his neighbors, dreams were signs of the future, and such premonitions were to be taken seriously.

Sweat organized his days by task rather than by the clock. Some jobs, such as shingling or building the breastwork, required both him and his helpers; others could be done by a single member of the crew. Sweat managed the entire project, but much of his daily work was interchangeable with that of his crew. On October 5, Sweat noted that "John pinned the bedroom breastwork"; two days later, Sweat himself "pinned and smoothed up the breastwork and nailed it up"; finally on October 9, Mark "finished the breastwork." Though their work in Maine was hard and demanding, these three New Hampshire artisans found time for occasional diversions. Conversation and conviviality came during meals with neighbors. Huskings provided special entertainment as men assembled to husk corn and swap stories over pints of rum.[21]

John and Mark served Sweat as apprentices, a time-honored tradition that perpetuated the craft and provided a steady source of labor. In this case, both were skilled, diligent workmen whom Sweat treated virtually as sons. In fact, after Mark's sudden death in the American Revolution, Sweat named a son after the deceased apprentice.[22] Sweat's use of apprentices adhered to common practice. The standard English arrangement called for a boy of thirteen or fourteen to bind himself to a master for a period of seven years. The master agreed to instruct the youth in the "Art & Mystery" of the trade, to provide "sufficient meat drink washing lodging and apparrel Suitable for Such an apprentice," and often at the conclusion of his indenture to give the young tradesman two suits, "one new, the other for Common Weareing."[23] In return, the master gained the services of an employee as well as the earnings that his apprentice accrued during his period of training. In America, the system became more flexible over time. Length of service varied considerably. Nathaniel Morrell, a boy of only twelve, was put out by his mother to the Portsmouth turner John Mills for eight and one-half years.[24] Thomas Sherburne, on the other hand, served a brief two-year apprenticeship with the joiner John Drew before moving to Boston to work for a cabinetmaker there.[25] In central New Hampshire, the joiner John Dunlap took on four apprentices who remained with him from two

to five years.[26] Though far from complete, surviving apprenticeship records suggest that the period of indenture was usually less than five years. A recent study of a colonial Massachusetts joiner yielded similar results: seven apprentices for Simeon Doggett of Middleborough served an average of four and one-half years each.[27]

After completing an apprenticeship, a youth set out on his own. Many worked as journeymen for other artisans. Masters provided housing or meals as well as a daily rate of pay. Journeymen joined the household, becoming an integral part of both craft and family activities. Such arrangements worked well much of the time. Yet newspapers and court records are peppered with evidence of the system's flaws, for not every laborer was reliable or capable, nor was every craftsman a decent master. Some apprentices sought an early end to their indenture by running away. The cabinetmaker Langley Boardman noted a typical incident in 1811:

> "ABSCONDED, from my service on *Saturday*, February 16, 1811, EDWARD SHERBURNE, an indented apprentice boy, is about nineteen years of age, about 5 feet six inches high, stout built, fresh countenance and round favoured…has acquired some knowledge of the cabinet making business—He is understood to have gone towards Boston in the mail stage…any person that will return said boy to me the subscriber shall receive *Twenty Dollars* and all necessary charges paid."[28]

Apprentices could tax their masters in other ways. The joiner Timothy Davis had to extricate his boys from jail. In 1715, his two sons, Robert and Samuel, both serving as apprentices at the time, were arrested for stealing rum.[29] Another apprentice was convicted of the theft of £30 from a Portsmouth storekeeper.[30] In 1732, Davis also billed one of his journeymen for "one day getting you out of prison."[31] One wonders why he bothered. Davis had already docked the journeyman for "five days work & your diet when you sp[o]iled ye Case of drawers and would not finish them" and "two days work you Loste when you Spiled the Stuff for Governour donbars [Dunbar's] bookcase."[32]

Though not without its trials, the apprenticeship system was a staple of colonial life. It ensured the continuation of craft techniques from generation to generation. John Drew, for example, trained Michael Whidden, who in turn taught his son Michael the joiner's trade. Kinship frequently solidified the ties of apprenticeship. Whidden married Drew's daughter Anna. The joiner Joseph Buss, who probably served with Timothy Davis, married Davis's daughter. During the eighteenth century, the majority of apprentices in Portsmouth came from local families; sons of craftsmen provided an obvious source of labor. Whidden, Buss, and Davis all trained their sons in the trade, and in Davis's case, that training extended through three generations of Timothy Davises.[33] In addition, in Portsmouth a small group of slaves provided further assistance for craftsmen. The joiner Joseph Buss, Jr., had a Negro named Toby, and the carver William Lewis owned a "Negro Lad." The latter must have been adept at the carver's trade, because after Lewis's death in 1764, another prominent carver, Ebenezer Dearing, purchased the slave.[34]

Though most woodworking apprentices were from local families, many of their masters came from outside the community. The town's steady growth and accessible location attracted craftsmen, principally from England and Massachusetts. Between 1715 and 1720, four English joiners—John Drew, Francis Drew, Mark Haddon, and Hugh Montgomery—arrived in Portsmouth. The next generation included London-trained craftsmen, Samuel Aris and Henery Golden, and the immigrant cabinetmaker Robert Harrold, who probably also trained in England. Massachusetts artisans reached the town in even greater numbers. John Gaines and Langley Boardman were natives of Ipswich. Joseph Davis trained in Boston before moving to Portsmouth in 1734; thirty years later, the upholsterer Joseph Bass made the same journey. The clockmaker William Fitz moved from Newburyport, and two

painters, John and William Gray, came from Salem.[35] These transplanted artisans altered local practices; their fresh approach to design and craftsmanship balanced the traditionalism of apprenticeship. The result was a continual give-and-take between immigrants and native-born workmen, which fostered both change and persistence within the furniture trade.

The output of Portsmouth shops varied considerably. Some artisans devoted much of their time to furniture making; others considered the trade merely a supplement to more lucrative woodworking tasks. John Drew, the English immigrant who moved to Portsmouth in 1716 after a brief stay in Boston, concentrated on house and ship joinery. His commission to oversee the interior construction, painting, and plastering of Archibald Macpheadris's imposing brick mansion (*fig. 3*) testifies to his skill and versatility. Though trained as a house joiner, Drew expanded into almost every area of woodworking in his new home of Portsmouth. Even furniture making, a trade he had rarely practiced in England, became a part of his business. His output of furniture, however, was limited. During his twenty-year career in Portsmouth, he sold only nineteen picture frames, thirteen tables, four chests, three desks, a desk and bookcase, two bedsteads, a cradle, two cases of drawers, and a "comode table."[36] His charges for furniture total just £65.7.6 and probably represent no more than four months labor for himself and his apprentices. In contrast, for the Macpheadris house alone, he received £1,040.12.4 in payment for his own work as well as for that of his crew.[37] For Drew, furniture making filled the time between major building projects (*for a discussion of Drew's career as a builder, see the preceding essay*).

In the smaller seaport of York, Maine, just ten miles northeast of Portsmouth, the joiner Cotton Bradbury (1722–1806) operated in much the same fashion. Throughout his fifty years at the bench, Bradbury devoted well over half of his time to household and ship joinery. An account with George Goodwin exemplifies the majority of his business: "December 1752 Then began a job in partnership with M^r Grow to finish The joyners work of your hous for 210 pounds old ten[or]."[38] In Bradbury's case, joiner's work included nearly every aspect of house construction except the erection of the frame. He laid floors; installed panelling, pediments, doors, and window sash; often painted the woodwork; and sometimes clapboarded the façade and shingled the roof. His furniture production far exceeded that of Drew but was limited to just a handful of plain, inexpensive forms: primarily chests, tables, cradles, bedsteads, and an occasional quilting frame, bread trough, picture frame, and cupboard or "bofat." The entire value of his furniture amounted to £377.5.6. Forty percent of the total consisted of pine chests for use in the home or aboard ship. Cradles and bedsteads made up 29 percent, and tables constituted another 15 percent.[39] Most of these items were made during a thirty-year period, from the start of his career in 1743 to the outbreak of the American Revolution. Though he continued to work until 1800, Bradbury's furniture making trailed off to only a trickle later in his life. A related task, however, did remain an important part of his business. Like many furniture craftsmen, Bradbury made coffins. In his case, coffin-making rivaled all of his other furniture-making activities. His account book records the sale of 99 coffins, ranging in price from £0.4.0 to £5.0.0 each, for a total charge of £234.17.2. Cotton Bradbury's furniture—from cradles to coffins—served the utilitarian needs of his neighbors. For more fashionable goods, residents turned to other craftsmen who focused primarily on furniture making. In York, while Bradbury filled orders for ordinary items, Samuel Sewall offered ambitious products reminiscent of Boston furniture.[40]

Within Portsmouth, a small number of artisans catered to the demand for stylish furniture. Regrettably, their business records do not survive. One can only

grasp glimpses of their careers through scattered bills and household inventories. The chairmaker John Gaines represents one such workman. Born in Ipswich, Massachusetts, in 1704, Gaines learned the turner's trade from his father but, once on his own, chose not to remain in his father's shop or to compete with it.[41] In 1724, John and a neighboring youth, Charles Treadwell, moved to Portsmouth. They achieved considerable success in their new surroundings. Both married into established families and, by 1728, had built modest houses on what is now Congress Street—then little more than a rutted path extending westward from Market Square (*see endpapers*).[42] Treadwell first worked as a barber, then turned to storekeeping at the urging of his wife. Together the couple developed a business that became the basis for a substantial family fortune. Across the street, Gaines set up a sizable chairmaking operation in the small shop near his house. His total output probably numbered in the thousands and included seating for local homes as well as for export to distant destinations. Between 1732 and 1738, the merchant John Moffatt purchased 268 chairs, including "3 doz chairs Sent in y^e Sloope to NfLand [Newfoundland]."[43] Moffatt's rival, William Pepperrell of Kittery, bought at least five dozen chairs during the same era, also for export.[44] These products ranged from plain, unfinished "white" chairs with split spindles costing 3½s. each (*perhaps similar to* 74A) to joined and varnished chairs with what Gaines called "banister backs" at £1 apiece. In his day, the term banister referred to a solid vasiform splat, and undoubtedly his banister chairs resembled the set that descended in his family (*see fig.* 30). Like his friend Treadwell, Gaines supplemented his craft income through mercantile affairs. He jointly owned a schooner and frequently resold foodstuffs acquired through trade.[45] When he died in 1743, at the young age of thirty-nine, Gaines had become not only a prolific furniture maker but also an aspiring entrepreneur. Had he lived longer, he might have eventually abandoned his craft for commerce, just as Treadwell did. For the residents of Portsmouth, trade offered the surest path to wealth.

Throughout his career, John Gaines described himself as a turner or chairmaker; both were specialized trades that demanded skill at the lathe. Cabinetmakers customarily had more varied talents and offered a wider array of goods. Though detailed accounts for Portsmouth cabinetmakers of the late eighteenth century have not survived, the documented career of a Hampton craftsman during the federal era illustrates the traditional role of the cabinetmaker in the Piscataqua region. Simon Towle was born in Hampton in 1789 and probably served an apprenticeship in the town.[46] On September 1, 1811, just a month before his twenty-second birthday, Towle began to keep a record of his accounts in a large leather-bound daybook. Over the next fifty-one years, he entered each customer's name, purchase, and payment, concluding the volume in 1862, four years before his death on April 25, 1866.[47] A survey of the first six years of his career reveals the diversity of his business. Three areas predominate: general labor; construction and repair of wagons and sleighs; and furniture making and repair.

General labor accounted for nearly 23 percent of Towle's income. The tasks varied from making window sash to painting a chimney piece and often were performed on site. The cabinetmaker charged customers for his own time and that of his three apprentices. Initially, the daily rate stood at $.75 for his own work and about $.45 for each of his apprentices. By 1817, Towle's rate had increased to $.90 and that of his workmen to $.50. Sleigh and wagon making constituted another 23 percent of his business but followed a seasonal schedule. He built and repaired sleighs in the winter and wagons in the spring. The sale of supplies (mostly lumber, putty, and paint) and the loan of cash provided 10 percent of Towle's income. The remaining 44 percent came from furniture making.

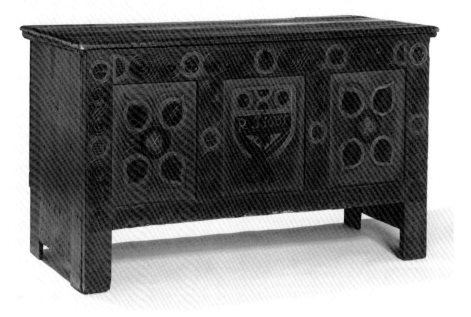

In his small shop, Towle and three apprentices made 283 pieces of furniture
over a six-year period at a total cost of $1,048.25. They provided clients from
Seabrook to North Hampton with every popular form of the era, except sideboards
and upholstered furniture. All told, his account book lists thirty-five different types
of objects within three broad categories: tables, case furniture, and furniture for
seating or sleeping. His tables ranged from kitchen tables for $2 to drop-leaf tables,
Pembroke tables, and card tables at about $5 each. His stock of case furniture in-
cluded secretaries averaging $30 each, bureaus at $15, and clock cases at $10. Such
large ambitious forms constituted his most expensive offerings, while simple seating
furniture was his cheapest. Kitchen chairs cost as little as $.83 each; dining chairs,
$2.50. His bedsteads typically had turned low posts, were stained or painted, and
cost about $2.50.[48] The variety of Towle's output far exceeded the limited repertoire
of earlier joiners, such as John Drew or Cotton Bradbury. Like the urban cabinet-
makers of nearby Portsmouth, he offered an expanded array of goods to meet the
specialized needs of consumers. Towle did so by devoting the majority of his time
to furniture making, in contrast to the more varied pursuits of Drew and Bradbury.

Though similar in scope to Portsmouth shops, Towle's cabinetmaking busi-
ness had two notable differences. First, Towle never referred to the use of imported
mahogany; presumably he made the vast majority of his furniture from native birch,
maple, and white pine. As a result, he charged less for his work than did his Ports-
mouth counterparts, who frequently relied on costly tropical woods for their best
work. In 1813, the year Towle sold his most expensive secretary for $36, the Ports-
mouth cabinetmaker Langley Boardman charged a client $55 for a comparable ver-
sion veneered with West Indian mahogany and she-oak (*see cat. no.* 34).[49] Second,
Towle did not make upholstered furniture. He never listed lolling chairs, easy
chairs, or sofas among his offerings, and even his chairs apparently had plank or
rushed seats. In Portsmouth, upholstered seating became popular after 1760 and
formed an essential part of the local furniture industry for more than a century.

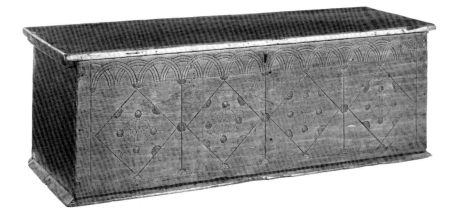

FIGURE 27.

Chest, Hampton, New Hampshire, 1660–1700. Eastern white pine, H. 16⅝; W. 49½; D. 18⅛.
Private collection. This chest, marked AM on the front, descended in the Marston family of Hampton
and may have been made by William Marston (ca. 1621–1704), a local carpenter.

The careers of John Drew, Cotton Bradbury, John Gaines, and Simon Towle
reflect the varied backgrounds and diverse activities of furniture makers in the
Portsmouth area. The surviving furniture from the region reinforces the individual
impact of particular craftsmen. Their work falls within the mainstream of British
design to be sure, but their singular interpretations of a style, whether it be manner-
ist, baroque, rococo, or neoclasssical, are often fresh and inventive.

Among the few documented forms of seventeenth-century furniture from the
Piscataqua region are two distinct groups of chests. Carved examples with Ports-
mouth histories (*fig. 26; cat. no. 2*) illustrate the work of an immigrant from the
West Country of England. This unknown artisan adopted the peculiar English
practice of using joinery only for the façade: the three-panel front is merely nailed
to the one-board sides. Further south along the New Hampshire coast, a Hampton
craftsman made plainer nailed chests and boxes with scratch-carved decoration in
geometric patterns (*fig. 27; cat. no. 1*). By the early eighteenth century, other Hamp-
ton carpenters had begun to produce more ambitious chests and press cupboards
that emphasized bold decorative schemes rather than incised ornament. On the best
preserved cupboard (*cat. no. 3*), painted trees and birds parade across the façade.
Though colorful, showy, and surely an object of great pride for its owners, the cup-
board harks back to an earlier era, when carved and joined versions occupied posi-
tions of great prominence in the home. The cupboard's continued use in Hampton
attests to the persistence of traditional forms in rural New Hampshire.

In urban Portsmouth, residents enjoyed more direct access to current fash-
ions. After 1700, immigrant craftsmen and imported furniture introduced wealthy
patrons to stylish patterns popular in Boston and London. A local variant of the ba-
roque style, characterized by conspicuous ornament and dazzling contrasts of color,
emerged. Yet the style was not homogeneous: the products of each shop had a dis-
tinct identity. Artisans developed their own expressions of the baroque, based on
their experience and skill as well their customer's preferences and pocketbook. The
most grandiose expression of the new style, today often termed "Queen Anne" after
the English monarch, appears in an ornate high chest made in 1733 for a member
of the Sherburne family of Portsmouth (*cat. no. 15*). The chest documents the full

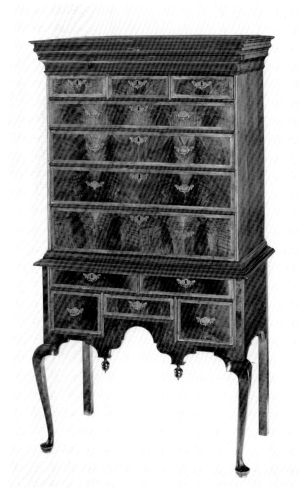

FIGURE 28.

*High chest, Joseph Davis (w. 1726–62), Portsmouth, New Hampshire, 1735–45. *Black walnut, birch, and *eastern white pine, H. 75; W. 40¼; D. 22⅜. Strawbery Banke Museum, gift of Mary Neal Kendall, 1991.191. The name Joseph Davis is written in chalk on the bottom of a drawer. The signature matches that on the blockfront dressing table in fig. 29. The legs on the chest are replaced.*

flowering of the curvilinear fashion in Portsmouth within months of its earliest known use in Boston.[50] The unknown maker of the chest closely followed eastern Massachusetts precedents in the shape of the curving cabriole legs and scrolled pediment. Yet, he imbued the form with playful extravagance through dramatic contrasts of figured woods and whimsical faces at the center of the inlaid shells on the façade. Such distinctive details readily distinguish this extraordinary chest from its Boston counterparts and clearly establish its unknown maker as a master of late baroque design.

Other groups of Portsmouth furniture, made just after the Sherburne high chest, can be linked to the craftsmen Joseph Davis and John Gaines. Davis learned his trade from the cabinetmaker Job Coit in Boston and worked there briefly on his own. By 1734, he had departed for Portsmouth, where he remained until 1762.[51] In Portsmouth, he produced a striking array of case furniture, which reflected his Boston background in varying degrees. A high chest signed by Davis (*fig.* 28) closely resembles eastern Massachusetts models in its veneering, drawer configuration, and skirt design. Only the birch banding around the drawers and massive cornice distinguish it from comparable Boston examples. On other items, however, Davis devi-

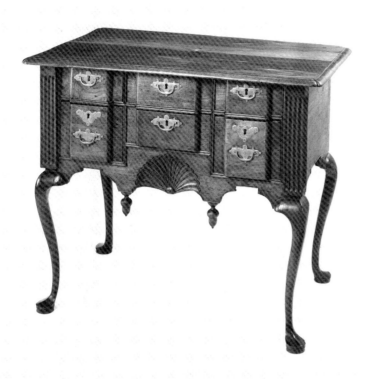

FIGURE 29.

Dressing table, Joseph Davis (w. 1726–62), Portsmouth, New Hampshire, 1735–50. Black walnut, maple, and eastern white pine, H. 29¾; W. 35¾; D. 22⅞. The Dietrich American Foundation, Philadelphia, Pennsylvania, 8.2.1.569. Will Brown photograph. The name Joseph Davis is written in chalk on the bottom of the upper middle drawer. The signature matches that on the veneered high chest in fig. 28. A detail of the hardware on the dressing table is shown in 16A.

ated dramatically from convention. His blockfront case furniture (*fig.* 29; *cat. no.* 17) incorporates flat angular blocking on the façade, large fluted pilasters at the corners, a bold shell along the skirt, and an inlaid compass star in the top. Though each detail emulated a Boston motif, their combination on a single object was unique to the work of Davis. Unfortunately, his skill as a craftsman failed to match his talent as a designer. He supported these large, ornamental cases with surprisingly delicate cabriole legs. On his known high chests, the legs proved too weak to carry the weight of the case and had to be replaced (*see cat. no.* 16). In one instance (*fig.* 28), a repairman inserted straight rear legs in place of the original cabrioles. Though a structural improvement, such alterations obscure the bold vision of this eccentric Portsmouth interpreter of the baroque.

John Gaines also introduced Massachusetts designs to Portsmouth. In his father's shop in Ipswich, he helped make turned chairs with backs composed of columnar split spindles, baluster-turned front legs, and stretchers with ball-reel-and-ball turnings.[52] He continued the pattern in Portsmouth. But, soon after his arrival there in 1724, the changing whims of fashion forced Gaines to add other elements to his stylistic repertoire. During the early 1730s, imported chairs from London (*cat. no.* 76) and Boston (79B) introduced Piscataqua patrons to the curving contours of the Queen Anne style.[53] Gaines created his own distinctive version (*fig.* 30), grafting peculiar variations of the standard baluster splat and yoke-carved crest rail onto the traditional plan of stretchers and legs that Massachusetts craftsmen had used for a quarter-century. On his most sophisticated products (*cat. no.* 78), he substituted cabriole legs for the more common turned legs. The concession to current

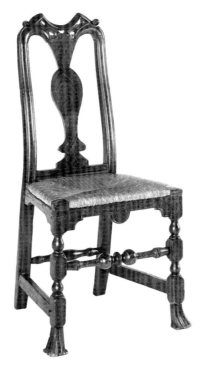

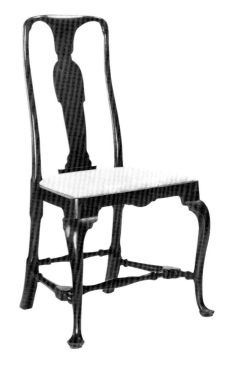

FIGURE 30.

*Side chair, attributed to John Gaines III (1704–
43), Portsmouth, New Hampshire, 1735–40.
*Soft maple, H. 40¼; W. 20½; SD. 14⅛; SH.
18¼. Private collection. This chair and three
matching ones descended from John Gaines III to
his daughter, Mary, who married the Ports-
mouth joiner David Brewster (1739–1818).
The chairs remain in the Brewster family.*

FIGURE 31.

*Side chair, Portsmouth, New Hampshire, 1735–
45. Black walnut and *soft maple, H. 41³/₁₆; W.
21¼; SD. 16¼; SH. 17. Strawbery Banke
Museum, Portsmouth, New Hampshire,
1991.160. Modeled on London chairs of the
1730s, this example descended in the Goodwin
and Storer families of Portsmouth.*

taste surely impressed his customer but demonstrated Gaines's inadequacies as a
craftsman. His cabriole legs lack the smooth, graceful contours of those fashioned
by more proficient artisans. One such maker skillfully modeled his chairs (*fig.* 31) on
imported English examples. Were it not for their Portsmouth history and use of na-
tive maple as a secondary wood, his chairs might easily be mistaken for London
products. Another unidentified chairmaker in the Portsmouth area used Boston ex-
amples as a guide. Except for minor differences in the layout of the stretchers, his
chairs (*cat. no.* 79) successfully duplicate the classic outline of the Boston Queen
Anne chair (79B). Gaines and his two competitors each developed a particular inter-
pretation of late baroque design. Gaines displayed the most creativity, but his rivals,
who copied foreign models, offered more sophisticated products. Their varied ap-
proaches to design reveal that even in Portsmouth—a town with fewer than 2,000
inhabitants in 1740—customers had several options for fashionable seating.

Chairs with cabriole legs represented the most expensive choice available to
local consumers. These products were destined for the best parlors and chambers of
the region's most opulent houses. Turned chairs with slat backs or vertical split
spindles were made in much greater numbers and at far less cost. Portsmouth-area
turners offered a wide variety of inexpensive patterns. Judging from surviving ex-
amples, the most common eighteenth-century plan had cone-and-ball finials and a
double arch capping the crest (*cat. no.* 74). Other popular designs include those with
crests resembling a fish tail (*cat. no.* 75) or fan (*fig.* 32). The latter have traditionally
been attributed to inland New Hampshire but can now also be ascribed to coastal

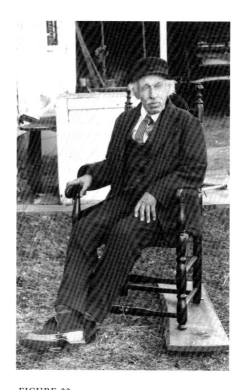

FIGURE 32.

*Armchair, Portsmouth, New Hampshire area,
1730–60. Maple and ash, H. 43½; W. 21½;
SD. 15⅞; SH. 15½. Yale University Art
Gallery, gift of Mrs. Paul H. Moore, 1971.15.1.
The fan-carved crest, ball finials, sloping arms,
and turned front legs resemble those on the chair
shown in fig. 33.*

FIGURE 33.

*Man in armchair with fan-carved crest,
Portsmouth, New Hampshire, 1895–1900.
Patch Collection, Strawbery Banke Museum,
Portsmouth, New Hampshire. This historic
photograph links chairs with fan-carved crests
like that in fig. 32 to Portsmouth.*

communities, because of photographic evidence of their use in Portsmouth in the
late nineteenth century (*fig. 33*).

The baroque world of Joseph Davis and John Gaines gave way suddenly to a
bold new fashion in the 1760s. The rococo style, frequently called "Chippendale"
after the English designer Thomas Chippendale, replaced the more restrained
Queen Anne style with sprightly naturalistic ornament, often asymmetrical in out-
line. Carvings in richly grained mahogany supplanted the veneered decoration of
the earlier era. Whimsical interpretations of Gothic and Chinese design accompa-
nied the pronounced French cast of the new style. A number of Portsmouth's most
affluent merchants gained first-hand exposure to the rococo through lengthy stays
in England on business. In 1763, Nathaniel Barrell returned from three years
abroad with a costly suite of carved London furniture, which included a set of chairs
(*cat. no.* 82), a writing table, and "a Large Sconce Glass" with a matching "Pair of
Carv'd Sconces."[54] The looking glass (*fig. 34*) embodies the essence of the rococo. Its
animated outline offers an eye-catching fantasy of pagodas, cascading vines, delicate
columns, and even a carved monkey perched within a cage of C-scrolls.

Other Portsmouth merchants relied on English agents or ship captains for
goods in the new taste. In 1766, just a year after their marriage, Woodbury
Langdon and Sarah Sherburne set out to furnish their home with an impressive ar-
ray of fashionable goods. Woodbury enlisted the help of his brother John, captain
of a merchant vessel headed to London. In a letter of April 1766, he asked John to
buy an elegant assortment of silver, pewter, and porcelain tablewares, as well as

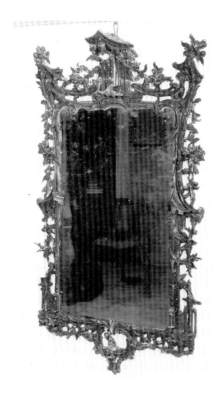

FIGURE 34.

Looking glass, Samuel Walker, London, 1763.
Spruce, H. 55; W. 31; D. 4. Private collection.
Brock Jobe photograph. While in London on
business, Nathaniel Barrell of Portsmouth
bought this ornate looking glass and two
matching sconces. The gessoed surfaces were never
gilded. Instead, Walker's bill to Barrell notes a
charge of 10½ s. for "Painting the Glass &
Sconces."

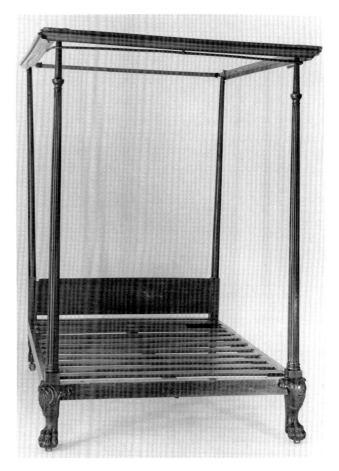

FIGURE 35.

Bedstead, probably London, 1755–75. Mahogany, black walnut,
beech, oak, and pine, H. 88 ¼; W. 62; D. 78. Colonial Williamsburg,
Williamsburg, Virginia, 1920–150. This bed descended in the Ham
family of Portsmouth.

looking glasses (*see cat. no.* 116), a marble slab table "supported in the newest Fash-
ion," and two fully outfitted high-post bedsteads.[55] The principal bedstead had
carved mahogany posts and casters; its bedding included "1 very good Feather Bed
[of the] best Tick with Bolster Pillows Blanketts Quilt"; the hangings consisted of
"Curtains Head Cloth Tester, Vallens, Basses" and were to be "neatly made after
the newest Fashion of fine Crimson Worsted Damask." To complement the bed,
Langdon ordered three matching window curtains "to haul up" in the Venetian
manner, three cushions for window seats, and sufficient crimson damask to cover an
easy chair and set of side chairs. A second bedstead "with Colour'd Posts & Casters
neat without Carved Work" had orange-and-white check hangings; once again,
matching fabric was to be used for window curtains, cushions for the window seats,
and a set of chamber chairs.[56] A surviving English bedstead with a Portsmouth his-
tory (*fig.* 35) illustrates the level of workmanship sought by Langdon and his con-
temporaries. The stylish paw feet, carved knees, and fluted shafts of the footposts
bespeak quality. When draped in expensive red damask and fitted with a thick, bil-
lowy feather bed, the bedstead presented a sumptuous appearance indeed. For
Woodbury Langdon, a well-connected young merchant coming of age in the 1760s,
the rococo offered the ideal vehicle for lavish display. Its florid ornament empha-
sized success and sophistication. Others also found it a fitting symbol of their sta-
tus, and soon it came to characterize the homes of Portsmouth's most powerful and
richest entrepreneurs.

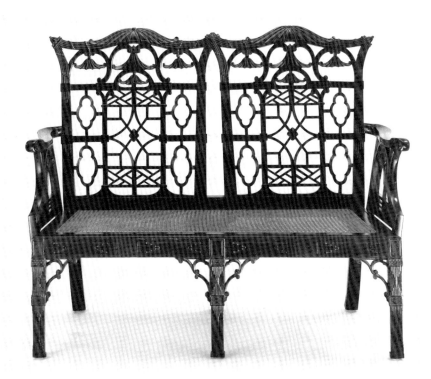

FIGURE 36.

Settee, London, 1763–67. Mahogany, H. 38⅛; W. 48½; SD. 21½; SH. 15. Colonial Williamsburg, Williamsburg, Virginia, 1959–351.1. This striking settee is part of a large set of seating furniture that probably belonged to Governor John Wentworth of Portsmouth. Both this and a matching example at the Moffatt-Ladd House in Portsmouth originally had three chair backs rather than two.

 The leading patron of the rococo in Portsmouth was undoubtedly the royal governor, John Wentworth (*fig.* 11). A native of the town, Wentworth had moved to Great Britain in 1763 at the behest of his father, the immensely wealthy merchant, Mark Hunking Wentworth. Equipped with the best letters of introduction that colonial society could supply, young John (then twenty-six) made many advantageous acquaintances in England and Ireland, which helped enhance his father's mercantile affairs and stabilize the family's declining political fortunes. His most influential ally proved to be a distant relative, Charles Watson-Wentworth, the marquess of Rockingham. For John, the relationship produced both aesthetic and political benefits. He stayed for several months at Wentworth House, Rockingham's grand country seat in Yorkshire, where he had access to one of Britain's greatest art collections and gained an appreciation for fine architecture. The edifying environment of Wentworth House greatly impressed the young colonial. He might well have remained there longer were it not for his appointment to succeed his uncle, Benning Wentworth, as governor of the province of New Hampshire. He returned to Portsmouth with great fanfare in the spring of 1767 and took up residence in a large home on Pleasant Street (*see fig.* 12). Though a "small hut" in his eyes, Wentworth furnished it grandly.[57] A spectacular set of London rococo seating furniture apparently filled one of the parlors (*fig.* 36; *cat. no.* 81). The set originally included two triple-chair-back settees, six armchairs, and probably six matching stools, and today ranks as the most ambitious English furniture in the Chinese taste with an American history.[58]

 For local furniture in the new fashion, Wentworth turned to a newly arrived artisan, Robert Harrold. The cabinetmaker's presence in Portsmouth is first noted

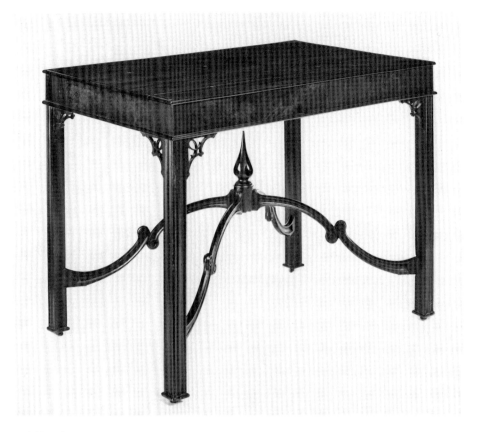

FIGURE 37.

China table, attributed to Robert Harrold (w. 1765–92), Portsmouth, New Hampshire, 1765–75.
**Mahogany, *soft maple, and *eastern white pine, H. 27¼; W. 35⁹⁄₁₆; D. 23³⁄₈. Strawbery Banke*
Museum, Portsmouth, New Hampshire, gift of Gerrit van der Woude, 1990.37. This table and a
companion kettle stand (fig. 38) probably belonged to Governor John Wentworth of Portsmouth. A
pierced gallery originally fit into a shallow dado along the edge of the top.

in a tax list for the year 1765. At the time, he lived with Richard Shortridge, a pros-
perous furniture maker, and may have worked as a journeyman for his landlord.[59]
Evidence of his earlier past is frustratingly elusive. No other Harrolds resided in the
town or neighboring communities.[60] Presumably, he trained in Great Britain and,
when still in his twenties, emigrated to Portsmouth.

Wentworth's first commission occurred just five days after his inauguration as
governor. The wardens of Portsmouth's Anglican church, Queen's Chapel, an-
nounced their intention to build a new pew for the governor and sought his advice
on the design.[61] On June 18, 1767, Wentworth presented a plan for a majestic
canopy with a pagoda roof and decorative columns.[62] Curtains of red damask were
to be draped at the back, and two large chairs with matching upholstery were to
form the appropriate seating. Harrold constructed the chairs; Joseph Bass, a Bos-
ton-trained upholsterer, made the curtains and probably covered the seats; and the
joiner Michael Whidden built the canopy.[63] One of Harrold's chairs (*cat. no.* 85) is
all that remains of this fanciful creation. He based its striking Gothic design on a
plate in an English pattern book of 1765 (85A), a publication that Wentworth him-
self may have supplied to the cabinetmaker. The governor possessed an extensive li-
brary, which included an architectural guide and perhaps a volume on furniture.[64]

Shortly after finishing the pew chairs, Harrold accepted an even more presti-
gious commission: a "Mehogony Chair for the Gover[no]ʳ."[65] The chair was des-
tined for the Council Chamber of the Provincial State House in Portsmouth.

Harrold's bill totalled a whopping £120 (Old Tenor), even without the silk damask cushion that Lydia Peirce supplied for an additional £44 (Old Tenor).[66] Neither the chair nor any description of it survives, and its appearance remains a subject of conjecture. Yet it obviously provided an impressive seat for the governor, not unlike the extant chairs made for the use of two southern governors during the late 1750s. Both chairs are monumental in scale and lavishly ornamented with carving. One stood in the Council Chamber of the first South Carolina State House in Charleston; the other probably occupied a similar position in the Virginia Capitol at Williamsburg.[67] Whether in Portsmouth or Charleston, these chairs of state had considerable impact on all who saw them and served as an invaluable endorsement of their maker's ability. For Robert Harrold, who at the time had just three years of local experience, the commission must have solidified his position within the community. Orders from other prominent local figures followed. His income rose dramatically, and by 1770 he had purchased a house and shop of his own, located within one block of Governor Wentworth's residence on Pleasant Street. His tax assessments chronicle his growing affluence. In 1765 he paid only 8s. in town tax; by 1772, this figure had risen sevenfold, to £3.[68]

Harrold's arrival coincided with a dramatic change in Portsmouth furniture. The provincial, sometimes peculiar designs of Gaines and Davis were replaced by sophisticated patterns resembling London models. The architect of the transformation was surely Harrold. Relying on his own training as well as on pattern books and fashionable English furniture imported by John Wentworth and his circle, Harrold developed stylish new forms well suited to a mercantile aristocracy closely linked to England. In all likelihood, he made a striking china table and matching kettle stand (*figs.* 37 *and* 38) for Governor Wentworth and his wife, Frances. He probably also constructed an imposing library bookcase (*cat. no.* 27) for Jonathan Warner, a cousin of the Wentworths. In 1760, Warner and his wife, Mary, moved into the stately brick mansion built by her father, Archibald Macpheadris, more than four decades before (*fig.* 3). They renovated the residence and introduced many new furnishings, including the bookcase, which became the focal point of the "Front Setting Room" (*fig.* 39) and, remarkably, still resides there today.[69]

In addition to case furniture and tables, Harrold provided patrons with a variety of seating furniture. Fashionable mahogany chairs derived from design books (*cat. no.* 86) and popular English patterns (*cat. no.* 87) predominated, but costly upholstered armchairs and couches also formed a major part of his business (*cat. nos.* 91 *and* 92). The upholsterer Joseph Bass collaborated on the more ambitious items. Born and trained in Boston, Bass had come to Portsmouth in 1764, just a year before Harrold, and served as its principal upholsterer for the next two decades.[70] Together, the two artisans created a sturdy, straightforward style of upholstered seating that carefully copied the broad proportions, straight legs, and serpentine backs of comparable London examples. Clearly Harrold dictated the designs. Their products bear little resemblance to the upholstered forms that Bass would have seen during his apprenticeship in Boston. Instead, in design as well as in such distinctive structural features as cross braces within the seat frame (86A), a decidedly London technique, Portsmouth upholstery reflected the capable hand of a British-trained craftsman, surely Robert Harrold.

Harrold undoubtedly had an impact on his competitors. Richard Shortridge, Shortridge's journeyman John Sherburne, and Solomon Cotton, who purchased Harrold's shop and may have worked with him, probably became familiar with prevailing English taste through contact with the immigrant.[71] They soon offered similar forms to customers, thus expanding Harrold's personal interpretation of the rococo into a town-wide style. At no other time during the eighteenth or early nine-

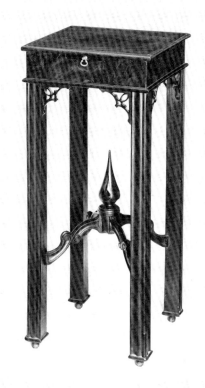

FIGURE 38.

Kettle stand, attributed to Robert Harrold (w. 1765–92), Portsmouth, New Hampshire, 1765–75. Mahogany, maple, and eastern white pine, H. 26⅜; W. 11¹⁵/₁₆; D. 11⅝. Warner House Association, gift of Mrs. C. C. G. Chaplin, 1989.1. This stand and its companion china table (fig. 37) probably belonged to Governor John Wentworth of Portsmouth. A pierced gallery originally fit into a shallow dado along the edge of the top.

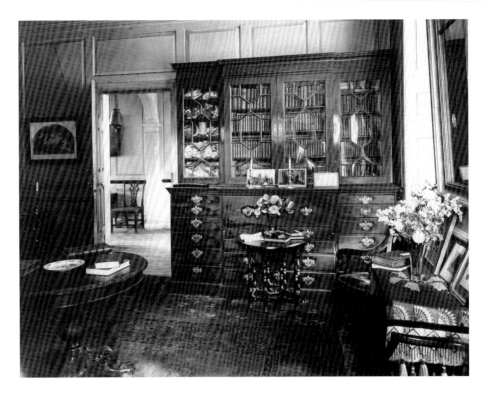

FIGURE 39.

"Front Setting Room" of the Macpheadris-Warner House, Portsmouth, New Hampshire. Photograph, ca. 1914. Mary Northend Collection, Archives, Society for the Preservation of New England Antiquities, Boston, Massachusetts. This historic view shows the library bookcase (cat. no. 27) made by Robert Harrold for Jonathan Warner in its original location.

teenth centuries was the relationship to English precedents as close as it was during the rococo era, nor was English influence during that period as pronounced anywhere else in New England.

Yet the popularity of English designs did not completely eliminate other sources of influence on local craftsmen. Patterns derived from eastern Massachusetts models continued to appear, especially in case furniture. The Portsmouth maker of a blockfront desk and bookcase for the Wentworth family (*cat. no. 25*) adhered to Boston prototypes. At least three later makers of blockfronts based their chests of drawers on imported Boston examples (*fig.* 40, *cat. nos.* 6 *and* 7), while another cabinetmaker fashioned drop-leaf tables with such distinctive earmarks of eastern Massachusetts furniture as scalloped skirts on the end rails, pronounced ridges along the knees of the cabriole legs, and claw-and-ball feet with side talons that rake back slightly (*cat. no.* 55).

During the 1790s the rococo yielded to a new style, termed "neoclassical" or "federal," in reference to its popularity during the early years of the republic. The fashion emphasized lighter forms, contrasting colors in paint or veneer, and motifs inspired by classical antiquity. In Portsmouth the introduction of neoclassical taste in furniture coincided with a change in the composition of the cabinetmaking trade. Harrold, Shortridge, and other key craftsmen active before the American Revolution had died. In their place came George Osborne from England in 1793 and the native-born artisan Mark Ham a year later.[72] Osborne seems to have had little impact, and Ham's career was all too brief. He had died by 1798, leaving behind a sizable shop with twenty-eight pieces of unfinished furniture ranging from birch table frames to a mahogany desk.[73] Just four months before Ham's death, Langley Boardman opened a shop in Portsmouth. This young newcomer from coastal Mas-

sachusetts introduced Piscataqua patrons to handsome Salem versions of neoclassical design. His furniture found a ready market, and soon he became the dominant figure in Portsmouth cabinetmaking. His business would extend far beyond his colonial predecessors. He would operate on a much larger scale and initiate new methods for selling his goods. His career symbolizes the advent of a new era in the furniture trade—an era to be explored in the next essay.

This survey has focused on the careers and furniture of the eighteenth-century woodworkers of the Piscataqua area. They constitute a diverse group, with varied backgrounds and differing levels of skill. Many performed a miscellany of tasks to earn a livelihood: weeding a turnip yard was all in a day's work for one Portsmouth joiner.[74] Yet some of these artisans did take on specialized roles. A handful concentrated on turning, others on upholstery, and still others on cabinetmaking. Their time devoted to furniture making fluctuated according to their degree of specialization. Cabinetmakers like Robert Harrold or Simon Towle derived the majority of their income from the production and repair of furniture, while joiners such as John Drew and Cotton Bradbury considered furniture making a modest supplement to more lucrative commissions to finish the interiors of newly built houses or ships.

The total output of these artisans was considerable. Except for occasional imports from Boston and London by wealthy merchants, the vast majority of furniture in Piscataqua homes came from local shops. These shops also benefited from the region's maritime economy. Ship captains often supplemented their cargoes of timber, fish, and hides with furniture. In 1752, the schooner *Molley* sailed from Portsmouth to Newfoundland with eight desks packed in cases.[75] Other ships carried furniture to the South, the West Indies, even the Azores. In an account of 1768, a ship captain at Tenerife in the Azores implored a Portsmouth merchant to send on the next vessel "12 Mapple Desks Mahogany colour with good Brass work," twelve dining tables, and six dozen black walnut chairs with leather seats.[76] An even more telling indication of the scale of the export trade appears in British customs records for a five-year period beginning in 1768. Piscataqua vessels shipped nearly 4,900 pieces of furniture during these years. Within America, only Philadelphia (7,916 items) and Boston (5,561 items) had higher totals.[77] Such statistics place Portsmouth among the leading centers of furniture production in the colonies.

Chairs made up the bulk of these pre-Revolutionary exports from Portsmouth. A popular Portsmouth model (*fig. 41*) matching the description provided by the Tenerife ship captain may well have been a favorite form of venture furniture. Related examples made their way to southern ports and several survive with provenances there.[78] The design is striking but plain, conveying stylishness through its Chippendale outline and leather seat, but it ranked among the least expensive patterns of upholstered furniture. Such attributes characterized most Piscataqua exports. More elaborate patterns enhanced with carving or inlay and constructed of costlier woods had a far more limited market. Affluent clients within the Portsmouth area ordered these ambitious articles largely for their own use. Though the number of such pieces was relatively small, they shed the most light on the furniture-making traditions of the Piscataqua. They illustrate the individual backgrounds of their makers. Many men came from eastern Massachusetts or England and, not surprisingly, much Portsmouth furniture resembles the products of the two areas. Nevertheless, inventive interpretations abound, especially in the work of early eighteenth-century artisans like Joseph Davis and John Gaines. As a whole, the best furniture of the town is remarkably flamboyant. Its showy demeanor perfectly suited a provincial society, which one visitor found as early as 1743 "to go beyond most others…in their sumptuous and elegant living."[79]

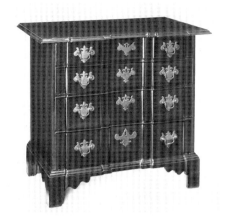

FIGURE 40.

*Chest of drawers, Portsmouth, New Hampshire, 1760–80. *Mahogany, *soft maple, and *eastern white pine, H. 30¹¹⁄₁₆; W. 34¾; D. 21⅛. Governor John Langdon House, Portsmouth, New Hampshire, Society for the Preservation of New England Antiquities, bequest of Elizabeth Elwyn Langdon, 1966.352. This chest has a history in the Langdon House since at least the late nineteenth century.*

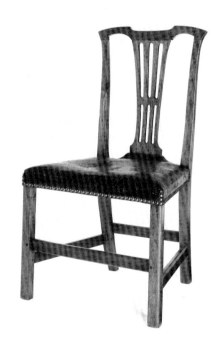

FIGURE 41.

*Side chair, Portsmouth, New Hampshire, 1765–90. *Black walnut, *soft maple, and *eastern white pine, H. 37¼; W. 21⅜; SD. 16¹³⁄₁₆; SH. 17. New Hampshire Historical Society, Concord, New Hampshire, gift of Richard F. Upton, 1978.81. This chair retains its original leather upholstery and bears the brand of an early nineteenth-century owner, Oliver Briard of Portsmouth.*

1. Brissot de Warville 1797, 366–67.

2. See especially Howells 1937, Garvin 1971, Garvin 1983, Candee 1976, Candee 1992.

3. See, for example, Saltonstall 1941; Brighton 1985; Brighton 1986; Brighton 1989; Winslow 1988.

4. Rhoades 1972, 15.

5. The dealer, Bill Graham of Haverhill, Mass., recounted the story to the author during a tour of Portsmouth on Oct. 14, 1989.

6. Candee 1976, 169–70; Jobe and Kaye 1984, 55–56.

7. John Roberts is identified as a cabinetmaker of Portsmouth in Oct., 1718; see Roberts v. Davis, Jan. 23, 1719, docket 17288, N.H. Provincial Court, State Archives. Roberts had worked in the town since at least 1714; see Davis v. Roberts, Aug. 16, 1718, docket 15303, N.H. Provincial Court, State Archives. For Roberts's use of "finenears," see preceding court case.

8. See advertisements of the Windsor chairmaker Josiah Folsom (*New Hampshire Gazette*, Sept. 19, 1797) and the ornamental painter John Gray, Jr. (*Oracle of the Day*, Dec. 1, 1798).

9. *New Hampshire Gazette,* Jan. 5, 1758.

10. Parsons 1976, 62–67, 299, 331.

11. The known locations of the residences and shops of eighteenth-century Portsmouth craftsmen are cited in Jobe 1993; see also appendix A at the back of this volume.

12. Harrold had purchased land for his house and shop from a larger lot owned by Mark Langdon. The transaction, dated Sept. 18, 1770, transfers a "certain Lot of Land now improved and in Possession of him the said Robert [Harrold] whereon he has built his present Dwelling House." Langdon to Harrold, 1771 deed, 102:154–55, N.H. Provincial Deeds, Rockingham County Court House.

13. *New Hampshire Gazette,* July 29, 1763.

14. Davis is listed "at Mills" in Portsmouth tax lists for the years 1736 through 1739 at the Portsmouth City Hall.

15. Kingsly James, 1745 inventory, docket 1182, N.H. Provincial Probate Records, State Archives.

16. Richard Shortridge, 1777 inventory, old series, docket 4326, Rockingham County (N.H.) Probate.

17. Sweat kept an account of his journey in a small receipt book, now owned by the New Hampshire Historical Society; see Lacy 1975. The pages of the book have been removed from their original binding, mounted onto larger sheets of paper, and rebound into an elgant leather volume titled *Journal - Samuel Sweat.* Sweat's journal has been transcribed and is available in typescript at the Historical Society. All journal quotations cited hereafter in the text are taken from the typescript.

18. Samuel Sweat, journal, 4.

19. Samuel Sweat, journal, 5–11.

20. Samuel Sweat, journal, 8.

21. Samuel Sweat, journal, 6–7. Sweat noted attending huskings at Mr. Bartlett's on Oct. 7 and at Mrs. Holbrook's on Oct. 14.

22. Lacy 1975, 222.

23. An excellent analysis of the apprenticeship system in London appears in Kirkham 1988, 40–56. The quoted conditions of apprenticeship are extracted from indentures for Portsmouth apprentices; see Drew v. Sherburne, Dec. 8, 1735, docket 13396; Mills v. Salter, May 19, 1747, docket 22555, N.H. Provincial Court, State Archives.

24. Mills v. Salter, May 19, 1747, docket 22555, N.H. Provincial Court, State Archives.

25. Drew v. Sherburne, Dec. 8, 1735, docket 13396, N.H. Provincial Court, State Archives.

26. *The Dunlaps,* 18, 53–54.

27. Hofer 1991, 9, 17.

28. *New Hampshire Gazette,* Feb. 19, 1811.

29. Welch, Stevens, and Prey v. Davis, July 1715, docket 21444, N.H. Provincial Court, State Archives.

30. Wentworth v. Locke, Apr. 13, 1737, docket 21636, N.H. Provincial Court, State Archives.

31. Davis v. Davis, Nov. 18, 1732, docket 13701, N.H. Provincial Court, State Archives.

32. See note 31 above.

33. Biographies of each eighteenth-century Portsmouth furniture craftsmen are given in Jobe 1993; see also appendix A.

34. Joseph Buss, 1762 inventory, docket 2873, N.H. Provincial Probate, State Archives. Buss had acquired Toby by 1753 when he billed Stephen Roberts of Dover for "9 Days Work my Negro." Buss v. Roberts, May 10, 1753, docket 05839, N.H. Provincial Court, State Archives. For Lewis and Dearing's slave, see William Lewis, 1764 inventory and 1782 administrative accounts, docket 3068, N.H. Provincial Court, State Archives.

35. Jobe 1993.

36. John Drew, account book, 1706–38, 193, Cumings Library, Strawbery Banke Museum.

37. John Drew to Archibald Macpheadris, bill, ca. 1716, box 1, folder 8, Portsmouth Athenaeum.

38. Cotton Bradbury, account book, 1743–1800, 46, Old York Historical Society.

39. The remaining 16 percent of his output consisted of a diverse array of goods, including occasional trunks, picture frames, bread troughs, quilting frames, "bofats," and cupboards.

40. Kaye 1985.

41. Hendrick 1964, 34–35, 41.

42. Brewster 1859, 133–38.

43. John Moffatt, ledger, 1725–60, 46, 120, New Hampshire Historical Society.

44. Pepperrell v. Gaines, Apr. 28, 1739, docket 12253, N.H. Provincial Court, State Archives.

45. Gaines's estate inventory included "one third of a schoner with her appurtinance" valued at

£90. John Gaines, 1744 inventory, docket 1097, N.H. Provincial Probate, State Archives. For evidence of Gaines's trading activities, see Gaines v. Pearson, May 19, 1741, docket 23626, N.H. Provincial Court, State Archives.

46. For a brief sketch of Towle's life, see Dow 1893, 2:1006–10.

47. Towle's daybook is in the collection of the Tuck Memorial.

48. Towle's most expensive bedstead between 1812 and 1817 was a field bedstead, which he sold to Captain Thomas Wood on Jan. 7, 1817, for $8. Simon Towle, daybook, 1811–62, Tuck Memorial.

49. Simon Towle, daybook, account with David Nudd, May 1, 1813, Tuck Memorial.

50. Evidence of the new style first appeared in a Boston upholsterer's account of 1729. The earliest reference to a fully developed Queen Anne case piece, presumably with a scrolled pediment and cabriole legs, occurred in 1733. Jobe 1991b, 108.

51. See cat no. 16, notes 3–6.

52. Hendrick 1964, 34–35. Gaines's father made three types of chairs. One group had horizontal slats, another had vertical split spindles, and the last had solid splats, which his father described as banister backs in his account book; see Hendrick 1964, appendix M. Gaines must have assisted in the production of these chairs while he worked as an apprentice in his father's shop. Few chairs can now be tied to this shop; a rare example, which descended in the Appleton family of Ipswich, is pictured in Jobe and Kaye 1984, 64.

53. Merchants' accounts confirm the importation of Queen Anne-style seating from London and Boston. During the 1730s, William Pepperrell, the wealthy trader of Kittery, Me., acquired chairs from Boston upholsterers as well as a business partner in London. See Singleton 1900–1901, 2:332; Thomas Baxter to William Pepperrell, bill, Dec. 26, 1739, SPNEA Archives.

54. Quoted in Jobe and Kaye 1984, 21.

55. Langdon and Sherburne to John Langdon, memorandum, Apr. 1766, Langdon Papers, Cumings Library, Strawbery Banke Museum.

56. See note 55 above.

57. Quoted in Mayo 1921, 64.

58. Nine pieces from the set are known. One of the settees and two of the chairs belong to Colonial Williamsburg; the other settee, four chairs, and the one surviving stool are at the Moffatt-Ladd House in Portsmouth.

59. Portsmouth Tax List, Mar. 1765, Portsmouth City Hall.

60. See cat. no. 86, note 5.

61. "Records of Queens Chapel from 1756 to 1816," 85, 86, St. John's Church.

62. Hall 1901, 11; Brewster 1859, 351–52. After the American Revolution, the pew was used by the Warden; in 1796, the canopy over the pew was purchased by Colonel Thomas Thompson and installed over the front doorway of his Pleasant Street house; see McLaughlin 1982, 20–21.

63. "Records of Queens Chapel from 1756 to 1816," 90, 99, St. John's Church.

64. No listing of Wentworth's library at his Portsmouth house survives. However, an inventory of his country seat in Wolfeborough included "Pains architect" among a library of 552 books, magazines, and pamphlets. See Starbuck 1989, 120. Garvin 1989, 35–36, discusses the impact that Paine's volume—probably James Paine's *Plans, Elevations, and Sections of Noblemen and Gentlemen's Houses* (London, 1767)—had on Wentworth.

65. "Province of New Hampshire to Mark Hunking Wentworth, Chairman of the Committee for finishing the State House pr Vote of the General Assembly," bill, Apr. 1769, Treasury Papers, State Archives; see also Garvin 1991, 227.

66. See note 65 above, "Province of New Hampshire to Mark Hunking Wentworth."

67. Rauschenberg 1980, 1–32; Gusler 1979, 70-71.

68. Portsmouth Tax Lists, assessments for 1765–71, Portsmouth City Hall.

69. Jonathan Warner, 1814 inventory, old series, docket 8936, Rockingham County (N.H.) Probate.

70. Bass first advertised his services in Portsmouth in the *New Hampshire Gazette,* Aug. 17, 1764. For more on Bass, see cat. no. 84.

71. Harrold refers to the sale of the shop to Cotton in a mortgage of 1777; see Haslett to Harrold, 109:304, N.H. Provincial Deeds, State Archives. Further information on Shortridge and Sherburne is given in cat. no. 87.

72. *Oracle of the Day,* Sept. 13, 1794; Osborne had arrived in Portsmouth by 1793, when he billed Stephen Chase for four desks and three bedsteads; see Osborne to Chase, bill, July 1793, box 3, folder 11, Chase family papers, Cumings Library, Strawbery Banke Museum. Osborne's gravestone identifies him as a native of London; see Frost 1945, 188.

73. Mark Ham, 1798 inventory, old series, docket 6507, Rockingham County (N.H.) Probate.

74. Mark Langdon to Nathaniel Peirce, bill, Mar. 8, 1769, case 7, folder 7, Wendell Collection, Baker Library, Harvard Business School.

75. "Invoice of Sundry Merchandize on board the Schooner Molley Delivered to Cap' Geo. Frost At Newfound Land July 1752," box 2, folder 2, George Ffrost Papers, New Hampshire Historical Society.

76. "Note of a Cargo for Theneriffe to be there in all March 1769," Sept. 28, 1768, box 3, folder 61–62, Warner House Papers, Portsmouth Athenaeum.

77. Jobe 1987, 165, table 1.

78. Colonial Williamsburg owns two chairs of this design with possible southern provenances (1939.98 and G1986.220).

79. Prince 1744, 383.

Portsmouth Furniture Making, 1798–1837

Johanna McBrien

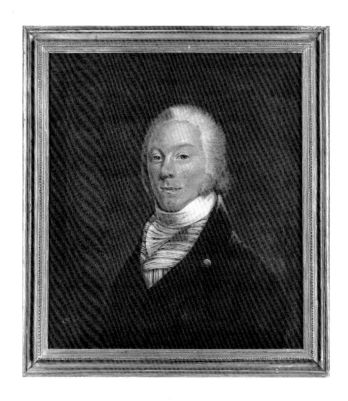

At the beginning of the nineteenth century, Portsmouth was a prosperous financial and business center. Wealthy merchants continued to dominate both the community's commercial and cultural spheres while pursuing a timeless quest for fortune and fashion. But the faces of the establishment had changed. Gone were the Tory aristocrats who had controlled the colonial development of the town. Interrelated clans of Wentworths, Sherburnes, and Warners no longer dictated the daily rhythms of mercantile activity. In their place appeared a new order. Shrewd entrepreneurs—Woodbury and John Langdon, Jacob and Abraham Wendell, James Rundlet, Jacob Sheafe, and John Peirce to name just a few—assumed the mantle of leadership for the federal city. In the furniture trades, a similar shift occurred. The cabinetmakers of the rococo era, now in their waning years, gave way to a new group working in innovative, classically inspired styles. Many of the key figures were recent arrivals. The seaport's rapid expansion attracted artisans from the surrounding towns of Dover, Durham, New Market, Rye, and Stratham as well as from the more distant urban communities of Boston, Salem, and Newburyport in Massachusetts.[1] These "immigrants" introduced new motifs and fresh approaches to furniture. They began their careers without a network of kinship ties, which in earlier generations had aided many local artisans in starting a business. Instead, they came armed only with their skill, acumen, and ambition. Once established, however, they often fostered a family operation, with sons, sons-in-law, cousins, or nephews continuing in the trade, though usually with less success than the original craftsmen.

The Portsmouth furniture industry in the early nineteenth century can be divided into two eras, each personified by a craftsman who contributed to changes within the cabinetmaking community. The first quarter-century was dominated by Langley Boardman (1774–1833). Boardman succeeded by catering to a clientele who could afford the most fashionable products. To facilitate production, he organized an integrated network of adjoining businesses, with the craftsmen occasionally working together yet retaining their independent status. The practice recalls the system used by eighteenth-century English firms, which encapsulated all aspects of furniture making within one shop.[2] A second period of production, beginning in the 1820s, is epitomized by the career of the cabinetmaker Samuel M. Dockum (1792–1872). Dockum offered a more varied repertoire in a wider price range than did Boardman. His customers were spread across the spectrum from sailors to ship owners, the largest number coming from the emerging middle class—small storekeepers, clerks, and tradesmen. His was an era of showrooms, warehouses, and increased marketing. Dockum continued the trend toward consolidation begun by Boardman. By the late 1820s, Dockum had united the essential elements of the industry within a single business, thus gaining greater control over the manufacture of his goods.

The first decade of the nineteenth century brought unparalleled growth to Portsmouth. Between 1798 and 1810, the town's population jumped nearly 30 percent, from 5,339 to 6,934.[3] A thriving commercial economy spurred the increase of and laid the foundation for a flourishing craft community. From 1800 to 1820, twenty-seven cabinetmakers (eight of whom were also joiners), one turner, one carver, three chairmakers, four ornamental painters, and two upholsterers are known to have practiced their trades in Portsmouth.[4]

The most successful of this group was the talented cabinetmaker from Massachusetts, Langley Boardman (*fig.* 42). A native of Ipswich, Boardman probably trained in Salem, perhaps through arrangements made by his uncle Francis Boardman, a prominent merchant in the town.[5] There the young Boardman came face-to-face with neoclassicism, the new style sometimes called "federal" in reference to its popularity during the early years of the republic. The fashion emphasized lighter forms, contrasting colors in paint or veneer, and motifs inspired by classical antiquity. During the early 1790s, as the style firmly took hold in Salem, Boardman must have seen (and helped build) the veneered and inlaid creations of such local artisans as William Appleton or Jacob and Elijah Sanderson. After working briefly on his own in Massachusetts, Boardman moved to Portsmouth and in 1798, at the age of twenty-four, opened a shop on Ladd Street.[6] Within a year, he boasted a ready-made line of furniture of the newest forms and fashions that included sideboards, lady's secretaries, night tables, and lolling chairs (*fig.* 43). His products met with immediate approbation. Affluent customers throughout the Piscataqua area turned to him for handsome pieces reminiscent of Salem examples (*see cat. nos. 8 and* 28). One of his favorite chair patterns (*fig.* 44) was based on a Salem model (94B). His design for a bookcase borrowed such earmarks of urban Massachusetts workmanship as a distinctive interlaced diamond at the center of the cornice (*fig.* 45).[7] In both cases, Boardman combined traditional motifs, such as molded legs or fretwork glazing, with more current ornament. On the bookcase, delicate string inlay and bold figured ovals of mahogany veneer introduce the new style, while the chair's geometric outline and tapering legs signal a similar shift. Both reflect a restrained sophistication characteristic of the finest furniture from Boston and Salem.

For the first decade of his career, Boardman maintained a commanding position in the trade. His most notable competitor—the firm of Jonathan Judkins and William Senter—did not begin operation until 1808 and never equaled Boardman's

Langley Boardman

INFORMS his friends and the public, that he has ready-made and for sale at his shop in Ladd-street, a general assortment of Cabinet work, among which are the following:

Side-Boards; Secretaries and Book-Cases; Ladies Secretaries, Bureaus; Commodes; Card-Tables; Dining-Tables; Pembrook-Tables; Night Tables; Pot-Cubboards; Candle-Stands; Fire-Screens; Lolling Chairs; Easy Chairs; and a variety of other articles which he will sell at the lowest prices for cash.

As he is determined to leave this town on the 1st of June next, any persons who wish to supply themselves in his line, are desired to call at his shop previous to that date.

Portsmouth, April 5, 1799.

FIGURE 43.

Advertisement for Langley Boardman from the New Hampshire Gazette, *April 5, 1799. Portsmouth Athenaeum, Portsmouth, New Hampshire.*

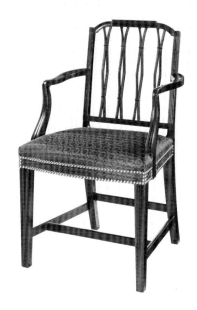

FIGURE 44.

*Armchair, attributed to Langley Boardman (1774–1833), Portsmouth, New Hampshire, 1800–1810. *Mahogany, *she-oak, *maple, and *pine, H. 35⅝; W. 20⁹⁄₁₆; SD. 17¹¹⁄₁₆; SH. 17⅛. Private collection. According to family tradition, Joseph and Temperance Pickering Coe of Durham, New Hampshire, acquired this chair at the time of their marriage in 1812.*

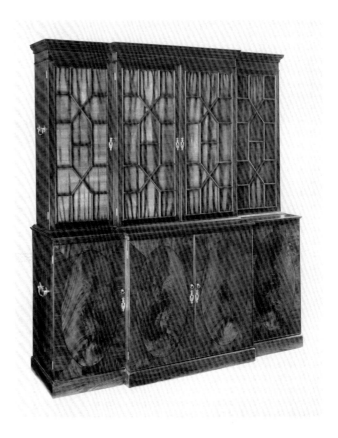

FIGURE 45.

*Library bookcase, attributed to Langley Boardman (1774–1833), Portsmouth, New Hampshire, 1808–15. *Mahogany and *eastern white pine, H. 87⁷/₈; W. 76¹/₄; D. 22¹/₄. Rundlet-May House, Portsmouth, New Hampshire, Society for the Preservation of New England Antiquities, gift of Ralph May, 1971.450.*

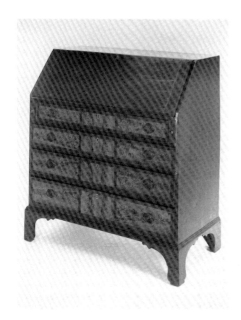

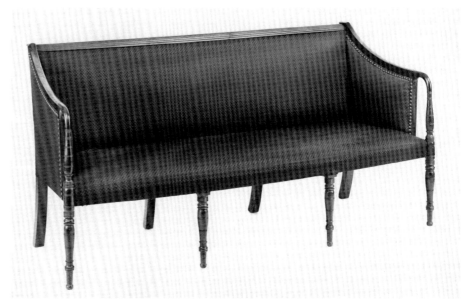

FIGURE 46.

*Desk, Judkins and Senter (w. 1808–26), Portsmouth, New Hampshire, 1812. *Birch, *mahogany, and *eastern white pine, H. 44¹/₁₆; W. 20⁷/₈; D. 42⁷/₁₆. Collection of the Maine State Museum, Augusta, Maine, 89.24.1. Courtesy, Maine State Museum. This desk was acquired by David Preble from Judkins and Senter for $23, according to a surviving bill of sale.*

FIGURE 47.

*Sofa, Judkins and Senter (w. 1808–26), Portsmouth, New Hampshire, 1816. *Mahogany, *maple, *birch, *ash, and *eastern white pine, H. 35⁵/₈; W. 73³/₄; SD. 24¹/₄; SH. 15¹/₈. Strawbery Banke Museum, Portsmouth, New Hampshire, gift of Gerrit van der Woude, 1988.227. Jacob Wendell of Portsmouth bought this sofa and a pair of card tables (cat. no. 64) from Judkins and Senter for $70.*

level of production.[8] Today Judkins and Senter are best known for their flamboyant case furniture with dramatic contrasts of birch and mahogany veneers (*fig. 46*). Yet these dazzling pieces document only a portion of their business. Judkins and Senter also made more subdued furniture of solid mahogany (*fig. 47*) as well as ornamental pine furniture decorated by local painters (*fig. 48*). Their work comprises a key segment of Portsmouth's federal output and together with the products of Boardman's shop accounts for much of the most stylish neoclassical furniture made in the town during the first quarter of the nineteenth century.

Boardman, like his fellow artisans, offered a wide range of services. In addition to making stylish household goods, his shop performed many mundane tasks—mending furniture, building coffins, setting up beds, and hanging wallpaper. Even such tedious jobs as "putting up [a] partition" for the New Hampshire Fire and Marine Insurance Company and supplying "staging poles and staging" for the Portsmouth Academy consumed shop time.[9] Boardman undoubtedly delegated much of this work to subordinates. By 1810, he employed at least seven people, a diverse crew of untutored apprentices and capable journeymen. His role within the business increasingly became one of a manager rather than a laborer, especially after he expanded his activities into real estate and commercial ventures. His title in town records chronicled his rise in status, changing from "cabinetmaker" to "merchant" by 1816, to "gentleman" by 1822, and to "Esquire" by 1825.[10] Many artisans aspired to climb a similar economic ladder and, if successful, to relinquish their trade. Yet Boardman never gave up cabinetmaking, and when he died in 1833, his obituary noted that he was "one of that small number, who, when wealth increases, do not abandon their trades."[11]

The entrepreneurial spirit of the new republic guided Langley Boardman far beyond that of his competitors. His success was unparalleled in Portsmouth's craft community. Boardman entered the town in times of prosperity and had the business skills and financial backing necessary to succeed. It is remarkable how quickly this outsider asserted himself. Within a few years of his arrival, he was speculating in land and investing in shipping, practices he continued throughout his thirty-five year career.[12] By 1807, he ranked among the top 10 percent of Portsmouth's taxable males, and over the years his wealth and status rose even more.[13]

The initial source of Boardman's income is uncertain. His numerous real estate dealings suggest that he had accumulated a substantial amount of capital soon after his arrival in Portsmouth. A small inheritance from his father, who died in 1776, was surely not the root of this fortune. Possibly money came from his mother, after she remarried in 1792, or from his wealthy uncle, Francis Boardman, who had died intestate, also in 1792.[14] Perhaps, too, his uncle's mercantile background induced the young craftsman to pursue commercial opportunities to supplement his craft income. In 1803, Langley Boardman acquired shares in a schooner and over his career invested in ten merchant vessels and several privateers. His returns from trade were limited: three-quarters of his vessels were lost at sea and only a few provided income for more than two years. However, these losses were more than offset by his profits from privateering.[15] During the War of 1812, he amassed a small fortune, which fueled future investments. Boardman became a shareholder in textile mills as well as in the Piscataqua Bank, serving as the first president of the latter in 1824. He also took on governmental tasks as a prominent member of the Democratic party, the dominant political force in Portsmouth. His fellow townsmen elected him to the State Senate, and he was subsequently appointed to the Governor's Council.[16]

To demonstrate his rising status, Boardman purchased a choice plot of land on Middle Street for a home site and began a house in 1804 (*fig. 49*).[17] The loca-

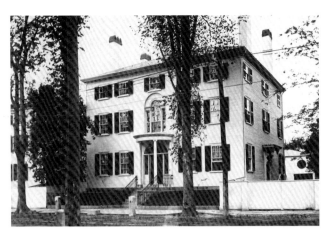

FIGURE 49.

Langley Boardman house, Portsmouth, New Hampshire, 1804–6.
Photograph, ca. 1900. Archives, Society for the Preservation of New
England Antiquities, Boston, Massachusetts.

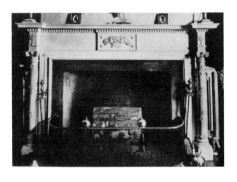

FIGURE 50.

Fireplace surround in the parlor of the Langley
Boardman house, Portsmouth, New Hampshire,
1804–6. Photograph by John Mead Howells,
ca. 1935, reproduced from Howells The Archi-
tectural Heritage of the Piscataqua *(1937),*
fig. 63.

tion, across from the grand federal mansion of John Peirce, proved to be a wise se-
lection for the up-and-coming tradesman. The rural lane was soon to become one
of Portsmouth's most fashionable neighborhoods, as a new generation of entrepre-
neurs, including James Rundlet and Samuel Larkin, moved there and built even
grander houses by the end of the decade (*see figs. 20 and 23*).[18] For the interiors of
his house, Boardman adopted a dressy array of decorative details borrowed from Sa-
lem buildings: sheaves of wheat and carved baskets of fruit graced the parlor chim-
neypiece and interior doorways, while free-standing columns encircled with climb-
ing vines flanked the fireplace (*fig. 50*). Such motifs reinforce Boardman's ties to Sa-
lem and document his interest in fine workmanship and design, traits that also
characterize his furniture.

Boardman's stately surroundings differed markedly from the living conditions
of other artisans. Most shared dwellings or lived in moderate-sized houses that dot-
ted the community. They labored in small shops often attached to their homes, or
they rented work space, usually in second-story rooms above other businesses.
Larger shops had modest showrooms for the display of the maker's inventory of
ready-made furniture.[19] These establishments were dispersed throughout the central
blocks of town around Fore, Market, Court, Congress, and Broad streets (see end-
papers). Boardman himself worked first on Ladd Street, off Market Street, then
moved to Ark Street, four blocks away. His operation soon outgrew these facilities,
and in 1802, while still working on Ark Street, Boardman purchased the first in a
series of buildings on Congress Street and relocated his business to the corner of
Congress and Vaughan streets.[20] By 1815, he owned nearly the entire block—at
least four dwellings and two shops. The neighborhood retained a rich craft tradi-
tion; here John Gaines had built a turning shop eighty years before and his son
George Gaines had worked as a joiner.[21]

Boardman's real estate purchases signaled a change in his shop practices. In
the buildings along Congress Street, Boardman brought together a group of inde-
pendent craftsmen who specialized in different aspects of furniture making. His ef-
forts improved efficiency and cut production costs. By leasing shop space to these
artisans, Boardman guided the industry toward the streamlined practices of the
early industrial era. Among his many tenants were the ornamental painters George
Dame (*fig. 51*), Henry Bufford, and J. K. Gilman.[22] The chairmaker Henry Beck
first operated his chair manufactory in one of the two shops leased by Boardman

and then moved to the second-floor chambers of what became known as "Boardman's Building."[23] In 1802, Boardman sold a back lot and buildings to up-holsterer William Sowersby, a craftsman from Boston, who succeeded Joseph Bass as the principal upholsterer of Portsmouth during the first quarter of the nineteenth century.[24] Boardman's control over these craftsmen was limited. They retained their independent status, advertising and producing goods for their own businesses. For Boardman, they provided the special services he needed—from decorative painting to upholstery—to meet the demands of his customers.

Boardman offered craftsmen not only shop space but also land for living quar-ters. Between 1801 and 1813, he sold lots near his residences, creating neighbor-hoods of mechanics. Soon after Boardman acquired his first house on Pleasant Street in the South End, he developed much of Cotter's Lane, a narrow path lead-ing from Pleasant Street to the South Mill Pond.[25] While building his Middle Street mansion, he sold lots on Joshua, Cabot, and Union streets. Surviving deeds describe the transactions in detail. Most artisans obtained three- or four-year mort-gages and agreed to pay the debt in goods or labor. Boardman received bed bottoms of sailcloth from sailmakers Joseph Walker and John Nelson; neighbor William Sowersby supplied upholstery work; Henry Beck provided "Chairs at cash price"; painter and glazier Ebenezer Pike paid in painting; hatter Nathaniel Seaward and cordwainer John Mitchell offered hats and shoes, presumably for Boardman's family or his apprentices.[26] Several joiners contracted to pay for ten lots with "joiner's work."[27] These craftsmen may have produced parts for furniture, built crates for shipping finished goods, performed odd jobs, repaired Boardman's vessels, or worked on his house (Boardman was constructing his mansion on Middle Street at the time). Such arrangements reflect Boardman's creative approach to business. Even his Middle Street home served initially as an investment; for nearly a decade he rented the house to others and lived on at Pleasant Street, then later near his shop on Congress Street. Not until after 1814 did he and his family move into the imposing residence on Middle Street.[28] Real estate speculation remained one of Boardman's ongoing interests throughout his career. All told, he brokered 174 par-cels of land and, in the process, helped transform the landscape of Portsmouth, sur-rounding the mansions of Middle and Pleasant streets with working-class neigh-borhoods.[29]

To sell their furniture, Langley Boardman and his fellow craftsmen relied pri-marily on word-of-mouth publicity. Newspaper advertisements were generally re-served for the notification of a change in address; furniture received scant mention. Only chairmakers varied from the norm. Rapidly changing styles of seating furni-ture, coupled with the competition of imported fancy chairs, prompted more active promotion of merchandise, and chairmakers adopted aggressive marketing tactics not yet tapped by other furniture makers.[30]

Escalating imports posed a particular threat to chairmakers. With increasing frequency, local vendue houses announced the arrival of chairs from other coastal cities. In 1811, the auctioneer Samuel Larkin advertised "8 setts Fancy Chairs, of different patterns; 3 do [ditto] Flat Top do. 11 do Bamboo do. The above Chairs were made in Salem, are well made and finished in an elegant and masterly style."[31] Though described as "masterly," these painted chairs were probably inexpensive products vying for the same middle-class market that local makers sought to reach. Costly imports of ambitious design were far less common. John Peirce owned a stately Salem library bookcase (*fig.* 52) that may well have prompted Portsmouth ar-tisans to offer their own interpretation of the form (*fig.* 53). London pianos and clocks (*see cat. no.* 41) occasionally became fashionable focal points of Piscataqua in-teriors.[32] But, aside from looking glasses, other English forms rarely appeared. The

GEORGE DAME,

HAS removed to the corner of Congrefs and Vaughan ftreets, by Portfmouth Stone, having taken a part of that convenient and pleafantly fituated ftore of Mr. L. Boardman, where he will be ready at all times to attend to the commands of his friends, and endeavour to execute their work to their perfect fatisfaction ; he will undertake to perform in the different branches of PAINTING, VARN-ISHING & GILDING, as follows : Chaifes, Signs, window and bed Cornices, fire Buckets, Standards, &c. Chairs orna-mented, and old Chairs repainted, varnifh-ed and ornamented. Picture Frames paint-ed and gilded. Gilding on glafs, &c.— Painting in Water colours on paper, vel-lum, filk, &c.

Ladies needle work neatly framed and glazed. *Alfo,*

Portrait and Miniature Painting, warranted likeneffes, and copies taken of Paintings and Pictures. Profiles handfome-ly painted on paper, three dollars each. Specimens may be feen at his fhop. A va-riety of Pictures with or without framcs, fome painted on glafs ; and a variety of Pro-file and other Frames.

N. B. *Wanted immediately, an active Lad as an apprentice, one from the country would be preferred.* Portfm Feb. 24.

FIGURE 51.

Advertisement for George Dame from the New Hampshire Gazette, *March 10, 1807. Ports-mouth Athenaeum, Portsmouth, New Hamp-shire.*

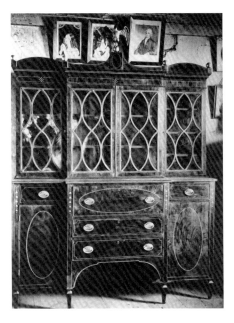

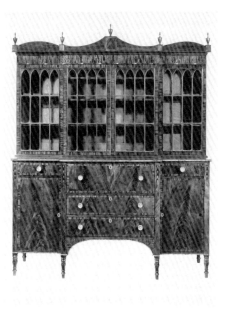

FIGURE 52.

Library bookcase, Salem, Massachusetts, 1800–
1810. Photograph, ca. 1895, reproduced from
Elwell Colonial Furniture and Interiors
(1896), pl. 25. This bookcase was probably ac-
quired by John Peirce for his Portsmouth house.

FIGURE 53.

Library bookcase, Portsmouth, New Hampshire,
1805–20. Courtesy, Israel Sack, Inc., New York,
New York.

FIGURE 54.

Invoice of furniture shipped by Judkins and
Senter (w. 1808–26) to Savannah, Georgia,
in 1818. Wendell Collection, Baker Library,
Harvard Business School, Cambridge,
Massachusetts.

importation of furniture from abroad declined dramatically. The federal merchants of Portsmouth displayed little of their forebears' fascination with fashionable London products. Although trading connections continued with England after the Revolution, a patriotic emphasis on domestic manufacture pervaded the region.

In Portsmouth, these domestic manufactures became a profitable export to other communities along the Atlantic Coast. Local ships sailed frequently to the ports of Philadelphia, Baltimore, Norfolk, Charleston, Savannah, and New Orleans as well as to Newfoundland, the West Indies, and Europe. Ship captains commonly advertised cargo space on these vessels, and furniture makers took advantage of the opportunity. Regrettably, export records do not survive to document the extent of the trade. It may not have matched the scale of the pre-Revolutionary years but was surely still sizable. Two invoices from the Brig *Hannah*, bound for Savannah in 1818, illustrate what may have been a standard export arrangement. The cabinetmaking firm of Judkins and Senter shipped "on their own Account & Risk" a cargo of household goods ranging from bureaus to bedsteads (*fig.* 54). The furniture was packed in sixteen cases and given a value of $561. The craftsmen instructed the captain of the vessel to dispose of the furniture "to the best advantage for Cash at private Sale if possible [,] if not at Auction."[33] The proceeds, less a 5 percent commission for the ship captain and a freight charge of $17, were to be returned to Judkins and Senter. The chairmaker John Grant, Jr., consigned Windsor chairs and rocking chairs worth $116 on the same voyage.[34]

Langley Boardman also engaged in the export trade, possibly using his own vessels to send furniture southward to the West Indies and South America. The business supplemented his ongoing work for neighboring customers and helped ensure steady employment for his crew. Unfortunately, without Boardman's family papers, it is impossible to measure the quantity of his shipments. A rare newspaper account notes a cargo of "furniture and other merchandise of Mr. Boardman" bound for Buenos Aires in 1825.[35] More tangible evidence appears in the furniture

itself. One of his most popular forms, a serpentine chest with canted corners and bracket feet (*fig. 55*), must have reached Charleston, South Carolina, and served there as a model for cabinetmakers (*fig. 56*). For Boardman, export furniture spread his federal fashions to distant ports, where they influenced local design (*see cat. no. 31*).

During the 1820s and 1830s, the furniture industry in Portsmouth underwent a gradual transformation. Products were still available on a custom basis, but ready-made goods sold through large warerooms occupied a growing proportion of the business. In addition, imported furniture from Boston and New York now flooded Piscataqua markets. Their presence altered patterns of local manufacture: Portsmouth firms trimmed their output to include only those goods for which they could compete and began to import other, less expensive mass-produced furniture. Finally, in a move toward improved efficiency, specialists in the furniture-making trades were united within one shop, a logical progression from Boardman's business arrangements.

In 1820, the population of Portsmouth stood at 7,327. Over the next twenty years, growth slowed dramatically. The town had gained only 560 persons by 1840.[36] Its economy faltered as commerce dwindled and nearby resources of timber were depleted. Periodic recessions drove some residents into bankruptcy—a far cry from the flourishing years at the turn of the century when Langley Boardman arrived in Portsmouth. The town's physical appearance was also in transition; tenement housing was erected for laborers from England, Ireland, and Europe after Portsmouth became a port of entry in 1820.[37] A visitor in 1832 found the community clearly on the decline: "The old town has such a wretched appearance that the spectator fancies himself removed to some small European hamlet just emerged from the horrors of war, pestilence or persecution."[38] Though surely exaggerated, the words toll an end to the boom years of the federal era.

By 1825, a new generation of Portsmouth craftsmen worked alongside the established artisans of the early nineteenth century. All told, thirty-five cabinetmakers, one turner, two carvers, four chairmakers, one gilder, four ornamental painters, and four upholsterers found employment in Portsmouth between 1820 and 1840.[39] The numbers are nearly double that from the preceding two decades, a common phenomenon in other coastal communities but surprising for a town lapsing into decline. The larger figures could be the result of greater accuracy in the recording of individuals in town directories and census records. A more likely explanation reflects the economic uncertainty of the times. An increase in business failures throughout the population may have resulted in more artisans working for shorter periods.[40] In many cases, workmen joined forces to pool resources but, unlike the earlier partnership of Judkins and Senter, these newer firms rarely lasted more than two or three years.[41] The volatile nature of the economy often drove firms apart, sometimes forcing craftsmen to leave the community or transfer into related trades. To prosper in this environment required craft skill, marketing savvy, an efficient operation, and the flexibility to adapt to changing conditions. Some artisans—especially, Samuel M. Dockum, Edmund Brown, and Ebenezer Lord—had such abilities and managed to maintain permanent careers in the town. But even they were not immune from economic disaster.

Samuel M. Dockum (fig. 57) followed Langley Boardman as the central figure in the Portsmouth furniture industry. Born in 1792 in the neighboring town of Greenland, New Hampshire, Dockum trained as a cabinetmaker and carver with Mark Durgin of Portsmouth.[42] By 1814, he had established his own business in Northwood, New Hampshire, but returned a year later to Portsmouth to work in partnership with Isaac Pinkham.[43] After only one year together, the two artisans parted company.[44] Dockum then operated independently until 1827, when he and

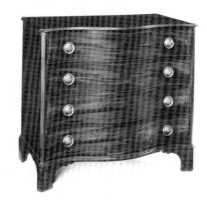

FIGURE 55.

*Chest of drawers, attributed to Langley Boardman (1774–1833), Portsmouth, New Hampshire, 1800–1810. *Mahogany and *eastern white pine, H. 36⅞; W. 42⅝; D. 23¹³/₁₆. Governor John Langdon House, Portsmouth, New Hampshire, Society for the Preservation of New England Antiquities, bequest of Elizabeth Elwyn Langdon, 1966.357.*

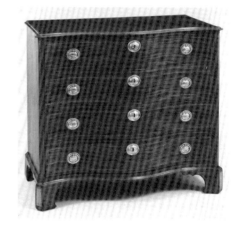

FIGURE 56.

*Chest of drawers, Charleston, South Carolina, 1800–1810. *Mahogany, *red cedar, and *eastern white pine; H. 37⁷/₁₆; W. 42¼; D. 23½. Yale University Art Gallery, New Haven, Connecticut, gift of C. Sanford Bull, BA. 1893, 1953.50.3.*

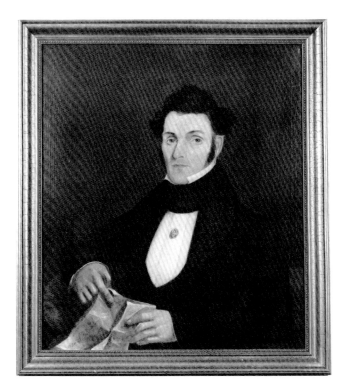

Edmund Brown formed the firm of Dockum and Brown. Once again, the partnership was brief. Their business failed in 1829, and the contents of their shop were sold at auction.[45] Both cabinetmakers quickly re-established themselves in the town's principal business district along Market and Fore streets.[46] These two streets soon became the central location for cabinet shops, in marked contrast to the scattered locations of eighteenth-century shops. Competition within the district was spirited. Dockum and his old partner Edmund Brown were each quick to praise his own offerings and to discredit the other's. In 1834, Dockum announced that "he has purchased 900 unpainted Chairs of superior quality, and of every description, and has employed a first rate Painter and Ornamenter to finish them. He would not hesitate to say they are the best article ever offered for sale in this market."[47] Brown countered with the announcement that he had "Chairs from one of the best Paint Shops in Boston, which he will warrant better Furniture than those which are botched up by some others."[48] Dockum seems to have gotten the upper hand, at least temporarily. He expanded his business significantly, and by 1834, his stock-in-trade was valued at the highest rate of any cabinetmaker in the town.[49] Like Langley Boardman, he was eager to show his success and had two portraits painted of himself, as well as one of his wife, Lucy.[50] After 1830, he moved into a house on Vaughan Street, a block from the bustling commercial environment of Congress Street, and somewhat nearer to his own business on Market Street.[51]

Dockum's position of prominence was short-lived. In contrast to Boardman, who diversified his investments, Dockum plowed his available income back into the expansion of his business. Credit helped fuel further growth. The arrangement worked well in times of prosperity but placed him in a precarious position when adversity struck. The Panic of 1837, a nationwide depression that devastated Portsmouth, left Dockum deep in debt. "He would also remind the public," noted

FIGURE 58.

Advertisement for the Portsmouth Furniture and Upholstery Warehouse from the New Hampshire Gazette, *April 8, 1834. Portsmouth Athenaeum, Portsmouth, New Hampshire.*

Dockum in an advertisement of September 30, 1837, "that those who have been unfortunate in business, caused by the distress of the times, especially need the patronage of their fellow citizens."[52] Yet he could not attract sufficient business, was unable to reimburse creditors, and eventually had to declare bankruptcy.[53] Dockum continued to work as a cabinetmaker in Portsmouth for the next thirty-five years but never regained his previous status.

The businesses of Dockum and his competitors differed noticeably from those of their predecessors. During the 1820s, Portsmouth cabinetmakers began to sell their furniture in buildings separate from their workshops. Langley Boardman initiated the practice in 1823, when he announced the opening of his "Furniture Room" at the corner of his Congress Street shop.[54]

Soon afterwards, other successful entrepreneurs established "warehouses," a new kind of facility designed to entice consumers with a large selection of goods. Businesses expanded to accommodate increased quantities of local and imported furniture; larger companies acquired buildings for production, storage, and sales. The rising scale of these new operations becomes most apparent when comparing them to their counterparts of only a decade before. In 1827, after the death of the cabinetmaker William Senter, an inventory was taken of the contents of the shop of Judkins and Senter.[55] The document listed fifty-three pieces of furniture in a shop that ranked as one of the largest in Portsmouth at the time. In 1837, Samuel Dockum put his entire stock up for sale to satisfy creditors. The vendue featured more than two hundred items, including "40 BUREAUS, 18 SOFAS, 30 pairs Card Tables, 24 Pembroke Tables, 8 large Elegant SECRETARIES, 9 Dining Tables, 10 Centre and Pier Tables, 20 Work Tables..."[56]

Dockum's goods had filled the showrooms of his Market Street "warehouse." In 1824, William Lawrence had introduced the term to Portsmouth in an advertisement of products for sale at his "Bedding Warehouse."[57] Ten years later, when Lawrence relocated to Exeter, Dockum took over the vacant area and opened it under a new name: the Portsmouth Furniture and Upholstery Warehouse (*fig.* 58). On August 5, 1834, he proudly announced in the *New Hampshire Gazette* that his fa-

cilities included "twelve commodious rooms" for the display of his new stock of goods, which "without fear of contradiction…contains the greatest variety in New-Hampshire, and in quality [is] inferior to none." Dockum was the first cabinet-maker in Portsmouth to attach a business name (rather than the name of a person or goods) to a shop. The change points to a new era of commercialism, as small shops overseen by individual masters gave way to larger corporate entities.

The advent of furniture and upholstery warehouses in Portsmouth was encouraged by the fashion for lavish upholstery. Dockum offered his customers the opportunity to order both fabrics and chair frames or to select from an assortment of ready-made articles. The variety of options appealed to consumers. Between 1829 and 1834, Dockum's upholstery business quickly escalated. Surviving accounts for those years record a three-fold increase in upholstery, from 6 percent of his total output in 1829 to 17 percent in 1834.[58] Feeling the pressure posed by Dockum's emphasis on upholstery, his leading rival in 1837—the firm of Edmund Brown and Alfred T. Joy—assured customers that they had taken "some considerable pains to inform [them]selves of the UPHOLSTERY business, and will now attend to stuffing new and old Sofas, Cushions, Chairs, &c. in a neat and workman-like maner."[59]

Dockum's decision to unify the trades of cabinetmaking and upholstery within one establishment moved the furniture industry to its final phase of development in nineteenth-century Portsmouth. Langley Boardman had fostered a network of interrelated shops within close proximity to one another. Dockum took Boardman's plan a step further, bringing together a diverse array of artisans within a single business in order to achieve greater control and efficiency in the workplace. During the early 1830s, Dockum employed two upholsterers, six journeymen cabinetmakers, at least four apprentices, and a single laborer.[60] He also took on journeyman turners and carvers occasionally and hired ornamental painters and gilders, some from Boston, on temporary contract to paint special shipments of chairs. Such numbers are dwarfed by those of larger establishments in Boston, New York, and Philadelphia. Nevertheless, his dozen or more employees constitute a significant increase from the two, three, or four workmen that crowded into the smaller shops of eighteenth-century Portsmouth.[61]

Dockum adopted new marketing techniques to reach consumers throughout the Piscataqua region. Between 1824 and 1835, he frequently advertised in newspapers and city directories. Other cabinetmakers increasingly turned to advertising as well, but none maintained so visible a profile.[62] Dockum repeatedly boasted that his goods were of the "newest fashions, as cheap, according to quality, as can be purchased in this town or elsewhere."[63] He was "constantly inventing new patterns" that followed Boston, New York, and Philadelphia examples and was always proud of his stock of imported chairs—"just received from Boston, 20 dozen of CHAIRS, of various kinds, and the newest fashions"—that supplemented his own products.[64]

His advertisements stressed style and affordability, two powerful incentives to customers. To better understand his clientele, one must turn to his account book for the years 1829 to 1834. Dockum dealt with 378 individuals, half of whom were part of a growing middle class. His total constituency seems to have been more varied than Boardman's. Truckmen, tailors, butchers, grocers, and farmers of modest means mingle in his accounts with rich lawyers and traders. The vast majority were residents of Portsmouth, though Dockum occasionally had dealings with people as far away as Newburyport and Boston. Most patrons bought only a piece or two at a time and often returned to buy more. Their most prevalent purchases were fancy chairs, rocking chairs, and smaller items like tables and washstands. Not surprisingly, more costly goods, such as Grecian sofas, couches, French bedsteads, and

spring-bottom easy chairs, were ordered less often. Prices ranged from $.66 for the least expensive chair pattern to $50 for a Grecian couch. In a typical account, recorded in a court case of 1826, Dockum billed a customer for a "mahogany field bedstead" at $13.50, "1 pair Grecian tables" at $12, and "1 Set yellow chairs" at $6.[65]

In addition to retail sales, Dockum also provided goods in wholesale quantities to vendors for resale. Nathaniel Haskell of Newburyport bought eleven bureaus in 1831 and James Cushing of South Berwick, Maine, acquired fifty-seven pieces two years later.[66] Sometimes too, Dockum supplied materials to other craftsmen for their own products. Cabinetmakers Jonathan Judkins, Edmund Brown, Ebenezer Lord, and Stephen Toppan bought carved table legs as well as carved feet for card tables, bureaus, and sofas. Others acquired sets of veneers, glue, haircloth, and in one case "pine…for 100 bureaus excepting the bottoms."[67] Though a small component of his business, his work for other artisans also reveals his stature as a carver. His fellow craftsmen respected his talents and often sought him out for their special needs.

The account book documents four other activities for customers: furniture repair, coffin making, architectural work, and ship carving. The first included a varied assortment of tasks. He received small sums for adding rockers to a cradle, mending a portable desk, replacing a leaf on a table, even "putting hair in Bass viol Bow."[68] Such odd jobs fill the pages of his ledger and indicate a sizable ongoing business. References to coffin making, household joinery, and ship carving, on the other hand, seldom appear. In total, they account for less than 10 percent of his output during this period. He sold only thirty-six coffins, ranging in price from a standard fee of $6 to a charge of $55 for a mahogany version with silver coffin plates, lead lining, and interior box.[69] In house and ship work, his efforts were limited to carving an occasional mantelpiece or ship's trailboard. Unlike his eighteenth-century counterparts, who performed an array of woodworking tasks, Dockum concentrated on the production and repair of furniture.

Most of Dockum's furniture was destined for the homes of his Piscataqua neighbors. He rarely made pieces for export. In his account book, just three major shipments are noted, and their destinations were the nearby cities of Portland and Boston.[70] Yet the export trade did serve as a significant outlet for other Portsmouth makers. In 1832, shipments of furniture from New Hampshire were valued at $27,125. Portsmouth products accounted for $14,600 of this amount and consisted of goods valued at $2,600 for New Hampshire and Maine, $8,000 for the rest of New England, and $4,000 for South America.[71] Though these figures seem sizable, they are dwarfed by the value of imported furniture coming into New Hampshire. In Dockum's case, the sale of mass-produced fancy furniture from Boston, New York, and Philadelphia exceeded the output of his own shop. His competitor, Edmund M. Brown, imported similar numbers of chairs. Their prices undercut local craftsmen and, as a result, brought fine chairmaking in Portsmouth nearly to an end. In place of these failing urban establishments, small "manufactories" sprung up in rural communities like New Market and Rochester, New Hampshire (*see cat. no.* 110). There, using cheap materials and labor, entrepreneurs produced gaily painted furniture at a low cost that could compete successfully with the influx of imports.

Rural chair factories often introduced mechanized equipment to speed the process of production. In 1834, Abraham Folsom of Somersworth, New Hampshire, invited dealers to examine the "*Common, Dining* and *Parlor* CHAIRS" at his manufactory before they shopped elsewhere. "The superior advantage of Water Power in the above business," he boasts, "will enable the subscriber to sell as *cheap as can be bought in Boston,* and warranted equally as good."[72] In Portsmouth, like other older urban seaports, craftsmen were slower to incorporate technological advances

FIGURE 59.

Desk, attributed to Samuel Dockum (1792–1872), Portsmouth, New Hampshire, 1820–30. Mahogany and eastern white pine, H. 37½; W. 36; D. 18; D. open 26. Courtesy, F. H. Pond. Brock Jobe photograph. According to family tradition, Samuel Dockum made this desk for his brother, Mark R. Dockum.

FIGURE 60.

Card table, Jonathan Judkins (1776–1844), Portsmouth, New Hampshire, 1828. Mahogany, eastern white pine, and basswood, H. 29¹⁵/₁₆; W. 36³/₁₆; D.18 ⅛; D. open 36³/₁₆. New Hampshire Historical Society, Concord, New Hampshire, 1983.2.

into their shop system. Cabinetmakers continued to build furniture largely by hand. Only one specialist made use of water power at an early date: the turner George Walker "having in operation a Lathe by water" in the spring of 1814.[73] Most artisans, whose shops were concentrated in the center of town, lacked access to water power. Later, when steam was introduced, these same individuals lacked the capital needed to convert to steam-driven machinery. As a result, the most mechanized tools in the town's cabinet shops were circular saws and horse-powered lathes, and these did not make their appearance until the mid 1830s.[74]

Though information abounds about Samuel Dockum and his colleagues of the 1820s and 1830s, remarkably few documented objects from this era survive. A writing desk and three pieces of doll's furniture made by Dockum for his daughter are all that can be linked with certainty to this prolific cabinetmaker.[75] The desk (*fig. 59*) is well made but plain, relying on figured mahogany veneers, thick rope-turned legs, and large stamped brass handles for visual respectability. The known work of Ebenezer Lord (*cat. no.* 68) and Jonathan Judkins (*fig.* 60) display much the same approach to design. Broad expanses of dazzling mahogany cover bold forms in the Grecian style, which closely relate to comparable examples made in Boston and Salem. Most documented Portsmouth products lack the opulence of earlier workmanship from the town. Instead, they demonstrate the popularity of fashionable but moderately priced cabinetry. Surely such furniture lay at the heart of the business developed by Dockum, an enterprising entrepreneur catering to a broad spectrum of middle-class buyers.

The careers of Langley Boardman and Samuel Dockum encapsulate the furniture industry of Portsmouth into two distinct periods. Both were characterized by entrepreneurial expansion but few advances in technology. In both, craftsmen sought to increase the size of their businesses, enlarge their profits, and elevate their own personal standing. Though a generation apart, Boardman and Dockum shared similar ideals and aspirations. Each was a skilled artisan, salesman, retailer, distributor, and trader. Yet their careers turned in different directions. Boardman arrived in Portsmouth just as a new generation of merchants, flush with profits from a flourishing economy, sought to outfit their homes. Coupling craft success with astute investments in shipping and real estate, he soon ranked among the town's wealthiest citizens. Dockum set out on a similar path. After Boardman's death, Dockum enlarged his business, no doubt intent on assuming Boardman's market. The expansion, however, had disastrous consequences. The Panic of 1837 reduced an aspiring entrepreneur to an ordinary mechanic. Dockum continued in business until his death in 1872, but like the industry as a whole, his output declined. He served merely the modest demands of a small town by the sea.

The author wishes to thank the following people for reading drafts of this essay: Richard Candee, J. Ritchie Garrison, Charles Hummel, Caitlin McQuade, Robert F. Trent, Philip Zea, and Philip D. Zimmerman. Special thanks are due to Catherine Hutchins, who has seen nearly as many drafts as I have, and to Brock Jobe, whose guidance and enthusiasm for the subject have made it a joy to be a part of the project from start to finish. In addition, I would like to express my appreciation to Brock for his editorial criticism and contributions to this essay.

1. For example, the cabinetmakers Isaac Pinkham and Alfred T. Joy came from Durham, Ebenezer Lord from New Market, Jonathan Judkins from Salisbury, Edmund Brown from Stratham, and Samuel Dockum from Greenland, New Hampshire. Massachusetts craftsmen who relocated to Portsmouth include the upholsterer William Sowersby from Boston, the cabinetmaker Langley Boardman from Ipswich, and the cabinetmaker John P. Somerby from Newburyport. For more information on the origins of nineteenth-century Portsmouth craftsmen, see McBrien 1993.

2. Kirkham 1988, 57–67.

3. Adams 1825, 319, 352.

4. These totals are culled from census records, tax lists, newspaper advertisements, tradesmen's accounts, and court records for Rockingham County, New Hampshire. These artisans are listed in appendix A at the end of this volume.

5. Biographies of Boardman are presented in Decatur 1937; 4–5; Rice 1974, 42–45; *Plain and Elegant* 1979, 141–42. The latter two offer the most accurate information. However, one hypothesis by Rice is probably incorrect. He suggests that Boardman was apprenticed to his father-in-law, Jacob Annable of Hamilton, Mass. Records of the period consistently describe Annable as a joiner and carpenter; someone with Boardman's skill in making furniture would surely have trained with a cabinetmaker.

6. Boardman presumably completed his apprenticeship in 1795, at the age of twenty-one. He no doubt continued to reside in the Salem area for another three years and perhaps met his future wife from nearby Hamilton at that time. Notice of his arrival in Portsmouth first appears in the *Oracle of the Day,* July 14, 1798.

7. For Salem furniture with string inlay forming an interlaced diamond at the center of the cornice, see Comstock 1966, 553–55; Montgomery 1966, no. 178; Conger and Rollins 1991, nos. 116, 121.

8. Biographical information on Judkins and Senter appears in *Plain and Elegant* 1979, 148, 151. A comparison of the value of the stock-in-trade of the two firms, taken from Portsmouth tax lists at the Portsmouth City Hall and the Portsmouth Public Library, reveals a noticeable difference in the scale of their operations. In 1817, Boardman's stock stood at $200, while Judkins and Senter each had stock valued at $50. By 1826, the totals had jumped to $3,100 for Boardman and $400 each for Judkins and Senter.

9. Langley Boardman to New Hampshire Fire and Marine Company, bill, Oct. 12, 1803, folder 17, box 9, Portsmouth Athenaeum; Nathaniel and John Haven, account book, 1808–11, p. 1782, Sept. 1809, New Hampshire Historical Society.

10. Aaron Wingate to Langley Boardman, 1816 deed, 210:115; Joshua Neal to Langley Boardman, 1822 deed, 230:439; Daniel Webster to Langley Boardman, 1825 deed, 246:1, Rockingham County (N.H.) Deeds.

11. *Portsmouth Journal,* Aug. 3, 1833.

12. Boardman's earliest real estate transactions occurred in 1800, when he purchased property on Pleasant Street from the Boston merchant David Pearse, Jr.; see Pearse to Langley Boardman, 1800 deeds, 154:280, 157:273, Rockingham County (N.H.) Deeds.

13. In 1807, Boardman ranked 133d on a tax base of 1,359 names; the author is grateful to Richard Candee for sharing his tabulated version of the 1807 tax list, preserved in the Portsmouth City Hall. By 1821, Boardman had become the tenth highest taxpayer in the town. Though clearly a man of considerable means, Boardman was not as wealthy as his assessment might suggest. His high tax resulted largely from his extensive holdings of real estate. Some merchants paid less in tax but possessed greater wealth, because their money was invested in non-taxable commerce. See 1821 tax list, Portsmouth City Hall. The author thanks Bernard L. Herman, University of Delaware, for sharing his work on the 1821 tax list and directory.

14. Langley Boardman had received a modest bequest of £43 when his father died in 1776; Thomas Boardman, 1776 will, docket 2737, Essex County (Mass.) Probate. Thomas's widow Elizabeth Howe Boardman married Richard Homan of Ipswich in 1792; he died in 1803 but left money only to his own children; *Vital Records of Ipswich,* 2:227; Richard Homan, 1803 will, docket 13750, Essex County (Mass.) Probate. Francis Boardman died of a fever in Haiti in 1792, leaving a sizable estate in Salem but no record of its distribution; Capt. Francis Boardman, 1792 inventory, docket 2683, Essex County (Mass.) Probate.

15. Boardman was part owner of the Schooner *Jones Eddy,* Brig *Belise,* Brig *Evelina,* Brig *Wessaweskeag,* Brig *Luna,* Brig *Margaret,* Ship *Concord,* Brig *Renown,* Brig *Aquilla,* Ship *James;* Nelson 1930-32, 3:38; see also Brighton 1986, 119–20. During the War of 1812, Boardman invested in two very successful privateers, the *Fox* and *Macedonian;* see Winslow 1988, 134, 152, 224, 239.

16. Boardman's probate inventory lists shares in the Piscataqua Bank, stage companies, textile mills, and the Portsmouth Athenaeum; Langley Boardman, 1833 inventory, old series, docket 12564, Rockingham County (N.H.) Probate. In addition to the posts noted here, Boardman was a charter member of the Society of Associated Mechanics and Manufacturers of the State of New Hampshire in 1803 and served as its president in 1813. See his obituary in *Portsmouth Journal,* Aug. 3, 1833; and his biographies in *Plain and Elegant* 1979, 141–42; McBrien 1993.

17. Jonathan Homer to Langley Boardman, 1803 deed, 164:500, Rockingham County (N.H.) Deeds.

18. Garvin 1983, 445–48, 496–500; Candee 1992, 114–15.

19. The location and size of craftsmen's housing as well as the layout of their shops were discussed by Richard Candee in a lecture, "Landscapes of Expectation," given at Old Sturbridge Village in April 1992; see also McBrien 1993, appendix.

20. William Odiorne to Langley Boardman, 1802 deed, 161:330, Rockingham County (N.H.) Deeds; *New Hampshire Gazette,* Aug. 23, 1803.

21. George Gaines died in 1809; two years later his son sold Gaines's house and shop to Boardman; John Gaines to Langley Boardman, 1811 deed, 189:421, Rockingham County (N.H.) Deeds. Boardman's other acquisitions on Congress Street consisted of the transaction cited in note 20 and three subsequent purchases: William Odiorne to Langley Boardman, 1803 deed, 166:38; George Gaines to Langley Boardman, 1804 deed, 165:466; and Benjamin Barnard to Langley Boardman, 1815 deed, 207:75, Rockingham County (N.H.) Deeds. For information on the careers of the turner John Gaines, see the preceding essay.

22. See advertisements for Dame, Bufford, and Gilman in the *New Hampshire Gazette,* Mar. 10, 1807 through Apr. 2, 1808; July 25, 1809; Jan. 2, 1816.

23. *Portsmouth Oracle,* Nov. 30, 1805; Beck remained in the Boardman Building until 1809.

24. Langley Boardman to William Sowersby, 1802 deed, 162:237, Rockingham County (N.H.) Deeds.

25. Boardman purchased the house on Pleasant Street as well as the property on Cotter's Lane from David Pearse, Jr.; see Pearse to Langley Boardman, 1800 deed, 154:280; 1800 deed, 157:273; 1801 deed, 157:415, Rockingham County (N.H.) Deeds. Boardman developed only the west side of Cotter's Lane; other speculators owned the east side. See Candee 1992, 69–73.

26. Joseph Walker to Langley Boardman, 1806 mortgage deed, 176:85; John Nelson to Langley Boardman, 1819 mortgage deed, 188:350; William Sowersby to Langley Boardman, 1806 mortgage deed, 176:133; Henry Beck to Langley Boardman, 1809 mortgage deed, 189:82; Ebenezer Pike to Langley Boardman, 1806 mortgage deed, 176:131; Nathaniel Seaward to Langley Boardman, 1811 mortgage deed, 194:484; James Mitchell to Langley Boardman, 1811 mortgage deed, 194:485, Rockingham County (N.H.) Deeds.

27. Josiah Peabody to Langley Boardman, 1806 mortgage deed, 174:131; Daniel Pitman and William Morton to Langley Boardman, 1806 mortgage deed, 174:132; James Dennet to Langley Boardman, 1806 mortgage deed, 176:84; Isaac Morton, Jr., to Langley Boardman, 1809 mortgage deed, 185:421; John and George

Perkins to Langley Boardman, 1809 mortgage deed, 189:81, Rockingham County (N.H.) Deeds.

28. Boardman remained in the Pleasant Street house until 1811, when he put the dwelling up for sale and moved into George Gaines's former residence on Congress Street; see *New Hampshire Gazette*, Jan. 11, 1811, and note 21. During this period Boardman rented his Middle Street mansion to Henry Ladd. In 1811, Boardman mortgaged the property for $2,000. Three years later he paid off the mortgage and apparently moved into the house shortly thereafter; Langley Boardman to Thomas Elwyn, 1811 mortgage deed, 189:424, Rockingham County (N.H.) Deeds. See also Candee 1992, 114–15.

29. Rice 1974, 45; McBrien 1993.

30. Kane 1976, 14–16; Skemer 1987, 18.

31. *New Hampshire Gazette*, Oct. 22, 1811.

32. Though far from complete, surviving import records for nineteenth-century Portsmouth do provide an outline of the trade. One volume at the National Archives for the years 1792 to 1806 lists only a handful of British imports; see Impost Book, 1792–1806, Portsmouth, N.H., Custom House, National Archives.

33. Judkins and Senter to Reuben S. Randall, invoice, Mar. 11, 1818, case 6, Wendell Collection, Baker Library, Harvard Business School.

34. John Grant, Jr., to Reuben S. Randall, invoice, Mar. 11, 1816, case 6, Wendell Collection, Baker Library, Harvard Business School.

35. *Portsmouth Journal*, May 28, 1825.

36. *Gazetteer* 1849, 151.

37. The changing character of the town was discussed by Richard Candee in his lecture, "Landscapes of Expectation" (see note 19); and by Bernard L. Herman in a paper, "Built Landscapes: Vernacular Architecture in Urban Landscapes," presented at the Strawbery Banke Museum, Portsmouth, in Feb. 1990.

38. Arfwedson 1834, 1:188.

39. These totals are culled from the Portsmouth city directories, which appear for the first time in 1821, and the same sources cited in note 4. The workmen are listed in appendix A.

40. Economic recessions in 1828, 1837, and 1842–43 prompted many to mortgage their personal property (principally household and shop goods) and some to declare bankruptcy. Records of these mortgages, beginning in June 1832, are preserved in the Portsmouth City Hall.

41. A similar situation arose in Newport, N.H.; see Garvin 1988, 221.

42. For biographical information on Dockum, see his obituary in the *Portsmouth Journal*, Oct. 12, 1872; Foss 1986. Dockum was apprenticed to Durgin in 1810, when he picked up goods for his master on a dozen occasions from the hardware merchant Jacob Wendell. Jacob Wendell, day book, 1809–10, p. 394, Apr. 18, 1810, and subsequent entries, Wendell Collection, Portsmouth Athenaeum.

43. *Concord Gazette*, June 6, 1814. Twenty-six miles west of Portsmouth, Northwood was located on the First New Hampshire Turnpike, the major thoroughfare between Portsmouth and Concord in the early nineteenth century. Dockum and Pinkham announced the formation of their partnership in the *New Hampshire Gazette*, Aug. 1, 1815.

44. *New Hampshire Gazette*, Nov. 12, 1816.

45. *New Hampshire Gazette*, Feb. 20, 1827; Mar. 27, 1829; Apr. 10, 1829.

46. Dockum initially rented second-floor space above Joseph Akerman's store at the corner of State and Ark streets but had moved to 13 Market Street by the fall of 1830; see *New Hampshire Gazette*, Mar. 30, 1830; Oct. 5, 1830. Brown remained in or near the former shop of Dockum and Brown on Fore Street for several years, then moved to Market Street by 1839.

47. *Portsmouth Journal*, Nov. 15, 1834.

48. *Portsmouth Journal*, July 23, 1835.

49. The failure of Pinkham and Dockum's business in 1829 left both men with no stock in trade. Dockum recovered quickly; town tax records at the Portsmouth Public Library document the rise of his stock-in-trade from $200 in 1830 to $2,000 in 1834. By 1836, it had reached $2,500, the highest amount in Dockum's career.

50. In addition to the portrait of Dockum illustrated in fig. 57, companion portraits of Dockum and his wife are in the collection of the Portsmouth Historical Society.

51. Dockum occupied at least three houses over the course of his lengthy career. In 1822, he purchased a residence on Bridge Street and remained there until at least 1829. By 1834, he had moved into a house at 7 Vaughan Street. In 1851, he acquired a nearby dwelling on Hanover Street. See McBrien 1993.

52. *Portsmouth Journal*, Sept. 30, 1837.

53. In April 1837, creditors sued Dockum for debts totaling $8,650. He mortgaged his household goods and sold the contents of his shop, but the proceeds proved insufficient to settle his accounts. Efforts to revive his business failed and on Feb. 12, 1842, he filed for bankruptcy to protect himself from creditors. See Cheever v. Dockum, 1837, series B, docket 17323; Jenness v. Dockum, 1837, series B, docket 17325; Gerrish v. Dockum, 1837, series B, docket 17462; Clark v. Dockum, 1837, series B, docket 17463; Dearborn v. Dockum, 1837, series B, docket 17629, Rockingham County (N.H.) Court, State Archives; Dockum to Cheever, personal mortgage, 1837, Records of Mortgages of Personal Property, 1832–37, 331–37, Apr. 13, 1837, Portsmouth City Hall; *Portsmouth Journal*, May 27, 1837; *New Hampshire Gazette*, Feb. 15, 1842.

54. *New Hampshire Gazette*, Oct. 14, 1823.

55. William Senter, 1827 inventory, old series, docket 11376, Rockingham County (N.H.) Probate.

56. *Portsmouth Journal*, May 27, 1837.

57. *New Hampshire Gazette*, Mar. 23, 1824.

58. Samuel Dockum, account book, 1829–34, James E. Whalley Museum and Library, Masonic Temple, Portsmouth, N.H. (hereafter Dockum account book).

59. *New Hampshire Gazette*, Nov. 14, 1837.

60. The number of workmen in Dockum's shop was culled from his account book, court records, and the 1821, 1827, and 1834 directories.

61. In 1833, a national report on manufactures noted that Portsmouth cabinet shops employed an average of thirty-five individuals a year. Dockum's account book raises doubts about the accuracy of this report. The figures may reflect extensive use of part-time laborers working on a seasonal basis in the larger workshops. *Documents Relative to Manufactures*, 1:175–233.

62. Donna-Belle Garvin noted a similar increase in advertising by cabinetmakers in Newport, N.H., during the 1820s and 1830s. She argues that the trend reflected increasing competition among craftsmen as well as the erratic economy of the era. See Garvin 1988, 221.

63. *Portsmouth Journal*, Jan. 9, 1830.

64. *Portsmouth Journal*, May 31, 1834; Apr. 23, 1825.

65. Dockum v. Marston, 1828, series B, docket 9686, Rockingham County (N.H.) Court, State Archives.

66. Dockum account book, 30, 127.

67. Account with Mark Adams, Dockum account book, 51.

68. Account with J. L. Lunt, Dockum account book, 11; see also Samuel Dockum to Universalist Society, bill, ca. 1824, bills and receipts 1824–25, South Church Records, Portsmouth Athenaeum.

69. Account with estate of Joseph Watson, Esq., Dockum account book, 64.

70. Dockum account book, 111.

71. *Documents Relative to Manufactures*, 1:602–3.

72. *Dover Gazette and Strafford Advertiser*, Apr. 14, 1835.

73. *Portsmouth Oracle*, June 4, 1814.

74. An inventory of Dockum's shop in 1837 lists "one horse power and lathes" as the only form of machinery; Clark v. Dockum, 1837, series B, docket 17463, Rockingham County (N.H.) Court, State Archives. An 1838 auction of the shop contents of the Portsmouth cabinetmaker Andrew Lewis included "1 Horse Power, 1 Large Lathe, 1 Circular Saw, 1 Up and Down Saw"; *New Hampshire Gazette*, Feb. 27, 1838.

75. These four items still remain in the hands of a Dockum descendant.

The Society for the Preservation of New England Antiquities
gratefully acknowledges
the generous support of the exhibition from

WILLIAM E. GILMORE AND TERRI C. BEYER

Clipper Affiliates
Durham, New Hampshire

The Currier Gallery of Art, Manchester, New Hampshire
September 15 – December 6
1992

Wadsworth Atheneum, Hartford, Connecticut
February 7 – April 4
1993

Portland Museum of Art, Portland, Maine
May 1 – July 11
1993

READER'S NOTE

THE CATALOGUE SECTION OF *Portsmouth Furniture* includes 117 individual entries of objects ranging in date from about 1675 until 1840, with the majority dating between 1725 and 1825. These objects have been selected from the approximately 2,000 objects that our research team identified as originating in the Piscataqua area. We selected items to be included in the book according to three basic criteria: credible documentation either to a maker or owner or both; aesthetic importance; or significance as a representative example of a common form. In addition to objects made in the Portsmouth area, we have included some imported examples with a history of use in Portsmouth, because they influenced local craftsmen and illustrate the range of furnishings within Portsmouth interiors.

The entries may be read both as individual essays and as an ongoing narrative. They are grouped according to furniture form: case furniture, tables, seating furniture, beds, and looking glasses and picture frames. Within each form, the examples appear in a developmental order (for example, turned chairs; late baroque and rococo joined chairs and upholstered seating; and neoclassical joined, fancy, and upholstered seating).

Dates, place of origin, and maker appear in the heading of each entry. The date and origin for each object are as specific as possible; date ranges are used unless documentation pinpoints a specific date or year. A craftsman's name is cited in the heading only if he is known to be the maker. Attributions are made only where strong evidence links an individual to a specific piece.

We have used different terms for the illustrations, depending on where they appear in the book. The color pictures, which follow page 414, are called "colorplates." The images illustrating the three introductory essays are called "figures." The pictures illustrating the entries are numbered according to the catalogue number, followed by "A," "B," and "C" for secondary illustrations.

Dates for the period before 1752 are Old Style, using only the new year; thus, February 19, 1722/23 is written as February 19, 1723. When known, owner's dates are listed under "Provenance" and have usually been omitted from the text. Craftsmen's dates are given whenever appropriate. The following abbreviations appear with dates: "b." for "born," "ca." for "circa," "d." for "died," "w." for "working."

Each entry is signed with the initials of its author(s), whose full names appear on the title page. The text of the entry is followed by structural notes, inscriptions, materials, dimensions, provenance, publications, and endnotes. Complete structural information about an object is cited in the structural notes unless it relates closely to a previous object. Designations for right and left (such as the left rear foot) denote points as seen by the observer. Woods are thoroughly identified under "Materials." Woods prefixed by * have been analyzed microscopically by Bruce Hoadley of the University of Massachusetts. All other woods were visually analyzed by Brock Jobe.

Many of the objects included in the book are owned by SPNEA. Those with provenances in the Langdon, Rundlet, and Sayward families are part of the perma-

nent collections on display at the Governor John Langdon House and the Rundlet-May House in Portsmouth and the Sayward-Wheeler House in York Harbor, Maine. Several other SPNEA-owned objects, listed here with credit lines referring to "Boston, Massachusetts," are from SPNEA's study collection.

All cited measurements are taken to the nearest sixteenth of an inch. The dimensions in each entry list overall height (H.), overall width (W.), and overall depth (D.) for case furniture, beds, and looking glasses and picture frames. For tables with leaves, the open depth (open) has been included. For seating furniture, seat depth (SD.) is substituted for overall depth, and seat height (SH.) is added.

Short titles are given for all published sources in the endnotes and "Publications" section of the entries, with the exception of manuscripts and untitled references in newspapers, auction catalogues, and *The Magazine Antiques* and related periodicals, which have full citations. Complete titles are provided in the bibliography at the back of the book. A list of repositories and their locations, consulted during the research for this publication, follows the bibliography.

The terminology reflects a mixture of period and present-day usage, with a preference given to the former whenever feasible. Most of the terms are the same as those used in Brock Jobe and Myrna Kaye, *New England Furniture: The Colonial Era*. Because the spelling of place names varies from one era to another, we have tried to use spellings appropriate to the context. For example, John Wentworth's eighteenth-century country estate is described as being located in "Wolfeborough," whereas twentieth-century references to the town, in conformance with modern usage, are spelled "Wolfeboro."

The following eight photographs provide a visual glossary of the terms used in the book.

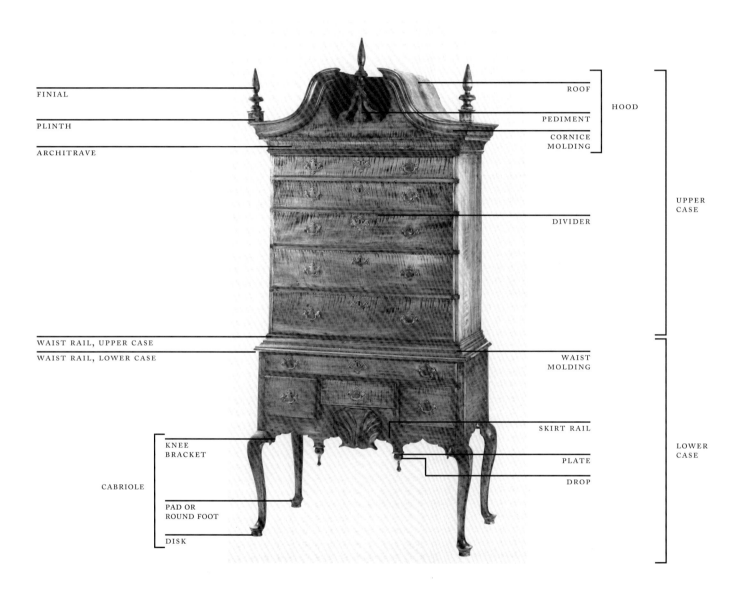

FINIAL

PLINTH

ARCHITRAVE

ROOF

HOOD

PEDIMENT

CORNICE
MOLDING

UPPER
CASE

DIVIDER

WAIST RAIL, UPPER CASE

WAIST RAIL, LOWER CASE

WAIST
MOLDING

SKIRT RAIL

LOWER
CASE

KNEE
BRACKET

PLATE

CABRIOLE

DROP

PAD OR
ROUND FOOT

DISK

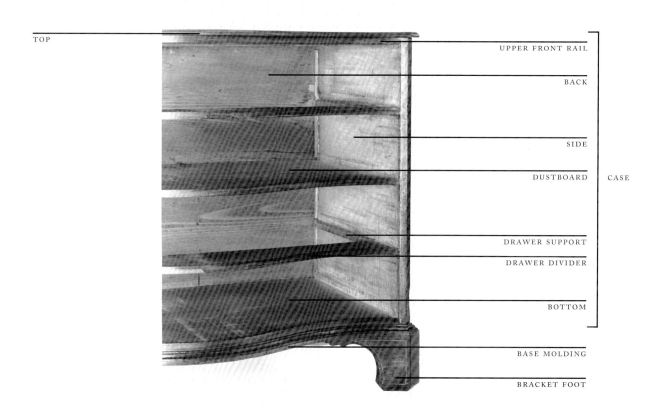

TOP

UPPER FRONT RAIL

BACK

SIDE

DUSTBOARD CASE

DRAWER SUPPORT

DRAWER DIVIDER

BOTTOM

BASE MOLDING

BRACKET FOOT

BASE
MOLDING

FRONT
FOOT

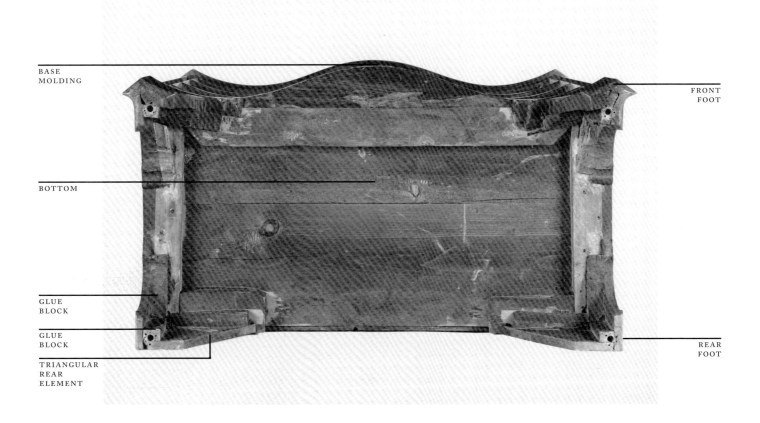

BOTTOM

GLUE
BLOCK

GLUE
BLOCK

REAR
FOOT

TRIANGULAR
REAR
ELEMENT

CORNICE

FRIEZE

DRAWER

PRIMARY
PARTITION

PIGEON-
HOLE
VALANCE

PIGEON-
HOLE

LID

LOPER

BACKPLATE

BAIL
HANDLE

TOP

PROSPECT
DOOR

BUTTON

SECONDARY
PARTITION

ESCUTCHEON

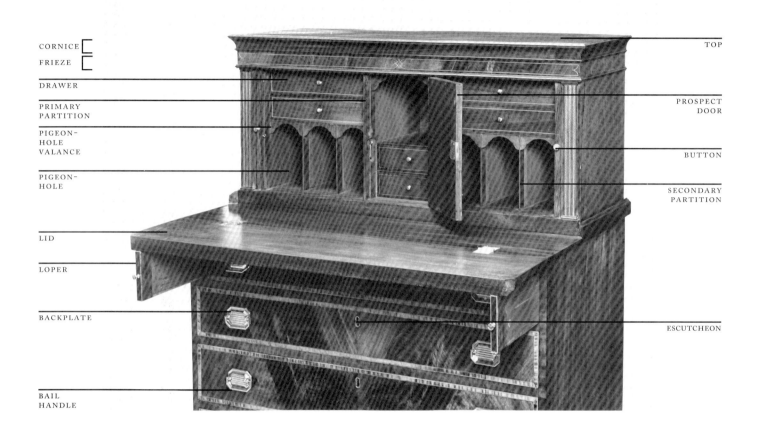

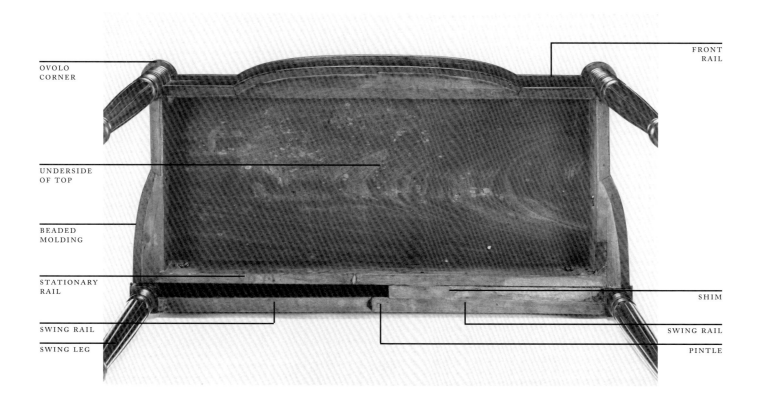

OVOLO
CORNER

FRONT
RAIL

UNDERSIDE
OF TOP

BEADED
MOLDING

STATIONARY
RAIL

SHIM

SWING RAIL

SWING RAIL

SWING LEG

PINTLE

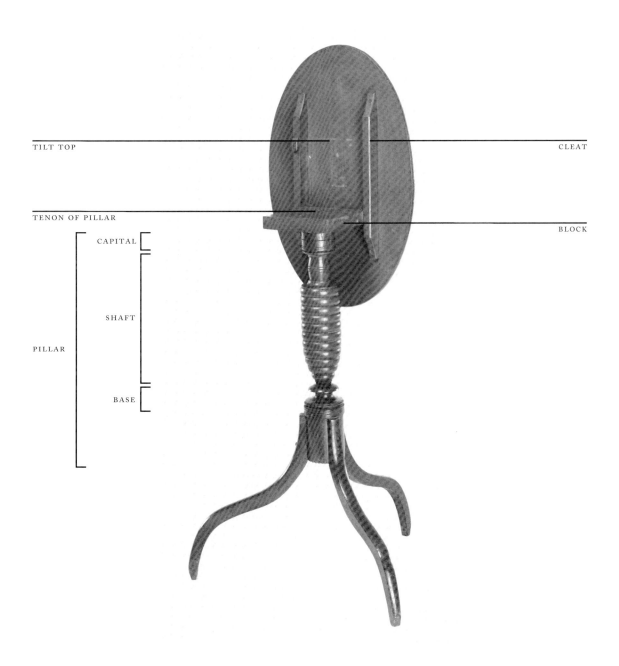

TILT TOP

CLEAT

TENON OF PILLAR

BLOCK

CAPITAL

SHAFT

PILLAR

BASE

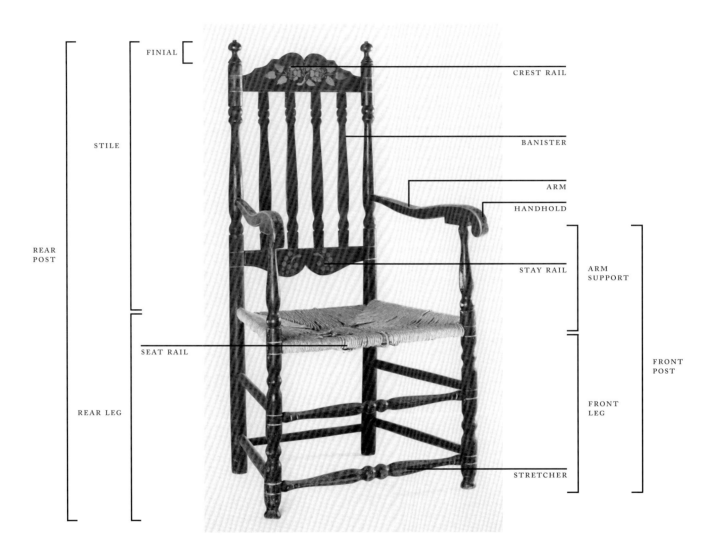

FINIAL

CREST RAIL

STILE

BANISTER

ARM

HANDHOLD

REAR
POST

STAY RAIL

ARM
SUPPORT

SEAT RAIL

FRONT
POST

REAR LEG

FRONT
LEG

STRETCHER

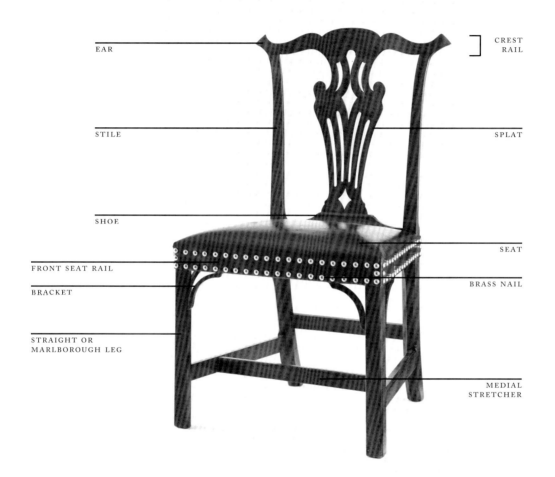

EAR

CREST
RAIL

STILE

SPLAT

SHOE

SEAT

FRONT SEAT RAIL

BRACKET

BRASS NAIL

STRAIGHT OR
MARLBOROUGH LEG

MEDIAL
STRETCHER

CATALOGUE

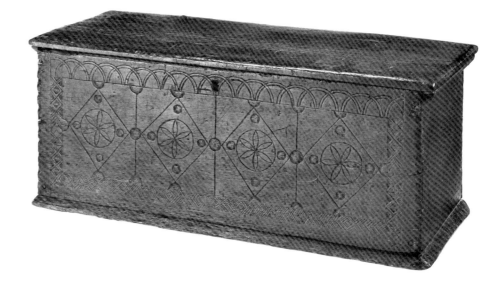

I

Chest

Hampton, New Hampshire
1675–1705
The Metropolitan Museum of Art
New York, New York
Gift of Mrs. Russell Sage, 1909, 10.125.22

THIS CHEST IS THE MOST ELABORATE and best preserved member of a group of at least six objects with related scratch-carved decoration that can be traced to the Hampton area. One object in this group (*fig. 27*) bears the initials "AM" and descended in the Marston family. According to tradition, it was made by Morris (or Maurice) Hobbs (ca. 1615–1705) of Hampton for Ann (Roberts) Marston, the second wife of William Marston (ca. 1621–1704), at the time of their marriage on June 5, 1675. Another, now in poor condition, descended in the Hobbs family and was given to the New Hampshire Historical Society in 1946. A fourth example, the largest of the group, was found in a barn in Hampton and acquired by Russell Kettell for the Concord Antiquarian Society (now Concord Museum, Concord, Massachusetts). It is naïvely composed; three of its diamonds are turned on their sides, while the fourth on the far right is more vertical and squeezed into place.[1]

The maker of these chests remains unknown. Morris Hobbs, to whom they have been attributed, was born in England and came to Hampton, New Hampshire, in the 1640s. He married Sarah Estow (or Eastow) there in 1669, the daughter of William Estow, and lived in his father-in-law's house. The inventory of the elderly Hobbs's estate, taken October 12, 1706, lists only about £64 worth of real estate and includes no clues that he pursued any craft other than farming. The documents refer to him as a yeoman. Hobbs's sister-in-law, Mary, was married to Thomas Marston (ca. 1615–90), the brother of William, establishing a connection between the two families.

William Marston is a more likely maker of these chests. He was a carpenter whose activity included work on the frame of the minister's house, and he is credited with building the first sawmill in Hampton. His second wife was the widow of James Philbrick, a mariner who drowned in the Hampton River on November 16, 1674. Marston's inventory, taken January 28, 1704, includes three chests but makes no mention of any woodworking tools. The Marstons and the Estows (and probably the Hobbses) came from Ormesby, in the county of Norfolk, England.[2]

The decoration on a box in a private collection (IA) provides a link between the scratch-carved group and a body of painted furniture from the Hampton area. The box, like the Metropolitan chest, has hatchwork decoration along the front corners, and it also has the characteristic lunette decoration along the top of the front. However, it is also carved with a heart at the center, flanked by tulips. The heart motif is found on a box with a painted heart (and painted pinwheels) in the Little collection, which is part of the painted furniture group represented in this catalogue by the Sarah Rowell cupboard (*cat. no. 3*).[3]

Chests like the Metropolitan example were the most common form of case furniture in seventeenth-century households and served a vital function as containers for clothing, sheets and other bed coverings, other textiles, and occasionally books and firearms. The tills inside were designed to hold small valuable articles, such as coins and jewelry, that otherwise might get lost within the cavity of the chest itself. In poorer households, a chest might also serve as a table for eating, or a place for sitting, working, or even sleeping.[4]

G W R W

Structure and Condition: The front and back are rabbeted and nailed to the sides with three large rose-headed nails at each corner, and the bottom is nailed in place. The front and side edges of the bottom were originally decorated with a broad bevel. The top is attached to the back with snipe's-bill hinges, and a till is located on the left side of the chest; a shelf below the till was present originally. Geometric scratch decoration covers the front of the chest and includes four diamonds filled with compass-work and outlined with interlaced lunettes along the top and hatching along the sides and bottom. Pinpricks ornament the compass-work circles on the façade. A column of eleven distinctive square notches is cut along each corner of the front.

Most of the beveled edge along the bottom board is worn away. The cleats are replaced. The lid for the till and the shelf below the till are missing. The top, which has a large crack extending from side to side, was once nailed shut, and the back has been reinforced with cut nails. The bottom may once have been fitted with shoe feet, as suggested by the presence of two pairs of nail holes in the bottom, located about 7½" from each side, or the chest may have been nailed to another object. Conservation records at the Metropolitan indicate that one hinge was repaired in 1949, and paint rings were removed from the top in 1980. The chest may have been cleaned and oiled after its acquisition by the museum in 1909, although no record of this treatment (common at the time) survives.

Inscriptions: "FC Higgins / Exeter" is inscribed in pencil on the outside of the back. "B" and "22" are also written in chalk on the outside of the back.

Materials: *Eastern white pine. The hinges are probably replacements, and the lock is old but not original.

Dimensions: H. 18⅜; W. 45½; D. 18⅜

Provenance: Early history unknown. Probably owned by Frank C. Higgins, an antiques dealer in Exeter, N.H., in the early twentieth century.[5] Given to the Metropolitan Museum in 1909 as part of the Bolles Collection.

Publications: Kettell 1929, no. 27.

1. For the New Hampshire Historical Society example, see *Historical New Hampshire* (Feb. 1948):19; the Concord Museum example is illustrated in Kettell 1929, no. 28. The writer is grateful to Hollis Brodrick, Frances Gruber Safford, and Mary B. Dupré for their assistance with this entry.

2. Genealogical data on the Hobbs and Marston families can be found in Dow 1893, 747–55, 836–53; William Marston's work as a carpenter is discussed on pages 363, 532–33, and in typescript genealogical notes prepared by the owner of the privately owned chest. Hobbs's inventory is docket 312 in the New Hampshire Provincial Probate Records at the State Archives, and his will and a power of attorney are in the Hobbs Papers at the New Hampshire Historical Society (acc. no. 1916.3). The Marston inventory is docket 283. A box attributed to the Hampton area was owned originally by Hannah Perkins Philbrick (1656–1739), the daughter-in-law of Ann (Roberts) Philbrick Marston. This box, now in the Art Institute of Chicago, varies from the Hobbs / Marston group in several details; it is illustrated in Naeve 1978, 2. Data on the Philbrick family is in Dow 1893, 918.

3. The box was found in a barn in Raymond, N.H., where it had been stored for many years. It was sold at Skinner, Inc., sale 1174, Oct. 31, 1987, lot 192. A related box in the Metropolitan Museum of Art is illustrated in Lockwood 1913, fig. 233; its carving is deeper and is probably by another hand. The Little box is illustrated in *Decorative Arts* 1964, no. 1, and in Little 1980, 20 (see also a related box illustrated on page 19). The writer thanks Hollis Brodrick for sharing his research on the box sold at Skinner, Inc. and his discovery of its relationship to the painted furniture from Hampton.

4. See Ward 1986, 5–6.

5. The Exeter city directory for 1911–12 lists Frank C. Higgins as an antiques dealer at 140 Water St., lodgings at 144 Water St.

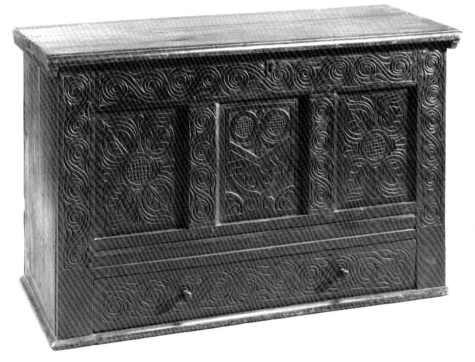

2

CHEST
(WITH LATER DRAWER)

Portsmouth, New Hampshire
1684
Virginia Museum of Fine Arts
Richmond, Virginia
The Mary Morton Parsons Fund for
American Decorative Arts, 81.26

THE FIRST THING TO SAY ABOUT THIS CHEST is that it is the earliest dated piece of furniture yet discovered that was made in New Hampshire. It is carved with "I 1684 W" on the center panel. The chest descended in the Williams family of Portsmouth and Kittery, Maine, to Grace Williams Treadwell (1874–1970) of Kittery; her acquaintances were convinced that the initials "IW" on the chest stood for a member of the Williams family. Second, it represents a rare survival in New England furniture: a chest with a joined front and board sides and rear. Third, it can be tied convincingly to an English regional joinery tradition in the West Country of England and therefore reinforces the strong West Country background of "the East," as people in Massachusetts Bay called the coastal regions from New Hampshire to New Brunswick (hence the term "Down East" to mean the state of Maine).

As a final dividend, this chest preserves alterations that undoubtedly date a mere thirty or forty years after its initial fabrication. These alterations are unusual because they were made with the intention of harmonizing with the original style of the chest, although it was probably old-fashioned at the time. The alterations consist of two patches filling the rectangular brackets of the sides, a bottom board, and a drawer with dovetails and seventeenth-century-style carving that obviously was executed by someone not trained to carve in that manner. These alterations have preserved the original portions of the chest beautifully and furthermore prove that the chest was of this odd hybrid construction and size when it was made in 1684. This is not a moot point, because the other related chest by the same hand (*fig. 26*),

carved with "RS 1685," now in the Museum of Fine Arts, Boston, has undergone substantial repairs to the sides and the replacement of the top; without the Williams-Treadwell chest, one could not be sure of the 1685 example's original size.[1]

Case pieces with joined fronts and board sides are indeed a rarity. Other than the two Portsmouth chests discussed here, the only New England objects to display this structural organization are a chest at the Smithsonian Institution and two wall cupboards, both at Winterthur. The immediate explanation for this approach might seem to be economy, and this idea gains plausibility when "lower" constructions like board chests with applied work in imitation of joinery or board chests with a front board carved to look like joined panels are examined. However, in the case of the Portsmouth chests, one seems to be dealing with a regional specialty.

It hardly seems a coincidence that the exact carving style seen on the fronts of the chests is found in Gloucestershire. Most notably, the shield-shaped reserve with foliate scrolls at the bottom is duplicated on the joined pulpit of the church of Upleaden, Gloucestershire, and the roundel connected to four floral buds by strapwork appears in many West Country chests. One of the most striking of these, in the Bristol City Art Gallery, is in fact a board chest with the front elaborately carved in facsimile of joined construction. These, and other examples of West Country joinery, certainly suggest that joined fronts nailed to board sides were a respectable regional variant.[2]

We would dearly like to know who the West Country maker of the 1684 and 1685 chests was. He probably was not John Pickering, Jr. (1640–1719), the most prominent carpenter, joiner, and real estate speculator of his generation and the son of John Pickering, Sr. (in Portsmouth 1633–died 1669).[3] Neither of these workmen is to be confused with John Pickering (d. 1657) of Salem, Massachusetts, also a carpenter and builder of the extant Pickering house in Salem.[4] While the English origins of all New England Pickerings are unknown, they may well have come from East Anglia. A more likely candidate for making these chests is the joiner Robert Williams, who was in Portsmouth in 1678 but moved to Kittery in 1682 to join a Baptist church. Again, the English origin of Williams is not known, but his Welsh-sounding name suggests that he may have been from the West Country.[5]

The front of the "RS 1685" chest has vermilion, verdigris, and yellow ocher painted decoration, which probably constitutes a later treatment. The "I 1684 W" chest has a thin red wash on the sides and top and a dark paint layer on the front that may date from the addition of the drawer and bottom board. The front panels of the 1685 chest are made of pine, while those of the 1684 chest are oak. Such differences in wood usage might seem incidental, but they might also suggest that both these chests were intended to be painted originally.

R F T

Structure and Condition: The riven oak front posts are grooved to receive the front panels and rabbeted to receive the board sides. The back board is rabbeted and nailed to the board sides. The mill-sawn pine bottom of the chest compartment is held in place at the front by nails driven through the lower rail of the front and rests on wooden strips nailed to the back and sides. The top was originally one board, but now has a replaced rear edge measuring 2½" deep. The front edge of the top is decorated with a quarter-round molding, gouge-struck arcs of various sizes, and two scribed lines. In addition to the eighteenth-century alterations cited in the text, large oak blocks were added to the case sides to serve as guides for the drawer. The drawer sides are each fastened to the front with one large dovetail and reinforced with a forged nail. At the rear, each side is rabbeted and nailed to the back with a single nail. The drawer bottom is a single pine board nailed up to the flush edges of the sides and back and a rabbeted edge on the front. The carving on the drawer front is an informal copy of the carving on the original chest façade. In 1980 Mervin Martin of West Chester, Pa., made knobs for the drawer and replaced missing cleats beneath the lid.

Inscriptions: "I 1684 W" chisel-cut on center panel.

Materials: *Red oak front posts, rails, panels, and drawer guides; *yellow pine lid, back, sides, and bottom of chest compartment; eastern white pine drawer front and all secondary work. Replaced hinges.

Dimensions: H. 29½; W. 47¹³⁄₁₆; D. 21⅜

Provenance: Descended in the Williams family of Portsmouth and Kittery, Me.; Grace Williams Treadwell (1874–1970), Kittery, Me.; Dr. Paul Taylor (d. 1978), Kittery, Me.; F. O. Bailey (auctioneer), Aug. 8, 1979, Kennebunkport, Me.; an unidentified dealer; Frank and Jeanne Demers, Topsfield, Mass.; purchased by the Virginia Museum of Fine Arts in 1981.

Publications: St. George 1979, lc–3c; Baker 1979, 4d.

1. Fairbanks and Trent 1982, 3:536.

2. Wells-Cole and Walton 1976, figs. 3, 15, nos. 5, 8, 9, 13, 22, 25.

3. Brewster 1859, 28, 49, 62, 68.

4. Cummings 1979, 51, 178–79.

5. Noyes, Libby, and Davis 1928–39, 757; Brewster 1859, 62; *Documents and Papers*, 8:61. The author wishes to thank Richard Candee, Ed Churchill, Robert Blair St. George, Frank Demers, and Edward S. Cooke, Jr., for their help in researching this entry. Genealogical investigation has not demonstrated that Robert Williams was the ancestor of Grace Williams Treadwell's mother, Grace Williams.

3

Cupboard

Hampton, New Hampshire
1700–1740
Yale University Art Gallery
New Haven, Connecticut
The Mabel Brady Garvan Collection,
1930.2189

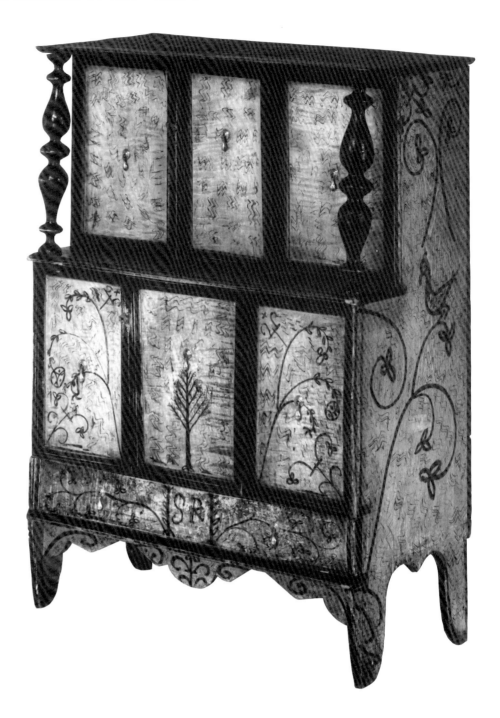

THIS EXTRAORDINARY CUPBOARD is one of the key objects in a group of early eigh-
teenth-century furniture associated with the Hampton, New Hampshire, area. In
1930, Esther S. Fraser published an article in *Antiques* on this group and linked
much of the work to a house carpenter and joiner named Samuel Lane (1698–
1776), who signed and dated a pine chest in 1719. (Although it is the Rosetta stone
in the identification of this Hampton furniture, the 1719 chest cannot be located
today.) Several cupboards, as well as related chests and boxes, have been identified
as part of this group. This cupboard, once owned by the Rowell family, is the most
elaborately painted and has the boldest turned decoration of any object in the
group. Fraser suggested that the Rowell cupboard may have been made by Lane's
master, due to its more sophisticated construction and delicate ornamentation when
compared to the 1719 chest. This painted group shares certain motifs with the
group of scratch-carved case furniture also associated with Hampton (*see cat. no.* 1).[1]

The fanciful trees and birds and other painted decoration on the Rowell cup-
board seem to be by the same hand that executed similar decoration on a chest with

one drawer in the Little collection, now owned by SPNEA (3A). This chest, which has a red background and is initialed "AB," also has its drawer divided (with paint) into a tripartite arrangement featuring the initials in the narrow center section and a roughly shaped skirt embellished with crude knee brackets and a shaped center drop.[2]

Cupboards such as this were among the most impressive articles of case furniture in seventeenth- and early eighteenth-century households. Although the chest of drawers had supplanted the cupboard as the most progressive form long before the Rowell cupboard was made, the cupboard must have retained some prestige in the rural climate of the Hampton area into the 1730s and 1740s. Its top may have been covered with a cupboard cloth, upon which might be arrayed the family's expensive articles of ceramics, glass, pewter, and possibly even silver. Its interior compartments, entered through a central door in both the upper and lower cases here, probably contained other drinking vessels and eating utensils, and its wide drawer at the bottom probably contained folded articles for the table. Although its expedient (not to say crude) construction and simple painted decoration are far removed from its more sophisticated joined and carved predecessors of the seventeenth century, the Rowell cupboard still retained significance within its context as an important focal point of the family's main living space.[3]

Related English examples have been published, associated most often with the northwest area of that country.[4]

G W R W

3A.

Chest with one drawer. Hampton, New Hampshire, 1700–1740. Eastern white pine, H. 33; W. 43½; D. 18¼. Society for the Preservation of New England Antiquities, Boston, Massachusetts, gift of Bertram K. and Nina Fletcher Little, 1991.554.

Structure and Condition: This small cupboard is of nailed-board construction and is made as a single unit. Its basic shape is created by rather thick and crude elements nailed and tenoned together. The overhanging top is supported by large ebonized turned balusters reminiscent of chair stretchers and nailed in place through the top. Applied moldings are used in the upper and lower sections to simulate paneled construction. The crude drawer construction is unusual: the front edge of each side is cut with a dovetail that slides into a vertical slot in the drawer front. The sides taper in height more than 1" from front to back (the drawer runners are nailed in place at a corresponding angle); the drawer bottom is set within the front, sides, and back and nailed in place; and the drawer back is riven and remains rough-hewn in the center. The side skirts are cut at the bottom in an M-shape characteristic of objects of this school. The most distinguishing characteristic of the cupboard is its original painted decoration, which includes trees, scrolling vines, large leaves and branches, and several roosting birds, as well as the initials "SR" in the middle of the drawer.

The cupboard has survived in superb condition, with only minor losses to the decoration and some shrinkage cracks and warping. An old varnish covers the original paint.

Inscriptions: "Sarah / Rowell" is written in black paint on the top of the cupboard, and "SR" is painted in black in the center of the drawer front.

Materials: *Soft maple case front, drawer front and sides, and balusters; *hemlock case sides and bottom; *eastern white pine drawer back, backboards, shelf, and other secondary elements. Four of the eight brasses are replacements.

Dimensions: H. 52 9/16; W. 36 7/8; D. 18¾

Provenance: According to a family tradition dating to the 1920s, this cupboard was redecorated as a dower chest for a Sarah Rowell, who married Benjamin Moulton (b. 1721) at an unspecified date, possibly in the 1740s. She may have been the Sarah Rowell (b. 1722) of Salisbury, Mass., the daughter of Job and Bethiah (Brown) Rowell. The cupboard descended to a Miss Smith of Exeter, N.H., who sold it to Charles W. Arnold, a leather manufacturer from Haverhill, Mass. In 1929, Arnold sold the cupboard to Francis P. Garvan of New York City, through Henry Hammond Taylor of Bridgeport, Conn. Garvan gave it to Yale the next year.

Publications: The cupboard has been published at least eight additional times since it first appeared in Nutting 1928–33, no. 472; for a complete listing, see Ward 1988, no. 199. The seminal article is Fraser 1930, 313.

1. See Ward 1988, no. 199, for related cupboards. The most closely related examples include one sold at Christie's, Jan. 19–20, 1990, lot 645; Randall 1965, no. 24; and Little 1984, 196–97. In addition to the 1719 chest and 3A, the group includes examples in the SPNEA collection (1949.84) and a private New Hampshire collection. Boxes include ones illustrated in Fraser 1930, fig. 5; and *Decorative Arts* 1964, no. 1.

2. Little 1984, 194, 196, and fig. 257. See also Fales 1979, 45.

3. Ward 1988, 375.

4. Fraser 1930, 314, fig. 3. Manuscript notes of John T. Kirk, Yale University Art Gallery, object file 1930.2189.

 4

Cupboard

(Colorplate 1)
Portsmouth, New Hampshire
1720–30
Museum of Fine Arts, Boston, Massachusetts
Purchased from the Henry Lillie Pierce
Residuary Fund, the Fund for Colonial Art, and
with contributions from Charles H. Tyler and
Templeman Coolidge, 20.602
Courtesy, Museum of Fine Arts, Boston

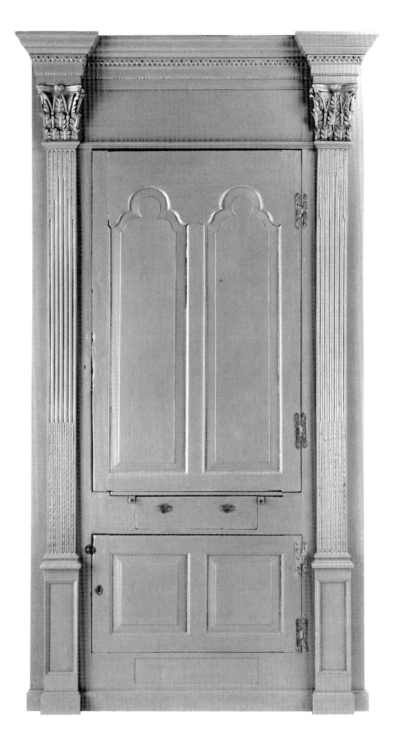

GEORGE JAFFREY II (4A), one of Portsmouth's wealthiest merchants, as well as a council member and chief justice of New Hampshire, built a hip-roofed mansion in Portsmouth sometime between the years 1720 and 1730.[1] In the early twentieth century, antiquarians studying the mansion recognized that its woodwork, particularly this corner cupboard, was of exceptional quality and character for such an early date. Wallace Nutting considered this piece "altogether the best built-in cupboard we have ever seen…in the number of its details, its enrichment, and its peculiarities, it is easily first."[2] William Sumner Appleton, founder of SPNEA, noted that "the best feature of the interior is the magnificent shell-top corner cupboard, perhaps as fine as any in America."[3] Considering the amount of mercantile wealth in Portsmouth in the early eighteenth century, it is not surprising that such a fine cupboard, or "beaufait," was constructed in one of the city's grandest houses.

The estate inventory, taken after Jaffrey's death in 1749, describes the house in detail. It contained two cupboards or "beaufaits," one in the "Parlour" and the other in the "Dining Room." These were the most public spaces in the house, where a visitor could not help being impressed by the grandeur of such a towering architectural feature, as well as by the dazzling array of imported tablewares stored within. This cupboard is probably the one that stood in the dining room. Its contents included:

16 White Earthen Plates		1 Pint Decanter	0.15.0
whole & crackd	£ 1.10.0	3 China Cups different Sorts	0.12.0
A pr. blue China Dishes	1.10.0	4 Saucers of different Sorts	0.10.0
A pr. Hollow Dishes		1 Quilted China Bowl Crack'd	1.00.0
burnt China 1 broke	1.00.0	2 Glass Bells	0.15.0
10 burnt China plates		1 China Cann	1.00.0
whole and mended	6.00.0	2 Glass Basketts	0.05.0
1 China bowl	1.10.0	1 Small Cruet	0.04.0
A pair of Cruets	0.12.0	1 Glass Candlestick	0.05.0
2 Glass Salvers	2.00.0	1 China Dish	3.00.0
3 Wine Glasses	1.00.0	1 Dº. broke	0.10.0
A small case for Spoons		1 Delph Ware Dish	0.10.0 [4]
Knives & forks	10.00.0		

Such an accounting suggests that the cupboard was crowded with tablewares, with some items situated to catch the eye and others stacked in a more haphazard way. Many appear to have been valuable items that were repaired and re-used rather than discarded when broken. So much damaged tableware might be an indication of declining wealth or simply the result of hard use over the years.[5] Jaffrey's silver or plate was inventoried separately, but some of the candlesticks, canns, cutlery, and salvers would have been kept in the cupboard. The tablewares could be prepared for use or displayed on the slide, an unusual feature secreted beneath the cupboard's upper door. Glass and ceramics continued to be stored in the cupboard as long as it remained in the house (4B). Sometime in the nineteenth century, however, it was moved from the dining room or north parlor to the room directly behind it.[6]

The men who built this outstanding example of architectural woodwork have not been identified, but the cupboard speaks eloquently of their skill. A carpenter or joiner constructed it as a single joined unit. The arched shell was made from nine pine planks that were glued together and then carved, while the curved back features six curved boards, which were sawn, bent into shape, and then nailed to the shelves (4C). A carver was responsible for such details as the stylized Corinthian capitals with mask-like terminals (4D), the bellflower trim within the fluting of the pilasters and on the archivolt, the crisply ribbed dome, and the central cluster of pomegranate and acanthus leaves (4E). Similar carving survives from the Joshua Peirce house, but no other examples are known. The carver Moses Paul (1676–

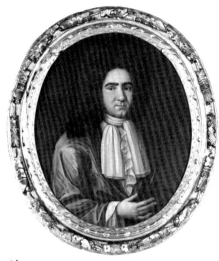

4A.
George Jaffrey II *(1682–1749), ca. 1705. Oil on canvas, H. 36¼ ; W. 31¼ (including frame). Private collection.*

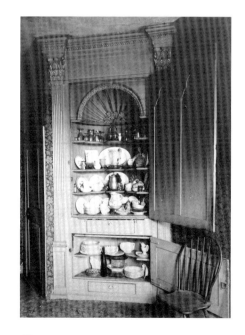

4B.
Cupboard while in the Jaffrey House, ca. 1914. Archives, Society for the Preservation of New England Antiquities, Boston, Massachusetts, gift of Wallace Nutting.

4C.

Back. The outer stiles and baseboard were added when the cupboard was installed at the Museum of Fine Arts in 1920.

1730), who was active in Portsmouth from 1696 to 1727, may have done the work.[7]

Once the carver had completed the cupboard, the painter took over. With its doors closed, the cupboard was a monochromatic greenish brown, probably the same color as the other woodwork in the room. When the doors were opened, a dazzling array of colors revealed itself, setting off the cupboard's contents to great effect. The curving rear wall was pea green, while the radiating shell surfaces were a deep verdigris green, and the narrow ribs were off-white. The edges of the ribs were picked out in bright coral red, as were the narrow front moldings of the shelves. The surface of the shelves was burnt umber. The inner archivolt was coral, and the outer one was pea green. The flat spandrel areas matched the exterior trim. Finally, the central pomegranate was coral red with off-white seeds, and the acanthus leaves were verdigris with off-white veins.[8] When this color scheme is considered, along with the carving, joinery, and monumental scale, the true architectural greatness of the Jaffrey cupboard reveals itself.

D C E

Structure and condition: The cupboard is a single unit. The stiles and rails of the façade are joined. The cornice molding, pilasters, bases, and capitals are nailed to the façade. The arched hood, carved from a glued stack of nine thick pine planks, rests on the top of the upper compartment of shelves. The compartment is backed by six curved boards, sawn and bent to shape, then nailed to the shelves, top, and bottom. The shelves are graduated in depth from 11" at the top to 9¼" at the bottom (depth at the center of each shelf). Old canvas covers the back. The upper compartment fits within the façade and is held in place with vertical pine strips nailed to the rear surface of the stiles and outer edges of the curved back. The construction of the lower compartment conforms to that of the upper with one exception: the use of four backboards instead of six. The shape of the single shelf in the lower compartment matches the decorative outline of the upper shelves. The doors are joined, with the stiles rabbeted and mortised to receive the rails. Two pins reinforce each mortise-and-tenon joint in the lower door, but none are used in the upper door. A serving slide fits into a slot above the drawer. Two original cleats nailed to the underside of the shelf run on L-shaped supports suspended from the bottom of the upper compartment. Thick but precise dovetails fasten the drawer at the corners. The bottom—a single board with grain running parallel to the front—is rabbeted along its front edge and set into a dado in the drawer front. Forged nails secure the bottom to the lower edge of the drawer sides and back.

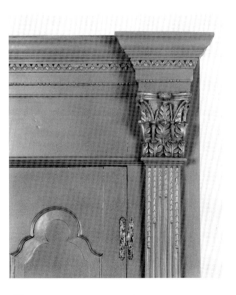

4D.

Cornice, capital, and upper section of pilaster.

The cupboard remains in good condition despite its relocation within the Jaffrey House and its transfer to the Museum of Fine Arts in 1920. The carved leaves at the center of the arched hood were chipped, and the keystone at the top of the hood disappeared long ago (*see* 4B). Other early repairs include: replaced supports for the drawer and curved left board for the back of the lower compartment, a pine liner nailed to the drawer back, and a 5½" patch to the left side of the drawer. When the cupboard was installed in the museum, a restorer replaced the corners of the cornice molding (probably reusing similar sections of molding from elsewhere in the Jaffrey House), added new stiles along the outer edge of the pilasters, reinforced the curved backboards with angle irons, eliminated the drawer below the bottom compartment, made a new base, and repainted the cupboard.

In 1991, Brian Powell of the SPNEA Conservation Center analyzed the paint history of the cupboard and a year later recreated the original decorative scheme. His research revealed that the hinges were not originally painted; subsequent layers of paint have now been removed, leaving the metal exposed. During the conservation process, Joseph Twichell carved a wooden replacement for the missing portion of the lower right leaf within the shell, and Christine Thomson sculpted a tip from an epoxy clay compound to replace a missing section of the center leaf.

Materials: *Eastern white pine. The brasses are old replacements with modern snipes. Original iron hinges on the doors, except for the bottom hinge on the lower door, which is an old replacement. The locks are replacements.

Dimensions: H. 125¼; W. 67½; D. 19½ (before conservation)

Provenance: Descended with the house of George Jaffrey II (1682–1749); to his son, George Jaffrey III (1718–1801); and then to his grandnephew, George (Jeffries) Jaffrey IV (1789–1856). Upon the latter's death, the Goodrich family purchased the house and, later in the nineteenth century, sold or rented the south half to the Simes family. The antiques dealer Israel Sack purchased the house at auction in September 1919 and sold it to Boston's Museum of Fine Arts in November 1919, which salvaged the cupboard along with paneling, tiles, and wallpaper. The house was razed in 1920.

Publications: Elwell 1896, pl.18; Appleton 1920, 33–34; Nutting 1924, no. 228, 247–48; Howells 1931, pl. 224; Garvin 1974, 80, fig. 96; Garvin 1983, 83–90.

1. The best biography of Jaffrey appears in *Sibley's Harvard Graduates,* 5:156–66. A survey of the 1727 city tax list reveals that Jaffrey was the fourth highest taxpayer that year, owing £31.4.0. Only Richard Wibird, Joshua Peirce, Sr., and John Rindge paid more, with Wibird owing £37.3.5. See 1727 Portsmouth Tax List, Portsmouth City Hall. The family fortunes dropped off dramatically by the next generation, when George Jaffrey III was assessed as the forty-second highest taxpayer in 1757; see Clark and Eastman 1974, 26.

2. Nutting 1924, 247–48.

3. Appleton 1920, 34.

4. George Jaffrey II, 1749 inventory, 17:524–32, N.H. Provincial Probate, State Archives. It is unclear what happened to the second cupboard. A photograph of the upper portion of a closely related example is in the Jaffrey file at the Museum of Fine Arts, Boston, and may have been the cupboard from the parlor. Its whereabouts is unknown. For more on the history of the architectural cupboard within the home, see Garrett 1990, 48–51.

5. See note 1.

6. A postcard of the Jaffrey mansion in the SPNEA Archives shows that the north parlor was outfitted with new woodwork about 1820. The cupboard may have been moved when the woodwork was installed.

7. Garvin 1983, 83–89. Paul also owned property near the Peirces and Jaffreys. The author would like to thank James Garvin for his assistance.

8. Results of paint analysis performed by Brian Powell, Architectural Conservator, Conservation Center, SPNEA, April 1991.

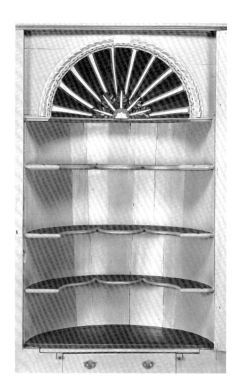

4E.

Cupboard interior.

5

BUREAU TABLE

Portsmouth, New Hampshire
1735–55
Private collection

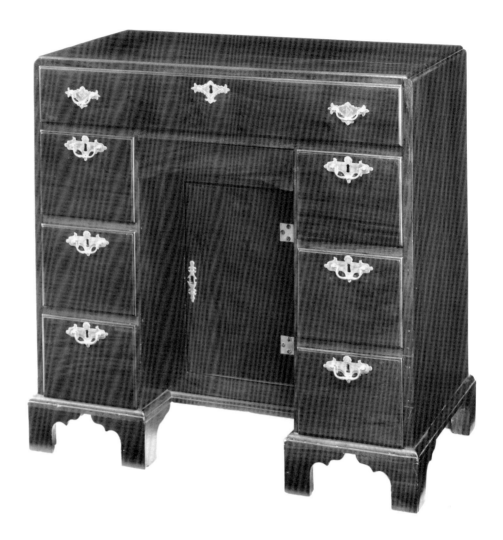

THIS DISTINCTIVE BUREAU TABLE belonged to John Wendell (1731–1808) of Portsmouth. The younger son of an eminent Boston family, Wendell moved to Portsmouth after graduating from Harvard in 1750.[1] He quickly rose to prominence through marriage into the powerful Wentworth clan and began an aspiring mercantile career. He soon shifted his business to real estate, developing vast tracts of land throughout New England. Though successful, he found it increasingly difficult to support his burgeoning family. His first wife, Sarah Wentworth, gave birth to eleven children before her death in 1772, and his second wife, Dorothy Sherburne, presented Wendell with eight more. Late in life, he wrote of his predicament:

> I have a very valuable estate in outlands, yet I am like Tantilus [*sic*] up to the chin in water, yet cannot drink. I have some thousands of dollars due me which I cannot collect without distressing my fellow men…Happy should I have been if a kind providence had permitted me to have been the sole support of helpless sisters, but a very large and dependent family has called for thousands more than I have had to help them.[2]

Saddled with family burdens and sporadic income, Wendell still had sufficient resources to live comfortably. He purchased fashionable goods from London, Boston, and Portsmouth, and added others through inheritance.[3] His second wife received the household goods of her brother, Daniel Sherburne, a prosperous bachelor, who died suddenly in 1778 at the age of thirty-five.[4] Wendell's estate inventory of 1808 depicts a well-appointed home, its parlors filled with mahogany furniture, twenty maps and pictures on the walls, and even "5 Earthen Images" on one mantel.[5] Yet

the house lacked such costly items as a clock, sofa, or silver hollowware.

Upstairs, Wendell's home contained four crowded chambers, two with high-post beds, window curtains, chairs, carpets, and "1 dressing Glass…1 table with draws."[6] This bureau table may well be one of the tables with "draws"; it and an English dressing glass (5A) descended together to Wendell's granddaughter, Caroline Quincy Wendell, and are described in her estate inventory of 1891 as "2 pieces: constituting one recessed small mahogany bureau and toilet stand with swivel glass, set of antique brasses."[7]

London retailers frequently exported dressing glasses to America.[8] Wendell's example—scooped along the front—conforms to a popular design of the 1740s. The bureau table also follows an English pattern. Its bracket feet, shaped drawer above the kneehole, and square-edged top resemble the work of John Chebsey of London (5B). Like many English examples, the top drawer of the Wendell table slides on a full dustboard, and the back consists of narrow vertical boards. Such similarities would suggest an English origin for the table were it not for the presence of white pine and coarse craftsmanship (compared to similar British examples). Its Portsmouth maker undoubtedly learned of the design through training abroad or by examining an imported bureau table.

The Wendell table ranks among the earliest known American bureau tables. References to the form first appear in a Boston inventory of 1739, and an inlaid example dates from about the same year.[9] The form grew more popular after midcentury but remained an expensive luxury. Boston craftsmen produced the greatest number in New England. Their blockfront versions appealed to wealthy customers near and far. In Portsmouth, at least two prosperous merchants acquired stylish Boston examples.[10] Local craftsmen, however, rarely received orders for the form, and today only John Wendell's bureau table can be ascribed to the town.[11]

B J

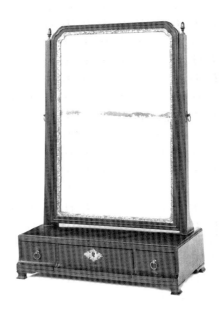

5A.

*Dressing glass. Probably London, 1740–55. *Mahogany, *white oak, *spruce, and eastern white pine, H. 24; W. 16⅛; D. 7½. Collection of Ronald Bourgeault, Wendell House, Portsmouth, New Hampshire.*

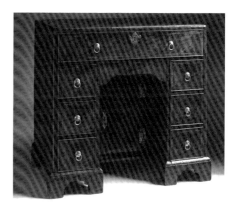

5B.

Bureau table. John Chebsey, London, 1730–45. English walnut and oak. Private collection. Courtesy, Mallett and Son, Ltd., London.

Structure and Condition: Blind dovetails join the case sides to the top. The bottom, sides, and top are each two boards. Rose-headed nails fasten the back—three vertical lap-jointed boards—to the rabbeted edge of the top and flush edge of the bottom. Thin partitions flank the central door and fit into dadoes in the dustboard and case bottom. Shallow dividers separating the drawers slide into dadoes in the case sides and partitions. Facing strips cover the front edge of the sides but not the partitions. The small drawers run on supports nailed to the case sides and partitions. The recessed compartment is a dovetailed box with a single shelf and, at the front, a mitered frame and hinged door. The bottom edge of the base molding is flush with the case bottom. The feet are glued to the base molding and backed with a vertical block and two horizontal blocks. The front feet are not mitered at the corner; instead, the front of the bracket is rabbeted to receive the side. Triangular rear elements are glued to the bottom and butt against the rear feet.

The drawers are dovetailed at the corners; the bottom of the drawer above the kneehole is nailed to the sides, back, and rabbeted edge of the front. The rest of the drawers have bottoms set into dadoes in the front and sides and nailed to the back.

During its long history in the Wendell family, the bureau table had numerous minor repairs. The family replaced several small chips in the

thumb-nail edge of the drawer fronts, a 3" section of the facing strip on the right case side, the entire facing strip on the left case side, the right base molding flanking the door, and three drawer dividers within the case. A century or more ago, a repairman removed and reattached all four feet; in the process, he reinforced the front feet with screws, replaced some of the support blocks, dispensed with the vertical blocks behind the rear elements, and probably replaced the front bracket of the right front foot and side of the right foot flanking the door.

In 1989, SPNEA conservators studied and conserved the table for the present owner. They corrected crude earlier repairs, reglued many loose elements, and tightened a shrinkage crack in the bottom of the case. Through microscopic analysis of the finish, they determined that the original coating had a linseed oil base that was slightly glossy and did not fully fill the pores of the wood. Later generations had applied two finishes, a spirit varnish and a shellac, then harshly stripped much of this away leaving many scratches on the surface. By 1989 a thick grime of dirt and oil polish covered the table. Conservators cleaned the surface lightly and finished it with a synthetic varnish (Acryloid B-72).

Inscriptions: "Mrs. Wendell" in ink on twentieth-century paper label on case bottom; "Miss Caroline Q Wendell" in pencil on the back of the middle left drawer; drawers numbered in pencil.

Materials: *Mahogany top, sides, drawer fronts, facing strips of drawer dividers, door, base molding, and feet; *eastern white pine for all secondary work. Original door hinges; replaced handles, escutcheons, and locks.

Dimensions: H. 31$^{15}$⁄₁₆; W. 31$^{15}$⁄₁₆; D. 16$^{9}$⁄₁₆

Provenance: Probably purchased by John Wendell (1731–1808) and left to his second wife Dorothy Sherburne Wendell (1752–1837), who kept it in the bedroom she occupied in the home of her son Jacob Wendell (1788–1865). Descended to Jacob; then to his daughter Caroline Quincy Wendell (1820–90); her brother Jacob Wendell II (1826–98); and Barrett Wendell (1855–1921), the son of Jacob II. In this century, the table passed to Barrett's son William G. Wendell (1888–1968); then to his son Francis A. Wendell (1915–79). In 1989 the present owner purchased the table at auction from the estate of Francis A. Wendell.

Publications: Lockwood 1913, 1:114; Sotheby's, sale 5810, Jan. 26–28, 1989, lot 1453.

1. The best summary of Wendell's background and accomplishments appears in *Sibley's Harvard Graduates*, 12:592–97.

2. Quoted in ibid., 597.

3. Only a handful of references to Wendell's household purchases survive. A bill from the Portsmouth mercantile firm of Barrell and Parker records the sale of a "Beaureau" at the inflated price of £80 Old Tenor in Sept. 1763; see John Wendell, Bills 1750–1807, folder 3, case 7, Wendell Collection, Baker Library, Harvard Business School. That bureau may well have been an English import. A "Memorandm freight from Boston Sept 27th 1764" records the shipment of a couch and a bookcase to John Wendell; see Quincy, Wendell, Holmes Papers, microfilm reel 27, document 248, Massachusetts Historical Society.

4. Daniel Sherburne, 1778 will, old series, docket 4529, Rockingham County (N.H.) Probate.

5. John Wendell, 1809 inventory, old series, docket 7985, Rockingham County (N.H.) Probate.

6. Ibid.

7. Caroline Q. Wendell, 1891 inventory, new series, docket 6696, Rockingham County (N.H.) Probate.

8. Jobe and Kaye 1984, 448–50. The Portsmouth merchant John Marsh paid £1.17.0 for "a dressing glass for a toilet" imported from London in 1769 (Marsh account book, 1768–74, 4, New Hampshire Historical Society.)

9. Goyne 1967, 26; the inlaid Boston bureau table is illustrated in Jobe 1974, 23. Another early example from Boston is japanned; see Christie's, Oct. 1, 1988, lot 430.

10. A Boston blockfront bureau table with rounded blocking belonged to Jonathan Warner of Portsmouth and is now in the collection of the Baltimore Museum of Art; another blockfront with flat blocking descended in the Wentworth family; see Christie's, June 16, 1984, lot 289.

11. An unidentified relative fondly recalled the bureau table when it stood in "grandmother's room" in Jacob Wendell's house during the late 1820s. She noted that "there was another dressing table between the windows, very black Mahogany. It had besides drawers a small closet in the middle where grandmother [Dorothy Wendell] loved to have Mehetable & Caroline play baby house"; "John, Dorothy & Jacob's Home," typescript, Wendell Collection, Portsmouth Athenaeum.

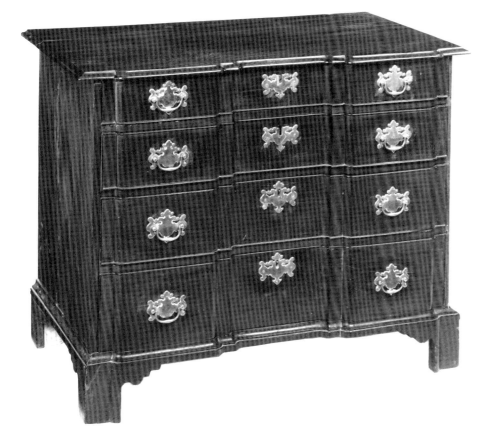

🌿 6

CHEST OF DRAWERS

Portsmouth, New Hampshire
1755–70
Private collection

DURING THE 1720S ENGLISH CABINETMAKERS enhanced their furniture with shaped façades such as the blockfront or bombé, both commonly called "swelled" in the period. Emulating London fashion, Boston craftsmen soon adopted similar shapes, especially the concave and convex panels of the blockfront. The design gained wide appeal (far more, in fact, than it had in England) and soon appeared in other New England communities.[1] Portsmouth artisans readily adopted the design. Their products include twelve distinctive examples—four dressing tables, one high chest, five chests of drawers, and two desk and bookcases—which represent the work of six different craftsmen.[2]

This chest of drawers probably belonged to George Ffrost I (1720–96), an enterprising merchant who learned his trade in the counting house of his uncle Sir William Pepperrell, became captain of one of Pepperrell's vessels, traded frequently with George Richards of London, and eventually became his partner. Ffrost resided in London during the 1750s and, after Richards's death, married his widow. Their marriage was brief; she died in 1757, and he returned to New Hampshire, married Margaret Smith of Durham in 1769, and removed to her home on the shores of Great Bay. Ffrost became an influential town leader, serving as a selectman and moderator as well as a chief justice of the county court of Common Pleas, and, from 1777 to 1779, a state delegate to the Continental Congress.[3]

The Ffrost chest is one of three blockfront case pieces by the same craftsman. The other two—a chest of drawers (6A) and a desk and bookcase (*cat. no.* 26)—supposedly belonged to Ffrost's uncle, Sir William Pepperrell.[4] Undoubtedly Pepperrell's patronage of a particular craftsman led Ffrost to order similar furniture, probably soon after his return from England in 1757. The Pepperrell and Ffrost chests are nearly identical; only the addition of a dressing slide on the Pepperrell chest and a variation in the edges of the drawer fronts distinguishes the two examples. Even the hardware on the two chests may have matched originally (the

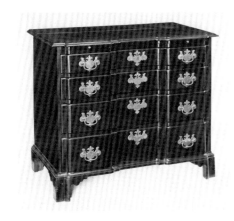

6A.

*Chest of drawers. Portsmouth, New Hampshire, 1755–70. *Mahogany and *eastern white pine, H. 31¹⁵/₁₆; W. 38³/₁₆; D. 22³/₁₆. Society for the Preservation of New England Antiquities, Boston, Massachusetts, museum purchase with funds provided by an anonymous gift, 1981.4. According to family tradition, this chest belonged to Sir William Pepperrell (1696–1759).*

6B.

Detail of case interior of the Ffrost family chest of drawers.

hardware on the Pepperrell chest is replaced but apparently duplicated the original set still in place on the Ffrost chest).

The design of the Ffrost and Pepperrell chests conforms to that of Boston examples at first glance, but close inspection reveals many telltale differences. Boston chests are typically narrower and taller than either of these Portsmouth examples. In addition, on most Boston chests, shallow dividers separate the drawers. Here, deep dividers (6B) serve as dustboards, providing added stability to the case and a surface for the drawer to slide on. Usually, the front base molding of Boston chests is joined to the case bottom with a single large dovetail. Here, the molding butts against the bottom, and the joint is reinforced with blocks glued to the underside of the bottom. On Boston chests, the edges of the dividers and case sides are beaded, while the drawer fronts are plain. Here, the opposite is true: the drawers of the Pepperrell chest have a molded thumbnail, and those of the Ffrost chest have an applied cockbead.[5]

The distinctive qualities of the Ffrost and Pepperrell chests—their broad proportions, deep dividers, and cockbeaded drawer fronts—provide clues to the identity of their maker. Rather than implying a Boston origin, they suggest that the maker, as yet unidentified, may have been an English immigrant or, at the very least, someone familiar with English construction through imported English furniture.

BJ

Structure and Condition: The case sides are dovetailed to the two-board bottom and slide in dovetail-shaped slots in the two-board top. Deep (12") drawer dividers separate each drawer; drawer supports originally backed the dividers, but only one of the supports remains. The original drawer stops are nailed to the case sides at the back. Mahogany facing strips cover the front edges of the case sides. The case back—three horizontal boards—is nailed to the rabbeted edge of the case sides and fits into a groove in the top.

The front base molding extends below the underside of the bottom and was originally backed with four blocks. The side moldings are each supported by a single block. The mitered front feet were each reinforced with two vertical blocks and two horizontal blocks. The triangular rear elements are coved along their diagonal edge and supported by stacks of two blocks glued to the case bottom. Each element fits against the lower edge of the case back and the rabbeted corner of a rear foot.

Thick dovetails join each drawer. The drawer bottom—a single board with grain parallel to the front—sits in dadoes in the front and sides and is nailed to the back with two original rose-headed nails. Two long blocks, glued to the underside of the bottom, back the lower edge of the front.

Inscriptions: Distinctive incised pattern of overlapping letters, "FRST," on the upper backboard, possibly an owner's mark of the Ffrost family.

Materials: *Mahogany case top, sides, front edge of drawer dividers, base molding, and feet; *yellow pine middle and lower backboards, case bottom, and secondary wood for drawer dividers; *eastern white pine upper backboard, support blocks for feet, drawer sides, bottoms, and

backs, and drawer stops. Original brass hardware and iron locks.

Dimensions: H. 30⅜; W. 39⅛; D. 22⅝

Provenance: This chest apparently descended with the contents of the family homestead in Durham, N.H., from George Ffrost I (1720–96); to his son George Ffrost II (1765–1841); to his grandson William Pepperrell Ffrost (1802–93); and to his great grandson George S. Frost (1844–1931), who married Martha Low in 1870 and had four daughters: Mary Pepperrell, Margaret Hamilton, Sarah Low, and Elizabeth Rollins. Mary Pepperrell Ffrost (1871–1947), the only sister to marry, wedded James Cowan Sawyer in 1897 and subsequently bequeathed the house and its contents to their children.

1. Lovell 1974, 131, 133.

2. The dressing tables and high chest (*fig. 29, cat. nos.* 16 *and* 17) are the work of Joseph Davis. One desk and bookcase (*cat. no.* 26) and two chests of drawers (discussed in this entry) document the hand of a second maker; the other desk and bookcase (*cat. no.* 25) represents a third craftsman. Finally, chests in the Winterthur Museum (Downs 1952, no. 167), SPNEA (*fig.* 40; Jobe and Kaye 1984, no.17), and a private collection (*cat. no.* 7) illustrate the distinctive characteristics of three additional cabinetmakers.

3. Frost 1943, 24; Lovett 1959, 61–62; for variations on spelling the surname, see Scales 1914, 571.

4. Jobe and Kaye 1984, no. 16.

5. The typical features of Boston blockfront chests are described in Lovell 1974, 81–89.

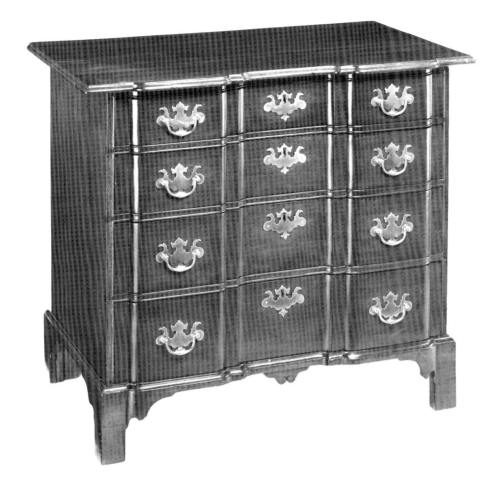

7

CHEST OF DRAWERS

Portsmouth, New Hampshire
1760–80
William E. Gilmore, Jr., and Terri C. Beyer

BOTH THE PRECEDING BLOCKFRONT CHEST and this one were made in Portsmouth, probably within a decade of one another. Yet, they differ in many subtle details and document the distinctive techniques of two different craftsmen. Here, the design more closely adheres to Boston precedents. Its proportions are taller and narrower than the Ffrost family chest (*cat. no.* 6). Its top has a typical ogee edge and a broader overhang at the sides and front. A string of wedge-shaped blocks beneath the sides of the top simulates the coved molding sometimes mounted on Boston chests.[1] The drawer dividers are shallow, and the drawers run on supports nailed to the case sides (7A). Again, like most Boston chests, a bead ornaments the edges of the case sides and drawer dividers, while the edges of the drawer fronts are plain. Finally, a decorative drop, similar to Boston examples, punctuates the center of the front base molding.[2]

Though conforming in its design to Massachusetts chests, this Portsmouth version reveals several unusual construction details. The top rests on the carcass, secured by screws driven through a front rail above the top drawer and blocks glued to the case back and top. In nearly all Boston examples (and the previous Portsmouth chest), dovetail-shaped slots are cut in the underside of the top to receive the upper edges of the case sides. At the base, the chest lacks the giant dovetail that frequently joins the front base molding to the bottom of Boston blockfront cases.[3] Instead, the front edge of the bottom is blocked to match the shape of the molding (7B) and fastened with glue and nails. In addition, the molding and bottom are the same thick-

ness, a rare feature in both Massachusetts and New Hampshire chests that elimi-
nates the need for support blocks behind the molding (8D illustrates the standard
approach). The drawers also display an idiosyncratic detail. The back surface of the
blocked ends of the drawer fronts is meticulously scooped (7c). Usually, the back
surface is sawn out, following a similar profile to the front, and the edge of the
drawer bottom is blocked to fit against the back surface. Here, a straight-edged
drawer bottom could be set into a groove in the back surface. The technique is com-
mon on straight-front chests and suggests that the maker adapted a familiar pro-
cedure to suit the special requirements of a form he was rarely called upon to build.

The source for this maker may well have been a specific Boston chest. Several
local merchants owned Boston examples.[4] The probable purchaser of this chest, the
merchant John Salter (1740–1814), could easily have instructed the craftsman to
base his design on a chest owned by a neighbor or colleague.[5] The result was com-
petently crafted and undoubtedly expensive but also bore unmistakable signs of in-
dividual expression. Today these distinctive traits distinguish the chest from related
Boston examples as well as the blockfront cases of other Portsmouth craftsmen.

B J

7B.
Case bottom.

Structure and Condition: The case sides are dovetailed to the bottom and to a horizontal rail beneath the top. The two-board case back is nailed to the rabbeted edges of the sides. The top is fastened to the front rail with screws and to the case back with three glue blocks. Sliding shouldered-dovetails join the 3¾" deep drawer dividers to the case sides. The sides never had facing strips. Drawer supports behind the dividers are each nailed to the case sides with three original rose-headed nails. A vertical strip nailed to each case side at the back serves as a stop for all four drawers.

The mitered front bracket feet are glued to the base molding. The maker reinforced each foot with a chamfered vertical block and added a horizontal block behind only the side portions of the front feet. The rear elements are glued to the bottom, butt against the rear bracket feet, and are reinforced with the usual complement of support blocks.

Thick but precise dovetails join the drawers. The top edge of the sides is chamfered. Each drawer bottom—two boards with grain running parallel to the front—fits into dadoes in the front and sides and is nailed to the back.

The chest remains in excellent condition with only one major repair: the base molding and feet on the left side of the case were replaced as a single unit more than a century ago. In addition, the vertical block for the left front foot and the right rear element are replaced; the left front horizontal block is missing. The interiors of the drawers have been varnished. The wedge-shaped blocks beneath the sides of the top have been reattached. The drop may be an old replacement.

Inscriptions: The case back is branded "I • SALTER" and bears a paper label inscribed in ink, "Mrs. Wendell."

Materials: Mahogany top, sides, base moldings, feet, drop, drawer fronts, and front edge of drawer dividers; eastern white pine for all secondary work. Original brass hardware and iron locks.

Dimensions: H. 32½; W. 37¹³⁄₁₆; D. 21⅞

Provenance: Presumably made for John Salter (1740–1814); acquired after his death by Jacob Wendell and descended in a similar manner as the Wendell family bureau table (*cat. no.* 5) until sold at auction to the present owner in 1989.

Publications: Sotheby's, sale 5810, Jan. 26–28, 1989, lot 1454.

1. Lovell 1974, 80–89, especially fig. 55.

2. Ibid., fig. 50.

3. Ibid., fig. 57 (note that the captions for figs. 56 and 57 have been transposed).

4. During the late eighteenth century, the Portsmouth merchant Jonathan Warner owned a Boston blockfront bureau table and chest-on-chest and Nathaniel Barrell, also of Portsmouth (*see cat. nos.* 82-83), acquired a Boston blockfront chest of drawers. The bureau table now belongs to the Baltimore Museum of Art; the chest-on-chest was advertised by John Walton (*Antiques* 57:3 [Mar. 1950]: 163); and the chest remains in the hands of descendants of the original owner.

5. For additional information on Salter, see Emery 1936, 9–11, and Kaye 1978, 1101.

7C.
Detail of drawer.

❦ 8

Chest of Drawers

Langley Boardman (1774–1833)
Portsmouth, New Hampshire
1802
Rundlet-May House
Portsmouth, New Hampshire
Society for the Preservation of New England
Antiquities, gift of Ralph May, 1971.683

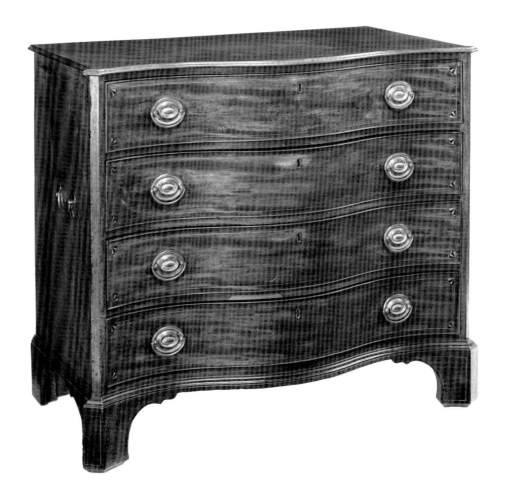

On July 14, 1798, Langley Boardman announced to the public in Portsmouth "that he carries on the Cabinet Makers' BUSINESS, at his shop in Ladd street, in all its various branches, with neatness, faithfulness and punctuality."[1] A tradesman of twenty-four, Boardman had recently arrived from eastern Massachusetts, bringing with him first-hand knowledge of the latest furniture designs of Salem.[2] He met with immediate success, no doubt in part because of his skill and background. But the timing of his arrival also enhanced his opportunities within the community. The deaths of cabinetmakers Robert Harrold in 1792 and Mark Ham in 1798 had reduced the pool of talented artisans just as a local building boom was about to begin. "There are immense Buildings going forward and the Town is astonishly altered" noted John Wendell in 1804.[3] Cabinetmakers were needed to fit out these stylish dwellings with fashionable furniture. Boardman readily complied.

One young merchant, James Rundlet, turned to Boardman for a wide array of furniture, carefully noting the purchases in his ledger (8A). By 1807, Rundlet had moved the items to his new residence on Middle Street (*fig.* 20), where many of them still remain. This serpentine chest of drawers from the house is undoubtedly the "Beaureau & handles" listed in the ledger. Its price of $28 exceeded that of any other single object and reflects its size and stylishness. The form was obviously a favorite of Boardman. A dozen related examples are known, but most lack carrying handles on the sides and inlaid quarter fans on the drawer fronts (*see fig.* 55).[4] This is the most elaborate version of the form by Boardman.

The essential elements of the chest—serpentine front, canted corners, and bracket feet—were common attributes of English rococo design.[5] American makers from Savannah to Portsmouth adopted the English formula but modified it in various ways. Toward the end of the eighteenth century, they also enhanced the form with neoclassical details and replaced the traditional arrangement of graduated drawers with drawers of equal height.

Boardman's version closely adheres to Salem models in the narrow cant of the front corners and peculiar C-curve along the inner edge of the bracket foot.[6] His construction also parallels Salem workmanship. At the upper corners, he dovetailed the sides to two slats and fastened the case top to the slats with screws. To enhance the rigidity of the case, he inserted a dustboard between the middle drawers (8B). To strengthen the rear feet, he dovetailed each bracket to a large rear element (8C). Beneath the case, he mounted support strips behind the base molding, mitered these strips at the front corners, and glued the feet and standard complement of support blocks to the base molding and backing strips (8D). The resulting product owes much to Salem-area design. Yet exact duplicates from Salem are not known. Boardman created a handsome variation that appealed to affluent customers throughout the Piscataqua region. A thriving export trade also carried the form to distant ports. Closely related Charleston examples (*fig.* 56) may well be based on chests shipped by Boardman to that southern port.

B J

Structure and Condition: Two horizontal backboards are nailed to the rabbeted rear edges of the case sides. Drawer dividers, measuring 6¼" at their deepest point, are secured with sliding dovetails to the case sides; thick facing strips cover the front edge of each side. Drawer supports behind the upper and lower dividers are glued into dadoes in the case sides. Drawer stops are glued to the sides at the back.

Fine but widely spaced dovetails bind the corners of each drawer. The front is made of four laminated strips veneered with mahogany. Cockbeading along the side edges covers the front half of the dovetails. The drawer bottom—two boards with grain parallel to the front—fits into dadoes in the front and sides and is nailed to the back with three original cut nails.

Except for a 2½" patch in the veneer on the bottom drawer divider, several minor chips and a slightly bleached surface, this chest is in excellent condition. It retains its original feet, support blocks, drawer supports, and drawer stops. The feet once had casters.

Inscriptions: Drawer dividers bear chisel-cut numbers: "I," "II," and "III"; the backs of the drawers are numbered "Nᵒ 1," "Nᵒ 2," "Nᵒ 3," and "Nᵒ 4" in old chalk.

Materials: *Mahogany case sides, top, feet, and base molding; mahogany veneer on eastern white pine drawer dividers and drawer fronts; *basswood support strip for base molding; *eastern white pine for all other secondary work. Original brass hardware and iron locks; missing bail for carrying handle on right side.

Dimensions: H. 36¼; W. 42¹¹⁄₁₆; D. 23⅛

Provenance: Descended with the house and possessions of James Rundlet (1772–1852); to his children Caroline (1797–1880) and Edward (1805–74). Caroline left her share to her sister Louisa Rundlet May (1817–95); Edward, to Louisa's son James Rundlet May (1841–1918). James received his mother's share and left the whole to his wife, Mary Ann Morison May (1844–1936), who bequeathed it to her son, Ralph May (1882–1973), the donor.

Publications: Page 1979, 1004; *Plain and Elegant* 1979, 24–25; Sander 1982, 59.

1. *Oracle of the Day*, July 14, 1798.

2. For published information about Boardman's career, see Decatur 1937, 4–5; Rice 1974, 42–45; and *Plain and Elegant* 1979, 141–42. Johanna McBrien, in her master's thesis for the University of Delaware, 1993, expands greatly upon these sources.

3. John and Dorothy Wendell to an unspecified son and daughter, Aug. 25, 1804, Wendell Collection, folder 2, case 7, Baker Library, Harvard Business School.

4. The related chests include four inlaid examples of the same design but without quarter fans; one descended in the Langdon family of

8A.

Detail of page 271 from James Rundlet's Ledger B, showing his purchases from Langley Boardman, January 12, 1802–January 13, 1804. Archives, Society for the Preservation of New England Antiquities, Boston, Massachusetts.

8B.

Case interior.

8c.

Dovetail joint binding rear element to rear bracket foot.

Portsmouth (*fig.* 55); another belonged to Montgomery Rollins (1867–1918) of Dover, New Hampshire in the late nineteenth century; the other two lack histories (Yale University Art Gallery, 1962.32.22, and Diplomatic Reception Rooms, U. S. Department of State, 64.55 [see Conger and Rollins 1991, 203–4]). Five more chests conform in shape and construction to the Rundlet chest but have no inlay; one was owned in the nineteenth century by Jacob Wendell of Portsmouth (Strawbery Banke Museum, 1988.229); another recently belonged to Bernard and S. Dean Levy, Inc., New York (inventory no. 33478); and the three others were sold at auction (Sotheby Parke Bernet, sale 3539, June 21–22, 1973, lot 453; Sotheby Parke Bernet, sale 4316, Nov. 27–Dec. 1, 1979, lot 1188; Sotheby's, sale H-2, Garbisch Collection, May 22–25, 1980, vol. 4, lot 1134). Two others, also by Boardman but without canted corners, descended in Portsmouth households, one in the Brewster family (Strawbery Banke Museum, 1975.6185), the other in the Parrott family (Moffatt-Ladd House, 1977.139). Two additional chests, though similar to the Boardman model, display different foot patterns and represent the work of other craftsmen in the area; one belongs to the Portsmouth Historical Society (Vaughn 9); the other was sold by Northeast Auctions, April 27–28, 1991, lot 434, and is now in a private collection.

5. The English designers William Ince and John Mayhew illustrated a "Comode Chest of Drawers" of this form in their *Universal System of Household Furniture* of 1762, pl. 43. Later English versions of the chest appear in Macquoid 1904–5, 370, and Kirk 1982, 182–84.

6. Two documented Salem chests resemble the Boardman bureau in many details. The first, made by Thomas Needham, lacks the canted corners and inlay but displays the same serpentine contour, broad proportions, and foot design (see Fales 1965, no. 28). The other, made by John Chipman, has a slightly different foot design, a decorative drop at the center of the front base molding, and no inlay, but the general features of its design as well as its construction closely relate to the Boardman chest. The Chipman example is privately owned and unpublished.

8d.

Case bottom.

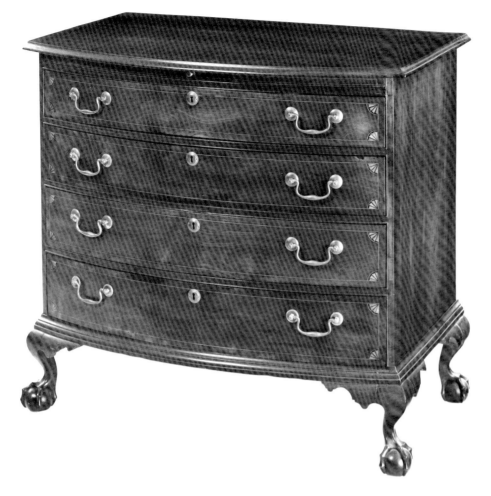

9

CHEST OF DRAWERS

Eastern New Hampshire, possibly Exeter
1800–1810
The Currier Gallery of Art
Manchester, New Hampshire
Gift of the Friends, 1960.17

THIS STYLISH CHEST introduces a new-shaped façade of the federal era—the bow-front. Contemporary price books refer to it as a "round-front" and place its cost midway between that of straight-front and serpentine examples. In the *Cabinet-Makers' London Book of Prices* of 1793, chests of each shape cost £0.18.0, £1.6.0, and £1.17.0, respectively.[1]

Though ornamented with neoclassical stringing and fan inlays, this chest conforms in construction to earlier cases. Like the preceding blockfront chests (*cat. no.* 6 and 6A), the case sides fit into slots in the underside of the top; on most federal chests the sides are dovetailed to slats screwed to the top (*see cat. no.* 8). Here, too, appear such traditional features as the molded edge of the top, stepped ogee of the base molding, and claw-and-ball feet.

Few cabinetmakers placed bowfront cases on claw-and-ball feet. The maker of this chest, however, preferred the form and had many customers for it. Six of his chests have nearly identical façades, and all but one feature a dressing slide just below the top.[2] His design for the feet is unmistakable—thin attenuated ankles extend down to angular claws with pronounced knuckles. His method for building the base is equally distinctive. The front molding is curved and rabbeted along its back edge to receive the case bottom. The molding also projects below the bottom and is backed by broad pine boards glued to the bottom (9A).

Though the characteristics of his work are readily identifiable, his name remains a mystery. He undoubtedly worked in coastal New Hampshire. One of the

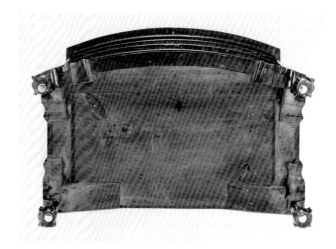

9A.
Case bottom.

chests descended in an Exeter family; another belonged to Levi Jones (1771–1847) of Milton, twenty-five miles northwest of Portsmouth.[3] This example lacks a history but has a crude map in chalk on the backboard. It apparently gives directions to an early owner's home, located on the Haverhill Road heading toward Concord. Such provenances suggest a rural location for the maker, an attribution reinforced by his choice of woods. For this chest, the most ornate in the group, he selected wide boards of native cherry rather than imported mahogany veneer. He also used much thicker pieces of pine than necessary to support the feet and base moldings, a standard practice in rural areas with easy access to inexpensive wood.[4]

The six chests illustrate the proficient hand of a professional cabinetmaker. Each chest is more carefully constructed and more neatly finished than many New Hampshire examples. Their maker understood traditional techniques of pre-Revolutionary case construction. His training, no doubt, had occurred before the 1780s. Yet changing fashions demanded a new vocabulary of ornament. This maker responded by grafting neoclassical elements, such as the bowfront and fan inlays, onto a rococo case.

BJ

Structure and Condition: The one-board case sides are dovetailed to the one-board bottom and fit into dovetail-shaped slots in the underside of the two-board top. The back—three horizontal lap-jointed boards—fits into a groove in the top and is nailed to the rabbeted rear edges of the case sides. Solid cherry dividers, measuring 4¾" deep, are fastened with sliding dovetails to the case sides. Each divider is bowed along both its front and rear edge. Drawer supports are nailed into dadoes in the case sides. Drawer stops are glued to the case sides at the back. The dressing slide—a pine panel set into a dovetailed frame—runs on supports and a divider similar to those for the drawers.

The front base molding is rabbeted along its back edge to receive the case bottom. All of the moldings project below the case bottom and are backed by broad pine strips glued to the case bottom. The claw-and-ball feet are tenoned into the case and flanked by narrow brackets reinforced with thick pine blocks. Broad triangular rear elements provide additional support for the rear feet.

The solid cherry drawer fronts and pine backs are dovetailed to the sides with large, precise dovetails. A broad arched bead decorates the top edge of the sides. The drawer bottom—a single board with grain running parallel to the front—fits into a dado in the front and sides and is nailed to the back.

A previous owner refinished the chest, varnished the interior of the top drawer, and made the unusual repair of veneering the inside surface of the left case side, presumably to cover shrinkage cracks and earlier damage. Other repairs to the chest include broken and patched rear corners of the case top, replaced drawer supports and possibly drawer stops, a 1" by 1¾" patch in the left case side above the center of the base molding, a crack in the right rear foot, a large chip in the front knee bracket for the left front foot, and the addition of a screw through the knee bracket into the left rear foot. Modern steel glides are mounted beneath the feet.

Inscriptions: Map in old chalk on the top backboard refers to "Hampshire" and "Hampshire / Concord" on the right side and "Haverhill" and "Haverhill ro[ad?]," the latter phrase written upside down, on the left side.

Materials: *Cherry top, front edge of writing slide, drawer dividers, drawer fronts, case sides, base molding, feet, and brackets; *eastern white pine for all secondary work. Replaced brass hardware and iron locks.

Dimensions: H. 34⅜; W. 38¼; D. 23½

Provenance: Acquired in Pennsylvania by the antiques dealer Charles Woolsey Lyon and sold to The Currier Gallery of Art in 1960.

Publications: Antiques 78:4 (Oct. 1960): 286; *The Currier Gallery of Art Bulletin* (Jan. 1961): 1–3; *Antiques* 80:5 (Nov. 1961): 472; *Decorative Arts* 1964, no. 49; *The Currier Gallery of Art Bulletin* (July–Sept. 1969): fig. 22; Komanecky 1990, 158.

1. *Cabinet-Makers' London Book of Prices* 1793, 1, 3, 5.

2. The chests include this one at the Currier Gallery; an unpublished example at the Nashua Historical Society; a mahogany version without inlay at SPNEA's Gilman Garrison House, 1966.1300; (*Antiques* 78:2 [Aug. 1960]: 133); a plain cherry chest from the Jones Farm in Milton, N.H. (*Antiques* 109:6 [June 1976]: 1161); another plain mahogany chest now in a private collection in southern California (*Antiques* 142:3 [Sept. 1992]: 356); and an unpublished mahogany chest found in the Peterborough area in the 1980s and sold to a private collector.

3. The SPNEA chest at the Gilman Garrison House descended in the Perry family of Exeter; Levi Jones's chest remained at the family farm in Milton until Richard Withington conducted an on-site auction of its contents on Aug. 20–21, 1974. The chest was purchased by Robert Avery Smith, a Vermont antiques dealer, who later sold it to the antiques department of Marshall Field and Company (see note 2).

4. Related chests by the same maker display even larger pine support blocks than appear on this chest. The pine boards that back the base molding on the mahogany example found in the Peterborough area (see note 2) cover more than half of the case bottom.

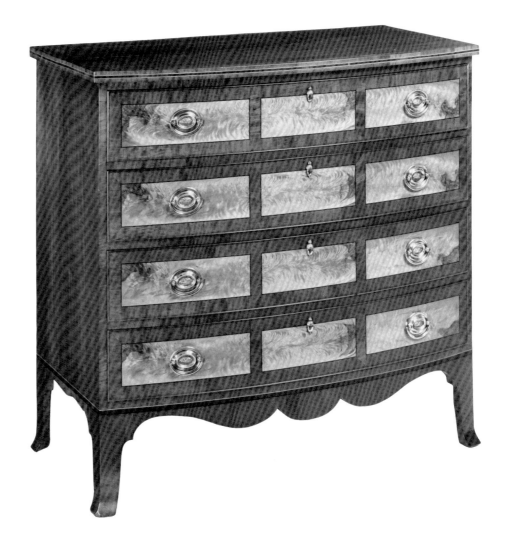

✤ IO

CHEST OF DRAWERS

Portsmouth, New Hampshire
1800–1815
Private collection

DURING THE LATE EIGHTEENTH CENTURY, British design books helped introduce the neoclassical style to America. Cabinetmakers and clients alike found them useful guides to the most timely and elegant furniture. One particularly popular design (10A) came from plate 76 of George Hepplewhite's *The Cabinet-Maker and Upholsterer's Guide* (third edition, 1794). Hepplewhite called it a plan for "Dressing Drawers" and intended that the top drawer should contain "the necessary dressing equipage; the others are applicable to common uses."[1] And indeed, there is evidence that the top drawer of this chest originally had compartments. Hepplewhite's gracefully restrained design, with its bowed façade, French feet, and scalloped skirt with central drop, probably inspired the maker of this chest (*cat. no.* 10), either directly or through someone else's work. This plate may also have been the source for others who experimented with the drop-panel form (*see cat. nos.* 11-13). The craftsman responsible for this chest used the overall form but adapted it by lengthening the foot, adding a tip at the terminus and a spur near the skirt, foregoing the inlaid fans in the skirt, and most dramatically, by compartmentalizing the façade with rectangles of contrasting flame-birch veneer. The black stringing that delineates each birch panel reinforces the visual impact of the contrasting woods.

Not only did the English export pattern books, but they also shipped large quantities of stamped brass hardware to the United States. This chest of drawers features the original silvered brass handles, with bail pulls and oval back plates with a floral basket motif (10B), and escutcheons with acorn-shaped pivoted covers (10C).

This suite of hardware, with its precious-metal finish, is representative of the high-end product marketed in Portsmouth. It was made by the partnership of Thomas Hands and William Jenkins, a Birmingham, England, company in business from 1791 to 1803.[2] Considering the expense of the hardware, coupled with the excellent design and workmanship of the case, it is not surprising to learn that the original owner of this chest was probably Henry Haven (1768–1823), a merchant and member of one of Portsmouth's first families.

The maker of this chest is not known, but the construction methods he employed are now recognized as classic elements of early nineteenth-century Portsmouth case furniture. They include: a single dustboard behind the middle drawer divider; dovetails to join the rear element to the rear bracket foot; a narrow mahogany top (approximately ¼" thick) glued to a pine frame, which in turn is screwed to two slats dovetailed to the case sides; hand-saw marks on the drawer bottom and case back; and finally, a series of continuous blocks glued along the lower edge of the drawer sides and drawer bottom.

D C E

IOA.

"Dressing Drawers," plate 76 in George Hepplewhite's The Cabinet-Maker and Upholsterer's Guide *(third edition, 1794). Courtesy, Printed Book and Periodical Collection, The Winterthur Library, Winterthur Museum, Winterthur, Delaware.*

Structure and Condition: The two-board case sides are dovetailed to the two-board bottom and to two horizontal slats at the top. The thin mahogany top is glued to a frame and secured to the case with screws driven through the slats and into the frame. The case back—three butt-jointed pine boards—is nailed to the rabbeted rear edges of the case sides and flush edge of the bottom. The skirt and feet are secured with support blocks glued to the case bottom. A large triangular rear element is dovetailed to the pine core of each rear bracket foot.

Dividers (measuring 5⅜" at their deepest) separate each drawer and are fastened to the case sides with sliding dovetails. In addition, a 13⅛" deep dustboard backs the middle drawer's divider, and drawer supports back the upper and lower dividers. The supports are glued to dadoes in the case sides; the dustboard slides in dadoes in the case sides.

The drawers are fastened at the corners with dovetails of good quality. Saw kerfs in the drawer sides overrun the dovetails slightly. The bowed drawer fronts consist of four laminated strips veneered with mahogany. Cockbeading on the drawers covers the front dovetails. Each drawer bottom—two boards with grain running parallel to the front—fits into dadoes in the drawer front and sides and is nailed to the back with three original cut nails. A continuous series of blocks is glued to the lower edge of the drawer sides and the underside of the drawer bottom. Hand-saw marks remain on the underside of the bottom, but not on the back of each drawer.

The chest is in excellent condition; all of the original drawer stops, drawer supports, and support blocks for the feet, skirt, and drawers survive. Only one major repair and a handful of minor ones have occurred. A crack in the top was repaired by gluing eleven small blocks beneath the split. The veneers on the right front foot and the right rear foot are cracked. The top drawer once had partitions; V-shaped grooves for the partitions are visible in the drawer front, sides, and back. The chest has been refinished within the past thirty years.

Inscriptions: Stamped "H•J" on the back of the brass bails; old chalk "V" on the underside of the front board of the case bottom; incised "X," "I," and "II" on the case back.

Materials: Mahogany sides and top; mahogany veneer on eastern white pine dividers, skirt, and feet; mahogany and birch veneer on eastern white pine drawer fronts; eastern white pine for all secondary work. Original silvered brass hardware and iron locks.

Dimensions: H. 38⅝; W. 41; D. 22

Provenance: Probably Henry Haven (1768–1823); descended in the Haven family; purchased at auction by Joseph Keown in 1977; purchased by the present owner in 1983.

Publications: "Auction," Antiques *and Arts Weekly*, Sept. 23, 1977, 4-5; Sotheby's, sale 5001, Jan. 27, 1983, lot 429; *Antiques* 124:6 (Dec. 1983): 1244.

1. Hepplewhite 1794, 13. A less ornate example derived from this plate has a Portsmouth area history and is owned by the Portsmouth Historical Society (EBC 129); a second chest is owned by the New Hampshire Historical Society (1940.16.3), but it does not have a history. See also cat. no. 34 for a desk and bookcase with a similar skirt.

2. Fennimore 1991, 89–91. Many handles survive with the "H•J" mark (*see cat. nos. 13, 21, 23, and 31*), indicating that Hands and Jenkins were very active during the twelve years of their partnership.

IOB.

Silvered brass handle.

IOC.

Silvered brass escutcheon.

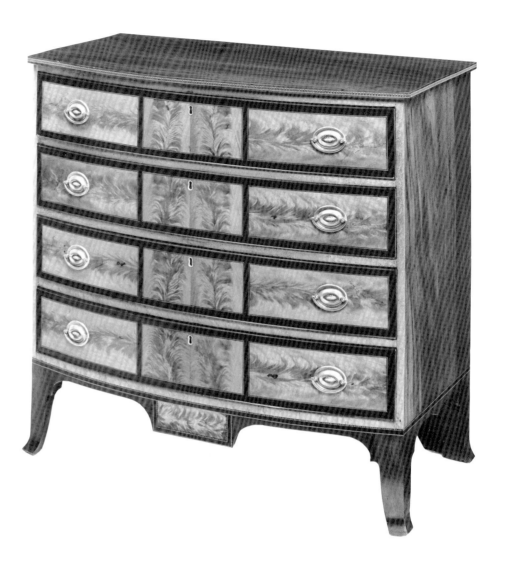

𝕴 11

CHEST OF DRAWERS

Portsmouth, New Hampshire
1805–15
Rundlet-May House
Portsmouth, New Hampshire
Society for the Preservation of New England
Antiquities, gift of Ralph May, 1971.646

A PROMINENT FEATURE on this chest of drawers is the drop-panel pendant, a detail enthusiastically adopted by workshops in the Piscataqua region during the early nineteenth century.[1] Most likely, the drop panel evolved from the earlier fashion of enlivening the skirt with a central carved shell or fan dropped below the base molding. Such a treatment was particularly common on rococo furniture from coastal Massachusetts.[2] With the advent of the neoclassical style, the drop became rectilinear in form and featured veneered geometric motifs. At the same time, the attenuated French foot came into use, creating a large space between the skirt and the floor. The drop panel visually offsets this void and provides a focal point for the central geometric patterns that typically adorn the drawer fronts of these bowfront chests. Craftsmen in other communities also used drop panels, but those from the Portsmouth area utilized it more frequently and to greater effect than their counterparts elsewhere.

This chest exemplifies another characteristic of Portsmouth furniture during the federal period—the use of contrasting woods in bold geometric patterns. Here the vibrantly figured veneers serve to emphasize the neat, symmetrical design of the drawer fronts. While the overall emphasis of the drawer pattern is horizontal, the maker chose to enliven the façade by placing the veneer in the central panels vertically (*see cat. no.* 10). He further enhanced the colorful effect by framing the drawers with bands of bird's-eye maple. In construction, the chest closely adheres to the preceding example. Both may well be the work of the same unknown artisan.

The two chests rank among the most ornate examples of the bowfront form. Less costly versions were widely available. A customer could choose a chest with case sides and top of native birch, stained to resemble the more expensive imported mahogany used on cat. no. 11, or a simpler version with less ornament. One maker frequently eliminated decorative inlay along the sides of the skirt and top (11A). On a plainer model (11B) he substituted mahogany veneer bordered by bands of birch for the more flamboyant arrangement of geometric birch panels. Such modifications trimmed the price but still provided patrons with the essential elements of the form: a colorful bowed façade with four drawers, French feet, and a drop panel.

A R H and B J

IIA.

Chest of drawers, Portsmouth, New Hampshire, 1805–15. Birch, mahogany, and eastern white pine, H. 37¾; W. 40¹³⁄₁₆; D. 20¾. Private collection.

Structure and Condition: The two-board case sides are dovetailed to the two-board bottom and to two horizontal slats beneath the top. The two-board top is secured to the slats by five original screws. The back of the case consists of two horizontal butt-jointed boards nailed to the rabbeted edges of the case sides and flush edge of the bottom. The bottom drawer runs on the bottom of the case; other drawers run on drawer dividers fastened with sliding dovetails to the case sides. Drawer supports behind the top and bottom divider are glued to dadoes in the case sides. A dustboard (11¼" deep) behind the middle drawer divider slides in dadoes in the case sides. The feet and skirt are a separate unit secured to the bottom of the case by glue blocks. Large triangular rear elements are dovetailed to the rear feet. The drop panel is backed with two layers of glue blocks.

The drawers are joined at the corners with widely spaced dovetails of good quality. The core of each drawer front consists of four laminated strips. The drawer bottom—two boards with grain running parallel to the front—fits into dadoes in the drawer front and sides and is nailed to the back with two original cut nails. A series of five butting glue blocks is set along the lower edge of the drawer sides and the underside of the bottom. Pronounced hand-saw marks are visible on the underside of each drawer.

When acquired by SPNEA in 1971 with the contents of the Rundlet-May House, the chest had late nineteenth-century wooden knobs, numerous chips on the cockbeading and feet, much cracked or loose veneer, and a dark, crazed surface that obscured the brilliant colors of the wood. In 1983 Robert Mussey of the SPNEA Conservation Center reglued all loose veneers and replaced the most noticeable chips, including the lower 1¾" of the front tip of the

left front foot and 2½" bands of veneer above the left front foot and at the center of the middle drawer divider. He also cleaned the surface of the chest, applied a shellac finish, and installed reproduction hardware of the appropriate design.

Inscriptions: Original sawyer's mark (diagonal slash over three vertical slashes) incised in case back; drawer dividers and drawer backs are numbered in modern pencil.

Materials: *Mahogany case sides and top; sugar-maple veneer on drawer dividers and front edge of sides; birch veneer and mahogany banding on drawer fronts and drop panel; *eastern white pine for all secondary work. Original bone escutcheons and iron locks; replaced brass handles.

Dimensions: H. 38⁷⁄₁₆; W. 41¼; D. 21¾

Provenance: Descended in the Lord family of South Berwick, Me., and Portsmouth to Mary Elizabeth Lord Morison (1817–1903); to her daughter, Elizabeth Whitridge Morison (1842–1920); to another daughter, Mary Ann Morison May (1844–1936), wife of James Rundlet May; to her son, Ralph May (1882–1973), who gave it to SPNEA in 1971.

1. Several related chests are now owned by museums. One with a history in the Sewall and Thompson families is in the collection of the Old York Historical Society (1971.5; see Sprague 1987a, no. 98). Bayou Bend owns another (B. 69.379; see Warren 1975, no. 165). The Henry Ford Museum has a representative chest (28.1.22).

2. See Downs 1952, nos. 165–68; Ward 1988, 253–59.

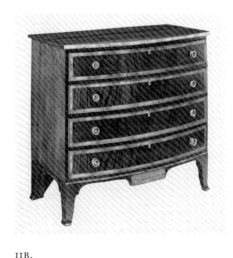

IIB.

Chest of drawers, Portsmouth, New Hampshire, 1805–15. Mahogany, birch, and eastern white pine, H. 37¾; W. 41¹¹⁄₁₆; D. 20½. Private collection. This chest is branded with the name of the original owner, J. F. Shores (1792-1871).

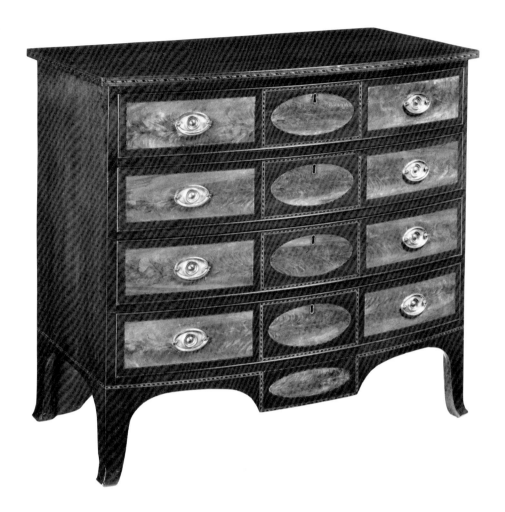

12

Chest of drawers

(Colorplate 2)
Probably Portsmouth, New Hampshire
1800–1815
Private collection

Numerous bowfront chests with drop panels survive, but this one is the handsomest and best-preserved example of the group. Moreover, it belongs to a select subgroup of six chests with ovals on the drawer fronts and drop panel (12A) instead of the more common rectangular motif. Other features peculiar to this group include: the lack of spurred French feet (*see cat. no.* 10); the absence of any solid mahogany in the case; and extensive use of alternating light- and dark-wood inlay cut diagonally for a spiral effect. The chests within this subgroup are probably the work of one shop, products of a craftsman who raised the drop-panel form to its highest level.[1]

Long associated with Portsmouth workshops, the drop panel remains a hallmark of area case furniture. It is somewhat surprising then, that the finest example from this group has a history of ownership in the Lane family from the Saco River valley in Maine.

The Saco River, with its forty-foot waterfall, opened up northern York County to lumbering, milling, and general commerce during the late eighteenth century.[2] The Lane family settled up-river from the great Saco Falls, first in Buxton near Salmon Falls, and later in Hollis.

Colonel Isaac Lane (1764–1833) probably purchased the chest for himself or his second wife, the widow Sarah Jones Randall (1776–1821), on a trip to Portsmouth or through an agent.[3] Lane was in a position to collect such fine furnishings because of his entrepreneurial skills and his access to Portsmouth. He owned a grist mill, a saw mill, and a store, as well as numerous ships harbored in Portland.[4] Dur-

ing the War of 1812, Lane served as a colonel of the 33rd Regiment of Infantry, a position that put him in contact with such prominent Portsmouth citizens as Governor John Langdon.[5] The Colonel's business declined during the embargo that preceded the war, causing a reversal of fortune from which he never fully recovered. The chest of drawers was probably conveyed to his daughter, Jane Maria Lane Bradley, before his death in 1833, in part to avoid selling it for debts against the estate.[6]
D C E

Structure and Condition: The veneered one-board case sides are dovetailed to two slats, which are in turn screwed to the veneered two-board top. The sides continue to the floor and form the skirt and feet sides. The front skirt and front portions of the feet are a separate unit secured to the case bottom by eighteen glue blocks. The two-board pine bottom fits into dadoes in the case sides. Hand-saw marks are visible on the inner surface of the case back. A full dustboard is set into dadoes in the case sides behind the middle drawer divider. Drawer supports, nailed into dadoes, back the upper and lower drawer dividers. Drawer fronts are comprised of three laminated strips of pine veneered with mahogany and birch. The cockbeading on the edges covers only the front quarter of the dovetails. The construction of the drawers conforms to typical Portsmouth practice (*see cat. no.* 10), but support strips were never glued to the drawer bottoms.

The chest survives in exceptional condition. Repairs include: restoration to sections of the rear feet; minor patches to the veneer and stringing; runners glued to the drawer bottoms along the lower edge of the drawer sides; repaired drawer supports and trimmed drawer stops. In 1990 the finish was cleaned, and the top was darkened to match the sides and front.

Inscriptions: Fragment of a typewritten label pasted inside the top drawer: "Her daughter Sar… / Randall m. Col… / Maria Jane Lane… / grandfather of Helen…" In ink below the typed inscription, "The Queen Anne highboy came… / line. Also… / June 1947." In pencil on the drawer dividers from top to bottom: "X4," "X3," "X2."

Materials: Mahogany veneer on eastern white pine case sides, top, drawer dividers, front skirt, and feet; mahogany and birch veneer on white pine drawer fronts; eastern white pine for all secondary work. Original brass hardware and iron locks.

Dimensions: H. 37⅜; W. 40⅞; D. 22⁷⁄₁₆

Provenance: Colonel Isaac Lane (1764–1833) and Sarah Jones Randall Lane (1776–1821); to Jane Maria Lane Bradley (1805–73); to Sarah Jane Bradley Wiggin (1831–1925); to Elizabeth Wiggin Coolidge (1851–1938); and to Elizabeth Coolidge Crosby. Purchased at auction by C. L. Prickett Antiques of Yardley, Pa., in 1990 for the present owner.

Publications: Christie's, sale 7000, Jan. 19–20, 1990, lot 722; Solis-Cohen 1990, 11c; Petraglia 1992, 102.

1. The group of related chests with birch ovals includes: one with a Saco, Me., history (see *Antiques* 44:1 [July 1943]: 35 and *Antiques* 52:2 [Aug. 1947]: 80); and one with a Hampton, N.H., history (see Montgomery 1966, no. 138). Other examples include: Lockwood 1913, 1:138, fig. 140; Lockwood 1926, 1:366, fig. 33; and Parke-Bernet, sale 629, Jan. 26–27, 1945, lot 249.

2. Sprague 1987a, 103, 104.

3. Family history states that the first owner of the chest was Sarah Dodge Jones, the mother of Sarah Jones Randall Lane. She married Dr. Nathaniel Jones in 1766 and lived in Cape Elizabeth, Me. It is unlikely that she would have acquired such a stylish piece of furniture so late in life.

4. Usher 1912, 19–20. Lane also served as a fifer in the Revolutionary War, a colonel in the War of 1812, the York County sheriff in 1811, and a member of the Governor's Council of Maine from 1820 to 1823.

5. Correspondence between Isaac Lane and John Langdon, Jan. to July, 1814, box 1, Isaac Lane Papers, collection 108, Maine Historical Society.

6. Isaac Lane, 1833 inventory, docket 11114, York County (Me.) Probate. Lane "in his life time, and immediately before his death did convey all his estate real and personal to certain persons." Eight days before he died, Isaac Lane sold all his remaining real estate and personal estate for $20,000, including the contents of his store in Hollis, to a consortium including his son Thomas, sons-in-law Ellis B. Usher and Samuel Bradley, and Jabez Bradbury. Isaac Lane, 1833 Deed, 146:243, York County (Me.) Deeds. Samuel Bradley owned three mahogany bureaus at the time of his death in 1849. Samuel Bradley, 1849 inventory, docket 1764, York County (Me.) Probate.

12A.

Detail of bottom drawer and drop panel.

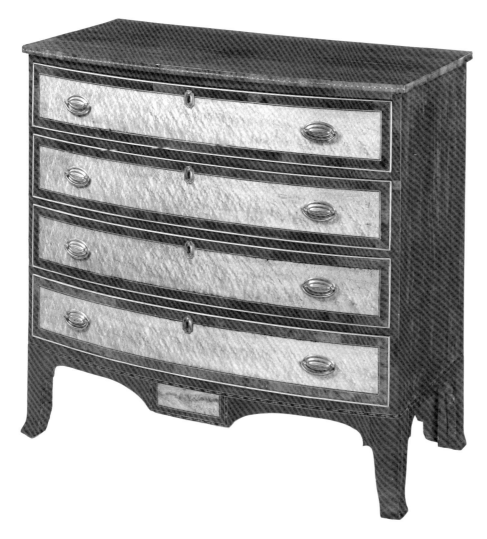

⁂ *13*

CHEST OF DRAWERS

Attributed to Joseph Clark (1767–1851)
Portsmouth or Greenland, New Hampshire
1810–14
The Currier Gallery of Art
Manchester, New Hampshire
Gift of Mrs. Howard C. Avery
in memory of her husband, 1979.83

BELLE AVERY (1866–1931) left an important legacy when she wrote the following in-
scription on the bottom of a drawer in this chest:

> Made in Great Grandfather Joseph Clarke Cabinet Shop in Portsmouth about 1810[.] A part
> of Grandmother Mary Moody Clarke Averys [wedd?]ing trousseau in 1813. Belle Avery.[1]

Mrs. Avery's interest in family history not only established the provenance of this
chest of drawers but identified its maker as well.

Joseph Clark (1767–1851) was born in Greenland, New Hampshire, a neigh-
boring township of Portsmouth.[2] According to Belle Avery, he worked as a cabinet-
maker in Portsmouth, but his presence there has not been substantiated. He appar-
ently remained in his native Greenland throughout his early career.

As with many of his peers, Clark experienced vexing legal problems. In 1809
he was summoned to court by James Folsom III of Exeter, New Hampshire, a sad-
dler, who alleged that Clark had promised "to pay him fifty two dollars in sleigh
work or cabinetwork" but had never fulfilled his obligation.[3] The case was ultimately
dismissed; however, it illustrates the variety of related tasks performed by cabinet-
makers such as Clark. A second case describes an action of 1817 filed by Henry Y.
Wiggin, a Durham cabinetmaker in neighboring Strafford County. He claimed that
Clark owed him $29.91 for his services as a witness from 1811 through 1814 in his
action against David Simpson. Details surrounding this litigation are not known,
but Clark pursued his case against Simpson all the way to the State Supreme
Court.[4]

Shortly after this case, Clark and his wife, Comfort Weeks (1773–1861), moved to Wolfeborough on Lake Winnipesaukee, then a remote area of Strafford County, New Hampshire.[5] It is surprising that he would leave his home town after so many years, but economic hardship and legal problems led him to seek new opportunities in Wolfeborough. Once established, Clark continued to practice his trade as a cabinetmaker, possibly until the end of his long life.[6]

Joseph Clark's eldest daughter, Mary Moody Clark Avery (1795–1876), followed the family to Wolfeborough in 1818, with her husband Samuel Avery (1785–1858) and two children. They were married on January 13, 1814, and one of their wedding gifts was this handsome chest of drawers.[7] Contemporaries considered Mrs. Avery to be blessed with many womanly virtues, and she was greatly admired:

> At her marriage she was young, small, and beautiful, but, as ever afterwards, full of life and energy…When she settled in Wolfeborough many friends thought of her as in a wilderness, of which very little was known except desolation…As the eldest daughter in a large family… a special responsibility was thrown upon her which admirably trained her for her life as wife and mother. Capable, energetic, prudent, hospitable, kind, sympathetic, are only some of the adjectives that describe her character.[8]

The esteemed Mrs. Avery took care of the home, while Samuel Avery became an increasingly successful shopkeeper, who also worked at shoemaking, milling, farming, real estate, and banking. He held a number of municipal positions and served as an officer of the Wolfeborough Academy. Mary Avery boarded many of the students in her home.[9]

This chest of drawers was undoubtedly one of the finest pieces of furniture in the Avery household. Its outline resembles that of more elaborate Portsmouth drop-panel examples (*see cat. nos.* 11–12). Clark's design, however, avoids compartmentalizing the façade, in favor of broad expanses of bird's-eye maple veneer on the drawer fronts. The original stamped brass hardware, by the partnership of Hands and Jenkins of Birmingham, England (*see cat. no.* 10), survives intact. The drop panel in the skirt features a rectangle of flame-birch veneer, instead of the expected bird's-eye maple. A closely related drop-panel lady's writing desk with nearly identical decorative inlay patterns and brasses was also made by Joseph Clark.[10] It too descended in the Avery family of Wolfeborough and represents the type of work that the family patriarch produced before he set up shop in the lakes region of New Hampshire.

DCE

Structure and Condition: The two-board case sides are dovetailed to the one-board bottom and to two horizontal slats set beneath the top. A pine frame is glued to the underside of the thin mahogany top and secured to the slats with screws. Drawer dividers are fastened with sliding dovetails to the case sides. The feet and skirt are glued to the underside of the bottom and reinforced with a series of support blocks. Triangular rear elements butt against the rear bracket feet and are held in place by a vertical glue block on each side of the rear element. The back consists of two horizontal butt-jointed boards nailed to the rabbeted edge of the case sides and flush edge of the case bottom and rear slat beneath the top.

Each drawer is dovetailed at the corners with thick but precise dovetails. The core of the drawer front consists of three laminated boards. The drawer bottom—a single board with grain running parallel to the front—fits into dadoes in the front and sides and is nailed with three original cut nails to the back. A series of blocks is glued to the bottom along the lower edge of the sides. Hand-saw marks remain on the underside of the drawer bottom.

The surface of the chest has been refinished and bleached, but the case itself remains remarkably intact. The top has three shrinkage cracks; the left side is also cracked. Two pine strips have been screwed to the underside of the top to prevent the shrinkage cracks on the top from expanding. The original drawer stops have been removed, shaved down, and reattached. There are several patches to the veneer on the case sides and drawer dividers.

Inscriptions: In pencil on the underside of the top drawer: "Made by Howards Great great Grandfather Clarke / For Howard Clifton Avery / from Belle Avery / Made in Great Grandfather Joseph Clarke / Cabinet Shop in Portsmouth about 1810 / A part of Grand mother Mary Moody Clarke Averys / [wedd]ing trousseau in 1813. / Belle Avery." Old numbers in chalk on the back of each drawer; chalk "X" on each drawer divider. Handles stamped "H•J" on the back of the bails.

Materials: Mahogany top; mahogany veneer on eastern white pine drawer dividers, skirt, and feet; mahogany and maple veneer on eastern white pine drawer fronts; *birch case sides and cockbeading on the drawers; birch veneer on eastern white pine drop panel; and *eastern white pine for all other secondary work. Original brass hardware; original locks in the top three drawers; bottom drawer never had a lock.

Dimensions: H. 37⅞; W. 40³⁄₁₆; D. 21⁵⁄₁₆

Provenance: Probably made by Joseph Clark (1767–1851) as a wedding gift for his daughter, Mary Moody Clark Avery (1795–1876), who married Samuel Avery (1785–1858) in Jan. 1814; to their son Augustine Decatur Avery (1814–1903); to his daughter Belle Avery (1866–1931); descended to Howard C. Avery. Mrs. Howard C. Avery presented it to The Currier Gallery of Art in 1979.

Publications: Michael 1972, 16–19; Michael 1976, 1, 6–7; Michael 1989, 34d–35d.

1. Inscription on the underside of the top drawer (see *Inscriptions*).

2. Clarke 1902, 342.

3. Clark v. Folsom, 1809 writ, Series A, docket 30629, Rockingham County (N.H.) Court, State Archives.

4. Clark v. Wiggin, 1817 writ, Series A, docket 44548, Rockingham County (N.H.) Court, State Archives.

5. Parker 1901, 241. Early in the twentieth century, the town simplified the spelling of its name to "Wolfeboro." Both spellings are used in this book, depending on the historic context of the reference.

6. Ibid., 524.

7. Clarke 1902, 343.

8. Rev. Leander Thompson, "Samuel Avery," in Merrill 1889, 377. The author was the son-in-law of Mary Clark Avery.

9. Ibid., 375–76.

10. Michael 1972, figs. 8–11. Also see Michael 1972, fig. 14, and Randall 1965, no. 35, for a similar chest of drawers marked "Sam…Barnes" (or Banes). An unusual group of drop-panel chests with turned legs have been attributed to Joseph Clark or his son Enoch (1802–65) by George Michael, but this group needs further research. See Michael 1989, figs. 2 and 3. The latter chest is owned by the Wolfeboro Historical Society (acc. no. 32), while the former is privately owned and currently on loan to SPNEA. Two other chests by the same hand appear in Michael 1972, figs. 63 and 64, and in *Antiques* 49:2 (Feb. 1946): 74.

14

CHEST OF DRAWERS

Portsmouth, New Hampshire
1815–25
Rundlet–May House
Portsmouth, New Hampshire
Society for the Preservation of
New England Antiquities,
gift of Ralph May, 1971.672

THIS BOWFRONT CHEST with reeded legs, ovolo corners on the top, and slender turned feet is an early example of what was to become an extremely common form. With its brilliant birch-veneered panels framed by rosewood-veneered banding, this example is truly sumptuous, even though the maker used birch instead of mahogany for the top and sides. Cabinetmakers often substituted local woods for the costlier imports, and birch could be readily stained to resemble mahogany. That this was an accepted method of construction is demonstrated by an advertisement in the *New Hampshire Gazette* in 1827:

> EBEN'R LORD, Respectfully informs his friends and the public, that he continues to manu-facture CABINET FURNITURE,… [including] Mahogany Bureaus—birch ends and tops with mahogany fronts… [1]

The turned feet on this example are slender and gracefully executed. The earliest documented use in Portsmouth of turned legs and reeded columns terminating in ovolo corners is the Wendell family sideboard, made in 1815 (*cat. no. 37*). Turned feet, which are made on a lathe, are simpler and cheaper to make than French feet (*compare cat. nos. 10 and 11*), which must be sawn and then frequently veneered. Later versions of this treatment are often bulbous and less intricately turned. The flame-birch and rosewood veneer here is matched and applied with great skill; pieces made only a few years afterwards tend to be less flamboyant. The formal de-sign of this chest of drawers, including its original stamped brasses embellished with acorns and oak leaves, together with its exceptional condition, make it a superb

example of the bold, elemental style that continued in Portsmouth well into the nineteenth century. [2]

ARH

Structure and Condition: The two-board case sides are dovetailed to the two-board bottom and to two horizontal slats at the top. Six original screws and fourteen support blocks secure the slats to the two-board case top. The legs extend from the floor to the top of the case. The case sides are tenoned and glued into vertical slots in the legs. The back is constructed of two horizontal butt-jointed boards nailed to the rabbeted edge of the rear legs.

The drawer dividers, which measure 5¾" at their deepest, are fastened with sliding dovetails to the case sides. A dustboard is set behind the middle drawer divider. The other dividers are backed by drawer supports, which are nailed and glued into dadoes in the case sides. Drawer stops are glued to the case sides at the back.

The drawers are fastened at the corners with widely spaced dovetails. Each drawer front is made of four laminated strips of pine veneered with birch and rosewood. The drawer bottom consists of a single board set into dadoes in the front and sides and nailed to the back with three original cut nails. A continuous strip is glued to the bottom and inside lower edge of each drawer side. Rough hand-saw marks remain on the underside of the drawer bottoms.

When acquired by SPNEA in 1971 with the contents of the Rundlet-May House, the chest retained all of its original structural elements (except one drawer stop) but displayed minor surface damage. The curly-birch top had warped and much of its original red stain had been cleaned away. The narrow bands of birch along the top and skirt had numerous small chips. The veneer on the drawer fronts had become loose in several areas. The cockbeading along the right side of the top drawer was missing. Shrinkage in the case sides had caused the drawer dividers to pop through the facing strips on the front edges of the case sides. Finally, a thick, grimy finish darkened by many layers of linseed-oil polish coated the façade. In 1983 Robert Mussey of the SPNEA Conservation Center reglued the loose veneer, replaced the missing cockbead and ten small pieces of birch banding, and reinstalled the drawer dividers in their original positions. In addition, he cleaned the surface of the chest with alcohol (leaving samples of the old finish under the hardware), stained the case

sides and top to match the original stain still evident on the turned feet, and refinished the entire chest with orange shellac.

Materials: *Birch top, sides, and legs; *birch and rosewood veneer on drawer fronts; *birch veneer on the edge of the top and skirt; mahogany veneer on the drawer dividers; *probably Spanish cedar cockbeading; *eastern white pine for all secondary work. Original brass handles except for bail posts for lower right handle; replaced escutcheons; original iron locks.

Dimensions: H. 39; W. 41⅞; D. 21¾

Provenance: This chest shares a provenance with cat. no. 8.

1. *New Hampshire Gazette,* Aug. 21, 1827.

2. See Montgomery 1966, no. 139, for a similarly designed and constructed chest of drawers, and Nutting 1928–33, no. 284, for a related chest with a drop panel.

15

HIGH CHEST OF DRAWERS

(Colorplate 3)
Portsmouth, New Hampshire
1733
Private collection

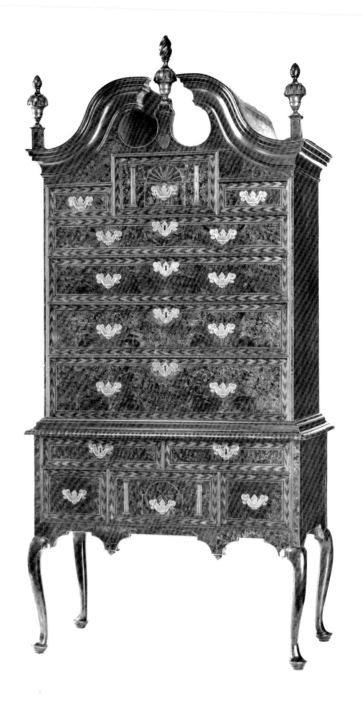

FEW PIECES OF EIGHTEENTH-CENTURY American furniture are more flamboyant than this veneered high chest. Its façade is a feast of pattern and color. Inlaid walnut plinths support the original maple finials. On the drawers, herringbone bands of contrasting veneer surround panels of burled maple; on the pediment drawer, applied pilasters and winged cherubs flank an arched panel and fan (15A). In the lower case, the panel frames a compass star on the central drawer. On each case side, a much larger arched panel is filled with walnut veneer and decorated with a mask and star (15B). Light and dark dentils ornament the waist molding. Such lively, whimsical details transform the chest into a statement of the maker's skill and creativity as well as the purchaser's standing within the community.

The chest itself provides a tantalizing clue to the owner's identity. A veneered heart at the center of the pediment bears the inscription "I+S / 1733" (15c). This unusual device, according to family history, refers to John Sherburne (1706–ca. 1736) of Portsmouth.[1] Like his father, the prominent merchant Joseph Sherburne, John pursued a mercantile career. He served initially as a master mariner and later

as a ship captain aboard one of his father's vessels. In 1731, he married Eleanor Mendum and apparently acquired this high chest just two years later. In 1735, his promising career ended suddenly when he was lost at sea, only months after the birth of his first son, Nathaniel.[2] This chest descended to Nathaniel and subsequently to Nathaniel's daughter-in-law, Elizabeth Warner Sherburne, who moved it to the Warner House in the early nineteenth century. It remained there for more than a century, prominently displayed in the second-floor hall but without its feet. During the late eighteenth century, someone sawed off the feet to fit the chest into a smaller room.

No household inventory survives to document the original context of the chest, but its ornate design suggests several conclusions. It undoubtedly stood in John Sherburne's best chamber. He probably described the form as a "Case of Draws" and may have had a matching "Dressing Table."[3] Within the chest, his wife stored table linens and bedding but perhaps not in the same quantities as her neighbor Anne Jaffrey Peirce, who filled a case of drawers with 7 pairs of sheets, 6 pairs of "Pillabers," 19 table cloths, 24 towels, 51 napkins, and 11 tea cloths.[4] Such textiles deserved a handsome repository because of their high cost in the colonial era. Peirce's stylish high chest and dressing table were among her most prized possessions; yet their value amounted to less than one-seventh that of the textiles within them. Even Sherburne's chest—one of the most expensive pieces of its day—probably cost less than the objects it contained.

Today, the significance of the Sherburne high chest extends well beyond the Piscataqua region. The inscription on its pediment establishes the chest as the earliest dated example of American furniture in the Queen Anne style. Boston cabinetmakers had begun to work in the new curvilinear fashion by about 1730. And indeed, this chest relates in many respects to Boston case furniture of the period.[5] However, the dramatic use of contrasting veneers, cherubs, and masks distinguish it from eastern Massachusetts examples. In construction, it also displays several unusual features, including dustboards (instead of shallow dividers) between the drawers, which point to a local origin. Like the idiosyncratic creations of Joseph Davis (*cat. nos.* 16–17) and John Gaines (*cat. nos.* 77-78), this stunning high chest illustrates the ambitious provincialism of the Portsmouth furniture makers during the first half of the eighteenth century.

B J

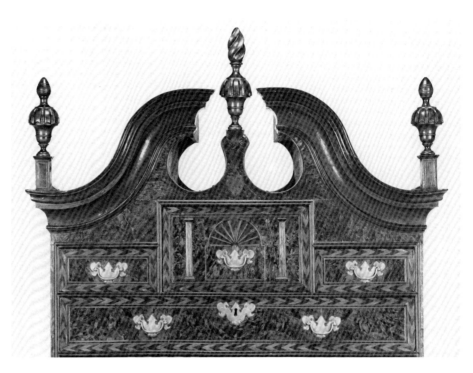

15A.

Pediment.

Structure and Condition: The high chest separates into two sections. The veneered one-board sides of the upper case are dovetailed to the one-board case bottom. The pediment is nailed to the front edge of the case sides. The circular openings of the pediment are lined with a beaded maple strip. A thick four-part cornice molding is glued and nailed to the pediment and case sides. The back of the hood conforms to the shape of the pediment. Below, three vertical backboards are nailed to the rabbeted lower edge of the back of the hood and rear edges of the case sides. The roof of the hood is nailed to the top edge of the pediment and back. A shelf behind the center of the pediment is fastened to support blocks nailed to the pediment and back. A stepped tier of vertical pine boards encloses the inner sides of the hood. The plinths for the side finials are held in place with small wedge-shaped black walnut blocks. The urn and flame of each side finial are separate elements; the larger central finial is a single unit. All three finials are made of two maple boards that were glued together, then turned and carved. Dustboards separate the drawers in the upper

case. Each board fits into a dado in the case sides; the front edge of the sides is covered with a veneered and beaded facing. The upper portion of the waist molding is attached to the upper case, projects 1" below the case bottom, and is backed with pine blocks.

The lower case is joined. The veneered one-board sides, the solid two-board back, and the front skirt are tenoned to the legs; wooden pins secure each joint. The top—a large pine panel framed by 4½" wide boards along the front and sides—is nailed to the top of the lower case. An upper tier of drawers runs on a dustboard resting on drawer guides nailed to the case sides; the lower tier of drawers runs on medial supports tenoned into the case back and set in notches in the front skirt. Vertical partitions, fastened much like the supports, separate the drawers in each tier; the lower edge of each partition tapers upward from front to back. Beaded maple strips outline the front and side skirts.

The drawers are joined at the corners with precise but thick dovetails. The front of each drawer is a single pine board veneered with wal-

nut and maple. The top edge of the sides and back is rounded. The bottom of the small drawers is a single board with grain running perpendicular to the front; the bottom of the large drawers consists of two boards, also running perpendicular to the front. The bottom of each drawer is nailed to the rabbeted edge of the front and flush edge of the sides and back. On the large drawers, runners are glued to the bottom.

The chest has had only two major repairs since the feet were removed in the late eighteenth century. An early restorer installed a large patch in the burl veneer on the right side of the upper case. In 1951, George Kernodle of Washington, D. C., replaced the missing feet, patched chips in the inlay on the front edge of the waist molding on the lower case, and replaced the side knee brackets for the front legs, the applied beads along the flattened arches of the skirt, and all of the drawer stops within both cases. Despite numerous cracks and small chips in the veneered surfaces, the chest remains in extraordinary condition. Fragments of the original drops are still in place.

Inscriptions: "I+S / 1733" on inlaid heart below central finial; "PJ [or 1]" written in old chalk on left partition in lower case; chalk "D" on one side and "3" on other side of right partition in lower case; old chalk numerals on most of the drawers. Three pencil inscriptions on the top of the lower case: "O. C. Yeaton / 1861," "HJ," and "H. H. J."

Materials: Black walnut finial plinths, cornice molding, upper waist molding, legs, and knee brackets; black walnut and maple veneer on eastern white pine pediment, drawer fronts, lower waist molding, front skirt, and case sides; maple finials, drops, and skirt bead; eastern white pine for all secondary work. Second set of brass hardware; original set was secured with snipes; probably second set of iron locks for large drawers and upper tier of drawers in lower case. The small right and center drawers in the upper case originally had wooden spring locks; the lower tier of drawers in the lower case never had locks.

Dimensions: H. 86¼; W. 40½; D. 22¼

Provenance: Probably John Sherburne (1706–ca. 1736); to widow Eleanor Mendum Sherburne (d. before 1804); to their only child, Nathaniel Sherburne (1735–1805); to his daughter-in-law, Elizabeth Warner Sherburne (1767–1846); to her son John N. Sherburne (1793–1859); to his

daughter Elizabeth Warner Pitts Sherburne (1822–1909) who married Pearce Wentworth Penhallow (1816-1885); to their son Thomas Wibird Penhallow (1846–1930); to his niece and subsequently to his grandnephew, the present owner.

Publications: Morse 1917, 28.

1. In describing this chest, Frances Clary Morse notes that the initials stood for "John Sherburne, whose son married the daughter of Colonel Warner"; see Morse 1917, 27. Actually, Sherburne's grandson married the daughter of Colonel Jonathan Warner's brother, Samuel, and received Jonathan's home, the Macpheadris-Warner House, by bequest in 1814. The chest was moved into the house early in the nineteenth century.

2. Biographical information on John Sherburne is sketchy; a brief account appears in Sherburne 1904, 230, 234.

3. "Inventory of the Estate of Nathaniel Peirce Late of Portsmouth Esq Deceas'd p[er] Appraisement Novr. 19th. 1762" included "1 Case of Draws & Dressing Table," an obvious reference to a matching high chest and dressing table; see Wendell Collection, folder 9, case 7, Baker Library, Harvard Business School. The term chest of drawers also appears in some Portsmouth inventories during this period and may refer on occasion to a high chest. John Sherburne's father, Joseph Sherburne, outfitted his best chamber with an elegant high-post bed, looking glass with brass sconces, "1 Table Dressing Box & 5 Brushes," and "1 Chest of Draws"; 1745 inventory, docket 1214, N.H. Provincial Probate, State Archives. In Joseph Sherburne's day, the chest of four drawers was a rare form, and the appraisers of his estate may have chosen the term "Chest of Draws" to describe the more common high chest.

4. Nathaniel Peirce, 1762 inventory, Wendell Collection.

5. The introduction of the Queen Anne style in Boston is presented in Jobe 1974, 42–48. Several Boston veneered high chests with scrolled pediments relate in their drawer configuration and vocabulary of ornament to the Sherburne chest; see Heckscher 1985, no. 157, and Flanigan 1986, no. 20.

15B.
Ornamental compass star on upper case side.

15C.
Inscription.

16

HIGH CHEST OF DRAWERS

Attributed to Joseph Davis (w. 1726–62)
Portsmouth, New Hampshire
1735–50
Diplomatic Reception Rooms
U.S. Department of State, Washington, D.C.
Gift of Mr. and Mrs. James L. Britton, 74.68

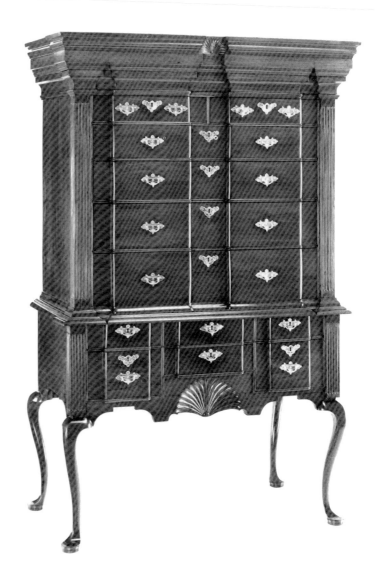

THIS IMPOSING HIGH CHEST, equally as dramatic as the preceding example, relies on a shaped façade rather than veneer for its impact. The two objects illustrate the diverse designs of two different Portsmouth craftsmen working at the same time. In this instance, the identity of the maker can be discerned. A matching dressing table (*fig.* 29) and related high chest (*fig.* 28) bear his chalk signature, "Joseph Davis."[1]

Davis is an elusive figure, in part because of his name. At least a dozen Joseph Davises resided throughout eastern Massachusetts and New Hampshire during the middle of the eighteenth century.[2] Yet careful sifting of the genealogical data yields tantalizing clues about the career of the "joyner" Joseph Davis. The record begins in Boston in 1726 when he signed a receipt "for my Master Mr Job Coit," a noted builder of blockfront furniture.[3] Davis remained in Boston until at least March 1733, then moved to Portsmouth within the year and married Christian Green soon afterward.[4] His business in Portsmouth continued until at least 1762, but he never achieved great wealth from his trade. His tax payment of 1757 was a modest £2, and creditors frequently sued him for debt.[5] A court case of 1762 notes that he had a son, Joseph, who worked with him, as well as a journeyman named Gifford.[6] His shop must have been small, perhaps comprising no more than two or three hands, but his output was quite varied. In addition to fine case furniture, he made inexpensive flag-bottomed chairs, probably in considerable quantity. In 1762, Cyprian Jeffry rented Davis "ye use of my Kitchen 3 months to Bottom Chaires in" and the "Celler room to Soak your flags."[7] Saddled with numerous debts, Davis left

Portsmouth shortly thereafter.[8] His name disappears from the tax rolls, and his career in New Hampshire comes to an end.

Davis learned of blockfront design during his early years in Boston but modified the pattern noticeably once in Portsmouth. The work of his master Job Coit has little in common with his own idiosyncratic style, epitomized by this high chest and the related dressing table (*fig. 29*).[9] Though separated long ago and now varying markedly in condition, these two items were undoubtedly made as a set. They feature the same distinctive pattern of blocked drawers, fluted pilasters, and a deeply lobed shell. The original hardware on the high chest conformed in both design and arrangement to that still intact on the table (16A).[10]

In construction, the two objects also display many identical characteristics. Davis glued a walnut board behind each front skirt. When carving the shell, he cut through the skirt into the board, leaving a visible seam where they join. To create the blocked façade, he applied curved blocks to straight drawer fronts, an efficient alternative to the more typical practice of sawing the blocked profile from solid fronts. He also cut a double-arched bead on the top edge of the drawer sides and a pronounced chamfer on the top edge of the back. In addition, Davis or a local sawyer scratched "#PR 18" onto the back of both objects.[11]

The dressing table closely corresponds to two other tables, one with a lengthy history in the Warner family of Portsmouth (17A). The high chest stands alone, one artisan's unique interpretation of blockfront design. Its massive upper case is capped with a deep architectural molding punctuated with a diminutive echo of the larger shell in the base. No doubt, the ambitious ornament and dazzling hardware pleased its purchaser and impressed all who viewed it. But its structural flaws may well have caused its owner grief. Davis placed the case upon attenuated, boldly curved cabrioles. Though graceful, they failed to provide sufficient support and within a half-century had broken and been replaced with stockier versions.[12] Recently, SPNEA conservators installed appropriate legs and brass hardware, both adapted from those on the dressing table. The chest now recreates its former magnificence and reveals the distinctive traits of its maker, Joseph Davis.

B J

16A.

Original hardware on dressing table by Joseph Davis in fig. 29. Portsmouth, New Hampshire, 1735–50. The Dietrich American Foundation, Philadelphia, Pennsylvania.

Structure and Condition: The chest separates into two cases. The two-board sides of the upper case are dovetailed to the one-board top and bottom. The lower three horizontal backboards are nailed to the rabbeted rear edges of the case sides. The thicker, top backboard extends beyond the case sides and is nailed with large T-headed nails to the back edge of the cornice. The complex profile of the cornice is assembled from five separate walnut moldings glued to four pine blocks and mounted as a unit to the case. A 23½" long block beneath the case top reinforces the front cornice. The deeply coved frieze at the base of the cornice conceals a drawer. Dustboards are installed beneath the frieze drawer and the pair of small drawers in the top tier. The remaining drawers run on supports glued to guides which in turn are nailed to the case sides. Shallow drawer dividers (4¾" deep) rest on vertical blocks stacked behind the front pilasters and nailed to the case sides. Each pilaster is a two-piece, L-shaped unit nailed to the corners of the case. A double-arched bead cut on the edges of the case frame and pilasters surrounds the drawers.

The top of the lower case—a pine panel set into boards along the sides and front—is nailed to the joined frame. The construction of the frame conforms to that of cat. no. 17.

The drawer construction throughout the chest is similar. Thick, precise dovetails bind the front and back to the sides. The bottom is a single board set into dadoes in the front and sides and nailed to the back. The grain of the bottom runs perpendicular to the front on the small drawers, parallel to the front on the large drawers. The top edge of the sides is decorated with a double-arched bead, the top edge of the back has a pronounced chamfer, and the lower rear corner of each drawer has a slight chamfer. Deep gouges were cut into the back of each drawer front for the original brass hardware.

The high chest has had three major restorations. The first probably occurred during the early nineteenth century, the second between 1901 and 1909, and the third by Joseph Twichell of the SPNEA Conservation Center in 1989 and 1992. In the process, the cabriole portion of the legs has been replaced twice, the drops originally mounted to the front skirt were removed, and the hardware on the drawers has been changed four times. Over the years repairmen

have replaced the beaded strip nailed to the lower edge of the front skirt, almost half of the double-arched molding on the case façade, the left side of the top left drawer, and all of the drawer supports within the case except the medial support below the bottom middle drawer. In addition, they have filled shrinkage cracks throughout the case with splines, patched the well-worn lower edges of the drawer fronts, and added runners to the lower edges of all drawer sides.

Inscriptions: On the inside back of the upper case in old chalk: "Piscatqua / Taply / Capt Lible [or Libbe] house" and a line of illegible script partially hidden by the dustboard below the cornice drawer. On the outside back of the upper case, in modern yellow crayon, "Colston Leigh." Scratched into the top of the lower case and the outside back of the upper case, "#PR 18."

Materials: *Black walnut case sides, moldings, pilasters, drawer fronts, front edge of drawer dividers, front skirt and block behind center of skirt, and legs; *modern red oak drawer supports for end drawers in bottom tier of lower case; *eastern white pine for all other secondary work. Replaced brass hardware (copied from original handles and escutcheons on matching dressing table); replaced locks.

Dimensions: H. 74⅛; W. 47⁵⁄₁₆; D. 25½

Provenance: Acquired by the noted Providence collector and dealer Charles L. Pendleton (1846–1904); sold in 1905 by Pendleton's estate to G. G. Ernst of Norwalk, Conn.; offered for sale at the auction of the Ernst collection in 1926 but did not sell; offered again by Ernst's widow, Juliet Wyman Ernst, in 1945; purchased by Maurice Rubin and in 1951 sold at auction to Colston Leigh, an antiques dealer of Basking Ridge, N.J.; subsequently acquired by James Campbell Lewis of Cornish, N.H., and sold at the auction of the Lewis estate in 1971 to the donors.

Publications: Lockwood 1901, frontispiece; Lockwood 1913, 1:102; American Art Galleries, Jan. 20–23, 1926, lot 848; Parke-Bernet Galleries, sale 622, Jan. 11–13, 1945, lot 610; O'Reilly's Plaza Art Galleries, Dec. 8, 1951, lot 421; *Antiques* 100:1 (July 1971): 13; *Antiques* 108:3 (Sept.1975): 505; Monkhouse and Michie 1986, 32; Jobe 1987, 175; Conger and Rollins 1991, 84–85.

1. In two earlier publications, Jobe 1987, 187, and Conger and Rollins 1991, 84–85, I refrained from attributing this high chest to Davis because of insufficient evidence. The recent discovery of the signed high chest (*fig.* 28) as well as additional information about his career now make an attribution possible. Though veneered, the signed high chest displays the same construction techniques as the dressing table and is undoubtedly the work of the same craftsman. The chalk signature on both objects matches that on surviving accounts kept by the Portsmouth joiner, Joseph Davis; see Sherburne v. Godfrey, Mar. 3, 1736, docket 11254 and Seavy v. Davis, May 24, 1757, docket 08197, N.H. Provincial Court, State Archives.

2. Rockingham County court records alone refer to four Joseph Davises: one of Bedford, who drowned in Mar. 1751; another who worked as a brick mason in Chesterfield; a third, identified as a husbandman of Durham; and finally the Portsmouth furniture maker. Another contingent of Joseph Davises resided in the Amesbury-Salisbury area of northeastern Massachusetts.

3. Lovell 1974, 99. In her article, Lovell attributes the Davis dressing table to Boston on the basis of the receipt. Davis's removal to Portsmouth by 1734 and the survival of a related table with a history in the Piscataqua area (*cat. no. 17*) suggests instead a Portsmouth origin for the distinctive blockfront furniture made by Joseph Davis.

4. Davis apparently still resided in Boston in Mar. 1733, when he was sued by John Banks (Banks v. Davis, Apr. 1733 session, docket 284, Suffolk County Inferior Court of Common Pleas, Mass. State Archives). He had relocated to Portsmouth by Mar. 12, 1734, when he witnessed a note of obligation from another Portsmouth joiner, John Sherburne (Sherburne v. Godfrey, Mar. 3, 1736, docket 11254, N.H. Provincial Court, State Archives).

5. For record of Davis's tax payment, see Clark and Eastman 1974, 30.

6. Jeffry v. Davis, June 8, 1762, docket 3949, N.H. Provincial Court, State Archives.

7. Ibid.

8. Davis may have moved to Newbury, Mass. The word Newbury appears next to his name on the Portsmouth tax list of 1762, the last list on which he is recorded; see "A List of Town and Province Tax for the year 1762 for the Town of Portsmouth," Portsmouth City Hall.

9. Coit's well-known desk and bookcase of 1738 is illustrated and discussed in detail in Lovell 1974, 90–95, and Evans 1974, 213–22.

10. The small drawers of the Wendell family bureau table (*cat. no.* 5) retain reused handles that match those on the Davis dressing table. Perhaps a repairman saved the handles from the high chest when installing wooden knobs on it in the nineteenth century (see Lockwood 1901, frontispiece) and later reused the hardware on the bureau table.

11. The purpose of this unusual inscription is unclear. The circular elements of the P, R, and 8 are scribed with a compass.

12. For an illustration of the chest with its second set of legs, see Lockwood 1901, frontispiece.

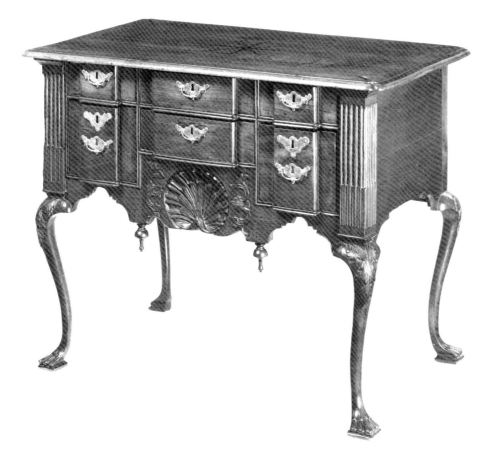

17

Dressing table

(Colorplate 4)
Attributed to Joseph Davis (w. 1726–62)
Portsmouth, New Hampshire
1735–50
Private collection

In 1901 Esther Singleton illustrated a distinctive blockfront dressing table (17A) in her classic work, *The Furniture of Our Forefathers*, and identified the owner as "Miss Sherburne, Warner House, Portsmouth, N.H."[1] Her home, the Warner House, was the brick dwelling built by John Drew for Archibald Macpheadris (*fig. 3*). After Macpheadris's death in 1729, the house passed to his daughter Mary, who married Jonathan Warner in 1760. Warner's niece, Mrs. Nathaniel Sherburne, next occupied the property, and for more than a century it remained in the Sherburne family. "The rooms," noted one visitor, "are filled with the furniture bought by successive generations."[2] By 1900, this table, the spectacular veneered high chest (*cat. no. 15*), and the library bookcase (*cat. no. 27*) had become venerable family relics in "one of the best-preserved old houses in the country."[3]

Like the preceding high chest, the Sherburne dressing table can be attributed to Joseph Davis because of its similarity to the table he signed (*fig. 29*). Once again, Davis failed to provide sufficient support for the massive case, and during the nineteenth century it was necessary to replace the legs.[4] Fortunately, a related example (*cat. no. 17*) survives intact to illustrate Davis's most ambitious work. Here Joseph Davis, perhaps assisted by a carver, applied a dazzling panoply of decoration: compass star and carrot-like inlays on the top, blockfront drawers crowded with brass hardware, stop-fluted pilasters, acanthus-leaf knee carving in high relief (18B), and an intricate double shell flanked by unusual leaf-carved borders at the center of the skirt. Davis's vocabulary of ornament reflects his training in Boston; nearly every

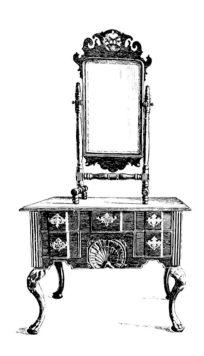

17A.

"Mahogany low case of drawers and mahogany looking glass." Dressing table: Portsmouth, New Hampshire, 1735–50. Looking glass: England, 1760–65. Illustrated in Esther Singleton's The Furniture of Our Forefathers *(1900–1901) 2:331. The looking glass originally hung on the wall but in the nineteenth century was mounted to a stand.*

motif has parallels in eastern Massachusetts furniture. Yet, no Boston cabinetmaker combined them all onto a single object.[5] Indeed, few pieces of American colonial furniture can rival the ostentation of this display.

The construction of the dressing table reveals several idiosyncrasies of Davis's work. He joined the frame in the standard manner but chose not to use pins to secure the joints. He did, however, pin the top to the frame. He fashioned the boldly curved legs from thick 3" pieces of stock. For three of the legs, he glued two boards together to create the necessary thickness, a practice that was also common in Boston cabinetry of this period. Within the case, he nailed thick drawer guides to the case sides and inserted large vertical partitions between the drawers (17B). To support the drawers in the upper tier, he glued pine strips to the guides and partitions but placed the lower tier on medial supports tenoned through the back and set into notches in the top edge of the front skirt.

When building the drawers, Davis adopted several distinctive techniques as well. To create a blocked façade, he glued a curved panel to each drawer front. He also cut pronounced chamfers at the rear corners of the drawer side and a slight chamfer along the rear corner of the back.

Davis's striking blockfront products were undoubtedly expensive in their day and were used in the homes of Portsmouth's wealthiest residents. Regrettably, not one of their original owners has yet been identified; this table's history extends back only to the nineteenth century.[6] Davis probably produced just a few of these distinctive case pieces. By the 1750s he had begun to concentrate on chairmaking. In 1762 he left Portsmouth, possibly for Newbury, Massachusetts, where his son worked as a chairmaker until 1803.[7] Nevertheless, his impact on Portsmouth cabinetmaking persisted for another half century, apparently through the work of one of his apprentices, as discussed in the next entry.

B J

Structure and Condition: The quarter-round edge of the two-board top is indented at the corners. The two-board case sides, one-board case back, and front skirt are tenoned to the legs. The pilasters, bases, and capitals are nailed to the upper portion of the legs. The acanthus-leaf carving ornaments the knees of all four legs. The deeply carved shell cuts through the skirt and into a walnut board behind it. Small rose-headed nails secure the original beaded strip to the case sides and lower edge of the skirt (except beneath the shell). Thick dovetails join each drawer front and back to the sides. The drawer bottom—one board with grain perpendicular to the front—is set into dadoes in the front and sides and nailed to the back. The top edge of the drawer sides is rounded.

The slender legs support a massive case and, not surprisingly, have sustained some damage. The left rear leg was broken at the knee long ago and has been repaired with two wrought iron straps and three new support blocks. The foot of the broken leg is missing its original pieced tip and is also chipped along its inside edge. The left front leg is cracked and missing its side knee bracket. The bracket for the left rear leg is replaced. Other repairs to the case are minor. The top of the case is now screwed to the frame. The drops are replaced. Nails reinforce some of the dovetails in the drawers. One of the drawers was lined with wallpaper in the nineteenth century.

Inscriptions: "J. E. SMITH" stamped into the top edge of the upper left drawer front; illegible chalk inscription on the inner surface of the left case side behind the drawer guide.

Materials: Black walnut top, sides, skirt, pilasters, drawer fronts, front edge of drawer dividers, and legs; unidentified stained wood for inlays in top; ash skirt bead; eastern white pine for all secondary work. Original brass hardware except for handles on end drawers in the lower tier; locks missing.

Dimensions: H. 30¼; W. 37½; D. 22⅝

Provenance: Possibly owned by Captain Joseph Richardson (1756–1824) of Durham; to his daughter Hannah Richardson Smith (b. 1789); to her son Joseph Edwin Smith (b. 1823), who stamped his name on a drawer of the table; to his first cousin Frances Richardson Treadwell (1833–1921), who gave the table to a Boston relative, Ruth K. Richardson; sold by Mrs. Richardson's niece to the present owner in 1971.

Publications: Ellis Memorial 1971, 18; Cooper 1980, 213; Fairbanks and Bates 1981, 114; Jobe 1987, 167–70.

1. Singleton 1900–1901, 2:331; an early photograph of the table appears in Morse 1902, 33.

2. Morse 1902, 127.

3. Ibid.

4. The present location of the Sherburne family table is not known. It presumably passed to an heir in 1930, when the contents of the house were distributed to family members. Though the table has not been examined, it undoubtedly had replaced legs by 1901. The thick, coarsely carved cabrioles depicted in the Singleton and Morse illustrations of the table (see note 1) differ noticeably from the original legs on the signed table and the one in this entry.

5. Jobe 1987, 166–67.

6. In 1971, the seller provided the present owner with a brief history of the table, noting that it had descended in the Richardson family of Durham to a Mrs. Treadwell, who gave it to Ruth K. Richardson of Boston. Genealogical information (Stackpole and Thompson 1913, 1:279, 342–43; 2:340) confirmed the history and helped to document the identity of the nineteenth-century owner who stamped the name J. E. Smith on a drawer; see *Provenance.*

7. See note 8, cat. no. 16. Davis's son Joseph, born in 1740, apparently departed with him in 1762 and later operated a shop at the corner of Milk and Lime streets in Newburyport; see Swan 1945, 225, and Benes 1986, 181.

17B.

Detail of case interior. Richard Cheek photograph.

18

Dressing table

Portsmouth, New Hampshire
1745–60
Collection of Mr. and Mrs. E. G. Nicholson

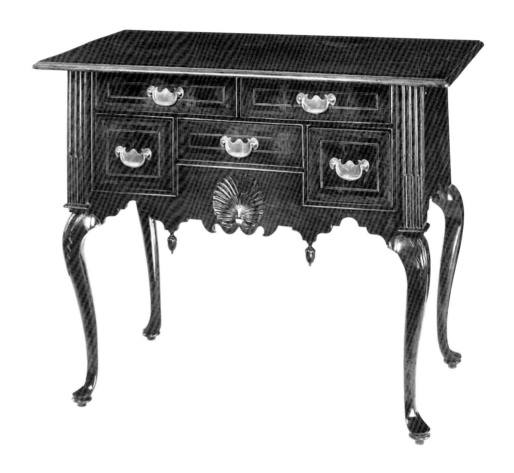

THIS STRIKING VENEERED DRESSING TABLE repeats many of the motifs seen on the preceding blockfront example. Stop-fluted pilasters, a double shell, acanthus carving, and an intricate skirt outline once again embellish an ambitious Portsmouth product.

Yet close inspection of the veneered table reveals the hand of someone other than Joseph Davis, the maker of the blockfronts. The handling of the carved details differs noticeably. The shell is shallower and more constricted, thus eliminating the need for the secondary walnut block that Davis mounted behind the skirt of his tables. The knee carving (18A) is an unusual adaptation of the V-shaped strapwork and acanthus on the previous table (18B). The craftsman chose to outline the leafage rather than delineate it. He also altered the pilaster design slightly. On the earlier table, the pilasters cover the upper portion of the legs. Here, the pilasters are narrower, with three flutes instead of four, leaving a sliver of the front legs exposed. Here also, the flutes extend to the top of the pilasters. The legs of the table display subtle variations as well. The S-curve of the cabriole is less pronounced, the ankles are thicker, and the feet rest on coved tips (18C) instead of a beaded disk.

The veneered table remains in excellent condition, with its original brass hardware and structural elements intact (18D) except for a break in the left front leg at the knee. An old chalk inscription, "£23," on the underside of a drawer may well refer to the original price of the table. The amount is consistent with the cost of fine case furniture in inflated Old Tenor currency at midcentury.

The table's importance lies not only in its quality and condition but also in its relationship to a group of thirteen pieces of case furniture made during the second half of the eighteenth century (*see cat. no.* 19). The group shares sufficient details of construction to attribute all to the same maker, an unknown artisan who probably trained with the builder of the blockfronts in the 1740s, then worked on his own in the Portsmouth area for the next fifty years.[1] His furniture documents the continuation of certain features from the era of the blockfronts. It also vividly demonstrates his acceptance over time of distinctive motifs that impart to his later pieces a character all their own.

B J

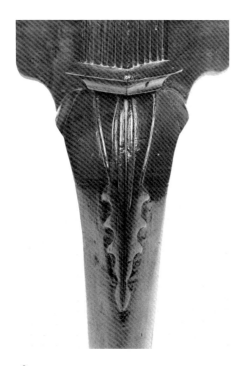 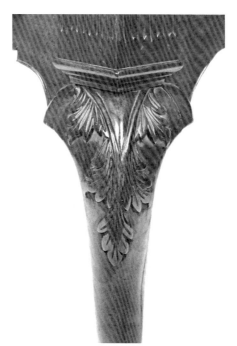

18A.

Detail of carved knee.

18B.

Detail of carved knee of cat. no. 17.

18C.

Detail of foot. Courtesy Christie, Manson and Woods.

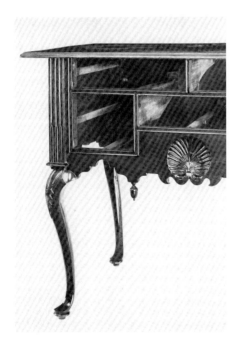

18D.

Detail of case interior.

Structure and Condition: The back and right side of the case are each a single board; the left side is two boards. The frame is joined in the standard manner with mortises and tenons, but no wooden pins reinforce the joints. The thin, two-board top is pinned to the frame. The skirt is chamfered along its lower edge; a beaded strip was never applied to the skirt. Sliding dovetails secure the shallow walnut drawer divider to the legs. A channel molding cut on the case frame surrounds the drawers. The pilasters are glued and nailed to the upper portion of the legs. Like the Joseph Davis dressing table (*cat. no.* 17), each rear leg is made of two boards glued together to create stock of sufficient thickness.

Triangular partitions separating the drawers in each tier are tenoned through the back and nailed into notches in the front skirt or divider (18D). The drawers in the upper tier slide on the top edge of the partitions for the lower tier. The drawers in the lower tier slide on medial supports, fastened in the same manner as the partitions. Drawer guides are glued to the case sides. Thick but precise dovetails bind the sides of each drawer to the front and back. The top edge of the sides is cut with a broad arched bead; the back has a pronounced chamfer. The drawer bottom—a single board with grain perpendicular to the front—fits into dadoes in the front and sides and is nailed to the back with rose-headed nails.

The table has had only one major repair: the left front leg was broken at the knee long ago and reattached with three screws. In addition, the drops and all of the knee brackets except the side brackets for the front legs are replaced. New pins now secure the top to the frame.

Inscriptions: "£23" in old chalk on drawer bottom; backs of small drawers numbered in old chalk, "X1," "X2," or "X3."

Materials: Black walnut top, sides, skirt, pilasters, channel molding, and legs; black walnut veneer on sycamore drawer fronts; light-wood stringing on case top and drawer fronts; eastern white pine for all other secondary work. Original brass hardware; never had locks.

Dimensions: H. 28⅞; W. 36¹⁄₁₆; D. 21⅞

Provenance: Sold by Israel Sack, Inc., in 1984 to a private collector; resold at Christie's in 1986 to the present owner.

Publications: Christie's, New York, Oct. 18, 1986, lot 516; Jobe 1987, 179–87.

1. A family memoir of the early twentieth century credits one of the objects in the group to John Demeritt (1728–1826) of Madbury, N.H.; see cat. no. 20. Contemporary evidence in support of the attribution has not been found; nevertheless Demeritt remains an intriguing candidate deserving of further research.

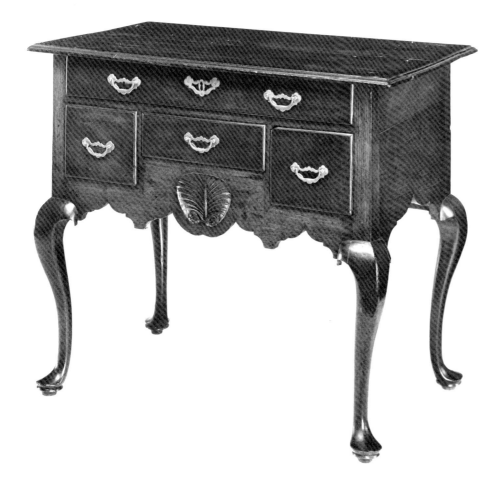

$\textbf{\textit{19}}$

DRESSING TABLE

Portsmouth or Dover, New Hampshire
1760–80
Private collection

IN PLAN AND CONSTRUCTION, this walnut dressing table resembles the preceding veneered example. The two tables illustrate the work of the same craftsman at different points in his career, with this example dating a decade or more after the previous one. Its original pierced hardware, knee bracket design, and drawer configuration (a single drawer rather than two in the top tier) are characteristic of furniture made after 1760.

The veneered table originated in Portsmouth. Its maker presumably trained with Joseph Davis there, then operated his own shop in the town for several years. Later in the century, he may have moved to Dover, an inland town twelve miles away. Like most joiners of his day, he undoubtedly performed a wide variety of tasks from housebuilding to hauling, from simple repair work to fine cabinetmaking. Judging from his surviving output, he served a sizable clientele. Five dressing tables, eight high chests, and one chest-on-chest can be attributed to his hand. These separate into three groups. The earliest example—the veneered table (*cat. no.* 18)—stands alone. A walnut high chest and four tables, including this one, form a second group.[1] The final seven high chests and the chest-on-chest document a later period of production that extended into the early years of the nineteenth century (*see cat. no.* 20).

Three of the five objects in the second group retain histories in the Dover area. One dressing table belonged to Temperance Pickering Knight (1730–1823) of Newington; another (19A) was apparently acquired by Samuel Hale (1718–1807), a

19A.

Dressing table. Portsmouth or Dover, New Hampshire, 1760–80. Black walnut and eastern white pine, H. 28¹⁵/₁₆; W. 34⁷/₈; D. 21½. The Currier Gallery of Art, Manchester, New Hampshire, gift of Miss Elizabeth Frost, 1966.2. The owner's name "S. Hale" is written in old chalk on the bottom of the middle drawer.

schoolmaster of Dover and later Portsmouth; and a high chest, which descended in another Dover family, remains in the town on view at the Woodman Institute.[2] The Hale table varies only slightly from the one featured here. Both display the same unusual palm-like shell, related skirt outlines, and thick cabrioles. Their minor differences express the individuality of a maker continually tinkering with his standard designs.

Though the ornament on his furniture might vary, the construction techniques used by this maker remained remarkably consistent. This table is the best preserved in the group and serves as an ideal document of his methods during the third quarter of the eighteenth century.[3] Like his other dressing tables, it is joined with mortise-and-tenon joints secured with small nails instead of pins. The thin ½" top is pinned to the frame and finished on all four sides with a narrow quarter-round edge. Each leg is formed from a single piece of 3" stock. The legs are sturdy cabrioles with broad knees and distinctive round feet resting on coved tips identical to those on the veneered dressing table (18c). Each front knee bracket features a spur along its inside edge—a detail also seen on eastern Massachusetts tables.[4] Gothic arches embellish the front and side skirts. The contour of each arch is slightly askew, an unusual feature that reappears on the convex curves beneath the shell. Drops originally flanked the carved shell.

The maker of these dressing tables constructed the drawers and their supports within the case in an efficient manner with a modicum of materials (19B). The drawer divider measures only 1⅜" deep, and the drawer partitions are barely 1" thick. Sliding dovetails secure the divider to the front legs and bind the partitions to the divider. The lower end of each partition fits into a diagonal notch in the skirt. Roughly cut strips of pine nailed to the case sides serve as guides for the drawers. Each drawer slides on two supports tenoned into the back of the case and set into slots in the skirt (for the lower tier of drawers) or the divider (for the upper tier). In his blockfront dressing table, Joseph Davis installed both medial and side supports (17B). His presumed apprentice used medial supports for his veneered table but switched to side supports for all of his later work. The decision followed the trend of the times. In New England, the typical drawer arrangement on a high chest or dressing table had become a single long drawer over three small drawers. Side supports were far more practical in such situations.

Thick, well-cut dovetails bind the sides of each drawer to its front and back. The bottom is set into dadoes in the sides and front and nailed to the back with rose-headed nails. A broad arched bead decorates the inner half of the top edge of the sides; pronounced chamfers are cut along the top edge of the back and lower rear corner of the sides. Many of these same structural features appear on the veneered dressing table and relate to those on Joseph Davis's blockfront cases as well, lending support for the theory that Davis trained the maker of the distinctive walnut dressing tables shown here and in the preceding entry.

B J

19B.
Detail of case interior of cat. no. 19.

Structure and Condition: The table retains all of its original elements as well as an old worn finish. The skirt is cracked. Two butterfly patches have been added beneath the top to pull the two boards of the top together. The left side of the top drawer is cracked and the dovetail joints are now loose.

Inscriptions: "V" in old chalk on most drawers; illegible chalk inscription on the underside of the top.

Materials: *Black walnut case top, sides, front skirt, drawer divider and partitions, drawer fronts, legs, and knee brackets; *eastern white pine for all secondary work. Original brass hardware; lock for top drawer is missing; other drawers never had locks.

Dimensions: H. 29¹/₁₆; W. 34¼; D. 20⅝

Provenance: John Walton, Inc.; to Mr. and Mrs. Hugh B. Cox; sold at Christie's in 1984 to the present owner.

Publications: Christie's, Collection of Mr. and Mrs. Hugh B. Cox, June 16, 1984, lot 414; Jobe 1987, 182–87.

1. Jobe 1987, 181–90, discusses the four dressing tables in detail; the high chest is owned by the Woodman Institute in Dover and has never been published.

2. Temperance Knight was the wife of John Knight (d. 1770), who operated a ferry between Newington and Dover Point. For information on Hale, see *Sibley's Harvard Graduates,* 10:497–501.

3. Much of the information on the construction of the dressing table is taken from Jobe 1987, 182–85.

4. Jobe and Kaye 1984, 278–79.

 20

HIGH CHEST OF DRAWERS

Portsmouth or Dover, New Hampshire
1785–1805
Private collection

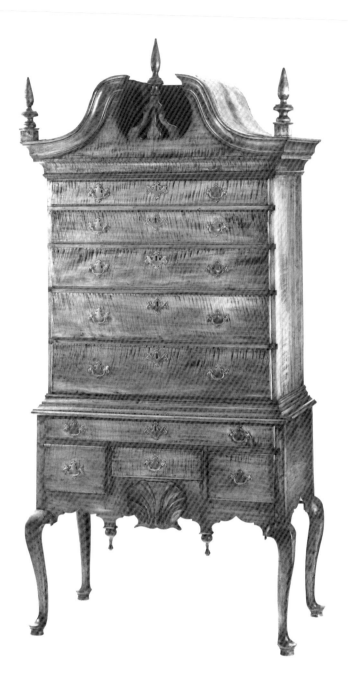

THE DEMERITT FAMILY has long been prominent in Madbury, a village adjacent to Dover. In 1929, Jennie DeMerritt chronicled the history of the family home and career of its most illustrious occupant, Major John Demeritt (1728–1826). His fame rested largely on his militia activities at the outbreak of the American Revolution. In December 1774 British troops set out from Boston to remove munitions from Fort William and Mary at the mouth of the Piscataqua River in New Castle. Aware of the scheme, local citizens acted first. Demeritt joined a group from Durham who seized much of the material and stored it at his farm until the following June, when "family tradition relates it was carried to Bunker Hill by him in an ox-cart, arriving in time to be of use to our forces there in the battle."[1] His exploits earned him the informal title of "Powder Major" and led later generations of the family to preserve any memento of his life, from household diaries to handsome furniture.

Of the surviving objects owned by the Powder Major, this high chest stands out as the most ambitious. It is described as a "high case of drawers" in the 1826 inventory of his estate and valued at $8, the highest sum for any piece of furniture other than the beds.[2] Six related chests by the same maker survive, but none feature

the ornate moldings (20A and B) or striking pierced pediment seen here.[3] In its original form, the pediment was even more dramatic than it is today.[4] During the late nineteenth century, a workman affixed the hood and backboard to what had been a sham pediment. The maker of the chest had merely attached a scrolled façade and moldings to a flat-top case and added a horizontal architrave to emphasize the division between the pediment and upper case. Historically, the sham pediment was a less expensive alternative to the enclosed version.[5] Here, the sham pediment offered a visual advantage as well. The pierced detail became a more dominant feature without a hood, casting vivid shadows against the wall.

The lower case of John Demeritt's high chest has much in common with the dressing table in the preceding entry. Both feature the same drawer arrangement, similar skirt outlines, an unusual shell in the center of the skirt, and coved tips beneath the round feet. The two cases share many structural details as well. They have nearly identical drawer guides, supports, and partitions, and the drawers themselves correspond. Even the treatment along the top edge of the drawer linings matches: a broad arched bead on the sides, a pronounced chamfer on the back. Both cases are undoubtedly the product of the same artisan. But, the high chest is a far later example of his work. Cut nails, rather than forged nails, secure the case back to the frame, proof that the chest was made after the introduction of nailmaking machinery in the late 1780s. The chest could have been built as late as 1805, near the end of the career of the craftsman responsible for an uncommon group of case furniture.

Though his identity remains a mystery, a suggestive clue appears in Jennie DeMerritt's family memoir. She notes that John Demeritt was "something of a mechanic" and credits the high chest to "the handiwork of this workman, who could build and construct as well as fight."[6] His shop, located near the entrance to the family farm, contained "tools for the making of furniture for the house and for neighboring houses, perhaps."[7] Indeed Simon Randall, the owner of an adjacent property, acquired a related high chest built by the maker of the Demeritt chest.[8] To date, corroborating evidence of Demeritt's work as a furniture maker has not been found. Several documents, however, do substantiate his skills at fine carpentry. In 1760 he was hired by the town of Madbury "to fit up the Personage house so as to make it tolerable Comfortable"; a decade and a half later he oversaw the repair of the meetinghouse.[9] By 1811 he had taken down his shop; his probate papers refer to him only as John Demeritt, Esquire (the result of having served as a justice of the peace for many years), and make no mention of tools or cabinetwork.[10] Nor is there any record of his having resided in Portsmouth, where he might have trained with Joseph Davis. For now, Jennie DeMerritt's attribution remains an intriguing possibility, worthy of further research.

BJ

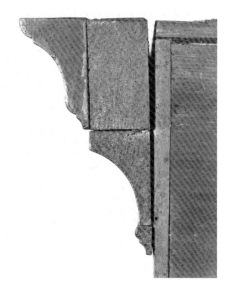

20A.

Detail of cornice molding.

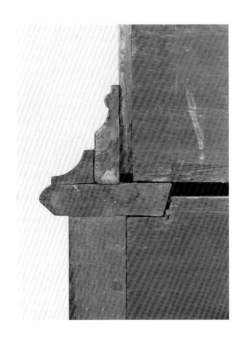

20B.

Detail of waist molding.

Structure and Condition: The chest separates into two sections. The one-board sides of the upper case are dovetailed to the two-board top and bottom. The cornice consists of three curved maple moldings backed by a pine block (20A). The case back—four horizontal lap-jointed boards—is nailed to the rabbeted edge of the case sides with cut nails. The finial plinths are glued to the cornice, and the caps are nailed to the plinths. The one-piece turned finials are secured with round tenons. Shallow (2¼" deep) drawer dividers are fastened with sliding dovetails that project through the case sides. The drawer supports are fastened in an unusual manner. The front edge of each support is tenoned into the drawer divider; the back edge is nailed to the case side. The lipped edges of the drawer fronts serve as stops for the drawers. The waist molding separates into two sections (20B): the upper section is nailed to the upper case, the lower L-shaped section consists of a narrow cove nailed to a broad rail, which in turn is pinned to the lower case. Two slats, mounted beneath the bottom of the upper case and nailed to the inner surface of the upper case sides, serve as major structural supports for the upper case. They rest on the broad lower rail of the waist molding.

The one-board sides and two-board back of the lower case are tenoned to the legs; each joint is fastened with four wooden pins. Two pins secure each mortise-and-tenon joint binding the front skirt to the legs. The construction of the shallow drawer divider and partitions conforms to that of cat. no. 19. Each knee bracket is glued and fastened to the case with a single nail. The coved disks beneath the round feet rest on thick turned pads.

The chest has had only one major alteration: the hood was enclosed in the late nineteenth century. The finials, though evincing considerable age, may be replacements. All remaining elements, including the knee brackets and drops, are original. The chest retains an old red stain beneath a crackled varnish.

Inscriptions: "Bottom" in chalk on the bottom of the upper case.

Materials: *Soft maple side finials and plinths, pediment, cornice and waist moldings, case sides, drawer dividers and partitions, front skirt, legs, drops, and drawer fronts; mahogany center finial; *eastern white pine for all secondary work. Original brass hardware; original iron locks in lower four drawers of upper case; original wooden spring lock in top drawer; the drawers in the lower case never had locks.

Dimensions: H. 88⅜; W. 41; D. 22

Provenance: Descended with the home of John Demeritt (1728–1826) to his son John Demeritt (1762–1846); to the younger John's son Hopley Demeritt (1792–1834) and his wife Abigail (Snell) Demeritt (1794–1885); to their grandchildren John DeMerritt (1856–1934) and Jennie DeMerritt (1863–1936), the author of the family genealogy, who sold the house and its contents to the parents of the present owners.

Publications: Jobe 1987, 185, 189–92.

1. DeMerritt 1929, 7. The author is grateful to Nancy Goss for her assistance with this entry.

2. John Demeritt, 1826 inventory, 33:293, Strafford County (N.H.) Probate. For more on this campaign, see Chase 1963, 20–34.

3. Five of the six related high chests have flat tops but are otherwise identical to this example. Three were advertised in *Antiques* 75:1 (Jan. 1959):12; 113:1 (Jan. 1978): 9; 125:3 (Mar. 1984): 619; another once belonged to John Walton, Inc. (Jobe 1987, 188); the fifth was sold by Skinner, Inc. (sale 1265, June 10, 1989, lot 146). The final chest also has a flat top but lacks a shell and features a different skirt outline. It matches the Demeritt chest in construction and belonged to Demeritt's neighbor, Simon Randall. The Randall chest is privately owned and has never been published. The only known case piece with a similar pierced ornament at the center of the pediment is a chest-on-chest sold at auction in 1981. It has never been examined by the author but does appear to be the work of the maker of the Demeritt high chest. See Sotheby's, sale 4692Y, Sept. 26, 1981, lot 394.

4. Much of the information on the construction of the pediment is taken from Jobe 1987, 191.

5. Jobe and Kaye 1984, 210–12.

6. DeMerritt 1929, 7.

7. Ibid., 3.

8. See note 3.

9. See references to Demeritt on Apr. 16, 1760 (p. 23), and June 24, 1776 (p. 94) in the Madbury Town Clerk's Records, 1755–1806, bound compilation of manuscript records, Madbury Town Hall.

10. A bill of 1811 for pulling down the shop is privately owned. Demeritt's inventory is cited in note 2; for his will (written on Nov. 10, 1814, and recorded on Feb. 3, 1826), see 34:7, Strafford County (N.H.) Probate.

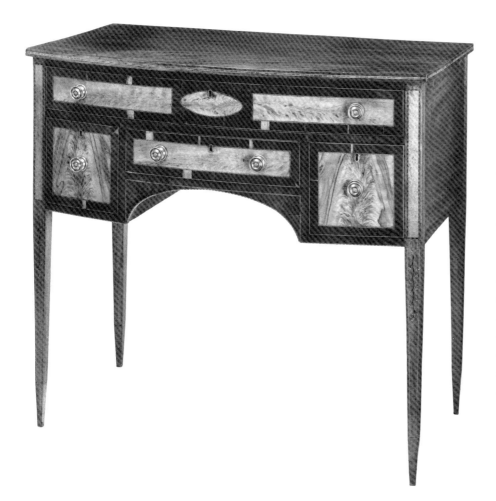

Dressing table

(Colorplate 5)
Attributed to Judkins and Senter (w. 1808–26)
Portsmouth, New Hampshire
1805–15
Rundlet-May House
Portsmouth, New Hampshire
Society for the Preservation of New England
Antiquities, gift of Ralph May, 1971.985

THIS HANDSOME FORM, frequently called a server or small sideboard today, served as a dressing table in the early nineteenth century. It provided a decorative home for such personal items as combs, jewelry, handkerchiefs, caps, ribbons, and cosmetics. Like its baroque and rococo predecessors, the table resided in a bedchamber but without its larger colonial companion—the high chest. The "North West Chamber" of John Peirce's elegant neoclassical mansion in Portsmouth reflected the fashionable arrangement of the day: a high-post mahogany bedstead with "copperplate" curtains, an easy chair slipcovered in a matching copperplate textile, eleven mahogany chairs, a night table, a washstand, a gilded looking glass, and "1 mahogany Dressing Table," appraised at what was in 1815 the considerable sum of $20. Of all the furniture in the room, only the bed had a higher value.[1]

This dressing table retains a lengthy Portsmouth history and closely relates to three others, which descended in the Treadwell, Rundlet, and Marvin families of Portsmouth.[2] All feature bowed fronts (known in the period as "sweep" fronts), arched skirts, identical drawer arrangements, and dazzling displays of contrasting veneers and inlays. On this example, flame birch, bird's-eye maple, and five different inlays ornament the mahogany frame (21A). Inlaid vines with floral sprigs enhance the narrow double-tapered legs. The sprigs were an alternative to the more typical bellflower-and-dot pattern seen on many tables (60B).

Similarities in construction (21B) link this table and the Marvin example. On both, the case sides and top are solid mahogany instead of veneer. The sides and

back are tenoned to the legs. Eight screws fasten the top to the frame. Broad pine drawer guides are nailed to the case sides, and two-board partitions separate each drawer in the lower tier. The front of each end drawer is made of solid mahogany veneered with mahogany and birch, but the core of the upper and middle drawer fronts consists of laminated strips of pine.

Such consistencies indicate the work of a single shop, probably that of Judkins and Senter (w. 1808–26). The dovetailing and drawer assembly duplicate that in the secretary (*cat. no. 33*) made by the firm for Jacob Wendell in 1813. On the drawer bottoms, for example, a continuous strip of pine is glued to the bottom along the lower edge of the drawer sides. Kerfs are sawn in the strip to create a series of blocks, and the back edge of the strip is cut off at a 45-degree angle (33E).

The four bowfront dressing tables with Portsmouth provenances document the popularity of the form along the Piscataqua and tie a half-dozen tables without histories to the region.[3] None exceeds this example in quality. Its striking veneers, distinctive inlay, and delicate legs make it a masterpiece of federal design.

ARH

21A.

Detail of drawer front and right front leg.

21B.

Detail of case interior.

Structure and Condition: The front rails and drawer divider are 3⁵⁄₁₆″ deep pine boards faced with mahogany veneer. Each drawer partition is made of two boards. The front board is tenoned through the drawer divider with two tenons and fastened to the lower front rail with a sliding dovetail; the rear board is tongue-and-grooved to the front board and mounted into a slot in the case back. The arched front skirt is backed by a vertical glue block in each corner and a series of four horizontal blocks. All drawers run on supports nailed either to the partitions or the drawer guides. Drawer stops are glued to the back of the case.

The table is in excellent condition. The top has been scraped and refinished. In 1983 the SPNEA Conservation Center replaced minor losses in the stringing and a triangular chip in the lower right corner of the arched skirt.

Inscriptions: Roman numerals—"I, II, III, IV"— are stamped with a chisel into the legs at the joints with the case sides. The initials "H•J" are stamped into the base plate of the brass knobs.

Materials: *Mahogany case sides, legs, and top; mahogany and birch veneer on drawer fronts; bird's-eye maple veneer on front legs; *eastern white pine for all secondary work. Original brass hardware and iron locks.

Dimensions: H. 34⅝″; W. 36⅞″; D. 20⅜″

Provenance: Acquired by James Rundlet May and his wife, Mary Ann Morison May, of Portsmouth sometime between 1881 and 1918; inherited by their son Ralph May (1882–1973) and donated as part of the furnishings of the Rundlet-May House in 1971. The early history of the table is unclear. Ralph May noted in one account that it belonged to his great-grandfather, Portsmouth merchant Samuel Lord (1788–1871), but on another occasion stated that "my father bought it and gave it to Aunt Lizzie [Elizabeth W. Morison, James Rundlet May's sister-in-law]."[4]

Publications: Lockwood 1913, 1:143; Sander 1982, 57.

1. John Peirce, 1815 inventory, old series, docket 8909, Rockingham County (N.H.) Probate.

2. The Treadwell table is owned by the Portsmouth Historical Society and illustrated in *Decorative Arts* 1964, no. 65; the Rundlet table (1971.681), acquired by James Rundlet in about 1810, remains in the Rundlet-May House and is owned by SPNEA. The Marvin table is in a private collection. It was acquired by William E. Marvin (1872-1938) shortly after he purchased the Langley Boardman house in Portsmouth in 1900 (*see cat. no.* 107). The table differs from cat. no. 21 in only two details. It is slightly larger in size and is supported by turned legs, matching those on cat. no. 23, rather than tapered legs.

3. The six examples include a tapered-leg table sold at auction (Sotheby's, sale 5551, Jan. 28–29, 31, 1987, lot 1244); three others with tapered legs at the Winterthur Museum (Montgomery 1966, no. 335), Museum of the Rhode Island School of Design (Monkhouse and Michie 1986, no. 33), and Metropolitan Museum of Art (misattributed to John Seymour of Boston in Stoneman 1959, no. 178); and two tables with reeded legs advertised by Israel Sack (*Sack Collection*, 5:1181; 8:2093). A seventh example, with reeded legs, may also be of Portsmouth origin (Parke-Bernet, sale 1039, Feb. 12, 1949, lot 153).

4. Stokes 1985, 21–23.

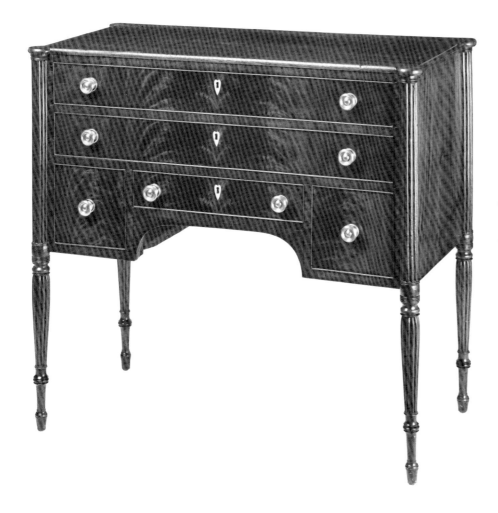

🌿 *22*

DRESSING TABLE

Attributed to Judkins and Senter (w. 1808–26)
Portsmouth, New Hampshire
1810–20
Private collection

ONE ALTERNATIVE TO THE BOWFRONT DRESSING TABLE (*see cat. no.* 21) is found in this unusual and commodious example. The design, which is rectangular with ovolo corners, displays two long drawers, instead of the more typical arrangement of a single long drawer, above three smaller ones. Only one other example features this three-tiered drawer plan.[1] It too has heart-shaped escutcheons of bone on the large drawers.

Design features and construction details of this table suggest that it was made in the local workshop of Jonathan Judkins and William Senter (w. 1808–26). A pair of card tables (*cat. no.* 64) purchased from this partnership by the merchant Jacob Wendell (1788–1865) has tapered and reeded legs as well as round spade feet that closely resemble those on the dressing table. Moreover, a painted dressing table, also acquired by Wendell from Judkins and Senter, has the same distinctive foot (*fig.* 48). The drawer construction of another Wendell item, the documented secretary of 1813 (*cat. no.* 33), matches that of the dressing table. On both, saw kerf overruns for the dovetails are visible on the drawer sides, and the cockbeading on the side edges of the front cover two-thirds of the dovetails (33D). In addition, continuous pine strips, sawn into small blocks, are glued along the lower inside edges of the drawer sides.

Many of these same structural features appear in the preceding bowfront dressing table (*cat. no.* 21). Though differing dramatically in design and woods, both apparently originated in the shop of Judkins and Senter. Together, they vividly illustrate the range of patterns offered by this prolific establishment.

A R H

Structure and Condition: Each case side—a single pine board with horizontal grain veneered with matched vertical flitches of mahogany—is dovetailed to the one-board case back. Pine posts are glued to the front corners of the case. The shallow (2⅜") front rails and drawer dividers are made of pine boards faced with mahogany veneer. The dividers are tenoned to the front posts; the rails beneath the case top and end drawers are fastened with sliding dovetails. Four screws secure the one-board top to the case. The front and rear legs continue upward to form columns at the corners of the case. The columns are notched to receive the case, and three cut nails are driven through the case into the columns. The partitions between the drawers in the bottom tier extend to the back of the case. Each partition is two boards, installed similarly to those in cat. no. 21. The drawers run on supports glued to the partitions or the drawer guides; drawer stops are glued to the back of the case. There is no case bottom beneath the lower middle drawer. Pine bottoms, fastened with glue blocks, back the rails beneath the end drawers.

The drawer construction parallels that of cat. no. 33. This dressing table retains all of its original elements but two missing drawer stops. Its surface has recently been refinished.

Materials: Mahogany top and legs; mahogany veneer on sides, dividers, skirt, and drawer fronts; eastern white pine for all secondary work. Original brass knobs and unusual heart-shaped bone escutcheons; original iron locks in upper two drawers.

Dimensions: H. 36¾; W. 39; D. 19½

Provenance: Descended in the Wentworth and Kimball families of Portsmouth to Dr. Shields Warren, Newton, Mass. Purchased by the present owner in 1982.

1. Sotheby's, sale 4835Y, Apr. 3, 1982, lot 258. This dressing table differs only in its hardware, substituting wooden knobs for brass ones.

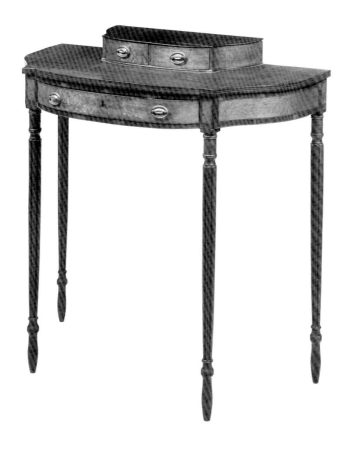

DRESSING TABLE

Portsmouth, New Hampshire
1805–20
Collection of Carl and Brenda Stinson

DRESSING TABLES came in a variety of shapes (*see cat. nos.* 21-22), but the elliptical form, with its sinuously curved lines, achieved substantial popularity in early nineteenth-century Portsmouth. This elliptical table boasts contrasting veneer of highly figured bird's-eye maple outlined by mahogany banding, which has bright dashes of yellow sapwood throughout. More subdued mahogany appears on the top and in the legs. Moreover, it survives in nearly original condition, retaining the diminutive stamped brass hardware manufactured by the partnership of Hands and Jenkins (*see cat. no.* 10). Only one other closely related dressing table is known, but it lacks a history of ownership.[1]

The original owner of the bird's-eye-maple-veneered example left his brand, "O. BRIARD," on it. Oliver Briard (b. 1775), son of Captain Samuel Briard,[2] was a merchant who owned a dry-goods store in Portsmouth as early as 1802.[3] He appears to have been a successful retailer of moderate wealth. In 1807 he paid a tax of $33.18, while fellow merchant James Rundlet paid $84.06. By 1817, his tax payment had increased slightly to $42.78, but Rundlet's share jumped to $376.09, suggesting that Briard remained a modest trader throughout his career.[4] He left Portsmouth after 1830, possibly for Boston, where his son resided as well as a relative, John Noble, whose name is inscribed on the table.[5]

The design of the Briard table recalls many contemporaneous examples from Salem, Massachusetts (*see* 62A) . A table that comprised part of the original furnishings of the Nathaniel Hooper House in Marblehead, Massachusetts (23A), is similar in form, if not in surface treatment, to the Portsmouth example. While the latter is alive with contrasting color and pattern, the Salem table presents a more stately appearance, through the exclusive use of richly figured mahogany.

23A.

Dressing table. Salem, Massachusetts, 1805–20. Mahogany, H. 39³⁄₄; W. 36; D. 17¹⁄₂. Private collection. Courtesy, Israel Sack, Inc.

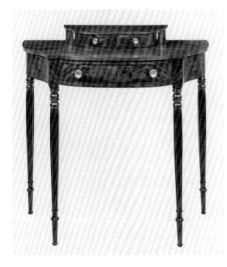

23B.

*Dressing table. Portsmouth, New Hampshire, 1805–20. *Mahogany and mahogany veneer, *birch, and eastern white pine, H. 35⁵⁄₈; W. 36³⁄₁₆; D. 17¹⁄₂. Rundlet-May House, Portsmouth, New Hampshire, Society for the Preservation of New England Antiquities, gift of Ralph May, 1971.645.*

Portsmouth workshops also offered elliptical dressing tables with mahogany as the primary wood. The Portsmouth entrepreneur Samuel Lord (1788–1871) owned one example (23B). Here, the craftsman selected subtly grained mahogany for the surface treatment but varied the leg design slightly, using flattened ball feet and a bulbous double baluster and ring turning in the capital.[6] This mahogany version of the elliptical dressing table represents the more typical Portsmouth interpretation of the form.[7]

D C E & A R H

Structure and Condition: All rails are tenoned to the legs with one exception: the front end of the side rails is glued against the outside surface of the front legs and reinforced with a single vertical support block. The veneer on the top covers a large pine board with diagonal cleats. Seven screws originally secured the top to the frame. Partitions for the drawer in the dressing table fit into dadoes in each front leg and the rear rail. A single cut nail is driven through the rear rail into each partition. A drawer support and guide is glued and nailed with cut nails to each partition.

The drawer in the dressing table is joined with dovetails of average quality. Slight saw kerf overruns for the dovetails are visible on the drawer sides. The drawer front consists of two laminated pine strips set one on top of the other and veneered. The drawer bottom is a single board, with the grain running parallel to the front, which is glued into dadoes in the drawer sides and front and nailed at the back with three cut nails. A series of butting blocks is glued to the drawer sides and underside of the bottom. Hand-saw marks are visible on the underside of the bottom. Each small drawer conforms in construction to the large drawer, except that the fronts are made from a single board, which is veneered, and the underside of the bottom is planed.

The dressing box is glued and nailed together. The top and bottom are made of solid mahogany; the sides are veneered. The sides of the box, measuring only ¹⁄₂" wide at the back, are thinner than on comparable boxes on other dressing tables. A shallow (1³⁄₄") partition separating the two drawers in the box is double tenoned to the top and bottom. Nails fasten the box to the table.

The table is in a remarkable state of preservation, retaining virtually all of its original support blocks, stops, and guides, as well as an old crazed finish. Minor damage includes a 4" split in the top above the left front leg and a noticeable warp along the front edge of the top.

Inscriptions: "O. BRIARD" is branded once beneath the bottom of the long drawer and twice beneath the top of the table. "John Noble / Boston Massechus [?] / September 26 1831 / Delta [?]" appears in ink on the underside of the bottom of the right drawer in the box. "OB / 1821" is incised twice on the back of the box and written in modern pencil on the bottom of the left drawer of the box. "H•J" is stamped on the bail of the brass handles.

Materials: Mahogany legs and top and bottom of the dressing box; mahogany veneer on table top and upper and lower front rails; bird's-eye maple veneer panels on all rails, drawer fronts, and sides of dressing box; birch upper and lower front rails; maple partition between drawers in dressing box; eastern white pine for all other secondary work. Original brass hardware and original iron lock in the dressing table drawer.

Dimensions: H. 36¹⁄₄; W. 35¹⁄₂; D. 17¹⁄₂

Provenance: Owned by Oliver Briard (b. 1775). Purchased at auction from a Portland, Me., estate by Robert Foley in June 1991; purchased from Northeast Auctions by the present owners in Aug. 1991.

Publications: Northeast Auctions, Aug. 3–4, 1991, lot 588; Hewett 1991, 12a–13a.

1. See Parke-Bernet, sale 2002, Dec. 1–3, 1960, lot 694. The form, legs, and surface treatment appear identical. The only variation is in the dressing box, which features only one drawer, and the brasses.

2. "Record Books of the First Church" 1918, 2a:456.

3. In the *United States Oracle*, Jan. 25, 1803, Briard thanked "his fellow citizens who assisted him in removing the greatest part of his stock of European and Household Goods, both exposed by the late fire in Market-Street on Sunday Dec. 26, 1802," and announced the re-opening of his business on Congress Street.

4. Portsmouth Tax Lists, 1807 and 1817, Portsmouth City Hall. The taxes were on his real estate and stock-in-trade.

5. Oliver Briard married Sally Noble in 1800; see *New Hampshire Gazette*, Nov. 11, 1800. The *Boston Directory* for 1831 lists only one John Noble, a cartman who lived at 49 Hanover Street, but no Briards. The 1834 edition lists "Briard (Oliver, Jr.) & Tolman (Joseph A.), dry goods, 307 Washington. B. boards 25 Summer."

6. The Portsmouth Historical Society owns a worktable with identical legs, while a chest of drawers in the Rundlet-May House (*cat. no.* 14) has the same cylindrical foot terminating in a small knob.

7. Related dressing tables include one marked "M M Salter / Greenland / N.H." owned by the Portsmouth Historical Society; a second sold at Skinner, Inc., sale 1362, Jan. 12, 1991, lot 124; and a third owned by Bernard and S. Dean Levy, Inc., that descended in the Marvin family of Portsmouth.

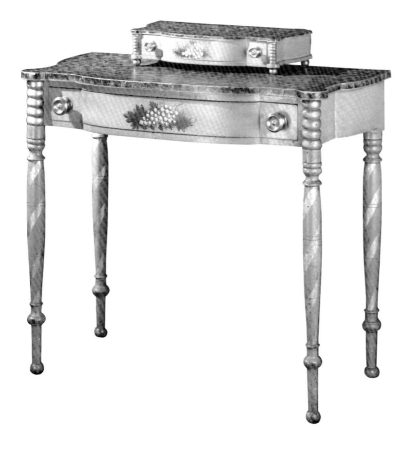

❦ *24*

Dressing table

(Colorplate 6)
Portsmouth, New Hampshire
1815–25
Abby Aldrich Rockefeller Folk Art Center
Williamsburg, Virginia, 74.2000.2

ALTHOUGH RELATED TO THE CLASSIC elliptical-shaped dressing tables popular in early nineteenth-century Portsmouth (*see cat. no. 23 and fig. 48*), this slightly later example features larger-scale parts arranged and decorated in a bold new way. The table is rectangular with an elliptic front, half-elliptic sides, and ovolo corners, a form also common to card tables (*see cat. nos. 63 and 64*). The thick ring-turned colonnettes supporting the ovolo corners of the top convey a more massive design approach, as do the thick tapering legs and the overall breadth of the case.

The form is enhanced by gaily painted surface decoration, which was executed by a specially trained painter and gilder such as Henry Bufford or Samuel Beck. In 1812, Beck offered "to give general satisfaction in painting and gilding Standards, Signs, window Cornices, Chairs, Dressing Tables, Stands, Desks, wash Stands."[1] Only an expert craftsman could have conceived and executed this remarkably vibrant decorative scheme. A shade of light blue covers the legs, frame, and dressing box, while a deep blue mottled pattern covers the top. This densely figured design was probably achieved through the use of sponges or putty. The central decorative motif, a cluster of grapes, is stenciled and then enhanced by freely painted lining. Even the legs are alive with the rhythmic movement of gilded spiral stripes. Ornately painted tables such as this one provided the consumer with a less expensive alternative to those finished in mahogany or even birch veneer. Plainer painted versions were also available, indicating that the furniture market in Portsmouth offered something for almost every household.[2]

A dressing table such as this would have brightened even the darkest bed-chamber. This may be what appealed to the Portsmouth merchant Abraham Wendell (1785–1865), when he bought it for his house on Pleasant Street. Thomas Sheraton described a dressing table as "so constructed as to accommodate a gentle-man or a lady with conveniences for dressing."[3] Perhaps Wendell used it himself, al-though it is more likely that his wife, Susan Gardner, or a daughter claimed the dressing table for herself. In 1840, financial troubles compelled Wendell to take out a mortgage on his house as well as much of its contents, including one "Dressing Table" and three "Toilet Tables."[4] This table must have been one of those mort-gaged. Fortunately Wendell redeemed it, and his heirs kept it in the family for an-other hundred and thirty years, ensuring its survival as the most outstanding piece of painted furniture from Portsmouth.

D C E

Structure and Condition: The rear rail is tenoned to the rear legs. Each side rail consists of a straight board nailed to a bowed block. The block is tenoned to the rear leg; the straight board is tenoned to the front leg. The drawer guides are glued to the straight portion of the side rails. The upper and lower front rails are dovetailed to a block glued to the inner face of each side rail. The one-board top is secured to the frame by means of screws affixed to the front, side, and rear rails. A medial brace beneath the top is tenoned into the rear rail and set into a dovetail-shaped slot in the front rail. The one-board top and bottom of the dressing box are nailed to the thick one-board sides. The gilded ball feet are round-tenoned into the table top.

The large drawer is joined with dovetails, which are neat and precise in execution. The drawer front consists of three boards: a bowed outer one glued at either end to straight boards. The bot-tom—three boards with grain parallel to the front—fits into dadoes cut into the front and sides and is nailed to the back. The small drawer conforms in construction, but the front is made from one board, and the bottom is glued to the rabbeted edges of the front and sides and nailed to the back.

The table remains in excellent condition, with the original decoration intact. The varnished surface has yellowed over time, giving the blue decoration a green cast.

Inscriptions: In old chalk beneath the top: "5=10.../ 1=6 wc / 1 = 26 deep at" and "6=3½ / 2=8."

Materials: Eastern white pine. Original brass hardware.

Dimensions: H. 36⅛; W. 36⅞; D. 18⁵⁄₁₆

Provenance: Abraham Wendell (1785–1865); to his daughter Vallina Wendell Peterson (1827–1911) of Brooklyn, N.Y.; to his granddaughter Frances Peterson Salter of N.Y. Purchased by Mrs. Stewart Lines, a great-great-granddaughter of Abraham Wendell, in the 1930s. Sold to Herbert Dyer Antiques about 1970; to James R. Bakker and Robert E. Cleaves; to an unidenti-fied antiques dealer; to William C. Putnam, who sold it to the Abby Aldrich Rockefeller Folk Art Center in 1974.

1. Advertisement, *New Hampshire Gazette*, Feb. 25, 1812.

2. Strawbery Banke Museum owns a plainer painted dressing table (1992.5) branded "W. EVANS," for William Evans (1776–1830), a Portsmouth joiner.

3. Sheraton 1803, 2:202. Possibly Vallina Wendell Peterson, Abraham's daughter, used the table, because she took it out of the house later in the nineteenth century.

4. Abraham Wendell, Personal Property Mort-gages, Feb. 17, 1840, Portsmouth City Hall. Some of his other painted furniture included: "six dark common Gilted chairs…six yellow common Gilted chairs…six common painted chairs." The inventory does not cite values for the furniture.

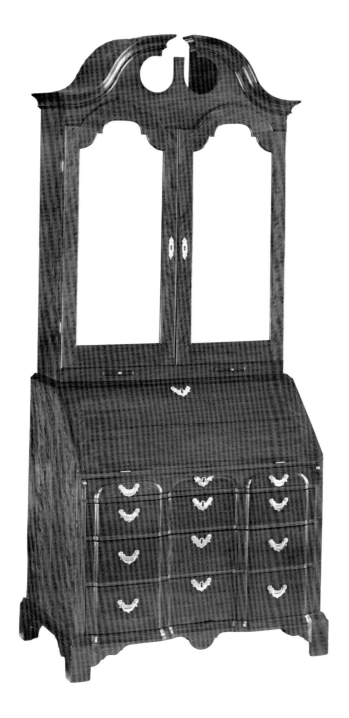

25

DESK AND BOOKCASE

Portsmouth, New Hampshire
1740–60
Private collection

No form of furniture better served the professional needs of Portsmouth's mercantile leaders than the desk and bookcase. It offered a surface for writing letters and business accounts, space for keeping ledgers as well as the household library, and lockable drawers for safely storing money, jewelry, and other valuable articles.[1] An imposing and often richly ornamented object, the desk and bookcase became an eloquent testament of the prominence of its owner. This catalogue features two stylish blockfront examples (*cat. nos. 25 and* 26) associated with the region's most successful merchant families: the Wentworths of Portsmouth and the Pepperrells of neighboring Kittery, just across the Piscataqua River. A grand library bookcase (*cat. no. 27*) acquired by another thriving importer, Jonathan Warner, follows. Though the three objects vary in date and design, all vividly reflect the educational interests, commercial background, and opulent lifestyle of the Piscataqua aristocracy.

The maker of cat. no. 25 based his design upon Boston models. One Massachusetts example (25A) offers a possible prototype.[2] Though more elaborate in its details, it closely resembles the Portsmouth desk and bookcase in form. Their desk

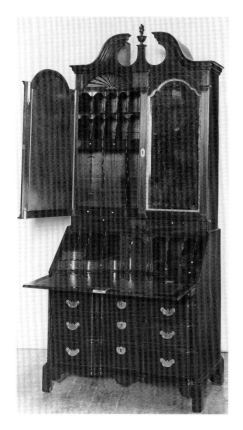

25A.

*Desk and bookcase. Boston, Massachusetts,
1740–50. Black walnut and eastern white pine,
H. 100 (including finial); W. 41¾; D. 23¼.
Private collection. Courtesy, Bernard and S.
Dean Levy, Inc.*

interiors match in arrangement as well as general outline (25B). On both, the recessed arch on the prospect door is indented at the upper corners. The pilasters beside the prospect door are sham fronts for document drawers. By releasing a spring lock behind the prospect door, the entire prospect section slides out, thus allowing access to the document drawers from the back. The blocked façades of the exterior drawers closely compare, though string inlay and thumbnail edges enhance the Boston desk. The makers of both objects cut out each drawer front from a single board, a standard Massachusetts procedure that differs noticeably from the two-piece fronts of Joseph Davis's cases (*see cat. no.* 16).[3]

Many features on the two upper cases also correspond. Both have mirrored doors, a rare and expensive feature that proclaimed the elevated status of their owners. Such mirrors, located directly above the candleslides, also served the practical function of enhancing the amount of artificial and natural light within a room. Distinctive arches cap the mirrors. Behind the arches are inlaid shells with alternating lobes of light and dark wood. On the Portsmouth piece, the rays emanate from a half-round disk flanked by black wings (25C), an unusual adaptation of the cherub at the center of the shell in the Boston bookcase.

At first glance, such similarities might suggest that both cases originated in Boston. However, close inspection reveals idiosyncratic details that distinguish the Portsmouth example from its Massachusetts counterpart. The opening at the center of the pediment is unusually narrow. Typically, the scrolls of the pediment are 5" to 6" apart; here, the void measures only 2½", a factor that forced the maker to develop a particularly thin finial for this desk and bookcase. Unfortunately, no hint of the finial's design remains.

The builder of the blockfront also adopted two other peculiar practices in the upper case. He fastened the bookcase doors to the case sides with broad brass hinges matching those on the desk lid. Because of their large size, the outer flap of each hinge is screwed into a shallow mortise on the case sides. On most bookcases, narrower hinges are mounted to the front edge of the sides, thus concealing the hinges when the doors are closed. Here, the hinges are exposed. Perhaps the maker considered the stronger hinges necessary to support the heavy mirrored doors. More likely, he chose to use what he had available. His construction of the two candleslides below the bookcase doors also reflects a distinctive, and not altogether successful, solution. Boston cabinetmakers frequently recessed the bottom of the bookcase and installed a frame for the candleslides beneath the bottom.[4] The plan permitted access to the slides and facilitated future repairs. The Portsmouth maker boxed the slides in by dovetailing the case bottom to the lower edge of the case sides and inserting a secondary bottom within the interior of the bookcase. Once the walnut facing was nailed to the front edge of the two bottoms, the slides became inaccessible for repairs. When one broke, a restorer had to cut a hole in the case bottom to reach the slide and its support blocks.

Within the lower case, three features stand out. The maker installed a stack of vertical walnut blocks between the drawer dividers, nailed them to the case sides, and faced them with the same channel molding that decorates the rest of the case façade. Second, he formed his front base molding of two elements: a contoured edge and a secondary support strip behind the recessed central block. He glued and nailed the two-part molding to the front edge of the bottom. The joint lacks the giant dovetail frequently seen on Boston cases.[5] Third, he created a distinctive outline for his bracket feet and varied that design on the front and side portions of the front feet. Massachusetts cabinetmakers commonly applied straight bracket feet and a decorative drop to the base of their desks. But, in this instance, the patterns of the feet and drop differ from any documented Boston examples.

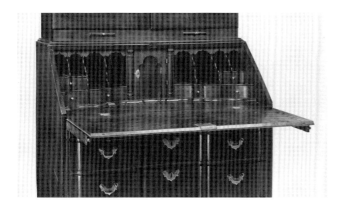

25B.
Desk interior.

25C.
Pediment detail.

Finally, the maker's choice of woods deserves special mention. He assembled a sizable stock of handsomely figured black walnut and used the wood lavishly throughout the desk and bookcase. He not only made all standard primary surfaces of the expensive imported walnut but also the tops of both cases, the cornice, bookcase shelves, and partitions within the desk interior. Other artisans of the era usually just faced these secondary elements with walnut; here the wood is solid.

According to family tradition, this desk and bookcase belonged to John Wentworth, the last royal governor of New Hampshire.[6] Born in 1737, Wentworth may well have been the second owner of the desk. After graduating from Harvard in 1755, he returned to Portsmouth to join the thriving mercantile firm founded by his father, Mark Hunking Wentworth (1709–85), who ranked among the colony's wealthiest and most influential residents. In 1763, the elder Wentworth sent John to England, where he remained until appointed governor of New Hampshire three years later. He arrived back in Portsmouth during the summer of 1767 and took up residence in a house on Pleasant Street belonging to his brother-in-law, John Fisher. He apparently used this desk throughout his eight years in the Pleasant Street house. He had intended to reside longer in Portsmouth, but the revolutionary turmoil of the 1770s brought his stay to an abrupt end. In July 1775, an armed mob forced Wentworth and his family to flee the town. He never returned. The new state government confiscated his possessions, then later permitted his father to acquire some of them. The desk, like many Wentworth items, passed to the Haven family of Portsmouth. These handsome objects testify to the affluence and taste of the Wentworth family during Portsmouth's pre-Revolutionary era.

BJ

Structure and Condition: The desk and bookcase separates into two sections. The upper case bottom—a single board beneath the candleslides—is dovetailed to the case sides. The solid walnut case top, three fixed shelves, and a secondary bottom above the candleslides fit into dadoes in the case sides. The back is made of four horizontal boards nailed to the rabbeted edges of the case sides. A fifth board, nailed in the same manner, backs the hood.

The cornice consists of a single solid walnut molding. The pediment is nailed to the front edge of the case sides. The thin, curved roof of the hood is nailed to the pediment, case sides, backboard, and hood sides. The rails of the doors are tenoned through the stiles; the mirrors fit against the rabbeted edges of the joined

frame and were originally backed with walnut panels screwed to the rear surface of the frame. Below the doors, slots for the candleslides are cut in a thick walnut facing strip nailed to the case sides as well as to the primary and secondary bottoms of the case. Each slide is a single walnut board veneered with a walnut thumbnail-molded cap. Guides for the candleslides are glued and nailed to the underside of the secondary bottom.

The two-board sides of the lower case are dovetailed to the solid walnut top and two-board pine bottom. The narrow ogee waist molding is nailed to the top of the lower case. The back of the lower case—three horizontal butt-jointed boards—is nailed to the rabbeted edges of the case sides. A channel molding cut on the case

frame surrounds the drawers. The 5¼" deep dividers are secured with sliding dovetails to the case sides. A thin walnut strip covers the edge of each case side. Drawer supports are glued and nailed to the case sides. In addition, the supports for the top drawer are tenoned into a brace that extends across the back of the case. The brace creates a secret compartment behind the drawer, which houses a small drawer accessible from the desk interior. Large wedge-shaped drawer stops are glued to the case sides at the back.

The stepped base molding is nailed in place. The central recessed block of the front molding is backed by a secondary piece of walnut. The base molding overlaps the bottom and is backed with support blocks (three widely spaced blocks along the front and four butting blocks along the sides). Each mitered front foot is supported with the standard complement of two horizontal blocks and a single large vertical block. The rear element is notched to fit around the support blocks behind the base molding, butts against the rear bracket foot, and is glued to a support block, which in turn is glued to the case bottom. The semicircular drop is glued to the base molding and backed by a horizontal block.

The 14" deep writing surface of the desk interior fits into dadoes in the case sides. The drawers rest on a shelf with a molded front edge nailed to the writing surface. The lid is composed of two horizontal boards tongue-in-grooved to vertical cleats. The vertical partitions and horizontal dividers for the desk interior are fastened in the usual manner: they slide in dadoes in the top, shelf, case sides, and other dividers or partitions. The drawers within the desk interior are neatly dovetailed at the corners. On all but the upper two end drawers, the bottom consists of one board glued to the rabbeted edges of the front, sides, and back. The bottom of each end drawer projects beyond the back. The top edge of the drawer sides is rounded; the top edge of the back is flat and cut with a slight bevel along its rear edge.

The large drawers vary slightly in construction from the drawers within the desk interior. The top edge of the sides is cut with a double-arched bead. The bottom—either three or four boards with grain perpendicular to the front—is nailed to the rabbeted edges of the front and sides and flush edge of the back. An original pine runner is glued and nailed to the lower edge of each side.

The desk and bookcase has had several major repairs. In *The Furniture of Our Forefathers*, Esther Singleton records the appearance of the desk in 1901: walnut panels in the doors replace the original mirrored glass, brass clock finials ornament the top of the bookcase, the feet are cut down at least 3", and the lower half of the drop is missing.[7] In 1992, SPNEA conservators removed the later finials, extended the feet, replaced the missing portion of the central drop, and cleaned the finish. Alan Miller of Quakertown, Pa., coordinated the reproduction of mirrored panels fashioned by Kenneth Kratz.

Inscriptions: A late nineteenth-century paper label tacked to the inside of the right bookcase door states: "This is the book-case which belongs of the top of the mahogany desk of drawer's, (now in E. A. H's room.) This piece of furniture belonged to Governor Wentworth."

Materials: *Black walnut case top and sides, pediment and moldings, bookcase shelves, desk lid, interior partitions, pigeonhole valances, prospect door, pilasters for document drawers, drawer fronts, lopers, and feet; *black walnut facings on eastern white pine interior dividers, desk shelf, and drawer dividers; unidentified light- and dark-wood inlays in black walnut arches behind doors; *eastern white pine for all secondary work. Original brass hinges, escutcheons, bookcase door latches, and handles (except knob on left candleslide); original locks for bookcase doors, prospect door, and exterior drawers; replaced lock for lid.

Dimensions: H. 94¾; W. 43; D. 25½

Provenance: Probably owned by John Wentworth (1737–1820); acquired by his father Mark Hunking Wentworth (1709–85) in 1775; later purchased by the Rev. Samuel Haven (1749–1806) and remained in his family home until 1897, when it passed to Alexander H. Ladd (1815–1912), who gave it to his daughter, Elizabeth (1845–1924), the wife of Charles E. Wentworth (1845–1912), great-great-grand-nephew of Governor John Wentworth; descended in the Wentworth family to the present owner.

Publications: Singleton 1900–1901, 2:369–70.

1. See Jobe and Kaye 1984, 226–28, for an eighteenth-century list of the contents of a desk.

2. The feet, finials, and hood of the related desk and bookcase are replaced. Nevertheless, the object remains the best surviving Boston model for the Portsmouth example. Another Boston desk and bookcase by the same hand is now on loan to the Diplomatic Reception Rooms of the U. S. Department of State (see Parke-Bernet, sale 1534, Oct. 9, 1954, lot 174).

3. On the middle two drawers of cat. no. 25, narrow walnut strips were installed by the maker to reinforce the thinnest portion of the front.

4. The Boston blockfront desks and bookcases discussed in Jobe 1991a, 412–19, illustrate the standard practice of recessing the case bottom to allow access to the candleslides.

5. Lovell 1974, 84–86 (note that the captions for figs. 56 and 57 have been transposed).

6. For information on Wentworth, see Wentworth 1878, 1:536–55; Mayo 1921; *Sibley's Harvard Graduates*, 13:650–81.

7. Singleton 1900–1901, 2:369.

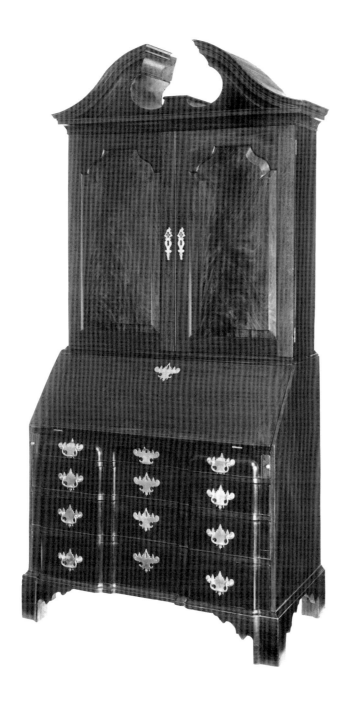

❧ 26

DESK AND BOOKCASE

(Colorplate 7)
Portsmouth, New Hampshire
1755–70
Society for the Preservation of New England
Antiquities, Boston, Massachusetts, museum
purchase with funds provided by an anonymous
gift, 1983.114

THIS HANDSOME BLOCKFRONT desk and bookcase resembles the preceding example
in form but varies significantly in detail. The Wentworth family piece (*cat. no.* 25) is
built of black walnut, has mirrored glass doors, and features inlaid shells behind the
arches of the bookcase doors. This desk and bookcase (*cat. no.* 26) is made of ma-
hogany, always had wooden panels in the doors, and lacks any decoration within
the bookcase. Instead of arched door panels projecting into the pediment, the
arches here are housed within the broad upper rails of the doors, and an architrave
clearly separates the bookcase from the pediment. The desk interiors also contrast
noticeably. Here, a plain, stepped interior (26A) replaces the intricate amphitheater
of the previous example. In proportion, too, the objects vary. The stepped interior,
architrave, and more restrained curve of the pediment emphasize the horizontality
of the object. Both wider and shorter (by 1½") than the Wentworth desk, it lacks
the vertical thrust of its earlier counterpart. These numerous differences reflect sty-
listic changes that occurred during the mid eighteenth century. In response to En-
glish fashions, craftsmen throughout New England adjusted the proportions of
their furniture and altered their decorative schemes.

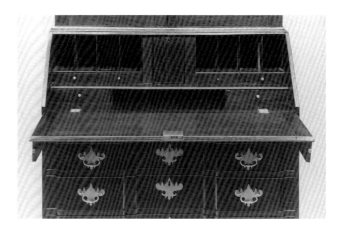

26A.

Interior of cat. no. 26.

According to family tradition, this desk and bookcase belonged to Sir William Pepperrell (1696–1759), the nabob of Kittery Point.[1] An eminent merchant, judge, and longtime member of the Governor's Council for the Massachusetts Bay Colony, Pepperrell achieved legendary fame for leading an expedition against the French at Fort Louisburg in 1745. In reward, George II made him New England's first baronet. Pepperrell relished his newfound status and sought to emulate the lifestyle of British nobility. He resided in the most ornate of all the early Piscataqua River mansions.[2] Opulent furnishings from England, Boston, and neighboring Portsmouth filled the rooms, and a retinue of servants attended to the needs of the family.[3] Apparently, late in his life, Pepperrell acquired this desk and bookcase for the stately residence. It subsequently passed to his widow, Mary, Lady Pepperrell, who in 1760 moved into a stylish new house in Kittery.[4]

After the death of Lady Pepperrell in 1789, appraisers prepared a detailed inventory of her possessions. Her "lower keeping room" included "1 old mahogany desk & bookcase" valued at £3.10.0, as well as two tables, a stand, a japanned tea table and tea china, thirteen chairs, and a gilt looking glass.[5] The room served as a sitting or dining room and contrasted with her more formal "hall" and parlor, both of which probably contained costlier furnishings.[6] Her placement of the desk in a more comfortable family room is consistent with period practice.[7] In 1762, a desk and bookcase belonging to the Portsmouth merchant Nathaniel Peirce stood in his "East Room," a secondary parlor that doubled as a dining room.[8] Twenty-four years later, Mrs. Moffatt's "setting room" housed another example, and in the early nineteenth century, the Portsmouth dining room of Jacob Wendell (*see cat. no.* 33) and sitting parlor of John Wardrobe each contained a "Secretary," as the form came to be called during the federal era.[9]

Though Sir William Pepperrell patronized craftsmen in many locales, he undoubtedly turned to a Portsmouth artisan for this desk and bookcase and a companion chest of drawers (6A). The same maker fashioned a blockfront chest for Pepperrell's nephew George Ffrost I of Durham (*cat. no.* 6) and a straight-front desk acquired (perhaps second hand) by James Rundlet of Portsmouth (26B). Both the Rundlet and Pepperrell desks are made of the same dense, dark mahogany and feature identical secondary woods: white pine for all but the birch lopers. Both also have similar stepped interiors, dustboards between the drawers, and bracket feet of the same profile. The design of their blocking and brackets owes much to Boston furniture.[10] But, other idiosyncratic details readily distinguish the two desks from Massachusetts products. The presence of dustboards, the severity of the desk interior (heightened on the desk and bookcase by the lack of pigeonhole valances), and

the absence of pilasters on the document drawers contrast with standard Boston practice. Furthermore, the desk and bookcase displays two surprising features that rarely appear elsewhere in New England. Cockbeading covers the edges of the drawer fronts. Though a common technique in England at the time, it remained an infrequent one in New England until the 1790s. An even more unusual detail caps the upper case. Instead of finials, a mahogany shelf fills the center of the pediment. Presumably it supported a carved or ceramic bust, much like that recommended by English design books of the period but rarely implemented by American craftsmen.[11]

 The particular combination of elements in the Pepperrell desk and bookcase suggests the hand of an artisan familiar with both English and Boston techniques. He obviously had an appreciation for finely figured woods and distinctive ornamental details. Though his identity remains an enigma, his stylish case furniture assures his place as one of Portsmouth's finest colonial craftsmen.

B J

Structure and Condition: The desk and bookcase separates into two sections. The one-board sides of the upper case are dovetailed to the one-board top and bottom. Four horizontal backboards are nailed to the rabbeted edges of the case sides. The hood has a single backboard nailed to the case sides and top. The bookcase doors consist of matched figured mahogany panels set into grooves in the joined frames. Within the bookcase, a series of dadoes are cut in the case sides for three adjustable shelves. The pediment is nailed to the front edge of the top. The two-piece cornice molding is nailed to the case sides, pediment, and along the front two-thirds of the hood sides. A coved architrave, matching the lower portion of the cornice in contour, is glued and nailed to the pediment. The solid mahogany shelf at the center of the opening extends from the pediment to the back of the hood. The sides of the hood measure only 2½" high and cant at a pronounced angle. Originally, thick cartridge paper was glued to the curved contours of the pediment opening. The thin curved pine roof is nailed to the top edge of the pediment and back.

The narrow coved waist molding is nailed to the top of the lower case. The two-board lower case sides are dovetailed to the one-board top and two-board bottom. Two horizontal backboards are nailed to the rabbeted rear edges of the case sides. Dustboards measuring 16½" in depth fit into dadoes in the case sides. A mahogany facing strip covers the front edge of each case side. Pine drawer stops are nailed to the case sides at the back. The base molding is nailed to the case. The blocked front molding is a single unit with a straight back edge that butts against the case bottom. The base moldings overlap the bottom and are backed with a series of horizontal blocks. The bracket feet are glued to the underside of the base molding, and each is supported with the standard complement of two horizontal blocks and one large vertical block. Each rear element—a large triangular block with a curved outside edge similar to that on Boston cases—butts against the rear bracket foot and is glued to a block attached to the case bottom.

The writing surface for the desk interior extends to the back of the case. The lid—a single horizontal board tenoned into vertical cleats—is attached to the writing surface with two brass hinges. The writing surface, partitions, and dividers are set into dadoes in the case sides, top, or writing surface. The prospect door falls forward rather than swings on hinges. The dovetailed prospect section slides out after releasing a spring lock behind the prospect door. The document drawers are accessible from the back of the prospect section. The pigeonholes never had valances. The interior drawers are fastened with dovetails of good quality. Each bottom is glued to the rabbeted edges of the front and sides and nailed to the back. The construction of the exterior drawers conforms to that of cat. no. 6.

This desk and bookcase has had numerous repairs. Old replacements include the back of both cases, two of the three shelves within the bookcase, and the lower edge of the lid. In addition, at an early date, someone glued stops to the back of the drawers, installed linoleum over the original cartridge paper lining the circular openings of the pediment, and, most noticeable of all, cut 3" off the feet. In 1983 and 1984 SPNEA conservators restored the missing portions of the feet, inserted splines in the case sides to fill sizable shrinkage cracks, and removed a dark linseed-oil polish that obscured an earlier finish.

Inscriptions: "X" in old chalk on the back of most drawers.

Materials: *Mahogany pediment, plinth, moldings, case sides, top, doors, lid, drawer fronts, feet, front edge of dustboards and lopers, and front edge of writing surface, partitions, and dividers within desk interior; *birch secondary wood for lopers; *eastern white pine for all other secondary work. Original brass bookcase door escutcheons, hinges, and latches; original brass buttons on interior drawers; replaced brass hardware on exterior drawers; original locks for bookcase doors, desk lid, and exterior drawers; replaced lid hinges.

Dimensions: H. 93¼; W. 44¾; D. 23¾

26B.

Desk. Portsmouth, New Hampshire, 1755–80. *Mahogany, *birch, and *eastern white pine, H. 42; W. 42⅞; D. 21¹⁵⁄₁₆. Rundlet-May House, Portsmouth, New Hampshire, Society for the Preservation of New England Antiquities, gift of Ralph May, 1971.792.*

Provenance: Supposedly Sir William Pepperrell (1696–1759); to his widow, Mary (Hirst), Lady Pepperrell (1704–89); acquired in the nineteenth century by the Gerrish family of Kittery and descended with a companion blockfront chest of drawers (6A) to Charles Gerrish; purchased by the Parsons family of York, Me., in the early twentieth century; sold by Alice Parsons to SPNEA in 1983.

Publications: Sack 1950, 159; Sotheby Parke Bernet, sale 3866, Apr. 30–May 1, 1976, lot 484; Jobe and Kaye 1984, 32; Kaye 1987, 234.

1. Fairchild 1976 provides an excellent summary of Pepperrell's career.

2. Garvin 1983, 93–103.

3. In 1737, Pepperrell wrote to his London factor, requesting a suite of chamber furnishings for his new house. The order included a dozen chairs, looking glass, case of drawers, and bed hangings; see ibid., 94. Pepperrell also patronized two Portsmouth furniture makers, John Gaines and Joseph Buss, Jr., between 1735 and 1742, and had many dealings with Boston merchants. A transcription of the Buss account is in the SPNEA files; the Gaines account is attached to Pepperrell v. Gaines, Apr. 28, 1739, docket 12253, N.H. Provincial Court, State Archives. Pepperrell's liveried servants are described in Parsons 1855, 232.

4. The desk's design suggests a date of origin after 1755, just four years before the death of Sir William Pepperrell. If not acquired by Pepperrell, the desk may well have been purchased by his widow during the 1760s for her new house. For illustrations and a brief history of the Lady Pepperrell House, see Howells 1937, 7–13, and Frost 1948, 14–20.

5. Lady Mary Pepperrell, 1791 inventory, docket 14800, York County (Me.) Probate.

6. The inventory includes a list of expensive objects in the "hall" but omits the contents of the parlor. The presence of a "Parlour chamber" indicates that the house had a parlor. One can only presume that its furnishings also exceeded in value those in the lower keeping room.

7. Garrett 1990, 65–66.

8. Nathaniel Peirce, 1762 inventory, Wendell Collection, folder 9, case 7, Baker Library, Harvard Business School.

9. The 1786 inventory of the estate of John Moffatt includes a room-by-room listing of the contents of the home of his daughter-in-law, Mrs. Moffatt; see old series, docket 5173, Rockingham County (N.H.) Probate. Jacob Wendell, ca. 1828 inventory, Wendell Collection, box 18, Portsmouth Athenaeum; John Wardrobe, 1806 inventory, old series, docket 7315, Rockingham County (N.H.) Probate.

10. For Boston models for the blocking and bracket design, see Jobe and Kaye 1984, nos. 19 and 27 (bracket), 50 (blocking).

11. Similar plinths appear in two designs for a desk and bookcase in Chippendale 1754, pls. 77, 78; the latter depicts busts atop the central plinth as well as two end plinths. Though no busts survive on Portsmouth-area furniture, one still remains within the pediment over the parlor fireplace of the Joseph Haven house, built about 1800 at 229 Pleasant Street in Portsmouth.

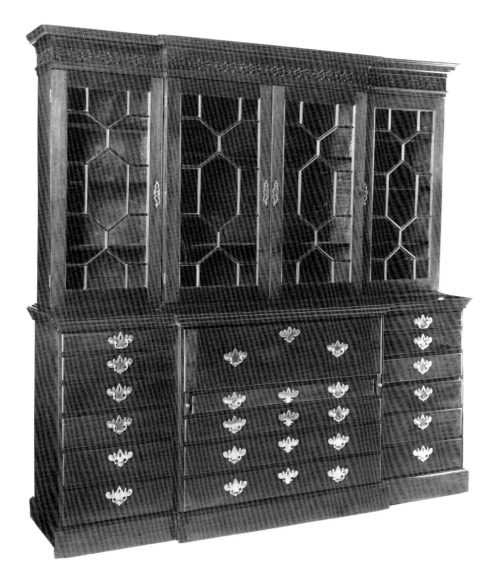

27

LIBRARY BOOKCASE

(Colorplate 8)
Attributed to Robert Harrold (w. 1765–92)
Portsmouth, New Hampshire
1765–75
Warner House Association
Portsmouth, New Hampshire
Gift of Mrs. John Curtis, 1980.1

THIS IMPOSING BOOKCASE originally belonged to Jonathan Warner (1726–1814) of Portsmouth. One of the town's most respected citizens, Warner served as a member of the Governor's Council prior to the American Revolution and frequently as the moderator of town meetings. He achieved a substantial fortune through trade. According to one contemporary account, "perhaps no person in this town transacted more mercantile business upon so large a scale."[1] He cut a commanding figure in the town, as his portrait well attests (27A), and left a memorable impression on the young Charles W. Brewster (1802–68), who later wrote in his *Rambles:*

> We well recollect Mr. W. as one of the last of the cocked hats. As in a vision of early child-
> hood, he is still before us, in all the dignity of the aristocratic crown officers. That broad
> back, long skirted brown coat, those small clothes and silk stockings—those silver buckles,
> and that cane, we see them still, although the life that filled and moved them ceased half a
> century ago.[2]

In 1760, Warner married Mary Macpheadris Osborne, widow of John Osborne of Boston, and moved into the brick mansion built by her father Archibald Macpheadris more than forty years earlier (*fig.* 3). The Warners renovated the residence and introduced many new furnishings, including this large bookcase, which was placed in his "Front Setting Room," where it still remains (*fig.* 39). Jonathan Warner's estate inventory of 1814 offers a detailed description of the room's late eighteenth-century elegance:

1 Looking glass $8		1 Japand fancy waiter 125c Window	
1 Chimney dº. $3	11.—	Cushions & foot stool 100c	2.25
14 glazed & framed pictures @ 34c	4.76	1 Glass globe 25c 1 Large mahog'y	
6 mahog'y hair bottom Chairs @250c	15.—	Book case & sett of Drawers $30	30.25
Brass Andirons, Shovel & tongs		A number Books (Folˢ. & Octˢ.) $64	64.—
& fender - Sconces	12.—	1 Jewelled Gold Watch $40 -	
1 mahogany breakfast Table	3.50	1 Carpet $10	50.—
1 marble Slab on mahog'y frame	10.—	Silver Plate 689 ᵒᶻ 6 ᵖᵈᵗ @$1	689.30[3]

At one end of the room, the chimney glass hung over a fireplace surrounded with newly installed transfer-printed tiles and fitted with a decorative cast-iron fireback.[4] The bookcase stood on the opposite wall; a window from the adjoining front wall provided light for working at the desk interior within the central top drawer of the lower case (27B). The marble side table fit between the two front windows, and the looking glass hung above it. The breakfast table and set of six chairs probably lined the opposing wall. The books, and perhaps the gold watch, were stored in the bookcase. The silver collection filled the locked closet next to the fireplace. Brass sconces and framed prints ornamenting the grain-painted walls provided a finishing touch.

The importance of the bookcase extends far beyond its immediate use by Warner as a handsome home for his extensive library. More importantly, it documents the local appeal of stylish rococo forms based on London fashions. Two well-known English design books—Thomas Chippendale's *Director* (1754) and William Ince and John Mayhew's *Universal System* (1762)—illustrate comparable objects.[5] Chippendale called the form a "library bookcase," Ince and Mayhew, a "gentleman's repository." Their designs customarily depict doors in both sections of the bookcase; one design in the latter book, however, shows drawers in the lower case as well as a similar fretwork pattern in the cornice.[6]

Portsmouth craftsmen had access to London pattern books and may possibly have referred to Ince and Mayhew's volume in planning this handsome example. More likely, the design was brought to Portsmouth by Robert Harrold, an immigrant craftsman who arrived in 1765 and quickly became the most prominent cabinetmaker in the town. Harrold secured the patronage of Governor John Wentworth (*see cat. no.* 85) and would have been the logical choice for Jonathan Warner, who was a cousin of the governor and a member of his council. Moreover, the ambitious sophistication of the bookcase links it to a masterful china table that probably also originated in Harrold's shop (*cat. no.* 48). Both feature the same distinctive fretwork pattern in the cornice (27C). Another bookcase with the same fretwork survives only as a fragment; it too was probably made by Harrold and was once nearly as grand as Warner's.[7] The two examples rank as the most elaborate pieces of pre-Revolutionary Portsmouth furniture.

The maker of the Warner bookcase adopted three distinctive construction techniques worthy of special mention. First, he built the upper case as a single unit but constructed the lower case of four separate pieces: waist molding and top, center and right wing, separate left wing, and base. Second, he used mahogany veneer on the right side of both the upper and lower cases but made the left side of solid mahogany. Finally, he inserted dustboards between the drawers, a standard English technique rarely employed in New England. Such features suggest the hand of an immigrant like Harrold who understood English furniture technology as well as design. But to judge from his odd assemblage of parts and inconsistent use of veneer, he probably did not build many of these large, ornamental bookcases.

This distinctive library bookcase is one of only a handful of surviving examples made in America before the Revolution and surpasses any other colonial ex-

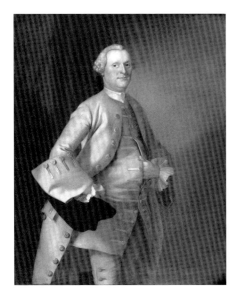

27A.

Jonathan Warner, *by Joseph Blackburn (1727–92), 1761. Oil on canvas, H. 50; W. 40. Museum of Fine Arts, Boston, Massachusetts, 83.29.*

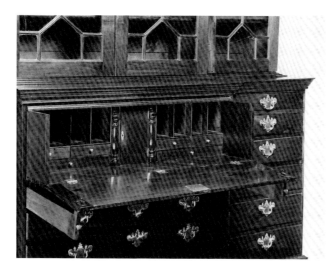

27B.
Desk interior.

ample in New England. Its presence in Portsmouth attests to the popularity of London fashion there and the ability of local craftsmen to meet that demand through stylish products of their own.

B J

27C.
Detail of fretwork in frieze.

Structure and Condition: The bookcase separates into five sections: bookcase, waist, center and right wing of lower case, separate left wing of lower case, and base. The upper case sides are dovetailed to the one-board pine top and bottom. The left case side is a solid, ⅝" mahogany board. The right case side is a pine board veneered with mahogany. The inner side of each wing butts against the sides of the central unit, and all are tenoned through the case top and bottom. Eighteen dadoes are cut in the case sides for adjustable shelves. Each wing has three original shelves; the central unit has two original shelves. Each shelf is a pine board faced with mahogany. The front frieze is a pine board veneered with mahogany and nailed to the front edges of the case sides. Fretwork panels are glued and nailed to the frieze. The cornice is a single mahogany molding backed with a wedge-shaped pine strip. The Greek key molding is a separate element glued to the cornice. The cornice projects 1⅛" above the case top and is now supported with nine pine blocks glued to the top and back edge of the cornice. The doors are joined: the rails are tenoned through the stiles. The doors never had curtains. The back of the upper case consists of four horizontal lap-jointed pine boards nailed to the rabbeted edges of the case sides.

The waist is a joined pine frame with a mahogany shelf faced with an intricate three-piece mahogany molding. The back rail of the frame is dovetailed to the side rails. The waist rests on the top of the lower case.

The right wing and central unit of the lower case are a single section. The sides are dovetailed to the one-board top and bottom. The inner sides of the wing and central unit—each one pine board faced with a maple strip and mahogany veneer—are tenoned through the top and bottom. Dustboards measuring 13½" deep are set into dadoes in the case sides. Each dustboard is made of pine with a 1¼" facing of maple veneered with mahogany. The large drawer in the central unit conceals a desk interior (27B). The drawer is a dovetailed box with a hinged front. To close the front, latches screwed to the inner corners of the front pivot into notches in the sides. When open, the front rests on two lopers with a notched upper edge. Each loper is a maple board faced with a 2" strip of mahogany. The prospect section is a dovetailed box that slides out after releasing a spring lock in the top of the prospect. Pine drawers behind the pilasters flanking the door are accessible from the back of the prospect section. The partitions and dividers of the interior are set into dadoes in the sides, top, and bottom of the desk drawer. The pigeonholes never had valances. The back of the case consists of two horizontal, lap-jointed boards nailed to the case sides, top, and bottom. Like the upper case, the right side of this unit is a single pine board veneered with mahogany.

The left wing is a separate unit constructed much like the right wing and central unit, except the outer side of the case is solid mahogany. The base is a dovetailed pine frame. The outer rails are veneered with mahogany. A solid mahogany coved base molding is glued and nailed to the top edge of the frame.

The drawers are fastened at the corners with small, precise dovetails. Each drawer front has a thumbnail edge, lipped at the top and sides. The bottom—two boards with grain perpendicular to the front—is nailed to the rabbeted edge of the front and sides and flush edge of the back. A pine strip is glued to the bottom along the lower inside edge of each drawer side. The construction of the small drawers in the desk interior corresponds to that of the large drawers, with two exceptions: the bottoms are glued to the rabbeted edges of the front and sides, and the bottoms never had support strips.

The bookcase has had many minor repairs throughout its history. Replacements include: the fretwork on the right side of the case; the rear 1¾" of the cornice molding; all of the molding below the frieze on the right side of the case; the applied dentil along the cornice of the central unit; a 12" long section of the veneer on the right side of the base; and a 4½" by ½" section at the upper front corner of the right side of the desk drawer. Most of the glass panes in the doors are original, but many are cracked. The last private owner refinished the entire object and installed a white moiré lining and fluorescent lighting within the bookcase. In 1992, SPNEA conservators removed the fabric and the lighting as well as contact paper within the drawers, stabilized the cracked glass panes in the doors, reglued all loose veneers, patched several small chips in the drawer fronts and the cornice, cleaned and waxed the case, and lacquered the hardware.

Inscriptions: "X" in old chalk on the back of many drawers; modern sales label from John S. Walton within the next-to-bottom drawer of the central section.

Materials: *Mahogany moldings, left case sides, bookcase doors, top of waist section, drawer fronts, and front edge of dustboards and lopers; mahogany veneer on right case side and frame of base; *soft maple secondary wood for lopers and strips on dustboards and inner case sides of right and left wing; *eastern white pine for all other secondary work. Original brass hardware except for bottom left escutcheon; replaced locks.

Dimensions: H. 95¼; W. 92¾; D. 21½

Provenance: Jonathan Warner (1726–1814); to his niece Elizabeth (1767–1846), who married Nathaniel Sherburne (1764–94); to her son John N. Sherburne (1793–1859); to his oldest daughter, Elizabeth Warner Pitts Sherburne (1822–1909), who married Pearce Wentworth Penhallow (1816–85); to their sons, Charles S. Penhallow (1852–1921) and Thomas W. Penhallow (d. 1930); later sold to William Richmond of Williams Antique Shop, Greenwich, Conn., in the late 1940s; shortly thereafter acquired in succession by the New York antiques firms of Israel Sack and John S. Walton; sold by the latter in 1950 to Brooks Bromley of Berwyn, Pa.; repurchased by Walton a year later and sold to Mrs. John J. Curtis of Darien, Conn., who donated it to the Warner House Association in 1980.

Publications: Illustrated Memories, unpaged; Singleton 1900–1901, 2: facing 432; Northend 1914, opposite 126; Morse 1917, 142; Nutting 1928–33, nos. 792–96; *Antiques* 58:4 (Oct. 1950): 231; Comstock 1962, no. 239.

1. *New Hampshire Gazette,* May 24, 1814.

2. Brewster 1859, 141.

3. Jonathan Warner, 1814 inventory, old series, docket 8936, Rockingham County (N.H.) Probate.

4. Garvin 1983, 61.

5. Chippendale 1754, pls. 60–76, especially 62–63; Ince and Mayhew 1762, pl. 21.

6. Ince and Mayhew, pl. 21.

7. This fragment, now at the Larkin House, State Historic Park, Monterey, Cal., descended in the Larkin family of Portsmouth. A later Portsmouth rococo bookcase with string inlay on the base was given to the Warner House Association in 1967. Doors originally covered the drawers in the lower case but were removed long ago. The only other related bookcase was advertised by Bernard and S. Dean Levy, Inc., in 1984; see *Levy Catalogue* 1984, 4:35.

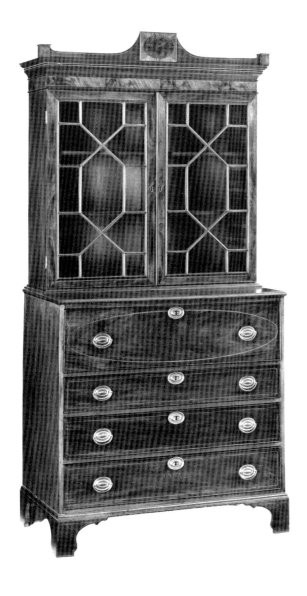

❧ 28

SECRETARY AND BOOKCASE

Attributed to Langley Boardman (1774–1833)
Portsmouth, New Hampshire
1800–1810
Rundlet-May House
Portsmouth, New Hampshire
Society for the Preservation of New England
Antiquities, gift of Ralph May, 1971.615

IN AN ADVERTISEMENT OF 1799, the Portsmouth cabinetmaker Langley Boardman listed among his wares, "Secretaries and Book-Cases."[1] The term describes a new form of desk and bookcase with a straight front instead of a sloped lid. "The accommodations therefore for writing," noted the English cabinetmaker George Hepplewhite, "are produced by the face of the upper drawer falling down by means of a spring and quadrant" (28A).[2] British publications by Hepplewhite and Thomas Shearer popularized the form during the 1790s, and it soon replaced the ubiquitous slant-lid desk of the pre-Revolutionary era.[3]

This handsome example retains many traditional features: bracket feet, four exterior drawers, and glazed doors in the Chinese taste (*identical to those on cat. no. 27*). Yet subtle changes reflect the influence of neoclassical design. The moldings are leaner, the feet more attenuated, and atop the cornice a narrow gallery with a central tablet replaces the bolder architectural pediments of earlier bookcases. In addition, string inlay lightens the appearance of the piece, and geometric patterns, particularly the oval, ornament the front. These details modify the character of the form. Unlike its more sculptural rococo predecessors, this secretary presents a flat, rectilinear façade that relies on contrasts of color and shape for its visual impact.

The overall design bears striking similarities to Salem furniture. A secretary by Thomas Needham displays a similar gallery above the cornice, and labeled examples by William Appleton and Jacob and Elijah Sanderson correspond in form, inlay, and desk interior layout.[4] One Appleton secretary even has the same inlaid

foot pattern and the same interlaced diamond inlay at the center of the frieze over the bookcase doors.[5] Another version by the Sandersons features a paneled back resembling the one here (28B).[6] Indeed, were it not for its history in Portsmouth and certain idiosyncrasies of its construction, this secretary might well be attributed to Salem. Instead, it represents the work of Langley Boardman, an Ipswich native who introduced the furniture designs of eastern Massachusetts to Portsmouth. A documented chest by Boardman (*cat. no.* 8) links this secretary to him. Both objects display the same drawer construction, foot design, and pattern of support blocks for the feet (8D). Moreover, the large triangular rear elements (8C *and* 28B) supporting both cases are dovetailed to the rear feet in identical fashion.

A related secretary without a bookcase also originated in Boardman's shop (28C). Though plainer, it matches its larger counterpart in construction and documents the presence of a less expensive alternative to the secretary and bookcase. The estate inventory of one Portsmouth resident who owned both forms illustrates their differing values. In 1826 Jonathan Folsom of Portsmouth possessed "one Secatary with a Bookcase [$]12.50 [,] one without the Bookcase 9.00."[7]

The owner of cat. no. 28 left no doubt of his identity. The name "Dr. Dwight" is branded on the bottom of every drawer but two small interior drawers behind the prospect door. The brand refers to Dr. Josiah Dwight (d. 1855), a prominent physician, "highly respected and beloved by all enjoying his acquaintance," who practiced for more than fifty years in Portsmouth (28D).[8] Dwight married Susannah Thompson in about 1807. They later moved into a grand house on Pleasant Street left to Susannah and her sister by their father, Captain Thomas Thompson (d. 1809). He also bequeathed to his daughters an elegant English piano and possibly this secretary.[9] Here both objects remained for almost half a century, elegant expressions of fashionable neoclassical taste during the early republic.
A R H and B J

Structure and Condition: This object separates into three sections: cornice frame, bookcase, and desk. The cornice frame is dovetailed at the corners and reinforced with a medial brace fastened to the front and rear rails with a sliding dovetail. A mahogany cornice molding backed by a triangular block of pine is glued to the front and side rails of the frame. A narrow strip of unidentified tropical veneer with light-wood stringing is glued to the fillet of the cornice. The end plinths are tenoned and glued to the top of the cornice. The pediment is a single board extending from plinth to plinth and secured with glue blocks. The veneered tablet is glued to the center of the pediment. Finials originally capped the plinths. A carved or brass ornament may once have surmounted the central tablet. The cornice frame rests on the top of the bookcase; two wooden pins on the bookcase fit into mortises in the frame to hold it in place.

The sides of the upper case are dovetailed to the one-board top and bottom. The back—a joined frame with two vertical panels—is nailed into the rabbeted edges of the sides and flush edges of the top and bottom. A series of ten dadoes is cut in each case side for two adjustable shelves. The joined mahogany frame of the bookcase doors is veneered with mahogany mitered at the corners and outlined with parallel strings of inlay. The muntins fit into narrow dadoes in the door frames. The doors had curtains at one

time. The upper case rests on runners fastened to the top of the lower case and fits against a one-piece mahogany waist molding glued and nailed to the lower case.

The two-board sides of the lower case are dovetailed to the pine top and bottom. The front half of the top is veneered with mahogany; an arched bead of mahogany is nailed to the front and side edges of the top. The construction of the paneled back corresponds to that in the upper case. The large secretary drawer slides on a dustboard set into dadoes in the case sides. The drawer itself is a dovetailed box with a hinged front. Thumb latches release the quadrant hinges, permitting the drawer front to fall. Green wool covers the writing surface. Bands of mahogany veneer mitered at the corners border the wool. The partitions and dividers of the desk interior fit into narrow dadoes cut in the drawer frame. Each pigeonhole valance is glued in place. Each interior drawer has a solid mahogany front outlined with string inlay. The drawer bottom is glued to the rabbeted edges of the front and sides and nailed to the back with original cut nails. Drawer stops are glued to the partitions and sides of the secretary drawer at the back.

The lower three exterior drawers are graduated. The upper drawer runs on a 3⅝" drawer divider backed by drawer supports, the middle drawer on a dustboard, and the bottom drawer directly on the case bottom. Sliding dovetails fasten the divider and front edge of the dustboards to the case sides; the drawer supports and rear portion of the dustboard are secured to dadoes in the case sides. Drawer stops are glued to the case sides at the back. The construction of the drawers duplicates that of cat. no. 8 with one exception: each drawer front is a single pine board veneered with mahogany. The construction of the feet and support blocks also parallels that of cat. no. 8.

When acquired by SPNEA in 1971, the secretary and bookcase retained nearly all of its original structural elements, including an early red stain on the case back and bookcase interior, as well as the original glass within the doors. Yet many areas of minor damage were apparent. The finials, prospect door, and possibly one bookcase shelf were missing; a narrow vertical patch covered the lower right corner of the secretary drawer front; the left quadrant hinge was broken; modern felt lined the writing surface; more than thirty-five chips marred the cockbeading on the drawers; the drawer supports for the next-to-top drawer had been replaced; and the finish had become uneven from sun-bleaching, grime, and layers of polish. In addition, large splines filled shrinkage cracks in the lower case sides, and the facing strips along the edges of the sides had begun to split. In 1983 Robert Mussey and Joseph Twichell of SPNEA conserved the secretary through a grant from the National Endowment for the Arts. They made a new prospect door, replaced the cloth on the writing surface, patched chips and cracks throughout the case, repaired the broken quadrant hinge, and added runners beneath the next-to-top drawer. During the conservation process, Mussey and Twichell discovered fragments of the original finish beneath the hardware as well as evidence of original lacquer on the brass door hinges and latches for the quadrant hinges. These areas have been preserved intact. The rest of the wood surface was cleaned lightly, then finished with orange shellac to approximate its original color. The brass handles and escutcheons were cleaned and coated with a toned lacquer.

Inscriptions: Branded "Dr • DWIGHT." on the bottoms of the bookcase and every drawer but the two small drawers behind the prospect door; "X" in pencil on the back of the lower three drawers.

Materials: *Mahogany plinths, pediment, moldings, case sides, front half of the sides of the secretary drawer, front edges of the dividers and partitions within the desk interior, and feet; mahogany veneer on the pediment tablet, frieze, bookcase doors, front half of the top of the lower case, drawer fronts, and dividers and dustboards between the exterior drawers; *eastern white pine for all secondary work except the *mahogany block behind the pediment tablet and mahogany frames for the bookcase doors. Original brass hardware except for two knobs on interior drawers and hinges and escutcheon on new prospect door; original locks except for middle two exterior drawers.

Dimensions: H. 88⅝; W. 43⅜; D. 22⅞

Provenance: Possibly Thomas Thompson (d. 1809); to his daughter Susannah Thompson Dwight (ca. 1785–1843) and her husband, Dr. Josiah Dwight (d. 1855); to their daughter Martha Strong Dwight Rundlet (1812–88); to their granddaughter Elizabeth Jane Rundlet Tilton (1840–1917); to her sister, Helen Isabel Tilton (1865–1940); to their cousin Ralph May (1882–1973), the donor.

1. *New Hampshire Gazette,* Apr. 23, 1799.

2. Hepplewhite 1794, 9.

3. Ibid., pls. 43–44; *Cabinet-Makers' London Book of Prices* 1793, pl. 7. Even after the introduction of the secretary and bookcase, production of slant-lid desks continued but rarely as a stylish form in mahogany or exotic veneers. Most Portsmouth desks of traditional design made after 1800 are of solid birch or maple. A rare exception appears in fig. 46.

4. Clunie 1976, 205, 271, pl. 43; Montgomery 1966, no. 178; Conger and Rollins 1991, nos. 116, 121. See also a related secretary with a Salem history in Strachan and Comstock 1965, 503, fig. 2.

5. Montgomery 1966, no. 178.

6. Conger and Rollins 1991, no. 116.

7. Jonathan Folsom, 1826 inventory, old series, docket 11091, Rockingham County (N.H.) Probate.

8. *Morning Chronicle,* May 5, 1855.

9. Thomas Thompson, 1809 will, old series, docket 8080, Rockingham County (N.H.) Probate. In his will, Thompson stipulated that one daughter, Margaret Brierly, receive a "wardrobe and drawers," while the other daughter, Susannah Dwight, be given "the Piano Forte." His inventory lists the value of the wardrobe and piano at the considerable sums of $25 and $80, respectively (see docket 8080). The latter, made by Longman and Broderip of London, is now on view in the Moffatt-Ladd House in Portsmouth (1977.10). Like the secretary, it bears the brand of Dr. Dwight. Shortly after Thomas Thompson's death, Margaret Brierly moved to England, where she soon died. Susannah Dwight subsequently received her sister's inheritance as well as her share of her father's house. Presumably, at that time Susannah acquired the "wardrobe." Could it have been the secretary branded by Dwight? Insufficient evidence is available at present, but further research may provide the answer.

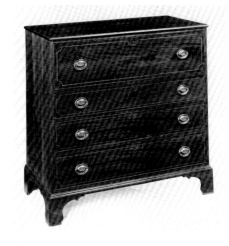

28C.

*Secretary, attributed to Langley Boardman (1774–1833), Portsmouth, New Hampshire, 1800–1810. Mahogany, *red pine, and *eastern white pine, H. 42¼; W. 43⅛; D. 22⅝. Newington Historical Society, Newington, New Hampshire. The secretary may have originally belonged to Richard Hart (1766–1843) of Newington, whose initials are branded on the case back.*

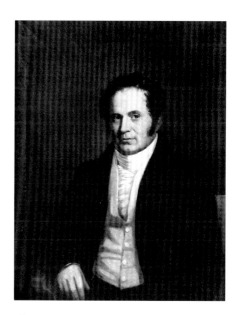

28D.

Dr. Josiah Dwight, *by Joseph G. Cole (1806–58), Portsmouth, New Hampshire, ca. 1829. Oil on canvas, H. 36; W. 28¼. Society for the Preservation of New England Antiquities, Boston, Massachusetts, museum purchase with funds provided in part by Mr. and Mrs. Joseph P. Pellegrino, 1988.38.2.*

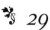 *29*

Desk

Portsmouth, New Hampshire
1805–15
Museum of Fine Arts, Boston, Massachusetts
M. & M. Karolik Collection of 18th-Century
American Arts, 41.576
Courtesy, Museum of Fine Arts, Boston

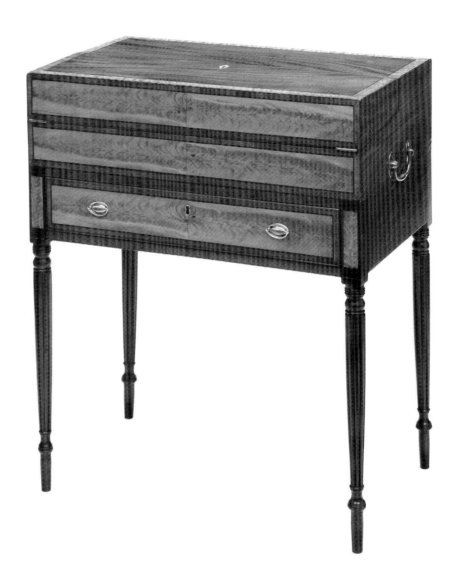

COMPACT CONVERTIBLE DESKS OF THIS FORM offered the consumer an alternative to larger secretary and bookcases such as cat. no. 28. The desk not only saved precious space but cost less than more substantial case furniture. When not in use, the writing surface and two interior drawers (29A) remain hidden behind the brightly veneered box-like frame. The hinged desk area swings open to provide a baize-covered surface for writing or reading. Storage compartments for books and paper are located beneath the writing surface.

The origin of this form remains obscure, but it could be derived from the mechanized harlequin table, which has a rectangular frame, flanking hinged lids, and a compartmentalized box that rises out of the frame through the use of springs and weights.[1] Another related form is the modest "portable desk" (29B), which shares the same box shape and hinged lid, but lacks legs, enabling it to be used on any available flat surface.[2] Desks were generally situated in back parlors, a secondary public space that frequently served as a multipurpose sitting room, dining room, and study.[3]

Previous authors have attributed this desk to Boston.[4] However, its design and history place it in Portsmouth. The reeded legs with the baluster and ring capitals appear on other examples of Portsmouth furniture (*cat. no.* 63). Six related desks from the Piscataqua region have been identified; one of them descended in the Wendell family and may be the writing desk Jacob Wendell purchased for $9.25 in 1813.[5]

The first owner of this desk, which is branded "J • HAVEN.," could have been Joseph (1757–1829), John (1766–1845), or Joshua (1779–1830) Haven, sons of the Rev. Samuel Haven (1749–1806) and merchants in Portsmouth. The inventory of Joseph's estate includes "2 Portable Writg desks" worth $5 in the southeast room.[6] John's estate was not inventoried, but the 1849 inventory of his wife's estate included an old desk worth $1 situated in the chamber over the front entry.[7] There is no surviving estate inventory for Joshua, the youngest brother, who built a home for himself in Portsmouth in 1812.[8] Regardless of which J. Haven originally owned the desk and other branded pieces (*see cat. nos. 37 and* 45), they provide tangible evidence of the varied furnishings used within one family's Portsmouth home.

DCE

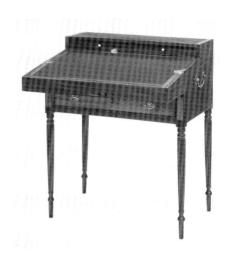

29A.

Desk interior.

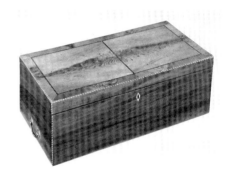

29B.

*Portable desk. Probably Portsmouth, New Hampshire, 1800–1815. Mahogany and birch veneer, *Spanish cedar, *eastern white pine, H. 8; W. 22; D. 11. Old York Historical Society, York, Maine, 1976.52. The desk originally belonged to Nathaniel (1732–1831) and Sally Sayward Barrell (1737–1805) of York.*

Structure and Condition: The desk consists of a dovetailed box fastened to a joined frame with a single drawer. A series of small rectangular blocks glued to the frame and underside of the bottom of the box bind the two units together. The hinged writing surface swings open and rests against the box façade. The legs extend to the top of the frame. The upper front rail of the frame is attached to the top of each front leg with a sliding dovetail. Drawer supports are nailed to the sides of the frame.

The long exterior drawer is fastened at the corners with large thick dovetails. Cockbeading covers the edges of the veneered drawer front. The drawer bottom is set into dadoes in the front and sides and nailed to the back. The bottom consists of two boards with grain parallel to the front. The construction of the small interior drawers matches that of the long drawer with two exceptions: the drawer fronts are solid mahogany and lack cockbeading. An old red wash covers the case back and storage compartments beneath the writing surface.

The overall condition of the desk is good, although there are shrinkage cracks on the sides and minor veneer loss. Modern baize covers the writing surface. Runners have been added to the bottom edges of the exterior drawer sides. The interior right drawer contains later partitions. Earlier in this century, perhaps during the late 1930s, the desk was refinished. In 1991, the Museum of Fine Art's conservator replaced missing veneer, removed a pair of later brass knobs from the exterior drawer, and mounted appropriate reproduction hardware into the original post holes.

Inscriptions: Branded "J • HAVEN."

Materials: *Unidentified tropical hardwood legs; mahogany drawer fronts in desk interior; *mahogany veneer on case top, sides, and drawer cockbeading; birch veneer and *hard maple banding on façade and drawer front; *eastern white pine for all secondary work except maple core for lower front rail. Replaced brass handles and ivory knobs; original hinges and lid lock.

Dimensions: H. 35¹¹⁄₁₆; W. 30⁷⁄₁₆; D. 18½

Provenance: Owned by J. Haven in the early nineteenth century; purchased by Martha and Maxim Karolik in 1940 and given to the Museum of Fine Arts, Boston, in 1941.

Publications: Hipkiss 1941, no. 31; Stoneman 1959, no. 46; Comstock 1962, no. 488; Kaye 1978, pl. 5, 1101–2; Davidson 1980, fig. 26.

1. *Cabinet-Makers' London Book of Prices* 1793, pl. 10, fig. 1. The basic harlequin table cost £3.6.0.

2. Two New England paintings depict portable desks in use within domestic interiors of the federal era. See Garrett 1990, 64, and Peterson 1971, pl. 13.

3. Garrett 1990, 65–66. Garrett notes that desks were largely men's furnishings and "connoted male learning and business acumen." The exception to this are specially designed lady's writing desks (*see cat. no. 30*).

4. Hipkiss 1941, 54; Stoneman 1959, 101.

5. Samuel Larkin to Jacob Wendell, receipt, July 31, 1813, Wendell Collection, case 13, Baker Library, Harvard Business School. This desk probably came from the workshop of Samuel Wyatt (1776–1863) of Portsmouth, who hired Larkin to auction the contents of his store on July 27, 1813, four days prior to the date on Wendell's receipt; *New Hampshire Gazette,* July 27, 1813. The Wendell desk is in the collection of Strawbery Banke Museum (1986.16); see *Antiques* 142:1 (July 1992): 100. A related example resided for more than a century in the Warner House in Portsmouth and is now owned by a descendant. The Winterthur Museum owns another (57.865); see Montgomery 1966, no. 193. A fourth is illustrated in *Antiques* 11:4 (Apr. 1927): 257; a fifth was sold at Skinner, Inc., sale 674, Apr. 25, 1980, lot 341; and a sixth was advertised by Israel Sack in *Sack Collection,* 2:321. A mahogany version with spiral-turned legs has descended in a Kittery family to the present owner; another was made by Samuel Dockum of Portsmouth between 1820 and 1830 (fig. 59).

6. Joseph Haven, 1829 inventory, old series, docket 11857, Rockingham County (N.H.) Probate.

7. John Haven, 1845 will, old series, docket 15023, Rockingham County (N.H.) Probate; Ann Woodward Haven, 1849 inventory, old series, docket 15719½, Rockingham County (N.H.) Probate.

8. Foster 1896, 25. Joseph, John, and Joshua Haven are the only J. Havens listed as property owners on the 1807 and 1817 city tax lists. Portsmouth Tax Lists, 1807 and 1817, Portsmouth City Hall.

 30

LADY'S CABINET AND WRITING TABLE

John Sailor (w. ca. 1809–33)
Philadelphia, Pennsylvania
1809
Governor John Langdon House
Portsmouth, New Hampshire
Society for the Preservation of New England
Antiquities, bequest of Elizabeth Elwyn
Langdon, 1966.368

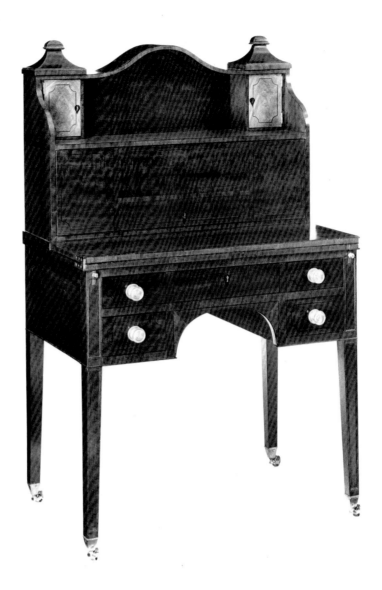

BY THE LATE EIGHTEENTH CENTURY, pattern books had become important sources for the transmission of ideas about furniture forms and styles from England to the United States. Two of the most notable examples were books by George Hepplewhite and Thomas Sheraton. They introduced the neoclassical style to their readership, who accepted it with enthusiasm. The maker of this desk relied on a popular design, plate 50 from Sheraton's *The Cabinet-Maker and Upholsterer's Drawing-Book*, published in London in 1793 (30A). Similar desks based on the same design were made by craftsmen in Philadelphia, Baltimore, and New York.[1]

Sheraton described the desk as "A Lady's Cabinet and Writing Table" and stated that it "is intended for writing on, and to hold a few small books in the back of the upper part."[2] With this in mind, Sheraton designed an elegant piece with shelves, pigeonholes, and ample drawer space behind a retractable front. The writing surface folds out of the way when not in use. Thanks to a sturdy frame and the practical use of casters, the desk could be moved easily about the room. The American maker of this example, John Sailor, varied Sheraton's prototype somewhat by adding lopers to support the writing surface, changing the pattern in the inlay motif, foregoing ornate trim on the legs, and simplifying the shape of the urns (30B).

This lightweight and portable form marks a change away from the massive, architectonic desk and bookcases popular a generation earlier. Moreover, the Sheraton-inspired example was designed specifically for ladies, indicating a growing concern with pleasing women as consumers.

Outstanding documentation survives for this desk, because both the maker and the first owner marked it. Sailor left his signature and the date 1809. He kept a shop throughout the 1820s in the vicinity of Seventh and Eighth streets in Philadelphia; then, in 1831, he sold off his stock because of declining business.[3] The Winterthur Museum owns a signed worktable by Sailor from 1813, the only other known piece by him.[4] Both the lady's desk and the worktable exhibit Sailor's accomplishments as a cabinetmaker.

Thomas Elwyn was the first owner of the lady's desk, although he probably bought it for his wife, Elizabeth Langdon Elwyn. Born in Canterbury, England, in 1775, Thomas Elwyn studied at Trinity College, Oxford, and came to Philadelphia in about 1797. He was reading law when he met his future wife, Elizabeth Langdon, the only child of John Langdon of Portsmouth, who was at that time a United States senator. After their marriage in 1797, the couple lived in Portsmouth at the lavish home of her uncle, Woodbury Langdon.[5] Elwyn was an attorney and a representative to the New Hampshire State Legislature. Upon his death in 1816, the inventory of his estate shows that he had a "secretary" valued at $30 in the front parlor and one in the front east bedroom worth $15.[6] Either of these desks could have been the one that survives today. Besides being an important example of pattern-book furniture, this desk documents the fact that Portsmouth citizens participated in an urban network that extended beyond the Piscataqua region to centers throughout the entire eastern seaboard.

D C E

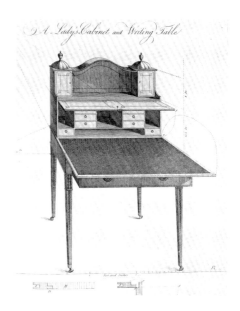

30A.
A Lady's Cabinet and Writing Table, plate 50 in Thomas Sheraton's The Cabinet-Maker and Upholsterer's Drawing Book *(1793). Courtesy, Printed Book and Periodical Collection, The Winterthur Library, Winterthur Museum, Winterthur, Delaware.*

Structure and Condition: The joined frame is fastened to the dovetailed upper case with eight screws. The interior of the frame resembles that of cat. no. 21, but the workmanship is more accomplished. The dovetailing for the drawers is finer and more precise. Drawer sides, bottoms, and backs are carefully planed to remove saw marks. The large drawers have fronts of white pine veneered with mahogany; the small drawers have mahogany veneered with satinwood, as well as mahogany sides and backs. The desk interior is constructed in a standard manner: partitions and dividers slide into dadoes, and the case back is nailed to the rabbeted edges of the sides.

When acquired by SPNEA, the desk had numerous pieces of lost or cracked veneer, stringing, and cockbeading. The hinges supporting the desk front had broken, and the front was stored in the recess above the partitioned compartments. The leather on the writing surface was replaced. Inappropriate replacement hardware was affixed to the drawers of the frame,

while the overall surface was covered with a thick, glossy oil-based polish. In 1989, Joseph Godla of the SPNEA Conservation Center conserved the desk, installed suitable hardware, and analyzed and restored the finish. Beneath the oil-based polish, he discovered a natural resin varnish over a layer of shellac. The shellac layer, which was probably the original finish, proved too thin and uneven to provide adequate coverage. Godla removed the oil-based polish, exposing the over-varnish, and used shellac to touch up the finish. The entire surface was waxed and buffed.

Inscriptions: Branded "T•ELWYN." on the backboard; "Chas. B. Meder." in pencil on the bottom of the lower right interior drawer; the compartment drawers and drawer openings are numbered consecutively; and in pencil on the bottom of the top drawer of the lower case "1809 Phil[a] December 5[?]/ Made By John Saylor."

Materials: *Mahogany legs, case sides, and domed caps over the upper case doors; *mahogany veneer on upper case top, drawer fronts, lid, and bookcase back; satinwood veneer on upper case doors and interior drawer fronts; stained holly string inlay on façade; *eastern white pine for all secondary work, except mahogany drawer sides and backs in desk interior. Original casters; original ebony knobs on interior drawers; replaced hardware and locks on exterior drawers.

Dimensions: H. 52; W. 31¹¹⁄₁₆; D. 20¼

Provenance: Thomas Elwyn (1775–1816) and his wife Elizabeth Langdon Elwyn (1777–1860); probably to their son, Dr. Alfred Elwyn (1804–84) of Philadelphia; then to their grandson Alfred Elwyn (1832–1924), a clergyman who lived in Portsmouth; and finally to their great-granddaughter, Elizabeth Elwyn (1871–1946), who married her cousin, Woodbury Langdon (1837–1921) in 1896. Elizabeth Elwyn Langdon lived in the Governor John Langdon House during the first half of the twentieth century and bequeathed the house and furnishings, including this lady's desk, to SPNEA in 1947.

1. For related desks with Philadelphia histories, see Flanigan 1986, nos. 87 and 88; for one with a Baltimore history, see Montgomery 1966, no. 188; and for a desk attributed to New York, see *Girl Scouts Exhibition* 1929, no. 718.

2. Sheraton 1793, 407. For a simplified version of the design, see *Cabinet-Makers' London Book of Prices* 1793, pl. 23, fig. 2.

3. Ducoff-Barone 1991, 993. Ducoff-Barone kindly provided this auction advertisement, which ran in *The National Gazette*, Apr. 2, 1831, "By Henry Erwin 19 N. 3rd [Street] Stock of a Cabinetmaker On Monday 11 inst. at 10 on the North Side of Arch nr 8th All the stock in trade of Mr. John Sailor, declining business, consisting of the balance of furniture on hand, materials tools, benches etc." Sailor was in the Philadelphia directory as late as 1833.

4. Montgomery 1966, no. 423.

5. After Woodbury Langdon's death in 1805, John Langdon purchased his brother's residence and gave it to Elizabeth and Thomas Elwyn; a copy of the original deed is preserved in the Langdon Papers at Strawbery Banke Museum.

6. Thomas Elwyn, 1816 inventory, old series, docket 9270, Rockingham County (N.H.) Probate. Elwyn maintained ties to Philadelphia throughout his life. His will reveals that he owned a house on Sansom Street in that city, which he left to his son John.

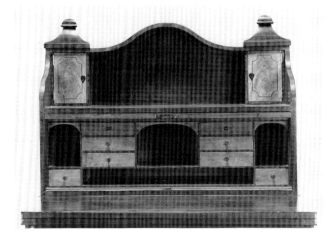

30B.

Desk interior.

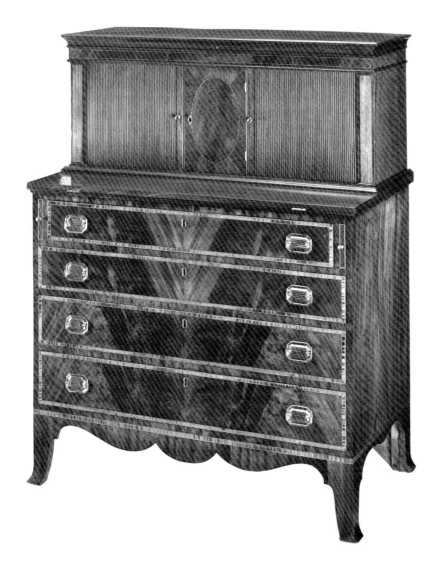

§ *31*

Tambour secretary

Attributed to Langley Boardman (1774–1833)
Portsmouth, New Hampshire
1800–1815
Society for the Preservation of New England
Antiquities, Boston, Massachusetts, gift of
Virginia L. Hodge and Katherine D. Parry,
1942.1355

TAMBOUR DOORS have long been associated with fine federal case furniture from Boston. Composed of wooden strips glued to canvas and set into tracks within the case, the tambour provided a flexible door that retracted from view as it was opened. The first instance of its use in New England appeared in the work of the English immigrant John Seymour, who established a shop at Creek Square in Boston in 1794.[1] Soon, craftsmen in Salem, Newburyport, and Portsmouth had adopted the mechanical innovation for writing tables and small secretaries.[2] Yet in these smaller communities, the form was never produced in quantity, apparently because of its high cost as well as the intrinsic fragility of the tambour panels. The device is an ingenious one, intended to work with a satisfyingly fluid movement, but it can degrade rapidly, as the English designer Thomas Sheraton noted, "being both insecure, and very liable to injury."[3]

This handsome tambour secretary is one of three closely related examples from Portsmouth.[4] All correspond in their overall design, desk interior plan (31A), and inlay pattern on the prospect door and frieze. Though none retain definitive Portsmouth histories, they share numerous details with the documented work of Langley Boardman and probably originated in his shop. The interlaced diamond at the center of the frieze on each example matches that on Dr. Josiah Dwight's secretary and bookcase by Boardman (*cat. no.* 28). Furthermore, they resemble the Dwight secretary in arrangement of support blocking for the base (31B) and in lower case construction (31C). Like their documented counterpart, large triangular rear

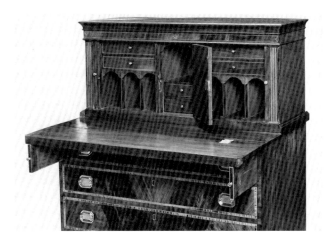

31A.
Desk interior.

31B.
Underside of the bottom of the lower case.

elements are dovetailed to the rear bracket feet. In addition, their foot and skirt design as well as drawer construction correspond to similar details on another secretary, made by Boardman and his journeyman Ebenezer Lord for William Morton of Portsmouth in 1813 (*cat. no.* 34).

Langley Boardman maintained a sizable business, servicing both local clients as well as purchasers in distant ports. His export trade extended as far as Buenos Aires, and, like his competitors Jonathan Judkins and William Senter, he probably shipped furniture to cities along the southern coast of the United States as well.[5] On occasion, these exports influenced local craft traditions. A cabinetmaker in Norfolk, Virginia, apparently used a Boardman secretary as a model for his own work (31D).[6]

Of the surviving furniture by Langley Boardman, this tambour secretary ranks among the best preserved. It retains nearly all of its original structural elements, hardware, and finish. These structural elements include a particularly distinctive feature that may help link other case furniture to Boardman's shop. Two blocks mounted to the top of the lower case fit into mortises in the upper case to prevent the case from sliding. A similar technique occurs on two small secretaries with glazed doors that descended in Portsmouth families.[7]

The stamped brass hardware on the tambour secretary bears the mark of its maker, Thomas Hands and William Jenkins of Birmingham. The firm exported

significant quantities of brass to America, and several examples of their work remain on Portsmouth furniture (*see cat. nos.* 10, 13, 21, *and* 23).[8] In addition to the standard assortment of handles and knobs, this tambour secretary retains a rare brass hook-and-eye latch on each tambour door. The eye was screwed to the edge of the door.[9] As the door closes, the eye slips through a slot in the adjoining partition and the hook drops into the eye to lock the tambour.

Original finishes rarely survive on furniture. Frequently owners cleaned and revarnished their possessions, removing any trace of their first surface coating. Such treatments have remained a traditional source of business for artisans. Even Langley Boardman, Portsmouth's most prolific furniture maker, was called upon to restore older furniture from time to time. In 1814, he charged one customer $1.50 for "scraping and pollishing pair of card tables."[10] The tambour secretary also underwent restoration, probably in the late nineteenth century. Mercifully, the repairman chose not to strip away the early finish but merely to cover it with a thick resin varnish. In 1990, microscopic analysis of the finish revealed two original coatings: a red stain beneath a rubbed beeswax finish. Much of the beeswax had soaked into the pores of the wood and was no longer visible on the secretary. SPNEA conservators carefully removed the later varnish and, using a heat gun, successfully brought the beeswax back to the surface.

During the federal era, beeswax had wide appeal as an inexpensive coating that could be rubbed to a high gloss. Boardman apparently made extensive use of the material for it survives on another stylish case piece attributed to his shop—a large library bookcase made for James Rundlet (*fig.* 45). Yet, the coating had its limitations. According to *The Cabinet-Maker's Guide* of 1825:

> bees'-wax has been used either by itself, or mixed with spirits of turpentine for a very considerable period…[it] at first produces a very good gloss, though it does not wear well, and is particularly liable to spot with wet, and look smeary when touched with the fingers.[11]

These disadvantages often led owners to replace wax finishes with more durable varnishes. Today, this tambour secretary is one of the few remaining objects that document this once common treatment.

B J

31C.
Lower case interior.

Structure and Condition: The secretary separates into two sections. The sides and top of the upper case are veneered; the bottom is faced with a 2" strip of mahogany. The sides are dovetailed to the top and bottom. The back of the case is a single horizontal board nailed to the rabbeted rear edges of the sides and top and flush edge of the bottom. The one-piece mahogany cornice is glued to the case sides and a veneered rail above the tambour doors. Below the front rail, a pine top for the desk interior is set into dadoes in the case sides and nailed from the back.

Each tambour door slides in L-shaped tracks that extend to the back of the case. Vertical partitions separate the tracks from the desk interior. The partitions and dividers within the desk interior are set into narrow dadoes in the case. The shaped valances of the pigeonholes are glued to the partitions and dividers and reinforced with small glue blocks. The prospect door is made of a single mahogany board veneered with mahogany. The drawers within the interior are neatly fastened with narrow dovetails. Each drawer front is solid mahogany with light-wood stringing. The bottom is glued to dadoes in the front and sides and is pinned to the back with wooden pins. The upper case fits

against the waist molding attached to the lower case. Two wooden blocks mounted to the top of the lower case prevent the upper case from moving once in place.

The top, sides, and bottom of the lower case are each two boards. The sides are dovetailed to the top and bottom. The veneered front board of the top serves as the writing surface. Two hinges secure the solid mahogany lid to the writing surface. The skirt and feet are separate units glued to the case bottom and backed with a series of horizontal blocks. A vertical block reinforces each foot. The construction of the front feet conforms to that of the secretary attributed to Langley Boardman and Ebenezer Lord (*cat. no.* 34): the mahogany facings on the front and side of each foot are butted and glued; however, the pine core behind the facings is mitered (31B).

Within the lower case, dividers separate the drawers. The dividers range in depth from 3⅜" to 4¼" and are secured to the case sides with sliding dovetails. A dustboard is set into dadoes behind the middle divider. Drawer supports glued and nailed to the case sides back the other two dividers. Drawer stops for the lower three drawers are glued to the case sides at the back. The stops for the top drawer are glued to the

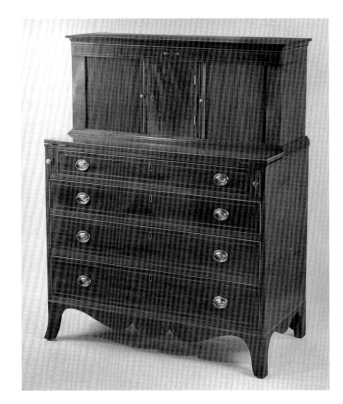

31D.

Tambour secretary. Norfolk, Virginia, 1800-1815. Mahogany and mahogany veneer, yellow pine, and yellow-poplar, H. 49¾; W. 38¾; D. 20⅜. Museum of Early Southern Decorative Arts, Winston-Salem, North Carolina, MESDA Purchase fund, 3807. Courtesy, Museum of Early Southern Decorative Arts.

case back. Rectangular lopers for the lid flank the top drawer. Each loper is a single pine board tongue-and-grooved into a 1¼" facing of mahogany. A shallow partition backed by a long guide separates the drawer from the loper. The partition is tenoned into the upper divider and rail beneath the writing surface. The guide is nailed into a support for the top drawer. A second guide above the loper and glued to the case side prevents the loper from tipping as it slides out.

The exterior drawers are fastened with fine dovetails at the corners. Each drawer front is a single pine board veneered with curly maple and figured mahogany. Cockbeading was never present, but a thick strip of mahogany covers the top edge of the front. The drawer bottom—

two single pine boards with grain parallel to the front—fits into dadoes in the front and sides and is nailed to the back with three original cut nails. A strip of pine blocks is glued to the bottom along the lower edge of the sides. Hand-saw marks remain visible on the underside of the drawer bottom and the inside of the case back.

Thorough examination of the secretary in 1989 revealed many areas of minor damage. The flaring tip of the right rear foot had fallen off; the tip of the left rear foot was missing; the sides of the waist molding had become loose and were stored in a drawer; veneer on the case top had cracked and begun to lift; veneer on the façade had become loose or chipped in several small areas; five bail posts were either missing or

broken; four knobs on the interior drawers were missing; and finally, the finish had darkened noticeably and begun to flake off. In 1990 Joseph Twichell of the SPNEA Conservation Center repaired the feet, reattached the waist moldings, reglued all areas of loose veneer, replaced the missing bail posts and knobs, and restored the original beeswax finish.

Inscriptions: "Bottom" in pencil on the underside of the bottom of the lower case; "X" in pencil on the drawer dividers; penciled numbers on the drawer backs; "Property of Mrs. Lovell Hodge and Miss Parry" in ink on label within next to top drawer; "H•J" stamped on back of bails.

Materials: *Mahogany moldings, upper front rail, tambour doors, pilasters, front edge of interior partitions and dividers, pigeonhole valances, interior drawer fronts, lid, lower case sides, and secondary wood for prospect door; mahogany veneer on upper case sides and top, front half of writing surface, prospect door, exterior drawer fronts, drawer dividers, skirt, and feet; maple veneer outlining drawer fronts and along top edge of skirt; eastern white pine for all secondary work. Original brass hinges, escutcheons, and handles except as noted under *Structure and Condition;* original iron locks in exterior drawers; replaced lock for prospect door.

Dimensions: H. 47½; W. 36¾; D. 20½

Provenance: Acquired in the early twentieth century in the Portsmouth area by Virginia L. Hodge and Katherine D. Parry to furnish the Lady Pepperrell House in Kittery, Me.; given with the house to SPNEA in 1942.

1. A native of Devonshire, Seymour immigrated to Portland, Me., in 1784 with his wife and eight children. The family removed to Boston in 1794; John Seymour and his son Thomas worked in partnership there until 1804. Two tambour writing tables labeled by the Seymours are known. See Stoneman 1959, 16–20, 28–30, 48–51, 54–55; Montgomery 1966, no. 184; and Sprague 1987d, 444–49.

2. For documented Salem examples, see Montgomery 1966, no. 187; Fales 1965, no. 23; and DAPC, 70.279. Another version, possibly from the Newburyport area, was sold by Anderson Galleries, sale 3843, Apr. 25–26, 1930, lot 254. The skirt design of the latter closely matches that of a Newburyport secretary with veneered doors at Historic Deerfield; see Fales 1976, 234.

3. Sheraton 1803, 2:316. The English typically employed the tambour on cylinder lids rather than sliding doors for writing tables and secre-

taries. The construction of the two forms is the same, and both were easily damaged.

4. For illustrations of the two related examples, see Anderson Galleries, sale 2214, Jan. 6–7, 1928, lot 40, and Sotheby Parke Bernet, sale 4478Y, Nov. 19–22, 1980, lot 1371. Additional photos of the latter were kindly provided to the author by Joseph and Robert Lionetti. The three tambour secretaries vary in just a few minor details. A birch oval ornaments the center of the prospect door of the secretary sold at the Anderson Galleries, while mahogany ovals decorate the other two. Cat. no. 31 is the only one in the group with curly maple banding on the drawers. Finally, the Anderson Galleries example is about 2" shorter than the others. The maker of these three secretaries may also have constructed a plainer version, sold at Parke-Bernet, sale 2016, Feb. 10–11, 1961, lot 383. Two additional tambour secretaries made in the Portsmouth area are clearly the work of another hand. See *Antiques* 52:5 (Nov. 1947): 295, and Parke-Bernet, sale 2103, Apr. 14, 1962, lot 276.

5. *Portsmouth Journal,* May 28, 1825; for a documented instance of furniture exportation to southern ports by Judkins and Senter, see fig. 54.

6. The Norfolk tambour secretary is discussed in Hurst and Priddy 1990, 1146–47, 1151, pl. 14; see also Bivins and Alexander 1991, fig. 5.

7. Both secretaries share other features with the tambour example. All three have the same skirt and foot design as well as the same interlaced inlaid diamond on the frieze. One of the secretaries descended in the Bowles family of Portsmouth and was advertised by Israel Sack; see *Sack Collection,* 2:545. The other belonged to Nathaniel T. Moulton of Portsmouth in the early nineteenth century and was advertised by Thomas Longacre of Marlborough, N.H.; see *Antiques and the Arts Weekly,* Aug. 3, 1990, 113.

8. Fennimore 1991, 89–91.

9. The eye for the right door is missing.

10. Boardman v. Wentworth, Jan. 2, 1815, series A, docket 38657, Rockingham County (N.H.) Court, State Archives.

11. Quoted in Mussey 1987, 293; see also 293–95 for further information about beeswax finishes.

32

LADY'S SECRETARY

Attributed to Judkins and Senter (w. 1808–26)
Portsmouth, New Hampshire
1808–20
The Currier Gallery of Art
Manchester, New Hampshire
Gift of the Friends, 1971.26

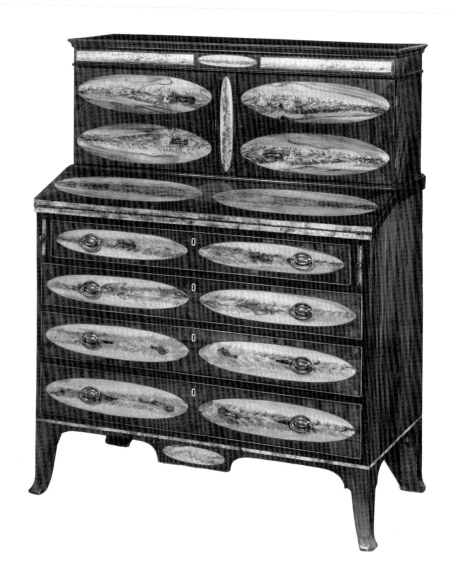

IN *The Cabinet Dictionary* OF 1803, Thomas Sheraton described "secretaries for la-dies, of small size, usually with a book shelf on the top part."[1] This type of secretary was available in Portsmouth as early as 1799, when the cabinetmaker Langley Boardman advertised "Secretaries and Book-Cases" as well as "Ladies Secretaries" for sale.[2] Sheraton's description encompasses a variety of moderately sized desks featuring storage space in the upper case, such as those with tambour doors (*cat. no.* 31) or this desk with veneered panels. The overall forms of the preceding secretary and this one are similar, but their surface treatments vary dramatically.

Rather than relying solely on the rich but subtle effects of mahogany veneer, this craftsman utilized mahogany along with highly figured birch to create a vibrant display of contrasting colors. Moreover, he arranged these veneers in an intricate design featuring rectangles surmounted by diamonds at the center and overlaid with ovals.[3] Geometric motifs cover the entire façade; even the top features a veneered oval and banded border. The maker cleverly adjusted the scale of the ovals to fit each section, and he selected extremely handsome wood. In less skillful hands, the combination of elaborate veneer with a complex surface treatment might have cre-ated a discordant effect, but the craftsman has handled his materials with such con-trol that this secretary stands as one of the most successful and dramatic examples of veneered furniture to come out of Portsmouth.[4]

This lady's secretary is almost certainly from the shop of Jonathan Judkins and William Senter. Its drawer construction matches that used on the Jacob

Wendell sideboard (*cat. no. 37*) and the Wendell secretary and bookcase (*cat. no. 33*), both of which are documented Judkins and Senter pieces. In addition, the case construction of the two secretaries is nearly identical, particularly in the shape of the triangular supports for the rear feet and in the series of small horizontal glue blocks reinforcing the front skirt (33c). Even the attenuated French feet boast the same upturned toe on both examples.

D C E

Structure and Condition: The secretary separates into two sections. The veneered sides of the upper case are dovetailed to the top and bottom. Support blocks are glued to the underside of the bottom along the front and sides. The back is nailed to the rabbeted rear edges of the case sides and top. Each door is made of a single horizontal pine board with vertical mahogany cleats. The right half of the interior contains four pigeonholes, four small drawers, and a narrow shelf. The compartmentalized details behind the left door are missing. The upper case fits within a waist molding attached to the lower case.

The hinged writing surface and the top of the lower case are each a single pine board with mahogany cleats. Nails secure both elements to the case sides. Beneath the top, a horizontal slat is dovetailed to the case sides. The same distinctive feature appears on the Wendell family secretary made by Judkins and Senter (*cat. no. 33*). The back—two horizontal butt-jointed boards—is nailed to the rabbeted rear edges of the case sides. The two-board bottom fits into dadoes in the case sides; each side extends down to form the side skirt and feet. The front skirt is a separate unit glued to the bottom of the case and backed by blocks. Two additional wedge-shaped blocks support the drop panel. A large triangular rear element is rabbeted and nailed to the back edge of each rear bracket foot.

The arrangement and construction of the drawer supports and dustboard within the lower case corresponds to that of cat. no. 31, with one exception—the top edge of each loper is tapered to support the sloping lid when it is open. The construction of the lopers and drawers matches that of cat. no. 33.

Though in good condition and retaining most of its original elements, the secretary does have shrinkage cracks in the veneer and a highly refinished surface. The green baize on the writing surface is replaced. The interior of the upper case bears traces of an old red stain. In addition, the right front foot and left rear foot are chipped, and one original support block for the feet is now stored in a drawer.

Inscriptions: "X" in pencil on drawer dividers and drawer backs; penciled numbers also on drawer backs.

Materials: Mahogany moldings, front edge of the lopers, and cleats on the door, writing surface, and lid; mahogany veneer on the case sides, feet, and drawer dividers; mahogany and birch veneer on the top, doors, slant lid, drawer fronts, and drop panel; she-oak veneer surrounding vertical oval in upper case and central oval in frieze; *eastern white pine for all secondary work. Replaced brass hardware on exterior drawers; original bone knobs on interior drawers; original hinges, locks, and bone escutcheons.

Dimensions: H. 53¾; W. 42½; D. 20⅜

Provenance: Purchased by The Currier Gallery of Art in 1971 from Fred L. Johnston, an antiques dealer of Kingston, N.Y.

Publications: Antiques 79:4 (Apr. 1961): 328; Buckley 1963, 199; Michael 1972, figs. 18–22; Currier Gallery of Art *Bulletin* 1 (1972): fig. 3; Komanecky 1990, no. 166.

1. Sheraton 1803, 2:303.

2. *New Hampshire Gazette*, Apr. 5, 1799.

3. Apparently the maker used the pine top of the lower case as a working surface when cutting out the large birch ovals that decorate the façade. Scribed lines in an oval pattern are scratched into the top.

4. Two related chests are illustrated in *Sack Collection*, 1:254 and 6:1449.

 33

Secretary and bookcase

(Colorplate 9)
Judkins and Senter (w. 1808–26)
Portsmouth, New Hampshire
1813
William E. Gilmore, Jr., and Terri C. Beyer,
on loan to The Currier Gallery of Art
Manchester, New Hampshire

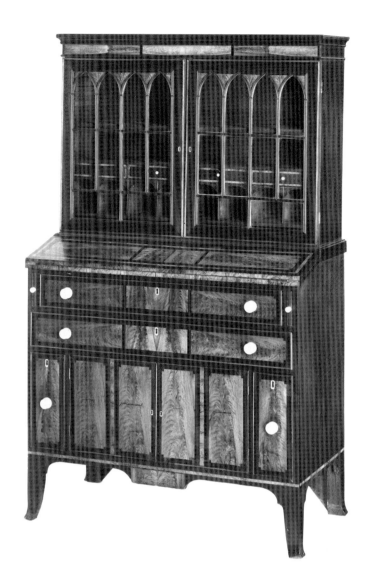

In 1813, Jacob Wendell (1788–1865), a Portsmouth bachelor and merchant, purchased this secretary and bookcase for the substantial sum of $50 from the cabinetmaking firm of Judkins and Senter.[1] Wendell, who carefully saved the receipt, used this secretary not only to store account books and receipts, but also as a place to write, read, and even to indulge in an occasional glass of spirits, which could be stored in the specially designed bottle drawers. Secretary and bookcases, especially those fitted with the unusual feature of bottle drawers, were designed for a gentleman's needs, while ladies relied on more delicately scaled varieties (*see cat. nos. 30, 31, and 32*).

Wendell purchased a commodious but old-fashioned hip-roofed house on Pleasant Street in 1815.[2] He furnished it with pieces already in his possession, like this two-year-old secretary, as well as with new items. A room-by-room inventory taken in about 1828 reveals that the secretary was kept in a room that doubled as a dining and sitting room. The furnishings included: the secretary, a sofa, a sideboard, a Grecian card table, one large carpet, six chairs, a clock, an astral lamp, various tablewares, and fireplace equipment. The dining table was stored in the entry.[3] Early in the twentieth century the secretary was still in the same room, but was subsequently moved to the parlor directly across the hall.[4]

Despite the vagaries of fashion, the Wendell family continued to use this secretary and bookcase for generations, ensuring its survival as one of the best documented and most stylish pieces of early nineteenth-century Portsmouth furniture.

The bookcase, which features glazed doors with Gothic lancet panes, contains adjustable shelves, drawers, and pigeonholes. The writing surface unfolds to rest on lopers situated on either side of the top drawer in the lower case (33A). Ample storage is available in the lower case, either in the top drawers or cupboard, which is flanked by bottle drawers. The use of a full dustboard to support the second drawer (33B) is a typical Portsmouth construction detail. In addition, Judkins and Senter's case pieces often feature a continuous row of small rectangular glue blocks behind the skirt and large triangular elements rabbeted and nailed to the back edge of the rear feet (33C). Other traits characteristic of this shop include: covering approximately two-thirds of the front dovetails on the drawers with cockbeading; extending the dovetail saw kerfs in the drawer sides at least ¼" beyond the dovetails (33D); and mounting a strip of rectangular blocks along the lower edge of the drawer sides, with the rear block cut at a 45-degree angle (33E). Mahogany, flame birch, and rosewood veneer envelop the case, giving it a surface that glows with color and pattern, proving that Judkins and Senter had a fine sense of design to correspond with their technical abilities. A closely related secretary and bookcase originally owned by William Shaw, a Portsmouth merchant who purchased a house in 1813, also came from Judkins and Senter's shop.[5]

Jacob Wendell began patronizing Jonathan Judkins (1780–1844) and William Senter's (1783–1827) establishment shortly after they opened for business in 1808, when he hired them to make gunstocks and alter a bedstead.[6] He continued to turn to the firm for minor tasks such as "making a Sign board 2.50" and "Mending furniture for Dorothy Wendell 1.50" in the early years, when both merchant and craftsmen were establishing themselves.[7] Wendell also inherited furniture and frequented local auctions, where he bought a variety of household items.[8] About 1815 Wendell's success seemed assured, so he turned to Judkins and Senter, then one of the preeminent cabinetmaking ventures in Portsmouth, to make additional furniture for his new home (*see cat. nos. 37, 64, and 70*). After he married and as his family grew, he bought a mahogany cradle for the extravagant price of $9 and a more utilitarian "Bedstead with Truckels" for $4.[9] Judkins and Senter dissolved their partnership in 1826, when Senter's health failed. A few years later Jacob Wendell saw his fortune dwindle to the point of near bankruptcy. But, he continued to turn to Jonathan Judkins, who maintained the workshop with the help of his sons, for minor purchases and repairs. Surviving receipts reveal that Wendell transacted business with Judkins through 1843, one year before the latter's death.[10]

D C E

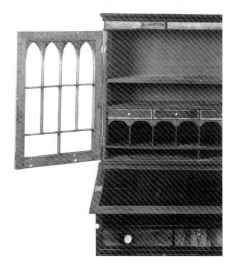

33A.
Bookcase interior and writing surface.

33B.
Detail of lower case interior.

33C.
Lower case bottom.

33D.
Front dovetails on a drawer in the lower case.

Structure and Condition: The secretary and bookcase separates into two sections. The veneered sides of the upper case are dovetailed to the top and bottom. The cornice, made of a single mahogany molding, is glued and nailed to the case sides and the upper edge of a front rail above the bookcase doors. A frieze of birch veneer and a narrow bead of mahogany covers the rest of the front rail. The back—two horizontal butt-jointed boards—is nailed to the rabbeted rear edges of the sides. There is one adjustable shelf and one fixed shelf within the bookcase. The latter is located above a row of four small drawers and eight pigeonholes. Each pigeonhole is secured with two small glue blocks. The rails of the glazed doors are tenoned into the stiles. The muntins are set into narrow dadoes in the rails and stiles. The doors once had curtains. The upper case fits against a waist molding glued and nailed to the lower case.

The hinged writing surface and top of the lower case are each a single pine board with mahogany cleats. Nails secure both elements to the case sides. Beneath the top, a horizontal slat is dovetailed to the case sides at the back to strengthen the frame. The construction of the two-board back duplicates that in the upper case. The two-board bottom of the lower case fits into dadoes in the veneered case sides; each side extends down to form the side skirt and feet. The front skirt is a separate unit glued to the bottom of the case and backed with five blocks (33c). Horizontal blocks also support the side skirts and rear elements. A single vertical block reinforces each foot.

Within the lower case, the rail beneath the writing surface and the dividers for the upper two drawers are fastened to the case sides with sliding dovetails. The lower divider is backed by a dustboard set into dadoes in the case sides. Behind the upper divider, broad supports for the lopers and upper drawer are glued into dadoes in the case sides. The lopers are made of pine boards tongue-and-grooved to 1¾" facings of mahogany. Deep partitions separate the doors from the bottle drawers in the bottom tier of the case. The partitions sit in dadoes in the case bottom and are secured at the top with nails driven through the dustboard. The doors consist of a horizontal board with vertical cleats. Stops for the drawers are glued to the case sides at the back.

The front of each large exterior drawer is a single pine board veneered with birch and rosewood. The bottom—one board with grain parallel to the front—fits into dadoes in the front and sides and is nailed to the back with three original cut nails. Hand-saw and mill-saw marks are visible on the underside of the drawer bottom and rear surface of the back, respectively (33E). The front of each interior drawer is made of a solid tropical hardwood outlined with birch banding. The bottom is glued into dadoes in the front and sides but not nailed to the back.

The secretary and bookcase survives in exceptional condition with nearly all of its original elements intact. Shrinkage cracks mar much of the veneer. An old red stain remains on the lopers, behind the doors in the lower case, and within the bookcase. The façade and case sides retain an old and darkened finish. The writing

surface was recovered with black velvet early in this century. Two panes of glass are cracked, and the lower left pane in the right door is replaced. The left side of the drop panel has an old basswood patch. The feet have several small chips.

Inscriptions: " Miss Caroline Q Wendell 38 Pleasant Street" in pencil on bottom of left interior drawer; all drawer backs numbered in pencil.

Materials: Mahogany moldings and front edge of lopers; unidentified tropical hardwood drawer fronts within bookcase and pigeonhole valances; mahogany veneer on case sides, fixed shelf within bookcase, interior of writing surface and lid, pigeonhole partitions, lopers, drawer dividers, skirt, and feet; mahogany and birch veneer on rails and stiles of the doors; rosewood and birch veneer on upper case frieze and lower case lid, drawer fronts, and doors; birch cockbeading and cleats for lower case doors; *soft maple for rails and stiles in the bookcase doors; *eastern white pine for all other secondary work. Replaced bone knobs; original brass hinges and iron locks.

Dimensions: H. 66⅜; W. 39¹⁵⁄₁₆; D. 20½

Provenance: Jacob Wendell (1788–1865); afterwards followed the same descent as cat. no. 5 until 1979, when sold from the estate of Francis A. Wendell by Roland B. Hammond to Robert Blekicki; purchased by the present owner in 1990.

Publications: Buckley 1963, fig. 4; Michael 1972, figs. 49–51.

1. Judkins and Senter to Jacob Wendell, bill, Sept. 30, 1815, Wendell Collection, folder 4, case 13, Baker Library, Harvard Business School. Wendell purchased this secretary in either February or September 1813. When he settled his account, he appears to have traded in another one: "1813 / Sept 6 By 1 Secretary $36." The notation is out of chronological order, and the total was never properly tallied.

2. Howells 1937, 52–55.

3. Jacob Wendell, ca. 1828 inventory, Wendell Collection, box 18, Portsmouth Athenaeum. See cat. no. 37 for a description of the tablewares.

4. Photograph of the Wendell parlor in Wendell 1940, n.p.

5. Randall 1965, no. 66. For a secretary with a similar bookcase but a varied lower case owned by the Trustees of Reservations, Stevens-Coolidge Place, see *Decorative Arts* 1964, no. 62.

6. *Plain and Elegant* 1979, 147–48, 151. Judkins and Senter to Jacob Wendell, bill, Mar. 25, 1810, Wendell Collection, folder 6, case 13, Baker Library, Harvard Business School.

7. Ibid; and note 1.

8. The Jacob Wendell collections at the Portsmouth Athenaeum and at the Baker Library, Harvard Business School, contain many receipts from Samuel Larkin, a Portsmouth auctioneer.

9. Judkins and Senter to Jacob Wendell, bills, Aug. 16, 1817, and Jan. 28, 1819, Wendell Collection, folder 4, case 13, Baker Library, Harvard Business School.

10. Jonathan Judkins to Jacob Wendell, bill, Aug. 24, 1843, Wendell Collection, Jacob Wendell: Bills and Receipts, 1843, Portsmouth Athenaeum.

33E.

Rear corner of drawer in lower case, showing angled glue block, widely spaced parallel mill-saw marks, and narrower hand-saw marks.

34

SECRETARY AND BOOKCASE

Attributed to Langley Boardman (1774–1833)
and Ebenezer Lord (1788–1877)
Portsmouth, New Hampshire
1813
Strawbery Banke Museum
Portsmouth, New Hampshire
Museum purchase with funds provided in part
by Joseph G. Sawtelle, Jr., 1983.6

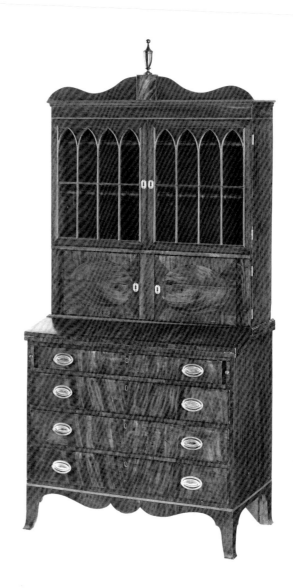

RICHLY DOCUMENTED and typical of local work, this secretary is a key object in the identification and understanding of Portsmouth federal-period furniture. It has numerous features characteristic of area examples, including a solid serpentine cornice with a rectangular tablet at the center; narrow Gothic arches in the bookcase doors; solid doors concealing the desk interior; and a skirt and foot design typical of Portsmouth furniture. The dark-wood veneer used here on the doors and the cornice has been identified as of the *Casuarina* spp. (often known as she-oak or Botany Bay wood), a type of veneer, probably imported from Australia either directly or indirectly, featured on many Portsmouth federal-period pieces. Light-wood inlay is used sparingly; rather, the maker employed richly figured mahogany veneers and geometric panels on the bookcase doors to achieve decorative effects.[1]

 The numerous inscriptions on this object enhance its value as a document of Portsmouth taste and cabinetmaking practices. It seems clear that it was made in the shop of Langley Boardman, possibly with the assistance of Ebenezer Lord, his first cousin, who also left his name on the object. Lord was born in New Market, New Hampshire, the son of Nathaniel and Lucy Boardman Lord. Although he probably apprenticed with Boardman, he is first recorded as working for Boardman in 1809, at the age of twenty-one, when he was one of perhaps half a dozen journeymen and apprentices active in Boardman's employ. He left Boardman's shop to serve as steward on the privateer *First Consul* during the War of 1812. That vessel, one of sixteen New Hampshire privateers, had an unsuccessful voyage in 1812. On

November 17 of that year, she was sold at auction, and lengthened and renamed the *Governor Plumer* by her new owners. Lord was probably back in Boardman's shop by that time. Fresh from a maturing experience at sea, Lord may have been feeling his oats and added his signature, copying the words used by the shop master, as a sign of independence. By 1815, Lord established his own cabinetmaking shop in Portsmouth, joined the Associated Mechanics and Manufacturers of the State of New Hampshire, and embarked upon a career that would last more than six decades and earn him distinction as a respected local citizen.[2]

The construction of this object reveals an evolution in techniques used in Boardman's shop as the nineteenth century began. About ten years earlier, in 1802, the shop produced a serpentine-front chest of drawers for James Rundlet (*cat. no.* 8) in a sturdy, traditional manner reminiscent of eighteenth-century objects in the rococo style. This secretary, in contrast, is made in a much more expedient and streamlined manner typical of federal-period construction.

The original owner of this secretary, as indicated by the maker's inscription as well as by multiple brands and signatures, was William Morton (ca. 1785–1865). Morton is termed a joiner in the 1821 city directory, and he lived on Joshua Street, probably on land he had purchased from Langley Boardman in 1808. It is possible that Morton, like Lord, was one of the numerous woodworking craftsmen who enjoyed employment in Boardman's shop at some time in their career.[3]

According to the inscription on the secretary, on September 10, 1813, Morton paid $55, a handsome price, for this object, and a surprisingly steep one for a craftsman of the middling sort. About two weeks later, Jacob Wendell purchased his secretary (*cat. no.* 33) from Judkins and Senter, now often considered the *ne plus ultra* of Portsmouth furniture because of its strong color contrasts created by dazzling birch and mahogany veneers, for $5 less. The difference is probably due to the use of imported *Casuarina* spp. veneer on the Boardman example and its extra doors covering the desk section.

Though varying in appearance, the two secretaries display many related structural details: comparable dovetailing, matching patterns of support blocking for the base, and strikingly similar methods for securing the top of the lower case. On both, the top is a single board with cleated ends nailed to the case sides. Slats beneath the top (two for the Boardman secretary, one for the Judkins and Senter example) are dovetailed to the case sides to strengthen the carcass. Yet, careful examination does reveal differences in the craftsmanship of the two cases. The vertical muntins on the doors of the Judkins and Senter bookcase flare noticeably at the top to reinforce the birch Gothic-arched panels (33A). On the Boardman secretary, the muntins are narrower and do not flare (34A). In addition, on the drawers of the Boardman secretary, the support strips along the lower edges of the sides lack the diagonal back corner seen on the work of Judkins and Senter (*compare* 34B *and* 33E). Such differences are minor. The remarkable consistencies verify the presence of a regional school of cabinetmaking within Portsmouth during the second decade of the nineteenth century, when competing cabinetmakers made similar products to meet the demand for fashionable case furniture.

In 1823, William Morton and his wife, Sarah (ca. 1794–1849), left Portsmouth for Salmon Falls Village, perhaps as part of the venture initiated the year before by several Portsmouth merchants, including James Rundlet, to establish the Salmon Falls Manufacturing Company, a textile mill. Although Morton left Portsmouth, he kept up his membership in the Associated Mechanics and Manufacturers until at least 1846. He died in Salmon Falls on December 13, 1865. His son, William H. Morton, went on to have a distinguished career in Rollinsford.[4]

G W R W

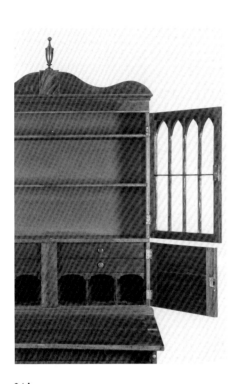

34A.

Case interior.

Structure and Condition: The secretary and bookcase separates into two sections. The sides of the upper case are dovetailed to the top and bottom. Four horizontal backboards are nailed to the rabbeted rear edges of the case sides. The pediment is secured to the case top with eight horizontal glue blocks. The central tablet is also supported by three vertical blocks; the turned finial appears to be original. The she-oak veneered frieze is secured to the case sides and top with three horizontal glue blocks and one vertical block in each corner. The cornice is a solid mahogany molding glued to the frieze and case sides. The bottom board of the bookcase is housed in dadoes in the case sides and projects ¾" to support the doors. The shelves are also housed in dadoes in the case sides. The front edge of the case sides and the shelves is decorated with a scratch bead. The joined bookcase doors are mounted to the case with two hinges each, and there is a triangular stop glued to the bottom shelf. The doors for the desk section are made of three horizontal boards that are tongue-and-grooved into cleats, and all boards are veneered. Each door conceals an interior compartment containing three pigeonholes with shaped valances surmounted by two drawers. The small drawers in the desk have fronts made of solid mahogany. The drawer sides are dovetailed to the front and back; the bottom is glued to the rabbeted edges of the sides and flush edge of the back. The drawers run on full dustboards with ½" mahogany facings, which fit into dadoes in the case sides and central partition. Drawer stops are glued to the sides of the case and central partition at the back.

The bottom of the upper case is recessed slightly, and three horizontal blocks glued to the underside of the bottom back the lower front rail. The upper case rests on the top of the lower case and fits against the waist molding glued to the lower case.

The lower case top and the hinged writing surface are nailed to the edges of the case sides. The sides are dovetailed to two shallow (2") horizontal slats beneath the top and to the two-board case bottom. The construction of the two-board back conforms to that in the upper case. The feet and skirt are secured to the bottom of the case with thirteen horizontal glue blocks. One vertical block also reinforces each foot. Large triangular rear elements butt against the rear bracket feet.

Within the lower case, shallow (2¼" to 2⅝") dividers separate the drawers. Sliding dovetails bind each divider to the case sides. Unlike the three preceding examples (*cat. nos.* 31–33), this secretary never had a full dustboard between the middle two drawers. Instead, drawer supports are glued and nailed into dadoes in the case sides. Drawer stops are glued to the case sides at the back. Lopers for the desk lid flank the top drawer. A vertical partition backed by a narrow guide separates the drawer from each loper. The partition is tenoned into the top divider and the front rail below the writing surface. The guide is nailed to a drawer support for the top drawer. Each loper is a pine board fastened with a tongue-and-groove joint to a mahogany facing.

The exterior drawers are dovetailed at the corners. Each drawer front is a single board veneered with mahogany and outlined with dark-wood inlay. Cockbeading was never present, but a thick strip of mahogany covers the top edge of the front. Each drawer bottom is made of one board with grain parallel to the front. The bottom fits into dadoes in the front and sides and is nailed to the back with original cut nails.

The secretary and bookcase retains all of its original elements except the stops for the drawers and lopers in the lower case. The bookcase doors once had curtains; one of the glass panes is cracked, but none are replaced. An old, possibly original, red wash covers the interior of the bookcase and the pigeonholes. The writing surface was relined at least a century ago with green baize. Several chips, small patches, and shrinkage cracks mar the veneered façade. Cracks in the front feet have been repaired. A modern angle iron reinforces the right end of the middle drawer divider.

Inscriptions: Branded "W MORTON •" four times on the left and right lopers. Signed on left loper "Langley Boardman Made this secretary / for Wᵐ Morton on September 10th 1813 / for the Sum of fifty five / Dollars / Portsmouth N.H." Also incised on the left loper "Eben Lord Made this Secretary / in the year." An additional inscription on the right loper reads "Sep 1813 / Mch 1861 repaired." There is another pencil inscription beside the two brands on the left loper that reads: "J N [or A] Morton [Mart?]." "William / Morton" is written in pencil on the upper case, and "William Morton / Portsmouth" is in pencil on the top board of the lower case. The upper case bears the old chalk inscriptions: "Back" on the outside of the back

and "Bottom" on the underside of the bottom. There is pencil numbering on the drawers and drawer supports.

Materials: *Mahogany pediment, moldings, case sides, interior drawer fronts, front edges of pigeonhole partitions and dustboards within desk interior, and secondary wood for bookcase and desk doors; mahogany veneer on pediment tablet, doors, desk partition, lid and writing surface, exterior drawer fronts, dividers, skirt, and feet; *she-oak (*Casuarina* spp.) veneer on frieze and bookcase doors; dark-wood inlay outlining drawer fronts; light-wood banding above skirt; *basswood lower case bottom; *eastern white pine for all other secondary work. Original hinges for doors and writing surface; replaced handles, escutcheons, and locks.

Dimensions: H. 87½; W. 40; D. 20¹¹⁄₁₆

Provenance: William Morton (ca. 1785–1865), a joiner of Portsmouth. Later history unknown. Purchased by Strawbery Banke Museum in 1983 from Peter J. Sawyer, an antiques dealer in Kensington, N.H.

Publications: Strawbery Banke, *Annual Report* 1982, n.p.; *Ellis Memorial* 1983, 34, fig. 10; Ward and Cullity 1992, pl. 7.

1. Perhaps the most closely related example is at the New Hampshire Historical Society; see *Decorative Arts* 1973, no. 38. Two examples in private collections are also closely related, including one with a very similar pediment and another with an almost identical upper case. See also one signed and branded by Supply Ham (and dated 1812) in *Sack Collection*, 7:1905. A related skirt design appears on cat. nos. 10 and 31. She-oak, or Botany Bay wood, is discussed in *Encyclopedia Britannica,* s.v. "Casuarinales," and in Hinckley 1960, 144–45. Botany Bay wood is one of the options for veneer given in the 1811 *London Cabinet-Makers' Union Book of Prices;* it was less expensive there than satinwood, ebony, and many other ornamental and exotic veneers.

2. Information on Boardman and Lord is derived in large part from Johanna McBrien's forthcoming University of Delaware master's thesis; see also Lord's obituary in *Portsmouth Journal,* July 21, 1877, and Winslow 1988, 133, 153, 178. A ca. 1779 desk and bookcase at the Metropolitan Museum of Art is signed "Nath Gould not his work," possibly by a disaffected journeyman in the shop of Nathaniel Gould (1743–82); see Heckscher 1985, no. 181.

3. The deeds between Boardman and Morton concerning property on Joshua Street are in the Rockingham County Registry of Deeds, Exeter, N.H., 183:247 (1808) and 196:335 (1812). I am grateful to Richard M. Candee for this information.

4. Frost 1945, 1:157; *Salmon Falls* 1974, 2; Catalfo 1973, 611–12. See also the record book of the Associated Mechanics and Manufacturers of the State of New Hampshire, Portsmouth Athenaeum. I would like to thank Kevin Shupe for his assistance.

34B.
Rear corner of a drawer.

35

SIDEBOARD

Portsmouth, New Hampshire
1800–1820
Strawbery Banke Museum
Portsmouth, New Hampshire
Gift of Mr. H. V. B. Richard, 1979.323

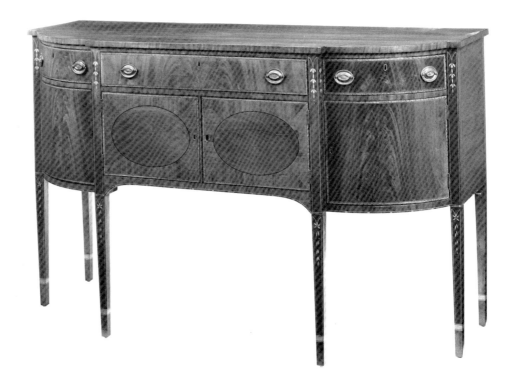

ITS BEAUTIFUL VENEERS and extensive use of pictorial inlay make this an important Portsmouth piece, as does a tantalizing inscription that strongly suggests a Portsmouth history (35A). The large ovals on the cupboard doors, set into mitered rectangles of veneer, serve as a visual focal point of the object, while the legs are embellished with distinctive floral inlays. At the top of the leg, beneath the rail, three large bellflowers descend down the leg, while below the bottom rail, two-petaled flowers trail down along a black vine from a five-petaled flower (35B).[1]

The signature "J Melcher" on the sideboard is probably that of the original owner. The 1790 Portsmouth census lists six J. Melchers as heads of household, two named James and four named John, who are possible candidates. The most likely choice is John Melcher (ca. 1760–1850), a printer and publisher. Melcher was apprenticed to Daniel Fowle, and, along with George Jerry Osborne, succeeded Fowle as publisher of the *New Hampshire Gazette* in 1786. He had a house on the corner of Congress Street and Prison Lane, where he lived with his wife Mehitable (ca. 1766–1829), and published the newspaper until he sold out in 1802. He retired in 1814, and, at his death, he was remembered as "a very exact and accurate printer and businessman, who made a snug property by his business, and lived in the best of health and spirits almost half a century after he retired from it."[2]

GWRW

Structure and Condition: The sideboard has a straight front and ovolo corners, and is supported by six tapered legs decorated with inlay at the front. The two-board case sides are tenoned to the front and rear legs, and the two-board back is tenoned to the rear legs. The top, a single mahogany board, is supported by a pine subtop frame, which is screwed in place to the case sides and back, interior partitions, and front rail. The drawer dividers are tenoned to the front legs. The drawers run on drawer supports nailed to the drawer guides, which in turn are glued to the case sides and partitions. The partitions separating the center from the end sections are tenoned to the two center front legs, respectively, and through the backboard. The bottom of each end section is a single pine board set into dadoes in the case sides and lower front rail and nailed to the lower edge of the partitions and case back. The two-board bottom of the center section slips into a dado in the front rail and is nailed to the back. Nine original glue blocks reinforce the bottom of the center section. The curved brackets beneath the doors are braced with triangular blocks. The two central doors are made of solid mahogany boards tongue-and-grooved to mahogany cleats and veneered. The end doors are made of eight horizontal laminations of pine let into mahogany cleats and veneered. The interior of the case has an old red wash.

The drawer sides are fastened at the corners with fine but widely spaced dovetails. The bottom consists of two boards running front to back and let into dadoes in the front and sides and nailed to the back.

There are three new medial braces made of yellow-poplar beneath the top. The sideboard has been refinished, but there are bleached and crazed areas. The drawers have been lined with modern green felt. Plugged holes in the doors above the escutcheons indicate that at one time the sideboard was fitted with knobs.

Inscriptions: "J Melcher" in chalk on the outside of the back and the underside of the bottom of the case.

Materials: *Mahogany top, sides, legs, drawer stops, core for central doors, and vertical cleats for end doors; mahogany veneer on drawer fronts, doors, upper front rail, divider, and skirt; maple banding on drawers and doors; *soft maple upper and lower front rails and divider; *eastern white pine for all other secondary work. Original brass hinges and handles; original iron locks.

35A.
Chalk inscription on the back.

Dimensions: H. 43⅛; W. 71³⁄₁₆; D. 26¼

Provenance: The original owner was presumably J. Melcher, whose identity remains elusive. In 1895, the sideboard was owned in Kittery Point, Me. The object was purchased on July 3, 1928, by Mrs. Harold Richard from Charles H. "Cappy" Stewart, the legendary Portsmouth antiques dealer, for $1,500. A paper long associated with the sideboard contains the following statement signed by John R. Wentworth: "This side board in / the Wentworth Family & finally / handed to John R. Wentworth / the Rightful Earl of Strafford / John Wentworth one of the originall / pioneers Gov. of Province of / Massachusetts." The connection of this history with the current sideboard is unclear; the history is probably apocryphal. The sideboard was lent to Strawbery Banke Museum in 1976 by Mr. Harold V. B. Richard of York Harbor, Me., and New York, N.Y., and made a gift in 1979.

Publications: Nye 1895, fig. 53.

1. Related examples include American Art Association, Nov. 7–9, 1929, sale 3787, lot 137; *Antiques* 130:4 (Oct. 1986): front inside cover. Inlaid bellflowers also appear on some Portsmouth card tables (*see cat. no.* 61).

2. Notes on the various J. Melchers, compiled by Carolyn Singer, are in the Strawbery Banke Museum object files (1979.323). For John Melcher the printer, see "Printers and Printing in Portsmouth," *Daily Morning Chronicle* (Portsmouth), Aug. 2, 1852; Portsmouth city directories; Frost 1945, 1:90; and Kidder 1960, 157–58.

35B.
Detail of front leg.

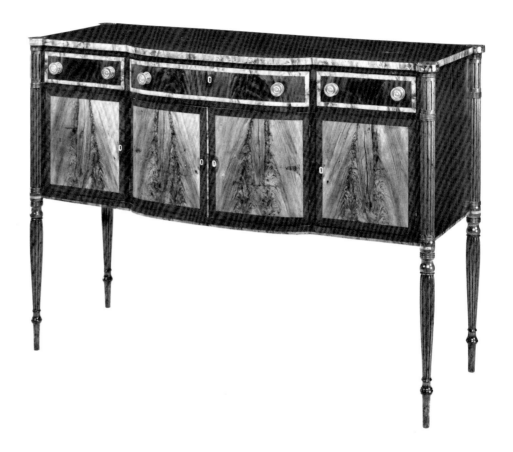

36

SIDEBOARD

Portsmouth, New Hampshire
1810–15
Private collection

THIS SIDEBOARD is characteristic of Portsmouth work in several respects, including the profile of its swelled and reeded legs, as well as the fluted decoration flanked by incised rings at the top of the legs. The use of colorful birch-veneer panels outlined with mahogany banding on the doors (a pattern reversed on the drawer fronts) gives it added distinction. The same maker embellished a closely related sideboard with a marble insert in the top and mahogany panels on both the drawers and doors (36A). The rectangular form of both examples, alleviated only by a slightly bowed center section, resembles that of other sideboards with local histories, including one that descended in the Goodwin and Hill families, as well as of Portsmouth card tables.[1]

According to tradition, this sideboard was owned originally by Capt. George Nutter (1767–1814), and his wife, Abigail Adams Nutter. Nutter was born in Newington, the son of Matthias Nutter, a ship carpenter, and his first wife, Martha Perkins Nutter, who were married in the South Church in Portsmouth in 1764.[2]

In the next generation, the sideboard was owned by Thomas Darling Bailey, and his wife, Martha Nutter Bailey, the daughter of Capt. George Nutter. T. D. Bailey, a merchant, was the maternal grandfather of Thomas Bailey Aldrich (1836–1907), the Portsmouth poet and editor, and was the prototype for "Grandfather Nutter" in Aldrich's autobiographical novel, *The Story of a Bad Boy* (1869).[3] One wonders if this sideboard was used in the dining room of the house on Court Street occupied for many years by the Baileys, and where Aldrich lived with his grandparents for several years as a young boy. After Aldrich's death in 1907, the house was

established as the Thomas Bailey Aldrich Memorial (now part of Strawbery Banke Museum) and furnished with many family articles, although this sideboard remained in the family and was not among them.

G W R W

Structure and Condition: The two-board pine top has cleats at each end and is veneered with mahogany; the pine boards run from side to side and the veneer from front to back. The top is screwed to the upper front rail and the back. The back, two pine boards placed horizontally, is dovetailed to the case sides. The case sides are two pine boards (running horizontally) veneered with mahogany (placed vertically). The one-board pine bottom is nailed to the lower edge of the backboard and held in place with blocks glued to the back edge of the lower front rail and case sides (both of which overlap the bottom by about ½"). Pine posts are nailed to the front corners of the case sides. The upper and lower front rails are secured with sliding dovetails to the corner posts. The front legs are notched for the case sides and corner posts.

A full partition separates the bowed central compartment from the end sections. Each partition consists of a veneered front stile backed by two horizontal pine boards mounted one on top of the other. The rear boards fit into a dado in the case back and are tongue-and-grooved to the front stile.

The drawers run on side supports nailed to the partitions or to drawer guides, which are nailed in turn to the case sides. The veneered front of the bowed drawer is mounted on three laminated strips of pine; each flanking drawer is veneered on a single pine board. The drawer bottoms are a single board with grain running from side to side, set into dadoes in the front and sides, nailed to the back with cut nails, and reinforced with one long block with four saw kerfs (simulating five blocks) glued to the bottom and lower edge of the sides. The center doors are of two laminated strips of pine attached to birch vertical cleats. There are hand-saw marks on the case back and underside of the case bottom.

The sideboard was conserved by Charles Dewey of Bennington, Vermont, in 1988. He cleaned and polished the surface and made several minor repairs to the veneer and banding. An old 4" x 6" clapboard covers a hole in the case back. Runners have been added to the sides of the bowed drawers; the backs of the doors have been painted brown; and braces have been added under the top.

Materials: Mahogany legs; mahogany and birch veneer on case top, case sides, drawer fronts, doors, drawer divider, and upper and lower front rails; eastern white pine for all secondary work except *birch cleats for doors. The locks, brasses, and escutcheons are replacements.

Dimensions: H. 41⅛; W. 57³⁄₁₆; D. 22³⁄₁₆

Provenance: According to family history, the sideboard was owned originally by Capt. George Nutter (1767–1814) and his wife, Abigail (Adams) Nutter (1770–1823). It descended to Thomas Darling Bailey (1787–1870) and his wife, Martha (Nutter) Bailey (1789–1861); to Caroline Augusta Bailey (1827–86); to Ida May Frost (1850–1927); to Charles Leonard Frost Robinson (1874–1916); to Elizabeth Alden Robinson (1900–1975); to the present owner.

1. The Goodwin-Hill family sideboard is illustrated in *Antiques* 125:5 (May 1984): 940. John Walton also owned a related example (photo, SPNEA files). A rectangular straight-front sideboard, possibly by the maker of cat. no. 36, was acquired by a York, Me., family early in this century and is now owned by the Old York Historical Society (1988.5).

2. Hardon n.d., 8, 83.

3. A photograph of Bailey is illustrated in Greenslet 1908, facing p. 6.

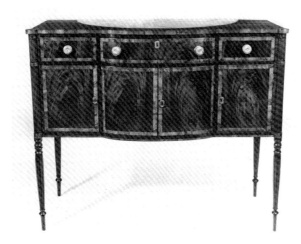

36A.

Sideboard. Portsmouth, New Hampshire, 1810–20. Mahogany, mahogany and birch veneer, and eastern white pine, H. 43¾; W. 53⅞; D. 21¼. Private collection. Courtesy, Israel Sack, Inc.

37

SIDEBOARD

Judkins and Senter (w. 1808–26)
Portsmouth, New Hampshire
1815
Strawbery Banke Museum
Portsmouth, New Hampshire
Gift of Gerrit van der Woude, 1988.228

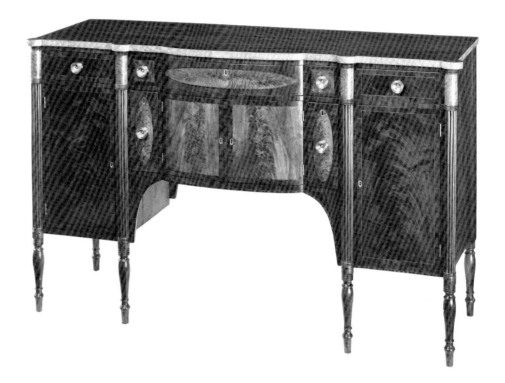

THIS DOCUMENTED SIDEBOARD links a distinctive group of case furniture to Portsmouth. The tripartite massing of the case recalls more commonly known Boston examples attributed to the partnership of John and Thomas Seymour. The Boston versions also feature rectilinear façades, extremely refined decorative elements such as elaborate carving and costly veneers of rosewood, cherry, and mahogany, and meticulous construction details.[1] Craftsmen in Portsmouth took exceptional pieces of Boston furniture as inspiration and added their own variations. In this example, their regional interpretation consists of a bowed central section paired with highly figured flame-birch and bird's-eye-maple veneer juxtaposed against the more subtle figure of mahogany (37A). None of the elements is carved.

This sideboard is not only signed by its maker but is also branded by one owner and documented through manuscript records to another, all of whom lived and worked in Portsmouth. The thriving furniture partnership of Judkins and Senter made the sideboard in 1815, according to the inscription on a drawer bottom (37B). It was probably sold later that year to one of the prosperous Haven brothers, either John, Joseph, or Joshua, who branded the piece "J • HAVEN." The sideboard somehow made its way back to Judkins and Senter, who sold it to Jacob Wendell on December 20, 1815, for $70.[2] It remained in the Wendell family home until 1988, where it was used in the parlor and later in the back dining room.[3]

The sideboard provided compartmentalized storage space for tablewares and liquor as well as serving as the most important piece of display furniture in the room. During Jacob and Mehetable's time its contents included:

1 Blue Printed Dineing Sett	10.-	2 doz Glass Plates 3$.	
1 doz Cutt Glass tumblers	2.-	1 pr Glass Pitchers 4/6.	3.75
3 pair " Decanters 3$	3.-	1 pair Glass Salts	0.75
2 Glass Dishes 3$	3.-	3 pair Decanter stands	1.[4]

The cut-glass decanters with their stands were probably kept on top of the sideboard, rather than within it, as show pieces designed to dazzle the eye and impress the visitor with the Wendell hospitality.[5]

Because the Wendell sideboard is firmly ascribed to Judkins and Senter, at least three other closely related sideboards can be attributed to the same workshop. One example that is similar both stylistically and structurally to the Wendell sideboard is now in the collection of the New Hampshire Historical Society. It descended in the Hayes family of South Berwick, Maine. A surviving photograph shows the sideboard prominently displayed in Hammond Vinton Hayes's dining room (95A). A somewhat plainer sideboard without a firm history is in a private collection. A rare variation on the large-scale tripartite sideboard sold at auction in 1944 (37C). Perhaps a patron wanted a diminutive version to fit a particular space or budget, so the flanking storage compartments were eliminated, leaving only the bowed central section. These examples are typical of the classic Portsmouth-style sideboard from the early nineteenth century.[6]

D C E

37A.
Detail of the front.

37B.
Inscription on the bottom of the top right drawer, "Made / &.../ January 22 / 1815 / by J & Senter."

Structure and Condition: The solid two-board back is tenoned to the rear legs; the veneered one-board sides are probably glued into slots in the front legs and tenoned into the rear legs. Long vertical strips are glued in each corner of the case. The rail above the drawers and a corresponding rail at the back of the case are dovetailed to the top edge of the case sides. The thin mahogany top is glued to a wooden frame and fastened with screws to the upper front rail and the case back. The 2½" drawer dividers below the end drawers are backed by dustboards. Partitions between the end and central sections are set into slots in the back of the case and secured with nails driven through the back into the partitions. The bottom of each end section is dovetailed to a case side and partition. The bottom of the central section is nailed into thick drawer guides for the bottle drawers and reinforced with support blocks. The central doors are composed of laminated strips of pine with mahogany cleats. The bowed drawer front also has a laminated core. Each end door conceals a single shelf resting on support blocks. The shelf and interior compartments retain their original red stain.

The construction of the drawers corresponds to that of the Judkins and Senter secretary and bookcase (*cat. no.* 33) made for Jacob Wendell with one exception: no cockbeading is present; instead, the top edge of the front is veneered with a thick strip of mahogany.

The sideboard had only one major repair during its lengthy history in the Wendell family. Late in the nineteenth century, John H. Stickney fastened upholstery webbing and wooden battens to the underside of the top to pull together a sizable shrinkage crack. In 1990 Strawbery Banke Museum employed Robert Mussey to reattach loose veneers, replace small chips in the banding and stringing, remove a thick darkened varnish, and refinish the sideboard with shellac.

Inscriptions: Branded on the left partition: "J • HAVEN."; written in pencil on the bottom of the top right drawer: "Made / & ... / January 22 / 1815 / by J & Senter"; in pencil on the right

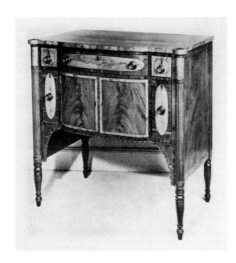

37C.

Sideboard. Portsmouth, New Hampshire, 1815–20. Mahogany and mahogany veneer, birch veneer, H. 41¼; W. 40¼. Sold at Parke-Bernet, sale 570, May 17–20, 1944, lot 754.

side of the upper right drawer: "George… Wendell Juy 18, 1838"; and in pencil on the underside of the top, "Repaired by John H. Stickney May 25, 1887, in the Old Custom House Penhallow St. Portsmouth, N.H."

Materials: *Mahogany top, legs, and core for the end doors and bottle drawer fronts; mahogany veneer on case sides, front skirt, end doors, and drawer fronts; mahogany and birch veneer on central doors, fronts of bottle drawers, and bowed central drawer; she-oak banding on front of bowed central drawer; bird's-eye-maple veneer on front legs above reeding and front and side edges of top; *unidentified tropical hardwood cleats for end doors; *yellow birch vertical strips at front corners of case; *basswood drawer guides and partitions; *eastern white pine for all remaining secondary work. Original brass hardware.

Dimensions: H. 42¹⁵⁄₁₆; W. 70⅛; D. 22⅝

Provenance: Probably owned by a J. Haven; to Jacob Wendell (1788–1865); then followed the same descent as cat. no. 5 until 1979. It remained part of the estate of Francis A. Wendell until Gerrit van der Woude presented it to Strawbery Banke Museum in 1988.

Publications: Plain and Elegant 1979, no. 7; Ward 1989b, 71–72; Ward and Cullity 1992, pl. 1.

1. See *Nineteenth-Century America* 1970, no. 12, and Smith 1970, 767.

2. Judkins and Senter bill to Jacob Wendell, June 29, 1816, Wendell Collection, folder 4, case 13, Baker Library, Harvard Business School. Also see Wendell's ledger entry for Jan. 7, 1816, ledger 2, 1814–27, 63, 1:B-6, Wendell Collection, Baker Library, Harvard Business School.

3. For an early twentieth-century view of it in the Wendell house, see Gurney 1902, 83.

4. Jacob Wendell, Apr. 1843 inventory, Wendell Collection, box 18, Portsmouth Athenaeum.

5. The decanters and stands or wine coasters are in Strawbery Banke Museum's collection; see Ward 1989b, 72. For more on the origin and use of sideboards, see Garrett 1990, 87–90.

6. The New Hampshire Historical Society sideboard (1982.25.1) is pictured in Sotheby's, sale 4835Y, Apr. 3, 1982, lot 254. An additional member of the group was sold at Sotheby's, sale 4942, Oct. 23, 1982, lot 100. Another example that may be related is illustrated in Skinner, Inc., sale 852, Oct. 29, 1982, lot 222.

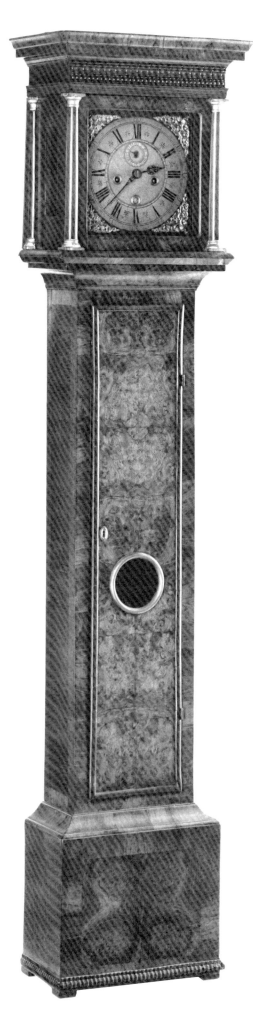

𓆸 *38*

Tall clock

Joseph Windmills (w. 1671–after 1702)
London
1700–1707
Private collection

ONLY THE VERY WEALTHY owned clocks in New Hampshire before 1750. The sun, moon, and tides were the clocks observed by most people. In the mid 1660s, a public bell was hung in the South End meetinghouse in Portsmouth.[1] It rang to call people to worship and to mark special occasions. Not until 1749 did local residents purchase a public clock by subscription. It was mounted in the steeple of the North End meetinghouse.[2] Martha Walton West of New Castle, widow of Edward, owned the first domestic timepiece recorded in the Piscataqua region. In January 1679, the appraisers jotted down "By 1 clock £4:00:00" in her extensive inventory.[3] But timepieces were rare.

Scotsman George Jaffrey I (1637–1707) was not "most people." He first emigrated to Boston in the late 1660s and had established himself in trade on the Isles of Shoals by 1676. Jaffrey moved to New Castle at the mouth of the Piscataqua the following year and was probably living in Portsmouth by the mid-1680s. He became speaker of the General Court and was appointed to the Governor's Council in 1702.[4] When he died five years later, Jaffrey's fortune was worth nearly £2,500.

This tall clock ranked among Jaffrey's most treasured possessions. In the inventory of his estate, its value of £1.10.0 was exceeded by only five entries: the six leather chairs, a large oval table, two look-

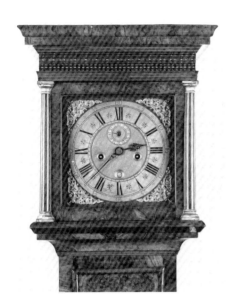

38A.
Hood and dial.

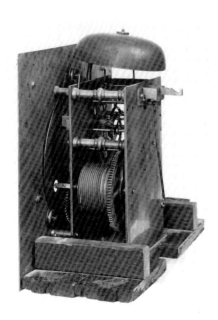

38B.
Clock movement.

ing glasses, a chest of drawers, and one bed, bedstead, and hangings.[5] The clock had been imported from London, where it was made by Joseph Windmills in about 1700, and Jaffrey was probably its first owner.[6]

When Jaffrey was twenty years old in 1657, the Dutch astronomer Christian Huygens (1629–95) applied the concept of a short, swinging pendulum to regulate the mechanical clock. Accuracy entered the realm of seconds rather than minutes. Later, a long pendulum and, in about 1671, an improved escapement (which regulated the pendulum's beat) were introduced.[7] Accuracy entered the modern age.

A man of Jaffrey's station deserved a fine clock, and he selected one desirable on both sides of the Atlantic. Windmills's clock was current with the improved escapement and long pendulum. The window in the waist door revealed the swinging pendulum bob. The shining dial with gilt cast-brass spandrels at the corners and silvered chapter ring caught the candlelight and told a universe of information (38A). Two hands (rather than a single hour hand) gave the time to the minute. The aperture below offered the date of the month. The dial above counted the seconds for the eager Renaissance mind. The two winding arbors told the observer to expect the clock to strike the hour.[8] An eight-day movement controlled the entire mechanism (38B).

Such a clock became a goal and a model for other consumers and craftsmen. Echoing the architectural traditions of Restoration England, this form, with its short base and long waist, was the first popular design for tall clocks. In the shape of a column with a base, shaft, and entablature above, the case is embellished with matched flitches of burled walnut veneer. Originally, a blind fretwork lined with bright cloth may have covered the frieze above the hood door. The rippled veneer on the cornice is a nineteenth-century replacement. Behind it, a slot emits the hourly peal of Jaffrey's clock.

The style of the Windmills clock influenced the first native clockmakers in coastal New Hampshire. They worked after 1750 in the rural towns drained by the Great Bay, especially around Kensington.[9] Their clock cases have the short bases and long waists still popular nearly a hundred years after their introduction (38c).

Versatile craftsmen, like Jonathan Blasdel, Jr. (1709–1802), of East Kingston, constructed clocks in the blacksmith's tradition of posted frame movements, in which the predominantly iron mechanism is mounted within a vertical frame, like a house, rather than sandwiched between brass plates. Both methods were employed by rural clockmakers in the Piscataqua region.

Jaffrey's clock was appreciated and then revered during the eighteenth and nineteenth centuries. After Jaffrey's death, his son, George II (1682–1749), a 1702 graduate of Harvard College, followed him to the Governor's Council in 1716. He built a grand Georgian house on Daniel Street in Portsmouth about 1730.[10] The clock was moved there and placed in the dining room not far from the beautiful beaufait (*cat. no.* 4) loaded with English and Chinese dishes. When the appraisers

of Jaffrey's estate saw the clock in 1749, they gave it a value of £35, by far the most costly item in the room.[11]

After George Jaffrey III died in 1801, the clock was acquired by Timothy Ham (ca. 1745–1824). When his son, watchmaker Supply Ham (1788–1862), died, the history and inherent value of the clock were still intact over one hundred and fifty years after it was made.[12] The appraisers noted "1 8 day Clock formerly Jaffreys [$]20.00."[13] In 1884, a line drawing of the clock was published in *New Castle: Historic and Picturesque* opposite an engraving of George Jaffrey I.[14]

P Z

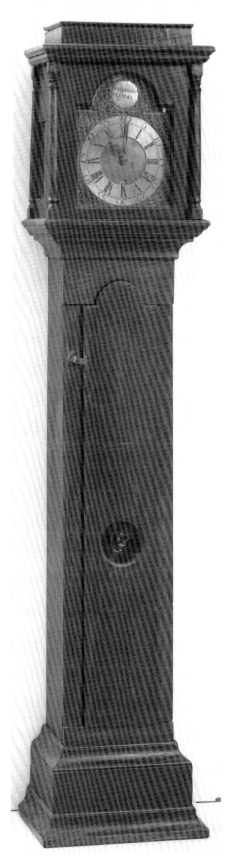

38c.

Tall clock. Works by Jonathan Blasdel, Jr. (1709–1802). East Kingston, New Hampshire, 1768. Maple and eastern white pine, H. 81½; W. 17½; D. 10. Courtesy, New Hampshire Antiquarian Society, Hopkinton, New Hampshire. Bill Finney photograph.

Structure and Condition: The case separates into two sections: hood and case. The hood sides—three vertical strips of oak veneered with walnut—are the primary structural elements of the hood. A front rail, concealed by the cornice and Victorian rippled banding in the frieze, is nailed to the front edge of each side. Corresponding veneered rails are glued to the hood sides. The cornice is a three-part veneered molding glued to the side and front rails. A thin pine top is nailed to the rails. A horizontal slat at the back of the hood is tenoned into the top edges of the hood sides. The door of the hood is made of oak stiles and rails lap-jointed at the corners. Veneered columns, notched to fit against the side edges of the doors, are fastened with glue and nails. Behind the door, a thick pine dial mat is nailed to the front edges of the hood sides. The rails and stiles of the mat are butt-jointed and veneered. The rear quarter-columns are glued to the hood sides and flat stiles behind the columns. Unlike most American clock cases, the molding at the base of the hood butts against the sides. On American examples, the molding extends beneath the hood sides and forms a shelf that supports the rest of the hood (*see* 40c). An unusual locking device once secured the door of the hood. The bolt of an iron latch mounted to the back of the upper front rail of the waist originally projected up through a horizontal wire loop nailed to the back of the lower rail of the door. The loop is now missing. The latch is only accessible by opening the waist door.

The oak case back is nailed to the rabbeted edges of the sides of the waist. Vertical strips are attached to the side edges of the back at the top and bottom to accommodate the hood and base. The back continues to the bottom of the case.

The sides of the waist extend to within 8½" of the bottom. A vertical oak strip is glued to the inside front corners of the waist sides. Bands of walnut veneer are glued to the front edges of the sides and support strips. Above and below the waist door, veneered pine rails are tenoned to the vertical support strips. The door is a single oak board with oak cleats veneered with ten matched flitches of burl veneer. A broad beaded molding outlines the door.

The front and sides of the base are veneered pine boards reinforced with pine posts at the front corners and rectangular blocks at the rear corners. Four matched flitches of walnut veneer ornament the front of the base.

The clock has had numerous repairs over the course of its long life. The top of the hood and rippled molding above the front door are mid-nineteenth-century additions. The glass within the side lights, hood door, and waist door has been replaced. The veneer on the moldings has numerous cracks and a ¾" chip near the right corner of the front base molding for the hood. The right rear corner of the base was damaged long ago; a repairman installed new support blocks within the case, glued a new strip along the right edge of the back, and apparently replaced the veneer on both sides of the base. The rippled base molding, case bottom, and feet are also later additions. The surface of the case was refinished early in this century.

Movement: Eight-day, weight-driven with anchor recoil escapement, rack-and-snail striking mechanism, seconds hand, and calendar dial.

Inscriptions: "J:Windmills London" engraved on the dial. A silvered plaque attached to the inside of the waist door is engraved as follows:

Owned 1677 by Geo. Jaffrey.

" 1720 " Geo. Jaffrey Jr.

" 1802 " Tim°. Ham.

" 1856 " Supply Ham.

" 1862 " Francis W. Ham.

" 1749 " Geo. Jaffrey.

" 1882 " Walter Lloyd Jeffries.

Materials: *English walnut stiles behind quarter-columns at rear corners of hood; English walnut veneer on moldings, columns, hood, waist, and base; *white oak secondary wood for doors, hood and waist sides, and support strips for waist sides; *red pine for all other secondary work. Original works, weights, and pendulum.

Dimensions: H. 81⅜; W. 19; D. 10¹³⁄₁₆

Provenance: George Jaffrey (1637–1707) of New Castle and Portsmouth, N.H.; to his son, George II (1682–1749), of Portsmouth; to his grandson, George III (1717–1801); subsequently acquired by Timothy Ham (ca. 1745–1824) of Portsmouth and descended to his son and grandson, Supply (1788–1862) and Francis W. (1828–1905); purchased by Walter Lloyd Jeffries in 1882 and descended to the present owner.

Publications: Albee 1884, 144–45; Brewster 1869, 156–59.

1. Brewster 1859, 56–57.

2. Adams 1825, 187.

3. Martha West, 1679 inventory, 1:223, N.H. Provincial Probate, State Archives; Bartlett ca. 1940.

4. *New England Historical and Genealogical Register* 15 (1861): 16–17; Brewster 1869, 68–69, 156–58.

5. George Jaffrey I, 1707 inventory, 4:331, N.H. Provincial Probate, State Archives.

6. For comparison with other British clock cases and dials, see Cescinsky and Webster 1913, 70–71, 137–45.

7. For a general description of these horological improvements, see Clutton 1982, 71–79. The vertical anchor recoil escapement worked in efficient harmony with the swinging pendulum below, slowing its path to a regular beat. It replaced the horizontal crown wheel escapement found on earlier clocks. The inventor of the new escapement is unidentified; Robert Hooke, William Clement, or Joseph Knibb are probable choices.

8. For an account of Windmills, see Clutton 1982, 648.

9. Parsons 1976, 18–19, 62–63. The earliest dated New Hampshire clock was made by Caleb Shaw (1717–91) of Kensington in 1749.

10. For photographs of the house and beaufait of George Jaffrey II, see also Garvin 1974, figs. 95, 96.

11. George Jaffrey II, 1749 inventory, 17:524, N.H. Provincial Probate, State Archives.

12. Brewster 1869, 156–59.

13. Supply Ham, 1862 inventory, old series, docket 18843, Rockingham County (N.H.) Probate. For a brief description of the Hams' watchmaking business, see Parsons 1976, 316.

14. Albee 1884, 144.

 39

Tall clock

Works by Thomas Jackson (ca. 1741–83)
Kittery, Maine
1773–83
Society for the Preservation of New England
Antiquities, Boston, Massachusetts, gift of the
estate of Florence Evans Bushee, 1976.243

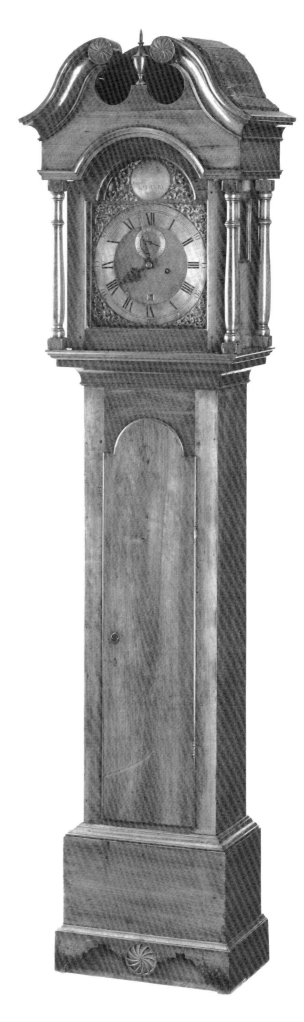

CLOCKMAKING DEVELOPED in Portsmouth with the growth of fortunes built through trade and politics. The Piscataqua's golden age in the quarter century before the Revolution expanded the market for luxury goods previously enjoyed by the elite cousinage that swirled around the Wentworths. Despite the wealth of the Wentworth clan, Portsmouth was still a small town that could not sustain specialized whitesmiths like clockmakers until after 1760.[1] The mercantile ties of the Wentworths, Atkinsons, Sherburnes, and Jaffreys directed their patronage to Boston and beyond with relative ease. Not until Portsmouth's lesser lights developed fine taste and ample credit did urban clockmaking find encouragement.

This clock is inscribed "Thoˢ. Jakson / KITTERY" and was made about 1780 by one of the few local clockmakers to find patronage in Portsmouth before the Revolution. The eight-day movement is competently made with heavy brass plates and thick posts (39A).[2] The beautiful cast-brass spandrels on the dial were probably imported (39B). The clock compares closely with another example made by Jackson in Kittery (39C).[3]

Jackson probably turned to different cabinetmakers to construct the two clock cases, which are both pretentious and provincial in their design. The clock shown in 39C is fitted with a sarcophagus hood of

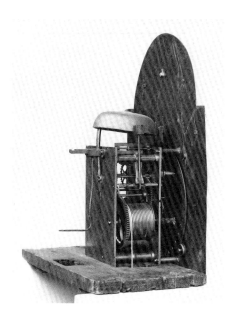

39A.
Clock movement.

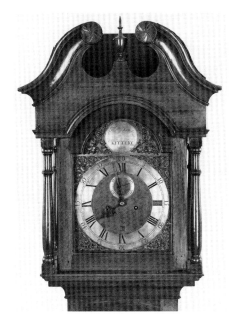

39B.
Hood and dial.

the sort popular between the 1720s and the 1760s.[4] At the same time, its moldings are lightweight and attenuated. Cat. no. 39 is also protected by a cherry case, originally stained a reddish brown. It has a scrolled pediment and a molded base with simulated bracket feet. Highlighted with pinwheels, the carving is related to work on cases for shelf clocks and desk and bookcases with coastal New Hampshire histories (40D).[5] The full rear columns on the hood contribute to the top-heavy design. The complex case construction indicates the work of a good craftsman unfamiliar with conventional construction (see *Structure and Condition*).

Until recently, the identities of Thomas Jackson of Portsmouth and Kittery and of the Englishman Thomas Jackson (1727 or 1733–1806) of Preston, Connecticut, have been confused.[6] The Piscataqua Jackson was born in New Castle in about 1741, the first year of Benning Wentworth's reign as governor. He was the son of Benjamin, a mariner, who died when Thomas was a toddler. Raised by widow Sarah Jackson, he enjoyed the support of his grandmother Mary Jackson of Portsmouth, where Thomas owned property by 1763.[7] His master is unknown, but a tall clock signed by Jackson and inscribed "BOSTON" may hold a clue.[8]

Jackson apparently worked in Portsmouth until about 1770.[9] His residence was listed as Kittery in 1773, when he was sued by John Griffith and Joseph Bass, an upholsterer, for non-payment of a debt. The suit resulted in the confiscation of Jackson's property on Divinity Street in Portsmouth.[10]

Griffith was an unlucky name for Jackson. Nathaniel Sheaff Griffith (ca. 1743–1821 or 1827), first of Hampton and later of Portsmouth, was a rival clockmaker, advertising in the newspaper, although none of his clocks are known to survive. He was joined by the English watchmaker, John Simnet (w. 1768–70), who moved to New York City.[11] Griffith's move to Portsmouth in 1769 set a competitive tone to Piscataqua clockmaking:

> Nath. Sheaff Griffith CLOCK and WATCH-MAKER; HEREBY informs the Public, That he has opened a Shop almost opposite the Rev. Dr. *Langdon's* Meeting-House, near the Parade in Portsmouth, at the Sign of the Clock and Watches — Where he makes and sells the best of Eight Day Clocks, — mends and cleans Watches, in as neat a Manner as any *Watch-Finisher* in Town or Country, & much cheaper…He will undertake to make Clocks for Meeting-Houses of any size—He has an excellent *Regulator,* by which Clocks and Watches may always [be] set. For Two and Six Pence per Year, he will undertake to keep Clocks in good Order. N.B. All watches sent to said *Griffith,* by the Southern, Western, or Eastern Post-Riders, will be mended or clean'd, and return'd as soon as possible, and as cheap as though the Owners were present themselves.[12]

Clockmaking in the Piscataqua, however, has deeper rural roots than urban ones because wealthy Portsmouth patrons looked to Boston or England for their clocks.[13] About 1750, members of the Purington and Blasdel families in Kensington, Kingston, and Chester, south and west of Exeter, began to make clocks for the rural elite (38c). The dials are sometimes similar to Jackson's and conceal either posted frame or plated movements. On the northern shore of the Great Bay, Paul Rogers (1752–1818) was the first of a small circle of Quaker clockmakers.[14] His work is distinctive for the economical use of iron rather than brass plates to support the movement (39D). Expensive brass was saved for the moving parts.

Jackson's credit problems and Griffith's competitive hiring of an unidentified English workman in 1774 kept Thomas in more rural circumstances across the Piscataqua River in Kittery.[15] He continued to make clocks, but he supplemented his livelihood with goods and produce. Between 1778 and 1781, Jackson kept an account with Portsmouth merchant Edward Sargent, from whom he borrowed money and purchased yard goods, salt, coffee, and rum as well as one-fourth of a

share in John Paul Jones's *Ranger* for £45. The state of Jackson's livelihood during the inflationary years of the Revolution is shown by his repayment to Sargent. Jackson bartered leather, fish, twine, "Cash from Rangers prizes £53," and just one cleaning of Sargent's clock in 1780.[16]

Three years later, Jackson died poor at the age of forty-two. His meager estate was appraised at £67.7.3.[17] The small house in Kittery stood on an acre and a half of land and apparently contained the shop, all valued at £30. The appraisers listed the clockmaking tools and unfinished work at a little over £20. No wheel-cutting engine is listed; Jackson may have rented one or taken his cast blanks to another craftsman. The clockmaker's furniture, clothing, and cooking implements comprised the rest of his estate. Although his work was very competent, Jackson's circumstances seem to suggest the least with which one could maintain a business in clockmaking and repair in the Piscataqua region:

Large Vice 12/ Smaller ditto 9/ hand Vice 3/ Steel Anvil 4/

2 Screw plates with taps 6/ wire plate 1/ pʳ. Screw Compasses 1/

Clock lathe 9/ Spiral Lathe 4/ Sliding gage 1/ tool for buttonmould 6d

2 Saws 6/ 2 pʳ. pliers 2/ 2 wimble bits 1/4 Hammer 1/6 1 Dᵒ. 8 Pair Smith's Bellows 18/ pʳ. flasks 12/ 16 moulds for castᵍ clock works 2/

4 new files 3/ 14 Small dᵒ. 7/ 40 old dᵒ. 10/ turkey Stone 6/

10 drills & 24 other Small tools 5/ pʳ. money Scales & weights 2/

12 ˡᵇ more or less old Copper & Brass 12/ 1 Candlestick 1/6 An eight-day Clock, unfinish'd 6£. A 30 hour dᵒ. unfinishd 4£

A Timepiece, unfinishd 24/ 7 ounces of Plate 46/8.

Jackson's patrons were the city's prospering upper-middle class before the Revolution and the rural elite, who enjoyed some capital but lacked the wealth and business connections to shop regularly in Boston or Portsmouth. The truly wealthy continued the tradition of looking beyond the Piscataqua for timepieces until the 1790s.

P Z

Structure and Condition: The clock separates into two sections: hood and case. The hood is built in a substantial but competent manner. The rear columns are full and free-standing. A horizontal top lies behind the pediment and is dovetailed to the sides of the hood. A backboard for the hood is nailed to the rear edge of the top. Two thin pine boards, forming the roof for the hood, are nailed to the pediment and the backboard. The rails of the door are tenoned to the stiles, and the joints are reinforced with wooden pins. The dial mat behind the door is also fastened with mortise-and-tenon joints secured with pins. The back of the mat is rabbeted along its inner edges to receive the dial. Small glue blocks affix the mat to the front edges of the hood sides. The arched upper rail of the mat extends behind the lower half of the pediment. Both the pediment and projecting boards along the sides are backed by thick cherry boards nailed to the mat or the hood sides. The cornice, like all the moldings on the clock, is made of solid cherry and fastened with nails. The pinwheel rosettes are not applied but carved directly on the cornice. At the bottom of the hood, a lap-jointed frame forms a shelf supporting the rest of the hood. The columns are round-tenoned into the shelf; the hood sides slide in dovetail-shaped slots in the shelf and are secured with nails driven from the underside of the shelf. The glass in the door and the sidelights of the hood is

original. The finial is a nineteenth-century replacement. The right stile of the hood door has a narrow 3" chip at the top, and the hood roof is missing a 2" strip.

The stiles of the waist extend to the floor. Mortise-and-tenon joints fasten the stiles to the rails above and below the door. The stiles are also rabbeted and nailed to the sides, which are rabbeted to receive the back. Support blocks were never glued at the corners of the waist. The sides bear no weight and terminate within the base 5" above the floor. Wooden strips are nailed to each side of the backboard to accommodate the width of the hood. The waist door is one board, thumbnail molded, and lipped on the four edges.

The front and sides of the base are mitered at the front corners and nailed to the lower portions of the waist sides and rail below the door. The base never had a bottom. The lower 1½" of the right front foot is replaced. In 1977, John Hill of Unionville, Pa., refinished the case and cleaned the dial.

Movement: Eight-day, weight-driven with anchor recoil escapement, rack-and-snail striking mechanism, seconds hand, and calendar wheel.

Inscriptions: "Thoˢ. Jakson / KITTERY" engraved on the dial. On the back of the waist door, in pencil: "May 31 1847 [77?] / J Green";

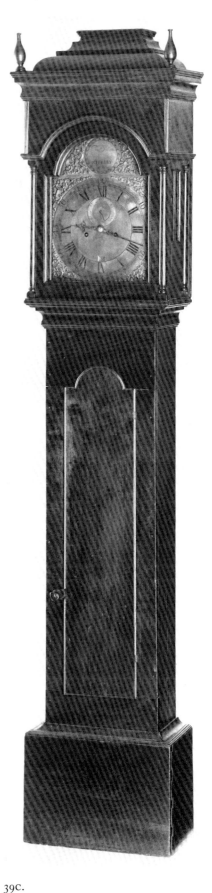

39C.

Tall clock. Works by Thomas Jackson (ca. 1741–83). Kittery, Maine, 1773–83. Cherry and eastern white pine, H. 88½; W. 19³⁄₁₆; D. 10³⁄₈. Private collection.

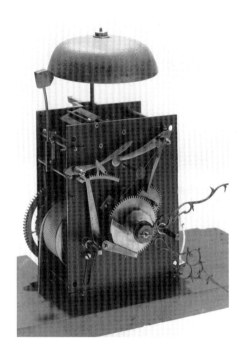

39D.

Clock movement. Paul Rogers (1752–1818) and Abner Rogers (1777–1809). Berwick, Maine, 1803–9. Courtesy, Old Sturbridge Village, Sturbridge, Massachusetts, 57.1.176, B20236.

"J.S.[?] Eastman / Oct 17 1845"; "Cleaned Dec. 22 1856 / By L. Crombie / Oiled June 8 1859 / 1869, Jan 6ᵗʰ cleaned by Luther Crombie / 1881, April 8 Cleaned." Also on the back of the waist door is a typewritten label by Lewis A. Dyer, 50 Federal Street, Boston, Oct. 24, 1942, which conveys inaccurate information about Jackson. On the back of the case is a label with the letterhead of "M. PHILBR / JEWELER / RYE BEACH, N.H.," on which is written "Repaired Jan 16 1902 / Cleaned / Nov 1908 / R D Whittier / Newfields." Several dates are inscribed in chalk on the inside of the left side of the waist, including "March / 14 1827 / Nov 1– 1855 / Nov. 13 / 1837." On the back of the case, probably in the cabinetmaker's hand, is inscribed in chalk, "Back."

Materials: *Cherry moldings, pediment, columns, hood door and sides, waist façade and sides, and base front and sides; *eastern white pine for all secondary work. Original hinges but replaced escutcheon and lock for the waist door. Original works, weights, and pendulum.

Dimensions: H. 88; W. 23; D. 12¹⁵⁄₁₆

Provenance: Purchased in the twentieth century from a Newburyport, Mass., antiques dealer by the Newbury dealer who sold it to Florence Evans Bushee, whose estate gave it to SPNEA.

Publications: Jobe 1978, 46–48; Jobe and Kaye 1984, no. 55; Churchill 1991a, 13b.

1. Pre-Revolutionary clock- and watchmakers in Portsmouth include: Nathaniel Sheaff Griffith (ca. 1743–1821 or 1827) of Hampton, N.H., and Portsmouth; Thomas Jackson (ca. 1741–83) of Portsmouth and Kittery, Me.; and John Simnet (w. 1768–70) of Portsmouth. Interestingly, although clockmakers were scarce in Portsmouth before the Revolution, the community supported eighteen silversmiths. See Parsons 1983, 129.

2. This Jackson movement has a central collet, or ring, and thick shoulders on the posts and a distinctive long pendulum cock.

3. The spandrels on the Jackson clocks relate closely to those on a clock made in the mid 1760s by Nathaniel Mulliken, Sr. (1722–67), of Lexington, Mass. See *Sack Collection*, 1:100.

4. A thirty-hour clock by Jackson in a similar case is pictured in Katra 1989, 47–48.

5. This cabinetwork is pictured in Sack 1950, 131; Montgomery 1966, fig. 168; *Decorative Arts* 1964, figs. 50, 77; *Antiques* 89:3 (Mar. 1966): 359; and Fales 1976, 236.

6. Churchill 1991a, 12b, 13b.

7. Benjamin Jackson, 1750 probate accounts, in *Documents and Records*, 34:41–42; Mary Jackson, 1755 will, in *Documents and Records*, 35:260–61.

8. If not trained in Boston, Thomas of Kittery was probably trained in Essex County, Mass. The Boston clock by Jackson is in a private collection and has not been examined. Until that is done, it is just as probable that this clock was made by the Englishman Thomas Jackson (1727 or 1733–1806), who settled in Preston, Conn. For clocks by the Connecticut Jackson, see Chase 1935, 3:99–101; Myers and Mayhew 1974, 61; Avery 1987, 71–72, 90–91.

9. Deed, Thomas Jackson to Tarbox and Dyer, Oct. 8, 1763, 38:folio 189, York County (Me.) Deeds. For tall clocks inscribed "Portsmouth" by Jackson, see: Skinner, Inc., sale 1332, June 16, 1990, lot 169; the collection of the Hammond-Harwood House, Annapolis, Md., as drawn in Dreppard 1947, 242, and pictured in Miller 1937, fig. 1800; and a private collection in Salem, Mass., in 1976 (see Parsons 1976, 321). For another tall clock inscribed "Kittery," see *Manchester Union Leader*, May 26, 1956, 1.

10. Griffith and Bass v. Jackson, Dec. 2, 1773, docket 3382, Rockingham County Court (N.H.), Series A, State Archives.

11. For the advertisements of Nathaniel Sheaff Griffith, see the *New Hampshire Gazette*, Apr. 17, 1767; Mar. 25, June 16, July 1, July 8, July 22, 1768; Mar. 17, Apr. 21, May 19, Aug. 25, Sept. 1, 1769; June 8, Aug. 31, 1770; Aug. 9, Dec. 27, 1771; Apr. 29, 1774; Mar. 30, 1779; Apr. 22, 1780; Dec. 7, 1782; Jan. 4, 1783; Apr. 2, 1788; Jan. 15, 1791; May 7 and June 18, 1796. For the Portsmouth advertisements of watchmaker John Simnet, see the *New Hampshire Gazette*, Dec. 16, 1768; Mar. 24, Apr. 14, May 26, July 4, July 14, Aug. 18, Sept. 22, 1769; May 18, June 15, June 29, 1770, as well as *The Boston Weekly News-Letter*, Feb. 9, 1769.

12. *New Hampshire Gazette,* Mar. 17, 1769.

13. Pre-Revolutionary clockmakers in the Piscataqua River basin include: Jonathan Blasdel, Jr. (1709–1802) of Amesbury, Mass., and East Kingston, N.H.; Jeremiah Fellows, Jr. (1749–1837) of Kensington, N.H.; possibly John Fifield (w. ca. 1758) of Kensington; Nathaniel Sheaff Griffith (ca. 1743–1821 or 1827) of Hampton, N.H., and Portsmouth; possibly Nathaniel Healey (w. ca. 1759) of Kensington; Thomas Jackson (ca. 1741–83) of Portsmouth and Kittery, Me.; Josiah Johnson (w. ca. 1770) of Kensington; Jacob Jones (1749–1839) of Kingston and Pittsfield, N.H.; John Jones, Jr. (b. 1753) of Kingston; Elisha Purington, Jr. (w. ca. 1750–68), of Kensington; Jonathan Purington (1732–1816) of Kensington; Paul Rogers (1752–1818) of Berwick, Me.; Caleb Shaw (1717–91) of Kensington; and Thomas Wille (ca. 1721–after 1790) of Durham, N.H. See Parsons 1976, 288–333; Palmer 1948:36–37.

14. Katra 1989, 50–78.

15. *New Hampshire Gazette,* Apr. 29, 1774.

16. Edward Sargent account book, 1771–1802, 4, New Hampshire Historical Society.

17. Thomas Jackson, 1784 inventory, docket 10125, York County (Me.) Probate.

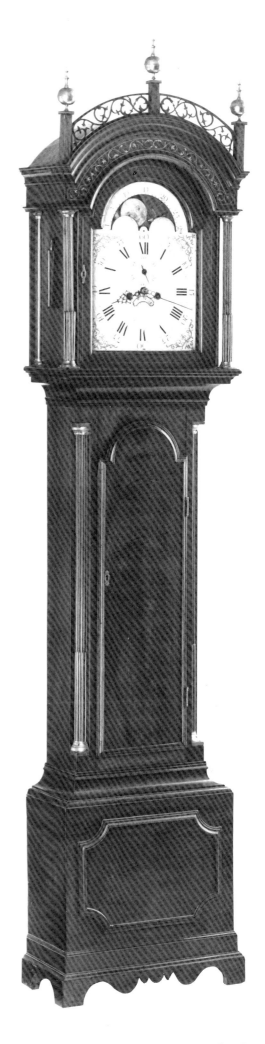

40

Tall clock

Works by William Fitz (1770–1827)
Portsmouth, New Hampshire
1791–98
Collection of Christopher and Kathleen Roper

THE GROWTH OF PORTSMOUTH and the expansion of New England's economy between the Revolution and Jefferson's crushing Embargo of 1807 urbanized the Piscataqua region. As if signaled by Washington's visit to Portsmouth in 1789, the old ways cemented by family ties and emblematic in grand Georgian architecture gave way to a new lifestyle. A growing population with new business interests, ennobled with republican virtue, promoted a wave of consumerism that supported the full range of urban craftsmen along Portsmouth's twisting streets.

In 1791, William Fitz, at age twenty-one, opened his clock-making shop in the center of Portsmouth. He quickly aligned himself with national pride and the promotion of American manufacture.

William Fitz, CLOCK & WATCHMAKER. TAKES this method to acquaint the public, that he has taken a SHOP, at the corner of *Market* and *Congress* streets, — where he carries on the business in its various branches on very reasonable terms, — and HAS FOR SALE, A great assortment of American manufactured PLATED BUCKLES — warranted to be of a superior quality to any imported. Cash, and the highest Price given for Old Gold, Silver, Brass & Copper.[1]

Fitz was born in Newburyport, Massachusetts, on January 21, 1770, the son of Mark and Elizabeth Campbell Fitz.[2] The town was something of a clockmaking center, and Fitz probably trained there.[3]

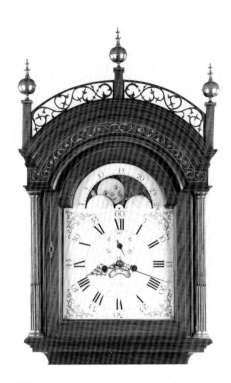

40A.
Hood and dial.

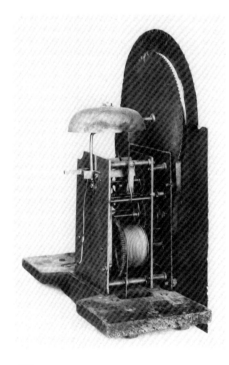

40B.
Clock movement.

After seven years in Portsmouth, he returned home.[4] Fitz next moved to Portland, Maine, where he advertised in 1802. Two of his children were born in Boston in 1809 and 1810. The latter year, he and an older son, William, Jr. (1796–1835), signed a shelf clock.[5] The senior Fitz died in New Orleans in 1827.[6]

Fitz made this clock in Portsmouth. The brass, eight-day movement is expertly made and fitted with an imported enamel dial marked "OSBORNE" on the false plate.[7] It provides the information and animation that draws people to clocks: date, hour, minute, seconds, and lunar phase (40A). The upper right corner of the front and rear plates of the movement are clipped, showing Fitz's conservation of expensive brass (40B).

The magnificent case represents the finest cabinetmaking known in the Piscataqua region. The arched door is emphasized with an applied molded edge that is balanced below by a molded panel with astragal corners and by the scalloped skirt. Amazingly, the boards that comprise the base are mitered and blind dovetailed rather than simply rabbeted and nailed. The hood is capped with a floral fretwork (the petals and birds' beaks are carved in low relief) that is mirrored with bone inlay in the frieze above the dial. The back of the hood is carefully dovetailed to the sides and the fine fretwork is neatly fastened with tiny wedge-shaped blocks to the roof (40C). Even the dial mat, which frames the dial and is hidden when the hood door is closed, is made of lap-jointed mahogany boards rather than the usual crudely joined pine.[8]

Fitz fashioned movements for diminutive shelf clocks as well as grander tall clocks. His smaller products are housed in distinctive architectural cases (40D) matching those used by Newburyport clockmakers David Wood and Daniel Balch, Jr. The similarity of clock cases made in Portsmouth and Newburyport shows that in cabinetmaking as in clockmaking, there were close ties between the two cities, which are only twenty-five miles apart.[9]

The tall case here is branded "S•HAM." It may have belonged to the merchant Samuel Ham (1770–1813), of Portsmouth, or the clockmaker Supply Ham (1788–1862), who owned George Jaffrey's clock (*cat. no.* 38). Whoever first owned the clock, its creation by local craftsmen must have been a source of pride in Portsmouth at the close of the eighteenth century.

P Z

Structure and Condition: The clock separates into two sections: hood and case. The hood door is joined; the one-piece rails are tenoned through the stiles but not secured with wooden pins. The sides of the hood are comprised of two boards: a tall, narrow board behind the door and a thicker board behind the cornice and frieze. They are fastened together with four forged nails. The lower board of each side is glued to the mahogany dial mat. No support blocks reinforce the joint. An arched backboard for the hood is dovetailed to the upper board of the hood sides. A curved roof of thin pine boards is precisely nailed to the cornice and backboard. The finial plinths are tenoned into the cornice. Their caps are replaced, but the finials are old and probably original. The fretwork is tenoned into the plinths. Three small wedge-shaped blocks reinforce the fretwork on each side. At the bottom of the hood, a joined frame forms a shelf for the support of the columns and carcass. Each hood side is tenoned through the sides of the frame, and the joints are wedged from beneath. The vertical stiles behind the rear quarter-columns are dovetailed to the rear edge of the frame and the arched backboard. The base molding is glued to the outer edge of the frame.

The back of the case is a single board nailed to the rabbeted rear edge of the waist sides. Vertical strips are nailed to the edge of the back at the top and bottom to accommodate the additional width of the hood and base. A row of eleven holes is drilled near the top of the case back to enhance the sound of the bell. The front rails of the waist are tenoned to the stiles. The stiles, in turn, are rabbeted and glued to the waist sides. A vertical strip of pine covered in glue-soaked linen reinforces the front corners of the waist. The broad coved moldings at the top and bottom of the waist are made of mahogany glued to wedge-shaped cores of pine. The waist door is a single pine board veneered with mahogany. The decorative molding on the door is secured with nails and glue.

The sides of the waist extend only 3" below the coved molding at the bottom of the waist. When building the base, the maker continued the front and sides to the floor, attached a plain stepped molding to the base, then cut out a decorative pattern in the lower edge of the moldings and base to form the skirt and feet.

The case and the works are in excellent condition. The only significant repair is the replacement of the left side of the fretwork. The brass stop-fluting in each column on the hood may have originally had eight reeds rather than the present six. The glazing within the right side-light of the hood is replaced. The molding along the left side of the waist door has been broken and reattached. A ½" patch is present at the bottom of the right front foot. The base now has no bottom; strips which may have once supported a bottom are nailed to the front, sides, and back of the base.

Movement: Eight-day, weight-driven with anchor recoil escapement, rack-and-snail striking mechanism, seconds hand, and lunar and calendar dials.

Inscriptions: "W. Fitz / Portsmouth" painted on the enamel dial; "S•HAM." branded on the inner surface of the backboard; "RS" inscribed in chalk on the outside surface of the backboard. "OSBORNE / Birmingham" marked on the false plate on the enamel dial.

Materials: *Mahogany moldings, fretwork, plinths, hood, waist sides, waist stiles and rails, base front and sides; mahogany veneer on waist door; bone inlay on frieze; *eastern white pine for all secondary work. Original finials, hinges, escutcheons, and locks. Original works, weights, and pendulum.

Dimensions: H. 94⅛; W. 20⅜; D. 10

Provenance: Originally owned by either Samuel Ham (1770–1813) or Supply Ham (1788–1862) of Portsmouth. Acquired from a private collection in Portsmouth by Herschel Burt of Exeter, N.H., in about 1970 and sold to the present owner.

Publications: Parsons 1976, 311, figs. 105–9.

1. *New Hampshire Gazette*, May 26, 1791.

2. Getchell 1989, 118–19, 145; Parsons 1968, 129–38.

3. Conlon 1968, 96–100. Fitz's master is unidentified. The principal clockmakers in Newburyport when he was of apprentice age were: Daniel Balch, Sr. (1735–89), Jonathan Mulliken II (1746–82), Daniel Balch, Jr. (1761–1835), and Samuel Mulliken II (1761–1847).

4. *Oracle of the Day*, Apr. 14, 1798.

5. Sotheby's, sale 5285, Feb. 2, 1985, lot 823. The backboard of the stylish federal case is inscribed, "Feb 2nd in the year 1810 by Fitz & Son."

6. Parsons 1976, 311.

7. Thomas Hadley Osborne operated one of the forty-eight businesses that made and painted clock dials in Birmingham between 1770 and 1815. He and one-time partner James Wilson ran two of the largest firms in the world. The false plates on the backs of the dials permitted interchangeable fitting to pre-existing, standard movements. The shape of the posts and other details of Fitz's clock bear a resemblance to the work of Thomas Jackson (ca. 1741–83) of Portsmouth and Kittery (*see cat. no.* 39). Although Fitz was a boy when Jackson died, the similarities may suggest a common training or source for clock parts in the Portsmouth or Newburyport area.

8. Three closely related cases are known. One retains bone inlay in the frieze but lacks its original fretwork. The dial is signed "Wᵐ. Fitz / Portsmouth." Now in a private collection, the clock was once on loan to the Museum of Fine Arts, Boston (see Parsons 1968, 137, fig. 5). The other two clocks are unsigned and unpublished. One is in the collection of the Moffatt-Ladd House; the other was sold in 1991 by Peter Eaton, a Newburyport antiques dealer.

9. For related shelf clocks from Newburyport, see Distin and Bishop 1976, 94–95; Heckscher 1985, 310–11; *Sack Collection* 3:832; Montgomery 1966, no. 168.

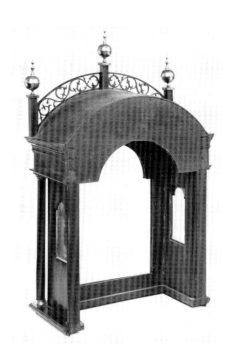

40C.
Back of hood.

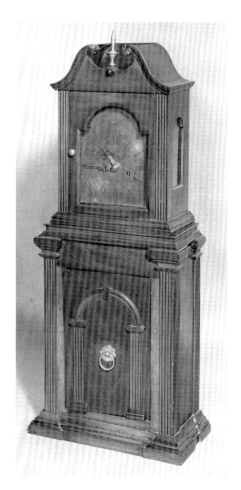

40D.
Shelf clock. Works by William Fitz (1770–1827). Portsmouth, New Hampshire, 1791–98. Cherry, H. 27¼; W. 11½. Private collection. Courtesy, Bernard and S. Dean Levy, Inc.

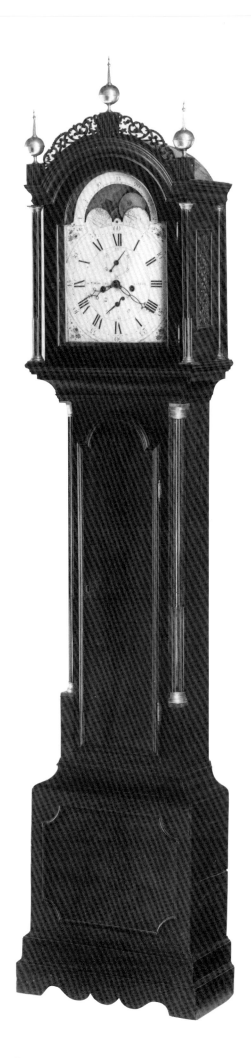

§ *41*

Tall clock

Works by Morris Tobias and Company
(w. 1792–1848)
London
ca. 1804
Collection of Stephen Decatur

ALTHOUGH PATRONAGE of local craftsmen was common in Portsmouth after the Revolution, some consumers, especially those with mercantile ties like the old colonial merchants, still looked abroad for clocks.[1] One who did so was Captain John Follett (1768–1820), the son of Captain Robert Follett. He was a shipbuilder and master at Kittery Point, as was his brother, Robert, Jr. (1770–1815).[2] The close family bonds are reflected in the name of his brig, *Two Brothers*.

On a voyage to England about 1804, John Follett purchased two tall clocks for his brother and himself, of which this is one. It is signed by Morris Tobias, an established London clockmaker working between 1792 and 1848.[3] The London-made case has the same floral fretwork, arched waist door with applied molding, simulated panel with astragal corners, and scrolled bracket base popular in the expertly made Portsmouth clock cases used by William Fitz (*see cat. no.* 40).[4]

This clock was owned by Robert, Jr., and descended in his family. Listed as "Clock & case 70 dol[s]" in Robert's 1815 probate inventory, the decreasing appraisals of the two Follett clocks show that some old-fashioned furnishings were not fully appreciated in the Portsmouth area in the nineteenth century.[5] After John died on October 18, 1820, his clock was valued at $40.[6] At the auction of his estate in 1822, the clock was "struck off" for $11.[7] Robert's clock apparently

passed to his sister, Mercy Follett. At her death in 1853, its status had slumped to that of a relic: "One long Cased English Eight day Clock [$] 8.00."[8]

Objects imported from England and the Continent generally brought the newest fashions to America. The clocks Follett purchased, however, reflect the prevailing style in Portsmouth for the period. In England, where neoclasssicism had dominated taste for thirty years, they would have been considered antiquated.

P Z

Structure and Condition: Though resembling cat. no. 40, this clock lacks its fine construction and extensive use of solid mahogany as a primary wood. Here, the thickest mahogany element—the rear stiles of the hood—measures only ⅜", and the sides of the waist and base are just ¼" thick. None of the broader moldings is solid; instead mahogany is veneered to spruce. Here, too, the case is assembled only with glue and nails; unlike the preceding two Portsmouth-area clocks, neither dovetails nor mortise-and-tenon joints bind any of the parts.

The clock separates into two sections: hood and case. Both the hood door and dial mat are veneered and lap-jointed. In addition, the upper rail of both elements is composed of two lap-jointed boards. A series of four vertical glue blocks secures each side of the hood to the dial mat. Fretwork panels on the sides are glued to paper and outlined with a beaded molding. The hood sides and dial mat rest on a horizontal spruce frame lap-jointed at the front corners and faced with a mahogany molding. The cornice is glued and nailed to the hood sides and a rail above the mat. Glue blocks secure an arched backboard to the hood sides. A curved roof of thin spruce boards is nailed to the top of the cornice and the backboard. A medial brace beneath the roof extends from the cornice to the backboard. The finial plinths are held in place with blocks glued to the roof. The fretwork is also fastened with small blocks but, unlike Portsmouth cases, is not tenoned to the plinths. The front columns project beyond the cornice in an awkward (though original) manner. The rear quarter-columns are glued to the hood sides and rear stiles.

The back of the waist—two vertical spruce boards—is nailed to the rabbeted rear edges of the sides. Spruce strips are glued to the backboard at the top and bottom to accommodate the additional width of the hood and base. Unlike most American cases, the seat board for the works does not rest on the top edge of the waist sides. Instead, the sides terminate just below the top of the upper cove molding, and the seat board sits on large spruce blocks glued to the waist sides. The rails above and below the waist door are glued into notches in the stiles. The quarter-columns are glued to the edges of the stiles and case sides. Vertical posts within the case reinforce the front corners. The door consists of a single board veneered with mahogany and outlined with an applied molding.

The front and back of the base fit within the edges of the sides. Nails bind the corners, and glue blocks within the base provide additional support. The stepped moldings are veneered, glued, and nailed to the base.

The clock retains nearly all of its original elements, and an old darkened varnish covers the surface. Minor damage has resulted from loosening glue joints within the case and the use of thin mahogany boards for the waist and base. The base has cracked and warped, and its bottom is missing. The dial has been harshly cleaned and the Tobias inscription overpainted. The glass in the hood door and the lower 4" of the applied molding on the left side of the waist door are replaced. The right portion of the fretwork gallery is cracked and chipped. In 1992, Peter Sawyer of Kensington, N.H., reglued all loose joints and resecured the base sides to the front and back.

Movement: Eight-day, weight-driven with anchor recoil escapement, rack-and-snail striking mechanism, seconds hand, lunar and calendar dials. Original works, weights, and pendulum.

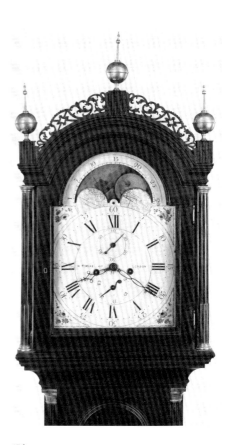

41A.
Hood and dial.

41B.

Clock movement.

Inscriptions: "M TOBIAS & CO LONDON" is overpainted on the front of the dial. "OSBORNE MANUFACTURY / BIRMING-HAM" is incised on the back of the moon dial. A paper label pasted to the back of the waist door reads: "'The Follett Clock' / This clock was brought from England on the Ship 'Two Brothers' / in 1805 (Capt John Follett Master). for the Robert Follett family / of Kittery Maine. It became the property of Col. John / Livingston Lawrence (John Lawrence Livingston) on the death of / his wife (the widow of Capt John Follett), in 1861, and after his / death the property of his 2nd wife (Lucy Cutts Lawrence). At / her death it was sold by her Estate to J.H. Kent of Portsmouth / N.H. in 1882, and by his widow to Stephen Decatur in 1904. / A companion clock, brought from England at the same time, / is the property of the heirs of the late Robert Follett Gerrish at / Kittery Pt. / [signed] Stephen Decatur / Aug. 1st 1904." An ink inscription on a smaller label repeats the history of the clock and adds that it was purchased by Mrs. Horace Kent at the "sale of furniture of Mrs. John L. Lawrence of Kittery." The following pencil inscriptions are written on the back of the waist door: "C Sweetser 5 27 44 / Portland Jan 17 Elliot / 1837 / 1848 / 1851 / D. Ober March 23th, 59 / Aug 29 1870 / J.W. Davis, Portsmouth N.H. / July 1929."

Materials: *Mahogany plinths, fretwork gallery, cornice and small moldings, columns, and sides of hood, waist, and base; mahogany veneer on hood door, dial mat, large cove moldings, waist door, waist rails and stiles, front of base, and base moldings; *unidentified tropical hardwood core for the waist door; oak secondary wood for rails and stiles of the hood door; and *spruce for all other secondary work. Original brass finials, keyhole escutcheons, hinges, and locks. Original works; probably original pendulum and weights.

Dimensions: H. 92; W. 197⁄8; D. 97⁄8

Provenance: Acquired by Robert Follett of Kittery, Me., from his brother John Follett; probably inherited by their sister Mercy (d. 1853) and, after her death, passed to John Follett's widow, Lydia Emery Follett (d. 1861) and her second husband, John Livingston Lawrence; purchased by J. H. Kent of Portsmouth in 1882; sold by Kent's widow in 1904 to Stephen Decatur, a collector, antiquarian, and scholar, in whose family it has descended to the present owner.

1. For examples of colonial Piscataqua patronage of English clocks, see Jobe and Kaye 1984, 257–60.

2. Stackpole 1903, 410.

3. Clutton 1982, 625.

4. A clock in a similar Portsmouth-made case is on view in the Moffatt-Ladd House in Portsmouth.

5. Robert Follett, 1815 inventory, docket 6005, York County (Me.) Probate.

6. John Follett, 1821 inventory, docket 5999, York County (Me.) Probate.

7. Ibid.

8. Mercy Follett, 1853 inventory, docket 6002, York County (Me.) Probate.

 42

TALL CLOCK

Works by Benjamin Clark Gilman (1763–1835)
Exeter, New Hampshire
1797
Private collection

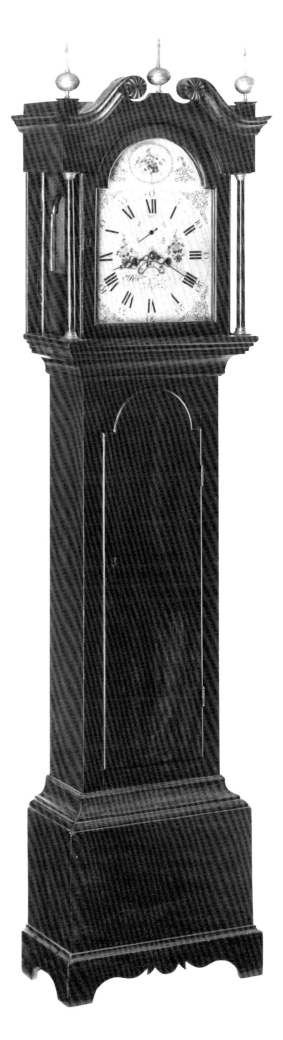

EXETER WAS THE CAPITAL of New Hampshire while Benjamin Clark
Gilman was coming of age. The founding of Phillips Exeter Academy
in 1781 added more worldly people to the mixture of consumers who
lived in or traveled to town. Gilman's much older brother, John Ward
(1741–1823), was a successful silversmith and engraver when Ben-
jamin was a teenager.[1] This growing market town was the perfect
proving ground for the young man's skill, inventiveness, and public
spirit. The son of Major John and Jane Deane Gilman, he married his
cousin, Mary Thing Gilman, in 1788 and settled into a busy life at
Exeter.[2] Gilman's first advertisement shows a willingness to pursue a
diverse array of manufacture, but working with precious metals and
luxury products had its drawbacks.

> BENJAMIN CLARK GILMAN. — Last Wednesday night the shop of the
> subscriber was broken open and a number of articles stolen…Said Gilman
> wishes to inform his customers, that he carries on the business of making a
> variety of fashionable Buckles, plated with silver, soldered on with hard or soft
> soder [*sic*] and in the best manner, which he will sell cheap for Cash, Old
> Gold, Silver, Brass, Copper, Pewter, Lead, or Country Produce. He flatters
> himself, from the encouragement he has receiv'd in the business of rectifying
> Clocks and Watches he has generally given satisfaction…[3]

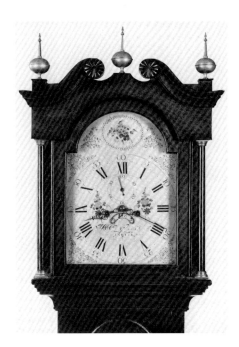

42A.
Hood and dial.

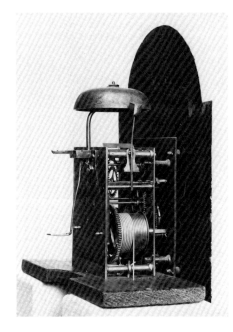

42B.
Clock movement.

Domestic objects documenting a craftsman's skill rarely tell the whole story. B. C. Gilman (as he signed his clocks and silver) also made a living as a merchant, instrument maker, mechanical engineer, and builder of public works.[4] In 1803, Gilman was awarded the contract to build the lighthouse at the entrance to Portsmouth harbor because of his "remarkable mechanical ability."[5] Gilman was already known for installing an aqueduct system at Exeter in 1797, which led to similar contracts in Portsmouth, Boston, Salem, and New London, Connecticut.[6] To build the lighthouse, Gilman simply advertised with Yankee understatement:

> Wanted. Immediately, a few good workman at the House-Carpenter's Business, to assist in framing a Frame for Portsmouth Lighthouse, and a good Workman or two at the Stone-Laying Business, — also part of the timber for said Frame, and a quantity of small round timber for the aqueducts — The timber to be delivered at Exeter. Enquire of Benjamin Clark Gilman.[7]

For the comfortable parlors of Exeter's well-to-do, Gilman also made tall clocks like this example sold in 1797 for $42. The floral dial was imported from Osborne's factory in Birmingham, England, but Gilman added his name and town in matching flourish below the calendar wheel (42A).[8] His mechanism is distinctive for the tapered brass collets on the arbors to provide a shoulder for the wheel (42B).

The local case by an unidentified cabinetmaker was grain-painted a couple of generations later.[9] It is well made and nicely eccentric. While the base of the clock is expertly fashioned of mitered boards, wrought nails were driven through the case sides attaching them to the backboard. As often found on northern New England furniture, the base molding and bracket feet are cut from one board.

Gilman also made small clocks cased in popular local styles.[10] However, by far his most distinctive and inventive model is a wall clock in the shape of a mahogany obelisk mounted with what appears to be a watch that runs, astonishingly, for eight days (42C). Within lies a fine-toothed movement with an anchor recoil escapement. The pendulum is suspended behind the pierced back plate on a metal strap. The dial is covered with the glass and frame of a pocket watch, completing the deception.[11] These products, big and small, document the career of one of the Piscataqua's most talented craftsmen.

P Z

Structure and Condition: Like the Jackson tall clock (*cat. no. 39*), this case displays the competent hand of a rural artisan, who carefully joined the parts with mortise-and-tenons or dovetails. The individual elements are not as massive, nor is the design of the case as provincial, as on its Kittery counterpart. Nevertheless, the makers of both objects adopted the same approach: to build a case to last for generations.

The clock separates into two sections: hood and case. The rails of the hood door are tenoned to the stiles, and the joints are reinforced with wooden pins. The dial mat behind the door is lap-jointed at the corners and nailed to the rabbeted front edges of the hood sides. The upper edge of the sides is dovetailed to a horizontal top behind the pediment. The cornice and frieze on the sides as well as the pediment at the front are secured with glue and nails. The scrolls of the pediment project 2¼" above the top of the hood. At the bottom of the hood, a horizontal frame forms a shelf supporting the columns and carcass. The side rails of the frame are tenoned to the front rail, and the joints are reinforced with pins. The dial mat rests directly on the frame; the lower edge of the hood sides are tenoned through the frame. The stiles behind the rear quarter-columns are dovetailed to the back edge of the frieze and the frame.

The one-board case back fits within the rabbeted edges of the waist sides. Strips are fastened to the backboard at the top and bottom to accommodate the additional width of the hood and base. Nails secure the sides of the waist and base to the edges of the back. The rails above and below the door are tenoned to the stiles, and the joints are reinforced with wooden pins. The stiles are rabbeted and nailed to the front edge of the case sides. The door is made of a single maple board.

The base is mitered at the front corners, and the joints are secured with glue blocks within the base. The front, sides, and back of the base continue to within 2" of the floor. The front base molding, feet, and skirt are a single element nailed in place. Corresponding elements are nailed to the sides of the base. Supplemental strips attached to the backboard extend to the floor and serve as supports for the rear feet.

The clock survives in exceptional condition, with virtually all of its original elements including the glass for the sidelights and hood door. During the nineteenth century, an ornamental painter grained the surface to simulate rosewood. By 1989 the graining had begun to flake and the present owner called upon Peter Sawyer of Kensington, N.H., to conserve the decoration.

Movement: Eight-day, weight-driven, with anchor recoil escapement, rack-and-snail striking mechanism, seconds hand, and calendar dial.

Inscriptions: "B:C Gilman / EXETER" painted on the front of the dial. The false plate behind the dial is marked "Osborne's / MANUFACTORY / BIRMINGHAM." Paper label pasted on the inner surface of the left side of the case reads: "August 8th 1797 / Bought Clock / Price 42 Dollars." On the same label written in another hand: "July 27 1803 / Feb 27, 1812." A second paper label pasted on the left side of the case is inscribed in ink: "Copy of above / August 7th 1797 / Bought Clock" [rest of label removed]. Below the paper labels on the left side of the case and on the case back are pencil inscriptions that record cleaning by G. D. Marden between 1924 and 1936 as well as a typed paper label by Marden that identifies Gilman and Osborne.

Materials: *Basswood cornice, frieze, and hood sides; *soft maple for all other primary work; *eastern white pine for all secondary work. Original brass finials, escutcheons, and hinges; original iron locks. Original works, weights, and pendulum.

Dimensions: H. 80⅝; W. 20½; D. 10⅛

Provenance: The clock is accompanied by a receipt: "34 Main St. / Exeter, N.H. / November 12, 1949 / Received from Mrs Sawyer / Three Hundred and Fifty dollars / for my Grandfather Clock / Anna Mae Lane." The clock was purchased in 1956 from Roland Hammond of North Andover, Mass., by the father of the present owner.

Publications: Buckley 1964, 60–61.

1. Parsons 1983, 4, 10, 21, 27–31, 48, 75, 77, 102, 132. John Ward Gilman was an accomplished metalsmith. Aside from silver, he engraved sheet music and made the first state seal of New Hampshire in 1776.

2. Gilman 1869, 96.

3. *New Hampshire Gazetteer,* Apr. 3, 1790. It is possible that the silver-plated buckles advertised by clockmaker William Fitz at Portsmouth in 1791 were made by Gilman (*see cat. no.* 40). For buckles made in the Piscataqua region, including some by John Ward Gilman, see Parsons 1983, 27–30.

4. Spinney 1943, 116–19.

5. As quoted in Spinney 1943, 116.

6. Parsons 1976, 313.

7. *Oracle of the Day,* Aug. 13, 1803; Garvin 1974, 38. Gilman's lighthouse marked the way to Portsmouth harbor until 1877.

8. Hoopes 1931, 166–68. Osborne and Wilson were partners between about 1772 and 1777. Wilson worked alone until sometime between 1808 and 1812. Mrs. Ann Osborne took over her husband's business in 1780, which became Ann Osborne and Son in 1787. The business became Ann and James Osborne in 1797 and James Osborne in 1808. The firm closed in 1818. Peter Sawyer of Kensington, N.H., notes that the florid signature painted here is unlike Gilman's sweeping style engraved on brass dials and unlike his confident "B.C.G." painted on a clock in the collection of the New Hampshire Historical Society.

9. A related case by the same maker is illustrated in Spinney 1943, 119.

10. For examples of Gilman's shelf clocks, see Sack 1950, 131; DAPC, Winterthur Museum, 78.1382.

11. Parsons 1976, figs. 465–69; Montgomery 1966, 208–9; see also, Rowell 1943, 7. Rowell's article shows the movement of the clock from the rear. Three of these clocks are known: this example at the Currier Gallery, accompanied with a watch paper and small diary, which descended in the Gilman family; one in the collection of the Winterthur Museum (57.605); and a clock with a replaced dial pictured in Skinner, Inc., sale 788, Jan. 8, 1982, lot 90K. The latter clock is also discussed in Stoneman 1959, 344. See also *Antiques* 107:5 (May 1975): 836.

42C.

Wall clock. Works by Benjamin Clark Gilman (1763–1835). Exeter, New Hampshire, 1800–1825. Mahogany and rosewood veneer with light-wood inlays, and eastern white pine, H. 34¾; W. 8¾; D. 4½. The Currier Gallery of Art, Manchester, New Hampshire, gift of Elizabeth Gilman Anderson, 1973.66.1.

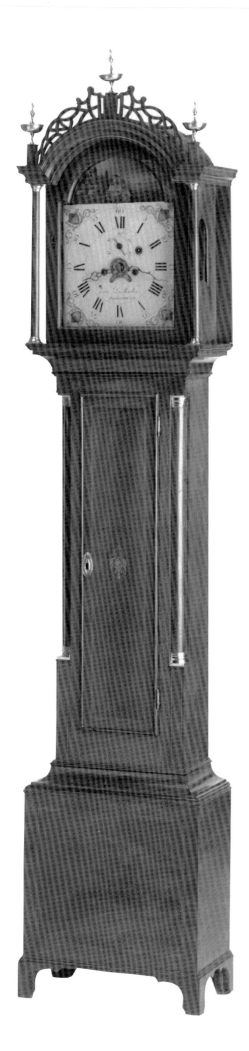

❧ *43*

TALL CLOCK

Works by Edward Sherburne Moulton
(1778–1855)
Rochester, New Hampshire
1801–13
Old Sturbridge Village
Sturbridge, Massachusetts, 57.1.125
Henry E. Peach photograph, B25691

NORTH OF PORTSMOUTH and Exeter lies Rochester, New Hampshire. Although the towns on the Great Bay and the Piscataqua River, including Portsmouth, are not particularly large, the salty inland waterway was an easy thoroughfare that supported an interconnected economy with urban aspirations. The numerous, large, two-story, central-chimney houses that ring the Great Bay prove the success of their owners. These people knew the value of time and supported clockmakers in outlying towns during the early national period.

Rochester's location encouraged industry and attracted clockmaker Edward Moulton in 1801. Born in Portsmouth on October 15, 1778, he was the son of Joseph and Lydia Bickford Moulton and a distant cousin of the Moulton family of silversmiths in Newburyport, Massachusetts.[1] Although Moulton's master is unknown, Portsmouth's clockmakers in the 1790s included William Fitz (1770–1827) (*see cat. no.* 40), John Gaines (1775–1853), Nathaniel Sheaff Griffith (1744–1821), and George Ham (1767–1832). Benjamin Clark Gilman (1763–1835) worked in Exeter (*see cat. no.* 42), and Paul Rogers (1752–1818) lived nearby in Berwick, Maine. *A Gazetteer of the State of New-Hampshire* describes Moulton's new town, which had a population of 2,118 people in 1810:

Near the centre of the town is a village called Norway plains, containing a meeting-house, a court-house, about 40 dwelling houses, and several stores. There are also in this town 4 grain-mills, 4 saw-mills, 2 carding-machines, and a cotton factory...One term of the district court of common pleas is held annually.[2]

The sale of luxury goods was competitive in Portsmouth and surrounding towns like Rochester. Moulton provided his clientele with jewelry, silver flatware, and skillfully made clocks.[3] Within two years of his arrival, Joshua Tolford (1771–1862) moved there from Gilmanton, New Hampshire. He had worked in Gilmanton since the 1790s and had advertised aggressively in the Concord newspaper. Moulton withstood the challenge, and Tolford moved to Saco, Maine, in 1804.[4]

This clock by Moulton is the kind of product that forced a competent crafts-man like Tolford to move on. Moulton's strategy was to offer quality and gadgetry to his customers (*fig. 43A*). The clock is fitted with an alarm attachment driven by a third descending weight wound through an extra aperture in the dial. Alarms are uncommon on tall clocks. Moulton's clocks also often have painted rocking ships that ply the high seas across the top of their enameled dials. The brass components of his movements are carefully finished, and each is beautiful in its own right. The case is equally accomplished, with stylish inlays on the columns and a patriotic eagle on the door.[5] The latter may well represent the work of a Boston or Salem specialist who sold his inlays to other craftsmen. Regrettably, the maker of this sophisticated case cannot be identified. He undoubtedly resided in the Portsmouth area; his design for the bracket base closely relates to other case furniture from the Piscataqua region. An intriguing candidate is Charles Dennett (1788–1867), a skilled Rochester cabinet-maker who is known to have made "Inlaid clock cases."[6] However, he did not estab-lish a workshop in Rochester until 1812, near the end of Moulton's stay in the town.

Moulton initially prospered in Rochester. At one time in 1806, his stock in trade was valued at $200, or the approximate value of four tall clocks.[7] (The town's total was $5,950.) He began to take on apprentices. James C. Cole (1791–1867) of Boston entered the shop in 1807. He went on to make tall clocks, patent time-pieces, and mirror clocks (*see cat. no. 44*).[8]

Rochester's prosperity could not support a clockmaker at every crossroad.[9] The population was falling at a time when it was growing elsewhere in rural New England. Between 1790 and 1800, it declined by two hundred people, and the trend would continue. In 1813, Moulton left Cole in his stead at Rochester and fol-lowed Tolford to better prospects in Saco, Maine. His rocking ships were more at home in the parlors along Casco Bay. Moulton continued his trade "in all its branches," including watch repair, for several years and became a leading citizen of the town. When Lafayette's tour proceeded down east in 1825, Moulton was on the committee to organize the visit of the "Nation's Guest" to Saco. The clockmaker died there on August 16, 1855.[10]

P Z

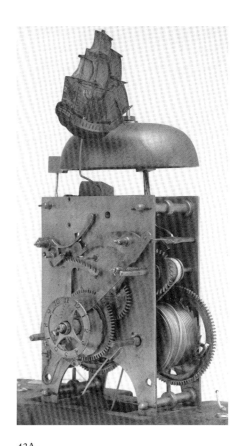

43A.
Clock movement. Henry E. Peach photograph, B25691.

Structure and Condition: The clock separates into two sections: hood and case. The rails of the hood door are tenoned through the stiles. The dial mat behind the door is also secured with mortise-and-tenon joints, then nailed to the rabbeted front edges of the hood sides. The cornice is made of a thin mahogany molding glued to thick cherry boards fastened to the hood. A narrow, arched backboard is dovetailed to the rear edges of the cherry boards behind the side cornice. The curved roof is nailed to the backboard and cherry board behind the front cornice. The plinths are set into shallow mortises in the top of the cornice. The fretwork gallery is tenoned and glued to the plinths. At the bottom of the hood, a mahogany lap-jointed frame forms a shelf for the columns and carcass. The hood sides are tenoned through the side rails of the frame. The vertical stiles at the back corners of the hood are dovetailed to the end of the frame and the boards behind the side cornice. The hood never had columns at the rear.

The one-board back of the case is nailed to the rabbeted edges of the waist sides. Strips of pine are nailed to the backboard at the top and bottom to accommodate the additional width of the hood and base. The rails above and below the door are tenoned into the stiles. The inlaid quarter-columns and blocks above and below the columns are glued to the front stiles and waist sides. Vertical posts within the case reinforce the front corners of the waist. Smaller (2½") wedge-shaped glue blocks supplement the corner posts. The waist door consists of a pine board with cleats at the top and bottom ornamented with an inlaid eagle, mahogany veneer, and beaded molding.

The veneered front of the base is rabbeted and nailed to the sides. Glue blocks within the base reinforce the front corners. The bottom is dovetailed to the sides of the base. The construction of the base molding and feet conforms to that on chests from the Portsmouth area. The base moldings are glued and nailed in place. The solid mahogany feet are glued to the underside of the base moldings. A vertical block supports each foot; originally two small horizontal blocks reinforced the front feet. Triangular rear elements butt against the rear bracket feet.

The clock has had several repairs. A previous owner replaced the fretwork, the stile at the right rear corner of the hood, the glass in the hood door, and the minute hand of the works. The lower right corner of the dial mat and the right side of the hood have been damaged and repaired. The rear feet and the bottom of the case have been removed and reattached. A dark, crazed varnish now covers the case.

Movement: Eight-day, weight-driven with anchor recoil escapement, rack-and-snail striking mechanism, alarm attachment, seconds hand, calendar wheel, and rocking ship.

Inscriptions: "Edw. S. Moulton. / ROCHES-TER NH." painted on the enamel dial. Partial label nailed to the inside surface of the backboard: "James Har 7 [or 9] M___." A Hanover fire company label, also incomplete, is nailed to the back of the case behind the movement. A brass plaque is screwed to the back of the waist door: "From Collection of / J. Cheney Wells / Southbridge, Massachusetts / No. 125." An old chalk inscription on both sides of the case reads: "N 1."

Materials: *Mahogany cornice, moldings, columns, hood sides and door, dial mat, and horizontal frame at the base of the hood; mahogany veneer on waist door and front and sides of base; *basswood hood roof; *cherry boards behind cornice; *eastern white pine for all other secondary work. Original hinges; replaced finials, waist door escutcheon, and locks; missing hood door escutcheon. Original works, pendulum, and one of the two weights.

Dimensions: H. 90⅞; W. 19½; D. 10¼

Provenance: Purchased by J. Cheney Wells from Antique Galleries, Boston, on Aug. 22, 1938, and bequeathed to Old Sturbridge Village.

Publications: Parsons 1976, figs. 57, 186–90; Zea and Cheney 1992, 109.

1. Moulton 1873, 36–38.

2. Merrill and Merrill 1817, 188–89.

3. Parsons 1976, 324. Moulton's career as a silversmith and his three touchmarks are discussed in Parsons 1983, 13, 57, 76, 114, 129.

4. Katra 1989, 20–24, 36; *Mirror,* Concord, N.H., July 14, 1794. *Decorative Arts,* 1964, fig. 91; Parsons 1976, 306.

5. For another example by Moulton, see *Antiques and The Arts Weekly,* Jan. 19, 1990, 16.

6. McDuffee 1892, 337; *Decorative Arts* 1964, fig. 91; Parsons 1976, 306.

7. As noted in Parsons 1976, 324.

8. Ibid., 57, 190, 114–15, 203.

9. Rochester clockmakers and apprentices include: Thomas Bryant (w. after 1807), James C. Cole (1791–1867), James Cross (w. 1825–30), Edward Sherburne Moulton (1778–1855), Enoch H. Nutter (1801–80), John D. Nutter (1811–90), and Joshua Tolford (1771–1862).

10. Katra 1989, 36–41.

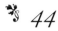 *44*

TALL CLOCK

Works by James Charles Cole (1791–1867)
Rochester, New Hampshire
1813–20
Collection of Mr. and Mrs. George B. D'Arcy

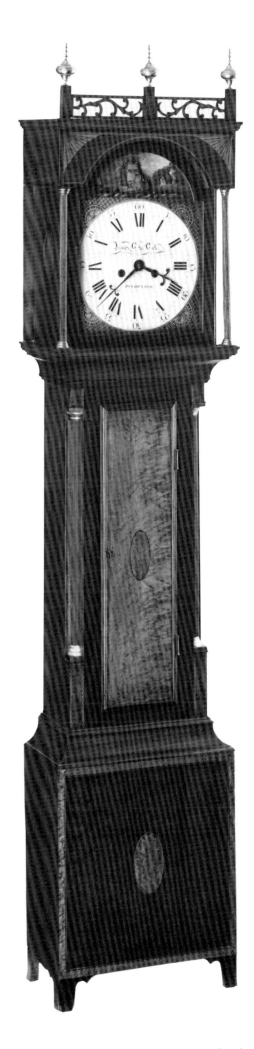

JAMES C. COLE SURPASSED HIS MASTER, Edward S. Moulton, in
clockmaking at Rochester, New Hampshire (*see cat. no.* 43). Born in
Boston in 1791, Cole moved northward as a boy. When Moulton
went to Saco, Maine, in 1813, Cole took over the shop at the corner
of Main and Arrow streets. He modernized the business in Rochester
and grew prosperous. He razed the old building and replaced it with a
brick one. The upper floor became the Masonic Lodge. "An energetic
workman, thorough and conscientious," Cole eventually employed
several journeymen and apprentices in clockmaking, watch repair, and
the retail jewelry and silver trade. Among his apprentices were his in-
laws, Enoch H. Nutter (1801–80) and John D. Nutter (1811–90).[1]

This clock and case are fine products of Cole's enterprise.[2] The
round white portion of the dial is superimposed on the traditional
arched clock face (44A), reflecting the fashion for dish dials used on
shelf and tall clocks by Aaron Willard (1757-1844) in Boston after the
War of 1812.[3] The mechanism is well made, with a commitment to
conserving brass (44B). The clock is deceptively animated by a rocking
ship, without the costly addition of a seconds hand or calendar wheel.

The case may be the work of Charles Dennett (1788–1867),
who was born in Barnstead, New Hampshire, and was apprenticed in
Gilmanton. He advertised "Inlaid clock cases."[4] Although the hood

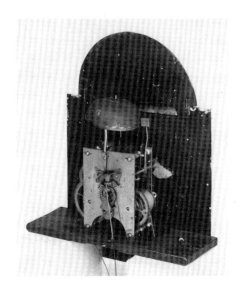

has a flat top, the case offers no concession to cost cutting. It is made of mahogany and birch and ornamented with inlaid fans and ovals. A pierced fretwork surmounts the top.

The clock descended in the prominent Jones family of Milton, just north of Rochester, and was probably purchased by Levi (1771–1847) after the War of 1812.[5] When he died in 1847, the estate included the farm of 700 acres and was worth over $31,000.[6] Like many of Jones's possessions, however, the "One Eight day Clock[,] case veneered $6.00" must have been deemed old-fashioned in this age of mass-produced Connecticut clocks. The highest appraisal of $15 went to his secretary full of books.

Notwithstanding, at the time of Jones's death, Cole was still in business, because he had changed with the times. Clocks like the one he sold to Jones were of a traditional type that comprised only a portion of his trade. In addition to silver flatware and jewelry, Cole, his apprentices, and competitors sold wall clocks patterned after the popular products of Simon (1753–1848) and Aaron Willard (1757–1844) in Roxbury and Boston. Willard-style patent timepieces or "banjo" clocks are known with Cole's name on the dial.[7] Cole also made the indigenous and more economical New Hampshire mirror clock (44c).[8] These products met the demand for less expensive timekeeping and linked traditional craft practices with industrialized clockmaking in the Piscataqua region.

P Z

Structure and Condition: The clock separates into two sections: hood and case. The rails of the hood door are tenoned through the stiles. The dial mat behind the door is lap-jointed at the corners and secured to the front edges of the case sides with glue blocks. The flat top behind the fretwork and the projecting frieze along the sides are nailed to the hood sides. The arched and inlaid front frieze is rabbeted and nailed to the front edge of each side frieze. The cornice is nailed to the frieze. The plinths are set back from the cornice and tenoned into the top of the front frieze. The fretwork fits into dadoes in the plinths. At the bottom of the hood, a joined birch frame forms a shelf supporting the columns and carcass. A narrow ogee mahogany molding is fastened to the frame with wooden pins. Stiles at the rear corners of the hood are dovetailed to the back edge of the frieze and frame. The hood never had rear columns.

The one-board back of the case is nailed to the rabbeted rear edges of the waist sides. Wooden strips are nailed to the backboard at the top to accommodate the additional width of the hood. Strips were not added for the base. The rails above and below the waist door are tenoned to the stiles. Each quarter-column and flanking plinth and cap are glued to the stiles and waist sides. A series of wedge-shaped pine blocks within the case secure the front corners of the waist. The door of the waist consists of a single birch board veneered with bird's-eye maple and flame birch and outlined with a cherry molding.

The construction of the base is unusual. The waist sides extend nearly to the floor. Large screws secure the waist sides to the base sides, which continue to the floor to form the side feet. The front of the base is rabbeted and nailed to the sides. The veneered front feet are separate elements nailed and glued to the lower edge of the base. At the back of the base, a horizontal slat is set into dadoes in the sides. The backboard extends through a notch in the slat to the floor.

The clock and its case survive in exceptional condition; minor patches on the front feet are its only damage.

Movement: Eight-day, weight-driven with rack-and-anchor recoil escapement, snail striking mechanism, and rocking ship attachment.

Inscriptions: "James Cha⁵ Cole, / ROCHES-TER." painted on the enamel dial. Pencil inscriptions on the back of the door record cleaning by R. Morrill between 1858 and 1869 and by J.L. Morril[?] between 1891 and 1905.

Materials: Mahogany plinths, hood door, and hood moldings; mahogany veneer on the front frieze, waist rails and stiles, front of the base, and front feet; unidentified tropical hardwood coved moldings above and below the waist door; birch fretwork gallery, side frieze, hood sides, columns, and rear stiles, waist sides, quarter-columns, and door, and base sides; birch veneer on front frieze, plinth and cap flanking quarter-columns, waist door, and front of the base; maple veneer on waist door; cherry molding on waist door; eastern white pine for all secondary work. Original brass finials, waist door escutcheon, and hinges; original iron locks; missing hood door escutcheon. Original works, weights, and pendulum.

Dimensions: H. 89; W. 19; D. 10¾

Provenance: Probably Levi Jones (1771–1847); descended in the Jones family of Milton, N.H., and consigned to auction by Miss Elizabeth Jones in 1974; acquired by the present owner at the Aug. 20–21, 1974, auction held on site by Richard Withington.

1. McDuffee 1892, 1:264–65, 2:469–70; Parsons 1976, 306, 325.

2. For examples of tall clocks by Cole, see Parsons 1976, figs. 171–75; *Antiques* 103:3 (Mar. 1973): 556; Skinner, Inc., sale 927, Oct. 29, 1983, lot 355; Randall 1965, no. 210; *Antiques* 100:4 (Oct. 1971): 483; *Decorative Arts*, 1964, fig. 91; American Art Association, Flayderman sale, Jan. 2–4, 1930, lot 497; DAPC, Winterthur Museum, 68.6070. For related clock cases, see Skinner, Inc., sale 1120, Nov. 1, 1986, lot 355; *Antiques* 124:4 (Oct. 1983): 672.

3. For example, see Randall 1965, no. 211; *Sack Collection*, 5:1318, 1378.

4. Parsons 1976, 306.

5. The Jones Farm in Milton is the home of the New Hampshire Farm Museum. The portrait of Levi Jones by a Mr. Willson and the Jones Tavern sign are in the collection of The Currier Gallery of Art. See Doty 1989, figs. 4, 58.

6. Levi Jones, 1847 inventory, 48:401, Strafford County (N.H.) Probate.

7. Parsons 1976, figs. 338–52. Willard-style patent clocks by Enoch Nutter of Rochester and Dover and James Cross (w. 1825–30) of Rochester are also known.

8. Ibid., figs. 373–75.

44C.

Wall clock. Works by James C. Cole (1791–1867). Rochester, New Hampshire, 1825–30. Eastern white pine and birch, H. 29⅞; W. 14; D. 5¼. New Hampshire Historical Society, Concord, New Hampshire, gift of Charles S. Parsons, 1972.89.53a.

45

Table

Probably Portsmouth, New Hampshire
1760–90
Strawbery Banke Museum
Portsmouth, New Hampshire
Gift of Thomas Bailey Aldrich Memorial
Association, 1980.606

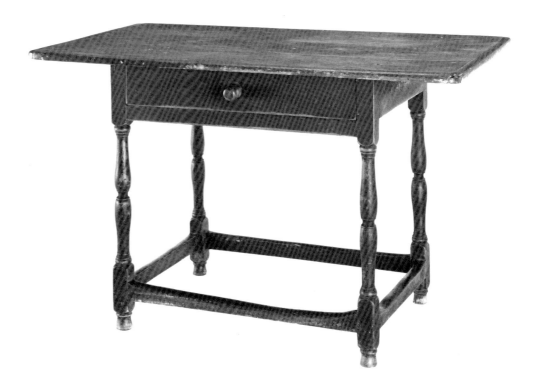

A VARIETY OF TABLES was used in eighteenth-century Portsmouth homes. House-hold inventories mention tables in almost every room in the house. Tables are iden-tified by material ("1 Marble slab wth Mohogony frame"), by size ("1 4 ft & 1 3½ ft Mahogany Tables"), or by shape ("oval"). Less frequently, the table's use is indi-cated: "small Mohogany supper table," "Kitchen" table, or even "1 Back-Gammon Table."[1] Some surviving tables clearly bespeak their function, such as a dining table or a candlestand. Others, like this example, are general purpose tables for any need involving an ample work surface and a bit of storage space. Now known as a tavern table, this common form with a large rectangular top, single drawer, turned legs, and square stretchers was most likely not used in taverns.[2] Rather, it was placed in the kitchen, for food preparation; it may also have been used in the parlor, with a cloth over it, for serving tea; or in a chamber, as a dressing table.[3]

The standard one-drawer, turned-leg table could be made easily and inexpen-sively by a local turner, chairmaker, or joiner in communities throughout New England. Because these tables are so ubiquitous and exhibit so little regional varia-tion in appearance, their origin is difficult to pinpoint. Cat. no. 45 is a rare example linked specifically to Portsmouth because of the presence of a local owner's brand, "J • HAVEN.," on the bottom of the drawer.

Haven was one of three merchant brothers—John, Joseph, or Joshua Haven—who also branded a Portsmouth-made desk (*cat. no.* 29) and sideboard (*cat. no.* 37).[4] While the latter two pieces were new when branded in the early nineteenth century,

this table is of an earlier date and evidently had been in Haven's possession for some years prior to branding. It is notable that this plain, somewhat old-fashioned table was worth enough to its owner that he bothered to mark it with his name.

Tables of this type were usually made of two types of wood. Availability of wide boards dictated a pine top, while maple was used for the legs because it turned easily. Paint covered the entire piece, thus disguising any variation in wood grain. On the Haven table, the top is scrubbed of paint from use and cleaning, but traces of original red paint survive on the base beneath a later coat of brown.

E R

Structure and Condition: The rails and stretchers are tenoned to the legs; each joint is secured with a single wooden pin. Eight pins fasten the one-board top with cleated ends to the frame. Each side rail is made of two parallel boards: an inner pine board nailed to an outer maple board with two original rose-headed nails. Drawer supports are tenoned into the front rail and nailed to the rear legs with one rose-headed nail each. Broad dovetails join the corners of the drawer. The one-board bottom slips into dadoes in the front and sides and is nailed to the back. The drawer bottom extends 7/16" beyond the back.

A 2" strip has been added to the front edge of the table top, and the right rear corner of the top has been patched. The stretchers are well worn.

Materials: *Soft maple legs, stretchers, rails, drawer front, and original knob; *eastern white pine top, inner side rails, and drawer sides, back, and bottom.

Inscriptions: Branded twice on underside of drawer, "J • HAVEN."

Dimensions: H. 26⅝/16; W. 43⅝; D. 24¹³⁄₁₆

Provenance: Owned by J. Haven of Portsmouth in the early nineteenth century. The table was among furnishings gathered in the Portsmouth area by Mrs. Thomas Bailey Aldrich during 1907 and 1908 to furnish the boyhood home of her husband, opened as the Thomas Bailey Aldrich Memorial in 1908 and transferred to Strawbery Banke Museum in 1979.

1. Rhoades 1972, 40–49, 164.

2. Ward 1991b, 108–9.

3. Jacob Wendell (1788–1865) of Portsmouth used a larger turned table of a design similar to cat. no. 45 as a kitchen table (Strawbery Banke Museum, 1972.92). For another Portsmouth kitchen table, see Jobe and Kaye 1984, fig. 56a.

4. Joseph Haven's 1829 inventory lists "1 Table .33" in the servant's chamber (old series, docket 11857, Rockingham County [N.H.] Probate); the 1849 inventory of John Haven's wife Ann lists "1 Old Table .25" in the "Chamber over front entry" (old series, docket 15719½, Rockingham County [N.H.] Probate). Either reference might describe this table at the time of these inventories.

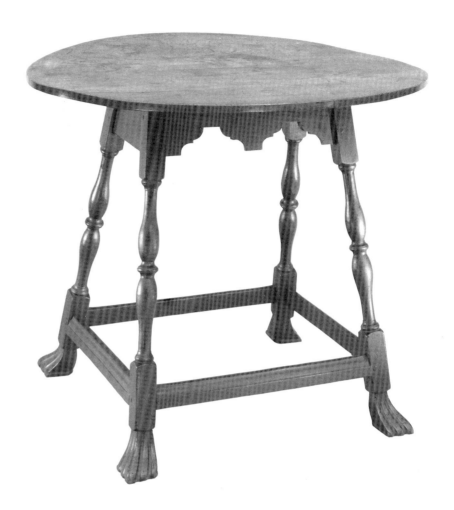

46

TABLE

Portsmouth, New Hampshire, or southern
Maine
1740–70
Metropolitan Museum of Art
New York, New York
Gift of Mrs. Screven Lorillard, 1952, 52.195.4

THIS STRIKING TABLE is the best preserved member of a distinctive group long associated with the Piscataqua region. All of these tables feature an oval top, scalloped skirt, splayed baluster-turned legs with central rings, and box stretchers. Within this formula, subtle variations may occur in the scalloping of the rails, elaboration of the turnings, or design of the feet. Structurally, all of the tables employ a cleat beneath the top, in an often unsuccessful attempt to prevent warping (46A).

The local association of these tables stems from a much-published example at the Old York Historical Society.[1] For antiquarians in the early years of the twentieth century, this table came to epitomize colonial craftsmanship of the area. Recent research on others in the group corroborates the traditional attribution to Portsmouth or southern Maine. A table at Bayou Bend was acquired from the Webber family of Shapleigh, Maine, and may have descended from the Kittery forebears of the Webbers.[2] The New Hampshire Historical Society owns a similar one that the donor believed came from New Castle, New Hampshire, but that is remembered in the antiques trade as having come from Kittery.[3] An example in the SPNEA collection (46B) descended in the Hasty family of Dunnybrook, now part of South Berwick, Maine, but part of York in the eighteenth century.[4]

Though often called tavern tables today, these handsome objects were in reality household furnishings of some pretension. This example is made of maple, stained reddish-brown to resemble costly imported black walnut.[5] Its oval top (chamfered along its lower edge to lighten its appearance), decorative skirt, and

bold Spanish feet elevate it above the vast majority of turned tables and suggest that it served a more formal function, probably as a tea table within a fashionable parlor.

Among the sizable group of splayed-leg tables, seven bear such strong similarities that one can confidently attribute them to the same shop.[6] Cat. no. 46 and the Hasty family table (46B) illustrate the distinctive traits of this important subgroup: a pair of flat-headed arches on the front and rear rails, a broad ogee-molded edge along the top of the stretchers, and either stylized Spanish feet or unusual turned tips at the end of the legs.

The large Spanish feet on several of the tables have led some to attribute them to John Gaines of Portsmouth, but the tables have little in common with his known work (*cat. no.* 77) and probably date after his death in 1743. Like Gaines, however, the unknown maker of the seven tables was an adept turner who also made chairs. A large group of related chairs (46C), probably from his shop, share the same distinctive ogee-molded stretchers and stylized Spanish feet seen on cat. no. 46. The location of that shop remains a subject of conjecture. York, Kittery, and Portsmouth are all possibilities. Each had productive, full-time turners during the mid eighteenth century.[7] One was surely the maker of these attractive tables and chairs.

E R

46A.
Underside of table.

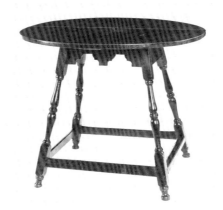

46B.
*Table. Portsmouth, New Hampshire, or southern Maine, 1740–70. *Soft maple and *eastern white pine, H. 25⁵⁄₁₆; W. 33⁷⁄₈; D. 27³⁄₄. Society for the Preservation of New England Antiquities, Boston, Massachusetts, museum purchase with funds provided in part by Mr. and Mrs. Joseph P. Pellegrino, 1988.53.*

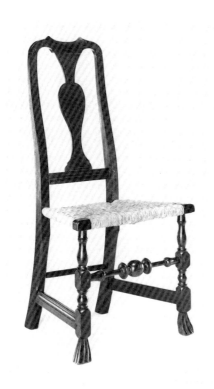

46c.

Chair. Portsmouth, New Hampshire, or southern Maine, 1740-70. Maple and ash, H. 41⅛; W. 20; SD. 14¾; SH. 17½. Museum of Art, Rhode Island School of Design, Providence, Rhode Island, Georgianna Aldrich Fund, 67.147.

Structure and Condition: The rails and stretchers are tenoned to the legs, and each joint is secured with wooden pins (two for the rails, one for the stretchers). Four pins fasten the two-board top to the frame. The cleat is nailed to the underside of the top. The front and rear rails are notched to receive the cleat. The lower back edge of the front and rear rails is chamfered; the lower front edge of the side rails has a narrow quarter-round bead. Each leg and foot are made from a single piece of 2½" stock. The original red wash is now covered by black paint on the legs, stretchers, and rails. One leg is cracked where it joins a stretcher, and a nail has been driven through the crack. The top displays a noticeable warp. At least a dozen additional nails have been driven through the cleat into the top to reduce the warp.

Materials: *Soft maple for all elements except *red oak cleat.

Dimensions: H. 27⅛; W. 31⅝; D. 26⅝

Provenance: The table was found "north of Boston" and sold by Collings and Collings of New York in 1923 to Mrs. J. Insley Blair, a Tuxedo Park, New York, collector; after Mrs. Blair's death, her daughter gave it to the Metropolitan Museum of Art.

Publications: Davidson 1967, no. 144; Kirk 1982, no. 391; Davidson and Stillinger 1985, no. 141.

1. This table is featured in *Decorative Arts* 1964, no. 2; Fales 1972, no. 38.

2. The provenance of the Bayou Bend table, once erroneously thought to be from Ipswich, Mass., is clarified in Plunket 1987, 1–3.

3. The New Castle history of the table is cited in Guyol 1958, fig. 7. Bill Graham, an antiques dealer in Haverhill, Mass., recalled that the table was picked by Harry Shayes from a house in Kittery and sold to Fred Finnerty, a dealer on Charles Street, Boston, then passed through many hands in the trade before Katharine Prentis Murphy acquired it for the Prentis Collection, which she gave to New Hampshire His-

torical Society. Telephone conversation with the author, Mar. 19, 1992.

4. Marie Donahue and Gladys Hasty Carroll, telephone conversations with the author, Mar. 13 and 19, 1992, respectively.

5. A closely related table in the collection of the Wadsworth Atheneum is, in fact, made of black walnut; see Nutting 1928–33, no. 1225.

6. The seven tables are in the collections of the Metropolitan Museum of Art (*cat. no.* 46); SPNEA (46B); Wadsworth Atheneum (see Nutting 1928–33, no. 1225); Bayou Bend (see Warren 1975, no. 23); Historic Deerfield (see Fales 1976, 142); New Hampshire Historical Society (see Guyol 1958, fig. 7); and a private owner (see *Antiques* 132:3 [Sept. 1987]: 483).

7. Mid-eighteenth-century turners in Portsmouth include George Banfield (d. 1760), Benjamin Main (w. 1765), John Mills (w. 1725–63) and his son Richard Mills (1730–1800), Joseph Mulenex (w. 1741–42), and Thomas Triggs (w. 1762–66). Kittery and York turners include Thomas Cutts (1724–95) and four members of the Wittum family (see Churchill 1991b).

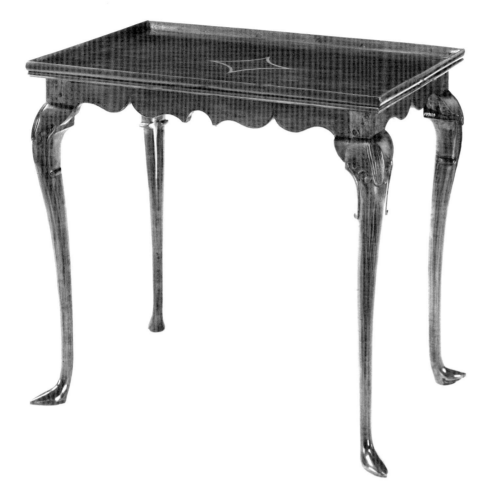

47

TEA TABLE

(Colorplate 10)
Portsmouth, New Hampshire
1740–75
Society for the Preservation of New England
Antiquities, Boston, Massachusetts, museum
purchase with funds provided by an anonymous
gift, 1991.114

IN NEW ENGLAND in the second quarter of the eighteenth century, rectangular tea tables based on English prototypes became *de rigueur* for those concerned with the elegant service of tea. Standard features of these tables include a molded rim around the top, scalloped skirts, and cabriole legs. Unlike the two preceding examples, this formal table was clearly intended for the sole purpose of serving tea. The molded rim, which protected the precious tea paraphernalia from sliding off the table, impeded its use for other activities.

The origin of this table has long eluded scholars.[1] Its slipper feet are reminiscent of those on tea tables from London and Newport. The stylized carving and volutes on the knees also echo Newport workmanship, while the overall design most closely resembles Boston tables with scalloped skirts. Yet other features distinguish the table from comparable objects produced in any of these communities. The inlaid diamond in the top enhances a surface that customarily was plain on American tables. In addition, the table combines two woods—mahogany for the top, maple for the frame—that rarely appear together on forms of such apparent sophistication. To mask the disparity in color, the maker covered the table with a layer of reddish brown stain.

The blade-shaped inlays at the corners of the top and the stylized carving on the knees do, however, relate to other examples of Portsmouth furniture. The placement of the inlay conforms to that on a dressing table attributed to Joseph Davis (*cat. no.* 17). The unusual flat carving on the knees of this tea table is similar

in character to that on the knees of another Portsmouth dressing table (*cat. no.* 18). The maker of this tea table worked within the vocabulary of elements essential to Boston and English tea tables but varied them to create his own composition. His source may well have been Boston tables imported into the Piscataqua region. Two such tables survive, both made of mahogany and decorated with shaped skirts that nearly match the one on this table.[2]

The table's history reinforces its ties to Portsmouth. A paper label beneath the top is inscribed: "This table came from my mother's mother, Sarah Parker Sherborne's house. I don't know whether it came from Sherborne's or Skillings. Susan Parker Parrott Spalding [,] September 5th 1883." Susan Spalding apparently transposed her grandmother's maiden and married names when she made this notation, because her ancestor Sarah Sherburne married Robert Parker in Kittery, Maine, in 1760.

The inscription also suggests that the table may have been in the household of Sarah's parents, Ephraim and Hannah Skilling Sherburne, who were married in Portsmouth in 1726. Ephraim was a successful shipbuilder with shipyards in Portsmouth and Kittery, and with his son-in-law Robert Parker, was involved in privateering during the Revolutionary War. Both families settled in Lee, New Hampshire. At Sherburne's death, he left his entire estate to his daughter Sarah and her husband.[3]

E R

Structure and Condition: The rails are tenoned to the legs and secured with a single pin at each joint. The knee brackets are glued to the front of the rails and the sides of the legs. The one-board top was originally secured to the frame by four glue blocks, which are now missing. The coved molding is attached to the rabbeted edge of the top with wooden pins. The table survives in good condition. Modern screws now secure the top to the frame. Three knee brackets and three toes are replaced. A late nineteenth-century restorer harshly stripped the table and applied a glossy varnish. In 1992 the staff at SPNEA's Conservation Center refinished the table.

Inscriptions: "This table came from / my mother's mother, / Sarah Parker Sherborne's house. / I don't know whether it came / from Sherborne's or Skillings. / Susan Parker Parrott Spalding / September 5th 1883." Inscription written in ink on a paper label pasted beneath the top.

Materials: *Mahogany top and applied rim; *soft maple legs, rails, and knee brackets; birch and ash inlay in the top.

Dimensions: H. 26⅝; W. 29¹⁄₁₆; D. 18¾

Provenance: Probably acquired by Ephraim Sherburne (1702–81) and Hannah Skilling Sherburne; to their son-in-law and daughter, Robert Parker (1735–1819) and Sarah Sherburne Parker (1742–1804); to their granddaughter, Susan Parker Parrott (1780–1852); to their great-granddaughter, Susan Parker Parrott Spalding (1814–89). Descended to Mrs. Spalding's sons, first to Dr. James A. Spalding (1846–ca. 1938) and second to Merrill Spalding (b. 1848); to the latter's son, whose widow sold it to SPNEA.

1. Harold Sack to Clement E. Conger, June 22, 1972; copy, SPNEA accession file.

2. For Boston examples see Jobe and Kaye 1984, no. 68; *Sack Collection*, 8:2196.

3. Cutter and Loring 1900, 388; Sherburne 1905, 57. For an account of one of Robert Parker's privateering ventures, see Saltonstall 1941, 113–16.

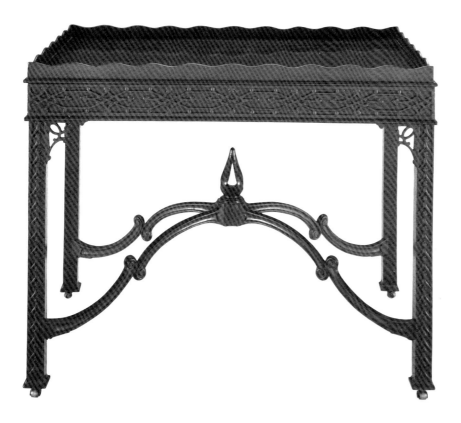

❦ *48*

China table

(Colorplate 11)
Attributed to Robert Harrold (w. 1765–92)
Portsmouth, New Hampshire
1765–75
The Carnegie Museum of Art
Pittsburgh, Pennsylvania
Museum purchase: Richard King Mellon
Foundation grant, 72.55.2

EARLY NEW ENGLANDERS treated tea drinking as a social ceremony. Its practice followed a strict code of manners and required specific furnishings.[1] A table for serving tea became an essential component of the ceremony and, in the process, a centerpiece of the fashionable parlor. During the 1750s, English artisans introduced a distinctive version, which they dubbed a china table. Thomas Chippendale pictured two patterns in *The Gentleman and Cabinet-Maker's Director* (48A). Rectangular in outline and fitted with a fretwork gallery, the form offered an elegant surface "for holding…a set of China." At the base, reverse-curved stretchers rose to a central-carved finial. The plan epitomized the whimsy and grace of the rococo.

Of the American interpretations of the form, none exceeded in elegance those produced in Portsmouth. Seven similar examples survive, all with undulating stretchers and a central-pierced finial.[2] This table, with applied fretwork on the rails and legs, is the grandest in the group. Though not based directly on Chippendale's design, it owes much to current London fashion.[3] Its fretwork pattern matches that shown by Chippendale's competitors, William Ince and John Mayhew (48B). Indeed, were it not for its American secondary woods and Portsmouth history, the table would readily be attributed to England.

This table belonged to Stephen Chase. The son of a prominent New Castle minister, Chase was educated at Harvard College, then returned to New Castle to pursue a mercantile career. In 1771 he married Mary Ann Frost; seven years later they moved to Portsmouth. There his shipping business flourished. He soon be-

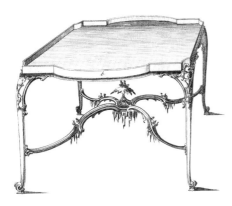

48A.

Design for a China Table, plate 34 in Thomas Chippendale's The Gentleman and Cabinet-Maker's Director *(1754). Archives, Society for the Preservation of New England Antiquities, Boston, Massachusetts.*

came one of the town's wealthiest citizens and in 1803 achieved political distinction as well, serving as a member of the State Legislature.[4] At his death on March 31, 1805, he left an estate valued at the substantial sum of $16,193.07½.[5]

The Portsmouth home of Stephen and Mary Chase (now owned by Strawbery Banke Museum) conformed to a standard Georgian plan.[6] Its central hall provided access to four first-floor rooms: a dining room and kitchen on one side and a parlor and back sitting room on the other. Bedchambers occupied corresponding spaces on the second floor. Soon after moving into the nine-year-old residence, the Chases enhanced the parlor mantel with rococo carving and probably hung the walls with a fashionable paper.[7] The tea table (and possibly a matching kettle stand) undoubtedly stood against a wall within this stylish context.[8] A dazzling display of china covered its polished mahogany surface. Such crowded arrangements of tea equipage were customary in affluent households. The Portsmouth ship captain William Pearne kept "60 peaces of Chiney" on his "Mohogany Tea Table on Casters."[9] At teatime, these rolling conversation pieces were "brought forward and placed in front of the lady who pours the tea."[10]

In time, the china table lost its place of prominence in the parlor. By 1820, widow Mary Chase had removed it to the back sitting room, a less formal living space that also contained a writing table, set of painted chairs, bookcase, and the family library of eighty-eight volumes. The china table was valued at only 75 cents in the inventory of her estate.[11]

The table's stylish grandeur must have continued to impress the family, for it remained a cherished heirloom for five generations. One family member deemed it worthy of a memorial plaque (see *Inscriptions*). And every owner lovingly preserved its fragile surfaces. Its condition, as a result, is exceptional. The table retains virtually all of its original elements, including twenty-four glue blocks beneath the top.

The design and construction of the Chase china table suggest the talented hand of someone familiar with British rococo furniture. A skillful and confident craftsman, he must have garnered lucrative commissions from Portsmouth's wealthiest residents and helped to transform local taste in the process. Obviously his repertoire included far more than just tables. He also made fine case and seating furniture in a London manner. His most imposing masterpiece may well have been the Warner family bookcase (*cat. no.* 27), which features the same distinctive fretwork design found on the table (*see* 27c). Documents linking a specific maker to either the Chase table or Warner bookcase do not survive. Yet research on the furniture trade reveals a likely candidate: Robert Harrold. Presumably a British immigrant, Harrold had arrived in Portsmouth by 1765 and soon secured several major orders for furniture. In 1770, the provincial government called upon him to make a "Mehogony Chair for the Gover[r][nor]." to use in the Council Chamber of the New Hampshire State House. The bill amounted to a sizable £120 (Old Tenor).[12] During the Revolution, Harrold relocated to Conway, a small community

amid the mountains to the north, but had returned to Portsmouth by 1783.[13] He continued to practice his trade and at his death in 1792 had just completed sixteen new chair frames and a clock case.[14]

Harrold's career was undoubtedly an influential one. Upon his arrival in Portsmouth, he lived briefly with Richard Shortridge and Mark Langdon, two established furniture makers.[15] One can easily imagine the impact that the young immigrant must have had; his use of the rococo may well have been a revelation to local craftsmen accustomed to more traditional designs. Harrold perpetuated the new style through apprenticeship, training two of his sons and possibly Solomon Cotton.[16] Though only scattered references to Harrold survive, he emerges as the central figure in Portsmouth cabinetmaking of the pre-Revolutionary era and the likely maker of the striking table acquired by Stephen Chase.

B J

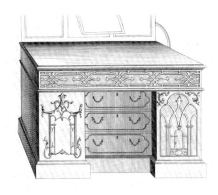

48B.

Design for a Bureau Dressing Table, plate 40 in William Ince and John Mayhew's The Universal System of Household Furniture *(1762). Courtesy, Printed Book and Periodical Collection, The Winterthur Library, Winterthur Museum, Winterthur, Delaware.*

Structure and Condition: The construction of the table conforms in most details to that of cat. no. 49. The veneered rails are tenoned to the legs, and each joint is secured with a single pin, instead of the two pins used on cat. no. 49. A beaded strip is nailed to the underside of the rails. Decorative fretwork is glued to the legs and rails. The top is fastened to the frame with twenty-four original glue blocks. The laminated three-piece gallery is mitered at the corners and secured with angled splines. The gallery fits into a narrow dado in the top. Each fretwork knee bracket is only fastened with two small nails. The carved stretchers butt against the legs and are secured with sliding dovetails to the turned and carved central finial. Iron "stretcher plates" are mounted to the underside of the stretchers and screwed into the legs (49B). Coved plinths are nailed to the bottom of the legs, and casters are screwed to the plinths.

A small shrinkage crack in the top is reinforced with a modern yellow-poplar block. All of the knee brackets are original but have been renailed. Dowels now strengthen the joints between the stretchers and central finial. The rear bracket for the left rear leg has a 1" chip. A thick, crazed varnish covers all finished surfaces.

Inscriptions: "Stephen Chase / 1742–1805 / Portsmouth, N. H." engraved on metal plate screwed to underside of end rail; "John S. Amory / Table from / Watertown / belonging to Theodore Chase" inscribed in ink on shipping label thumbtacked to inside of front rail.

Materials: Mahogany top, gallery, applied fretwork, knee brackets, legs, stretchers, finial, and secondary wood for end rails; mahogany veneer on rails; maple secondary wood for front and rear rails; eastern white pine for support blocks. Original iron stretcher plates; old but probably replaced casters.

Dimensions: H. 28⅝; W. 36¼; D. 22⁷⁄₁₆

Provenance: Stephen Chase (1744–1805); to his widow Mary Frost Chase (1752–1819); probably to their son William (1774–1834); to his brother Theodore (1786–1859); to Theodore's son, George B. Chase (1835–1902) of Boston, who married Anne Lowndes of South Carolina in 1860; to their daughter Gertrude Lowndes (b. 1868) who married Harcourt Amory (1855–1925) in 1891; to their son John S. Amory; acquired by Ginsburg and Levy, Inc., of New York from Harry Arons of Ansonia, Conn., in the late 1940s and sold to Lansdell Christie; purchased by The Carnegie Museum of Art at the auction of the Christie collection in 1972.

Publications: Antiques 61:5 (May 1952): 391; Buckley 1964, 59; *Decorative Arts* 1964, no. 36; Sotheby Parke Bernet, sale 3422, Oct. 21, 1972, lot 67; Owsley 1973, 9; Owsley 1976, 266–67; Jobe and Kaye 1984, 33; Heckscher and Bowman 1992, fig. 102.

1. For an insightful survey of the custom of tea drinking in eighteenth-century America, see Roth 1961, 61–91.

2. The design of this table is unique; the other six closely resemble cat. no. 49. Four have histories of ownership in Portsmouth. Cat. no. 48 belonged to Stephen Chase. A table now at the Warner House (1933.1) was owned by William Whipple of Portsmouth and is identified as "1 railed Tea Table 48/ [shillings]" in the 1788 inventory of his estate (old series, docket 5176, Rockingham County [N.H.] Probate); see

Giffen (Nylander) 1970a, 117. A similar table at the Metropolitan Museum (61.42) probably belonged to William Knight (1725–93), a Portsmouth merchant; see Heckscher 1985, 188–89. Another table, recently given to Strawbery Banke Museum (1990.37), descended with a matching kettle stand in the Wendell family of Portsmouth and may have originally belonged to Governor John Wentworth; see figs. 37 and 38. The remaining tables are cat. no. 49 and two in private collections (*Girl Scouts Exhibition* 1929, no. 653, and *Los Angeles County Museum Bulletin of the Art Division* 7:1 [Winter 1955]: 40, 44).

3. No surviving English china table provides a perfect prototype, but many are reminiscent of the Chase table; see Macquoid 1904–5, 290, fig. 655; *Antiques* 86:6 (Dec. 1964): 693; Hinckley 1971, 205–7; DAPC, Symonds Photograph Collection, Winterthur Museum, 59.1933.

4. For biographical information on Chase, see Chase and Chamberlain 1928, 105; *Sibley's Harvard Graduates*, 16:34–35. The two sources disagree on the date of his birth. Chase and Chamberlain cite Jan. 22, 1742; *Sibley's* gives Feb. 2, 1744. The latter has been used here.

5. Stephen Chase, 1805 inventory, old series, docket 7381, Rockingham County (N.H.) Probate.

6. The house, built in about 1762, is illustrated in *Antiques* 142:1 (July 1992): cover.

7. Garvin 1983, 280, 283.

8. Stephen Chase's inventory refers to a mahogany "Tea stand" valued at $2.50; see note 5. In the 1820 inventory of his widow's estate, the stand and china table are listed together as "1 Large tea stand [$].50 1 Tea table .75" (old series, docket 10019, Rockingham County [N.H.] Probate). Possibly they were made as a set.

9. William Pearne, 1790 inventory, old series, docket 5542, Rockingham County (N.H.) Probate.

10. This comment made by a French visitor to Virginia in 1791 is quoted in Roth 1961, 76–77.

11. Mary Chase, 1820 inventory, old series, docket 10019, Rockingham County (N.H.) Probate.

12. "Province of New Hampshire to Mark Hunking Wentworth, Chairman of the Committee for finishing the State House pr Vote of the General Assembly," bill, Apr. 1769, Treasury Papers, State Archives; see also Garvin 1991, 227.

13. Annual tax assessments record his presence in Portsmouth from 1765 to 1792 except for the years 1775 through 1783. He had acquired land in Conway in 1771; a deed of 1777 identifies him as a resident there. See Portsmouth Tax Lists, Portsmouth City Hall; Lang to Harrold, 1771 deed, 102:281, Rockingham County (N.H.) Deeds; Haslit to Harrold, 1777 mortgage, 109:304, Rockingham County (N.H.) Deeds.

14. Robert Harrold, 1792 inventory, docket 5743, old series, Rockingham County (N.H.) Probate.

15. The tax assessment for 1765 notes that Harrold resided with Richard Shortridge; the assessment for the next year lists him at Mark Langdon's. See note 13.

16. Presumably he trained his sons Tobias and Joseph, whom he left "all my joiner's tools of every kind" in his will of Dec. 31, 1791. Cotton may have trained briefly with Harrold or worked as a journeyman in his shop. When he left for Conway, Harrold turned his shop over to Cotton; see Bigelow to Harrold, 1779 deed, 111:114, Rockingham County (N.H.) Deeds.

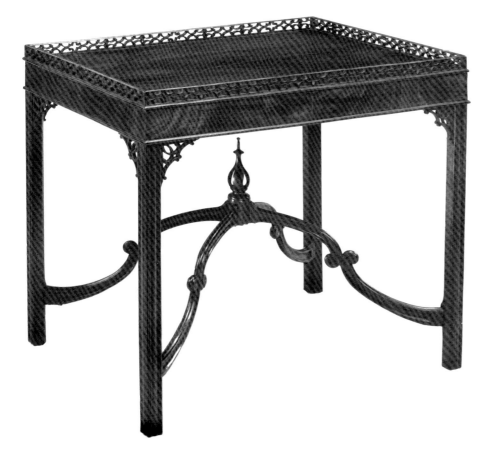

Attributed to Robert Harrold (w. 1765–92)
Portsmouth, New Hampshire
1765–75
Diplomatic Reception Rooms
U. S. Department of State, Washington, D. C.
Gift of Rear Admiral Edward P. Moore and
Mrs. Moore, 66.100

49

CHINA TABLE

THE PRECEDING CHINA TABLE IS UNIQUE. Of seven surviving examples from Portsmouth, only cat. no. 48 has fretwork on the rails and legs. The others resemble the table featured here.[1] Its reverse-curved stretchers, central finial, fretwork brackets, and molded legs are characteristic of the form. Presumably all had fretwork galleries as well, but only this one now retains its original gallery. The tables closely correspond in construction and probably originated in a single shop. Because of its fine condition, this table offers insights into the working methods of that shop.

The maker fashioned the frame from solid mahogany legs and maple rails. He used a molding plane to shape the outer edges of the legs and a drawknife and block planes to chamfer the inside corners. He tenoned each rail to a leg and fastened the joint with two wooden pins. Afterwards, he applied crotch mahogany veneer to the rails and tops of the legs, then nailed a beaded mahogany strip to the underside of the rails. To strengthen the frame, he inserted a medial brace between the front and rear rails.

The craftsman selected a thin mahogany board for the top and secured it to the frame with glue blocks and nails. A narrow dado was cut in the top for the gallery. Like his English counterparts, he formed the gallery from three laminated strips of veneer with opposing grains: the outer two with horizontal grain, the center one with vertical grain. A fretwork pattern was transferred to the veneer, holes drilled to accommodate a fret saw, and the design sawn out. He joined each mitered corner of the gallery with two angled splines. For the knee brackets, he used ⅜"

stock rather than veneer. He chose a common English fretwork pattern and secured each bracket to the frame with two small finishing nails and a glue block.

The assembly of the stretchers and central finial concluded the construction process. Like comparable English tables, the stretchers were butted against the legs and secured with sliding dovetails to the central finial (49A). Iron braces, called stretcher plates in contemporary English price books, were mounted to the underside of the stretchers and screwed into the legs (49B).[2] Each stretcher was sawed out following a pattern, then carved with chisels, gouges, and rasps. To make the central finial, the craftsman began with a 2¼" block of mahogany measuring 8" high. He drilled holes through the upper portion, carved out the piercings, turned the block on a lathe, and added the final carved details.

Though the maker finished the table on all four sides, he designed it with a front and back. The front features two book-matched pieces of mahogany veneer on the rail and decorative carving on the finial. Several smaller strips of veneer cover the rear rail, and the back of the finial is plain. Other Portsmouth china tables display a similar treatment on the rails. Craftsmen must have considered it unnecessary to ornament both sides since owners kept the tables against a parlor wall except when needed at teatime.

The craftsmanship of this china table is proficient but not exceptional. Its construction involved routine joinery, veneering, and lathe-turning as well as tedious sawing and carving. Yet its straightforward structure belies the table's significance. The sophisticated design integrates disparate elements into a unified whole. The artisan responsible for this table, and probably the others in the group as well, worked in a confident manner and obviously understood English rococo design. Such an accomplished sense of design and such telltale English traits as the stretcher plates and laminated gallery point to the hand of an English immigrant craftsman, probably the noted Portsmouth artisan, Robert Harrold (*see cat. no.* 48).

BJ

49A.
Sliding dovetail joints binding stretchers to central finial.

49B.
Underside of stretcher and leg showing iron stretcher plate.

Structure and Condition: The table has had several repairs. At least a century ago, one leg broke just below the rails, and a repairman skillfully spliced a new lower end to the original leg. During the 1920s, a restorer scraped the top and refinished the entire table. Presumably at this time, a large shrinkage crack in the top was braced from beneath with a series of small blocks. When acquired by the antiques dealer John Walton in the 1950s, approximately one-quarter of the fretwork gallery was broken or missing. Walton repaired the fretwork; in 1988 SPNEA conservators mended additional breaks in the gallery. Three of the knee brackets have been replaced. The table never had casters.

Inscriptions: "This Table belongs to Mary Anderson [?] Poore of ... [?], Greenwood [or Greenland], Maine" written in pencil on paper label pasted beneath top.

Materials: *Mahogany gallery, top, knee brackets, legs, stretchers, and finial; mahogany veneer on rails; *soft maple secondary wood for rails and medial brace; *eastern white pine support blocks. Original stretcher plates.

Dimensions: H. 27⁷⁄₁₆; W. 32½; D. 22½

Provenance: Presumably owned in the late nineteenth century by Mary Anderson Poore; purchased in the 1950s by John Walton from "a scout on the Mass. North Shore, who would not divulge his source"[3]; sold in 1959 to Rear Admiral Edward P. Moore and Mrs. Moore, who donated the table to the Diplomatic Reception Rooms in 1966.

Publications: Biddle 1963, 45; Smith 1970, 767; Fairbanks 1976, 49; Cooper 1980, 142; Fairbanks and Bates 1981, 172; Denker 1985, 6; *Sack Collection,* 9:170; Conger and Rollins 1991, no. 61.

1. See cat. no. 48, note 2, for a list of the seven Portsmouth china tables and their current locations.

2. Among the list of charges for building a Pembroke table in the *Cabinet-Makers' London Book of Prices* of 1793 (p. 94) is :

A turned stretcher to fix in center-bit holes by a pin at each end -------------------------- 0 0 9
If fitted to the legs, and fix'd with stretcher plates ------------------------------------ 0 1 3

3. Undated handwritten note attached to a photograph of the china table prior to its restoration by John Walton in the 1950s. The photograph is now part of the archives of Walton Antiques, Inc.

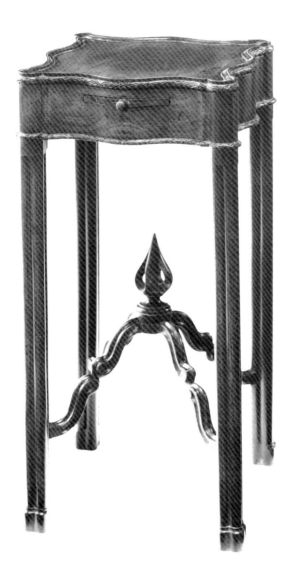

⚜ 50

Kettle stand

Attributed to Robert Harrold (w. 1765–92)
Portsmouth, New Hampshire
1765–75
Moffatt-Ladd House
Portsmouth, New Hampshire
In care of The National Society of The Colonial
Dames of America in the State of New Hampshire
On loan from a Moffatt descendant

While Portsmouth china tables represent the pinnacle of elegance in the service of tea, a few owners chose to enhance the presentation still further by the addition of a matching kettle stand. These four-legged stands were just large enough to hold the kettle for hot water used to brew and dilute tea and to rinse teacups.[1] The large and heavy kettle was safely restrained by a molded rim, and often a small slide was provided, which could be pulled from beneath the tabletop to hold a teapot or cup while it was filled with hot water. In the 1760s, Chippendale referred to such stands as "tea-kettle-stands"; later in the century, as the classical urn form was adopted as a hot-water vessel, the tables became known as "urn stands."[2]

Kettle or urn stands appear in several Portsmouth probate inventories in the 1780s, usually in association with a tea table. For example, in 1782 John Marsh, a prominent merchant, had in his parlor "1 tea Table & stand for a tea urn [£] 6:_:_." Another merchant, Jacob Treadwell, had "1 Jappand Urn & Stand"—a painted tin hot-water urn on an urn stand—near his "Mahogany Tea Table" in 1787.[3] William Whipple, a merchant and a signer of the Declaration of Independence, had "1 Rail'd stand 24/" and "1 railed Tea Table 48/. 1 sett China 24/" amongst his furnishings at the time of his death in 1788. Whipple's tea table (*see cat. no.* 48, *note 2)* resembles cat. no. 49 but is missing its gallery or "rail."[4] Whipple's kettle stand is lost.[5]

This kettle stand descended in the Ladd family of Exeter and Portsmouth. It bears a paper label inscribed by the great-great-granddaughter of Mrs. Eliphalet Ladd (1750–1838), stating that the stand belonged to Mrs. Ladd and passed, pre-

sumably through her daughter, Charlotte Ladd Langdon (1782–1870), to the "Langdon aunts" of the father of the author of the inscription. Originally from Exeter, Colonel Eliphalet Ladd (1744–1806) married Abigail Hill in 1772 and moved to Portsmouth in 1792. Ladd was a ship captain and shipowner and later a successful merchant. His probate inventory, taken in 1806, includes thirteen pages itemizing dry goods, tools, and hardware in his store, worth a total of $14,265.16½.[6] Bank shares and real estate brought his entire estate to the enormous value of $90,917.67. In his "mansion" in Portsmouth he had eight "stands" ranging in value from 50 cents to $6. Among the few furnishings recorded at his farm in Stratham is "1 Tea Stand $4." The latter could well refer to this kettle stand; an old-fashioned item in 1806, it may have been relegated to the parlor at the farm, where it was nonetheless imposing enough to attract the attention of the inventory-takers and merit a high valuation.

Although documentary evidence proves the existence of several kettle stands in Portsmouth in the eighteenth century, only one other Portsmouth stand is known to have survived to the present day (*fig. 38*). It has straight sides, pierced brackets, and molded square legs matching its china table (*fig. 37*). Cat. no. 50 is unique, for while sharing the reverse-curved stretchers rising to a pierced finial of the other stand and the china tables, it has cluster-column legs, serpentine sides, and a carved leaf molding along the upper and lower edge of the rails. Similar legs appear on one other piece of Portsmouth furniture: the unusual chair made by Robert Harrold for Governor John Wentworth (*cat. no. 85*). The resemblance of the legs leads us to attribute this stand to Harrold. Like the chair, it derives from English sources.[7] Such a rare survival in American furniture underscores the influence of London rococo fashion in Portsmouth during the pre-Revolutionary era.

E R

Structure and Condition: The serpentine rails are tenoned and glued to the upper ends of the cluster-column legs. Seven horizontal wedge-shaped glue blocks secure the top to the frame. A single vertical block reinforces each corner of the frame. The applied molding on the top is glued to a strip of leather set into a dado measuring ⅛" deep and ¼" wide. Leaf carving ornaments the edges of the top and a beaded strip nailed to the underside of the rails. Each stretcher is fastened with a sliding dovetail to the central finial and mounted to the leg with an iron stretcher plate (similar to that in 49B). The slide runs on L-shaped supports nailed to the underside of the top.

Well over a century ago, a repairman probably replaced the applied molding and drove four mahogany pins through the top into the legs. In 1987 SPNEA conservators reglued loose joints within the frame and reattached one corner of the molding.

Materials: Mahogany top, rails, legs, stretchers, finial, and slide; *eastern white pine glue blocks and supports for slide; *cherry glue blocks. Replaced brass knob on slide; original iron stretcher plates.

Dimensions: H. 26⅛; W. 12⅞; D. 12¾

Provenance: Colonel Eliphalet Ladd (1744–1806); to his widow, Abigail Hill Ladd (1750–1838); to their daughter, Mrs. John (Charlotte Ladd) Langdon (1782–1870) of Buffalo, N.Y.; to two or more of her unmarried daughters, Caroline Eustis (1812–83), Harriet Olivia (1815–82), and Mary Ladd (1819–96); to a nephew; to his daughter; to her son, the present owner.

Inscription: Label on underside of top is inscribed in ink, "This table belonged to Mrs. Eliphalit / Ladd—my great, great grandmother / [signed by mother of present owner] / Given to my father by his Langdon Aunts."

Publications: Goss 1990, 636, 646.

1. Roth 1961, 88. The frontispiece of this pamphlet reproduces a painting entitled *An English Family at Tea*, which shows a kettle stand and a maid waiting with a kettle as tea is prepared.

2. Chippendale 1762, pl. 55; Hepplewhite 1794, pls. 55 and 56. For period images of hot-water urns in use, see Roth 1961, fig. 9, and Praz 1971, fig. 64.

3. John Marsh, 1782 inventory, old series, docket 4765; Jacob Treadwell, 1787 inventory, old series, docket 5289; both Rockingham County (N.H.) Probate.

4. William Whipple, 1788 inventory, old series, docket 5176; John Moffatt, 1786 inventory, old series, docket 5173; both Rockingham County (N.H.) Probate. This table is now in the collection of the Warner House; see Giffen (Nylander) 1970a, fig. 5;

5. Whipple lived with his wife Katherine Moffatt Whipple in her father's home, now known as the Moffatt-Ladd House. The tea table and stand were located in the back parlor in 1786, when they were mistakenly recorded in his father-in-law John Moffatt's estate inventory. As a result of a misreading of the inscription on the stand and a lack of genealogical information (which has since been made available to the Moffatt-Ladd House), cat. no. 50 was erroneously published as being the lost Whipple stand; see Goss 1990. Goss 1991 and Nancy Goss, telephone conversation with the author, Mar. 19, 1992.

6. See biography of Eliphalet Ladd, Dempsey 1980, n.p.; Eliphalet Ladd, 1806 inventory, old series, docket 7544, Rockingham County (N.H.) Probate. Ladd was involved in the same privateering venture as Robert Parker, owner of cat. no. 47; see cat. no. 47, note 2.

7. Edwards 1954, 3:156, fig. 2, also has serpentine sides, a carved molding, and cluster-column legs. The English stand has a gallery of the type the Portsmouth stand may have had.

51

Urn stand

Probably Portsmouth, New Hampshire
1795–1810
New Hampshire Historical Society
Concord, New Hampshire
Bequest of Louise B. Douglass, 1958.62.2

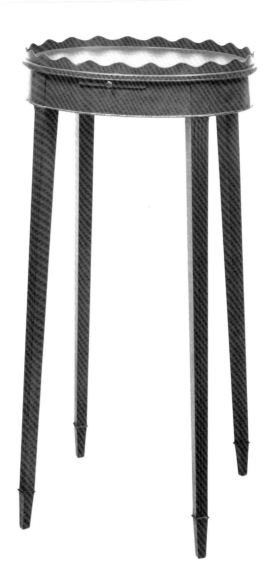

THIS URN STAND is one of the few furnishings with a history of ownership by John Langdon, whose magnificent Georgian mansion still stands on Pleasant Street in Portsmouth. Langdon was a highly successful merchant who turned to politics later in life. His position as a United States senator (1789–1801) and as governor of New Hampshire (1805–9 and 1810–12) were foremost among his public offices.[1]

As a prominent public figure, Langdon entertained often, hosting a number of well-known visitors including George Washington. Langdon invited the illustrious general for tea in 1789 along "with a large circle of Ladies." Washington recorded that of all Portsmouth's houses, "Col. Langdon's may be esteemed the finest."[2] Langdon's urn stand was thus not just a decorative trifle; it no doubt saw heavy use in a household known for its hospitality.

George Hepplewhite's *Cabinet-Maker and Upholsterer's Guide* of 1794 featured six patterns for what he called an "urn stand." Similar in form to rococo kettle stands (*cat. no.* 50), these served much the same function. They were meant to support a hot-water urn, the neoclassical equivalent of a tea kettle. Hepplewhite noted that the slide "draws out to set the tea-pot on," while filling it from the urn.[3] Such urns were often vasiform in shape and served as the ceremonial center for the late eighteenth-century tea ritual. An accompanying urn, also said to have belonged to Governor Langdon, survives with this stand.[4]

Langdon took great pains in furnishing his house, ordering upholstery fabric and carpets from England, tablewares from France, and dining chairs from Phila-

delphia, as well as buying goods locally.[5] The origin of this urn stand, however, remains difficult to pinpoint. While the gallery on this stand relates to Portsmouth tables (*cat. no.* 48), the distinctive beaded molding appears on Massachusetts pieces.[6] Langdon owned Boston-made chairs (79A) and could have purchased the stand in Massachusetts, but it remains more likely that the urn stand was a product of a Portsmouth workshop.[7]

E R

Structure and Condition: The gallery is set into a dado cut in the top. Five screws pass through the rails into the top to secure it to the frame. Beading on the lower edge of the frame is nailed to the underside of the rails. The rails appear to be tenoned to the legs. Linen is glued to the inside surface of the rails and legs, obscuring construction details. The slide runs on two supports tenoned into rails. The gallery has been cracked and patched; veneer on the rails is also cracked in several places. The stand was stripped and refinished in 1967.

Materials: Mahogany top, gallery, slide, and legs; mahogany veneer on rails; *soft maple rails; *eastern white pine supports for slide.

Dimensions: H. 30⅛; W. 15¼; D. 11⅞

Provenance: Said to have been owned by Governor John Langdon (1741–1819); bequeathed by Louise B. Douglass of Dover, N.H., to the New Hampshire Historical Society.

1. For more on Langdon and his house, see Jobe and Moulton 1986, 638–41; and Cleary 1978, 22–36. Langdon's clothespress is owned by Strawbery Banke Museum (1981.686). The house is owned by SPNEA.

2. Excerpts from George Washington's diary as quoted in Cleary 1978, 28 and 29.

3. Hepplewhite 1794, 11.

4. The copper and brass urn is also owned by the New Hampshire Historical Society (1958.62.1).

5. Cleary 1978, 31.

6. A Massachusetts card table on loan to SPNEA has similar beading as well as fluted, square tapered legs (43.1939). For a Massachusetts stand, see Montgomery 1966, no. 368.

7. Kaye 1978, 1098 and 1100, pls. 1, 2.

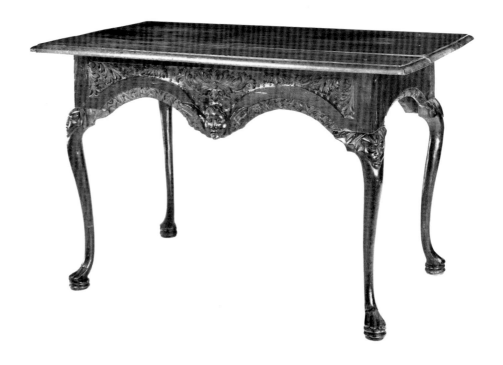

52

Altar table

Attributed to Joseph Davis (w. 1726–62)
Portsmouth, New Hampshire
1735–45
Saint John's Church
Portsmouth, New Hampshire

Unlike most New England towns, Portsmouth has had an active and influential Anglican establishment since its founding. The Anglican clergyman Richard Gibson arrived in 1638, and for twenty years no other church existed within its borders. The growing influence of Massachusetts and increasing immigration from the Bay Colony soon gave Congregationalism the upper hand, but a small contingent of residents remained steadfast in their support of the Church of England.[1] In 1732, plans for constructing a place of worship were initiated. The organizers secured a dramatic site atop a knoll overlooking the Piscataqua River and in 1734 consecrated a new wooden edifice capped with a handsome spire at the western end.[2] The structure was named Queen's Chapel in honor of Queen Caroline, who made a gift of prayer books, a Bible, and a silver communion service for use at the altar.[3] Two years later, the Reverend Arthur Browne agreed to become the first permanent rector of the parish. A graduate of Trinity College, Dublin, Browne was a learned gentleman with a gift for oratory and an "attachment to the ceremonies of the church," as one contemporary noted.[4] He quickly earned the respect of his parishioners and remained a leading figure in Portsmouth until his death thirty-seven years later. Browne's induction as rector brought the church additional gifts, including a silver chalice and probably this striking altar table.

The table provided an ornate surface for the display of the silver altar service presented by the Queen. Though of local origin, it follows an established London formula. The arrangement of the carved acanthus leaves, winged cherub (52A), and

masks (52B) adheres to that on an altar table made for an English church (52C). Yet no one would ever confuse the two examples; they vary dramatically in sophistication and scale. The English table epitomizes the bold, confident classicism of the best London furniture of the late 1730s. Its American counterpart, by comparison, seems naïve, awkward, and insubstantial. Nevertheless, the ambitious aspirations of the latter are readily apparent. Its maker sought to create an opulent object that would impress onlookers and offer a fitting home for the sacred articles of the altar. Within the provincial context of colonial Portsmouth, he succeeded superbly.

Fortunately, his identity can be discerned. The distinctive features of the table reveal the unmistakable hand of Joseph Davis, the Boston-trained artisan who moved to Portsmouth in 1734 and produced a flamboyant group of blockfront case furniture (*cat. nos. 16 and* 17). The slender cabriole leg, unusual toed foot scribed with long parallel veins, and scalloped "sock" at the top of the foot also appear on his finest surviving dressing table (*cat. no.* 17). For the front legs of both tables, Davis glued together two boards to create stock of sufficient thickness. He also employed similar patterns of carved foliage in high relief on the front rails. Above the cherub on the altar table, he centered a complex arrangement of leaves around a rosette grazed with cross-hatching. Flanking the shell of the dressing table, he set small curling sprigs around a plain rosette. Such relationships point to Davis, possibly working in collaboration with a local carver. Regrettably, no record of this impressive commission survives among the papers of the church, which was renamed St. John's in 1791. Many of the earliest documents were destroyed by fire, and the table itself nearly suffered a similar fate.

In the early hours of Christmas Eve, 1806, debris from a burning building on nearby Bow Street lodged on the steeple and set it ablaze.[5] According to an eyewitness, "it presented a splendid and imposing spectacle for about an hour, and then fell upon and crushed in the roof, immediately setting the whole interior in flames."[6] As an awestruck crowd observed the scene, two bystanders entered the church and rescued the most important relics, including the altar table and silver service, one of two large rococo armchairs (*cat. no.* 85), and a baptismal font.[7] Had it not been for their heroic efforts, none of the furnishings would have survived. Within days, parishioners began to plan for a new brick structure to replace the charred remains of their beloved chapel. They solicited designs from the Portland architect Alexander Parris and, exactly six months after the fire, laid the cornerstone with grand fanfare. When consecrated on May 29, 1808, St. John's Church ranked as the costliest and most architecturally advanced building in Portsmouth.[8] Yet its interiors retained a link with the past. The venerable artifacts treasured by previous generations were in place once again. The silver service and altar table occupied a prominent position along the back wall of the sanctuary. Today, they still remain in this handsome edifice, regularly used and appreciated by the congregation.

B J

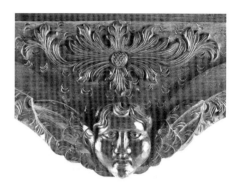

52A.
Carved cherub and acanthus leaves at the center
of the front rail.

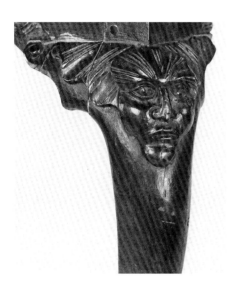

52B.

Carved mask on the knee of the cabriole leg.

Structure and Condition: The skirt outline of the rear rail matches that of the front rail. Each front leg is made of two boards glued together to create 3" stock. The top consists of four narrow boards. The rails are tenoned to the legs; each joint is secured with two wooden pins. The winged cherub at the center of the table is a separate element glued and nailed to the front rail. Six glue blocks secure the top to the frame. A repairman replaced the top and its support blocks, possibly in 1918 when the table was repaired and refinished (see *Inscriptions*). Several knee brackets have been damaged but none are replaced; the left front bracket is missing. The rounded back edge of the rear feet has been cut away to allow the table to fit flush against the wall.

Inscriptions: "Repaired and Refinished by G. P. Fernald Portsmouth N. H. / Nov. 1918" in pencil on the rear rail; "St. John's Church" in chalk on the underside of the top.

Materials: Cherry rails, brackets, and legs; black walnut top; eastern white pine blocks beneath top.

Dimensions: H. 28⅞; W. 49⁵⁄₁₆; D. 27¼

Provenance: Made for Queen's Chapel; rescued from a fire which consumed the building on Dec. 24, 1806; and installed at St. John's Church in 1808.

Publications: McLaughlin 1982, 52; Jobe 1987, 170.

1. Religion in early Portsmouth lacked the devotion and zeal that characterized the neighboring colony of Massachusetts Bay. As one church historian noted in 1901, "the leading motive of the settlers of the Massachusetts towns was Re-

ligion. That of the New Hampshire settlers was business" (Hall 1901, 3). Richard Gibson only remained in the Piscataqua region for four years; Joshua Moodey, the first permanent Congregational minister in Portsmouth, did not begin to serve there until 1658. For further information on the Anglican presence in Portsmouth, see Alden 1808, 25–26; Hall 1901; Daniell 1981, 64–65; and McLaughlin 1982.

2. Little information regarding the construction of the church is available; the best accounts appear in McLaughlin 1982, 19–20; and Garvin 1983, 142–43.

3. These relics as well as others received by the church have long been a subject of interest; see Alden 1808, 27; Davis 1894; Hall 1901; and McLaughlin 1982, 42–62.

4. Adams 1825, 236.

5. Ibid., 339–40.

6. *Portsmouth Journal*, Sept. 29, 1849. The author, identified in the article only by the letter L, was probably Alexander Ladd; see Brewster 1859, 353.

7. Brewster 1859, 353.

8. For an excellent account of the rebuilding of St. John's Church and a thorough assessment of its architectural significance, see Garvin 1973.

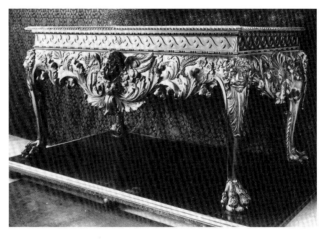

52C.

Altar table. Probably London, 1735–45. Private collection. Photograph, inscribed "Carved Altar St. Clares Rye Church." Courtesy, Robert Wemyss Symonds Collection of Photographs, The Winterthur Library, Winterthur Museum, Winterthur, Delaware.

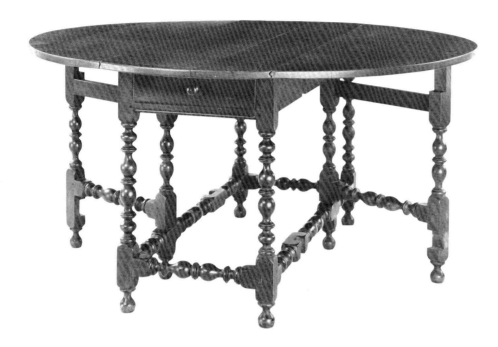

🌿 *53*

DINING TABLE

Boston, Massachusetts
1710–40
Wolfeboro Historical Society, Inc.
Wolfeboro, New Hampshire
Gift of Mrs. Esther Whitton Britton, 32.3

GEORGE VAUGHN, a member of Portsmouth's gentry, owned "2 large Oval Tables 3 £: one Small one 15/," which he kept in his best room.[1] Joseph Sherburne's "Great Hall" contained "1 Large Black Walnut Table £3:10:0" and a "middling Maple ditto 2:10:0."[2] These descriptions refer to oval drop-leaf tables with turned legs and stretchers similar to this one. Large-sized versions of this form were designed for use as dining tables but could easily double as writing surfaces or as places to spread out sewing. The single deep drawer may have held cutlery or linens. When not in use, the table remained against a wall ready to be pulled into the center of the room as needed.[3] This form of table served as an essential component in a well-furnished parlor until the 1740s, when tables with cabriole legs usurped its place, relegating it to less prominent rooms.[4]

Boston was a major production center for the finest examples of this type of drop-leaf table. Chairmakers, who were experienced turners, made a great number of them for local use and export.[5] Some of their wares were shipped to the Piscataqua River area, where wealthy families such as the Pepperrells of Kittery, Maine, and the Wentworths of Portsmouth constituted an eager market for top-quality imports. The Pepperrells owned a closely related table,[6] while this example is said to have been the property of Royal Governor John Wentworth, who kept it at his extensive country estate in Wolfeborough, New Hampshire. Inventories taken after Wentworth forfeited his property list a "Large Mahogany Table" in the library and an "old round" table kept in the kitchen.[7] Either entry could refer to this

table. Portsmouth-area craftsmen must have been familiar with Boston drop-leaf tables like this one and used them as models for their own versions.[8]

This type of dining table was generally made from black walnut or maple, but here the primary wood is mahogany, a costly import. The intricate turnings feature a complex, rhythmic pattern of mirrored balusters and rings (53A). Moreover, when fully open this table boasts a diameter of nearly 60", making it an unusually large example. Its condition is remarkable—even the original hinges secured with screws and rose-headed nails survive, as do many of the leather collars beneath the nails (53B).[9] Perhaps the table's Wentworth heritage saved it from hard use by subsequent owners, ensuring its survival as one of the finest and best preserved examples from the group.[10]

D C E

Structure and Condition: The side rails, end rail, and stretchers are tenoned into the legs with two pins at each joint. The rail beneath the drawer is tenoned into the legs and secured with one pin at each joint. The stationary leg of the swing support is round-tenoned into the rail and the stretcher. The feet are round-tenoned into the stretcher. The swing leg fits into a notch in the side rail and is notched above the foot to fit into a corresponding recess in the stretcher. Three notches are cut into each side rail for the hinges of the top and leaves. The

drawer supports are nailed with rose-headed nails to the rails. A medial brace across the frame is set into a notch in each side rail. The two-board top is fastened to the rails with wooden pins. The two-board leaves are hinged to the top. Their common edges meet in a standard tongue and groove.

The drawer is dovetailed at the front and nailed at the back with rose-headed nails. The upper rear corner of the drawer sides is cut away,

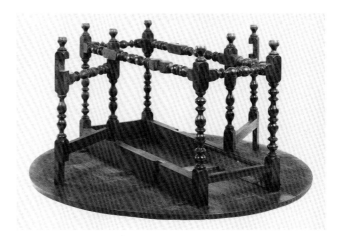

53A.
Underside of the table.

forming a notch that stops the drawer against the medial brace. The one-board bottom is nailed to the rabbeted edge of the front and flush edge of the sides and back with rose-headed nails.

The table displays little wear and few repairs. In 1991, Joseph Twichell of SPNEA's Conservation Center reglued the two-board top and re-pinned the top to the frame. It had been re-pinned at least twice before. At an earlier date a restorer moved the hinges on one side of the top approximately 1" and refinished the frame and top.

Inscriptions: Incised shadow on the top: "Mrs. W. J. Britten / 1 round…gateleg table / in diameter (five) feet…" Chalk "X" on the inside of the right drawer front.

Materials: *Mahogany top, leaves, end rails, drawer front, knob, legs, and stretchers; *white oak medial brace and drawer back; *eastern white pine for all other secondary work. Original hinges with some of the original screws and rose-headed nails with leather collars still in place. Wooden knob may be original.

Dimensions: H. 29¼; W. 59¾; D. 22½, D. open 60

Provenance: Supposedly descended in the Wentworth family of Portsmouth to Governor John Wentworth (1737–1820); acquired by Margaret Whitton Raynard Stoddard (d. ca. 1829) of Wolfeborough, N.H.; descended to her nephew Thomas L. Whitton (1811–1903); to his granddaughter, Mrs. Esther Whitton Britton (1877–1971), who donated it to the Wolfeboro Historical Society.

1. George Vaughn, 1727 inventory, docket 676, N.H. Provincial Probate, State Archives.

2. Joseph Sherburne, 1745 inventory, docket 1214, N.H. Provincial Probate, State Archives.

3. For more on how these tables were used, including an illustration of this type of table in a period setting, see Jobe and Kaye 1984, no. 58.

4. Venable 1989, no. 3.

5. Jobe and Kaye 1984, no. 58.

6. The Pepperrell table is now in the collection of the Old York Historical Society (1988.14).

7. Starbuck 1989, 116 and 128. The former quotation is from the inventory of 1779, while the latter is from the 1785 inventory. A third inventory was made in 1780, but the furniture account appears to be incomplete.

8. The Woodman Institute in Dover, N.H., owns a locally made drop-leaf table (1978.1.28) that is a contemporary of this one, but it is maple and does not have such intricate turnings.

9. For more information, see Streeter 1973, 25, fig. 4. This technique served as an aid to tightly grip the nail and as a buffer against wood shrinkage. James Garvin states that this procedure was called "botching" by contemporaries in Portsmouth and was commonly used there. Conversation with the author, Feb. 13, 1992.

10. Jobe and Kaye 1984, no. 58, note 2. They note eighteen related examples to a table in SPNEA's collection (1971.65), excluding this table and the one in the Bybee Collection (see note 4), both of which are mahogany and have closely related turnings.

53**B**.

Hinge secured with screws, rose-headed nails, and leather collars.

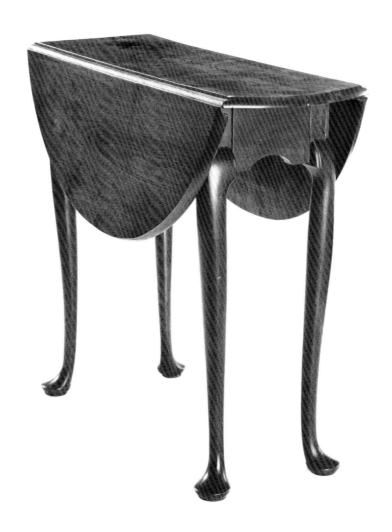

54

Tea table

Portsmouth, New Hampshire
1735–70
Governor John Langdon House
Portsmouth, New Hampshire
Society for the Preservation of New England
Antiquities, bequest of Elizabeth Elwyn
Langdon, 1974.358

This diminutive tea table, with an oval drop-leaf top, is an example of the baroque or Queen Anne style, which began to appear in Portsmouth in the 1730s. The drop-leaf form can be found on earlier examples, but the turned legs that were the hallmark of the William and Mary style (*cat. no.* 53) and the plain end rails have been supplanted by sinuously curved elements. The cabriole leg and pad foot, along with an arched skirt, present an advance in well-integrated design. Also, tables such as this seldom have drawers, which would detract from the unified effect.

The shift to cabriole-legged tables necessitated changes in construction methods. William and Mary-style drop-leaf tables often had six or even eight turned legs. Most cabriole-legged tables made in New England have only four legs. Two legs are stationary, and the other two swing out to support the leaves. Earlier tables relied on round tenons in the stretchers and rails to enable movement (*cat. no.* 53), but this table features a pintle hinge. The movable portion of the swing rail pivots on this interlocking and pinned hinge, while the fixed portion is nailed to the stationary rail. The craftsman took particular pains with this hinge, rounding off the ends at the joint rather than leaving them straight (54A). Even the joint between the top and the leaves underwent refining, with the development of the rule joint. Corresponding quarter-round grooves cut into the edge of the top and leaf ensured a tighter fit when the leaf was in use. The technique had become standard by 1755, when the Portsmouth chairmaker William Dam owned "1 Rule Joynt black Walnut Table 4 foot" valued at £15.[1]

The small size of this table, as well as the presence of expensive imported black walnut as its primary wood, suggests that it served as a tea table and was kept in one of the best rooms of the house. Thomas Cotton placed his teapot, silver spoons, and tea table in "ye Beed Room," while Nathaniel Peirce stored a walnut table, tea set, and tea kettle in the "West Lower Room."[2] This table has a history of ownership in the Langdon family of Portsmouth, and in the early twentieth century, Mrs. Woodbury Langdon kept it in the southeast parlor of the Governor John Langdon House.[3] The Langdons prized this table enough to have it professionally repaired in 1913, ensuring its survival as a family heirloom.[4]

This table adheres to a standard Queen Anne design formula—oval top, arched skirt, cabriole legs, and pad feet—and is constructed in a typical New England manner. A closely related Boston table, one supposedly owned by John Hancock, provides a precedent for this design within the region.[5] The Portsmouth maker of the Langdon table may have had access to a Boston example to emulate. However, the Portsmouth version has one distinctive feature that distinguishes it from its Boston counterpart: a thumbnail-shaped bead on the front inside corner of the knee on each leg.[6] Two nearly identical tea tables, one at Strawbery Banke Museum (1975.4084) and the other privately owned, share the same form and construction details, as well as the characteristic beaded edge. All three tables are the product of the same unidentified Portsmouth workshop.

D C E

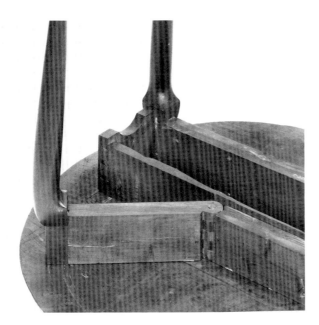

54A.
Underside of the table.

Structure and Condition: The swing rails are tenoned to the legs. Each joint is secured with two wooden pins. A distinctive round pintle hinge is used to pivot the swing rails. Stationary rails are dovetailed to one end rail and nailed to the fixed portion of the swing rail with four rose-headed nails. The one-board top is secured to the one-board leaves with two hinges. The top is secured to the frame by the means of four wooden pins. The bottom of the pad foot is lined with a thin disk.

In 1913, G. P. Fernald screwed the top to the frame, replaced the pintle in one pintle hinge, added wire nails to secure the dovetail joints binding the end and stationary rails, and refinished the surface. He also scraped the underside of the top at the corners, obliterating any evidence of its original glue blocks.

Inscriptions: On the bottom of the stationary rail in modern chalk: "Langdon." In pencil on the bottom of the swing rail: "Repaired and refinished / By / G.P. Fernald Dec 1913." The hinges are stamped "I F."

Materials: *Black walnut end rails, legs, top, and leaves; *soft maple swing rails; *eastern white pine stationary rails; one *hickory pintle hinge; and one replaced *birch pintle hinge. Original iron hinges.

Dimensions: H. 25⅗; W. 30⅛; D. 11½, D. open 31¹⁵⁄₁₆

Provenance: May have descended in either the John or Woodbury Langdon families of Portsmouth to Woodbury (1837–1921) and Elizabeth Elwyn (1871–1946) Langdon; bequeathed by Elizabeth Elwyn Langdon to SPNEA.

Publications: Jobe and Moulton 1986, 639.

1. William Dam, 1755 inventory, docket 1951, N.H. Provincial Probate, State Archives. The joiner Joseph Buss (before 1700–1756) helped take the inventory.

2. Thomas Cotton, 1746 inventory, docket 1162, N.H. Provincial Probate, State Archives; and Nathaniel Peirce, 1762 inventory, Wendell Collection, folder 9, case 7, Baker Library, Harvard Business School.

3. Postcard of the southeast parlor, photograph by Douglas Armsden, ca. 1960, SPNEA Archives. For a photograph of the table in that room, see Jobe and Moulton 1986, 639.

4. See *Inscriptions* for the mark left by G. P. Fernald, the furniture restorer.

5. See Sotheby Parke Bernet, sale 3422, Oct. 21, 1972, lot 43, for an illustration of this table, formerly part of the Lansdell K. Christie collection. A related table is in the Bybee Collection; see Venable 1989, no. 10.

6. Thumbnail beads appear on contemporary tables from Pennsylvania, but here the bead usually continues up the leg to the top. See Downs 1952, no. 320.

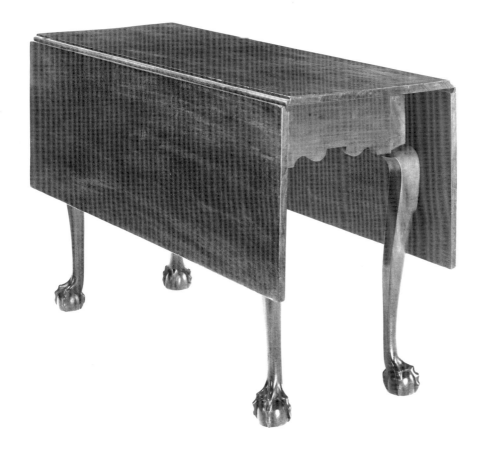

55

DINING TABLE

Portsmouth, New Hampshire, area
1760–85
New Hampshire Historical Society
Concord, New Hampshire
Gift of Hosea Canney, 1940.14.1

THE FEATURES OF THIS SUBSTANTIAL DINING TABLE—the rectangular top with
squared edges, shaped skirt on the end rails, cabriole legs, and claw-and-ball feet—
are typical of rococo tables from New England. Innovations introduced by the new
style include the rectangular top, which supplanted the oval variety, and the carved
taloned foot, a more fashionable and costly alternative to the round or pad foot.[1]
Rich, highly figured mahogany replaced black walnut as the material of choice.

This table measures nearly 4' wide, a standard width for a rococo dining table.
Its maker and owner might have described it as a "Four foot Mehogany Table w.
Claw feet."[2] Designations according to width were commonplace in the eighteenth
century. In 1740 Michael Whidden II sold the shopkeeper Daniel Wentworth a
group of tables, all identified by size: "To Six threefoot & half tables @ 15ˢ p foot
15:15:0 To one fourfoot Table 3:-:- To one threefoot Table 2:5:0."[3] Stephen
Chase, a Portsmouth merchant, owned "1 - 3 foot Mahogany Table 4.50" and "2 -
4 feet Mahogany Tables $6 - 12.00."[4] Pairs of tables such as Chase's could be used
butted together or singly as the occasion called for.

Virtually every Portsmouth household, except those of the poorest residents,
had at least one drop-leaf dining table. They were pressed into service in whatever
room the family selected for meals. This could be a separate space identified as a
dining room such as the one in the Jaffrey house (*see cat. no.* 4). Designated dining
rooms became popular in the eighteenth century, when Englishmen began to emu-
late this French innovation. Some fashion-conscious Americans followed suit, but

the majority continued to dine in any convenient room, depending on the season and the numbers to be served.[5] John Salter kept "1 pair four foot Tables" in a room that also contained a tea stand, Pembroke table, and thirteen chairs.[6] Jonathan Warner stored "2 - 6 feet mahog'y din'g tables" in the lower entry hall, where they could be moved into the parlor or front sitting room at mealtime.[7] When needed, the table would be situated in the center of the room, with its leaves opened, and its top covered with a white linen cloth, which protected the polished mahogany.[8]

The design of this dining table is for the most part typical of New England tables made during the second half of the eighteenth century, but three particular details are important clues in identifying its place of origin. First, a sharp crease descends down the corner of the knee, stopping abruptly 6" from the rail. Previously, scholars identified this feature as characteristic of North Shore, Massachusetts, furniture.[9] Second, the skirt on the end rails follows an unusual outline, where reverse curves meet at the center in a flat-headed arch. And finally, the top is mounted to the frame in a peculiar manner. Four long rectangular blocks are glued and nailed to the underside of the top and pinned to the stationary rails (55A). The advantage to this technique is that the blocks are attached to one surface rather than two, which allows them to move with the changes in humidity and still hold firmly. Other, more common methods include: driving pins through the top into the frame; fastening screws through the frame into the top; or mounting glue blocks to the inner surface of the rails and the underside of the top.[10]

These three features appear on a sizable group of drop-leaf tables, three of which have provenances in the Portsmouth area. Although the tables vary in size, shape of their tops, and foot design, they were undoubtedly made in a single shop between 1755 and 1780. This table, previously owned by Hosea Canney of Center Harbor, New Hampshire, is the best surviving example from the group. It descended in the Hawkins or Canney families, who lived in the Portsmouth area in the eighteenth century, before moving to Center Harbor in the Lakes Region.[11] A variation on the Canney table belonged to Shipley Ricker of South Berwick, Maine (55B). Its oval top and round feet conform to traditional design,[12] while a table that

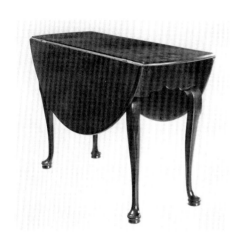

55B.

*Dining table, Portsmouth, New Hampshire, area, 1760–85. *Mahogany, *birch, *eastern white pine, and *hickory, H. 27¾; W. 47½; D. 16¹¹/₁₆, D. open 46 ¹¹/₁₆. Society for the Preservation of New England Antiquities, Boston, Massachusetts, gift of the estate of Florence Evans Bushee, 1976.233. This table was formerly owned by the Ricker family of South Berwick, Maine.*

55A.

Underside of the table.

descended in the Jaffrey family of Portsmouth (55c) exhibits even more rococo traits than the Canney table, because the square top is finished with serpentine edges.[13]

The histories of these tables suggest that they originated in the Portsmouth area. The maker understood eastern Massachusetts design. His work contrasts with the London-inspired china tables made at the same time (*cat. nos. 48 and 49*), indicating that Portsmouth craftsmen were influenced by ideas originating in both areas. However, the distinctive method that this artisan used for securing the top to the frame and such details as the creased knee and skirt profile ensure that his hand is recognized even today.

D C E

Structure and Condition: The stationary rails are dovetailed to the end rails and nailed to the fixed portion of the swing rails. Two shims are inserted between the stationary and swing rails. The swing rails are tenoned and pinned to one movable leg and one fixed leg. Each swing rail pivots on a wooden pintle hinge. A pair of iron hinges fastens each one-board leaf to the one-board top.

The pins securing the blocks beneath the top to the stationary rails are replacements. Casters were once present. One leaf has two cracks at the joint with the top. The old finish has darkened and crazed.

Materials: Mahogany legs, end rails, top, and leaves; *birch swing rails; *hickory pintle pins; *eastern white pine stationary rails, shims, and support blocks. Original iron hinges.

Dimensions: H. 27⅛; W. 47⁷⁄₁₆; D. 18, D. open 46¾

Provenance: Presumably descended in the Canney or Hawkins families to Hosea Canney (1863–1941), who kept it on his farm in Center Harbor, N.H., on Lake Winnipesaukee; given to New Hampshire Historical Society in 1940.

1. Jobe and Kaye 1984, no. 64.

2. John Baker, 1780 inventory, old series, 79:427, Suffolk County (Mass.) Probate, as quoted in ibid.

3. Whidden v. Wentworth, May 14, 1741, docket 25753, N.H. Provincial Court, State Archives.

4. Stephen Chase, 1805 inventory, old series, docket 7381, Rockingham County (N.H.) Probate.

5. Garrett 1990, 78. For more on the origins of the dining room, see Hood 1991, 122–26.

6. John Salter, 1815 inventory, old series, docket 8948, Rockingham County (N.H.) Probate.

7. Jonathan Warner, 1814 inventory, old series, docket 8936, Rockingham County (N.H.) Probate.

8. Garrett 1990, 82. The cloth was removed between the dessert and fruit and nut courses.

9. Fales 1965, no. 76.

10. For examples of tables using these more common methods, see Jobe and Kaye 1984, nos. 60, 64, and 63, respectively.

11. A chart of Canney's ancestors, in the object file at the New Hampshire Historical Society, shows that various relations resided in Exeter, Hampton, Dover, and Barnstead, N.H., while others hailed from Kittery, Me.

12. The table (1976.233) is marked "Shepley Ricker's Table / So. Berwick." For more, see Jobe and Kaye 1984, no. 61.

13. The top is original to the frame. This table is still owned by a descendent of the Jaffreys. George Jaffrey III (1718–1801) may have been the original owner. See also cat. no. 4. Other tables in this group, which do not have provenances, include: a tea table at the Winterthur Museum (see Downs 1952, no. 307); two tea tables in private collections; a dining table, privately owned, which is virtually identical to a table sold at Sotheby Parke Bernet, sale 4478Y, Nov. 19–22, 1980, lot 1322; and another privately owned dining table.

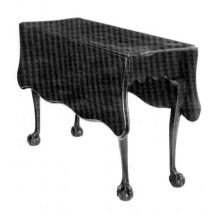

55c.

Dining table, Portsmouth, New Hampshire, area, 1760–85. Mahogany, birch, eastern white pine, H. 27¼; W. 46½; D. 17 ½, D. open 45. Private collection. This table was formerly owned by the Jaffrey family of Portsmouth.

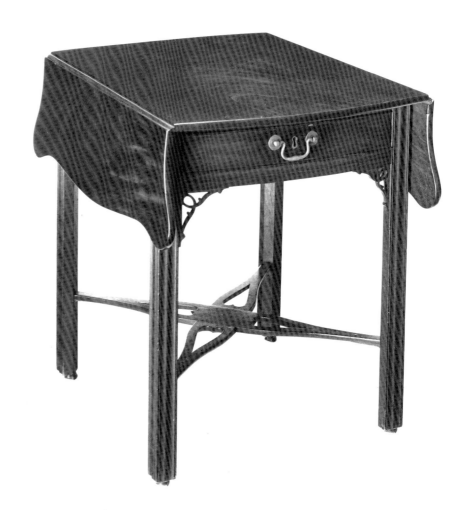

56

PEMBROKE TABLE

(Colorplate 12)
Portsmouth, New Hampshire
1760–90
Private collection

IN 1803, THOMAS SHERATON RECALLED that the Pembroke table got its title "from the name of the lady who first gave orders for one of them, and who probably gave the first idea of such a table to the workmen."[1] This may be apocryphal, but the name Pembroke became synonymous with breakfast tables featuring drop-leaves, four fixed legs, and a drawer. Thomas Chippendale published a related design for what he called a "Breakfast Table" as early as 1754.[2]

The fashion-conscious of Portsmouth ordered specially designed breakfast or Pembroke tables to be used in their parlors or dining rooms. The Loyalist, John Fisher, claimed a "Pembrock work table Mohogony £3" on his 1778 inventory of losses.[3] Capt. John Parrot owned "1 Mahogany Dining table 1..16 / 1 ditto Pembroke ditto 1..10 / 1 ditto Tea ditto ..12."[4] All three tables were kept in the same room, one that was equipped to handle a variety of dining needs. Madam Elizabeth Wentworth also owned a Pembroke table, which she kept in her "Dining Room" along with one oval mahogany table, a tea table, and five black walnut chairs.[5] This Pembroke table belonged to Judge William Hale of Dover, New Hampshire. When the Judge died in 1849, it was situated in his sparsely furnished "N. East Room," along with two mahogany hair-seated sofas and a lone astral lamp.[6]

A particular pattern of Pembroke table enjoyed widespread popularity in Portsmouth. More than a dozen related examples feature straight molded legs, pierced cross stretchers, fretwork brackets, serpentine leaves, a cockbeaded drawer front with a plain brass handle, and a beaded molding between the drawer and

brackets.[7] Subtle variations sometimes distinguish the tables. This example has knee brackets with a single loop in each corner, but a four-petaled flower appears on a table in the Department of State.[8] The piercings on most stretchers resemble a carrot, while this example features a heart.[9] The execution of the pierced pattern, with its chamfered edges, is neater than that on many of the related examples.

Most of the rococo Pembroke tables from Portsmouth are similarly constructed (56A). A pair of swinging flaps (often called "flys" in the period)[10] supports each leaf; a broad bead caps the top edge of the drawer sides; the lap joint at the center of the cross stretchers is reinforced with nails; and stretcher plates secure the stretchers to the legs. This last detail, which echoes the treatment on Portsmouth china tables (*see* 49B), follows standard English practice.[11] The overall design of these tables resembles English examples as well, indicating that an English-trained craftsman, such as Robert Harrold, was the driving force behind this body of work.[12] Minor variations in construction suggest, however, that more than one Portsmouth shop offered this type of table to the public.

D C E

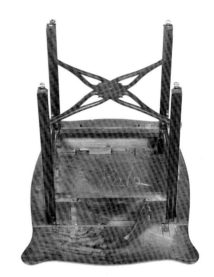

56A.
Underside of the table.

Structure and Condition: The stationary rails and fixed ends of the flaps are mortise-and-tenoned to the legs. Each flap pivots on a wooden pintle hinge. A pair of iron hinges fastens each board leaf to the one-board top. Four screws reinforced by a series of glue blocks affix the frame and top. The knee brackets are glued and nailed to the frame. As on most Pembroke tables, the end rail simulates a drawer front.

A single drawer runs on supports nailed to the stationary rails. The mahogany drawer front is 1¾" thick. The cockbeading along the top and bottom was cut directly on the drawer. The side cockbeads (now missing) were originally applied. The drawer bottom fits into dadoes cut in the front and sides and is nailed to the back. The drawer stops are missing, and the left front and the right rear knee brackets are replaced. Angle irons were added to strengthen the joint binding each leg to the front and rear rails.

Inscriptions: On the underside of the top, in old chalk: "E Hale." Scratched into the drawer bottom: "Hale."

Materials: Mahogany top, leaves, legs, stretchers, end rail, drawer front, and knee brackets; *soft maple stationary rails; *hard maple flaps; maple pintle pins; and *eastern white pine for all other secondary work. Original brass handles and escutcheons on drawer front and end rail; original iron lock, stretcher plates, and hinges; original casters.

Dimensions: H. 28⁵⁄₁₆; W. 23; D. 28¾, D. open 39¼

Provenance: Presumably owned by William Hale (1765–1848) and his wife, Lydia Rollins Hale (1773–1841) of Dover, N.H.; descended to their daughter, Elizabeth Hale (1800–1882), who married Jeremiah Smith (1759–1842); to their grandson, Jeremiah Smith II (1837–1921); acquired by their granddaughter Martha Hale Low Ffrost (1841–1925), wife of George Seward Ffrost (1844–1931); descended in the Frost family of Durham until it was acquired by an area antiques dealer who sold it to Robert Blekicki; he sold it to the present owner.

Publications: Ellis Memorial 1978, 90.

1. Sheraton 1803, 284.

2. Chippendale 1754, pl. 53. The design features serpentine leaves, Marlborough legs, and crossed pierced stretchers. For more on this form, see Jobe and Kaye 1984, no. 66.

3. As quoted in Rhoades 1972, 46.

4. John Parrot, 1790 inventory, old series, docket 5518, Rockingham County (N.H.) Probate.

5. Elizabeth Wentworth, 1795 inventory, folder B, box 1, Wentworth Papers, Portsmouth Athenaeum.

6. William Hale, 1849 inventory, docket 271, Strafford County (N.H.) Probate. A dressing table and bedstead also survive with Hale family histories (*see* 19A *and cat. no.* 111).

7. Eight related tables have Portsmouth-area histories: a pair belonged to the local merchant Richard Hart (Jobe and Kaye 1984, fig. 1–37); a privately owned pair descended in the Warner family; a single table belonged to Jacob Wendell in the nineteenth century (Sotheby's Arcade, sale 1269, Jan. 26, 1989, lot 481); another was owned by a Mrs. Pierce (Parke-Bernet, sale 2510, Jan. 28, 1967, lot 94); another came from the Ffrost family of Durham, N.H. (Henry Ford Museum, 30.756.10); and another descended in a Portsmouth family (Portsmouth Historical Society, BK78. Two assembled pairs in the U.S. Department of State (Conger and Rollins 1991, no. 60) and a single table at Strawbery Banke Museum (1991.163; see Christie's, sale 7398, Jan. 17-18, 1992, lot 482) lack histories. See also note 9.

8. Conger and Rollins 1991, no. 60.

9. For an example with the same stretcher, see Parke-Bernet, sale 2510, Jan. 28, 1967, lot 72.

10. *Cabinet-Makers' Book of Prices* 1793, 91.

11. Conger and Rollins 1991, no. 60. The braces on this table are iron, but others in the group are wood.

12. For English examples, see Parke-Bernet, sale 1700, Oct. 19–20, 1956, lot 142; and Kirk 1982, figs. 1410, 1411.

❧ 57

Pembroke table

Portsmouth, New Hampshire
1795–1810
Private collection

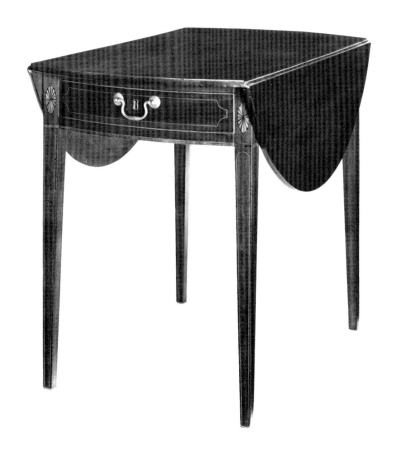

During the federal period Pembroke tables, "the most useful of this species of furniture," became a staple in the repertory of Portsmouth cabinetmakers.[1] Because of their moderate size and convertible design, they were used during meals as well as at lessons and sewing sessions. Langley Boardman's advertisement of 1799 announced that he had "a general assortment of Cabinet work, among which are the following:…Commodes; Card-Tables; Dining-Tables; Pembrook-Tables…"[2] Three years later, James Rundlet and John Wendell each purchased a Pembroke table from Boardman for $12 and dining tables for $10 and $15, respectively.[3] In 1807, the Portsmouth cabinetmaker Samuel Wyatt sold Benjamin Lapish a Pembroke table also costing $12. This was the same price as a mahogany table measuring 4' that he purchased but $3 less than a card table and $4 less than a "sweld bureau." A light stand, lolling chair, and common bedstead were appreciably cheaper.[4] These calculations indicate that the market price for a Pembroke table such as this one was $12, putting it in the mid-range on the cost scale of furniture.

With the advent of the neoclassical style, Pembroke tables became more delicate than their robust rococo predecessors. This example features straight tapered legs inlaid with stringing and paterae in contrasting woods, a bowed drawer with an inlaid astragal motif, and D-shaped leaves that form an oval top when raised. The elaborately pierced cross stretchers of the Hale family table (*cat. no.* 56) have been abandoned altogether, as have the molded legs, the fretwork brackets, and the serpentine leaves. Structurally, the tables are similar (57A), except that the neoclassical

version has only a single flap instead of a pair supporting each leaf.

Although references to Pembroke tables in federal Portsmouth are commonplace, documented examples of the form do not survive in substantial numbers, especially those with tapered legs.[5] This table bears the brand of an early owner, "PURCELL"; surprisingly, the surname appears without a first initial. Misses Nancy (1767–1843) and Susan Purcell (ca. 1777–1861), two comfortably situated sisters, were the only residents with that surname in Portsmouth in the early nineteenth century.[6] Jacob Wendell acquired the table, possibly at auction, at a later date.[7]

D C E

57A.

Underside of the table.

Structure and Condition: The end rail and fixed portion of the flaps are tenoned to the legs. The stationary rails are nailed to the flaps with six cut nails. Each flap pivots on a pintle hinge. The end rail consists of three laminated boards that are veneered and finished to match the drawer front. A vertical block is glued at the rear corners of the frame. A pair of iron hinges fastens each one-board leaf to the one-board top. The top was originally screwed to the frame with six screws, but only five remain. The drawer runs on supports nailed to the stationary rails. A stop was glued to each stationary rail at the back, but one is missing. The drawer bottom fits into a dado in the front and sides and is nailed to the back. The table has had only one significant repair: the right rear leg was broken and angle irons added to fasten it to the rails. In 1989, the present owner removed the angle irons and reglued the break, then cleaned and coated the table with shellac.

Inscriptions: Branded "PURCELL" on left swing rail and the drawer bottom.

Materials: *Mahogany top, leaves, and legs; mahogany veneer on drawer front and end rail; birch inlays; *soft maple swing rails; and *eastern white pine for all other secondary work. Original brass handles and escutcheons on drawer front and end rail; original lock and hinges.

Dimensions: H. 27⁹⁄₁₆; W. 33⅞; D. 20⅛, D. open 40¾

Provenance: Owned by a member of the Purcell family of Portsmouth; acquired by Jacob Wendell (1788–1865); descended in the Wendell family (*see cat. no.* 5); purchased at Sotheby's by the present owner.

Publications: Sotheby's, sale 5810, Jan. 26–28, 1989, lot 1452.

1. Hepplewhite 1794, 12.

2. *New Hampshire Gazette*, Apr. 5, 1799 (*see fig.* 43).

3. Ledger B, 271, James Rundlet Papers, Archives, SPNEA (*see* 8A); and bill from Langley Boardman to Mr. Wendell, Aug. 4, 1802, Wendell Collection, folder 4, case 13, Baker Library, Harvard Business School. Mr. Wendell probably refers to John Wendell (1731–1808).

4. Bill from Samuel Wyatt to B. Lapish, 1807, Benjamin Lapish Papers, folder 2, box 1, Durham Historical Society. The prices charged include $5 for a mahogany stand, $3 for the bedstead, and $8 for a lolling chair.

5. Examples with reeded legs are more common. One example survives in the Rundlet-May House, SPNEA (1971.521); another in a private collection is branded "G•McCLEAN" for Capt. George McClean of Portsmouth (see *Sack Collection*, 8:2219).

6. Wentworth 1878, 515. The sisters lived in the Portsmouth home of their brother-in-law William Gardner.

7. A second Pembroke table descended in the Wendell family, but it has serpentine-shaped leaves and top. See Sotheby's, sale 5810, Jan. 26–28, 1989, lot 1441. Jacob Wendell frequently purchased furniture at auction (*see cat. no.* 29, *note* 5).

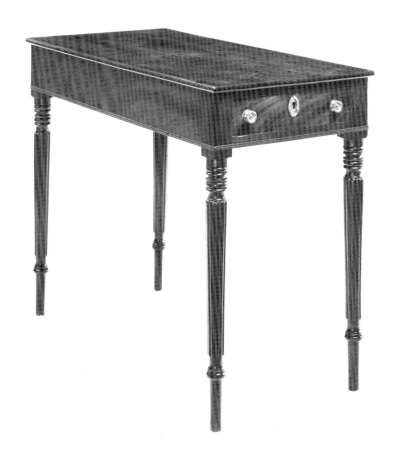

58

WRITING TABLE

Portsmouth, New Hampshire
1810–20
Strawbery Banke Museum
Portsmouth, New Hampshire
Museum purchase with funds provided in part by
Mr. and Mrs. B. Allen Rowland, 1991.3

THE FORM OF THIS UNUSUAL TABLE is probably that of a reading and writing table, the name given by Thomas Sheraton to a more complicated version of the form illustrated as plate 44 in his *Drawing-Book*. Although this table lacks the adjustable top and candleslide at one end depicted in Sheraton's design, it is rectangular and has a single drawer subdivided into compartments for pens, ink, sand, and other writing materials. The ring turnings and reeding of the legs vary from the norm in Portsmouth, but it is likely nonetheless that the table was made locally.[1]

This conclusion is based largely on the bold inscription (more than a foot wide) with the name of its original owner, John Welch Foster, and the place, Portsmouth, New Hampshire (58A). Foster was born in Boston on June 16, 1789, the son of James (1748–93) and Elizabeth (Hiller) Foster. After the death of his father, he was adopted when four years of age by his maternal uncle, Joseph Hiller, the well-known collector of the port of Salem, Massachusetts. Foster attended school in Salem and then entered into the bookselling business in Boston about 1802. In 1805, he took a position in the counting-room of his brother-in-law's business in Havana, Cuba, where he remained until 1807. Returning to Boston, he joined the firm of John Tappan, a large importer of English goods, and became a member of the Old South Church. In 1811, he served as supercargo on a voyage from Baltimore to Lisbon, nearly perishing in an accident on the way back.

Perhaps seeking a more sedate life, he came to Portsmouth in December of 1812 as the junior and active partner in the bookselling firm of Tappan and Foster

on Market Street. In 1818, he began what would become a long avocation as a teacher in the South Parish Church Sunday School. In 1824, he married Mary Appleton (1799–1879), and they lived in a house on Pleasant Street. For many years, Foster served as secretary of the Portsmouth Athenaeum, an appropriate position for a man who spent much of his life writing and involved with books.

After Foster's death on January 17, 1852, his friend James F. Shores, Jr., published *A Memorial of John W. Foster*, edited by Andrew P. Peabody and issued within the year.[2] This volume includes a Sartain engraving of Foster as the frontispiece, a forty-page memoir of Foster by the editor along with other addresses and resolutions of a memorial nature, and nearly four hundred pages of Foster's correspondence, addresses, and miscellaneous writings. It is tempting to think that he composed many of these works at this very table. Foster's estate inventory, totaling $14,634.07, includes many tables, but this particular table cannot be identified precisely in the list.

Foster's daughter, Miss Sarah H. Foster, published *The Portsmouth Guidebook* (1876 and later editions), and his son, Joseph Hiller Foster, succeeded to his business and later became treasurer of the Portsmouth Savings Bank.

G W R W

58A.

Inscription on the underside of the bottom.
Courtesy, Bernard and S. Dean Levy, Inc. New York, New York.

Structure and Condition: The table is of joined construction; the one-board side and rear rails are tenoned into the legs. A bead molding is attached to the lower edge of the rails. The one-board top was originally screwed to the frame with six screws (it is now attached with ten screws). The top barely overhangs the frame and has a rounded edge.

Two long strips nailed to the underside of the top serve as drawer guides, and three small blocks are glued along each side guide. Drawer supports are nailed to strips, which in turn are nailed to the side rails. Two vertical blocks are glued to each rear corner of the frame to serve as drawer stops; one vertical block is glued to each front corner.

The drawer extends nearly the full depth of the frame. Originally, the drawer had a row of three small compartments at the front, and one or two larger compartments at the rear, divided from each other by thin mahogany partitions. The drawer is fastened at the corners with dovetails of good quality; the bottom is a single board with grain running from front to back, let into a dado in the front and sides, and nailed to the underside of the back. Four widely spaced horizontal blocks are glued along the lower inside edge of the right drawer side, and five similarly spaced blocks are glued to the other side.

Although it has been refinished, the table is in good condition. The drawer has been divided internally into four compartments; the drawer stops have been replaced; and there are minor repairs and shrinkage cracks. The top has many small circular stains.

Inscriptions: "J. W. Foster / Portsmouth / NH" is written in black ink or paint on the underside of the top.

Materials: *Mahogany top, drawer front, and legs; mahogany veneer on side and rear rails; *basswood secondary wood for rear rail; *eastern white pine secondary wood for side rails and all other work. Replaced brass hardware.

Dimensions: H. 28⅛; W. 34¾; D. 17¼

Provenance: The table was owned originally by John W. Foster (1789–1852) of Portsmouth. It was acquired from "a Boston resident in whose family it had descended" in the 1930s by Ted Samuel, a San Francisco collector; later owned by the New York antiques firm of Ginsburg and Levy; acquired by Leonard Sunshine of New York and Connecticut; and subsequently owned by Bernard and S. Dean Levy, Inc., of New York City, who sold it to Strawbery Banke Museum in 1991.

Publications: *Antiques* 37:3 (Mar. 1940): 118; *Antiques* 86:1 (July 1964): 15; *Decorative Arts* 1964, no. 68; Ward and Cullity 1992, pl. 19.

1. For related American tables, see Comstock 1962, fig. 570 (a New York table more closely related to the Sheraton design), and *Sack Collection*, 3:773, attributed to Massachusetts. The Sheraton plate is facing p. 396 in Sheraton 1803.

2. Biographical information is derived from Peabody 1852. See also John W. Foster, 1852 inventory, old series, docket 16308, Rockingham County (N.H.) Probate.

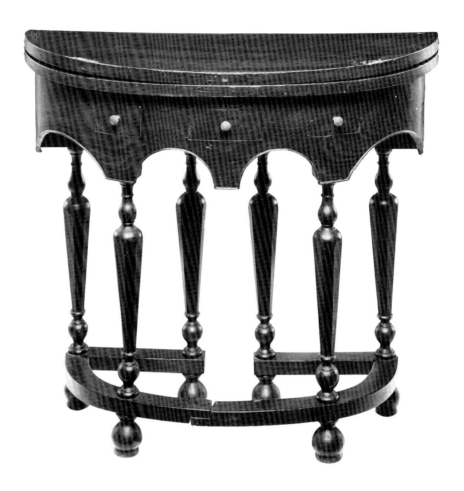

59

CARD TABLE

England
1690–1710
Warner House Association
Portsmouth, New Hampshire
Gift of Mrs. George B. Lord, 1968.2

THIS OVAL CARD TABLE IS AN EXTREMELY EARLY AND RARE EXAMPLE of a specialized form that is perfectly suited to its function. Its compact size and convertible design make it easy to move about and set up, and it offers just enough playing surface for four cardplayers. There are three small drawers for gaming apparatus, such as counters, decks of cards, and dice. A slide above the center drawer provided a convenient space for candlesticks during evening games. When not in use the table would be placed against a wall, most often in one of the reception spaces of the home.

The elite citizenry in early eighteenth-century Portsmouth, particularly those who sought to emulate their peers in the home country, imported furnishings from England. George Jaffrey owned a tall case clock made by Joseph Windmills of London (*see cat.* 38). Archibald Macpheadris ordered "one Deske, one book case, one dresing table, twenty four Chairs, one box looking Glasses" to be shipped from Bristol, England, in 1716.[1] An imported card table such as this was a status symbol in its day.

Games of chess, cards, dice, and tables (later known as backgammon) were played in England as early as the fifteenth century. Manuals like *The Compleat Gamester* (1674) not only explained the rules for numerous card games but cautioned that if an individual was unfamiliar with a popular game he "would be reckoned low-bred and hardly fit for conversation."[2] Indeed, card playing was so popular

by the early eighteenth century that the contemporary chronicler and poet, Jonathan Swift, satirized the craze in his 1729 poem, *The Journal of a Modern Lady*:

> The table, cards and counters set,
> And all the gamesters ladies met,
> Her spleen and fits recovered quite,
> Our madam can sit up all night;
> 'Whoever comes I'm not within-
> Quadrille's the word, and so begin.'[3]

Women were just as susceptible to the pleasures of card playing as men. Indeed, the intimacy of a card table was an acceptable forum for courting men and women to meet. Among the most popular card games during this time were ombre (a three-handed game), quadrille (a slightly later game for four players), and the two-handed piquet.

In order to accommodate these intimate card games, specially designed card tables came into fashion in England. Like the Warner House example, these tables usually have circular- or oval-shaped hinged tops, six turned and faceted legs designed so that two of them swing, flat stretchers, and small drawers in the front rail (59A).[4] This table is slightly less ornate than other examples because of its plain ball feet, simple D-shaped stretcher, and arched skirt. Walnut veneer is the common surface treatment; however, this example's veneer has been obscured by mid-nineteenth-century graining over earlier black paint. The playing surface was often covered in green baize or even velvet, but such fragile linings seldom survive. This early group of tables relates stylistically to dressing tables, high chests, and multipurpose tables of the period.

D C E

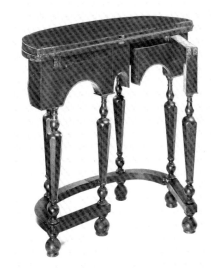

59A.

Table from rear, with one leg open.

Structure and Condition: This table is fastened with glue and nails; mortises and tenons are not used in the frame. The front rail is an extremely thin piece of bent wood that has been glued and nailed to the stationary rear rail. The front rail is covered with veneer. A solid bottom has been nailed to the frame, completely enclosing the underside of the table. The drawers run on the fixed bottom, between drawer guides. Each drawer is dovetailed at the corners. The drawer bottom is glued to the rabbeted edges of the front, sides, and back. Two swinging rear legs fit into notches cut into the stationary rear rail, similar to the traditional gate-leg construction (*see* 53A). A round tenon at the end of each leg extends through the stretcher and turned foot. The central drop is missing. The old green silk table cover is not original.

Materials: Walnut veneer on top, leaf, rails, and drawer fronts; *limewood top and leaf; *Sylvestris pine front and back rails; *beech stretchers and swing rails; *spruce inner wall of back rail and drawer guides; *white oak drawer components; and *fruitwood legs and feet. Replaced brass drawer knobs.

Dimensions: H. 27⅞; W. 30¹¹⁄₁₆; D. 11¾, D. open 23¼

Provenance: The table probably descended in the Wendell family of Portsmouth to George Boardman Lord (1871–1947) and his wife Marion Wendell Lord. They lived at 118 Pleasant Street in Portsmouth in the home previously owned by her parents, Frederick Sleeper Wendell (1836–1920) and Mary J. Wendell (1839–1928). Frederick Wendell was the great-grandson of John Wendell (1731–1808), whose estate inventory listed "1 round Card Table .75;" see 1808 inventory, old series, docket 7985, Rockingham County (N.H.) Probate. Mrs. Lord gave the table to the Warner House Association in 1968.

Publications: Antiques 26:4 (Oct. 1934): 129.

1. Bill of lading to Archibald Macpheadris from R. Browning, May 2, 1716, Warner House Collection, Portsmouth Athenaeum.

2. Edwards 1954, 3:193.

3. Rogers 1983, 370.

4. Similar tables are in the collection of The Victoria and Albert Museum (see Edwards 1954, 3:194, fig. 5); and the Untermeyer Collection at the Metropolitan Museum of Art (see Gloag 1958, 47–48, figs. 233, 234). See also Lockwood 1913, 2:196–97; and Symonds and Ormsbee 1947, pl. 31, top.

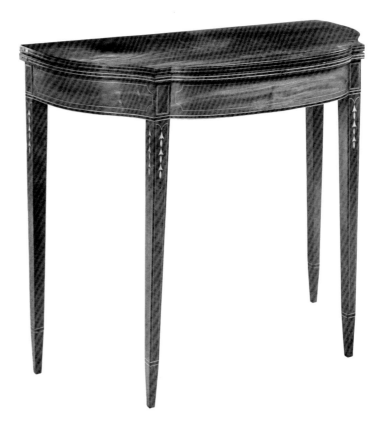

60

CARD TABLE

Langley Boardman (1774–1833)
Portsmouth, New Hampshire
1807
Private collection

CARD TABLES CONTINUED TO BE a relatively uncommon furniture form in Portsmouth until the early nineteenth century, when local cabinetmakers stepped up their production to meet the increased demand. Society in the federal era enjoyed a new sense of freedom and fun, which included the pursuit of card playing by people of all classes. They indulged their passion at home, in assembly houses, and in taverns.[1] Those who could afford to do so purchased pairs of specially designed tables for their homes in order to host fashionable card parties, which took place in the early afternoon or in the evening after dinner.[2] The wealthy merchant John Peirce kept three mahogany card tables in his parlor, while Samuel Ham, a merchant of equal stature, made do with only one.[3]

When George Ffrost II of neighboring Durham, New Hampshire, wanted card tables for his newly renovated home, he sought out Langley Boardman, one of Portsmouth's finest cabinetmakers. Ffrost, a merchant, magistrate, and farmer, purchased a pair of card tables, including the one illustrated here, in 1807 (94A).[4] The year before, he had bought a set of chairs from the craftsman (*cat. no.* 94). The tables and chairs have descended in the Ffrost family and still remain in the house for which they were made.

Square tables such as this one, with elliptic fronts, serpentine ends, and tapering legs, traditionally are associated with eastern Massachusetts workshops, but Portsmouth craftsmen also adapted this design for their own use.[5] In addition to the Ffrost table, Joseph Akerman II of Portsmouth owned a closely related example

(60A),[6] and two of John Peirce's tables belong to this group as well.[7]

The Ffrost and Akerman tables share many decorative motifs, including the pattern of string inlay on the rails and legs, the banding along the skirt, leaf edges, and cuffs, and most noticeably, the bellflower inlay on the legs (60B *and* 60C). However, the flowers on the Ffrost table are more boldly drawn, and they are situated slightly higher on the leg, providing a focal point and visual support for the surmounting panel on the rail. The treatment of the panel also varies between the two examples. That on the Ffrost table is plain mahogany outlined by a checkered border, but the Akerman version sports flame-birch inlay in the panel, surrounded by a rope-twist border. This touch of birch detracts from the uniformity of the design but may have delighted Mr. Akerman.

Ffrost's table features unusually fine construction details, such as the use of solid mahogany for the front and side rails as well as for the pair of support blocks at each corner of the frame (60D). The cabinetmaker took particular pains with these blocks to ensure that the two pieces meet at a right angle. Other furniture associated with Boardman displays similarly meticulous craftsmanship (*cat. nos.* 8, 28, *and* 94). The front and side rails of the Akerman table are laminated white pine boards veneered with mahogany (60E). Moreover, the white pine support blocks are larger and lack the same attention to detail. Such differences point to the presence of two shops working in a similar manner in Portsmouth. Their designs echo popular Boston-area patterns and suggest the influential role of Massachusetts native Langley Boardman in the spread of the neoclassical style.

D C E

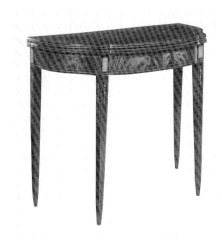

60A.

Card table, Portsmouth, New Hampshire, 1800–1815. Mahogany, mahogany, birch, and rosewood veneer, birch, eastern white pine, H. 29¾; W. 35⁵/₁₆; D. 18⅝, D. open 35³/₁₆. Collection of Peter Carswell. This table was originally owned by Joseph Akerman II.

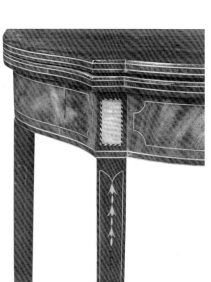

60B.

Front corner of the Ffrost family table.

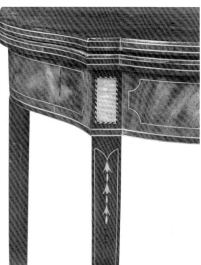

60C.

Front corner of the Akerman family table.

60D.

Underside of the Ffrost family table.

60E.

Underside of the Akerman family table.

Structure and Condition: The left rear leg swings out to support the one-board leaf. The swing rail pivots on a pintle hinge, which retains its original wooden pin. The swing rail is tenoned to the rear legs. The stationary rail is dovetailed to the side rails. A shim is set between the stationary rail and the fixed end of the swing rail. Nine original cut nails fasten the stationary rail and shim to the swing rail. The side rails are glued to the front legs and supported with vertical blocks. The front rail is tenoned into the front legs. The one-board top is secured to the frame with the original screws. The leaf is attached to the top with standard hinges. A rectangular tenon is present at the midpoint of the back edge of the top, and a corresponding mortise is cut into the leaf. The underside of the top retains an old darkened finish; a similar treatment occurs on cat. no. 61 (*see* 61B). The table is in excellent condition except for minor water damage, stains, bleaching, and veneer chips.

Materials: Mahogany top, leaf, front and side rails, and glue blocks; *cherry swing rail; and *eastern white pine for all secondary work. Original hinges.

Dimensions: H. 29¾; W. 35⁵⁄₁₆; D. 17¹¹⁄₁₆, D. open 35½

Provenance: First owned by George Ffrost II (1765–1841); then descended in his family to the present owner (*see cat. no.* 6).

1. Ward 1982, 16–17.

2. Ward 1982, 17.

3. John Peirce, 1815 inventory, old series, docket 8909, Rockingham County (N.H.) Probate; and Samuel Ham, 1813 inventory, old series, docket 8702, Rockingham County (N.H.) Probate.

4. For more on Ffrost, see Lovett 1959, 60–72.

5. Hewitt *et al.* 1982, nos. 9, 20, and 21.

6. The Akerman table was probably one of a pair that sold at auction on July 10, 1821, for $10 (from an inventory of the estate of Joseph Akerman in the possession of the present owner).

7. The related pair of tables from the Peirce mansion lacks bellflower inlay; see Schwenke 1980, 32. For a pair of tables nearly identical to the Akerman table, see Northeast Auctions, Aug. 4, 1991, lot 589.

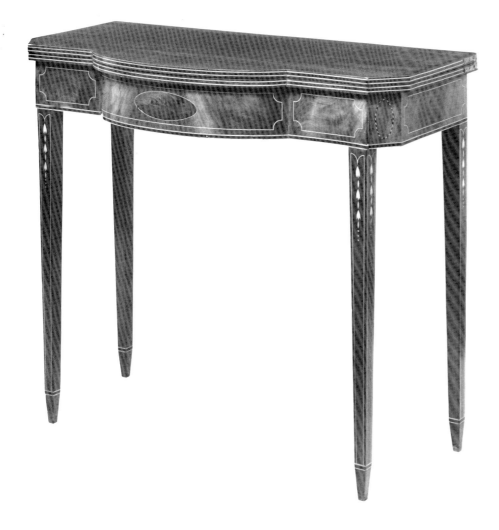

🌿 61

CARD TABLE

Portsmouth, New Hampshire
1800–1815
Private collection

WHEN NOT IN USE, a card table assumed the grander role of pier table in the federal home. Set against the wall, often between windows and under a gilt looking glass, the table lent an air of sophistication to even the plainest parlor. Not surprisingly, New England craftsmen consulted patterns of both forms when developing their own designs for card tables. One particular plan for a pier table published by George Hepplewhite in 1788 (61A) inspired an especially popular form of card table in Portsmouth. The design features a bowed front, canted corners, straight sides, and tapered legs with spade feet. The Portsmouth version eliminates Hepplewhite's overlay of ornament in favor of more subdued string inlay and less ambitious bell-flowers. In addition, the Portsmouth interpretation shifts the placement of the front legs from the canted corners to the straight ends of the front rail. Though detracting from the harmony of the table, the adjustment does facilitate its construction and enhance its structural stability. The straight rails are tenoned directly into the legs, and the side rails are glued against the outside edge of the leg (61B). Fastening the rails to a canted leg would have created a far weaker joint.

At least twenty-one Portsmouth card tables follow this distinctive pattern.[1] All are remarkably similar and may well be the product of a single shop. Their modifications are limited to minor changes in the inlay and foot design. Sometimes paterae embellish the canted corners, and on one example the string inlay above the bellflowers forms a Gothic arch.[2] The feet vary from a narrow attenuated taper to a mere extension of the leg, set off only by an inlaid cuff.[3] This table represents the

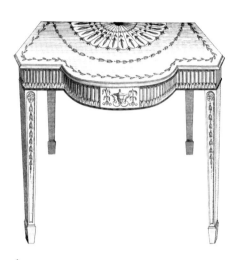

61A.

Design for a pier table, plate 64 in George Hepplewhite's The Cabinet-Maker and Upholsterer's Guide *(third edition, 1794). Courtesy, Printed Book and Periodical Collection, The Winterthur Library, Winterthur Museum, Winterthur, Delaware.*

61B.

Underside of the table.

standard version of the form. Its construction adheres to common New England practice with one exception: the fabrication of the bowed front. Two laminated strips of basswood form the curve of the bow. Four screws secure the bow to the straight birch ends of the front rail.

This card table is one of a pair that descended in the Wentworth and Kimball families of Portsmouth. Related examples retain more definitive histories. Branded tables belonged to Henry Tredick, Leonard Cotton, and Oliver Briard, all prominent residents of Portsmouth in the federal era (*see appendix B*).[4] Another still remained in a family collection in nearby Dover, New Hampshire, at the turn of this century.[5] Such a plethora of pieces with provenances firmly link this unusual design to Portsmouth. Of all the Piscataqua patterns of tapered-leg card tables, this plan and the previous one (*cat. no.* 60) enjoyed the widest appeal.

A R H and B J

Structure and Condition: The left rear leg swings out to support the one-board leaf. The swing rail pivots on a pintle hinge and is tenoned to the rear legs. The rear stationary rail is dovetailed to the side rails. A thick shim fits between the stationary rail and fixed end of the swing rail. Nine original cut nails are driven through the stationary rail and shim into the swing rail. Seven original screws fasten the frame to the one-board top. A small tenon is located at the center of the back edge of the top. A corresponding mortise is cut into the back edge of the leaf. Except for its refinished surface, the table is in excellent condition.

Materials: Mahogany legs, top, and leaf; mahogany veneer and light-wood inlay on front and side rails; birch swing and side rails, straight ends of front rail; basswood bowed rail; eastern white pine stationary rail. Probably original hinges.

Dimensions: H. 30½; W. 35⅛; D. 17⅝, D. open 35⅜

Provenance: This card table shares a provenance with cat. no. 22.

1. The twenty-one tables consist of the following: cat. no. 61 (one of a pair); one branded "L. COTTON." at Strawbery Banke Museum (1992.2), Christie's, sale 7398, Jan. 17–18, 1992, lot 474; one branded "H. TREDICK," American Art Association, sale 4085, Feb. 9–10, 1934, lot 367; one branded "O. BRIARD," Sotheby's, sale 5680, Jan. 30, 1988, lot 1825; one acquired by Clifford Drake, a pioneer collector of Hampton, N.H., Nutting 1928–33, no. 1050; one pictured in an early twentieth century

photograph of the Stephen Toppan house of Dover, N.H., SPNEA Archives; a pair at the White House, *Antiques* 116:1 (July 1979): 122; five others advertised for sale in *Antiques* 89:3 (Mar. 1966): 348; 90:1 (July 1966): 13; 114:4 (Oct. 1978): 742; 115:3 (Mar. 1979): 931; two shown in *Sack Collection*, 1:205, 6:1487; an assembled pair sold at auction, Northeast Auctions, Mar. 15, 1992, lot 531; and three unpublished examples in private collections.

2. For a table with paterae on the corners, see *Antiques* 90:1 (July 1966): 13; the table with Gothic arch inlay is illustrated in Christie's, sale 7398, Jan. 17–18, 1992, lot 474.

3. For tables with long narrow tapered feet, see *Antiques* 89:3 (Mar. 1966): 348, and Sotheby's, sale 5680, Jan. 26–28, 1988, lot 1825. Two tables without a distinct taper at the foot sold at Northeast Auctions, Mar. 15, 1992, lot 531.

4. See note 1.

5. The Toppan family table in note 1.

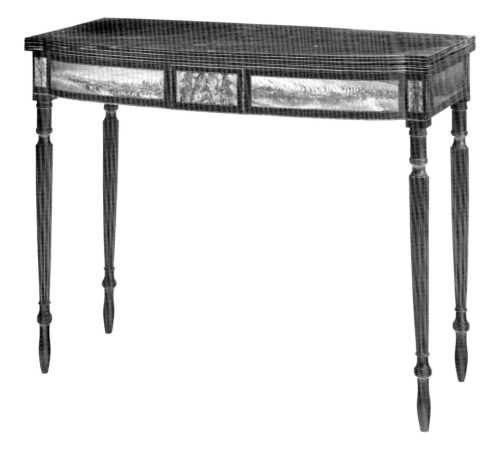

62

CARD TABLE

Portsmouth, New Hampshire
1805–20
Moffatt-Ladd House
Portsmouth, New Hampshire
In care of The National Society of The Colonial
Dames of America in the State of New Hampshire
On loan from a Ladd descendant, 6.1978

THIS TABLE HAS A LONG HISTORY OF OWNERSHIP in the Moffatt-Ladd House in Portsmouth. Maria Tufton Haven Ladd and her husband, Alexander Ladd, probably brought it to the house, which had been given them in 1819 by Mrs. Ladd's father, the wealthy merchant and financier, Nathaniel Appleton Haven.[1] In the early nineteenth century, the customary location of such a table would have been in a parlor. By 1855, however, when Alexander Ladd died, the inventory of his estate indicates that this card table was being used in the west bedchamber, while a newer and more fashionable "Marble Top Center Table" appears to have usurped the place of honor in the drawing room.[2] This change in furnishings reflects a shift in the behavior patterns of polite society in mid-nineteenth-century America—away from gaming and toward informal and edifying family gatherings around a permanently situated table. A photograph of the Moffatt-Ladd House parlor taken half a century later shows that values had changed again: the card table was now once more situated in a position of prominence.[3] Doubtless the colonial revival, with its ensuing interest in all things related to the early American past, had prompted the table's return.

 The design of the table has long been linked to Salem. In 1933, Fiske Kimball attributed an identical example to the town because the shape of its top and legs resembled a documented table by the cabinetmaker Nehemiah Adams.[4] We now know that Portsmouth artisans adopted these features as well. Three card tables, three dressing tables, and a piano frame, all with Portsmouth histories, fea-

ture the same distinctive leg. Moreover, two of the card tables display similarly shaped tops and veneer patterns.[5]

The Gardner family card table, which was made in Salem (62A), bears a striking resemblance to the Ladd table.[6] One of a pair made for the Salem merchant John Gardner, it features a square top with an elliptical front rail, reeded legs, and bulb-shaped feet. Gardner was known to trade with the cabinetmaker Nathaniel Safford late in 1805 and with Thomas Needham in 1812.[7] Either man could have made the table. Safford was actually a native of Exeter, New Hampshire, and could have trained there.[8] He moved to Salem while in his mid-twenties.

Besides having tops of the same shape, the most noteworthy feature that the two tables share in common is a reeded leg with an elongated bulb foot. Although similar, the Portsmouth example has more attenuated capitals and feet, resulting in a strong vertical emphasis; the Salem version seems more compressed by comparison. Both craftsmen used mahogany for the primary wood, but with a significant difference in the choice of wood for the rails. The Portsmouth maker used native flame-birch veneer for a highly charged contrast, while the Salem artisan employed a more costly mahogany veneer, creating a rich, subdued effect. Both examples feature string inlay and banding as well as a geometric veneered detail at the midpoint of the front rail. The construction techniques applied to both tables, including a

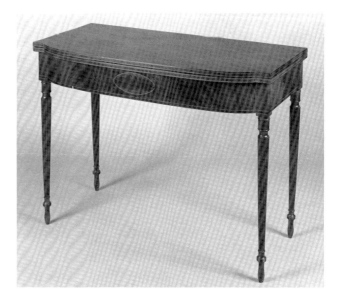

62A.

Card table. Salem, Massachusetts, 1805–15. Mahogany, mahogany and she-oak veneer, light-wood inlay, birch, and eastern white pine, H. 29⅜; W. 40; D. 19⅞, D. open 40. Private collection. Originally owned by John Gardner, Jr. (1771–1847) of Salem.

curved laminated front rail made from two boards (*similar to* 60E) and the placement of glue blocks, are nearly identical.

The documented Portsmouth card tables prove that this design had a wider popularity than previously thought. The presence in Portsmouth of a craftsman such as Langley Boardman, who was thoroughly familiar with the products of Salem workshops (*see cat. no.* 8), could explain how this and other designs fashionable in Salem became commonplace in the Piscataqua River region. Coastal New England, with its relatively short distances, fluid patterns of migration, and closely knit class of artisans, fostered the development of an interrelated network that allowed the ready transmission of ideas.

D C E

Structure and Condition: The left rear leg swings out to support the one-board leaf. The swing rail pivots on a pintle hinge and is tenoned to the rear legs. A vertical maple block, neatly cut with faceted edges, is glued to the swing rail and upper rear corner of the swing leg. The block serves as a stop for the swing leg when the table is closed. The stationary rail butts against the right side rail and is dovetailed to the left side rail (*see* 63A). A thick shim fits between the stationary and fixed portion of the swing rail. Six original cut nails are driven through the stationary rail and shim into the swing rail. The side rails and front rails are tenoned into the front legs. Vertical support blocks are glued within each corner of the frame (two at the front, one at the back). Six original screws are driven through the frame into the top. A tenon with faceted edges is located at the center of the rear edge of the top. A corresponding mortise is cut on the leaf. An old red wash covers the exposed surfaces of the swing rail. The original finish may remain beneath layers of darkened polish, which have become spotted from water.

The table is in exceptional condition, with only two minor repairs. A break in the right rear leg just below the rails has been glued; two nails reinforce the joint binding the swing rail and leg.

Materials: Mahogany legs, top and leaf; *mahogany and birch veneer on front and side rails; birch swing rail; *basswood front rail; maple block at upper rear corner of swing leg; *eastern white pine for all other secondary work. Original hinges.

Dimensions: H. 30; W. 37½; D. 17¹⁵/₁₆, D. open 35⅞

Provenance: Probably purchased by Maria Tufton Haven Ladd (1787–1861) and

Alexander Ladd (1784–1855); to their son Alexander Hamilton Ladd (1815–1900); to the latter's daughter Ann Parry Ladd Ward (1842–1925); and then to the mother of the present owner.

Publications: Giffen (Nylander) 1970a, 117.

1. Goss 1991, 2, 5, 6.

2. Alexander Ladd, 1855 inventory, old series, docket 17091, Rockingham County (N.H.) Probate.

3. "Parlor, Moffatt-Ladd House," ca. 1912, SPNEA Archives. The house was probably a museum when this photograph was taken.

4. Kimball 1933, 220, fig. 7. See Greenlaw 1974, no. 142, for more on this table.

5. Related Portsmouth pieces include a card table that descended in the Langdon family (SPNEA, 1966.304); a card table branded "L. COTTON." (Kaye 1978, 1102, pl. 4); a piano branded "DR • DWIGHT" (Moffatt-Ladd House, 1977.10); a dressing table branded "O. BRIARD" (*cat. no.* 23); a dressing table that descended in the Marvin family; and a dressing table with a simplified leg that descended in the Peirce family. A nearly identical card table appears in a photograph of the Wentworth-Coolidge Mansion, ca. 1900, SPNEA Archives.

6. For other related card tables with Salem attributions, see Randall 1965, no. 99; Clunie 1977, 1010–11, figs. 5, 6; and *Sack Collection,* 1:213.

7. John Gardner, day books, Oct.–Dec. 1805 and Apr. 1812, Peabody and Essex Museum. The author would like to thank Dean Lahikainen for sharing this information.

8. Safford 1923, 41.

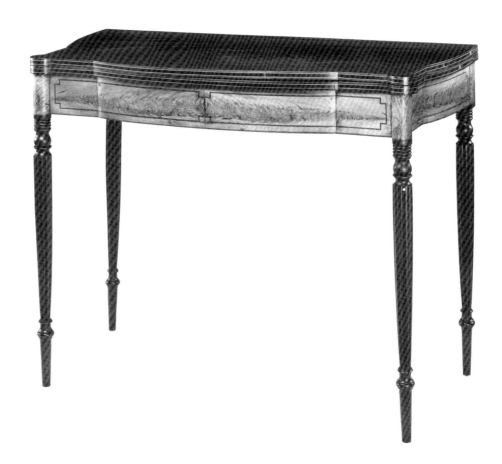

63

CARD TABLE

Portsmouth, New Hampshire
1808–15
Rundlet-May House
Portsmouth, New Hampshire
Society for the Preservation of New England
Antiquities, gift of Ralph May, 1971.487A

THIS CARD TABLE MAKES A GRAND IMPRESSION. Its broad proportions (2" to 4" wider than the three previous card tables) give it a presence that few other tables possess. The shape adheres to a common Portsmouth plan: handsome reeded legs support a bowed frame with ovolo corners (*see cat. no.* 64). Here, the form is enhanced with vibrant contrasts of color. A band of flame-birch veneer provides a dramatic foil to the dark mahogany of the top and legs. Rectangles delineated by strips of diagonally striped inlay, indented at the corners, lend a further note of flamboyance.

Ten card tables match this one in shape and decoration.[1] Histories of ownership link the group firmly to the Portsmouth area. One descended in the Larkin family of Portsmouth; another was owned by the family of Josiah Bartlett, the prominent physician, jurist, and signer of the Declaration of Independence, who resided in nearby Kingston, New Hampshire.[2] A third table was acquired in Exeter at the turn of this century, and a pair advertised in 1929 as Portsmouth had probably come from a home in the town.[3] Cat. no. 63 retains the best documentation of all. The merchant James Rundlet purchased it and a companion table soon after moving into a new house on Middle Street in 1808 (*fig.* 20).[4] Today the pair remain in his most fashionable parlor.

Four other acquisitions by Rundlet—a pair of sofas (*cat. no.* 105), a delicate worktable (*cat. no.* 66), and a mahogany Pembroke table—have turned legs much like those on the card table.[5] All display the same pattern of thick reeds with arched

caps. The varied heights of the legs required slight adjustments in their design. On the sofa and worktable, a collar surmounts the reeding. Here, as on the Pembroke table, the collar is compressed to provide space for a baluster turning. Nevertheless, the similiarities are sufficient to attribute all six objects to a single shop. The identity of that shop remains elusive. Rundlet's only surviving ledger lists several purchases from the noted cabinetmaker Langley Boardman between 1802 and 1806 (*see* 8A).[6] His later accounts have been lost and, with them, any record of furniture commissions for the new house. Rundlet may have continued to patronize Boardman, or possibly his journeyman Ebenezer Lord, but proof of the relationship awaits further evidence.

One unusual construction detail may help pinpoint the table's origin. Most federal artisans in coastal Massachusetts and New Hampshire assembled a card table in a standard manner. They tenoned the front and side rails to the front legs and at one back corner fastened the side rail to the stationary rail with dovetails (63A). For this table, the maker dovetailed the rails of the frame at all four corners and set the front corners of the frame into quarter-round notches in the legs. He fastened the frame to each front leg with a single large screw and covered the head of the screw with a vertical corner block. In addition, he cut the flaring necks of the dovetails in the side rails, so that only the ends of the dovetails were visible from the back (63B). The technique represents a distinctive solution to the dilemma of joining rectangular rails to a round leg.[7] Though lacking the strength of a standard mortise and tenon, the joint offers an expeditious alternative for tables with ovolo corners. Here, it has served its purpose well for nearly two centuries on one of Portsmouth's finest federal card tables.

B J

63A.

Rear corner of cat. no. 62, showing dovetail joint.

Structure and Condition: The left rear leg swings out to support the one-board leaf. The swing rail pivots on a pintle hinge (which retains its original iron pintle) and is tenoned to the rear legs. A thick (⅞") shim fits between the stationary rail and fixed portion of the swing rail. Six original cut nails are driven through the stationary rail and shim into the swing rail. The bowed portions of the front and side rails are separate elements glued and nailed to straight boards; a table by Judkins and Senter displays the same technique (*see* 64A). A vertical block is glued within each corner of the frame. Six original screws affix the frame and top. A small tenon is located at the center of the back edge of the top. A corresponding mortise is cut on the leaf. This table and its mate have always been cherished family heirlooms and, as a result, survive in exceptional condition. In 1983 SPNEA conservators Robert Mussey and Joseph Twichell removed a thick dark layer of linseed-oil polish and reattached the right front leg to the corner of the frame with glue and a new brass screw.

Inscriptions: Chisel-cut "II" on the underside of the top. "R. May" in pencil on the inside of the front rail.

Materials: *Mahogany top, leaf, and legs; birch and rosewood veneer on front and side rails; light-wood stringing and inlay on rails and edge

63B.

Rear corner of cat. no. 63, showing dovetail joint.

of top and leaf; *birch swing rail; *eastern white pine for all secondary work. Original brass hinges.

Dimensions: H. 31¾; W. 39¹³/₁₆; D. 19½, D. open 39¹/₁₆

Provenance: This card table shares a provenance with cat. no. 8.

Publications: Sander 1982, 58.

1. The ten related tables consist of the following: one from the Larkin family of Portsmouth and now in the collection of the Larkin House, a historic house museum within Monterey State Historic Park in Monterey, Cal. (455-2-37 L. H.); another owned by The Currier Gallery of Art (1961.16); a pair described as "from Portsmouth, New Hampshire" in a 1929 auction catalogue, American Art Association, sale 3787, Nov. 7–9, 1929, lot 369 (the same pair may appear in *Antiques* 18:2 [Aug. 1930]: 109); a single table illustrated in *Antiques* 57:5 (May 1950): 330; another noted as having been in Exeter in about 1900, Sotheby Parke Bernet, sale 4268, June 20–23, 1979, lot 1169; one from the Keown Collection, Sotheby's, sale 5001, Jan. 27, 29, 1983, lot 422; a fine example originally owned by the Bartlett family of Kingston, N.H., and now in a private collection, Seaboard Auction Gallery, Bartlett sale, June 2, 1989; an unusual version with a thin mahogany top glued to a pine frame and then secured to the rails of the table, Skinner, Inc., sale 1350, Oct. 27, 1990, lot 105; and one advertised in *Sack Collection*, 7:1756. A related table was owned by Edmund Tarbell of New Castle, N.H., in the early twentieth century. Several versions with similar decoration but serpentine rather than bowed rails survive; see *Antiques* 17:5 (May 1930): 429; Sotheby Parke Bernet, sale 4076, Feb. 1–4, 1978, lot 956. For a small group of card tables that resemble cat. no. 63 but lack the Greek key motif, see: *Sack Collection*, 1:153, 8:2195; Sotheby's, sale 5500, Oct. 24–25, 1986, lot 202; and Barquist 1992b, 180–82.

2. See note 1.

3. See note 1.

4. Stokes 1985, 12.

5. All four objects are still in the Rundlet-May House. The Pembroke table (1971.521) has rectangular leaves with rounded corners, birch veneer on the drawer front and end rail, and birch panels at the top of the legs. The design of its feet, reeded legs, and baluster turnings is virtually identical to that of the card table.

6. In an unpublished paper Jayne Stokes attributed the Pembroke table to Langley Boardman on the basis of an 1802 reference in Rundlet's ledger (*see* 8A); Stokes 1985, 11. However, the reeded legs and rounded corners of the leaves suggest that this table was made at least five years later. Boardman's Pembroke table, now lost, probably had square tapered legs like the chairs that he sold to Rundlet in 1802 and 1803 (*see cat. nos. 96 and* 101).

7. Judkins and Senter adopted this method of construction for their turned-legged card tables, raising the possibility that the firm made this table as well. However, minor differences between cat. no. 63 and their documented tables suggest two different hands, working in a similar manner (*see Structure and Condition for cat. no. 64*).

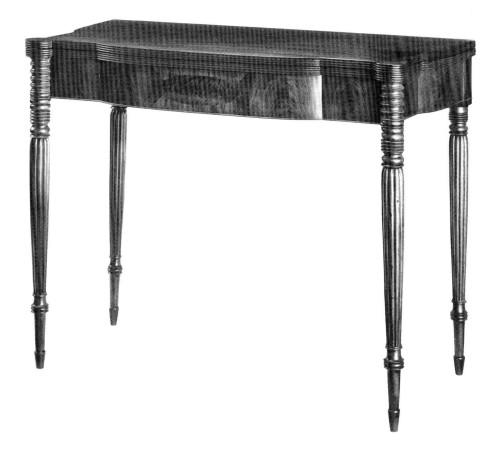

CARD TABLE

Judkins and Senter (w. 1808–26)
Portsmouth, New Hampshire
1816
Strawbery Banke Museum
Portsmouth, New Hampshire
Gift of Gerrit van der Woude, 1989.9.1

JACOB WENDELL purchased this card table and its mate from the partnership of Jonathan Judkins and William Senter in 1816, shortly after his marriage to Mehetabel Rogers (*see cat. no. 33*). Earlier that same year he bought a sofa (*fig. 47*), worktable (66A), two dressing tables and basin stands (*see cat. no. 70*), and a bedstead (*cat. no. 113*), all from Judkins and Senter.[1] He methodically noted these purchases in his ledger on a page entitled "Account of Cash pd for Sundries for furnish^g my House."[2] Wendell kept the tables in the parlor along with the suite of fancy chairs and settee he ordered from New York City (*cat. no. 100*), a Brussels carpet, a chimney looking glass, fireplace tools, and two stools.[3]

Wendell's card tables feature the same square shape with an elliptic front, half-elliptic ends, and ovolo corners (64A) as Rundlet's table (*cat. no. 63*), but this version also has details typically associated with later neoclassical furniture. The turned legs on this example, while similar to Rundlet's, are less distinct in their design and more massive in their proportions. Ring turning on the colonnettes, along with beading on the edges of the leaf, top, and skirt, provide a linear energy seldom utilized by earlier Portsmouth craftsmen. The choice of woods also hints at a new design spirit. Instead of boldly figured golden-colored birch, Judkins and Senter used a rich brown mahogany veneer, offset by rosewood veneer in a slightly different shade. Even the spade feet, a typical motif used by their shop (*fig. 48*), are ebonized. All of these details hint at the direction that Judkins and Senter would take as they strove to keep abreast of the changing neoclassical style.[4]

DCE

Structure and Condition: The left rear leg swings out to support the one-board leaf. The swing rail pivots on a pintle hinge (which retains its original oak pintle) and is tenoned to the rear legs. A thick (⅞") shim fits between the stationary rail and fixed portion of the swing rail. Six original cut nails secure the stationary rail and shim to the swing rail. Like the preceding card table (*cat. no.* 63), the side rails are dovetailed to the front and stationary rails, and the front corners of the frame are glued into quarter-round notches in the legs. But here, two nails (instead of a single screw) secure each front corner to a leg, and the frame never had vertical support blocks at the corners. The bowed portions of the front and side rails are separate elements glued and nailed to straight boards. A beaded edge is glued and nailed to the underside of the front and side rails. Seven screws affix the frame and top. A mortise and tenon was never installed along the back edge of the top and leaf. The table is in exceptional condition, with all of its original elements.

Inscriptions: The number 104 is printed on a label on the rear rail. Three ovals, similar in size to that on the front rail, are scratched into the stationary rail.

Materials: *Mahogany legs, top, leaf, and cockbeading; mahogany veneer on front and side rails; *rosewood veneer panel on front rail; *birch swing rail; *white oak pintle hinge pin; and *eastern white pine for all secondary work; original hinges.

Dimensions: H. 30¼; W. 38⅛; D. 18⁷⁄₁₆, D. open 36¹³⁄₁₆

Provenance: Purchased by Jacob Wendell (1788–1865); then it followed the same descent as in cat. no. 5 until 1979. It remained in the estate of Francis A. Wendell, until Gerrit van der Woude presented it to Strawbery Banke Museum in 1988.

Publications: *Plain and Elegant* 1979, no. 9; Ward 1989a, 70 and 72; Ward and Cullity 1992, pl. 8.

1. Judkins and Senter to Jacob Wendell, bill, June 27, 1816, Wendell Collection, folder 4, case 13, Baker Library, Harvard Business School.

2. Ledger 2, 1814–27, 63, Wendell Collection, 1:B-6, Baker Library, Harvard Business School.

3. Jacob Wendell, ca. 1828 inventory, Wendell Collection, box 18, Portsmouth Athenaeum.

4. Strawbery Banke Museum owns a card table that descended in the Springfield family of Rochester, N.H., which is also probably from the shop of Judkins and Senter (1979.204). The construction details and overall form are identical to the Wendell table, but it is slightly later in date. It features massive spiral turned legs, thick rings in the colonnette, and varying shades of mahogany veneer.

64A.
Underside of the card table.

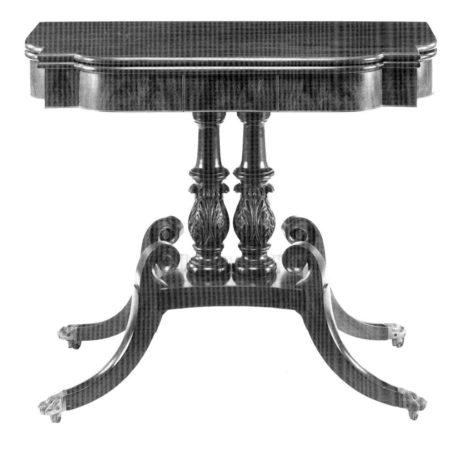

CARD TABLE

Probably Portsmouth, New Hampshire
ca. 1821
Strawbery Banke Museum
Portsmouth, New Hampshire
Gift of Gerrit van der Woude, 1990.30

THIS WELL-CRAFTED OBJECT descended in the Wendell family of Portsmouth. It may be the "Grecean Card Table" bought for $17.50 by Jacob Wendell on September 13, 1821, at a Samuel Larkin auction. If such was the case, the table was probably considered Grecian in style because its two principal decorative features—the acanthus carving on the twin pedestals and the four arched legs ending in scrolled volutes—are references to classical antiquity. In the 1820s, Portsmouth cabinetmakers such as Ebenezer Lord advertised mahogany Grecian card tables, as well as worktables (*cat. no.* 68), center tables, and sofas described as being in the Grecian mode.[1]

The shape of this table—square with an elliptic front and half-elliptic ends—was encountered infrequently in Benjamin A. Hewitt's classic study of federal-period tables with turned and straight legs, and then only in Salem, Massachusetts, and points north.[2] Another unusual feature of this table is the double carved-and-turned pedestals that support the swiveling top (65A); most American and English examples have one or four such supports. The acanthus carving also has a distinctive star-punched background.

Similar tables and ornament are not common in local work. An important exception is a pair of related tables in a private collection that have a history in the Parrott family of Portsmouth, possibly dating back to Enoch Greenleafe Parrott (1781–1828), a merchant (65B). These tables have a single pedestal and are heavier in feeling, suggesting they were made several years after the Wendell table, but they share the same manner of scrolled legs, arrangement of turned and carved elements

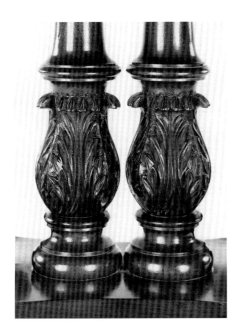

65A.
Carved pillars.

65B.
Card table. Probably Portsmouth, New Hampshire, 1825–30. Mahogany, mahogany veneer, and eastern white pine, H. 31¹⁄₁₆; W. 36⅝; D. 19⁵⁄₁₆, D. open 36⅝. Private collection. This table descended in the Parrott family of Portsmouth.

on the pedestal, shape of the top, and use of two strips of vertical beading to create a panel on the front rail. It is entirely possible that they and the Wendell table were produced in the same shop. Another closely related example, with twin pedestals, was sold at auction twice in the 1980s, and another table, with a heavier, single pedestal, belonged to the Warner family of Portsmouth.[3] Thus although the form was made in Boston and New York, as well as in other places, the existence of this small group of examples with Portsmouth histories points toward a local origin for the group. As such, they are important expressions of the Empire style in the Piscataqua area.

GWRW

Structure and Condition: The two pedestals of this table are tenoned through the base and wedged and screwed in place from underneath. At the top, they are tenoned into a birch cleat, which in turn is screwed to the front and rear rails of the frame. The four legs are secured to the base plate with a single screw each. The top and leaf are each of a single board, and they pivot in a fashion typical of tables from this period. A wide tenon is located at the center of the back edge of the top; a corresponding mortise is cut on the leaf. The bottom of the frame is made of a single pine board held in place by means of glue blocks mounted to the lower edge of the side, front, and rear rails. The bowed portion of the front and side rails consists of separate pine boards faced with mahogany, which are glued and nailed to the straight ends of the side and front rails. The rear rail is a single pine board dovetailed, with exceptionally precise dovetails, to the side rails.

Three of the four legs have broken at their juncture with the base; L-shaped iron braces have been screwed in place to reinforce the repair. The table has been refinished.

Inscriptions: "2" in pencil on the inside bottom of the frame.

Materials: Mahogany legs, base plate, pedestals, top, and leaf; mahogany veneer on front and side rails; *birch cleat; *basswood glue blocks underneath top; *eastern white pine for all other secondary work. The brass casters are probably replacements.

Dimensions: H. 31⅛; W. 36¹⁵⁄₁₆; D. 18¹¹⁄₁₆, D. open 36¹⁵⁄₁₆

Provenance: Acquired by Jacob Wendell (1788-1865) in 1821; then it followed the same descent as in cat. no. 5. It remained part of the estate of Francis A. Wendell until Gerrit van der Woude presented it to Strawbery Banke Museum in 1990.

1. Ledger entry, Jacob Wendell, ledger 2, 1814–27, 62, Wendell Collection, Baker Library, Harvard Business School. *New Hampshire Gazette,* Aug. 21, 1827; *Portsmouth Journal,* Jan. 3, 1829.

2. Hewitt 1982, 69, 188.

3. Sotheby's, sale 5208, June 30, 1984, lot 653, and Sotheby's, sale 5282, Jan. 31–Feb. 2, 1985, lot 835. Christie's, Mar. 10, 1978, lot 196.

🌿 *66*

WORKTABLE

Portsmouth, New Hampshire
1808–15
Rundlet-May House
Portsmouth, New Hampshire
Society for the Preservation of New England
Antiquities, gift of Ralph May, 1971.926

So when household duties were done, they [women] were ready to take their seat in the parlor with a basket of mending or sewing on the pretty work table, a book, perhaps the last Scott's novel, perhaps an 'Edinburg Review' lying in close neighborhood.[1]

THE NINETEENTH-CENTURY RECOLLECTIONS of Marianne Silsbee affirm the central role of the worktable in New England domestic life. During the federal era, cabinetmakers introduced new forms of furniture specifically for women. None had greater appeal than the worktable, a stand with one or two drawers which contained partitions for thread, thimbles, needles, and scissors. Frequently, a deep lower drawer or fabric bag could hold unfinished sewing. A shelf, as Thomas Sheraton noted in 1793, served the same purpose, offering as well "a convenience for sewing implements."[2]

This striking example with a scalloped shelf belonged to the Portsmouth merchant James Rundlet and his wife Jane (Hill) Rundlet and probably stood in their small back parlor. Rundlet's neighbor Jacob Wendell kept a similar table (66A) in his "Back Sitting Room."[3] Located across the central hall from the kitchen, each back room provided an informal space for year-round family use. A set of six chairs, light stand, Pembroke table, looking glass, and inexpensive carpet supplemented the worktable in Wendell's room.[4] Later, an iron stove was installed to ensure an inviting atmosphere on even the coldest New Hampshire days.[5]

Though similar in design, the Wendell and Rundlet tables document the work of different artisans. Wendell purchased his table for $10 from Judkins and

Senter in 1816.[6] Rundlet left no record of his acquisition, but the construction of the table points to another maker, possibly Langley Boardman or his journeyman Ebenezer Lord (*see cat. no.* 68). The popularity of the form makes an attribution difficult. Twenty-two closely related examples with scalloped shelves survive.[7] Every maker of fashionable furniture in Portsmouth undoubtedly offered the form. It became a favored local alternative to the Massachusetts version with a sewing bag instead of a shelf.

The Rundlet worktable ranks as the finest in the group. Brightly figured veneers create a dazzling display of color. Mitered sections of she-oak veneer frame birch ovals on the drawer, and panels of bird's-eye maple ornament the upper end of the legs. Distinctive reeding and a swelled foot similar to that on the Briard dressing table (*cat. no.* 23) or Ladd card table (*cat. no.* 62) embellish the lower portion of the legs. Though small in scale, this table commands attention. The vibrant veneers, bold legs, and overall proportions (particularly the relationship between the top, shelf, and floor) enhance its impact. Furthermore, its construction echoes the fine quality of its design. The drawer is made entirely of mahogany. Its dovetails are neat and precise. The shelf and scalloped gallery are skillfully shaped and more securely fastened than those on many related tables. Few pieces of furniture better illustrate the confident, flamboyant products of Portsmouth.

B J

66A.

Worktable. Judkins and Senter (w. 1808–26). Portsmouth, New Hampshire, 1816. Mahogany, birch and bird's-eye-maple veneer, maple, and eastern white pine, H. 30⁵/₁₆; W. 16³/₈; D. 16¹/₈. Collection of Mr. and Mrs. E. G. Nicholson.

Structure and Condition: The rails are tenoned to the legs. Thick (¾") pine drawer guides are glued to the case sides; drawer supports are nailed to the guides. The shelf rests on supports tenoned to the legs. The scalloped gallery is nailed and glued to the shelf and supports. Twelve glue blocks secure the top to the frame. The drawer bottom is set into grooves in the front and sides and nailed to the back. Long strips of coarse mahogany are glued along the lower edge of the drawer sides. Only two of the six original partitions remain in the drawer. The left rear leg was broken and repaired long ago. The upper front rail has a 3½" patch at the joint with the right front leg. SPNEA conservators cleaned and refinished the table with shellac in 1982.

Materials: *Mahogany top, rails, shelf, gallery, and all drawer parts; birch and she-oak veneer on the drawer front; bird's-eye-maple veneer on the legs; *eastern white pine blocks beneath the top, drawer guides and supports, and shelf supports. Original escutcheon and lock; never had handles.

Dimensions: H. 29⅛; W. 17; D. 16¹⁵/₁₆

Provenance: This table shares a provenance with cat. no. 8.

Publications: Sander 1982, no. 56.

1. Silsbee 1888, 26.

2. Sheraton 1793, 415.

3. Jacob Wendell, ca. 1828 inventory, Wendell Collection, box 18, Portsmouth Athenaeum.

4. Ibid.

5. In a "Memorandum of Articles to be added to my Statement of effects, May 1843," Jacob Wendell includes "1 Stove in Back room [$] 8," Wendell Collection, box 7, Portsmouth Athenaeum.

6. Judkins and Senter to Jacob Wendell, bill, June 27, 1816, Wendell Collection, folder 4, case 13, Baker Library, Harvard Business School.

7. The twenty-two related tables divide into three groups: stands with reeded columns at the corners of the frame; stands with square upper legs and one drawer such as the Rundlet example; and stands with square upper legs and two drawers such as the Wendell table. Four of the first version are known: see Lockwood 1913, 1:145; *Sack Collection,* 4:1106 and 6:1601; Walton Photo Files, Walton Antiques, Inc. Seven tables related to the Rundlet version are known: Montgomery 1966, no. 400; *Antiques* 96:1 (July 1969): 57; Sotheby Parke Bernet, sale 3571, Nov. 17, 1973, lot 906; Fales 1976, 128; Sotheby's, sale 5001, Jan. 27, 29, 1983, lot 420; *Sack Collection,* 1:70; one pictured in the parlor of the Ferguson house in Portsmouth in about 1900 (SPNEA Archives). Nine tables related to the Wendell version are known: Nutting 1928–33, no. 1167; *Antiques* 73:2 (Feb. 1958): 138; two tables in *Levy Catalogue,* 3:54; *Antiques* 113:6 (June 1978): 1190; Sotheby Park Bernet, sale H-2, May 23–25, 1980, lot 729; Sotheby's, sale 5622, Oct. 24, 1987, lot 423; Rodriguez Roque 1984, 379; and one in SPNEA's collection, 1949.463.

৬ 67

Worktable

Portsmouth, New Hampshire
1805–20
Private collection

Sewing was an important accomplishment for a woman, a practical skill that could be executed in a creative way. It offered a pleasurable respite from daily routine, as Lucy Maria Buckminster noted in a letter from Portsmouth of October 15, 1816:

> Olivia came with me to Dr. Coffin's, where we have rooms, and where we all pass'd the last winter very pleasantly—excepting the occasional unceremonious visits to the parlors, or nurseries of our friends—the needle—that modern distaff, and books, diversified our days.[1]

The portable worktable helped ladies perform this task more efficiently, albeit with a touch of vanity.

The previous worktable represents a Portsmouth alternative to the classic Massachusetts form, which features a fabric bag. This striking and unusual table closely copies Boston counterparts from the same era. Its swelled frame, reeded legs, and reel turnings on the colonnettes emulate similar features on Boston examples (67A). The Portsmouth version's frame is serpentine, but the Boston counterpart pushes this curvilinearity even further. A pronounced feature of cat. no. 67 is the distinctive Portsmouth leg, with its sequence of reels, rings, and flattened baluster in the upper leg, midleg reeding, and an elongated bulb foot (*compare cat. no. 63*).[2] Nearly identical motifs appear on the Boston example, but they are executed with more finesse. Another characteristic feature of Portsmouth furniture is the use of highly figured veneer, almost to the point of excess. Contrasting veneer appealed to Boston craftsmen as well, but their selection and arrangement of woods ensured

67A.

Worktable. Boston, Massachusetts, 1805–15. Mahogany, mahogany and bird's-eye-maple veneer, H. 27½; W. 19½; D. 16. Private collection. Courtesy, Bernard and S. Dean Levy, Inc., New York, New York.

that the surface pattern more successfully integrated with the form. Moreover, the Boston table features finer construction than the Portsmouth one. Boston attracted the best craftsmen in New England, and their products reflect the wealth and sophistication of their community.[3] Portsmouth craftsmen adapted the Boston model, but varying design sensibilities within the two communities resulted in subtle differences in the final product.

DCE

Structure and Condition: The serpentine side and rear rails are each a thick pine board dovetailed at the corners and veneered with mahogany. The inside surface of the rails is straight. The drawer divider and corresponding rails above and below the drawers are glued into large mortises in the side rails. The corners of the frame are glued and nailed into quarter-round notches in the legs. A narrow band of flame-birch veneer ornaments the lower edge of the frame. The one-board top is glued to the upper front rail and top edge of the back. The drawers run on supports nailed to the side rails. Small drawer stops are glued to the top of the supports at the back. The top drawer is fitted with seven compartments. The core of each veneered drawer front is a single pine board curved along its outside and inside surfaces. Saw kerfs on the drawer sides overlap the narrow dovetails about ¼"; the drawers of the Wendell family secretary display a similar treatment (*see* 33D). The drawer bottom—a single board with grain running from side to side—fits into dadoes in the front and sides and is nailed to the back with a single cut nail.

Not long after its construction, the table was fitted with a bag below the drawers. Narrow, 12" long notches were cut in the legs to accommodate the corners of the bag. The bag remained in place for many years, leaving a pronounced shadow line on the underside of the frame. The table has been refinished in shellac, though traces of a thick darkened varnish are still visible within the turnings. Three cracks in the thin top have been reglued. Eight small blocks beneath the top reinforce the largest crack.

Inscriptions: "MSM" in pencil on the underside of the bottom of the lower drawer. There is an illegible inscription in red pencil on the left side rail of the top drawer.

Materials: Mahogany legs and top; mahogany veneer on the sides and back; she-oak and birch veneer on the front rails, drawer divider, and drawer fronts; unidentified light- and dark-wood inlay on drawer fronts; eastern white pine for all secondary work. Replaced brass knobs and probably replaced iron lock in the top drawer; original bone escutcheons.

Dimensions: H. 29¾; W. 17⁷⁄₁₆; D. 17

Provenance: Purchased from an unknown source by the Henry Ford Museum; deaccessioned and sold at Christie's to the present owner in 1989.

Publications: *Antiques* 97:4 (Apr. 1970): 516; Christie's, sale 6742, Jan. 1989, lot 704.

1. Lucy Maria Buckminster to Edward Everett, Oct. 15, 1816, Am. 2006 (14), Boston Public Library. She was the daughter of the Rev. Joseph Buckminster of Portsmouth; married John Farrar, a Harvard University professor, in 1819, and died in Cambridge, Mass., in 1821.

2. See Nutting 1928–33, no. 1168, for a seemingly identical table that may be this one. A matching table descended in the Salter family of Portsmouth and is now in a private collection. Closely related tables by the same maker are illustrated in *Sack Collection*, 5:1239, 6:1568. SPNEA owns one that is missing its legs, (1977.330). A less refined variation is in a private collection.

3. The best example of an exceptional craftsman migrating to Boston is John Seymour, who left Portland by 1796 to establish a partnership with his son Thomas. See Sprague 1987c, 165–66.

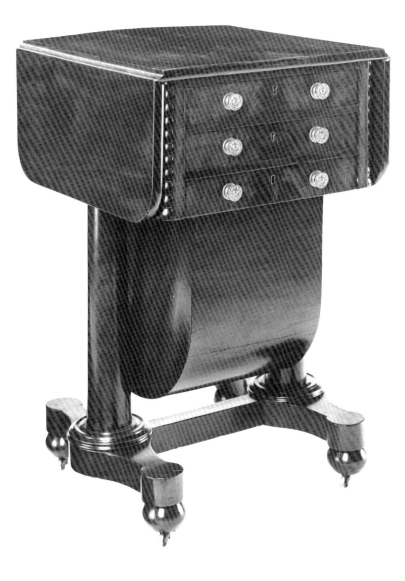

❧ 68

WORKTABLE

Ebenezer Lord (1788–1877)
Portsmouth, New Hampshire
1825–35
New Hampshire Historical Society
Concord, New Hampshire, 1982.97

ALTHOUGH IT SERVES THE SAME FUNCTION, this worktable in the Empire style differs markedly from its predecessors (*cat. nos. 66 and 67*). It has a drop-leaf top supported by flying rails (rather than a flat top); it is supported by two columnar supports joined at the base by a rail and resting on four turned feet with casters (rather than by four reeded legs); and, most significantly, it has a large U-shaped drawer or wooden "bag" (instead of an open shelf with a serpentine gallery) for holding sewing materials. Although federal-era cabinetmakers in Massachusetts and elsewhere frequently made worktables with a sliding cloth bag, Portsmouth makers rarely followed suit until after 1820. Langley Boardman's inventory of 1833 includes "2 Work Tables with Bags" valued at $8 each amongst his "Stock in Trade."[1]

The design of this well-made table emphasizes geometric shapes and figured mahogany and mahogany veneers, both common attributes of the simple Grecian style. Ebenezer Lord advertised "Grecian Work Tables" in the Portsmouth newspapers in the late 1820s, and presumably the term refers to tables of this type. Lord added a column of ball turnings at each corner of the frame, an unusual decorative touch. Lord also advertised two other types of worktables: common and painted.[2]

Although Lord was at work in Portsmouth for more than fifty years, this worktable is one of the few products that can now be linked with his name. One of them is a federal secretary produced in the shop of Langley Boardman when Lord was employed there (*see cat. no. 34*). Another, a plain Empire center table now in a private collection, bears the same stenciled brand as the worktable and represents

68A.

Stenciled label on drawer bottom.

Lord's later output, as does this table. Lord's shop was located on Penhallow Street for many years; he was a frequent advertiser in the local papers, was part of a number of partnerships, and he must have produced several thousand objects during his long career.[3]

The worktable is more finely crafted than the secretary made a decade earlier; the earlier object reflects an expedient level of workmanship characteristic of New England federal-period work. Lord also made use of yellow-poplar as a secondary wood in this table. The wood must have been imported from outside the area by Lord or a local lumber merchant, since it is not native to northern New England and is rarely encountered in Portsmouth objects prior to the Empire period.

The Lord worktable is one of the few documented examples of Portsmouth Empire furniture. Together with the Grecian card table owned by Jacob Wendell (*cat. no.* 65), the lolling chair owned by Samuel Lord (*cat. no.* 103), and a sofa (*cat. no.* 107) and sideboard (Strawbery Banke Museum) associated with Langley Boardman, it evokes the changes in taste that occurred in the 1820s.[4]

G W R W

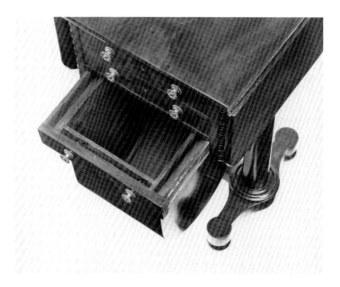

68B.

Interior of sewing bag.

Structure and Condition: The sides of the case frame are two boards thick, glued and nailed together. The inner board is pine; the outer board is made of two narrow boards: an upper fly rail of birch and a lower rail of pine veneered with mahogany. The back is dovetailed to the inner board of each side. A quarter-column of ball turnings is glued to each corner of the case frame. The 2" deep drawer dividers are tenoned to the sides. The top is pocket-screwed to the case, and six original blocks are also glued to the underside of the top and the inner surface of the sides. Each leaf is secured with two hinges. The columnar supports for the case frame are round-tenoned into the underside of the sides and round-tenoned into the trestle plinths. Only a small crescent-shaped section of the column is visible at the top inside the case of the table; however, the wood in that section is dark and hard, the columns show no signs of cracking or lifting, and there is no readily apparent vertical seam, all of which suggests that the columns, in an unusual manner, are solid mahogany rather than veneered. The medial stretcher is fastened with a sliding dovetail to each trestle plinth. Each foot is secured to the plinth with three cut nails and glue.

The drawers run on supports glued to the sides of the frame. The top two drawers are of normal construction, while the bottom one serves as a bag drawer. On the top two drawers, the sides are dovetailed to the front and back with fine dovetails; the bottom is a single board with grain running parallel to the front and is set into grooves in the front and sides and nailed to the underside of the back. The top edge of the front, sides, and back is flat; the sides extend ¼" beyond the back to serve as stops. The front, sides, and back of the bag drawer are joined in a similar manner, and a framework for the bag is set within the drawer. The sides of the framework are let into shallow grooves in the drawer front and back and nailed in place through the back with two nails; the front and back of the framework are housed in grooves in the framework sides. The bag drawer consists of mahogany sides dovetailed at the top to the sides of the framework and four curved pine boards veneered with mahogany, which form a U-shaped cavity.

The table has been refinished but otherwise remains in excellent condition. An iron brace was once mounted beneath the medial stretcher and plinth. The interior of the drawers retains an old red stain.

Inscriptions: "EBENEZER LORD" is stenciled in black on the top of the bottom of the top two drawers. The drawer dividers bear the penciled inscriptions "x14" and "x15"; the backs of the drawers bear the penciled numbers "14" and "15."

Materials: Mahogany leaves, feet, sides of bag, and ball-turned quarter-columns at the corners of the case frame; mahogany veneer on mahogany top; mahogany veneer on *eastern white pine case back, drawer fronts, drawer dividers, rail beneath the fly rail, U-shaped front and back of bag drawer, trestle plinths, and medial stretcher; the columnar supports appear to be mahogany; *birch swing rails; *eastern white pine inner sides of case frame, support blocks beneath the case top, and drawer linings; yellow-poplar framework within the lowest drawer. Replacement circular brass pulls; probably original hinges, brass casters, and locks (missing in the top drawer).

Dimensions: H. 29⅜; W. 18⅛; D. 18

Provenance: The early history is unknown. The table was purchased in 1980 from Philip H. Bradley Co. of Downingtown, Pa., by Donald L. Fennimore of Wilmington, Del., from whom it was purchased by the New Hampshire Historical Society in 1982.

1. Langley Boardman, 1833 inventory, old series, docket 12564, Rockingham County (N.H.) Probate. The Lord table is probably derived from a Boston example. The Museum of Fine Arts, Boston, owns a two-drawer table (1980.358) made by the firm of Emmons and Archibald that has similar columnar supports and a wooden bag drawer (covered in silk).

2. *New Hampshire Gazette,* Aug. 21, 1827; *Portsmouth Journal,* Jan. 3, 1829. A related table with more typical Empire-style scroll feet is illustrated in *Antiques and the Arts Weekly,* July 13, 1984, 93. In 1842, Lord sold John Knowlton a "harp pattern Work Table" for $12, presumably an example with some sort of lyre base; the invoice is in the Ebenezer Lord Papers (Ms. 90), Cumings Library, Strawbery Banke Museum.

3. Lord's career is discussed in the entry for cat. no. 34.

4. For an illustration of the sideboard (1974.653) see Howells 1937, 209.

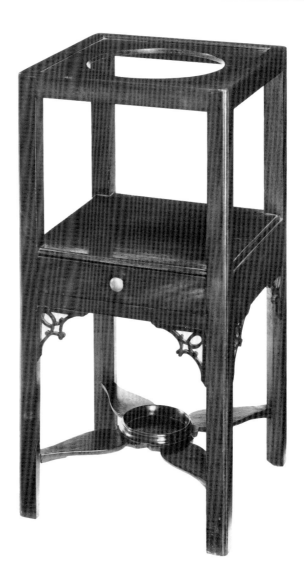

✸ 69

Basin stand

Portsmouth, New Hampshire
1765–75
Private collection

During the second half of the eighteenth century, chamber furnishings became increasingly specialized. Artisans introduced the toilet table, night table, bureau table, and basin stand—each with its own special purpose. A lady's *toilette* of "paints, pomatums, essences, patches…, the pincushion, powder-box, [and] brushes" graced the top of the cloth-covered toilet table.[1] The night table or night chair provided an elegant home for the chamber pot. The bureau table, with its arrangement of small, locked drawers, offered secure space for costly perfumes, jewelry, and such accessories as night caps, stockings, or gloves. The basin stand, or washstand as it was often called, held the essential articles for bathing or shaving: soaps, razors, basin, and bottle. English furniture designers disguised these utilitarian articles in fashionable cases so that, as Thomas Sheraton noted, "they may stand in a genteel room without giving offence to the eye."[2]

Thomas Chippendale published several designs for basin stands, and by the 1770s the form had become commonplace in well-appointed English homes.[3] But craftsmen in this country rarely produced the form before the federal era. This is one of three rococo examples from Portsmouth, all built by the same maker and originally fitted with cross stretchers embellished with a ring at the center.[4] A basin slipped into the hole; a water bottle sat within the ring. This example belonged to the prominent land speculator John Wendell and stood in his chamber (*see cat. no.* 5). Appraisers described it as a "Washing stand" in his estate inventory of 1808. Above it hung a "Gilt Frame looking Glass," an essential accoutrement for shaving.[5]

The design of the stand conforms to current London taste.[6] Its fretwork brackets, straight legs, and shaped stretchers are earmarks of the so-called "Chinese Chippendale" style. Wendell owned four other items with similar ornament: a Pembroke table with pierced stretchers, a side table made with a top of mahogany rather than the expected marble, and a matching china table and kettle stand (*figs. 37 and* 38).[7] Subtle relationships within the group abound. The legs of the china table, kettle stand, and side table have the same molded profile, consisting of an ogee and bead. Though London cabinetmakers favored the profile, their New England counterparts rarely adopted it, except in Portsmouth (*see also cat. nos.* 86, 91, *and* 92). All of the Wendell items but the side table have decorative stretchers. In each case, the stretchers are butted to the legs rather than fastened with mortise-and-tenon joints. For the china table, the maker secured the legs and stretchers with a common English device, the iron stretcher plate (*see* 49B). On the Pembroke table and basin stand, mahogany plates serve the same purpose (69A). The plate is screwed to the underside of the stretcher and inserted into the leg. On the smaller kettle stand, a single nail fastens each stretcher to a leg. Similarities in design and construction point to a common origin for the group. The influential immigrant Robert Harrold (*see cat. no.* 48) probably made the china table, kettle stand, and side table. The Pembroke table and basin stand are the work of Harrold or a native artisan imitating his style.

John Wendell apparently did not purchase the five tables directly from Harrold or his colleague. Instead, they entered his possession through inheritance and purchase at auction. His wife Dorothy received the basin stand from the estate of her brother Daniel Sherburne, who died in 1778, while according to family tradition, John Wendell acquired the side table, china table, and kettle stand from the sale of the confiscated estate of John Wentworth, the last royal governor of New Hampshire.[8] By about 1795, all five items were in place, an impressive instance of London-inspired design in one eighteenth-century Portsmouth household.[9]

B J

Structure and Condition: The rails are tenoned into the legs but not reinforced with wooden pins. The top is nailed to the rabbeted edge of the rails; a flat mitered rim frames the top. The shelf is nailed to the sides and back of the frame for the drawer. The cross stretchers are lapped at the center and secured to the legs with wooden stretcher plates. Four original forged sprigs fasten the circular rim to the center of the stretchers. Two sprigs attach each fretwork bracket to the leg and frame. The drawer runs on supports nailed to the legs. The bottom is nailed into the rabbeted edges of the front and sides and flush edge of the back. The grain of the drawer bottom is parallel with the front.

Careful inspection of the basin stand prior to its sale at Sotheby's in 1989 revealed several repairs, including two replaced fretwork brackets and two broken and chipped brackets, a broken drawer support and a replaced drawer stop, a 3½" patch in the left front foot and shrinkage cracks in the stand's top and drawer bottom. In addition, a solid top, installed in 1912, covered the original pierced top. In 1990, the present owner commissioned SPNEA conservators to remove the later top, repair the broken brackets, and clean the finish.

69A.

Underside of basin stand.

Materials: *Mahogany legs, top, shelf, rails, drawer front, brackets, stretchers, and stretcher plates; *eastern white pine drawer supports, stops, and drawer sides, back, and bottom. Replaced knob on the drawer.

Dimensions: H. 31½; W. 14¾; D. 14¹³⁄₁₆

Provenance: This stand shares a provenance with cat. no. 5.

Publications: Sotheby's, sale 5810, Jan. 26–28, 1989, lot 1449.

1. Quoted from Chambers's *Cyclopaedia* of 1727–41 in Edwards 1954, 3:343.

2. Sheraton 1802, 322.

3. Chippendale 1762, pls. 54, 55.

4. A mahogany example with later string inlay is on view at the Moffatt-Ladd House (1977.143); another stand, lacking its original cross stretchers, descended in the Parrott family of Portsmouth and is now in a private collection.

5. John Wendell, 1808 inventory, old series, docket 7985, Rockingham County (N.H.) Probate. The inventory lists the stand and looking glass together on one line, suggesting that the glass hung directly above the stand. The appraisers valued the stand at $2, the glass at $3.

6. Two related washstands, probably of London origin, feature pierced cross stretchers resembling those on Portsmouth Pembroke tables (*see cat. no.* 56); see Edwards 1954, 3:366, fig. 5, and Benes 1986, no. 177. The latter belonged to the Newburyport merchant Nathaniel Tracy during the late eighteenth century.

7. The Pembroke table was sold at auction in 1989; see Sotheby's Arcade, sale 1269, Jan. 26, 1989, lot 481. The side table is published in Lockwood 1913, 2:192, and appears in a view of the Wendell house parlor (*see acknowledgments*).

8. John Wendell married Dorothy Sherburne on August 20, 1778, and shortly thereafter they took possession of the stylish household goods owned by her brother, Daniel Sherburne. He was a young unmarried merchant who took ill and died suddenly late in 1778. In his will he gives "unto my said Sister Dorothy all my Household Furniture of every sort and kind of which an Inventory is to be taken all which I will should remain in my dwelling House during her Residence therein until she may marry and when that Event takes Place, Then shal she take the whole therof, agreable to said Inventory excepting what is worn out in the family Service in necessary use." Sherburne's inventory listed many costly items, including "1 Large Gilt & flowr'd Looking Glass" valued at £7.10.0 and "1 Mahogany Washing Stand" valued at £1.16.0. See Daniel Sherburne, 1809 will and inventory, old series, docket 4529, Rockingham County (N.H.) Probate. The early history of the side table, china table, and kettle stand are more elusive. In 1912, William G. Wendell repeated a family tradition, noting that the items were said "to have belonged to the last Colonial Governor; Sir John Wentworth, and are thought to have been bought in on the confiscation of his property and ensuing auction by John Wendell." See Wendell 1912, 8. Though the claim seems plausible, collaborating documentation from the eighteenth century has yet to turn up.

9. After Governor John Wentworth's removal from Portsmouth in 1775, his household possessions passed to his father, Mark Hunking Wentworth, and were sold at auction in 1794, upon the death of Mark's widow, Elizabeth Wentworth (*see cat. no.* 81).

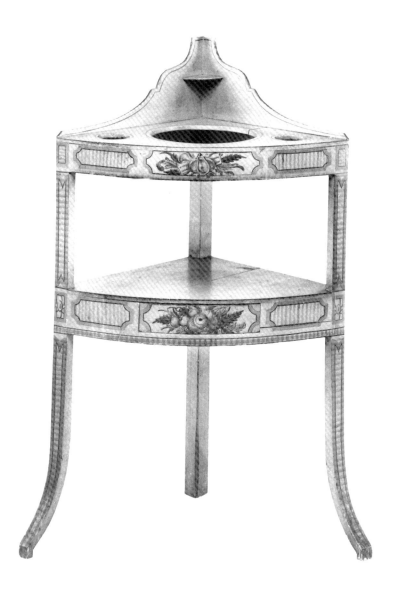

70

BASIN STAND

Judkins and Senter (w. 1808–26)
Portsmouth, New Hampshire
1815–16
Wentworth-Coolidge Mansion
Portsmouth, New Hampshire
Property of the State of New Hampshire
WC-10-86

IN 1788 A "NEW" BASIN STAND appeared among the designs of George Hepple-white's *Cabinet-Maker and Upholsterer's Guide*. "This is a very useful shape, as it stands in a corner out of the way," noted Hepplewhite.[1] The pattern quickly became a popular one in veneered and painted wood, both in Great Britain and America. A triangular form, it featured a shaped splash board, medial shelf with a single work-ing drawer and two "sham" drawers, three delicately shaped legs, and stretchers for stability. This well-preserved painted example lacks a stretcher, but its front legs "spring forward, to keep…[the stand] from tumbling over" as Thomas Sheraton ad-vised in *The Cabinet Dictionary*.[2]

Like cat. no. 69, this stand belonged to the Wendell family, but in this case Jacob Wendell acquired it and a matching dressing table (*fig.* 48) directly from the maker, the shop of Judkins and Senter. The cabinetmaker's bill records the sale of a "Table and Stand" for $11.50 in early 1816. Wendell's own "Account of Cash p^d for Sundries for furnishing my House" confirms the payment of $11.50 to Judkins and Senter on January 7, 1816, for a "Toilet & wash Stand."[3] The basin stand conforms to pattern-book sources such as the Hepplewhite plate. The dressing table reflects a more provincial interpretation of British design. Its unusual turned spade feet are a distinctive attribute of the work of Judkins and Senter. The same foot appears on a pair of card tables made by the firm for Wendell in 1816 (*cat. no.* 64).

Jacob Wendell's 1828 household inventory reveals that he owned two painted toilet sets, one in the parlor chamber, the other in the chamber over the back sitting

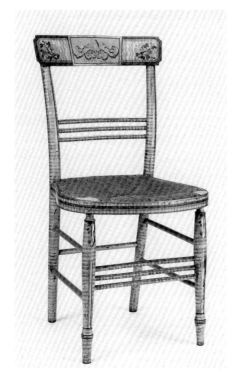

70A.

Fancy side chair. Portsmouth, New Hampshire, 1815–25. Painted wood, H. 35³/4; W. 18³/16; SD. 16; SH. 17⁵/8. Rundlet-May House, Portsmouth, New Hampshire, Society for the Preservation of New England Antiquities, gift of Ralph May, 1971.637.4.

room.[4] By 1891 this set (*cat. no. 70 and fig.* 48) had moved to the middle chamber, where an appraiser described it as, "1 triangular pine wash hand stand in colonial yellow, 1 toilet-table, two drawers, brass pulls, in ditto." A "stone-china" ewer and basin were still in place in the washstand's pierced top. All four pieces were valued at $2.50.[5]

Despite years of use, the washstand and dressing table survive in a remarkable state of preservation, especially considering the fragile nature of painted decoration. The amount of decoration and its neat execution place this set in the middle range of painted furniture available to the consumer. A more costly version, belonging to Jacob's brother Abraham Wendell, has sponge painting and gilt striping (*cat. no.* 24). Here, a plainer pattern features wavy lines simulating curly maple and reserve panels adorned with neoclassical-style fruit, flowers, and musical instruments. An identical linear pattern, paired with foliated motifs, ornaments a set of five fancy chairs that descended in the Rundlet and May families (70A).[6] The same artist undoubtedly decorated the chairs and chamber furniture. Henry Beck, a chairmaker and painter, may have been that craftsman. His advertisement of September 19, 1815, states "that he has taken an apartment in a shop belonging to JUDKINS & SENTER, in Broad-Street, where he intends carrying on the *Chair-Making Business* in its various branches. He will also paint and repair old and injured Chairs at a moderate rate."[7] Within four months of Beck's arrival, Wendell had acquired his painted dressing table and washstand from the firm of Judkins and Senter.
D C E

Structure and Condition: The bowed front rails, constructed of two laminated boards, and the straight side rails are tenoned into the legs. The top and the lower shelf are nailed to the rails. The splashboard is dovetailed at the rear corner and nailed to the top. The small quarter-round shelf against the splashboard is held in place by two glue blocks. The drawer is dovetailed at the corners. The drawer bottom fits into dadoes in the front and sides and is glued to the back. The front of the drawer is made from one piece of pine. The supports for the drawer are missing. Dirt has darkened the feet, and minor chips and scratches mar the surface of the stand.

Materials: *Basswood legs and front rail; *eastern white pine for all other work. Missing brass knob.

Dimensions: H. 39¹/8; W. 27¹/4; D 14⁷/8

Provenance: Jacob Wendell (1788–1865) to Francis A. Wendell (1915–79) in the same manner as cat. no. 5. Consigned to Roland B. Hammond in 1980 and sold to Robert A. Blekicki; purchased by the State of New Hampshire in 1986.

Publications: Antiques 128:3 (Sept. 1985): 347.

1. Hepplewhite 1794, 15, pl. 83.

2. Sheraton 1803, 1:36.

3. Jacob Wendell, ledger 2, 1814–27, Jan. 7, 1816, 63, Wendell Collection, 1:B-6, Baker Library, Harvard Business School.

4. Both sets were valued at $4. Jacob Wendell, ca. 1828 inventory, Wendell Collection, box 18, Portsmouth Athenaeum.

5. Caroline Q. Wendell, 1891 inventory, new series, docket 6696, Rockingham County (N.H.) Probate.

6. An identical side chair with a matching settee and rocking chair are in the collection of the Stevens-Coolidge House. Another set of chairs with the same decoration is in the Crowninshield House at the Hagley Museum.

7. *New Hampshire Gazette*, Sept. 19, 1815. Other furniture decorators active in Portsmouth at this time are Henry Bufford and George Dame.

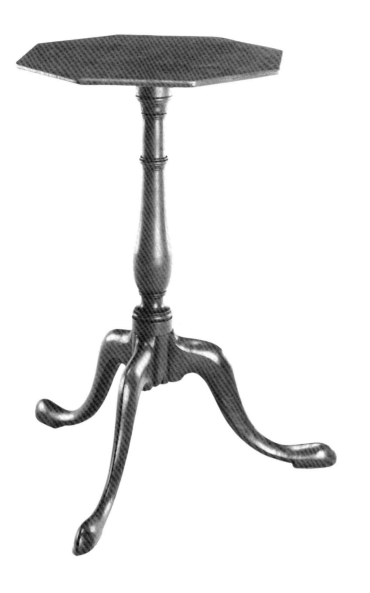

§ 71

STAND

Portsmouth, New Hampshire
1770–1800
New Hampshire Historical Society
Concord, New Hampshire
Gift of Mr. and Mrs. Charles L. Kaufmann,
1977.34.10

VIRTUALLY EVERY MIDDLING AND UPPER-CLASS household in Portsmouth included a stand. Most often they were used in bedchambers as lightweight portable tables that could support a candlestick as well as books, refreshments, or an invalid's medicine.[1] Fashionable stands were made of mahogany and could appear in any of the best rooms. In 1782, John Marsh kept one mahogany stand in his parlor, a smaller stand of mahogany in his dining room, and a modest maple one in a bedchamber.[2] The mariner Capt. Nathaniel Sherburne outfitted his parlor with "One square Mahogany Table at 3½ feet…One Mahogany Pembrook Table…[and] One Ditto Round Stand."[3] Capt. George McClean owned only one "Birch Light Stand," which he kept in the "Small Front Chamber."[4]

By the 1820s the term light stand or plain stand gradually replaced that of candlestand, which was commonly used in the eighteenth and early nineteenth centuries. This change resulted from the increased use of lamps. Caroline King remembered that her parents' bedroom contained " 'The light stand' (as we always called a pretty old-fashioned three legged round table) with two brass lamps upon it…"[5] Characteristics of the form include three cabriole legs that are secured by sliding dovetails to a turned pillar, which is tenoned through a plate mounted to the underside of the top (71A). The top could be either fixed, as is this example, or hinged to tilt down as a space-saving measure.

In 1756 Providence, Rhode Island, joiners fixed the price of a "Candel Stand with mehogeney @ [£] 12, Black walnot Ditto @ 10, Maple Ditto @ 8." A larger

tilt-top tea table, identified as a "Mehogeney Stand Table," cost £30, more than double the price of a stand.[6] Nearly thirty years later, John Dunlap of Bedford, New Hampshire, noted a similar variation in cost. In 1784 he charged a customer £8 for a "Round Tea table" and £3 for a "Candle Stand."[7] The lower prices of the 1780s reflect Dunlap's use of inexpensive native woods as well as the presence of a devalued currency.

The maker of this stand is not known, but the owner, Capt. Charles Blunt, left his brand on it. He used the stand in his mansion on Pleasant Street in Portsmouth, which he financed through his success as a ship captain and shipowner. Blunt met a sudden and violent end on a voyage to the West Indies, where he was stabbed to death and thrown from his ship by pirates.[8] An inventory of his belongings includes: "1 light Stand and toilet Stand [$]3.50" in a bedchamber and "1 old Stand 0.75" in the kitchen.[9] Capt. Blunt also owned a lamp worth $2 in addition to "Candlesticks & Lamps" valued at $2.50.

The distinctive features of Blunt's stand are its swelled pillar and octagonal top. Though popular in England, the simple swelled turning at the base of the pillar was rarely adopted by New England furniture makers.[10] They preferred an urn instead. In addition, they typically chose a round or square top for a stand and often embellished the latter shape with serpentine edges.[11] The octagonal top remained an unusual treatment until the federal era.

Another stand with a similarly swelled pillar survives in the Rundlet-May House in Portsmouth. Although just a fragment, the stand was preserved as a relic of the days when people moved about in the dead of night with only a feeble candle or lamp to light the way.[12] Like the spinning wheel and grandfather clock, stands became revered symbols of the colonial era.

D C E

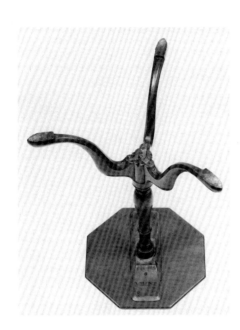

71A.
Underside of the table.

Structure and Condition: The turned pillar is tenoned into the rectangular cleat, which in turn is screwed to the underside of the top. Three metal straps form a Y-shaped brace beneath the pillar and legs. There is a pronounced chamfer cut in the underside of the legs and the cleat; a narrow scratch bead runs along the bottom edge of the feet. The table is in good condition. Two nails have been driven through the top into the cleat. The top, which is stained and abraded, has one shrinkage crack. Traces of black paint on the underside of the pillar and feet suggest that the table was once painted. One leg is chipped at the joint with the pillar.

Inscriptions: Branded "C BLUNT." on the cleat.

Materials: Mahogany top, pillar, and legs; *soft maple cleat. Original iron brace.

Dimensions: H. 27½; W. 16⁵⁄₁₆; D. 16⅝

Provenance: Owned by Capt. Charles Blunt (1768–1823); later acquired from a Hampton, N.H., area family by Richard Mills; sold to Mr. and Mrs. Charles L. Kaufman, who gave it to the present owner in 1977.

Publications: New Hampshire Historical Society Newsletter (Summer and Fall, 1977); Kaye 1978, 1101 and 1104.

1. Garrett 1990, 113. Garrett illustrates a certificate of membership in the Associated Body of House Carpenters, New York, 1796. It features a field bed, Windsor chairs, and a tripod stand in a chamber used as a sick room.

2. John Marsh, 1782 inventory, old series,

docket 4765, Rockingham County (N.H.) Probate.

3. Capt. Nathaniel Sherburne, 1795 inventory, old series, docket 6036, Rockingham County (N.H.) Probate.

4. George McClean, 1820 inventory, old series, docket 10175, Rockingham County (N.H.) Probate. It was valued at $.75.

5. As quoted in Garrett 1990, 122–23.

6. *John Brown House Exhibition* 1965, 174–75.

7. *The Dunlaps* 1970, 230.

8. *New Hampshire Gazette*, Apr. 15, 1823.

9. Charles Blunt, 1823 inventory, old series, docket 10643, Rockingham County (N.H.) Probate.

10. For English versions, see Kirk 1982, figs. 1435–36. Occasional examples from Newport are known; see Moses 1984, 50, for one with an octagonal top. The swelled pillar occurs more often on New York tables and stands; see Blackburn 1976, 79.

11. Jobe and Kaye 1984, no. 76.

12. Rundlet-May House, SPNEA (1971.811). The stand is missing the original top, and half of each leg has been removed and fitted with modern casters. A small marble slab rests on the cleat. A second, more complete stand is owned by the Portsmouth Historical Society (H45). Also see Christie's, sale 5810, Jan. 26, 1985, lot 300, for another version of this form.

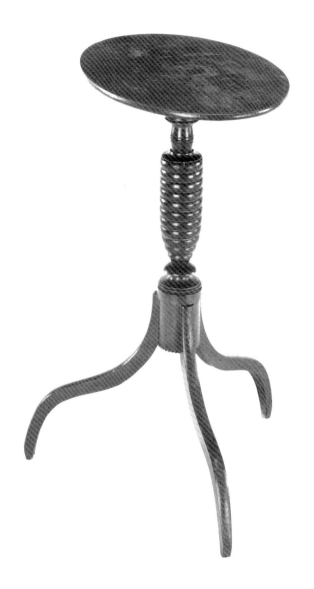

✧ *72*

Stand

Probably Newington, Durham, or Dover,
New Hampshire
1805–20
The Newington Historical Society
Newington, New Hampshire

Certain forms of furniture, such as sofas, sideboards, and secretaries, originated mainly in urban centers. More utilitarian objects, especially stands, tables, chests, and painted chairs, fell within the purview of craftsmen in both the city and the country. As a result, the quality of these latter products can vary greatly. Among stands, for example, some reflect a subtle sophistication based on English sources of design (*cat. no.* 71). Others, like this one, are idiosyncratic creations of naïve charm.

The slender legs and oval top of this stand are typical features on examples made throughout New England. It is the unusual turning on the pillar that sets this stand apart. A series of thick graduated rings, reminiscent of a beehive, comprise the pillar. This motif appears often on other early nineteenth-century furniture from the Piscataqua area. A two-drawer worktable made in coastal New Hampshire or southern Maine features the same motif (72A).

Other distinctive features of this stand include: flat spider legs with chamfered tips instead of spade feet; proficiently executed chip carving along the bottom edge of the pillar; a wooden latch to secure the tilt-top rather than one of brass (72B); and the use of birch and maple for the primary elements. The presence of mixed woods indicates that the stand was originally stained or painted, and it indeed still retains an old red stain. Though the maker of the stand cannot be identified, he was undoubtedly a skilled artisan who probably worked in a rural setting within the Piscataqua region.

D C E

Structure and Condition: The pillar is square-tenoned through the plate, which in turn is fastened with round-tenons to the cleats. Each cleat is secured with two original screws to the underside of the one-board top. The legs are attached to the pillar with sliding dovetails. An iron brace never reinforced the joint.

Only two minor areas of damage mar the table's pristine condition. A screw has been driven through one leg to re-secure it to the pillar. The top is scuffed and abraded.

Materials: *Birch top, cleats, latch, and legs; *hard maple pillar.

Dimensions: H. 28¾; W. 20¹³⁄₁₆; D. 14

Provenance: Acquired by the Newington Historical Society early in the twentieth century from a local family.

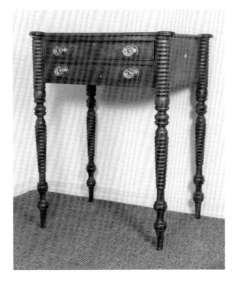

72A.

Worktable. Portsmouth, New Hampshire area, 1810–30. Mahogany, mahogany veneer, and eastern white pine, H. 28⅞; W. 22¼; D. 17⅜. Private collection. Brock Jobe photograph.

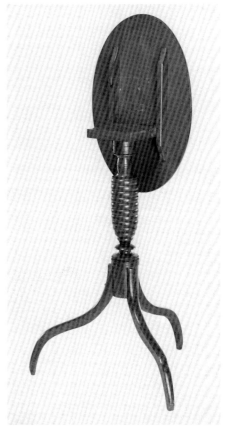

72B.
Back of the stand.

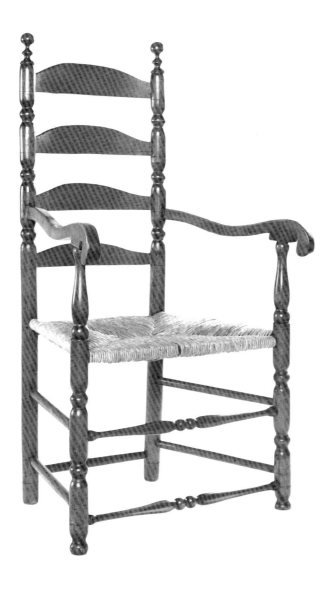

§ 73

Armchair
Portsmouth, New Hampshire, area
1740–90
Private collection

TURNED CHAIRMAKING for home use and for export was a growing industry in Portsmouth by the mid eighteenth century. Although fewer craftsmen worked there than in Boston or Newport, Piscataqua turners were shipping chairs to the Maritime, mid-Atlantic, and southern colonies by the 1730s. Ladder-back side chairs, similar to this armed version, were prevalent, but other furniture forms, like tables and framed chairs with mortises and tenons and some turned parts, were shipped as well.[1] In 1737, the Portsmouth turner John Mills, a native of Bristol, England, sued John Pain, mariner, for making off with "one Dozen & an half of frame Seat Chairs of y[e] value of Sixteen Shillings p[r] Chair[,] three doz. of three Splat Chairs of y[e] value of five Shillings p[r] Chair[,] one Round Chair of the value of forty five Shillings[,] one Carved Tea Table of the value of three pounds."[2]

Mills's "three Splat Chairs" were probably common ladder-backs. When Robert Jacobs died at Portsmouth, the appraisers had also defined his ladder-back chairs by the number of slats: "4 four back chairs 0.16.0."[3] Although usually just listed as chairs, period references sometimes describe the material of the upholstery or the color: for example, "flagg [rush] bottomed chairs," "black chairs" in reference to the usual paint choice, or "white chairs" made of unpainted, raw wood.[4]

Before the Revolution, armchairs were often called "great chairs." Throne-like and dominant among seating forms in early households, great chairs in the seventeenth century were heavy and bold like most furniture; in the eighteenth century, armchairs were lighter and were often sold with matching side chairs.

The turner applied his long-handled chisels and gouges to whirling pieces of wood mounted on the lathe to create cylindrical shapes. Bold, repetitive motifs multiplied with his rhythmic beat and the growing pile of ash and maple shavings on the floor. The turner's round balusters and rings were prominent when viewed from any angle. Round mortises were quickly drilled with an auger to receive the integral tenons of the chair's parts.

In the hierarchy of armchairs, this example represents the basic model by a Portsmouth turner. He undoubtedly made more elaborate chairs, but here the style-bearing elements are only the turned front posts, the stretchers between them, and the upper portions of the rear stiles, particularly the finials. The slats and the arms, being outside the turner's specialty, are plainly sawn and shaped. The void between the thin seat and the turned back was probably filled with a cushion.

The style of these turned chairs was similar to common seating furniture in other urban areas, especially Boston.[5] Examples from Portsmouth are characterized by ball-and-ring finials, serpentine arms with drooping handholds, and elongated baluster and double-ball turnings on the front stretcher. This chair descended in the Ffrost family of Durham and relates to several others found in the area.[6]

P Z

Structure and Condition: The stretchers and seat rails are round-tenoned to the posts. The tops of the front legs are round-tenoned to the arms, and each joint is reinforced with a single pin. The arms are tenoned into the rear stiles, but the joints are not reinforced with pins. The four slats are tenoned to the rear stiles; only the top slat is reinforced with pins. Scribe lines on the posts mark the joints with the slats, arms, seat rails, and stretchers. The chair has been stripped of paint, and the bare wood has a clear varnish. Traces of red and black paint remain. The rear feet have been pieced 2³⁄₁₆". The lower front stretcher is replaced. The front feet retain their original height.

Materials: *Soft maple posts and arms; *ash slats; *red oak stretchers and front and side seat rails; *birch rear seat rails. Replaced rush seat.

Dimensions: H. 46; W. 25¾; SD. 15¾; SH. 17

Provenance: The chair shares a provenance with cat. no. 6.

1. Mills's framed seat chairs were probably like the chair with a "crook't back," (*cat. no.* 80). "Piscataqua" chairs, a twentieth-century collectors' term for a leather chair with an uncarved crest rail, were probably made in Boston during the first quarter of the eighteenth century rather than in New Hampshire. Forman 1988, 283.

2. Mills v. Pain, 1737, docket 14811, N.H. Provincial Court, State Archives.

3. Robert Jacobs, 1736 inventory, docket 882, N.H. Provincial Probate, State Archives.

4. For a discussion of period terminology in seating furniture in the Portsmouth area, see Rhoades 1972, 38–39. Between 1750 and 1775, the materials recorded in 75 estate inventories for chair bottoms rank as follows: leather (53), flagg (38), harrateen (a worsted material) (12), horsehair (10), furniture or blue check (5), damask (5), and cheney (another worsted cloth) (3). John Gaines sold John Moffatt both "black" and "white" chairs. The price of the former amounted to £3.12.0 per dozen, while that of the latter was only £2.2.0. John Moffatt ledger, Oct. 24, 1732–May 1738, 46, 120, New Hampshire Historical Society.

5. Jobe and Kaye 1984, no. 79.

6. The first owner was probably either George Ffrost I (1720–96) or George II (1765–1841). See cat. no. 6; Frost 1943, 24–25, 35; and Lovett 1959, 60–72, for biographical information on the Ffrosts. A related armchair is owned by the Portsmouth Historical Society; another descended in the Demeritt family of Madbury, N.H.

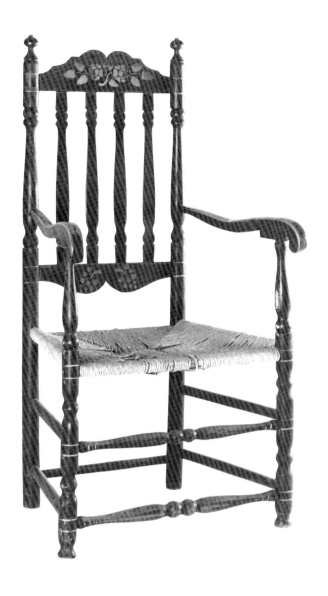

ARMCHAIR

Portsmouth, New Hampshire, area
1750–1800
New Hampshire Antiquarian Society
Hopkinton, New Hampshire, 36

BANISTER-BACK CHAIRS made by turners were popular in the Piscataqua region and elsewhere until the end of the eighteenth century. Their complex silhouette created a decorative intricacy reminiscent of imported cane-back chairs but at a fraction of the cost.[1] During the mid 1720s, one Boston merchant noted that London cane chairs ranged in price from 13*s*. to 21*s*. per chair.[2] By comparison, Portsmouth turner John Gaines charged just 3½*s*. for common banister-backs.[3] Such a striking difference reflected the use of inexpensive native woods and the mechanized procedures of local turners.

The construction process involved rapid replication of parts and efficient methods of assembly. The banisters were normally made from two billets of wood, turned to shape on a lathe, then sawn into four half-banisters and installed between the stay and crest rails with the flat side against the sitter's back.[4] The flanking stiles were usually turned to the same shape. Makers also fashioned the stretchers on a lathe but quickly roughed out the seat rails with a drawknife and spokeshave. Templates ensured a consistent outline for the crest rails and stay rails. Each was sawn to the prescribed pattern and frequently chamfered on the back to lighten its appearance. Turners stockpiled the parts until needed, then assembled them with round mortises and tenons at every joint except those fastening the banisters, crest, and stay rail. The joints were sometimes glued but more often tightened naturally from the use of greener wood for the posts than for the stretchers and rails. As the posts dried, they shrank firmly around the tenons, creating a solid, long-lasting bond.

This armchair represents the most prevalent pattern of banister-back in the Piscataqua region. Examples originated in coastal communities from York, Maine, to Hampton, New Hampshire, and perhaps as far inland as Loudon and Gilmanton, near Lake Winnipesaukee.[5] The style is characterized by the sloping, double-arched crest rail; a finial of a flattened ball with a turned tip mounted above a tapered shoulder; a double-ball turning above an elongated baluster and a lower compressed baluster in each banister; a double-arched stay rail below the banisters; and serpentine arms with drooping handholds. Turners also offered plainer versions of these chairs, with no decorative turnings below the seat rails (74A).

Certain features of the form are regional traits that appear on other types of seating furniture. The shape of the arms and front stretchers, for example, match that on slat-back chairs (*cat. no. 73*), other patterns of banister-back chairs (75A), and even splat-back chairs with turned bases.[6]

The turning was never crisply executed in this shop tradition, possibly reflecting manufacture near the end of the eighteenth century. Our perception of sloppiness, however, may in fact have been a purposeful attempt by these turners to lighten or federalize the baluster form.

P Z

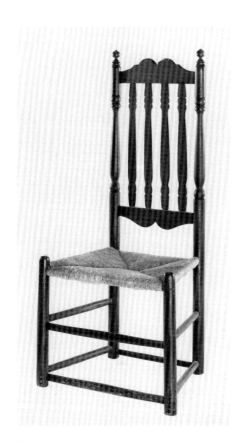

74A.

Side chair. Portsmouth, New Hampshire, area, 1760–1800. Maple and ash, H. 40¾; W. 19; SD. 13¼; SH. 14½. Society for the Preservation of New England Antiquities, Boston, Massachusetts, gift of Joseph W. Hobbs, 1966.422.

Structure and Condition: The stretchers and seat rails are round-tenoned to the posts. Round-tenons also join the top of the front posts to the arms and the arms to the rear stiles; a single pin reinforces each joint. The crest and stay rails are tenoned to the rear stiles; a single pin reinforces each crest rail joint. The banisters are tenoned to the crest and stay rails. Circular scribe lines in the rear posts mark the joints with the crest rail, stay rail, seat rails, and stretchers.

The chair is in excellent condition. The left front foot is chipped, and all feet have been cut down slightly. A nineteenth-century owner applied the present stenciled decoration and striping over an earlier coat of black paint.

Inscriptions: "1702" painted on the crest rail; a typewritten label tied to the left rear stile records the history of the chair (*see Provenance*).

Materials: Maple posts, arms, crest rail, banisters, and stay rail; ash seat rails and stretchers. Possibly original rush seat.

Dimensions: H. 45⅜; W. 23; SD. 16⅛; SH. 16¹⁄₁₆

Provenance: Descended in the Drake family of Hampton and New Hampton, N.H.; purchased for $1 by the New Hampshire Antiquarian Society on May 12, 1873, from the estate of Fletcher W. Wells (d. 1872), the husband of Sarah Drake of Bristol, N.H.

1. Forman 1988, 229–79.

2. Varying levels of decoration on the chairs accounted for the range in price. Thomas Fitch to Silas Hooper, Sept. 23, 1725, Fitch letterbook, 1723-33, Massachusetts Historical Society.

3. In May and July 1733, Gaines charged £2.2.0 per dozen for "white" chairs, probably unpainted banister-backs of plain design. See note 4 of cat. no. 73.

4. One exception to the considerate practice of placing the smooth surface of the banisters against the sitter's back is found in chairs made by the related Spencer and King workshops of Hartford, Conn., and Deerfield, Mass. See Trent 1984, 175–94.

5. Chairs of this pattern have been a staple of household auctions in New Hampshire and coastal Maine for the past century. Probably more than 150 survive. The Old York Historical Society retains the single largest group, an assembled set of eight acquired by the local antiquarian Elizabeth Perkins in the early twentieth century. Other examples include an armchair at Historic Deerfield owned in the nineteenth century by the photographer Emma Lewis Coleman (1853–1943) at York, Me., and Deerfield, Mass.; another armchair purchased by the Parsons family of York early in this century; two nearly identical armchairs with Portsmouth provenances (one in a private collection, the other at the Warner House); a distinctive variation of the form that descended in the Gove family of Hampton, N.H.; and two inland versions formerly belonging to the Batchelder family of Loudon, N.H.

6. A splat-back chair with a straight yoke at the center of the crest (*similar to cat. no.* 80) has serpentine arms with drooping handholds much like those of this banister-back armchair. The chair is owned by the Warner House Association (1978.2).

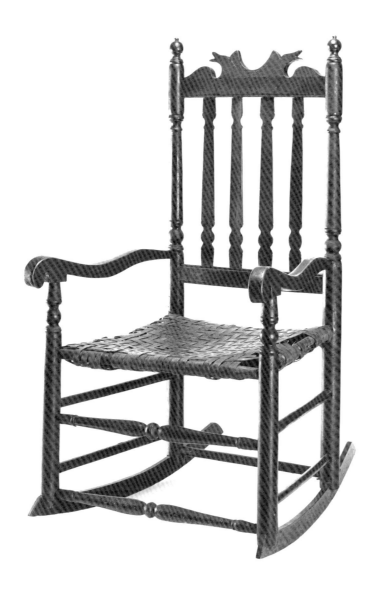

SOME TURNERS ALONG THE NEW HAMPSHIRE and Maine seacoast made banister-back chairs inspired by the ocean.[1] The crest rails on this chair have paired fish tails perpetually poised for a dive into the briny deep. The turner's imagination was normally limited by the straight billets required for his lathe. Here he borrowed from the natural world of S-curves found in the work of the carver and cabinetmaker to make the crest rail's dorsal fins and flukes, which he sawed from a thin board with the aid of a template. Naturalistic motifs were more easily expressed in expensive joined chairs with carved cabriole legs, feet, and crest rails (*cat. no.* 78). The flaring fish tails may have been the turner's answer to the extended ears on the crest rails of so-called Chippendale-style chairs (*cat. no.* 89).

In 1930 the antiquarian Walter A. Dyer noted the presence of these chairs in the Portsmouth-Dover-Rochester area north of the Piscataqua River.[2] However, fish-tail chairs were also made in several workshops southward into Essex County, Massachusetts, through the second half of the eighteenth century.[3] Dozens survive, but few are strictly alike. This armchair has three distinctive features: tapered columns on the stiles, matching squat baluster turnings on the front and rear posts, and a thick turned ring at the center of each front stretcher. The proportions are commodious, the turnings well-defined. Such individual details point to an accomplished but not prolific turner. The chair's history suggests that he worked in Berwick or neighboring Kittery; the chair descended in the Goodwin family and long remained a fixture of the General Goodwin House in South Berwick.[4] Two

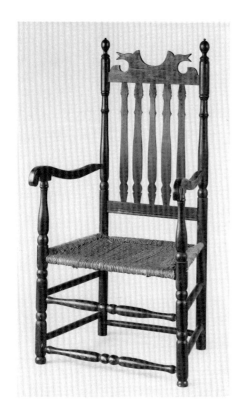

75A.

*Armchair. Probably Portsmouth, New Hampshire, 1740–90. *Soft maple and *ash, H. 46⅜; W. 23; SD. 16⅞; SH. 15¼. Yale University Art Gallery, New Haven, Connecticut, The Mabel Brady Garvan Collection, 1930.2256.*

turners fashioned chairs in the area during the second half of the eighteenth century: Samuel Brackett (w. 1694–1752) of Berwick and Thomas Cutts (1724–95) of Kittery.[5] The latter is a more likely candidate for making this chair.

Many fish-tail chairs share characteristics with other turned seating furniture, suggesting that makers offered the flamboyant crest as an option to customers. The turnings on an armchair in the Yale University Art Gallery (75A) are a more precise version of those on the Drake family chair (*cat. no. 74*). A plainer side chair (75B) may well have been crafted by the maker of the Drake chair or a less ambitious counterpart (74A). These products probably represent the work of Portsmouth turners, such as George Banfield (or Banfill), William Dam, John Mills, or his son Richard Mills.

George Banfield (w. 1725–60) was born in Portsmouth during the 1680s and, according to an account of 1734, worked as a "Chair Maker all[s] [alias] Dish Turner."[6] His sister Abigail married the Boston carver Thomas More in 1715, and Banfield himself was related to local joiners William Locke and Richard Shortridge.[7] The fish-tail chairs have a native quality aligned with a lifelong experience on the Piscataqua, like Banfield's.

The promising career of William Dam was cut short by his untimely death in 1755, at the age of twenty-six. A native of Newington, a rural community just west of Portsmouth, he had probably moved to the busy seaport to serve an apprenticeship with Banfield or the elder Mills, then set out on his own at midcentury.[8] His estate inventory listed among his shop goods: a lathe and tools, "unfinished work of Chairs, Flags," and an assortment of completed turned furniture, including seventeen chairs, three stools, four tables, and three bedsteads.[9]

John Mills emigrated from Bristol, England, about 1725. By the mid 1730s, he was shipping venture cargoes of chairs and tables and making balusters for John Moffatt. The merchant begrudgingly credited him for sixty-nine banisters for a staircase, forty more for the back stairs, and a dozen chairs "not worth half the money."[10] Mills's skill as a turner is documented by the staircase in his own house, built about 1760.[11] As Portsmouth's leading turners, both Mills and his son worked on the new State House and provided chairs for the building in 1762.[12]

The range of turned seating furniture with consistent decorative motifs, like the fish-tail crest, and their sheer numbers suggest origins in an active, urban shop, like Banfield's or Mills's. Over a couple of generations, their apprentices probably scattered through the region and became conduits of a provincial style.

P Z

Structure and Condition: The construction of the chair matches that of cat. no. 74. The rockers were added in the mid nineteenth century. A thick, crazed layer of black paint covers an earlier red stain. The left side seat rail is missing. The splint seat is broken in many places. A modern screw reinforces the joint between the right stile and arm.

Inscriptions: "129" in pencil on a small, adhesive label on the underside of the stay rail.

Materials: *Soft maple posts, arms, crest rail, banisters, stay rail, and front stretchers; ash side and rear seat rails, left stretchers, and upper right stretcher; beech lower right stretcher; white oak front seat rail and rockers. Old but probably replaced splint seat.

Dimensions: H. 42¼; W. 23⅜; SD. 17; SH. 16½

Provenance: Descended in the Goodwin family of South Berwick to Miss Elizabeth Goodwin, who sold it to the present owner in 1958.

1. Many published examples, made throughout the Piscataqua region and northern Essex County, Mass., are known. See *The Antiquarian* 6:1 (Jan. 1926): 42; Nutting 1928–33, nos. 535, 1938, 1957; American Art Association, sale 3878, Jan. 8–10, 1931, lot 238; Fales 1976, fig. 37; Kane 1976, no. 47; *Antiques* 117:4 (Apr. 1980): 750; Christie's, sale 6922, Oct. 21, 1989, lot 232. Other chairs with similar crest rails are in the Peabody and Essex Museum (129,949), Historic Deerfield (64.160), the Portsmouth Historical Society (FK259), Shelburne Museum (3.3–210), and Strawbery Banke Museum (1975.318). Chairs with similar turnings are owned by the New Hampshire Historical Society (1956.273, 1966.30.14, and 1965.505).

2. Dyer 1930, 30–32, 56.

3. The armchair at the Peabody and Essex Museum cited in note 1 descended in the Benson family of Salem.

4. Built in 1797 by General Ichabod Goodwin, the house is a traditional center-chimney, two-story structure with an old-fashioned arched pediment over the door. Later generations filled the house with family possessions and, in the early twentieth century, opened it to the public. A handbill of about 1936 in the SPNEA Archives promotes the "Genuine Heirlooms" within the house and the modest admission price of twenty-five cents. In 1958 Miss Elizabeth Goodwin dispersed the contents of the house and sold the property.

5. Churchill 1991b, n.p.

6. Noyes, Libby, and Davis 1928–39, 74; Godfrey v. Banfield, 1734, docket 15460, N.H. Provincial Probate, State Archives.

7. Thomas and Abigail More to George Banfield, 1725 deed, Portsmouth Historical Society Collection, Portsmouth Athenaeum. Banfield married Miriam Shortridge, the daughter of Richard and Alice Shortridge, in 1710, and Mary Locke in 1727.

8. Dame 1957, 46.

9. William Dam, 1755 inventory, docket 1951, N.H. Provincial Probate, State Archives.

10. Garvin 1983, 75–76, 79, 165–74; John Moffatt, ledger, 1725–40, 70, New Hampshire Historical Society.

11. Mills occupied his new house for only a few months. It later served as the residence of the Whipple family.

12. Garvin 1991, 223.

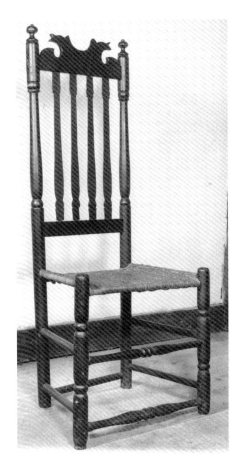

75B.

Side chair. Probably Portsmouth, New Hampshire, 1740–90. Maple, H. 42¾; W. 18⅜; SD. 12⅜; SH. 15¼. Old York Historical Society, York, Maine, 79.18. Brock Jobe photograph.

76

SIDE CHAIR

London

1725–35

Society for the Preservation of New England
Antiquities, Boston, Massachusetts, gift of Mr. J.
Devereux DeGozzaldi, 1985.759

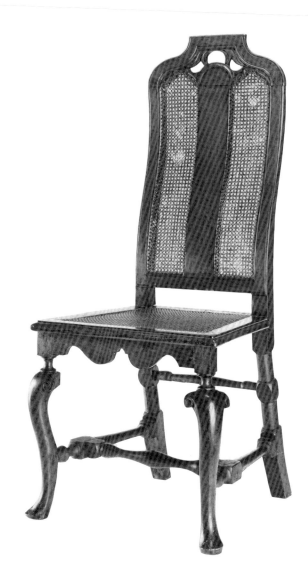

IMPORTED CANE CHAIRS reigned for a half century as the preferred choice in seating furniture for affluent Piscataqua patrons. During the 1680s, local residents began to acquire them through Boston merchants or directly from England. William Pepperrell (d. 1734) probably purchased two sets for his Kittery mansion and later gave them to his son, the hero of the Battle of Louisburg, Sir William Pepperrell (76A).[1] George Jaffrey I, a Portsmouth merchant and member of the Governor's Council, owned a cane couch and seven cane chairs at his death in 1707.[2] Another council member, prominent jurist, and enterprising trader, Joseph Sherburne, kept two sets of six cane chairs in his home.[3] George Vaughn, who returned to Portsmouth in 1715 to become Lieutenant Governor after a decade in England, outfitted his house with a cane armchair and six "Common" chairs to match.[4] In 1728 the English immigrant William Kelly sold "one Great Cain Chair and twelve Smaller Cain Chairs" to his son-in-law, Charles Treadwell.[5] Within Piscataqua society, cane chairs provided a clear measure of wealth and social prominence. Lining them along the walls of the best parlor or chamber, as custom dictated, accentuated their opulence. The addition of a down-filled cushion upon the seat enhanced their appearance and heightened their comfort. Through design, arrangement, and upholstery, the chairs linked their owners with the world of London fashion.

Most likely the chairs of Jaffrey, Sherburne, Vaughn, and Kelly resembled those of Pepperrell: lean, upright examples with bold carving and extravagant turnings. One can imagine then, the dramatic impact this cane chair must have had on

its original owner. Instead of the intricate detail and vertical thrust of its early baroque predecessors, this chair presents "yᵉ New fashion."[6] Its sinuous outline and solid splat, reminiscent of Chinese chairs, reflect the introduction of the style we have come to call Queen Anne. The design—from its round feet to its scrolled top—forms a unified whole, unencumbered by carved ornament. A cushion would have softened the awkward transition between the seat and back. To the colonial sitter, the plan combined grace and ease. The "crook't back" offered welcome relief from the stiff and uneven contour of the earlier carved chairs. The chair exemplifies the final phase of cane chair production in London; by the 1740s the once-prominent industry had come to an end.[7]

Though the chair's original owner cannot be ascertained, its provenance offers a clue. It is one of a set of six (of which four survive) that stood in the Cutts family house in Saco, Maine, when acquired by Samuel Batchelder, a Boston industrialist, in the 1830s. The dwelling's first owner, Thomas Cutts (1736–1821), may have received the set from his former employer, Sir William Pepperrell.[8] When Cutts erected his house in 1782, he modeled it on Sparhawk Hall, the mansion Sir William built for his daughter forty years earlier.[9] Cutts furnished the public rooms of his old-fashioned building with ornate furniture in the new neoclassical style but fitted several of the private rooms on the second floor with "old chairs." One upper chamber housed "11 old chairs in entry" worth $3, another had "6 old chairs" valued at $2.50, and a third contained "9 old chairs" valued at $2.50.[10] Any of these notations could refer to this set of chairs, which would have been nearly one hundred years old at the time.

By then, the chairs had lost the luster they once had. The cane had become damaged, the cushions were gone, and the seats had probably been upholstered (see *Structure and Condition*). Nevertheless, their importance was still apparent to the Batchelder family, who later restored them to their original appearance. Today, they provide a rare illustration of the transfer of British design in "yᵉ New fashion" to the Piscataqua. In Portsmouth, the style would soon flourish through the individual expressions of native craftsmen (*see cat. nos.* 78 *and* 79).

D C E *and* B J

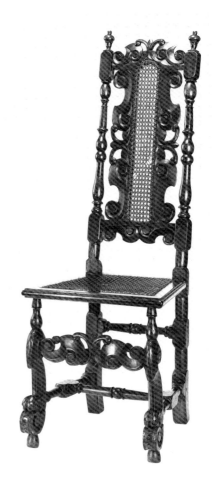

76A.

Side chair. London, 1695–1715. Beech, H. 51; W. 18½; SD. 15⅞; SH. 19. Governor John Langdon House, Portsmouth, New Hampshire, Society for the Preservation of New England Antiquities, bequest of Elizabeth Elwyn Langdon, 1966.287. This chair probably belonged originally to William Pepperrell of Kittery.

Structure and Condition: Standard rectangular mortises and tenons are used throughout except for the round-tenons that secure the rear stretcher. The rear seat rail is tenoned to the side rails, not to the legs as one would expect. Pins reinforce the joints only between the side stretchers and rear legs.

In the nineteenth century, the outer edge of the front and side seat rails was trimmed, and the seat was upholstered. The Batchelder family later removed the covering, restored the missing edge of the rails, and replaced the caning. Several subsequent repairs have been undertaken. The tips of both front feet have been patched. The left rear leg was broken and glued at the joint with the left stretcher. The skirt has been reattached with screws to the legs, and an iron strap was added beneath the corners of the rear seat rail. The chair is stained reddish-brown and covered in an old varnish, which has begun to craze. Damage from powder-post beetles is evident on the stretchers, legs, and seat rails.

Inscriptions: "N° 3" in ink on the underside of the right stretcher. (Other surviving chairs in the set are inscribed "N°2," "N°5," and "N°6.")

Materials: *Beech for all work. Replaced cane on the seat and back.

Dimensions: H. 44; W. 18⅝; SD. 15⅛; SH. 18⅛

Provenance: Apparently purchased with the Cutts house by Samuel Batchelder (1784–1879); descended in the Batchelder family to Mrs. DeGozzaldi; to her daughter Amy DeGozzaldi Hall; to Mrs. Hall's nephew, J. Devereux DeGozzaldi, the donor.

1. Jobe and Kaye 1984, 320. The other surviving chairs from the Pepperrell sets are at the Moffatt-Ladd House (1–2.1978). Related cane chairs with Portsmouth provenances include one owned by Paul Wentworth in the eighteenth century and now at the Moffatt-Ladd House (1978.119) and another that descended in the Fernald family and was recently given to Strawbery Banke Museum (1992.17). Brewster's *Rambles* mistakenly notes that the latter chair had arrived in 1631 with the earliest settlers of Portsmouth (then called Strawbery Banke); see Brewster 1859, 21.

2. George Jaffrey I, 1707 inventory, 4:224–32, N.H. Provincial Probate, State Archives.

3. Joseph Sherburne, 1745 inventory, docket 1214, N.H. Provincial Probate, State Archives.

4. George Vaughn, 1727 inventory, docket 676, N.H. Provincial Probate, State Archives.

5. This privately owned document records the sale of the cane chairs and "one Case of Draws ferneared" to Treadwell. According to Brewster's *Rambles,* Kelly and his family had "enjoyed much affluence in England, but by a sudden reverse of fortune they were reduced to poverty." They emigrated to New Castle where he earned a livelihood as a fisherman. His daughter Mary married Charles Treadwell, an Ipswich barber who had removed to Portsmouth in 1724. The young couple took up storekeeping as a sideline and grew wealthy from the business, in large part because of Mary's "polite attentions to her customers." See Brewster 1859, 136–37.

6. During the 1730s New Englanders frequently referred to "yᵉ New fashion" when placing orders for furniture with their London agents. Sir William Pepperrell, for example, used the term to describe a dozen chairs in 1737; see Jobe and Kaye 1984, 339, note 6.

7. Ibid., 337.

8. Ibid., 338.

9. Candee 1987, 71–72.

10. Thomas Cutts, 1821 inventory, docket 3908, York County (Me.) Probate. For more on the furnishings of the Cutts house, see Sprague 1987b, 112–14.

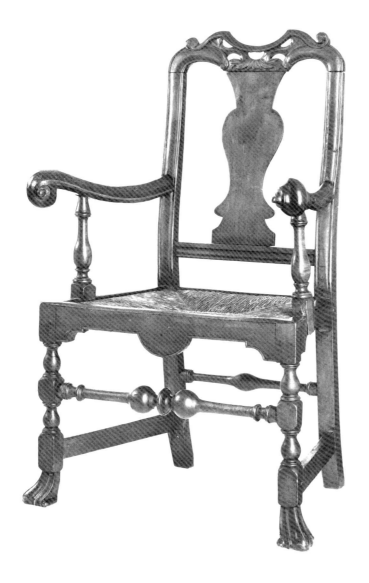

࿏ 77

Armchair

(Colorplate 13)
Attributed to John Gaines III (1704–43)
Portsmouth, New Hampshire
1735–43
Collection of Peter Elliot

For more than a century, chairs attributed to John Gaines have typified for antiquers the furniture made in the Piscataqua region. Small in scale and bold in detail, his chairs represent to many the best in provincial design. For the nineteenth-century author and newspaperman Charles Brewster, Gaines chairs were central to self-identity. In 1869, he noted in his *Rambles about Portsmouth:*

> We have in daily use, and as good as new, four chairs made by our great grandfather, John Gains, in 1728. He built the house in the rear of the Mechanics Reading Room in that year, and these chairs he made for his parlor.[1]

The four chairs still remain in the Brewster family and today are the cornerstone in the identification of Gaines's work (*fig.* 30). Their solid, baluster splats and "crook't backs" clearly place them within the Queen Anne style. Despite their family history, the chairs were probably made well after 1729, when the new curvilinear fashion is first recorded in Boston.[2] Tempting though it may be to speculate that the style developed simultaneously in Portsmouth, Boston was larger, economically dominant, and more up-to-date. Gaines probably did not begin the set until the mid 1730s.

 This armchair, which nearly matches the Brewster chairs in design as well as construction, reveals Gaines at his best. Here he has carefully balanced old and modern motifs on a masterfully proportioned frame. The baluster arm supports and ram's-horn arms unify the old-fashioned turned base with the more fashionable bowed back, which is surmounted by imaginative carving that pierces the crest rail. Although the design on the crest is usually linked only with Gaines, it may have

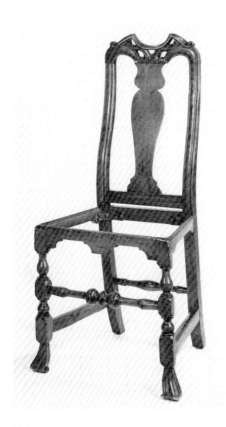

77A.

Side chair. Attributed to John Gaines III (1704–43). Portsmouth, New Hampshire, 1735–40. Maple, H. 41. Private collection. Courtesy, Israel Sack, Inc., New York.

been inspired by Boston chairs or perhaps their English antecedents.[3] The splat, however, reflects his own interpretation of the new Queen Anne style.

Gaines had sufficient business to repeat and perfect his formula. His chairs became remarkably consistent, varying only slightly in the shape of the splat or front seat rail.[4] For a set that descended in the Tufts family of Dover, he adopted a splat design popular throughout the Portsmouth area (77A); on another set, perhaps slightly later in date, he chose a peculiar pattern that few, if any, other craftsmen employed (78c). He also made banister-back chairs, although most are difficult to attribute to him.[5] The turned bases of his products resemble those of eastern Massachusetts chairs, as one would expect considering his background.

John Gaines III came from a family of turners. His father, John, Jr. (1677–1748), his younger brother, Thomas, Sr. (1712–61), and later his nephew, Thomas, Jr. (1740–1821) all practiced the trade in Ipswich, Massachusetts. An account book kept by his father and brother demonstrates a high level of specialization in their coastal town, including the export of chairs to other British colonies.[6] The economic climate permitted the Gaineses to master their methods and to achieve in their chairs a hybrid of urban taste and rural inventiveness.[7]

John III took these experiences and expectations with him to Portsmouth in 1724. There he quickly became a respected member of the community. He married Ruth Waterhouse of Portsmouth on January 18, 1728 and resided on what is now Congress Street, near the intersection of Fleet Street. His shop was adjacent to the house. Gaines served in a variety of minor town positions, including constable and surveyor of highways—a tradition that his son George would expand upon during the second half of the eighteenth century.[8] He apparently kept two or three hands in his shop and sometimes employed others.[9] His clientele included the Piscataqua region's most prominent figures. In 1736, he sold Sir William Pepperrell "1 dos[n] banister Chairs 12£," which may well have resembled the Brewster family chairs.[10] Over a six-year period, the merchant John Moffatt bought 268 chairs, principally for export.[11] By 1743, Gaines had achieved a thriving business and begun to supplement his income with mercantile ventures of his own. At his death, at the young age of thirty-nine, he left shop goods valued at the considerable sum of £124.8.6 as well as a one-third share in a schooner. His entire estate was worth more than £1130, ranking him among the more affluent craftsmen in the community.[12] At the time, his success as an artisan was measured by worldly goods. However, Gaines's legacy from less than twenty years at the bench far eclipsed his income; through the rare merger of urban taste, old-fashionedness, and imagination, he created distinctly American furniture.

P Z

Structure and Condition: Standard rectangular mortise-and-tenon joints secure all elements with three exceptions: the front and rear stretchers are round-tenoned to the legs, and the arm supports are round-tenoned to the arms. A single pin reinforces the joints fastening the seat rails and side stretchers to the legs. The rush seat is not removable. The seat frame rests on a strip nailed to the rear rail and small notches cut in the inner corners of the front legs. A facing strip nailed to the top edge of the rails holds the seat in place. Each front leg and foot are made from a single piece of 3" stock.

The chair is in exceptional condition. Small chips mar the left volute of the crest rail, the outer tip of the left handhold, the inside tip of the right front foot, and the back of the left rear foot. The strips that cover the rear and side edges of the seat rails are replaced. The seat frame may also be replaced. An early twentieth-century photograph in the Winterthur Museum Library (DAPC, 66.1358) shows the chair with an unupholstered seat frame and plank bottom. Sometime before 1930, a repairman removed the bottom and added the present strip along the rear rail that supports the seat.

Materials: Soft maple for all work except eastern white pine support strip on the rear seat rail. Replaced rush on the seat.

Dimensions: H. 42³⁄₁₆; W. 25½; SD. 16⅜; SH. 18⅛.

Provenance: Acquired in the early twentieth century by Katrina Kipper, a Boston antiques dealer; owned since about 1930 by a succession of private collectors, including Mrs. Frederick S. Fish of South Bend, Ind., George Thompson of Pittsburgh, and Mitchel Taradash of Ardsley-on-Hudson, N.Y.; purchased by Israel Sack, Inc., in 1974 and sold to Kenneth Milne of Old Lyme, Conn.; acquired a year later by the present owner.

Publications: Antiques 20:5 (Nov. 1931): 294; Sack 1950, 19; *Antiques* 66:3 (Sept. 1954): 186; *Decorative Arts* 1964, no. 9; Cooper 1980, 213.

1. Brewster 1869, 355.

2. Jobe 1974, 42–43.

3. A Boston chair with a similar crest is in the collection of the Winterthur Museum (59.2115); see Forman 1988, 306–08. It is possible that a specialized carver, rather than Gaines himself, fashioned the distinctive crest rails of his chairs. During the second quarter of the eighteenth century, several carvers worked within the region. The most prominent were William Dearing (1706–87) of Kittery and William Lewis (1722–64) and Moses Paul (1676–1730) of Portsmouth. Other Portsmouth furniture also features ornate carving that may be the work of a specialist; see cat. nos. 17, 52, and 78.

4. Nearly thirty surviving chairs with related crests can be attributed to Gaines. A complete listing of the chairs is in the SPNEA's files.

5. One of the few banister-backs that can be attributed to Gaines is a much restored armchair at the Winterthur Museum (54.515). Undoubtedly he made hundreds of common, inexpensive banister-back chairs throughout his career, but none of his standard products can now be identified.

6. The account book, first discussed in Comstock 1954, is now in the Joseph Downs Rare Books and Manuscripts Collection at the Winterthur Museum Library. For a detailed study of the Ipswich careers of the Gaineses, see Hendrick 1964, *passim.* Zea 1984, 63, extrapolates the essential nature of their activities.

7. A side chair attributed to John Gaines, Jr., or his son Thomas reflects the inventiveness of their work; see Zea 1984, 64.

8. The careers of John and George Gaines are summarized in Decatur 1938, 6–7; and Hendrick 1964, 41–53.

9. Surviving court cases and town tax lists indicate that Gaines employed Joseph Mulenex as a turner in his shop and worked with two joiners, William Locke and John Martin. See Gaines v. Mulenex, 1742, docket 10587, N.H. Provincial Court, State Archives; Gaines v. Locke, 1743, docket 23624, N.H. Provincial Court, State Archives; Portsmouth Tax List for 1736, City Hall.

10. Pepperrell v. Gaines, 1739, docket 12253, N.H. Provincial Court, State Archives. The term banister refers to a central splat, not a series of turned spindles; see Jobe 1974, 42.

11. John Moffatt, ledger, 1725–40, pp. 46, 120, Oct. 24, 1732–May 1738, New Hampshire Historical Society.

12. John Gaines, 1744 inventory, docket 1097, N.H. Provincial Probate, State Archives.

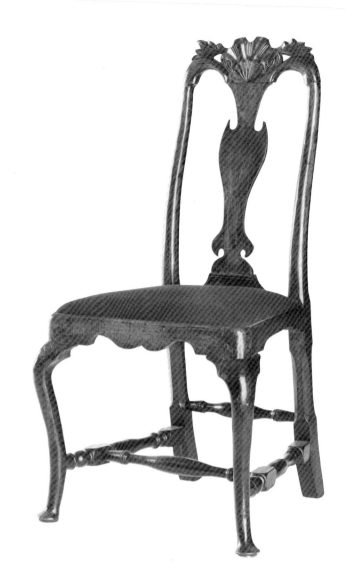

78

SIDE CHAIR

Attributed to John Gaines III (1704–43)

Portsmouth, New Hampshire

1735–43

The Currier Gallery of Art

Manchester, New Hampshire

Gift of Amoskeag Bank, Bank of New Hamp-
shire, William N. Banks Foundation, Cogswell
Benevolent Trust, Mrs. Alvah C. Drake, Mr.
Henry Melville Fuller, Mr. Christos Papoutsy,
Mrs. Lawrence W. Shirley, and Sturm, Ruger
and Company, Inc., 1987.58

DURING HIS NINETEEN YEARS IN PORTSMOUTH, John Gaines adapted his designs to suit changing tastes. By 1740 he had added fashionable cabriole-legged chairs like this one to his repertoire. Part of a set of twelve (of which four survive), it is deeply scored on the front seat rail with the Roman numeral "XI" (78A).[1]

Gaines bedecked the chair with all the earmarks of the new style. A characteristic outline of contrasting curves extends from the cabriole legs to the scalloped front skirt and onto the bow of the ornate back. To heighten the lavish display, Gaines upholstered the slip seat with costly leather or worsted.[2] Of the two, leather predominated in Portsmouth, as it did elsewhere, and may well have been used here. The furnishings of George Vaughn exemplified the pattern. This affluent merchant, who served as lieutenant governor of New Hampshire from 1715 to 1717, owned "11 high backd leather Chairs" and "6 low backd D°." but had none covered in cloth.[3]

Gaines worked within an established design tradition. The proportions of this chair conform to a common New England formula of the 1730s, derived from London cane chairs of the preceding decade (*cat. no. 76*). The plan of the base closely adheres to that of Boston chairs, though with slight modifications in the shape of the stretchers (*compare with* 79B). Yet no one would confuse this example with a Boston product. Its back varies dramatically from convention (78B). Gaines adopted the rare practice of rounding the stiles and devised his own peculiar interpretation of the baluster-shaped splat. At the crest, he placed his most commanding detail, a

carved double shell with sprigs at the side. The florid carving is reminiscent of the baroque crest rails of Gaines's turned chairs (*cat. no. 77*) but far more ambitious. Only two surviving objects of the period display comparable ornament, a dressing table and an altar table made by Joseph Davis (*cat. nos. 17 and 52*).

The ornate carving may represent the hand of a specialist. Two candidates, William Dearing and William Lewis, worked in the area during the second quarter of the eighteenth century. However, evidence on the chair itself suggests that Gaines performed the carving. The coarseness of the crest is consistent with the craftsmanship on the rest of the chair. The maker chose not to scrape away the marks of his spokeshave on the crest, stiles, or legs. He worked swiftly and rather sloppily. In the process, he never mastered the subtle curve of the cabriole leg or the graceful transition between the leg and foot. Nor did he successfully integrate the crest with the splat or stiles. The double shell overwhelms the frame. Its eye-catching prominence must have appealed to its original owner but now emphasizes the naïveté of the design.

Though more stylish than Gaines's turned furniture, this chair seems cruder and more provincial. The reason lies in the craftsman's training and experience. Gaines learned the trade of turning from his father and became adept at working on the lathe (*see cat. no. 77*). His turned chairs display a refinement derived from repetition. He easily replicated turned parts with proficiency and mastered only those carved details, such as Spanish feet and molded stiles, necessary for his standard products. He settled into a comfortable niche for which there was clearly a significant demand. A turned chair with the same splat as the cabriole chair demonstrates his mastery of a familiar form (78c). Building a cabriole-legged version stretched the turner's capabilities. The new chair involved learning a new trade, that of the joiner. Gaines clearly struggled with the challenge. This chair includes the elements of the form without its elegance. Perhaps with additional orders, he might have improved upon the design. However, he probably never had the opportunity. This is the only set of surviving cabriole-legged chairs that can be ascribed to him. Other craftsmen controlled this market and produced more sophisticated examples in the Queen Anne style (*see cat. no. 79*).

P Z and B J

78A.
Detail of front leg and seat rail.

78B.
Chair back.

Structure and Condition: Standard rectangular mortise-and-tenon joints fasten all major elements with two exceptions: the medial and rear stretchers are round-tenoned to the side stretchers and rear legs, respectively. A single pin reinforces each joint for the side stretchers, seat rails, and crest rail. All of the knee brackets are original; each is secured with glue and a single T-head nail. The shoe is nailed to the top of the rear rail and projects ⅜" beyond the front of the rail. The chair was once painted. The tips of both front feet are patched. The tip of the outermost leaf on the right side of the crest is missing. The slip seat is replaced. Old damage from powder-post beetles is evident on the rear legs, rear seat rail, and shoe. In 1987, the SPNEA Conservation Center recovered the seat, added thin wafers beneath the round feet to compensate for heavy wear, and filled the most noticeable insect damage with a beeswax filler.

Inscriptions: "XI" cut with a chisel into the back of the front seat rail.

Materials: *Soft maple for all work except eastern white pine slip seat frame. Reproduction green worsted upholstery.

Dimensions: H. 40⅝; W. 20¾; SD. 15¾; SH. 17½

Provenance: Acquired in the mid twentieth century by a Massachusetts collector; purchased by Nathan and Simon Nager of the Dedham Antique Shop and sold to The Currier Gallery of Art in 1987.

Publications: Komanecky 1990, 155.

1. The other three chairs from the set are numbered IIII, VIII, and X in a similar manner. Number IIII belonged to Chandler Brooks (1812–98) of Kittery in the mid nineteenth century and is now in a private collection. Number VIII is owned by the Winterthur Museum (55.120); see Hummel 1970, 900–901. Number X was bought in the Portsmouth area before 1930 by the local antiques dealer, Charles H. "Cappy" Stewart, and later given by Maxim Karolik to the Museum of Fine Arts, Boston; see Randall 1965, no. 132. The same distinctive numbering appears on a related chair with a turned base (78c).

2. Rush slip seats were a third option in Portsmouth (*see cat. no. 79*). However, the one original seat frame from this set lacks the rounded edges characteristic of a seat made for rush. The original frame accompanies the chair at the Winterthur Museum (see note 1).

3. George Vaughn, 1727 inventory, docket 676, N.H. Provincial Probate, State Archives. Vaughn's other seating furniture consisted of two joint stools, seven cane chairs, four black chairs, and "one Double chaire." It is possible that the cane chairs had cushions, but none are listed in the inventory.

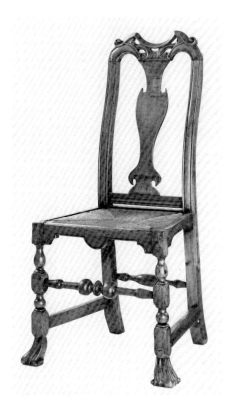

78C.
*Side chair. Attributed to John Gaines III (1704–43). Portsmouth, New Hampshire, 1735–43. *Soft maple, ash, and eastern white pine, H. 41⁵⁄₁₆; W. 21; SD. 14³⁄₁₆; SH. 17³⁄₈. Metropolitan Museum of Art, New York, New York, Rogers Fund, 1944.44.29.*

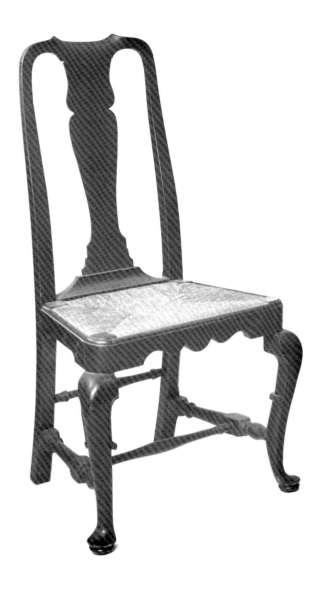

79

SIDE CHAIR

Portsmouth, New Hampshire
1740–65
Bernard and S. Dean Levy, Inc.
New York, New York

JOHN GAINES III WAS NOT THE ONLY CHAIRMAKER IN PORTSMOUTH during the second quarter of the eighteenth century. His competitors included William Dam (1729–55), George Banfield (d. 1760), John Mills (w. 1725–63), and his son, Richard (1730–1800). Unfortunately, the identity of their wares is not preserved by bills of sale or family tradition. However, some seating furniture with local histories of ownership that differ noticeably from Gaines's work undoubtedly originated in their shops.

Two chairs from a rival shop tradition (*cat. no. 79 and* 79A) show that a skilled craftsman, better than Gaines, provided patrons with options in price and style. Both chairs retain a long association with New Castle, the island community adjacent to Portsmouth. In the early nineteenth century, cat. no. 79 belonged to Jane Watkins Bell Amazeen, wife of the enterprising New Castle ship captain Ephraim Amazeen.[1] Its prior history is unclear; possibly Jane's grandfather, Colonel Thomas Bell, was the original owner.[2] When new, the chair formed part of a set of at least six (of which two survive). Its design followed a stylish Boston model, replete with such characteristic traits as a yoke crest, rounded shoulders, contoured back, baluster-shaped splat, scalloped front seat rail, cabriole legs with round feet, and block-and-turned side stretchers. The similarities point to the appeal of Boston furniture throughout the Piscataqua area. Though English products carried the most cachet, Boston goods did not fall far behind. In 1739 William Pepperrell of Kittery purchased a costly set of twelve "Walnut Chairs [with] Compass Seats" from the Bos-

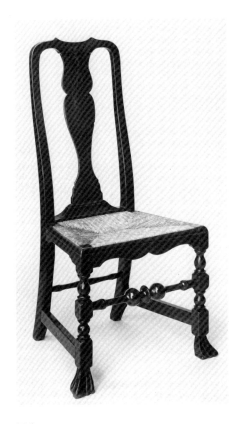

79A.
*Side chair. Portsmouth, New Hampshire, 1735–
65. Cherry, H. 41½; W. 19; SD. 14¾; SH. 17⅜.
Private collection.*

ton upholsterer Thomas Baxter.[3] The maker of Jane Bell Amazeen's chair probably learned of the form through an imported example such as that owned by John Langdon of Portsmouth (79B).

To the basic Boston formula, the Portsmouth artisan added carved scrolls on the knees (which originally continued onto the missing knee brackets), lamb's-tongue chamfers on the rear legs, and an S-curve above the neck of the splat that resembles a deflating balloon.[4] This splat design was shared by competing shop traditions in the Piscataqua region (*compare with cat. no. 80*).

The same craftsman also made turned-leg chairs such as 79A. Its large Spanish feet, rectilinear side stretchers, and ball-reel-ball front stretcher are customarily attributed to Gaines, but the details actually represent a regional style based on eastern Massachusetts furniture. The leg and stretcher pattern, for example, matches that of Boston leather chairs of the 1720s.[5] However, unlike Spanish feet carved in Boston, the bolder Portsmouth versions are cut from a single block without the addition of "toes" to conserve wood. Other minor variations distinguish Boston models from this particular example. Its maker simplified the design of the front skirt by omitting the semicircular drop at the center. He also repeated distinctive details from Jane Bell Amazeen's chair including the lamb's-tongue chamfer on the rear legs, the pattern of the splat (though attenuated on this example), and the use of rush on the slip seat. The last of these deserves special mention. In Boston, slip seats were commonly covered in cloth or leather; in Portsmouth, rush offered a less expensive alternative and did not require the services of an upholsterer. To prevent the rush from tearing, the maker rounded the edges of the seat frame.

This chair, like cat. no. 79, remains in exceptional condition. It is one of a set of four sold at a New Hampshire auction in 1986. Though the set lacks a specific history, a matching chair, possibly from the same set, belonged to Nellie Card of New Castle in the late nineteenth century.[6]

P Z and B J

Structure and Condition: Standard rectangular mortise-and-tenon joints fasten all major elements with two exceptions: the medial and rear stretchers are round-tenoned to the side stretchers and rear legs, respectively. The rear seat rail is reinforced with two pins at each joint. The joints for the crest, side stretchers, and side and front seat rails are reinforced with a single pin. The shoe is nailed to the top of the rear seat rail. The back edges of the crest and stiles are chamfered. A quarter-round bead ornaments the top edge of the seat rails. The sides of the slip seat frame are tenoned to the exposed ends of the front and back.

The chair is now covered with at least three layers of paint; the outermost coat of red has clouded and crazed. The original knee brackets have been missing for at least a century; the present owner installed new brackets in 1990. The right front foot was broken long ago and its tip replaced. An extra pin has been added to secure the front seat rail to the right front leg.

Materials: Maple for all work. Old but probably not original rush on the seat.

Dimensions: H. 40⁷⁄₁₆; W. 21⁷⁄₈; SD. 16⁷⁄₈; SH. 15⁷⁄₁₆

Provenance: According to family tradition, owned by Jane Watkins Bell Amazeen (1777–1849), wife of the New Castle ship captain Ephraim Amazeen (b. 1779); to their daughter Martha Bell Amazeen Marvin (1808–47) and her husband William Marvin (1810–80); to their son William Marvin (1840–1919); to his son William E. Marvin (1872–1938), a prominent lawyer and mayor of Portsmouth who acquired the Langley Boardman house on Middle Street in 1900 (*see cat. no.* 107); to his daughter and grandson, who sold the chair to the present owner in 1990.

Publications: Howells 1937, fig. 66.

1. A descendant of Jane Watkins Bell Amazeen compiled the provenance of the chair; see letter from Willard Emery to Diane Carlberg, May 13, 1991, SPNEA files.

2. A resident of New Castle, Thomas Bell commanded the small garrison at Fort William and Mary from 1735 to 1772; ibid.

3. The order, dated Dec. 26, 1739, included ten side chairs at £3.10.0 each and two armchairs at £6.0.0 each, plus "Canvas to pack in" at £0.10.0; see Thomas Baxter, 1740 bill, SPNEA Archives.

4. One Boston chair pattern, featuring a similar splat and scrolls on the knees, may possibly have served as the specific source of cat. no. 79; see Jobe 1974, 44.

5. Ibid., 40; also see Forman 1988, nos. 75–76, 78–79.

6. A memorandum given to the present owner of the chair by his mother notes that it had "belonged to Horace's Aunt Nellie Card of New Castle." The statement probably refers to Nellie A. Card (1859–1941), a lifelong resident of the town.

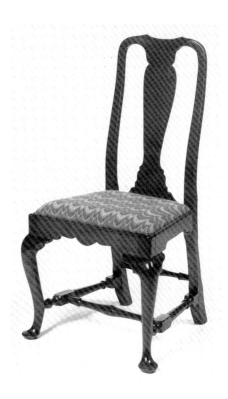

79B.
Side chair. Boston, Massachusetts, 1740–65. Black walnut, H. 40⅛; W. 21⅜; SD. 16⅜; SH. 17¼. Old Sturbridge Village, 5.45.7. This chair, branded "J: LANGDON" on the rear seat rail, belonged to John Langdon (1741–1819) of Portsmouth.

80

Armchair

Portsmouth, New Hampshire, area
1735–75
New Hampshire Historical Society
Concord, New Hampshire
1965.509

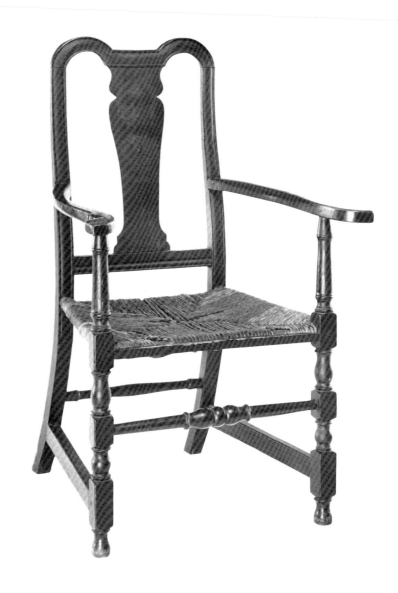

AFTER 1735, CHAIRMAKERS PAIRED contoured "crook't backs" with turned frames to attract buyers who found the cost of cabriole-legged chairs prohibitive but wanted more than a chair constructed entirely of less expensive turned pieces. In Portsmouth, the curvilinear splat, molded stiles, and yoke crest were costly carved concessions to modern design. The interpretation of these elements varied from shop to shop. John Gaines developed a distinctive pattern with a pierced crest (*see cat. no.* 77). The anonymous makers of 46c and 79A devised other solutions that are plainer in outline but equally idiosyncratic. Cat. no. 80 presents a fourth regional design. The shape of the yoke crest forms its most distinguishing characteristic. Typically, the beaded edges of each shoulder end in a volute just above the upper corners of the splat.[1] Here, the beaded edges continue straight across the center of the yoke. The distinctive treatment became a popular option in several shops. Another maker offered the crest on chairs with flat stiles, a simpler baluster splat, and fully turned base (80A).

The geographical range of the crest pattern probably extended from York, Maine, to Portsmouth and perhaps along the inland towns bordering on the Piscataqua and its tributaries. An armchair and side chair with flat yokes descended respectively in the Goodwin and Chadbourne families of South Berwick, Maine, and may well have been made in the town.[2] The chair in 80A belonged to a York collector for most of this century and could have originated there or possibly in South Berwick.[3] Two similar chairs, acquired by Mrs. Arthur Rice of Portsmouth

early in this century, may have been constructed in the seaport.[4] Cat. no. 80 belonged to the Pickering family, who moved from Newington, a rural community adjacent to Portsmouth, to Barnstead, New Hampshire, at the end of the eighteenth century.[5]

Of all the versions of the form, this armchair is the most distinctive. Columnar turnings, rather than common balusters, support the arms. The flat profile of the arms simulates in two dimensions the sculptural ram's horn of Gaines's chairs (*cat. no. 77*) and the plainer serpentine arm of more common slat-backs and banister-backs (*cat. nos. 73–75*). The maker added oval handholds with pointed tips, a peculiar plan with no known counterparts. The decorative turnings of the front stretcher—a ball flanked by balusters—vary dramatically from the standard Piscataqua patterns of two balls (*cat. no. 73*) or a ball-reel-and-ball (80A). These singular qualities suggest the hand of an accomplished rural turner or joiner who made small numbers of chairs for his neighbors. Each ornament selected by the maker demanded only the minimum of freehand shaping or carving. However, the finished product gives the air of the costly carved chairs, surpassing the workmanship invested in turned chairs constructed only of straight, repetitive parts.

P Z and B J

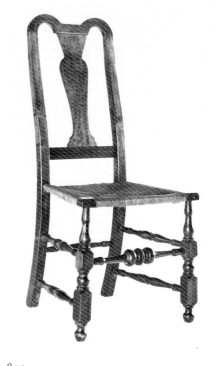

80A.

Side chair. Portsmouth, New Hampshire, area, 1740–75. Maple, H. 40³⁄₁₆; W. 18³⁄₄; SD. 13¹⁄₂; SH. 17¹⁄₄. Collection of Robert and Frances Lord.

Structure and Condition: This chair is comprised of a turned base and joined back. Standard rectangular mortise-and-tenon joints fasten all parts of the back as well as the side stretchers. The front and rear stretchers, seat rails, and arm supports are secured with round mortises and tenons. A single pin reinforces each joint for the crest rail, arms, and front and side stretchers. The chair is now painted brown, and the splat is decorated with a stenciled basket of flowers and a dove within a wreath. This late nineteenth-century surface covers a light brown stain. A pine facing strip has been added to the front seat rail. Large plugs fill holes in the sides of the right front and rear legs at the seat rails. The round tenons of the front and rear seat rails now project through the right legs. The right arm may be an old replacement. The left handhold is broken, and a portion of its tip (measuring 2¹⁄₂" by 1³⁄₄") has been replaced. The round tenon of the left arm support projects through the handhold. A large shrinkage crack is present in the right rear leg about 3¹⁄₂" above the floor. The rear legs are warped and cant to the left.

Inscriptions: "Vase-splat transitional chair. / Owned by Isaac W. Hammond. Purchased / from Pickerings. Sold to Society by / Mr. Harry Hammond" is typed onto a label affixed to the underside of the right stretcher.

Materials: *Soft maple posts, crest rail, splat, stay rail, arms, and stretchers; *ash right and left seat rails; *red oak front seat rail; *white oak rear seat rail; *eastern white pine facing strip on front seat rail. Old, possibly original rush on seat.

Dimensions: H. 40⁷⁄₈; W. 26¹⁄₄; SD. 16¹⁄₂; SH. 16⁷⁄₈

Provenance: Purchased by Isaac W. Hammond (1831–90) from the Pickering family of Concord, N.H., whose ancestors moved from Newington to Barnstead in about 1790; sold by his son, Harry Hammond (1867–1955) of Concord, to the New Hampshire Historical Society in the early twentieth century. Harry Hammond's brother, Otis Hammond, served as Director of the Society from 1910 until 1944.

Publications: Historical New Hampshire 20:1 (Spring 1965): 42–43.

1. For molded crests of the standard pattern, see Jobe and Kaye 1984, nos. 92, 93.

2. The Goodwin family armchair was sold at Sotheby Parke Bernet, sale 3866, Apr. 30–May 1, 1976, lot 471. The Chadbourne family side chair is privately owned.

3. The present owners acquired the chair in 1985 at the auction of the estate of Roger Lucas, a longtime York antiques collector and dealer.

4. Mrs. Rice presented the chairs to the Warner House Association. One is an armchair (1978.2), the other a side chair (1979.1). Both were made by the same craftsman.

5. Pickering 1884, 7–10.

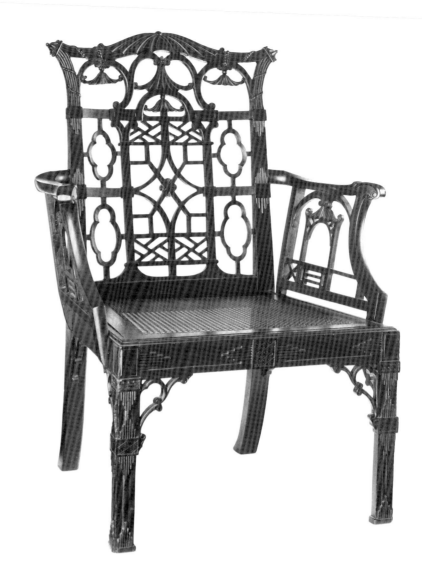

81

ARMCHAIR

London
1763–67
Moffatt-Ladd House
Portsmouth, New Hampshire
In care of The National Society of The Colonial
Dames of America in the State of New Hampshire
Gift of Mrs. Alexander Haven Ladd
1977.103.2

THIS STYLISH LONDON IMPORT in the Chinese taste is barely akin to a chair from China, but it is replete with lines and motifs that said "Chinese" to Englishmen in the middle of the eighteenth century. The one element that really is Chinese in design is the straight leg, which came to dominate Portsmouth chair design of the period. Only in Portsmouth, not in England or elsewhere in America, was the cabriole completely forsaken in favor of the straight leg.

Though dramatic in appearance, this solitary chair merely hints at its original impact. For the true aesthetic jolt, picture the chair in context; it is part of an extant set of six armchairs, one stool (81A), and two settees (*fig.* 36).[1] The settees are now double chairbacks, but both were wider, cut down in the nineteenth century from triple chairbacks. The suite had additional stools and probably crimson damask cushions for the caned slip seats.[2] It may have shared a parlor with a matching china table and kettle stand (*figs.* 37 *and* 38), creating a splendid Chinese ambience, a veritable oriental fantasy in which to drink that all-important Chinese beverage, tea.

The components of the suite are extraordinary: stools, settees, and armchairs but no side chairs. Such sets are rare and special. An English example is the duke of Beaufort's set of armchairs in the Chinese bedroom in Badminton House, Gloucestershire.[3] New Hampshire Governor John Wentworth had a suite of armchairs and one sofa in a room of his Wolfeborough estate, a country seat complete with a deer park.[4] Two Portsmouth merchants, John Langdon and Samuel Moffatt, had sets of twelve French chairs (*see cat. no.* 91). The arrival of this suite (*cat. no.* 81) in Portsmouth may have promoted a taste for sets of armchairs.

The suite may also have fostered a taste for the Chinese style. In his Wolfeborough estate, the Governor had a room with Chinese wallpaper.[5] The Governor's younger brother, Thomas Wentworth, owned a less ornate English set of four side chairs and two armchairs with fretwork backs (81B). Soon local artisans began to offer fashionable tables and chairs in the oriental taste (*see cat. no.* 48).

Who was the original owner of this pretentious suite? It reputedly belonged to the American-born John Wentworth, who, while residing in England in 1766, was named Governor of New Hampshire, Judge of the Admiralty, and Surveyor of the King's Woods in America (*see fig.* 11). Some documents point to John Fisher, the English-born husband of the Governor's sister, Anna. Fisher held posts as Collector of Customs for Salem and Marblehead, Naval Officer for New Hampshire, and Deputy for Newbury, Massachusetts, and York, Maine.[6]

The trail to the original owner is muddy. When the Governor returned to Portsmouth to assume his royal duties in 1767, he resided in his brother-in-law Fisher's Portsmouth mansion.[7] When the Royal Governor and his family fled, the Fishers did too. A document filed by Fisher claiming compensation for the loss of possessions left behind lists:

6 Mahogany Carved arm chairs with crim:sion Damask Cushions at 6.10/	39.-.-
2 Sofias carved Mahogany with Crimson Damask Cushions	26.-.-
4 Stools with ditto 65/	13.-.-[8]

The chairs are not designated "Chinese" as are others in the document, but the components match and are valuable enough to be this suite.

The Governor also submitted a claim for losses but without an itemized inventory. One can only guess at the grandeur of the confiscated contents of his Portsmouth home. According to the claim, they totalled £514 lawful money, a princely sum that even exceeded the value of the furnishings at his lavish Wolfeborough estate.[9]

Whether Wentworth or Fisher, the original owner of the set was familiar with London taste, had resided in England, and considered such an impressive set of furniture appropriate to his rank. Of the two, the Governor is the more likely candidate. John Wentworth had lived in England for three years, had frequented palatial English estates, and, as we shall see, was a man who relished courtly splendor (*cat. nos.* 85, 90).

The history of the set after the Revolution is well documented. In 1780 Mark Hunking Wentworth, father of John Wentworth and Anna Wentworth Fisher, received the furniture in payment for a debt owed him by the state.[10] Although not the suite's original owner, he may well have paid the bill for it. He was far wealthier than his children and provided houses for all of them. He bought the mansion house for the Fishers, acquired the house now known as the Wentworth-Gardner House (*figs.* 9 *and* 10) for his son Thomas, and probably paid the construction costs for the Governor's grand estate in Wolfeborough. After Mark Hunking Wentworth's

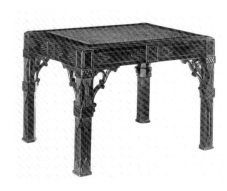

81A.

Stool matching cat. no. 81. Mahogany, H. 15⅝; W. 22¼; D. 17⅜. Moffatt-Ladd House, Portsmouth, New Hampshire, in care of The National Society of The Colonial Dames in the State of New Hampshire, gift of Mrs. Theodore Lyman Storer, 1977.103.4a.

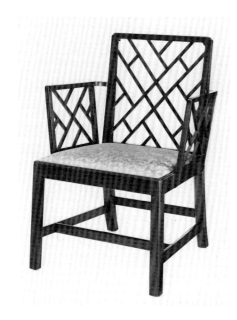

81B.

*Armchair. London, 1761–68. *Mahogany and*
**beech, H. 35⅝; W. 25⅝; SD. 20¼; SH. 17¼.*
Gore Place Society, Waltham, Massachusetts, gift
of Gregory B. Smith, F424-G. This chair is part
of a set originally owned by Thomas Wentworth
(1740–68), brother of Governor John
Wentworth.

death, the set passed to his widow Elizabeth and in 1794 was acquired at the auction of her estate by the Portsmouth merchant Nathaniel Appleton Haven (*see Inscriptions*).

The ornate design of this set has few peers. It is not based on any known pattern-book plate and relates only vaguely to Chinese chairs in Thomas Chippendale's *Director* and Robert Manwaring's *Real Friend and Companion*.[11] The ears flanking the crest are distinctive. Similar ones appear on two other English chairs. One chair, almost as ornate as cat. no. 81, is without attribution or provenance.[12] Another, with a pagoda crest similar to cat. no. 81 and a fretwork back akin to Thomas Wentworth's chair, was formerly at Normanton Park, the country seat of Sir Gilbert Heathcote in Lincolnshire.[13] This opulent residence also included a set of "6 India Back and arm Chairs japand to imitate the Bamboe" supplied by Thomas Chippendale in 1768.[14] The term India back had wide appeal and may well have been the expression used by Wentworth when describing his own set of chairs.

No surviving documentation pinpoints the maker or date of cat. no. 81. Its sophisticated design and accomplished carving clearly reflect the work of talented artisans, both cabinetmakers and carvers, probably working together in the same London shop. The date of manufacture could not predate 1763, the year the Fishers were married and John Wentworth went to England. Most probably, the Governor ordered the suite after receiving his new posts in 1766 and before he departed for home in 1767.

The chair epitomizes one way in which English design crossed the ocean—through the object itself. It surely attracted attention from local residents but never served as a source for local craftsmen. Perhaps the design was too pretentious, too aristocratic, to be copied. Sometimes, however, this manner of transferring design led directly to American copies, as illustrated by the next pair of chairs.

M K

Structure and Condition: Standard rectangular mortise-and-tenon joints secure the seat rails to the legs, the arm supports to the arms, and the stiles to the crest rail. The major structural elements of the fretwork on the back and beneath the arms are also secured with mortises and tenons. Screws fasten the arm supports to the side seat rails, the arms to the rear stiles, and the carved knee brackets to the legs and seat rails. The joined slip seat rests on the rabbeted edges of the front and side rails, original two-piece quarter-round blocks in the front corners of the frame, and a support strip nailed to the rear seat rail. The rear rail and shoe are a single unit. The carved decoration on the stiles, front and rear seat rails, and front legs is applied onto veneer. The crest and arms are carved from solid wood.

This chair survives in better condition than any other example in the set. The left half of the left pagoda roof on the back is replaced, and portions of the Chinese railing beneath both arms are missing. The fretwork has numerous shrinkage cracks; many of the cracks have been filled with splines. A thick darkened varnish now covers the surface.

Inscriptions: "Milton Mass. July 4 1922 / This Chair is the Property of my Son / Alexander H. Ladd / Wᵐ J. Ladd" written in ink on paper label mounted beneath left side of slip seat. "III" cut into front seat rail and front of slip seat. An older label, once affixed to another chair in the suite and now preserved separately, is inscribed in ink: "This chair was bought by / the Honᵇˡ N A Haven at the Auction of Mʳ Mark Wentworth / furniture in 1794. It was / given

me by my Mother / August 1843 / Maria T. H. Ladd."

Materials: *Mahogany for all work except oak strip nailed to rear seat rail. Replaced cane on the seat.

Dimensions: H. 38¹¹⁄₁₆; W. 29; SD. 20; SH. 15⅝

Provenance: Originally owned by John Wentworth (1737–1820) or his brother-in-law John Fisher (d. 1805); confiscated by the New Hampshire state government at the outbreak of the American Revolution and presented to John's father Mark Hunking Wentworth (1709–85) in 1780; descended to his widow Elizabeth Rindge Wentworth (1716–94); sold at the auction of her estate to Nathaniel Appleton Haven (1762–1831); to his widow Mary (Polly) Tufton Moffatt Haven (1768–1842); to her daughter, Maria Tufton Haven (1787–1861), who married Alexander Ladd in 1807; to her son, Alexander Hamilton Ladd (1815–1900); to his son, William J. Ladd (1844–1923); to his son, Alexander Haven Ladd (1874–1958); given to the present owner by his widow, Elinor Merriam Ladd (1875–1966).

Publications: Lockwood 1913, 2:101; Morse 1917, 223–24; Giffen (Nylander) 1970a, 115; Naeve 1971, 554.

1. Two armchairs and one settee are at Colonial Williamsburg (1959.351.1–3); one armchair is marked "II" on the slip seat and front seat rail, the other is unmarked. The rest of the suite is at the Moffatt-Ladd House; see Giffen (Nylander) 1970a.

2. Crimson was the favored color for such elegance and for Chinese design especially.

3. Hayward 1969, 1.

4. Starbuck 1989, 118.

5. Garvin 1989, 36.

6. In 1972 Elizabeth Rhoades presented this theory based on Fisher's claim of losses. John Fisher, 1778 claim, 2:608–21, transcription at the New Hampshire State Library, from "Records of the Commission for Enquiring into the Losses and Services of American Loyalists 1783-90," Public Record Office, London (hereafter "Loyalist Claims").

7. Ibid., 2:615.

8. Ibid., 2:601.

9. His furnishings at Wolfeborough were valued at £499.18.0. John Wentworth, 1785 claim, 5:2034, "Loyalist Claims."

10. Colonial Williamsburg curatorial files, 1959.351.1–3, quoting a measure passed by the New Hampshire Legislature on April 27, 1780.

11. Compare with Chippendale 1762, pls. 26–28, and Manwaring 1765, pls. 10–12.

12. Edwards 1954, 1:285, fig. 186.

13. Gilbert 1978, 1:248–49, 2:101, fig. 167.

14. Ibid., 1:250. Chippendale provided two sets of slip seats for the chairs. One set is described as "pincushion seats stuff'd in Canvas to be cover'd with Needlework." The other set had cane seats like those on cat. no. 81.

 82

SIDE CHAIR

(This page)
Samuel Walker
London
1763
Society for the Preservation of New England
Antiquities, Boston, Massachusetts, museum
purchase with funds provided in part by Mr. and
Mrs. Joseph P. Pellegrino, 1988.36.2

 83

SIDE CHAIR

(Opposite page)
Portsmouth, New Hampshire
1763–64
Old York Historical Society, York, Maine
Gift of Mrs. James F. Blaisdell and Family
1978.366

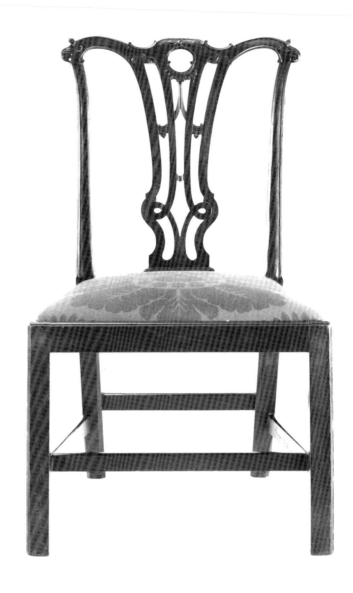

ALTHOUGH THESE CHAIRS were made an ocean apart, until recently they shared a common history. The chairs document the double role of imported furniture—giving London style to a New England house and serving as the direct design source for American-made furniture. The Portsmouth-made chair (*cat. no.* 83) is an American addition to an English set. With the London chair in hand, the Portsmouth craftsman could do more than replicate the imported model; he surely took the opportunity to make a template for future use in serving other customers.[1]

The next best thing to owning imported English furniture was owning furniture identical to imported English furniture. In 1772, South Carolina cabinetmaker Richard Magrath, originally of London, was no longer advertising his London connection but proudly claiming to make "carved Chairs of the newest fashion…of the same Pattern as those imported by Peter Manigault, Esq."[2]

The importer of this set was Nathaniel Barrell, a Boston-born Portsmouth merchant whose shipping connections included a brother in just about every important British port. In 1758, while representing the family (father and nine brothers) in Portsmouth, Barrell married Sally Sayward of nearby York, Maine. After a three-year stint with the family business in London, Barrell returned in 1763, with some select objects of English manufacture, including a set of six chairs "ye Seats covd wth Crimson Damask @ 22/ [£]6.12.-."[3]

The chairs were shipped in March 1763 to a house Barrell's father-in-law had built in York. The Barrells resided there while Nathaniel remained the family's

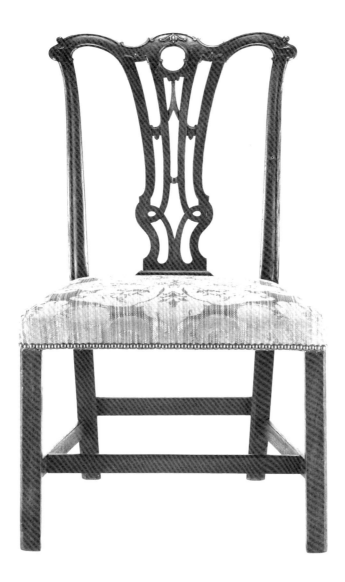

agent in Portsmouth. The English set remained in the York house until 1935; the Portsmouth copy, until 1978.

Barrell was not the only one to import chairs of this pattern, a design that enjoyed some popularity in England. And Barrell's unknown Portsmouth cabinetmaker was not the only craftsman with a template for the pattern. Unlike cat. no. 81, which was apparently too elegant to serve as a model for copies, this design appealed to merchants in many locales. Similar chair backs were made in Philadelphia, Baltimore, and Williamsburg, Virginia.[4]

All the known related examples combine the splat design with a crest with rounded shoulders, no ears, and only a small volute that protrudes beyond the stiles. The crest, particularly popular in England, was not favored elsewhere in New England. Round-shouldered crests became one of the many English features of Portsmouth chairs. Philadelphia and some of the English examples with this chair back have cabriole legs.[5] Clearly by 1763 cabrioles were less than stylish to Portsmouth society. Straight legs were another English feature that became standard on Portsmouth chairs.

When Barrell had his local craftsman replicate the design of the English chair, he made an adjustment, choosing to upholster the seat rails rather than insert a slip seat. Barrell's decision reflected a new fashion in Portsmouth, resulting from the arrival of the town's first professional upholsterers. On July 29, 1763, a Henry Golden announced in the *New Hampshire Gazette* that he was an "Upholster from

LONDON," spelling his first name "Henery," and promising to do "all Manner of Chairs, Safoys, Sattees, Couches, &c." A year later, Joseph Bass advertised his upholstery services (*see cat. no. 84*).

Barrell's choice of over-the-rail upholstery for his copy was consistent with Portsmouth design; however, the appearance of that upholstery was very special. The outer cover was crimson silk, probably matching the textile of the English prototype. To assure that the iron tacks securing the underupholstery did not show through the thin fabric, the cabinetmaker cut a shallow rabbet along the face of the front and side seat rails to recess the tacks. The rabbet is most unusual, but then again, side chairs are rarely upholstered in silk. With its lavish use of a lavish fabric, Barrell's Portsmouth chair appeared even more elegant than its English model.

M K

Structure and Condition: Cat. no. 82: Standard rectangular mortise-and-tenon joints fasten all elements (including the medial stretcher). Pins do not reinforce the joints. The shoe and rear seat rail are a single element. The seat frame never had corner blocks. The joined slip seat rests on the rabbeted edge of the front and side seat rails and a mahogany strip nailed to the rear rail. Of the six chairs in the set, this one survives in the best condition. Though recovered long ago, the slip seat still has small fragments of the original crimson damask upholstery. In 1990, SPNEA conservators cleaned the surface and reupholstered the seat in reproduction damask.

Cat. no. 83: Standard rectangular mortise-and-tenon joints fasten all elements (including the medial stretcher). Pins do not reinforce the joints. The shoe is secured to the rear seat rail with two nails. Unlike most rococo chairs, the rear seat rail is solid mahogany. The front legs never had upholstery peaks projecting above the seat rails (*see cat. no. 84*).

The chair has sustained only minor damage. A large chip mars the back corner of the left rear leg. A pin now strengthens the joint binding the right rear leg and right seat rail. The crest rail is cracked at the joints with the stiles. The seat has been reupholstered four times. The first reupholstery had occurred by the end of the eighteenth century. Presumably, the fragile silk covering became worn and Nathaniel Barrell turned to a cabinetmaker in York to reupholster the chair. The craftsman replaced the original webbing with a pine plank which he glued to strips nailed to the side seat rails. The plank still remains in place and continues to serve as the foundation for later covers. After the chair was photographed for this catalogue, it was upholstered in a reproduction damask and ornamented with brass nails, conforming to the original pattern.

Inscriptions: Cat. no. 82: "IIII" cut into rear seat rail and slip seat. Cat. no. 83: "2" in chalk on inside of rear seat rail.

Materials: Cat. no. 82: *Mahogany for all work except *beech slip seat. Reproduction red damask on seat. Cat. no. 83: *Mahogany legs, crest, splat, shoe, rear seat rail, and stretchers; *soft maple front and side seat rails; *eastern white pine seat and support strips. Modern striped red damask on seat.

Dimensions: Cat. no. 82: H. 37⅜; W. 22; SD. 17⁵⁄₁₆; SH. 17.

Cat. no. 83: H. 37⁷⁄₁₆; W. 22³⁄₁₆; SD. 17⁵⁄₁₆; SH. 17⅝

Provenance: Cat. no. 82: Nathaniel Barrell (1732–1831); to his son John Barrell (1776–1867); to his son Charles Colburn Barrell (1817–1899); to his daughter Theodosia Barrell (1864–1941), who sold the chair as part of a set of six to the Parsons family of York; purchased by SPNEA from Miss Alice Parsons in 1988.

Cat. no. 83: This chair descended with cat. no. 82 to Charles Colburn Barrell; to his daughter Anna Barrell Blaisdell (1869–1954); to her son James F. Blaisdell (1901–77), whose widow and family donated the chair to Old York Historical Society in 1978.

Publications: Jobe and Kaye 1984, 20.

1. Several Portsmouth chairs conform in design to cat. no. 83 but lack its carving. All may be the work of the same individual. A set of six descended in the Gerrish family of Kittery, Me.; see American Art Association, sale 4193, Oct. 25–26, 1935, lot 285. Another pair is now at the Moffatt-Ladd House; see Giffen (Nylander) 1970a, 117, fig. 4; 118, fig. 6. A single side chair without a provenance is illustrated in *Antiques* 102:4 (Oct. 1972): 569.

2. *South Carolina Gazette,* July 9, 1772, as quoted in Prime 1929, 175–76.

3. Jobe and Kaye 1984, 21. All of the chairs survive, two at SPNEA, four at the Old York Historical Society (1990.6–9). Barrell also acquired a matching set of uncarved English chairs, two of which were given to the Old York Historical Society (1978.367) with cat. no. 83. Samuel Walker must have supplied these as well, but they are not listed on the surviving bill.

4. Kirk 1982, 269–70; Gusler 1979, 143.

5. For Philadelphia chairs, see Kirk 1972, figs. 80–82; for an English chair, see Kirk 1982, fig. 948.

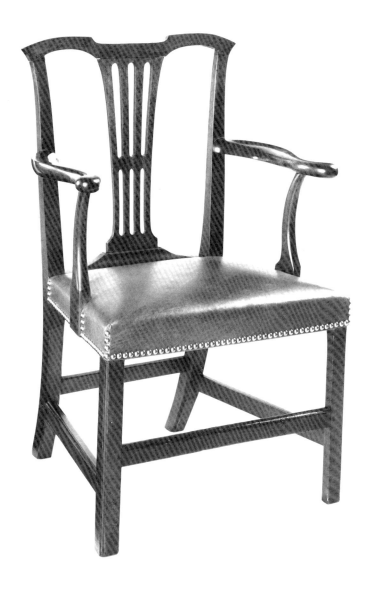

84

ARMCHAIR

Portsmouth, New Hampshire
1764–85
State House, State of New Hampshire
Concord, New Hampshire
Gift of Clara Wentworth Carr Caverly

BY THE MID 1760s, the merchants of Portsmouth demanded nothing less than over-the-rail upholstery on their cabinetmaker's chairs. The cabinetmakers prepared the seat frames for upholstery in what became standard fashion: projecting the front legs above the rails (84A). Newly arrived upholsterers then covered the chairs.

Henry Golden, "Upholster from LONDON" (*see cat. no.* 83), had advertised his services in the summer of 1763, but apparently his stay was brief. His name disappears from the tax rolls after only one year.[1] In 1764 Joseph Bass (1744–1822), a native of Boston, ventured to Portsmouth. He probably learned the upholstery trade from his older brother, Moses Belcher Bass, who had established a successful business in Boston in 1757.[2] Upon completing his apprenticeship, Joseph faced the prospect of keen competition in Boston, where at least half a dozen prominent upholsterers vied for business, so he set off for more promising environs. He first advertised his services in Portsmouth on August 17, 1764 and for the next twenty years served as the community's principal upholsterer.[3] Undoubtedly, he played a key role in popularizing upholstered forms in Portsmouth. He became a respected voice in local affairs, filling numerous municipal posts, holding key offices with the Masons, and taking an active part in the Revolution. He reached the rank of major and fought in campaigns in Canada, New York, and New Jersey.[4] Upon his return from the war, he continued his career as an upholsterer but by 1800 had moved into general merchandising and eventually became Inspector of Customs for Portsmouth.[5]

Bass surely used the nailing pattern that is seen on this chair. It was the favored finishing touch in Portsmouth upholstery. The seat is not only finished in a horizontal row of brass nails (the alternative—a horizontal double row), but with a single vertical row at each corner. Single vertical edging is distinctively Portsmouth. The present replacement upholstery conforms in material and nailing pattern to the original (*see Structure and Condition*). Leather was not as stylish as cloth upholstery, and one row of nails is less dressy than two. Over-the-rail upholstery became so customary in Portsmouth that even seats of lesser importance, like this one, were treated in this manner.

The chair is minimally decorated—the style calls for no decorative carvings—and is remarkably similar to many common English chairs of the period. The design may have come to Portsmouth through an immigrant craftsman or an imported object. Patrons readily accepted the pattern, and it quickly became the town's standard inexpensive upholstered chair. Thousands were made, and many survive.[6] Some found their way through the export trade to Southern ports.[7] The form was remarkably consistent (*see also fig.* 41). The chairs are of birch or walnut, not the more costly mahogany. They typically are covered in leather and the seats are braced with large triangular corner blocks (here only at the front). At the base, they have a stretcher between the front legs, rather than between the side stretchers. The yoke-like crest is reminiscent of Chinese furniture.[8] The splats are usually pierced but sometimes solid, giving the angular chair an even more Chinese aspect.[9] Less stylish versions were made with turned legs and rush or splint seats (84B).[10]

Cat. no. 84 exemplifies the form at its best. Plain but neatly constructed, it has beaded edges on the front legs and stretchers as well as precise chamfers along the back edges of the rear posts and tips of the feet. The sculptural serpentine arms lend a graceful note of refinement that echoes the treatment on Chinese prototypes and on more fashionable Portsmouth chairs (*see cat. no.* 88).

When given to the State of New Hampshire in 1877, this chair was about a century old, and its importance lay in its supposed association with Governor Benning Wentworth. The tie, however, is spurious. The chair was probably first owned by its reputed "second" owner, Judge John Wentworth, who lived in Somersworth, a small community fifteen miles north of Portsmouth.[11] John Wentworth was chosen a member of the House of Representatives in 1749 and became its speaker during the 1770s, while his better known cousin and namesake served as governor. Perhaps, the donor presented the chair to the state because it had served as the speaker's chair during Wentworth's days in the legislature.

M K

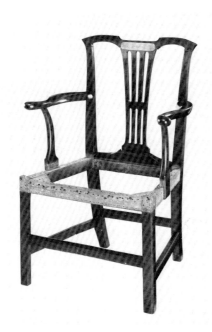

84A.

Cat. no. 84 with its silver plaque and without upholstery, showing its front corner blocks and the projecting peaks on the front legs.

Structure and Condition: Standard rectangular mortise-and-tenon joints fasten all elements with only one exception: the shoe is nailed to the rear seat rail. Instead of the customary screws, tenons secure the arm supports to the seat rails and the arms to the rear stiles. A single pin reinforces each mortise-and-tenon joint except those for the splat. Original triangular blocks are nailed at the front corners of the seat (*see* 84A).

The chair survives in excellent condition. The crest rail is patched along its lower back edge between the splat and right ear. Screws have been added to secure the arm supports to the seat rails. During the late nineteenth century, an engraved silver plaque was screwed to the crest (*see Inscriptions*). In 1991, the staff of the SPNEA Conservation Center removed a well-worn century-old leather cover and reupholstered the chair using a minimum of nails to preserve the frame. Layers of ethafoam and polyester batting were placed on the rails. The leather was secured with pins to the ethafoam; the shanks of the brass nails were clipped off and the nailheads glued to the

leather. At the same time, the silver plaque on the crest was removed, and the uneven finish of the chair blended with a mixture of orange shellac and Orasol dyes.

Inscriptions: A silver plaque, once screwed to the crest rail but removed in 1991, is inscribed "Gov. Benning Wentworth 1741" (*see* 84A). An iron plaque nailed to the lower edge of the rear seat rail bears the painted inscription: "Governor / Benning Wentworth / 1741–1767 / Judge / John Wentworth / 1776–1781 / Mrs. Col. / James Carr / REVOLUTION / Clara Wentworth / (Carr) Caverly / 1837 / State of / New Hampshire / May 30ᵗʰᵉ 1877." Stenciled on the same iron plaque are the words: "STATE OF / NEW HAMPSHIRE / EX 78."

Materials: Birch legs, crest rail, splat, shoe, arms, arm supports, and rear seat rail; *maple front and side seat rails; eastern white pine front corner blocks. Modern brown leather on seat.

Dimensions: H. 37⅜; W. 25⅜; SD. 17½; SH. 16¾

Provenance: Judge John Wentworth (1719–81); to his daughter, Susannah Wentworth Carr (1760–1833); to her daughter, Clara Wentworth Carr Caverly (b. 1788), who donated it to the State of New Hampshire in 1877.

1. Portsmouth Tax List, 1763, Portsmouth City Hall.

2. Moses Belcher and Joseph Bass were sons of Moses Bass, a Boston brewer. For information on the family, see Bass 1940, 30, 49–52. On Sept. 12, 1757, Moses Belcher Bass advertised upholstery goods, "at his Shop, just opened in Ann Street"; *Boston Gazette,* as quoted in Dow 1927, 166.

3. *New Hampshire Gazette,* Aug. 17, 1764. Bass's only competitor, William Sowersby, did not arrive in Portsmouth until 1784. Like Bass, Sowersby was trained in Boston.

4. Foss 1972, 388. For wartime correspondence from Bass, see *Documents and Papers*, 17:371–73, 377–78.

5. Bass's last advertisement as an upholsterer appeared in the *New Hampshire Gazette,* Apr. 27, 1800. He continued to advertise the sale of other goods, especially garden seeds, until Mar. 31, 1807. In his obituary, he is described as Inspector of Customs for the port of Portsmouth; see *Portsmouth Journal,* Apr. 13, 1822.

6. The many closely related examples with over-the-rail upholstery include: a pair at SPNEA that descended in the Langdon family of Portsmouth (Jobe and Kaye 1984, no. 126); another pair in the Wentworth-Coolidge Mansion on the outskirts of Portsmouth that have a long history in the mansion; a set of four at the Woodman Institute that descended in a Dover, N.H., family (1978.1.15); a single side chair branded by the merchant Oliver Briard and now at the New Hampshire Historical Society (fig. 41); a privately owned armchair branded by the merchant John Salter (Kaye 1978, 1103, fig. 6); a privately owned pair that probably belonged to Benjamin Chadbourne of South Berwick, Me., in the late eighteenth century; and an undocumented set of three retaining their original leather upholstery, one of which is owned by the Winterthur Museum (91.45). A related chair with solid knee brackets has a history in the Larkin family of Portsmouth and is now at the Larkin House, a property of the Monterey State Historic Park (484-2-2986). Slip-seated versions include: a single side chair owned by Jacob Wendell of Portsmouth in the early nineteenth century and now at Strawbery Banke Museum (1989.13) and another side chair that descended in the Frost family of Durham and now at the New Hampshire Historical Society (1983.23).

7. Portsmouth furniture makers engaged in an active export trade during the third quarter of the eighteenth century. Chairs constituted the bulk of that trade; see Jobe 1987, 164–65. Colonial Williamsburg owns two chairs of this design with possible southern provenances (1939.98 and G1986.220).

8. For Chinese precedents, see Ellsworth 1971, 108, 109, 112.

9. Portsmouth versions with solid splats include an unaccessioned side chair at the New Hampshire Historical Society that may have belonged to the Rev. Jeremy Belknap (1744–98) of Dover, N.H.; another side chair in the Pendexter House in Dover in 1927; a privately owned pair acquired by the antiques dealer Kenneth Robb at an auction in Salisbury, N.H., in the 1980s; and an undocumented side chair owned by SPNEA (1985.696).

10. A Portsmouth version with turned legs and Spanish feet is illustrated in *Antiques* 100:5 (Nov. 1971): 728.

11. Wentworth 1878, 1:371–80.

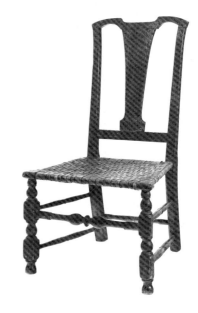

84B.

*Side chair. Portsmouth, New Hampshire, area, 1760–95. *Birch, *soft maple, and *white ash, H. 34⅛; W. 19⁷⁄₁₆; SD. 15; SH. 14. Society for the Preservation of New England Antiquities, Boston, Massachusetts, museum purchase with funds provided by Roland B. Hammond, 1986.3.*

 85

ARMCHAIR

Robert Harrold (w. 1765–92)
Portsmouth, New Hampshire
1767
St. John's Church, Portsmouth,
New Hampshire

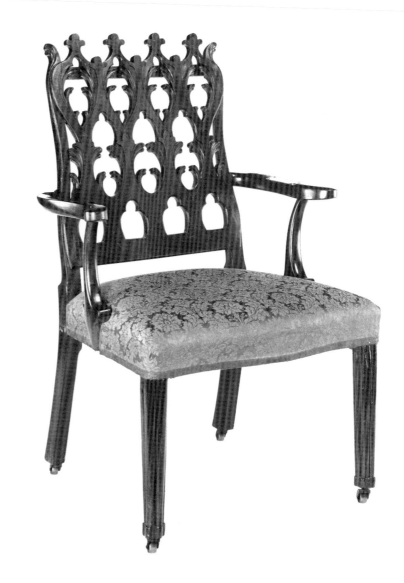

THE DESIGN FOR THIS EXTRAORDINARY CHAIR came to America in a pattern book, Robert Manwaring's *The Cabinet and Chair-Maker's Real Friend and Companion* of 1765 (85A). The design is too spectacular ever to have been anything but rare. This chair and its mate were probably the only American examples to be derived from that pattern.

Manwaring calls the chair with its trefoils, "Gothick." Appropriately enough, the history of cat. no. 85 resembles a Gothic romance, replete with an erroneous but royal provenance, ties to Governor Wentworth and George Washington, a rescue from a fiery demise, and documentation to an exceptional Portsmouth cabinet-maker.

For many years, the chair was believed to have been given by Queen Caroline, consort of King George II, to Queen's Chapel, an Anglican church built in Portsmouth in 1732 and named in her honor.[1] Perhaps the Queen did present the books and plate that she reputedly bestowed upon the chapel in 1732, but she could not have given this chair, which clearly dates from a later era.[2]

The chair does have royal associations, although at some remove—it was made for the King's representative in Portsmouth, the Royal Governor, John Wentworth. In 1767, upon his return from England to assume his post as governor, Wentworth ordered a new pew to be constructed for his use at Queen's Chapel. He presented a plan for it to Michael Whidden, a talented joiner who had been in business since 1752.[3] The pew was raised above the others in the church and adorned

with festoons of red curtains and a heavy wooden canopy bearing the royal arms.[4] To make two chairs for the pew, the governor—or the parish, or Whidden—turned to Robert Harrold, a recently arrived cabinetmaker skilled in English work, who may have been briefly in Whidden's employ. The parish paid Harrold £9.12.0 for his work, which did not include upholstering the chairs.[5] The pew curtains and chair seats were the work of Joseph Bass.[6]

Perhaps the governor, who handed Whidden a plan for his pew, also handed Harrold a copy of Manwaring's pattern book. Surely the governor selected the style of his chairs—a Gothic style appropriate for church furnishings and executed in an elaborate manner suited to the rank of a royal representative.

In 1768, Harrold went on to make an expensive (alas no-longer-extant) chair for the governor's use at the State House. Harrold's work on the pew chairs may have recommended him for the State House assignment. As the craftsman able to make a splendid chair for the governor, Harrold had secured himself a special place in Portsmouth cabinetmaking. And John Wentworth must have been pleased with his elegant and aristocratic pew chairs. The American-made, English-style chair was perfect for an American-born governor with the most fashionable English tastes.

After the Revolution, the pew continued to be used by persons of rank. President George Washington sat on this chair when he attended church during his visit to Portsmouth in 1789. To commemorate the occasion, someone wrote on the seat rail shortly thereafter, "Gen.l Gorge Washington Chair" (85B).

Two years later, with "Queen's Chapel" seeming a rather inappropriate name, the parish was incorporated as St. John's Church. On the morning of December 24, 1806, St. John's caught fire, and this chair (but not its mate) was among the few items saved.[7] Alexander Ladd snatched it from the pew; presumably the inscription identified the right chair to save.[8] Often an historic association helps an object survive; in this case, it preserved a key object in the history of American design.

The provenance and secondary woods of the chair confirm its American origin. Yet its pattern-book source and immigrant maker emphasize its English ties. The legs are clustered columns, a fashionable London motif that rarely appears on American furniture (*see cat. no.* 50). The original upholstery further enhanced the elegance of the chair. A cover of red worsted damask was decorated with a double row of brass nails.

In the early nineteenth century, the arms and arm supports were replaced. Yet, even as an armchair, this seat is wide—26½". The special roles of the chair and its client account for its substantial scale. Its aristocratic appearance befitted the royal position of John Wentworth.

M K

85A.

Design for a "Gothick" chair, plate 15 in Robert Manwaring's The Cabinet and Chair-Maker's Real Friend and Companion *(1765). Courtesy, Boston Athenaeum, Boston, Massachusetts.*

85B.

Ink inscription on the seat rail.

Structure and Condition: Standard rectangular mortise-and-tenon-joints fasten the seat rails to the legs. The carved back is made of a single mahogany board screwed to two horizontal cleats, which in turn are tenoned into the stiles. Though the arms and arm supports are replacements, their construction conforms to pre-Revolutionary models. Each arm support is tenoned to the seat rail and the arm, following the same method employed on cat. no. 84. A screw secures the arm to the stile. The base of the arm supports is sawn out for scrolls but not carved. The seat never had corner blocks or braces. Like cat. no. 86, the bow of the front seat rail is made of a shaped strip glued to a straight rail. In 1969, Morgan Willis of Model Upholstery Company, Portsmouth, installed the present upholstery. The right front leg is cracked just below the seat rail.

Inscriptions: "1770" written in chalk as part of an otherwise illegible inscription on inside surface of front seat rail; "Gen¹ Gorge Washington Chair" in ink on the underside of the front seat rail (85B); "THE GIFT OF / QUEEN CAROLINE A. D. 1732 / OCCUPIED BY GEN'L GEORGE WASHINGTON / SUNDAY NOV 1, 1789" engraved on silver plate screwed to right arm; "St. Johns Church consecrated February 16 1848 / The Communion Cloth & the coverings for the Chairs & Crickets / were presented by Mʳˢ Andrew Halliburton" inscribed in ink on a paper label that accompanies the chair; "Fringes and ochestra / curtains" inscribed in pencil on preceding label; "2 chairs upholstered Nov. 1969 / By Morgan Willis, Model uphol. Co. / Ports. N. H." in magic marker on another label that accompanies the chair.

Materials: Mahogany back, arms, arm supports, and legs; *maple seat rails; eastern white pine bowed strip mounted to the front seat rail. Modern red damask on seat; replaced casters.

Dimensions: H. 45⅜; W. (at handhold) 30⅛; W. (at the seat) 26½; SD. 23⅝; SH. 18¼

Provenance: Made for Queen's Chapel; rescued during the fire of 1806 and two years later placed in St. John's Church, where it still remains.

Publications: Brewster 1859, 352–53; Hall 1901, 11, 14.

1. Hall 1901, 11; Brewster 1859, 350–53.

2. Hall 1901, 8; Brewster 1859, 350.

3. On July 30, 1761, the parishioners of Queen's Chapel voted to take down the governor's pew and enlarge the church, with the understanding that another pew "be built in due time in some other part of the Church at the Expence of the parish for the Use of the Govʳ. of this Province." The renovations were completed within a year, but no action was taken on the governor's pew until May 20, 1767, when church members decided that the Wardens should "wait on his Excellency Jnᵒ. Wentworth Esqʳ. to know his pleasure in finishᵍ The Pew, design'd as a Governors Pew." On June 18, the Wardens met with Wentworth, and "he Gave the plan to Michael Whidden Joiner." See "Records of Queens Chapel from 1756 to 1816," 47, 85, 86, St. John's Church. For information on Whidden, see Garvin 1983, 109–10.

4. Hall 1901, 11; Brewster 1859, 351–52.

5. "Records of Queens Chapel from 1756 to 1816," 90, 99, St. John's Church.

6. Ibid. See cat. no. 84 for information on Bass.

7. Hall 1901, 14–15; Brewster 1859, 353.

8. In about 1808, a replacement was made for the mate destroyed in the fire. The maker of the copy modified the design slightly. The legs are straight, rather than tapered; incised lines ornament the trefoils on the back; a stretcher is placed between the rear legs; and the arms are thicker and the arm supports have carved scrolls at the base. The replacement also remains at St. John's Church.

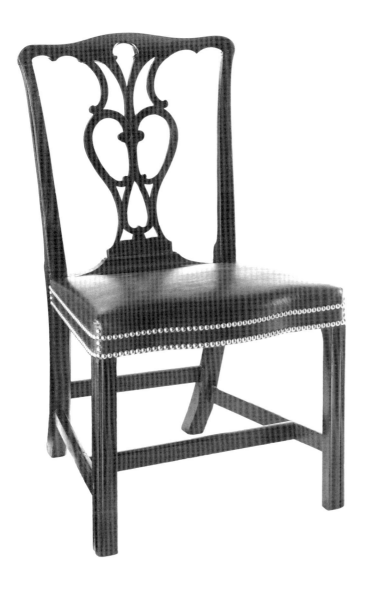

86

SIDE CHAIR

Attributed to Robert Harrold (w. 1765–92)
Portsmouth, New Hampshire
1765–75
Society for the Preservation of New England
Antiquities, Boston, Massachusetts, museum
purchase, 1990.189

ALTHOUGH THIS CHAIR and its mate have no history of ownership, an identical pair, probably from this very set and certainly by the same hand, descended in the family of Charles Wentworth Storrow, suggesting a Wentworth family connection.[1] All of the design features point to a Portsmouth origin. Its straight molded legs, over-the-rail upholstery, bowed front seat rail, round-shouldered crest, and broad seat follow an English tradition adopted in the town. One need only look glancingly at Boston or Newport chairs to know this chair was not shipped to Portsmouth from another New England port.

Structural evidence also supports the attribution to Portsmouth. As on many chairs from the town, braces slip into notches in the corners of the seat (86A), and veneer covers the rear seat rail. Both traits conform to English practice but rarely appear in American work. The bowed front is formed by gluing a shaped strip to a straight front rail, an efficient alternative to shaping the rail itself, which is a more time-consuming process. The technique became a hallmark of Portsmouth chairs (*see cat. nos.* 85 *and* 88). The secondary woods—white pine, maple, and birch—also reflect local preferences.

The armchairs of this design supply conclusive proof.[2] Their arm supports feature the same scrolled volutes at the base seen on armchairs with fine Portsmouth provenances, including cat. no. 88 (*see* 88A). Chairs with these arm supports were once attributed to nearby Newburyport, Massachusetts. This study should end that mistaken attribution.

Like the preceding Gothic chair (*cat. no.* 85), this one has a direct source in Manwaring's *Cabinet and Chair-Maker's Real Friend and Companion* of 1765. The rare splat pattern is modeled on plate 4 (86B). The few surviving examples with this design are probably the work of one craftsman, active in Portsmouth and with access to Manwaring's publication. That individual was undoubtedly the maker of the previous chair, Robert Harrold.

Harrold arrived in Portsmouth in 1765, bringing with him English skills and possibly the English pattern book (though his patron Governor John Wentworth could have supplied the book to him).[3] For two years, Harrold worked for others but was out on his own in 1767, when he made a pair of chairs for Governor Wentworth's pew at Queen's Chapel (*cat. no.* 85). A year later he made an extravagant "Mehogony Chair for the Gover[no]ʳ," a royal seat for use in the Council Chamber of the State House.[4]

Although Harrold's early career in Portsmouth is documented, his English past is not. We must gather clues to his English roots in his career and his workmanship. Harrold won the patronage of wealthy Portsmouth men because his work pleased a governor with very English tastes. He maintained an affiliation with the Church of England and may have become a member of Queen's Chapel.[5] During the Revolution, he removed to Conway, in the mountains north of Portsmouth, perhaps to escape the patriotic fervor that gripped the seacoast. He returned in 1783 and continued in his trade until his death in 1792.[6] Such activities imply an English background for the cabinetmaker. His furniture affirms his English training and attests to his impact. Indeed no artisan had a more influential role in the development of the rococo in Portsmouth.

M K

86A.

Corner brace set into notches in the seat rails.
The leg projects above the rails, forming a peak
to support the upholstery.

Structure and Condition: Standard rectangular mortise-and-tenon joints fasten all elements with one exception: the shoe is nailed to the rear seat rail. A single pin reinforces each joint except those for the splat. The medial stretcher is joined to the side stretchers with tenons rather than sliding dovetails. A slight quarter-round curve embellishes the top edge of the stretchers. The front legs project above the seat rails, forming peaks to accommodate a roll of marsh grass for the upholstery.

When acquired by SPNEA, the chair had several minor areas of damage. A tattered century-old brocade covered the seat. The seat frame had become loose; new pins secured the joints binding the legs to the side and front seat rails; and a series of angle irons that once reinforced the corners of the seat had been removed. A narrow strip of veneer was missing along the lower edge of the rear seat rail; and an old fracture in the left rear stile just above the rear seat rail had been filled with a dowel and putty. In the fall of 1990, SPNEA conservators reglued the seat frame, replaced the missing strip of veneer on the rear seat rail, and removed the filler in the left rear stile and inserted Araldite epoxy into the hollow area and covered it with a mahogany patch. In addition, they reupholstered the chair, following the same "nail-less" technique used on cat. no. 84. The double row of brass nails matches the original pattern.

Inscriptions: "X" in chalk on the left rear corner brace.

Materials: *Mahogany legs, crest, splat, shoe, and stretchers; mahogany veneer on rear seat rail; *soft maple front and side seat rails; *birch rear seat rail and corner braces; eastern white pine bowed strip on front seat rail. Modern brown leather on seat.

Dimensions: H. 37¾; W. 22⅛; SD. 19¹⁄₁₆; SH. 17⅛

Provenance: Purchased by SPNEA at auction, Newport County Auction Gallery, Mar. 14, 1990.

Publications: Antiques and The Arts Weekly, (Mar. 9, 1990): 175.

1. The Wentworth-Storrow chairs were sold at Northeast Auctions, May 24, 1992, lot 561.

2. Armchairs of this design include one in *Georgia Collects* 1989, 123; one sold at Sotheby Parke Bernet, sale 3596, Jan. 24–26, 1974, lot 393; one advertised by Robert O. Stuart in *Maine Antique Digest,* June 1989, 7b; and two in the photo files assembled by the antiques dealer John Walton. A side chair with the same splat belonged to Sheafe Walker of Concord, N.H., in the early twentieth century; see Skinner, Inc., sale 641, July 7, 1979, lot 140.

3. Harrold lived and probably worked with the cabinetmakers Richard Shortridge and Mark Langdon in 1765 and 1766, respectively. See cat. no. 48, note 15.

4. "Province of New Hampshire to Mark Hunking Wentworth, Chairman of the Committee for Finishing the State House pr Vote of the General Assembly," bill, April 1769, Treasury Papers, State Archives; see also Garvin 1991, 227.

5. Two Queen's Chapel documents link Harrold with the church. The Parish Register records the birth of three of Harrold's children: James (1767), Tobias (1768), and Mary (1770); typescript, 23, 26, 28, Portsmouth Athenaeum. The "Records of Queens Chapel from 1756 to 1818" lists a "Richard Harrold" as a parishioner in 1766 and 1767; original ledger, 75, 87, St. John's Church. The dates coincide with the arrival of Robert Harrold to Portsmouth and suggest that the clerk mistakenly wrote Richard rather than Robert. No other references to a Richard Harrold have been found in Portsmouth records.

6. See cat. no. 48, note 13.

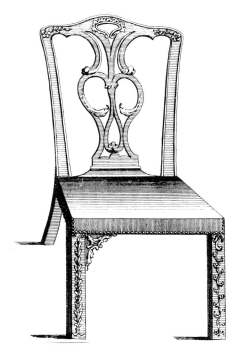

86B.

Design for a "Parlour" chair, plate 4 in Robert Manwaring's The Cabinet and Chair-Maker's Real Friend and Companion *(1765). Courtesy, Boston Athenaeum, Boston, Massachusetts.*

87

SIDE CHAIR

Attributed to Robert Harrold (w. 1765–92)
Portsmouth, New Hampshire
1765–75
Society for the Preservation of New England
Antiquities, Boston, Massachusetts, gift of
Virginia L. Hodge and Katherine D. Parry
1942.1238

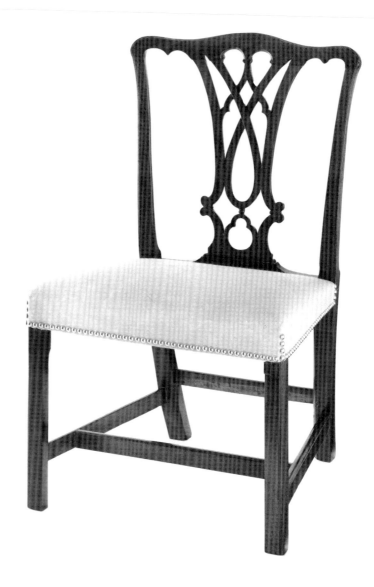

THIS HANDSOME CHAIR epitomizes Portsmouth rococo design and craftsmanship. Its characteristics correspond closely to the preceding chair (*cat. no.* 86). Both feature the same crest, borrowed from Robert Manwaring's pattern book; the same rounded contours along the back of the crest and stiles; the same delicate, airy appearance to the splat; and the same arrangement of corner braces (*see* 86A). On both chairs, the rear seat rail is veneered and blind tenons secure the medial stretcher to the side stretchers. In short, the same individual made both chairs. That man was Robert Harrold.

Here Harrold pared away some of the embellishments of the preceding chair. He substituted a plain leg for the more sophisticated molded version on cat. no. 86. In addition, he eliminated the bow in the front rail and decorated the seat with only a single row of brass nails. Such variations reflect the patron's desire and purse, not the hand of another artisan.

For his splat design, Harrold turned to a popular English Gothic pattern. A nearly identical chair can be seen in Matthew Pratt's painting of the London studio of Benjamin West (87A).[1] The design became a staple of London cabinet shops but does not appear in the published design books of the day. Possibly Harrold carried templates with him when he emigrated. His version matches its English counterparts in nearly every detail but the secondary woods. Such characteristic British features as broad proportions and corner braces readily distinguish it from the products of artisans in other major New England centers.

The design appealed to Portsmouth citizens. Merchants Matthew S. Marsh, Richard Hart, and William Rice branded their chairs like this, making it easy to trace them to Portsmouth.[2] Numerous unbranded examples with Portsmouth histories provide further evidence of local interest in the form.[3] Matching armchairs have arm supports with scrolled volutes at the base, much like that on the next chair (*cat. no.* 88).[4]

Harrold may well have introduced the pattern to Portsmouth, but others soon offered it, as several related chairs clearly show. The chair branded by Marsh (87B) features far thicker elements within the splat. Sliding dovetails join the medial and side stretchers instead of the blind tenons used by Harrold. The maker of the Marsh chair probably did not make cat. no. 88.[5] Thus in five chairs, we have an exceptional view of the work of three craftsmen: cat. nos. 85, 86, and 87 by Harrold; 87B and cat. no. 88 by other able artisans.

Portsmouth craftsmen worked in a similar manner. Harrold's competitors were probably native-born and learned of English styles from the immigrant Harrold. Five candidates emerge from what is known of Harrold's career. One, Richard Shortridge (1734–76), employed Harrold when he arrived in 1765. John Sherburne "servd wth" Shortridge as an apprentice, shortly after Harrold came to Portsmouth. In 1766 Harrold worked with the aging joiner and furniture maker Mark Langdon (1698–1776).[6] Harrold also had a long association with Solomon Cotton (1745–1805), selling his Portsmouth shop to the younger Cotton when he departed for Conway at the outbreak of the Revolution.[7] Finally, in his work on the pew chairs (*cat. no.* 85), Harrold may have influenced the man responsible for the joinery of the pew, Michael Whidden (1731–1818). Of these artisans, Shortridge or Cotton stand out as the most likely maker of the Marsh chair. Through the work of Harrold and his rivals, English rococo taste took root and flourished in Portsmouth. *M K*

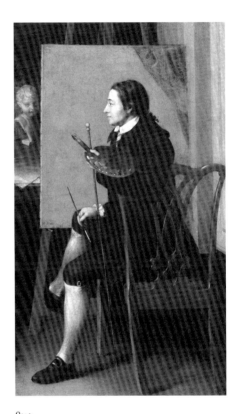

87A.

Detail of The American School, *by Matthew Pratt. London, 1765. The Metropolitan Museum of Art, New York, gift of Samuel P. Avery, 1897.*

Structure and Condition: The construction of the chair matches that of cat. no. 86 with two exceptions: the front seat rail is straight rather than bowed, and the front legs are flat rather than molded. The upholstery peaks at the top of the front legs have been cut slightly. Screws now secure the original corner braces. The back edge of the medial stretcher has an old chip. A light-colored sapwood streak runs through the rear stretcher. The pins binding the mortise-and-tenon joints for the side and front seat rails are replaced.

The chair remains in excellent condition. When acquired by SPNEA in 1942, it was upholstered in only its third covering, an early twentieth-century gold damask. SPNEA staff removed the fabric and in 1990 recovered the chair in a reproduction yellow worsted, using a nail-less method similar to that for cat. no. 84. The single row of brass nails conforms to the original pattern.

Inscriptions: "I" marked on the base of the splat and notch of the shoe.

Materials: *Mahogany legs, crest rail, splat, shoe, and stretchers; mahogany veneer on rear seat rail; *soft maple seat rails and corner braces. Modern yellow worsted on seat.

Dimensions: H. 38⅛; W. 22¼; SD. 18¹⁄₁₆; SH. 18

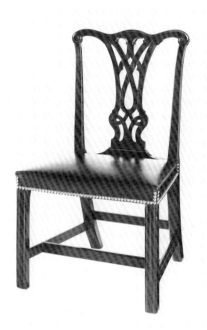

87B.

*Side chair. Portsmouth, New Hampshire, 1765–80. *Mahogany, *soft maple, and *eastern white pine, H. 37¾; W. 22¹⁄₁₆; SD. 18; SH. 16⅝. Diplomatic Reception Rooms, U.S. Department of State, Washington, D.C., 73.46.1. Branded "M.S. MARSH" on the rear seat rail, this chair belonged to Matthew Sheafe Marsh (1773–1814), a prominent Portsmouth merchant.*

Provenance: Part of a collection assembled in the Portsmouth area by Virginia L. Hodge and Katharine D. Parry in the early twentieth century to furnish the Lady Pepperrell House in Kittery, Me.; given to SPNEA in 1942.

Publications: Jobe and Kaye 1984, no. 121.

1. Surviving London chairs of this pattern include: a pair at the Victoria and Albert Museum (W.56–1926), Hinckley 1971, no. 282; a set probably ordered by Charles Carroll of Maryland in 1771 (Weidman 1984, 6); an armchair at the Metropolitan Museum of Art (44.83) mistakenly attributed to Massachusetts (Comstock 1962, no. 246); and a set of four side chairs, which match the armchair at the Metropolitan (*Antiques* 49:1 [Jan. 1946]: 50).

2. The Hart chair is in a private collection; two other sets owned by Hart feature splat patterns similar to that on cat. no. 88; see Jobe and Kaye 1984, no. 120, especially note 1. A chair branded by Rice is pictured in Decatur 1938, 7.

3. Unbranded chairs with Portsmouth histories include: a matching armchair and side chair that descended in the Gerrish family of Kittery, Me., and now belong to SPNEA (1988.37.1–2); an assembled pair of side chairs at the Moffatt-Ladd House (1977.80–81) pictured in Giffen (Nylander) 1970a, 117–18; another side chair at the Thomas Bailey Aldrich House owned by Strawbery Banke Museum (1980.726); a pair of side chairs with added arms acquired in Portsmouth in 1840 by Henry Flagg French, the father of the sculptor Daniel Chester French, and now on view at Chesterwood (69.38.465, 483), and a privately owned example which remained in the Warner House until 1930. In addition, a pair of uncarved versions of the chair branded by Matthew S. Marsh (87B) descended from the Haven family of Portsmouth to the Doe family of nearby Rollinsford. The pair is now owned by SPNEA (1984.1) and pictured in *Maine Antique Digest,* Sept. 1983, 4f; a matching pair without a history appears in *Sack Collection*, 1:192.

4. Related armchairs with scrolled volutes at the base of the arm supports include: one example sold at Parke-Bernet, sale 2324, Jan. 22–

23, 1965, lot 449; another advertised by Israel Sack (*Sack Collection*, 2:342); and a pair from the Garbisch collection (Sotheby's, sale H2, May 23–25, 1980, lot 1092). During the late nineteenth century, Sarah Orne Jewett kept a similar armchair with plain arm supports and flat serpentine arms in the parlor of her home in South Berwick, Me.; see a 1931 photograph of the room in the SPNEA Archives.

5. Born in 1773, Matthew S. Marsh was not the original owner of the pair of chairs bearing his brand. One might assume that he inherited them from his father John (d. 1777). But the available evidence suggests otherwise. In 1770 John Marsh acquired a set of eight chairs from Robert Harrold (John Marsh, account book, 1769–75, 10, Aug. 28, 1770, New Hampshire Historical Society). The 1770 set could not have been the branded set, which originally consisted of at least ten chairs. No other entry in the account book cites a larger set, and John Marsh's estate inventory does not list a set of ten or more chairs (John Marsh, 1782 inventory, old series, docket 4765, Rockingham County [N.H.] Probate). Like many Portsmouth merchants, the younger Marsh probably bought the large set secondhand at a local auction.

6. Listed at "Sawtridges" in the 1765 tax assessment, Harrold undoubtedly worked with the native artisan in some capacity; a year later he is listed with Mark Langdon, suggesting that he resided and possibly worked with the eminent artisan. See cat. no. 48, note 15. Sherburne was with Shortridge for at least 1768 and 1769.

7. Harrold refers to the sale of his shop to Cotton in a mortgage of 1777; see Haslett to Harrold, 109:304, Provincial Deeds, State Archives.

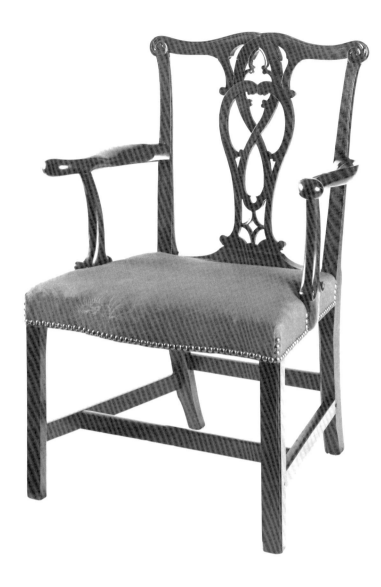

ARMCHAIR

(Colorplate 14)
Portsmouth, New Hampshire
1765–80
Governor John Langdon House
Portsmouth, New Hampshire
Society for the Preservation of New England
Antiquities, bequest of Elizabeth Elwyn
Langdon, 1966.286

THIS CHAIR REVISED American furniture history. Until recent years, Portsmouth Chippendale design went unrecognized. Dealers, collectors, and curators routinely ascribed Portsmouth chairs to Newburyport, Massachusetts. The inscriptions on this chair corrected decades of misattribution, enabling Portsmouth to assume its true place in the history of American furniture.

When SPNEA staff first studied the chair in the summer of 1976, we found three inscriptions on the splat shoe. The boldest, "1776 PORTSMOUTH John Langdon," looked like labored script of recent date.[1] The second inscription, written in pencil, read, "Admiral Dewey held this piece in his hand and examined it Sept 2 1901." The admiral, a native of Portsmouth, was in his hometown on that date. He may have been visiting Woodbury Langdon, in whose parlor this chair was photographed no later than 1897.[2]

The reference to Dewey covered an older inscription in ink, which was not legible. In an attempt to decipher the writing, we traced the visible bits of pen strokes onto transparent mylar, mounted the mylar on the window, and looked at the scratchings from time to time—for months. Everyone who entered the office was asked to look at the mylar in the window; no one could read it. Then one October day there it was: a readable "Portsmouth NH."

Now knowing the size and style of the script, we were able to reconstruct the entire inscription: "Hon Geo G Brewster Portsmouth NH 1832." Brewster, a dentist and clockmaker, was a great-grandson of Portsmouth chairmaker John Gaines;

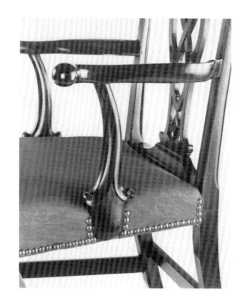

88A.

Arm and arm support.

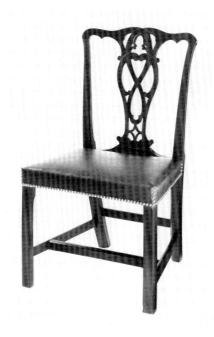

88B.

*Side chair. Portsmouth, New Hampshire, 1765–75. *Mahogany, *soft maple, and *birch, H. 38⅜; W. 22; SD. 18¼; SH. 17. Society for the Preservation of New England Antiquities, gift of Virginia L. Hodge and Katherine D. Parry, 1942.1209.*

brother of Charles W. Brewster, chronicler of Portsmouth history and events; and son of Samuel, who owned "1 Mahogany arm Chair."[3] The inscription, made not long after the chair itself, firmly linked the chair to Portsmouth, placing it in a Portsmouth family.

The newly readable Brewster inscription allowed us to attribute several chairs with similar splats to Portsmouth. One related example was branded "R HART."[4] The "R HART" chair—supposedly the work of a mythical R. Hart, cabinetmaker of Newburyport—opened a new avenue of research. Was Hart from Portsmouth? Indeed he was, but he was a merchant, not a craftsman; the owner of the chair, not the maker.

Following the clues of the splat design and of the several "R HART" branded pieces of furniture, we developed a file of related furniture. We also began a file of branded furniture (*see appendix B*); the names multiplied: D. Austin, C. Blunt, I. Salter, C. Storer, S. Ham, J. Haven, L. Cotton, and J. Langdon. Every one was that of a Portsmouth merchant. The designs in the two files began to overlap, and Portsmouth design of the late eighteenth and early nineteenth centuries took shape again in the twentieth.[5]

A large body of related seating furniture emerged when files of chair designs and of owners' brands were collated. These chairs were rather elegant, very English, all with straight legs, most with seats upholstered over the rails, a goodly number with bowed seat fronts, and all from Portsmouth. The splat design on cat. no. 88 proved to be the most common pattern. For a crest, Portsmouth artisans chose between two designs: the version with round ears seen here or the earless pattern borrowed by Robert Harrold from Robert Manwaring's design book (88B; *see also cat. nos. 86 and* 87).[6]

Armchairs played an especially important part in relating chair designs to Portsmouth. The distinctive scrolled design at the base of this arm support (88A), which had previously been dubbed the hallmark of Joseph Short of Newburyport and repeatedly used to ascribe furniture to that town, was now recognized as a Portsmouth trait and used as the basis for correct attributions (*see cat. no.* 84).

The variety of workmanship in the chairs of this one design reveals that several Portsmouth artisans were making similar upholstered chairs. Cat. no. 88 represents the best work by an unidentified competitor of Robert Harrold. Though its legs are plain and the seat has only a single row of brass nails, the chair exceeds others in quality, having well-carved ears, nicely sculpted arms, a bowed seat, and well-carved scrolls on the arm supports. Another chair by the same maker displays a less graceful arm (88c).

The construction of this armchair parallels the work of Harrold in most details. Like cat. no. 86, a shaped pine strip is affixed to the front seat rail to create a bowed surface, the rear seat rail is veneered, and diagonal braces strengthen each corner of the seat. Here too, the stiles are decorated with a scratch bead, and the back edges of the stiles and crest are rounded. But the chairs do have subtle differences. The medial and side stretchers are fastened with sliding dovetails instead of the blind tenons used by Harrold. Below the stretchers two corners of the rear legs are chamfered rather than one. Such minor variations show the work of a craftsman familiar with Harrold's furniture and intent on working in the same manner.

M K

Structure and Condition: The construction of the chair matches that of cat. no. 86 except for the distinctive features noted in the text. A bead ornaments the front corner of the legs. Four original rose-headed nails fasten the bowed strip to the straight front seat rail. Each arm support is tenoned into the arm and through the side seat rail; the arm is tenoned to the rear stile. Neither screws nor wooden pins originally reinforced the joints for the arms or their supports. The chair remains in excellent condition, with only minor chips and an old refinished surface. In 1977, the seat was reupholstered with a reproduction worsted. The single row of brass nails follows the original pattern.

Inscriptions: The splat shoe bears three inscriptions: "Hon G^eo G Brewster / Portsmouth NH / 1832" in ink; "Admiral Dewey held this piece in his hand and / examined it Sept 2 1901" in pencil; and "1776 / PORTSMOUTH John Langdon" in ink. The shoe and splat are numbered with two C-shaped marks cut with a gouge.

Materials: *Mahogany legs, crest rail, splat, shoe, and stretchers; mahogany veneer on rear seat rail; *soft maple seat rails and corner braces; *eastern white pine bowed strip affixed to front seat rail. Reproduction embossed red worsted on the seat.

Dimensions: H. 38⁷⁄₁₆; W. 26⁷⁄₈; SD. 20³⁄₈; SH. 17¼

Provenance: Probably Samuel Brewster (1768–1833); to George Gaines Brewster (1797–1872); acquired before 1897 by Woodbury (1837–1921) and Elizabeth Elwyn (1871–1946) Langdon; bequeathed by Elizabeth Elwyn Langdon to SPNEA.

Publications: Kaye 1978, 1101, fig. 4; Jobe and Kaye 1984, no. 119.

1. Someone added the Langdon inscription in the late nineteenth century, possibly to entice Mrs. Woodbury Langdon to purchase the chair for her home, the Governor John Langdon House.

2. The photograph in Corning 1897, 620, was taken by Davis Brothers of Portsmouth. An original print is preserved in the SPNEA Archives.

3. Samuel Brewster, 1834 inventory, old series, docket 12612, Rockingham County (N.H.) Probate; see also Jobe and Kaye 1984, 404, note 3. For genealogical information on the Brewster family, see Brewster 1908, 10–11.

4. The branded "R HART" chairs include one pictured in *Sack Collection,* 7:2001; and two formerly owned by Richard Yeaton and now in the collection of Strawbery Banke Museum (1992.18.1–2).

5. For discussion of the research process, see Kaye 1978.

6. Nearly sixty Portsmouth chairs with this splat pattern are known. Those with round-eared crests like cat. no. 88 include six carved examples: 88c; another armchair closely resembling 88c sold at Sotheby's, sale 4942, Oct. 23, 1982, lot 197; a side chair in Nutting 1928–33, 2:2300; a pair from an assembled set of six sold at Parke-Bernet, sale 2604, Oct. 21, 1967, lot 147; and a cut-down side chair owned by SPNEA (1942.202). The group also contains three slip-seated armchairs: one at Historic Deerfield (1032) (Fales 1976, 64); a second advertised by Israel Sack in *Antiques* 70:3 (Sept. 1956): inside cover; and a third in *Sack Collection,* 3:802. The remaining chairs with round-eared crests are uncarved and upholstered over the rails. They include: a side chair pictured in a Portsmouth interior in 1896 (Elwell 1896, pl. 28); a side chair advertised in *Antiques* 8:1 (July 1925): 1; an armchair in Cescinsky and Hunter 1929, 137; another armchair in *Antiques* 63:5 (May 1953): 395; a set of five side chairs sold by Skinner, Inc., sale 1000, Oct. 27, 1984, lot 132; a side chair sold at Sotheby's, sale 6132, Jan. 30–Feb. 2, 1991, lot 1439; a side chair sold at Christie's, sale 7368, Oct. 19, 1991, lot 196; a side chair in *Sack Collection,* 4:941; privately owned side chairs that belonged to Portsmouth merchants Enoch Greenleafe Parrott (1780–1828) and Elisha Hill 3rd (1777–1853), respectively; and a side chair with original underupholstery and two sets of three side chairs, all owned by SPNEA (1942.1216, 1942.1210–12, 1942.1213–15). Chairs resembling 88b are remarkably consistent in appearance and may well have originated in a single shop. All have plain backs and seats upholstered over the rails. The group is comprised of: the three branded chairs cited in note 4; a pair pictured in a 1931 photograph of the parlor of the Sarah Orne Jewett House, SPNEA Archives; a pair once in the Wentworth-Gardner House (Howells 1937, fig. 91); a set of eight advertised by Israel Sack in *Antiques* 43:5 (May 1943): 203; a side chair with its original horsehair upholstery in *Antiques* 104:4 (Oct. 1973): 539; a set of six side chairs from the Hirshhorn collection sold at Sotheby's, sale 4851Y, Jan. 30, 1982, lot 1113; two side chairs sold at Christie's, sale 8006, June 2, 1990, lot 216, and sale 7367, Oct. 19, 1991, lot 130, respectively; and a privately owned side chair and matching armchair that resided in the Warner House until 1930. A final chair at the Tate House, a house museum in Portland, Me., conforms to the group in its splat design but has a replaced crest.

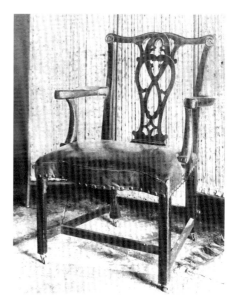

88c.

"Sherburne Chair." Portsmouth, New Hampshire, 1765–75. Photographed by Studio of H. R. Rolfe, Philadelphia, ca. 1895. Portsmouth Athenaeum, Portsmouth, New Hampshire. This chair, which may have belonged to Daniel Sherburne (1743–78) of Portsmouth, descended to his sister, Dorothy Sherburne, who married John Wendell in 1778, and subsequently to their son Isaac, who moved to Pennsylvania in 1830.

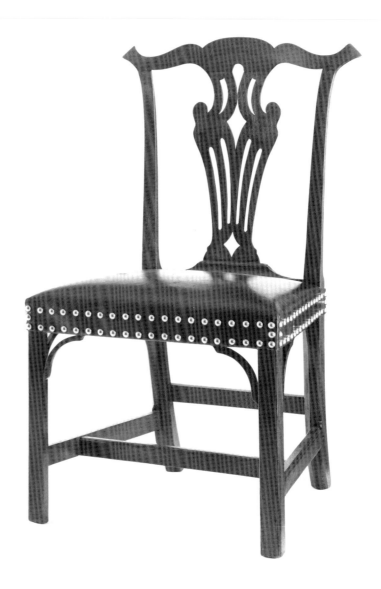

89
SIDE CHAIR

Portsmouth, New Hampshire
1765–90
Society for the Preservation of New England
Antiquities, Boston, Massachusetts, museum
purchase with funds provided by Lane W. and
Nancy D. Goss, 1987.20

A BOLD FEATURE—very pronounced ears—distinguishes this chair from those that precede it. Projecting ears flank the crests of many New England chairs, urban and rural, including some that are adaptations of this design (89A). In the context of the other chairs in this catalogue, an observer might wonder if this, too, can be from Portsmouth. It can, and it is.

Though the chair is most unusual (in its splat design, brass nailing pattern, and perhaps unique construction), it shares certain traits with other Portsmouth products. The straight legs, rounded back of the crest and stiles, and over-the-rail upholstery are familiar Portsmouth features. Provenance also links the chair to the town. It is one of a set of at least seven owned by the local merchant Jacob Wendell in the early nineteenth century. Six remained in Wendell's Portsmouth home until 1980 (*see Provenance*). A matching set belonged to Colonel John Wentworth (1745–87), a prominent Dover, New Hampshire lawyer (not to be confused with the governor and judge of the same name).[1] Rush-seated versions also have Piscataqua histories. A Portsmouth collector acquired a pair at the turn of this century (89A); another pair, now at Strawbery Banke Museum, came from a family with eastern New Hampshire ties.[2]

All of the chairs—upholstered and rushed—originated in a single shop. The maker devised a distinctive formula with elements borrowed from various sources. The brackets at the front corners of the seat and the beaded edge along the top of the stretchers resemble similar details on Boston chairs.[3] The lamb's-tongue cham-

fers on the rear legs are a finishing touch reminiscent of the treatment on two baroque chairs with New Castle, New Hampshire, histories (*cat. no. 79 and 79A*). The splat combines characteristic motifs—a baluster outline, vertical piercings, and diamonds—in an uncharacteristic manner. The result, termed a "harp back" by the Wendell family in 1891, is one maker's unique contribution to Piscataqua design.[4]

The craftsman's upholstery methods are equally distinctive. Typically, the back edge of the show cover is nailed to the rear seat rail, then the shoe is fastened to the rail. Here, the shoe sits ½" above the rail and is tenoned into the stiles. The show cover, in this case leather, has been pulled through the slot between the shoe and the rail and nailed to the back edge of the rail (89B). The leather continues around the rear corners of the legs—a practice similar to that used on Boston leather chairs of a half century earlier.[5] The peculiar techniques suggest the hand of someone more accustomed to making rush-seated chairs. In this instance, the shoe serves the same purpose as a stay rail on a banister-back chair. A double row of widely spaced brass nails completes the upholstery process.

The chair was given a spring seat in the early twentieth century, but ample evidence was available to guide SPNEA conservators in recreating its initial appearance. Photographs of 1887 and 1901 depict the entire set of Wendell chairs with leather covers and brass nails conforming to the original pattern.[6] The matching Colonel Wentworth chairs retain their original underupholstery and fragments of original leather as well. The contour of their seats displays the same crisp outline seen on other Portsmouth rococo chairs with original upholstery; yet the foundation for the seats varies from usual practice. Chairs by Robert Harrold have narrow seat rails and pronounced peaks at the top of the front legs; a linen roll stuffed with marsh grass originally formed a firm front edge for the upholstery.[7] On this example, the height of the seat rails exceeds that of most chairs, the top of the front legs never projected above the seat rails, and the front edge of the seat never had a roll of marsh grass. Harrold probably called upon Joseph Bass to upholster his chairs, but the idiosyncratic maker of the Wendell and Colonel Wentworth chairs most likely performed this task himself.

The work of another Portsmouth maker (89C) provides an intriguing parallel to the Wendell chairs. A set that descended in the Goodwin family of Portsmouth features a similar pattern of fretwork brackets, chamfered rear legs with lamb's-tongue stops, and a standard English splat pattern popular throughout New England.[8] The splat outline and central diamond suggest a possible source for the distinctive back of the Wendell chair. Though more typical in its appearance, the Goodwin set has its share of odd traits. The brackets are fastened with sliding dovetails to the legs and seat rails. The rear seat rail and shoe are a single element, a common English technique rarely used in the colonies. The top edge of the stretchers is flat rather than rounded, and the medial stretcher is tenoned through the side stretchers—a surprising feature that readily distinguishes the set from others.

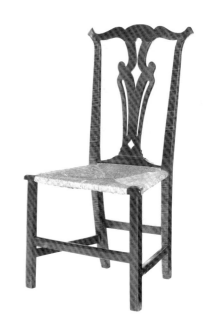

89A.

Side chair. Portsmouth, New Hampshire, 1765–90. Maple, H. 38¹³⁄₁₆; W. 19⅞; SD. 14⅞; SH. 17⅛. The Warner House Association, Portsmouth, New Hampshire, lent by the late John H. Rice, 1979.4.

89B.

The rear seat rail and splat shoe of cat. no. 89. In the original upholstery, iron tacks fastened the leather to the back edge of the rear seat rail.

The Goodwin and Wendell chairs illustrate distinctive patterns of seating furniture. Unlike the artisan responsible for cat. no. 88, they chose not to copy Robert Harrold's work but instead may have looked to eastern Massachusetts furniture for inspiration. Judging from what has survived of their products, they did not produce many chairs. They may have been joiners rather than cabinetmakers. Their work is neat and competent in its joinery, and in such a detail as the lamb's-tongue stops for the chamfers, a common architectural ornament. One suspects that they were equally adept at finishing household interiors and building furniture. In making chairs, they adapted from Portsmouth cabinetmakers the features their clientele wanted: over-the-rail upholstery and straight legs and stretchers. Today their striking chairs document their skill and broaden our understanding of the range of furniture making traditions within eighteenth-century Portsmouth.
M K

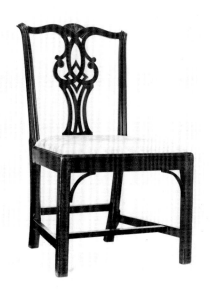

89C.

*Side chair. Portsmouth, New Hampshire, 1765–90. *Mahogany, *soft maple, and *eastern white pine; H. 36¼; W. 21⅝; SD. 17½; SH. 16¼. Strawbery Banke Museum, Portsmouth, New Hampshire, gift of Eleanor R. Snelling, 1974.42.*

Structure and Condition: Standard rectangular mortise-and-tenon joints fasten all major structural elements. A single pin reinforces each joint for the crest, seat rails, and stretchers. Sliding dovetails secure the medial stretcher to the side stretchers. Fretwork brackets are glued and nailed at the front corners of the chair frame but were never present at the rear. Only the side bracket for the right front leg is original. It is made of walnut, the others are mahogany. The seat frame originally had no corner blocks or braces.

When acquired by SPNEA in 1987, the chair had an early twentieth-century spring seat, modern triangular corner blocks, and a glossy refinished surface marred with water spots. In 1990, SPNEA conservators removed the spring seat and discovered evidence of three prior coverings and the original brass nailing pattern. The conservators upholstered the seat with lay-

ers of ethafoam, polyester batting, and brown leather, following the nail-less method used for cat. no. 84. The contours of the upholstery were based on the related Wentworth family chair with original underupholstery, which the New Hampshire Historical Society kindly lent to SPNEA during the conservation process. The conservators wiped the finish with denatured alcohol to remove the water spots, then added layers of super blond shellac and paste wax to complete the treatment.

Inscriptions: "[]e Q[] Wendell / []68 Pleasant Street" in pencil on the inside of the right seat rail. Partially obscured by a modern corner block, the name probably refers to Caroline Quincy Wendell.

Materials: *Black walnut legs, crest rail, splat, shoe, rear seat rail, left side knee bracket, and stretchers; *soft maple front and side seat rails; mahogany replaced knee brackets; ash modern corner blocks. Modern brown leather on seat.

Dimensions: H. 39³⁄₁₆; W. 22⁷⁄₈; SD. 17¼; SH. 17⁵⁄₁₆

Provenance: Possibly owned by John Wendell (1731–1808) and left to his second wife Dorothy Sherburne Wendell (1752–1837); descended to their son Jacob Wendell (1788–1865); to his daughter Caroline Quincy Wendell (1820–90), who kept the chair as part of a set of "7 English walnut chairs, harp back, in black leather" in the south parlor of the Wendell family home on Pleasant Street, Portsmouth; to Caroline's brother, Jacob Wendell II (1826–98); to his son Barrett Wendell (1855–1921). After 1921, this chair was separated from its six mates and eventually sold at auction to SPNEA in 1987. The rest of the set remained in the Wendell House until 1980, when they were sold to a private collector.

Publications: Decorative Arts 1964, no. 34 (matching chair from same set); Christie's, Jan. 24, 1987, lot 202.

1. A pair from the Wentworth set are owned by the New Hampshire Historical Society

(1977.34.9.1–2). An identical set without a provenance is pictured in *Antiques* 72:3 (Sept. 1957): 251. For a slip-seated version, see *Antiques* 52:1 (July 1947): 2.

2. The pair at Strawbery Banke Museum (1987.903.1–2) was given by Harland Newton, a Boston lawyer, who either purchased the chairs in the Portsmouth area or inherited them from his wife, a Lord family descendant of Kingston, N.H. Another rush-seated example was sold at Sotheby Parke Bernet, Feb. 1–4, 1978, sale 4076, lot 1019.

3. For Boston chairs with these features, see Jobe and Kaye 1984, nos. 113, 123.

4. Caroline Quincy Wendell, 1891 inventory, new series, docket 6696, Rockingham County (N.H.) Probate.

5. A pair of Boston leather chair with original upholstery is pictured in Jobe 1974, 40.

6. The 1887 photograph is one of four views of the interior of the Jacob Wendell House still preserved in the house; a duplicate print is in the library of Strawbery Banke Museum. The 1902 photographs are part of the album, "An Old Homestead in New England 1902," also in the Strawbery Banke Museum library. Two views of the chairs from the album are published in Gurney 1902, 84.

7. A Portsmouth chair owned by SPNEA (1942.1236) retains the original rolled edge on the front seat rail and the raised corners of the front legs; see Jobe and Kaye 1984, 430, fig. 133b.

8. An unusual cabriole-legged armchair with the same splat and carving on the crest is attributed to Salem, Mass., in ibid., no. 116. It may actually be a Portsmouth chair by the maker of 89c or possibly a Salem source for that maker.

90

SIDE CHAIR

Portsmouth or Wolfeborough, New Hampshire
1769–70
Society for the Preservation of New England
Antiquities, Boston, Massachusetts, gift of the
Congoleum Corporation, Portsmouth, New
Hampshire, 1985.695

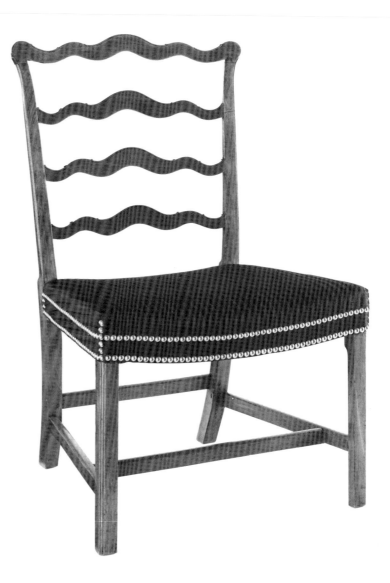

WHEN FRANCES WENTWORTH, Governor John Wentworth's wife, wrote in October 1770, "I live in the woods," she was living in Wolfeborough, in one of the largest and grandest estates in eighteenth-century America.[1] The governor intended to live in his country seat from May to November, "except any Provincial Business shou'd call me a few days to Town."[2] Town— Portsmouth—evidently had little appeal for him at the time.

The governor was interested in "Courts and European Magnificence," in contrast to Michael Wentworth, a newly arrived distant English relative, who, the governor wrote, was more American, talking "of Agriculture, American Cultivation…& increasing Cattle."[3] The governor was not establishing a farm; he was building "a Lilliputian W'tw'rth House here—My Domestics mostly Yorkish:—& some from W.—But to resemble the Original Essentially."[4]

The "Original" was Wentworth House, Yorkshire, England, home of another distant relative but close friend, Charles Watson-Wentworth, the marquess of Rockingham.[5] The governor relished his time spent at the marquess's estate during his stay in England from 1763 to 1767. His copy was none too "Lilliputian": the mansion house was over one hundred by forty feet, and its estate encompassed thousands of acres, numerous large outbuildings, and an enclosed six-hundred-acre deer park.[6]

The governor returned to America with a large retinue of English domestic help and horses.[7] His quote suggests that he may have obtained a few of his York-

shire servants from the marquess. His retinue may even have included craftsmen; the estate buildings included a shop for a blacksmith, a joiner, and cabinetmakers, all under one roof.[8]

The construction and finishing of his "Lilliputian" house personally occupied the governor. Frances Wentworth's letter from "in the woods" continued: "I wish you were here to take a game of billiards [the mansion had a billiard room] with me as I am all alone,—The Governor is so busy in directions to workmen that I am most turn'd Hermit."[9]

She noted that "the Great Dining Room is nearly compleated," but said no more. Inventories made after the estate was confiscated, following the Wentworths' flight from New Hampshire in 1775, show that the dining room had a sofa and eight maple chairs (two were armchairs) with "Hair Bottoms" [horsehair upholstery].[10] The library sofa and six chairs were also of maple but had leather seats. Leather was less expensive than horsehair, a recent and especially fashionable English import.[11]

This is a maple chair; its seat rails retain evidence of original horsehair upholstery. It is said to be from Wentworth House, and, judging from its upholstery, it is from the dining room set. Two of the chairs survive. An inscription on this one annotates its original ownership in Wentworth House, Wolfeborough (as it was spelled at that time); the other chair, which is now owned by the Wolfeboro Historical Society, is labeled "From Wentworth Mansion…" The objects themselves tend to affirm their distinguished reputation. They are unusually fine for maple chairs, having neatly carved beads on the crest and slats, the finishing touch of two rows of brass nails, and a most luxurious feature—saddle seats.

The particular pattern of these undulating slats was popular in Portsmouth and took two forms: pierced (90A) or solid like this example. Most related chairs have the piercings. The ears may be rounded, as these are, or somewhat more elongated. Simpler versions were made with either pierced or solid slats, two or three slats beneath the crest, rush or splint seats, and front stretchers instead of medial stretchers.[12]

Among the many English versions of the design is a mahogany chair (90B) with pierced slats and with arms that were added long ago in Portsmouth. This example may actually be the prototype for all similar Portsmouth chairs.[13] With its American arms, it could easily pass as Portsmouth made. The turn about is fair play; Portsmouth chairs were for years mistaken for English ones. Several craftsmen worked in a very English manner, and the designs they made so closely followed the current London style that, without microscopic analysis of the wood, it may be impossible to distinguish them.

The governor's maple chair looks English but is as American as its wood. It has all the hallmarks of a Portsmouth product, yet it may have been made on site in the estate's joinery and cabinetmaking shop. The cabinetmaker probably was from Portsmouth but possibly was from Yorkshire.

If one cannot tell whether the governor's side chair was made by a Yorkshireman or a Portsmouth man, that is how the governor wanted it. He intended Wolfeborough to be another Yorkshire. And if one cannot easily differentiate Portsmouth from London furniture, it is because, following the lead of the Wentworths, that was what the merchants of Portsmouth intended. As the Wolfeborough estate was to be "a Lilliputian W'tw'rth House," so Portsmouth was to be a "Lilliputian" London.

M K

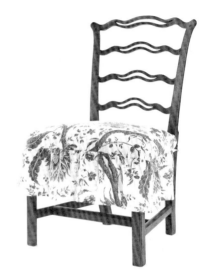

90A.

Side chair. Portsmouth, New Hampshire, 1770–1800. Cherry, H. 38 1/16; W. 21 13/16; SD. 17; SH. 17 1/2. Society for the Preservation of New England Antiquities, Boston, Massachusetts, gift of Virginia L. Hodge and Katherine D. Parry, 1942.1236. The chair, now covered in a reproduction copperplate-printed slipcover, belonged to Tobias Lear (1762–1816), a Portsmouth merchant who served as George Washington's personal secretary from 1786 until Washington's death in 1799.

Structure and Condition: Standard rectangular mortise-and-tenon joints fasten all elements with one exception: sliding dovetails secure the medial stretcher to the side stretchers. A single pin reinforces each joint for the seat rails and side and rear stretchers. A scratch bead ornaments the outer edge of the stiles; along the top edge of the slats and crest rail, the bead separates into three segments, each with curled tips. The back of the stiles is rounded; the crest tapers at the back to a narrow flat surface. The front legs project above the seat rails, forming peaks to accommodate a roll of marsh grass that originally provided a firm front edge for the upholstery (*see cat. no.* 86). Original braces are set into slots in the front corners of the seat. The top edge of the stretchers is slightly rounded, much like that of cat. no. 88.

Though the chair is largely intact, it has had several repairs. During the early twentieth century, it was disassembled, stripped of an earlier finish (perhaps a grained surface much like that on a matching chair at the Wolfeboro Historical Society), reassembled using white glue and new pins at the joints, finished with a clear varnish, and reupholstered. In 1982, Aleck Troen, a Boston upholsterer, covered the seat in a blue silk moiré. In 1990, SPNEA conservators removed the upholstery and installed layers of ethafoam, polyester batting, and a striped horsehair, following the nail-less method adopted for cat. no. 84. The double row of brass nails conforms to the original pattern.

Inscriptions: "Chair From the mansion of the last Colonial Governor of N.H., the first summer home / in America, 'Wentworth House,' residence of His Excellency Gov. John Wentworth / built 1768 overlooking Smiths Pond now Lake Wentworth. Bought from Mrs. Sadie Hutchins dealer / Wolfeboro, N.H." in modern pencil on inside of rear seat rail. "This / chair / restored / by / Aleck / Troen / 3/22/82 / Boston / Mass." inscribed in pencil in 1982 on the left side seat rail.

Materials: *Soft maple for all work. Reproduction striped black horsehair on seat.

Dimensions: H. 37¼; W. 23; SD. 18⅞; SH. 16¼

Provenance: Governor John Wentworth (1737–1820); acquired in the twentieth century by the Wolfeboro antiques dealer Sadie Hutchins; sold by Ronald Bourgeault in 1982 to the Congoleum Corporation and given to SPNEA in 1985.

1. Quoted in Garvin 1989, 30.

2. Quoted in ibid., 28.

3. John Wentworth, letterbook, 1767–78, 1:78, transcription at the New Hampshire State Archives, from the original in the Public Records Archives, Halifax, Nova Scotia.

4. Ibid.

5. *Sibley's Harvard Graduates,* 13:651.

6. John Wentworth, 1785 claim, 5:1980, transcription at the New Hampshire State Library, from "Records of the Commission for Enquiring into the Losses and Services of American Loyalists 1783–90," Public Record Office, London (herewith "Loyalist Claims").

7. *Sibley's Harvard Graduates,* 13:652.

8. John Wentworth, 1785 claim, 5:1980, "Loyalist Claims."

9. Quoted in Garvin 1989, 30.

10. Starbuck 1989, 117.

11. The earliest reference to horsehair in Portsmouth appears in the 1771 advertisement of Joseph Bass, who offered for sale "Black figur'd Horse Hair for Chair Bottoms," *New Hampshire Gazette,* Dec. 27, 1771.

12. Several pierced-slat chairs have curled beads on the crest and slats similar to those on cat. no. 90. The group includes the following (all with over-the-rail upholstery unless noted otherwise): set of four side chairs and two armchairs with saddle seats from the Peirce Mansion of Portsmouth (Howells 1937, fig. 32), the same set apparently belonged to John Batdorf of Meadowbrook, Penn., in 1966 (*Antiques* 90:2 [Aug. 1966]: 226); set of three side chairs with saddle seats (American Art Association, sale 3825, Mar. 7, 1930, lot 184); pair of side chairs (*Antiques* 50:3 [Sept. 1946]: 164); armchair with a saddle seat and carved scrolls at the base of the arm supports (*Sack Collection,* 6:1444); and set of four slip-seated chairs at Strawbery Banke Museum (1974.244–47). Pierced-slat chairs without beaded decoration include: an armchair at the Worcester Art Museum (1933.3); two privately owned side chairs branded "D. AUSTIN," one of which retains its original leather upholstery (*Antiques* 88:5 [Nov. 1965]: 598); four side chairs with saddle seats (Parke-Bernet, sale 4379, Mar. 12, 1938, lot 73); three cherry side chairs at Strawbery Banke Museum (1979.296–298) from the same set as 90A; a slip-seated side chair at Strawbery Banke Museum (1974.248); and a pair of rush-seated side chairs that belonged to Samuel Lord of Portsmouth (Jobe and Kaye 1984, 430). Cat no. 90 and a matching chair from the same set at the Wolfeboro Historical Society are the only known versions of this popular form with solid slats and carved beading on the crest and slats. Dozens of uncarved versions survive, many with histories in the Newbury area of northeastern Massachusetts; see Jobe and Kaye 1984, nos. 134, 135. Possible eastern New Hampshire examples include: a widely dispersed set of side chairs that belonged to Josiah Bartlett of Kingston, one of which is now at the New Hampshire Historical Society (1977.10.2) (*Decorative Arts* 1973, no. 51); a pair of side chairs in the Thomas Bailey Aldrich House at Strawbery Banke Museum (1980.752.1–2); and a slip-seated side chair at Strawbery Banke Museum (1974.249).

13. Presumably, similar English examples served as a source for a Baltimore cabinetmaker, Warwick Price, who also constructed chairs of this design; see Weidman 1984, no. 9.

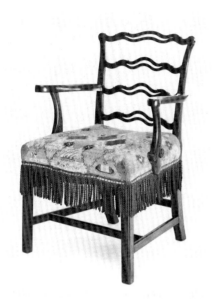

90B.

*Side chair with added arms. Probably London, 1760–70. *Mahogany, *spruce, and beech, H. 36⅞; W. 26¾; SD. 19⅞; SH. 17¾. North Church of Portsmouth, on loan to the Portsmouth Historical Society, LR 123. The chair originally had a saddle seat similar to that of cat. no. 90, but in about 1871 its seat was modified. The chair is branded with the maker's initials "ID" beneath a crown.*

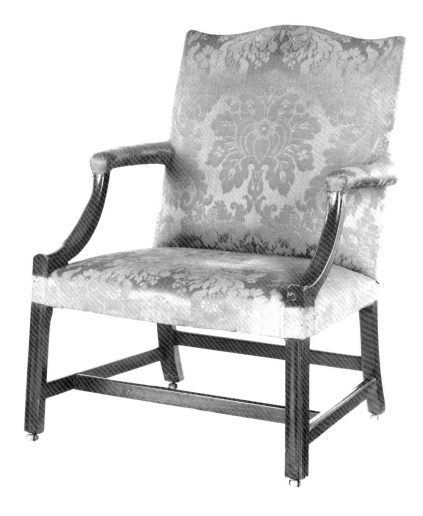

Attributed to Robert Harrold (w. 1765–92)
Portsmouth, New Hampshire
1765–75
Strawbery Banke Museum
Portsmouth, New Hampshire
Gift of Gerrit van der Woude, 1989.7.1

91

FRENCH CHAIR

TODAY WE ADMIRE CHIPPENDALE CHAIRS with carved wooden backs, but eighteenth-century tastemakers preferred chairs with upholstered seats and backs covered in expensive textiles. As Graham Hood has shown in his study of the residences of royal governors at the time of the Revolution, the most prestigious chairs were those with stuffed seats, backs, and open arms covered in silk damask.[1]

Even at the highest levels of English patronage, some informality reigned in the terminology for these chairs. Thomas Chippendale's accounts with his wealthiest clients refer to such chairs variously as "Elbow chairs wt. stuffd Backs & Seats," "Cabriole Armd Chairs," "French-elbow chairs," "French Backstools," or just "French chairs."[2] The term backstool had been in use since the seventeenth century, but cabriole chair and French chair were relatively new terms. According to Chippendale, the latter were typically "intended to be open below at the Back: which make them very light, without having a bad Effect." These particular designs emulated their Louis XV prototypes with some fidelity.[3] In Portsmouth, one account identified the form as a "French Easy Chair."[4] Calling it an easy chair was a slight bowdlerization, but the term did convey the idea that the seat and back were stuffed even though the arms were not entirely enclosed and padded. We can be certain of one term that was *not* used during the rococo era—lolling chair. Though often applied to the form today, it did not come into general use until after 1800.

While the best English frames of this type often had extravagant carving on the legs, seat rails, arm supports, and back frames, sometimes supplemented with

gilding, the average English example was fairly severe. The usual pattern had straight legs (called Marlborough legs at the time) that could be plain, beaded, or molded; rectangular stretchers of an H-shaped configuration; backward-sweeping arm supports mounted atop the front legs; a straight or curved arm with or without scrolled grips at the front; and a square back, framed separately from the rear legs. Several English chairs with these features descended in Portsmouth families and may have served as models for locally made examples such as cat. no. 91.[5]

This chair and its numerous relations (91A) are remarkably English not only in appearance but also in construction. The use of English techniques points to an English-trained craftsman. The leading candidate is Robert Harrold, an immigrant who arrived in Portsmouth in 1765 and quickly secured major commissions from the town's most influential citizens.[6] Like Harrold's side chairs, this upholstered chair has a broad seat with braces at each corner of the seat frame and a bowed front formed by a shaped strip affixed to the straight front rail (*see cat. nos.* 85, 86, 87). Blind tenons secure the medial stretcher to the side stretchers, a common Harrold technique. Furthermore, the distinctive ogee molding on the front legs matches that on a pair of side chairs attributed to Harrold (*cat. no.* 86). The molding is a common London pattern but rarely appears on American furniture.

The early history of this upholstered chair is unclear. During the nineteenth century, Jacob Wendell of Portsmouth probably acquired it and a matching chair at auction or through inheritance. A related object—a couch with scrolled ends (*cat. no.* 92)—also descended in the Wendell family. It features the same molding profile seen here as well as the same braces at the corners of the seat. Similar sets of armchairs and matching couches in England strongly suggest that these objects were made *en suite* and descended together from their first owner.

It is a testimony to the exalted level of mercantile wealth in Portsmouth that these costly upholstered armchairs attained a high degree of popularity.[7] In the most opulent houses, the chairs were used in sets. The Moffatt family built the huge Moffatt-Ladd House in 1763. Ostensibly, the house was a gift from John Moffatt (1694–1786) to his son Samuel Moffatt (1738–80), but Samuel went bankrupt in 1768 and fled to St. Eustatius in the Caribbean to avoid having his assets seized. Through adept legal maneuvers, his father retained title to the house and its contents. A partial inventory of the house made in 1768 listed "12 Mahogany French Easy Chairs." These are probably the same set listed as "12 large mahogany chairs cov'd with furniture check" in the father's 1786 inventory and the "Arm'd Chairs with backs & bottoms cover'd" listed in the 1788 inventory of William Whipple, the brother-in-law of Samuel Moffatt, who also lived in the house.[8] Governor John Wentworth had a set of expensive chairs in his house in Wolfeborough, described in a 1779 inventory as "8 Mahogany Chairs with arms all Mahogany with Damask & backs with Trucks & Cloth Covers."[9] The "Trucks" were casters like those seen on cat. no. 91 and the Wendell couch, while the cloth covers were slip covers. Finally, John Langdon owned a costly set of similar chairs, for which he ordered purple and white chintz or check fabric "Sufficient to Cover Twelve, Large Arm'd Chairs, Bottoms and Backs and one large Settee—the Chairs and Settee I have by me [in Portsmouth]."[10]

The pair of French chairs from the Wendell family remain in the best condition of the many surviving examples from the town. This chair retains all of its original upholstery foundation underneath a later layer of red wool damask, while the other has lost the seat stuffing. A noteworthy feature of these foundations is the apparent lack of tufts in the back to hold the grass and horsehair stuffing in place. Because the stuffing was not so secured, it has slumped down into the bottoms of the backs creating a defective bulge now known as a "bustle." There is no evidence

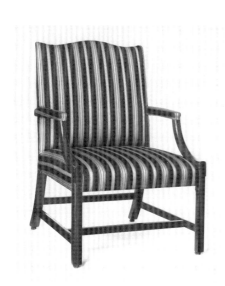

91A.

French chair. Portsmouth, New Hampshire, 1765–80. Mahogany, maple, and beech, H. 41⅛; W. 29⅜; SD. 23½; SH. 15¾. Private collection. This chair descended in the Haven family of Portsmouth.

of an original fixed cover on either the Wendell chairs or the couch. The entire suite of furniture may have been furnished initially with loose covers.[11]

R F T

Structure and Condition: Standard rectangular mortise-and-tenon joints fasten all major structural elements (including the medial stretcher). A single pin reinforces each joint for the seat rails and side and rear stretchers. The back is a single joined unit mounted to the rear legs in a customary manner. The stay rail is tenoned to the stiles, which in turn are tenoned to the crest rail. The stiles fit against the tapered ends of the rear legs and are secured with screws driven through the legs into the stiles (see 101B for the same technique on a neoclassical lolling chair). The front leg and arm support are joined at the midpoint of the seat rails. Upholstery now covers the joint, but originally the seam may have been visible, as shown on a related chair (91A). The arm is tenoned through the stiles. Braces slip into notches in the seat rails at the corners of the seat. The chair retains all of its original elements except its outer covering. Modern webbing now reinforces the original underupholstery on the seat. In 1991, Strawbery Banke Museum placed a slipcover over the damask upholstery shown here. A small triangular block has been added at each front corner of the seat. The right arm support has been broken and poorly repaired at the joint with the arm. An angle iron strengthens the joint between the right arm and stile.

Inscriptions: "PROPERTY OF / W. G. WENDELL" stamped onto a brass plaque on the rear seat rail.

Materials: *Mahogany arm supports, legs, and stretchers; *birch for all secondary work. Original casters; early twentieth-century red damask on seat, back, and arms.

Dimensions: H. 40½; W. 29⅝; SD. 25¼; SH. 14¾

Provenance: Acquired by Jacob Wendell (1788–1865) in the nineteenth century; its subsequent descent follows that of cat. no. 5. It remained part of the estate of Francis A. Wendell (1915–79) until Gerrit van der Woude gave it to Strawbery Banke Museum in 1989.

Publications: Ward 1989b, 124; Ward and Cullity 1992, pl. 5.

1. Hood 1991, 287–313. See also Hutchinson 1884–86, 1:559ff; and Heckscher and Bowman 1992, 211–13.

2. Gilbert 1978, 1:137, 142, 159, 160, 182, 184, 206, 209, 224, 255, and 279.

3. Chippendale 1762, 4 and pls. 19–23.

4. Moffatt v. Moffatt, Mar. 2, 1768, docket 25135, N.H. Provincial Court, State Archives.

5. An English upholstered chair virtually identical to 91A was acquired in the Portsmouth area by collectors in the early twentieth century and given to SPNEA (1942.1202). A pair of English chairs at the Old York Historical Society (1988.7–8) descended in the Peirce family of Portsmouth.

6. For information on Harrold's career, see cat. nos. 27, 48, 85, 86, and 87.

7. Portsmouth chairs related to the Wendell pair include: a single, plain example that also descended in the Wendell family and is now in a private collection; an unusual example with pointed "Chinese" ears and fluted straight legs at the Governor John Langdon House (SPNEA, 1966.309); and a chair with a straight crest rail at the Moffatt-Ladd House (1978.230).

8. Giffen (Nylander) 1970a and b, 113–22, 201–7; Rhoades 1972, 129–43.

9. Starbuck 1989, 118.

10. John Langdon, undated addendum to letter, ca. 1785, Langdon Papers, Strawbery Banke Museum.

11. Walton 1973, no. 56, illustrates an English conversation piece that depicts a French chair with a loose-fitting check slipcover. Many of the chairs cited in note 2 were provided with slipcovers by Chippendale's firm.

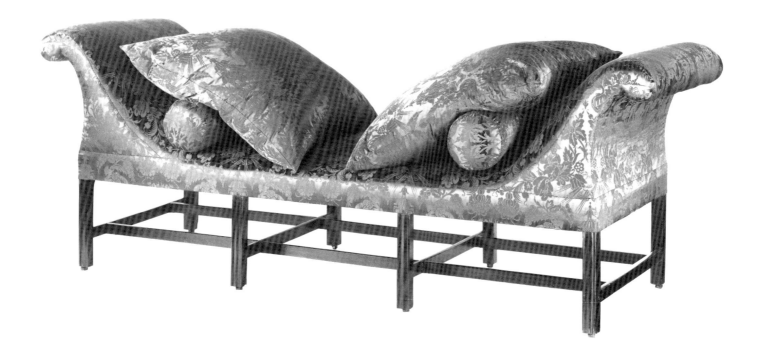

🌿 92

COUCH

Attributed to Robert Harrold (w. 1765–92)
Portsmouth, New Hampshire
1765–90
The Henry Francis du Pont Winterthur
Museum, Winterthur, Delaware, 1992.103

THIS IS THE ONLY SURVIVING PORTSMOUTH sofa or couch made before 1790. As luck would have it, the object is the only known American Chippendale version of a couch with scrolled ends. Moreover, it retains its original upholstery foundation.

Unfortunately, the exact provenance of this elegant seating form is unclear. Like the preceding armchair (*cat. no.* 91), the couch belonged to Jacob Wendell of Portsmouth in the nineteenth century. No evidence links it with Wendell's father, John (1731–1808); presumably it was made for some other well-to-do Portsmouth resident and was acquired secondhand by Jacob Wendell, either through purchase at auction or inheritance. The couch is visible in photographs of the south front chamber of the Jacob Wendell house taken between 1887 and 1913, when the house was owned successively by Jacob Wendell's daughter, Caroline Quincy Wendell (1820–90), his son, Jacob Wendell (1826–98), and his grandson, Barrett Wendell (1855–1921). The couch remained in the Wendell family until 1989, when it was sold at Sotheby's in New York.[1]

Little question exists that this is a Portsmouth product. The secondary woods—birch and white pine—support a New Hampshire origin, as does the existence of a group of related Portsmouth upholstered armchairs with nearly identical framing, proportions, and casters. Three of these chairs descended in the Wendell family along with the couch, and two of these have the identical ogee molded profile on the front legs. All these expensive upholstered objects were made in the same shop, probably that of Robert Harrold (*see cat. no.* 91).

That this couch is a Portsmouth product brings one no closer to understanding its original name or function. In seventeenth- and eighteenth-century parlance, most long upholstered seats without backs were known as daybeds or couches, whether they had one head or two. The ultimate ancestors of the couch were the dining couches of classical antiquity, but all European couches, sofas, ottomans, and other luxurious seating forms of the eighteenth century retained an association with the Near East, particularly Turkey, as the names themselves suggest. In the European imagination, low seats strewn with pillows were thought to constitute the principal furnishings of the sultan's public rooms and also, inevitably, of harems. While one-ended cane couches had achieved a measure of popularity from 1680 to 1720, the form never came into widespread use. The inference is quite strong that daytime lounging on a daybed or couch retained in some circles an association with aristocratic women and courtesans. The closest design parallels that can be found for the Wendell couch are those made for niches in Parisian town houses of the 1760s and 1770s.[2]

So rare were such couches in America that a Portsmouth inventory appraiser of the 1820s referred to one as a "Mahogany Sofa without back," a manifest absurdity, since a sofa by definition must have a back. His failure to correctly identify a couch as such is difficult to imagine, given the fact that overtly neoclassical "Grecian" couches were readily available from Portsmouth cabinetmakers during the 1820s. The appraiser began to write some other term and then wrote "Sofa" over it, so evidently he was confused.[3] The 1891 inventory of Caroline Quincy Wendell, taken by her nephew James Rindge Stanwood (d. 1910), is hardly more illuminating; it refers to the couch as a "large size yew-tree Lounge in flowered chintz."[4]

Given the rarity of major eighteenth-century seating with original upholstery foundations, the stuffing of the Wendell couch calls for some analysis. The webbing strips are tacked to the rails—from side to side and front to back—in the traditional manner. The sackcloth laid on top of the webbing begins at the level of the seat rails and goes up and around the scrolls, and it displays an unusual technique. In most cases, the edge rolls that soften the side seat rails and the great scrolls would be fashioned of separate pieces of linen. Here they are made of the same piece of linen as the sackcloth.[5] This was probably thought to be an economical and clever solution, but it was inherently dangerous, because if the sackcloth were ever to tear (as it did), the grass contained within the edge rolls would be set free.

On top of the webbing and combined sacking and edge rolls was laid a thick layer of grass. The grass was placed lengthwise in the seat and crosswise on the scrolls. The grass was then softened by a heavy skimmer of curled horsehair that appears to have been adulterated with cow or pig hair. All the stuffing was contained by a top layer of linen tacked to the sides of the seat rails and the scrolls. The long sides were covered by linen panels and borders, and the ends under the scrolls were lined with linen panels, as well. All of the top linen was replaced with jute burlap in

1887, when the couch was repaired and re-covered by John A. Stickney, a local artisan who worked on many of the Wendell family objects.

How the Wendell couch was covered originally is not a moot point, given the fact that it was almost certainly *en suite* with a set of upholstered chairs. In aristocratic English circles and some elevated American households like those of royal governors, suites of backstools and sofas were given fixed covers of silk damask or wool moreen and slipcovers of linen checks or cotton chintz. However, an equally prevalent approach was to use loose covers only, so that the covers could be changed with the seasons or laundered. This was almost certainly the case here. In addition to a slipcover, the couch probably had round bolsters and large pillows much like those on English and French examples. The cushions made it easy to adjust the curve above the great scrolls for lounging.

R F T

Structure and Condition: This unusual form is constructed much like a sofa. Standard rectangular mortise-and-tenon joints fasten all major structural elements, and most of the joints are reinforced with pins. The seat rails are tenoned into the four outer legs; the inner legs are tenoned into the seat rails (but, unlike the other joints within the frame, are not pinned). The side and medial stretchers extending from front to back are tenoned into the legs. Three pairs of longitudinal stretchers are tenoned to the side and medial stretchers. Large scrolls are tenoned into the front and rear seat rails. Pine rolls are set between the scrolls and fastened with nails driven through the scrolls into the end of the rolls. Braces are inserted into slots in the corners of the seat. Two sway-backed medial braces are set into slots in the front and rear seat rails. When sold at auction in 1989, the couch was covered in yellow damask over chintz. Much of the underupholstery was intact; however, the frame was loose, and several stretchers were broken and reinforced with metal straps. In 1990, Robert Trent and Mark Anderson repaired the frame; Terry Anderson and Trent conserved the original upholstery, recovered the couch, and made pillows and bolsters for the wings.

Inscriptions: "Reupholstered & repaired by John A. Stickney June 1 1887" in pencil on the inner surface of one of the scrolled supports.

Materials: Mahogany legs and stretchers; birch seat rails, braces, and scrolled supports for wings; eastern white pine rolls for wings. Original casters; reproduction green silk damask on seat and wings.

Dimensions: H. 32⅜; W. 90¼; SD. 30⅛; SH. 15¾

Provenance: Acquired by Jacob Wendell (1788–1865) in the nineteenth century; its subsequent descent follows that of cat. no. 5 until sold at auction to Richard and Gloria Manney in 1989; sold to Winterthur Museum in 1992.

Publications: Lockwood 1913, 2:150; Sotheby's, sale 5810, Jan. 26–28, 1989, lot 1445; Trent 1991, 34d–37d.

1. Photographs of the couch in the Wendell house are in the collection of Ronald Bourgeault and the Portsmouth Athenaeum. The couch is illustrated in Lockwood 1913, 2:150, when it belonged to Barrett Wendell.

2. Trent 1991, 34d–37d; *Brongniart* 1986, 44, 86–87; *Durand* 1984, 315; Duboy 1986, 27.

3. Sarah Langdon, 1828 inventory, old series, docket 11548, Rockingham County (N.H.) Probate.

4. Caroline Quincy Wendell, 1891 inventory, new series, docket 6696, Rockingham County (N.H.) Probate.

5. A similar technique appears on a Portsmouth rococo side chair with original underupholstery; see Jobe and Kaye 1984, no. 133.

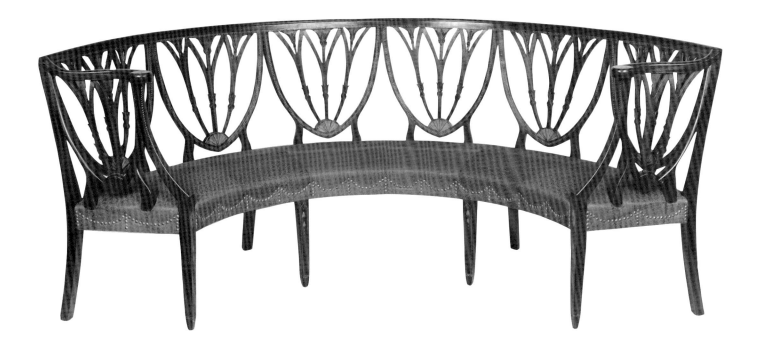

THIS UNIQUE SETTEE has a well-documented past. It was made to fit the plan of a circular staircase (93A) in a three-story mansion built in 1799 by John Peirce, a Portsmouth merchant whose estate was valued in 1814 at some $103,000. The Peirce house (*fig.* 18) has always interested architectural historians because of its strong visual relationship to Massachusetts houses designed by Charles Bulfinch and Samuel McIntire. However, the house has a history of having been constructed by the Portsmouth builder John Miller (1773–1813), and the Peirce settee is also a local product. Indeed, its design is unprecedented in Massachusetts seating furniture and may represent an original concept. It seems to be a fusion of a chair-back settee like the "Bar back Sofa" illustrated as plate 26 in George Hepplewhite's *Cabinet-Maker and Upholsterer's Guide* and a small upholstered seating form intended for a window embrasure or wall niche. The settee gains further interest because the curved staircase which enclosed it was the earliest in the Portsmouth region.[1]

Peirce had allied himself by marriage to the Wentworth family and received mercantile training in the counting house of Daniel Rindge. He held several major political offices and became a prominent land owner and insurance broker. He was one of a number of Portsmouth merchants who built large new houses outside the town center between 1790 and 1810.[2] Peirce's probate inventory indicates that his house was severely yet expensively furnished with neoclassical furniture. The settee in the "Front Entry" was identified as "1 mahogany hair bottom sofa" and was valued at $10. It may have been upholstered *en suite* with the mahogany furniture in

 93

SETTEE

Portsmouth, New Hampshire
1800–1810
The Henry Francis du Pont Winterthur
Museum, Winterthur, Delaware
Gift of Henry Francis du Pont, 57.1015

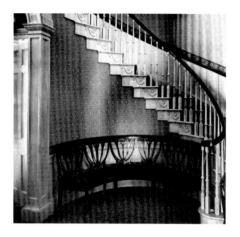

93A.

The settee in situ in the Peirce house, photographed by Newton W. Elwell for his book, Colonial Furniture and Interiors *(1896). Archives, Society for the Preservation of New England Antiquities, Boston, Massachusetts.*

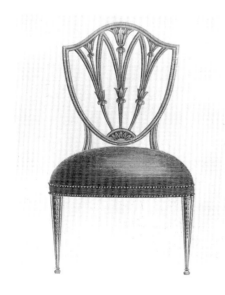

93B.

Design for a chair, plate 5 in George Hepplewhite's The Cabinet-Maker and Upholsterer's Guide *(third edition, 1794). Courtesy, Printed Book and Periodical Collection, The Winterthur Library, Winterthur Museum, Winterthur, Delaware.*

the northwest room or parlor, in haircloth (probably black). The other furnishings of the entry included four yellow armchairs, a carpet, and a glass lantern.[3]

The maker of the settee evidently struggled with the layout and execution of this unusual commission. The "Bar back Sofa" in Hepplewhite's *Guide,* which has four complete chair backs plus two half-backs for the arms, has a flat back combined with an undulating crest rail and "elbows" or arms. According to Hepplewhite's comments, the settee was to be used with a set of matching chairs in a parlor. In designing the Peirce example, the maker abandoned the undulating crest rail, because modeling it to conform to a circle would have posed insuperable problems. Urn-back chairs with flat crest rails are known from New York but represented a novelty in New England.[4] Further modifications of the Hepplewhite form were the substitution of the chair-back pattern in plate 5 of the *Guide* (93B) for the five-splat design seen in the settee; the inclusion of a full, two-ribbed back under each arm; and the use of an inlaid, flat scroll arm instead of the twisted and ramped elbow with forward-facing rosette seen in the design plate.

Even with these simplifications and modifications, the settee was difficult to frame. The front and rear seat rails are triple-ply and conform to an absolute circle rather than a section of an ellipse. The crest rail is made of five or six curved lengths of mahogany and is veneered on the front and back and capped by a two-sided torus molding; presumably these were intended to hide the joints between sections of the crest. It is noteworthy that the plan of the crest rail is of a greater diameter than that of the rear seat rail, so that the settee retains some degree of layback for comfort. Tremendous difficulties seem to have been encountered in plotting and framing the outer rails and vertical splats or banisters of each successive chair back. In order to force each back unit to conform to the curve, the outer rails were mitered at their bottoms, while the three banisters were each made separately and mitered where they abut each other under the crest (93C). Considerable sloppiness in the crest mortises for all these elements indicates that they may have been located pragmatically rather than laid out mathematically—clearly some fudging of the joints took place.

The lack of total confidence betrayed by the framing of the Pierce settee is masked by profuse stringing, inlay, and carving. In fact, the settee functions as an index artifact for several forms of decoration seen in other Portsmouth furniture. These include the birch pendant husks and patera on the outer front legs (93D), the birch-and-ebony chevron stringing outlining the arm supports, the birch-and-mahogany herringbone stringing outlining the chair backs, and the shaded birch fans or rondels inlaid on the bottoms of the chair backs and on the volutes of the arms. *R F T*

Structure and Condition: Standard rectangular mortise-and-tenon joints fasten all major structural elements. Unlike the preceding couch (*cat. no.* 92) and the majority of Portsmouth rococo seating furniture, the joints are not reinforced with pins. The curved front and rear seat rails are laminated; the side seat rails are solid. Each outer front leg and arm support is made of one piece of mahogany. The seat rails are tenoned to the outer legs; the inner legs are tenoned to the underside of the seat rails. A single screw secures the joint of the arm, crest, and outer stile. Three sway-backed medial braces are secured with sliding dovetails to the top edge of the front and rear seat rails. A triangular block is nailed with four original cut nails at each corner of the seat frame. The inner legs have had numerous repairs at the juncture with the seat rails. Angle irons once reinforced the rear inner legs and rear seat rail. The stringing on the back and arms has had many minor losses. The tapered tips of the legs below the inlaid cuffs may be replaced. The original upholstery foundation, horsehair cover, and brass nails may have survived until the settee was acquired by Henry Francis du Pont in 1948. It is now covered in a figured silk and cotton cloth resembling horsehair and ornamented with brass nails that conform to the original pattern.

Materials: Mahogany legs, crest rail, arms and splats; birch and ebony inlay; *soft maple seat rails and medial braces; *eastern white pine corner blocks. Modern brown silk and cotton cloth on seat.

Dimensions: H. 34⅜; W. 84⅛; SD. 16¼; SH. 14¾

Provenance: John Peirce (1746–1814); to his son Joshua W. Peirce (1791–1874); to his grandson William A. Peirce (1836–1910); to his great grandson J. Winslow Peirce (1881–1947). A year after Winslow Peirce's death, his widow Constance H. Peirce sold the settee to Henry Francis du Pont. The settee remained in the entry hall of the Peirce mansion throughout its lengthy history in the Peirce family.

Publications: Elwell 1896, pl. 26; *Antiques* 1:1 (Jan. 1922): cover; Howells 1937, fig. 30; Chamberlain 1940, 15; Montgomery 1966, no. 21; Bishop 1972, 256–57; Garvin 1974, 90–91; Garvin 1983, 360–72, fig. 116.

1. Garvin 1983, 360–72.

2. Davies 1874, 367–72.

3. John Peirce, 1814 inventory, old series, docket 8909, Rockingham County (N.H.) Probate.

4. Montgomery 1966, 108–9.

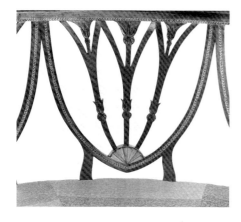

93C.
Splat of cat. no. 93.

93D.
Inlay on leg of cat. no. 93.

94

SIDE CHAIR

Langley Boardman (1774–1833)
Portsmouth, New Hampshire
1806
Wentworth-Coolidge Mansion
Portsmouth, New Hampshire
Property of the State of New Hampshire
Gift of the Sawyer Family, WC–1–83

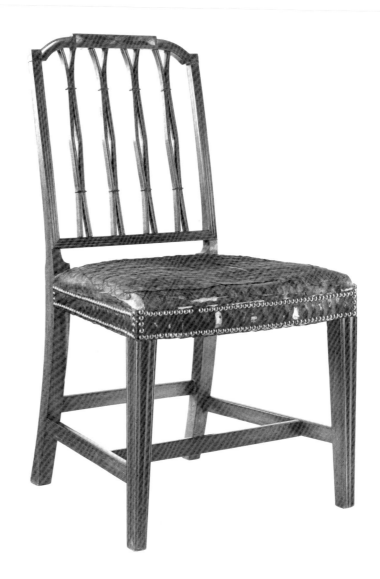

FEW OBJECTS RETAIN A MORE COMPLETE RECORD of their past than this square-back chair, one of a set of six side chairs and two armchairs. On November 14, 1806, George Ffrost II purchased the set for $76 from the cabinetmaker Langley Boardman (94A). Ffrost, a comfortably situated merchant and civil servant in Durham, New Hampshire, had just renovated his eighteenth-century home and was in the midst of outfitting his new parlor.[1] He turned to Boardman for elegant furniture and must have been pleased with the result, because he returned the next year to purchase a pair of card tables (*cat. no.* 60).

Boardman based the Ffrost chairs on a popular eastern Massachusetts design. Nearly every detail, from the molded tapering legs to the diamond-shaped banisters of the back, matches that on a set made for the Crowninshield family of Salem (94B). Typically, the Massachusetts examples have three pairs of banisters rather than four, and the side rails are shaped rather than straight. On more elegant versions, the legs are reeded and tipped with spade feet. Sometimes too, the stretchers are eliminated, foregoing structural stability in favor of increased sophistication. Elizabeth Derby West, the wealthy and worldly heiress from Salem, owned such a stylish set at her Danvers estate, while a virtually identical set may have been the property of Benjamin Bussey, a Boston silversmith.[2]

Boardman's reliance on Massachusetts design is consistent with his background. A native of Ipswich, he probably trained as a cabinetmaker in the Salem area and, upon moving to Portsmouth in 1798, brought an urban Massachusetts in-

terpretation of the neoclassical style to the New Hampshire seacoast. Local customers readily accepted his patterns, especially this square-back chair design.[3] The Portsmouth merchant James Rundlet acquired a set that is virtually identical to Ffrost's, with the same herringbone pattern worked in mahogany on the tablet in the crest.[4] Joseph Coe and his wife, Temperance Pickering Coe, acquired another set of the same design when they married in 1812 (*fig.* 44).[5] A prominent Durham shipbuilder and merchant, Joseph Coe resided within a mile of the Ffrosts and was a close acquaintance of the family.[6] Perhaps Temperance's parents, the Pickerings of New Market, purchased the chairs for her upon her marriage. One can also imagine Joseph or Temperance admiring the chairs in the Ffrost household and ordering a similar set for their own home. Though purchased six years later, the Coe chairs vary in only two details from those of their Durham neighbors. The tablet in the crest is veneered with she-oak, a tropical wood with pronounced rays resembling oak, and squares of she-oak are placed at the lower corners of the back instead of the mitered reeding on the Ffrost chairs.[7] A fourth set of similar chairs supposedly belonged to Jacob Wendell (1788–1865) of Portsmouth.[8] In this case, flame-birch veneer adorns the tablet in the crest and the squares at the corners of the back.

All four sets survive in good condition, but the Ffrost chairs stand out as the best of the group. They retain their original triangular blocks at the corners of the seat (each still secured with two cut nails) as well as all of their original upholstery. The upholstery techniques generally follow standard New England practice. Widely spaced strips of webbing are tacked to the top of the seat rails (94c). A layer of linen sackcloth follows; its front and side edges form rolls, which are stuffed with marsh grass and tacked along the top of the rails. The rolls create a pocket, which is filled

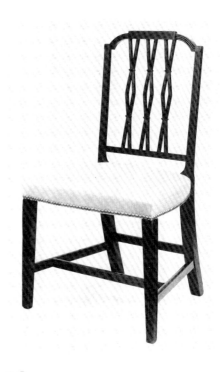

94B.

Side chair. Salem, Massachusetts, 1795–1810. Mahogany; H. 36¼. Private collection. Courtesy, Israel Sack, Inc. This chair is one of a set of six that descended in the Crowninshield family of Salem and was sold by the American Art Association, sale 4126, November 8–10, 1934, lot 553.

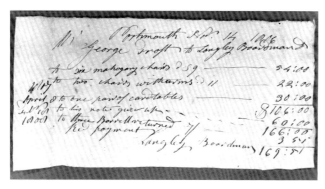

94A.

Bill from Langley Boardman to George Ffrost II. 1808. New Hampshire Historical Society, Concord, New Hampshire. Courtesy, New Hampshire Historical Society, Concord, New Hampshire. Bill Finney photograph.

94C.

Underside of the seat of cat. no. 94, showing the original webbing and sackcloth.

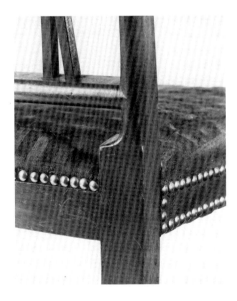

94D.

Back of the rear seat rail of cat. no. 94.

with grass and curled hair. An outer layer of linen is tacked to the face of the rails. A show cover of striped horsehair is pulled over the rear rail and tacked into a rabbeted edge along the back (94D), then tacked to the underside of the front and side rails. A double row of brass nails ornaments the front and side rails, while a single row runs along the rear rail. The upholstery may represent the work of William Sowersby (ca. 1762–1837), an upholsterer working in Portsmouth from 1784 until 1834, one year after Boardman died. Sowersby contracted with Boardman to upholster chaises and furniture in exchange for a piece of land. This transaction occurred in 1806, the year that George Ffrost bought his chairs from Langley Boardman.[9]

D C E

Structure and Condition: Standard rectangular mortise-and-tenon joints fasten all elements with one exception: sliding dovetails secure the medial stretcher to the side stretchers. Pins do not reinforce the joints. Each banister consists of two vertical elements glued at the necks and ornamented with narrow beaded collars. The corners of the back feature small squares of veneer at the top and mitered reeding at the bottom. The reeding is cut into the solid stay rail and stiles. The front seat rail is made of a single bowed board, with sawn curves on both the inner and outer surfaces. The original horsehair upholstery is torn and frayed.

Materials: Mahogany legs, crest rail, banisters, stay rail, and stretchers; mahogany veneer on the crest and rear seat rail; *birch front, rear, and left seat rails; *soft maple right seat rail; *eastern white pine corner blocks. Original striped black horsehair on seat.

Dimensions: H. 36¾; W. 20¼; SD. 17⅜; SH. 17⅜

Provenance: This chair shared a provenance with cat. no. 60 until 1983, when the Sawyer family donated it to the Wentworth-Coolidge Mansion.

Publications: Stackpole and Thompson 1913, 342.

1. In 1800 George Ffrost II purchased an early eighteenth-century house overlooking the town landing in Durham and a year later hired the housewright Jacob Odel to rebuild it. A surviving contract between Odel and Ffrost records the full extent of the work; see Jacob Odel, contract, Dec. 9, 1801, Frost Papers, New Hampshire Historical Society.

2. Hipkiss 1941, no. 114; Randall 1965, no. 174. Both sets are in the collection of the Museum of Fine Arts, Boston.

3. Individual examples of the design include a side chair at the Moffatt-Ladd House (1977.13); a pair of side chairs sold at Sotheby Parke Bernet, sale 4478Y, Nov. 19–22, 1980, lot 1366; and an armchair sold at auction by Daniel Olmstead on June 19, 1992. The armchair is pictured in the *Portsmouth Herald,* June 18, 1992, 2.

4. See Sander 1982, no. 55. Only three side chairs remain from what was once probably a set of six side chairs and two armchairs.

5. In the early twentieth century, Sarah Tappan Coe (1873–1961), wife of Richard Coe, the grandson of Joseph and Temperance, recorded the history of the chairs onto paper labels and affixed the labels to the seat rails. The inscription notes: "Six side chairs and two arm chairs of / mahogany, upholstered in black figured / damask with brass nails, were part of / Grandmother Coe's (Temperance Pickering) / wedding outfit in 1812." For additional information about the Coe family, see Bartlett 1911, 253–54, 372.

6. The Ffrost house overlooked Joseph Coe's shipyard at the town landing in Durham. Considering the small circle of prominent families in Durham, the Ffrosts and Coes must have had a close association.

7. Portsmouth furniture makers frequently used she-oak (*Casuarina* spp.) as a veneer during the federal period; see cat. nos. 34 and 66.

8. The Wendell set, sold at auction in Ipswich, Mass., by L. A. Landry Antiques on Nov. 14, 1991, is pictured in *Antiques and the Arts Weekly,* Nov. 1, 1991, 59.

9. William Sowersby to Langley Boardman, 1806 deed, 176:133, Rockingham County (N.H.) Deeds; see also McBrien 1993, chap. 2.

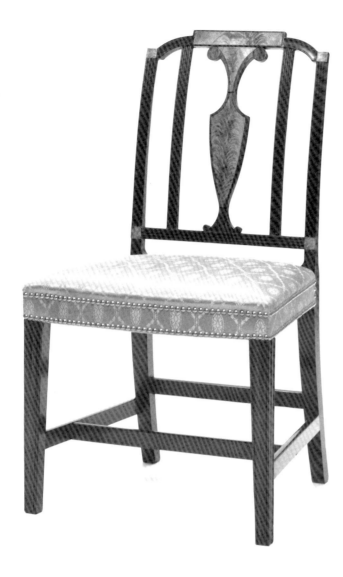

✿ 95

Side chair

Attributed to Langley Boardman (1774–1833)
Portsmouth, New Hampshire
1805–11
Museum of Fine Arts, Boston, Massachusetts
Gift of Mr. and Mrs. Guy Warren Walker
1945.885
Courtesy, Museum of Fine Arts, Boston

THIS CHAIR, one of a set of ten side chairs and two armchairs, belonged to Susan Lord Hayes and her husband, Judge William Allen Hayes of South Berwick, Maine. Family tradition holds that Mrs. Hayes's father, General John Lord, gave the set to the couple as a wedding gift in 1811.[1] The novelist Sarah Orne Jewett recalled that Judge Hayes was an accomplished and cultivated man, who "had the instincts of an English country squire and lived like one on his great estate of 1500 acres in South Berwick, bringing up his sons and daughters to be ladies and gentlemen."[2] The family seems to have divided the set between the north and south front rooms of their large home, with "six mahogany chairs" in each of the primary public spaces. The south room was certainly the more utilized of the two, because it contained the Franklin stove, a piano, two card tables, a variety of seating furniture, plants, and portraits of Mrs. Hayes and the Judge.[3] The chairs, a mahogany sideboard, silver, and portraits descended to the Judge's grandson, Hammond Vinton Hayes (95A), who had homes in Boston and Hingham, Massachusetts.[4]

Prominent families like the Lords and Hayeses sometimes looked to Boston for furniture. This chair, because of its stylish design, was formerly believed to have been made there, possibly in the workshop of the Seymours.[5] The design for the back is a distinctive combination of a veneered vasiform splat flanked by two finely reeded vertical banisters. The grain of the flame birch perfectly complements the upward movement detailed in the outline of the splat. Squares of birch at the corners of the back echo the contrasting color and figure of the splat and crest.

Recent research indicates that this striking chair originated in Portsmouth, rather than Boston. The Thompson family of Durham, New Hampshire, owned a closely related example, which appears in a late nineteenth-century photograph of the library in the Judge Ebenezer Thompson House.[6] The chair backs are identical, but the Thompson version has turned and reeded front legs, stump rear legs, and no stretchers (95B). The chair was probably purchased by the Judge's son, Colonel Ebenezer Thompson (1762–1828), a Portsmouth resident who acquired a sideboard from Langley Boardman in 1803.[7] Both the Thompson and Hayes chairs share key features with documented Portsmouth furniture. The reeded legs and flattened ball feet of the Thompson chair resemble those on a dressing table made for James Rundlet (23B) and a two-drawer worktable that descended in a Portsmouth family.[8] The Hayes set matches in many details the set supplied by Boardman to George Ffrost II of Durham in 1806 (*cat. no.* 94). The two sets have the same arrangement of triangular corner blocks within the seat (*see* 94C). They also have identical legs, stretchers, arms, and seats. While comparable legs and stretchers do sometimes appear on urban Massachusetts chairs, the seat pattern does not. Typically, the side seat rails on Salem and Boston federal chairs are curved.[9] On the Hayes and Ffrost sets, they are straight. The outline of the backs of the two sets is virtually the same. Even the distinctive details on the back of the Hayes set have Portsmouth parallels. The reeded banisters follow a standard pat-

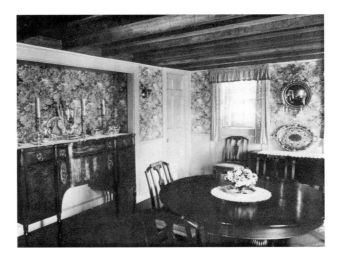

95A.
Interior of the Hammond Vinton Hayes house in Hingham, Massa-chusetts, ca. 1930. Reproduced from Katharine Richmond's John Hayes of Dover, New Hampshire, A Book of his Family *(1936), opp. 145. New England Historic Genealogical Society, Boston, Massa-chusetts.*

tern, frequently seen on square-back chairs with straight crest rails (*see* 97A). In addition, the use of flame-birch veneer on the crest and corners of the back is repeated on a set of Portsmouth chairs that descended in the Wendell family.[10]

Such a lengthy list of related features places the Hayes chairs firmly within the furniture-making tradition of federal Portsmouth. In design and construction, they suggest the hand of Langley Boardman at his best. The veneered vasiform splat transforms a standard back into an exceptional expression of neoclassical taste. For the Lords and Hayeses, both of nearby South Berwick, Boardman offered furnishings of high caliber only a short distance from home.

D C E

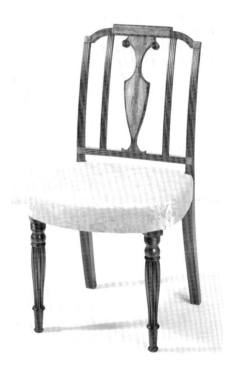

95B.

Side chair. Portsmouth, New Hampshire, 1805–15. Mahogany and birch veneer, H. 36. Private collection. Courtesy, Israel Sack, Inc., New York, New York. This chair is identical to those owned by Colonel Ebenezer Thompson (1762–1828) of Portsmouth.

Structure and Condition: The construction of the chair matches that of cat. no. 94. The crest tablet has an ⅛" vertical strip of birch veneer along the left edge, which appears to be original. The chair has been refinished and twice reupholstered in the twentieth century. In 1990, Andrew Passeri installed the present reproduction silk damask covering. The double row of brass nails duplicates the original pattern.

Materials: *Mahogany legs, crest rail, banisters, stay rail, and stretchers; mahogany veneer on rear seat rail; birch veneer on splat, tablet, and corners of the back; *birch seat rails; *eastern white pine corner blocks. Reproduction ginger-colored silk damask on seat.

Dimensions: H. 36⅜; W. 20; SD. 17¾; SH. 17

Provenance: Supposedly given by General John Lord to his daughter Susan (1790–1870) upon her marriage to William Allen Hayes (1783–1851) on June 2, 1811; descended to their son, Augustus Lord Hayes (1826–1906); to his nephew, William Allen Hayes (1862–1917); to William's brother, Hammond Vinton Hayes (1860–1947). Mr. and Mrs. Guy Walker purchased the set and gave a pair to the Museum of Fine Arts, Boston in 1945.

Publications: Richmond 1936, opp. 145; Randall 1965, no. 184; Bishop 1972, no. 375; for other chairs from the same set, see Stoneman 1959, 310–11; *Antiques* 86:5 (Nov. 1964): 502; *Antiques* 108:3 (Sept. 1975): 461; *Antiques* 111:5 (May 1977): 994, 997; Rodriguez Roque 1984, no. 69.

1. Ten of the chairs are pictured in *Antiques* 86:5 (Nov. 1964): 502. The set is now divided among several owners including: the Museum of Fine Arts, Boston (Randall 1965, no. 184); the Chipstone Collection in Milwaukee (Rodriguez Roque 1984, no. 69); a private collection in Houston (*Antiques* 108:3 [Sept. 1975]: 461);

and Mr. and Mrs. Robert Lee Gill of New York (*Antiques* 111: 5 [May 1977]: 994, 997).

2. Richmond 1936, 239.

3. William Allen Hayes, 1851 inventory, docket 8907, York County (Me.) Probate. The set was still split between the "Parlor" and "Drawing Room" twenty years later; see Susan Hayes, 1871 inventory, docket 8904, York County (Me.) Probate. A 1906 inventory, taken before the contents of the house were dispersed, noted "Carved mahogany and inlaid chairs with haircloth seats, 10 side chairs, 2 arm chairs at $50.00 each $600.00"; see Hayes House inventory, 1906, Old Berwick Historical Society.

4. Richmond 1936, 422 and opp. 145.

5. Stoneman 1959, 310–11.

6. Photograph, Thompson Papers, Special Collections Library, University of New Hampshire. The Thompson chair may be the one that appears without a provenance in *Sack Collection*, 1:233, no. 588. For an identical chair with its original horsehair upholstery, see *Antiques* 11:4 (Apr. 1927): 257.

7. Bill, Oct. 11, 1803, Thompson Papers, Special Collections Library, University of New Hampshire.

8. The worktable is in the collection of the Portsmouth Historical Society (PL33). A matching table was advertised in *Antiques* 93:3 (Mar. 1968): 289.

9. Chairs of the federal era usually have a bowed front and half-bowed sides. English design books consistently depict the shape (see Hepplewhite 1794, pls. 1–11), and urban Massachusetts makers followed suit (see Randall 1965, nos. 158, 162–66, 168, 170–74).

10. *Antiques and the Arts Weekly,* Nov. 1, 1991, 59.

96

Armchair

Langley Boardman (1774–1833)
Portsmouth, New Hampshire
1802
Rundlet-May House
Portsmouth, New Hampshire
Society for the Preservation of New England
Antiquities, gift of Ralph May, 1971.446.7

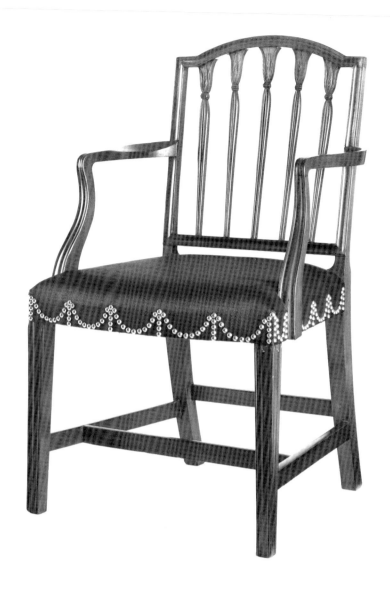

Like the two preceding chairs (*cat. nos.* 94 *and* 95), this example can be ascribed to the cabinetmaker Langley Boardman. It is one of a set of six side chairs and two armchairs acquired from Boardman by the Portsmouth merchant James Rundlet on September 13, 1802. According to Rundlet's ledger (8A), the set cost $68. Four years later, the price of a comparable set had increased to $76. The latter set (*cat. no.* 94), purchased by George Ffrost of Durham, is identical to Rundlet's chairs from the seat rails to the floor. At the arms, the chairs match as well. Furthermore, they exhibit all of the same construction details: triangular corner blocks within the seat frame, partially veneered rear seat rails, and sliding dovetails to join the medial and side stretchers. The original upholstery of the seats was nearly the same.[1] Both had similar foundations and matching show covers of striped black horsehair.[2] Only a variation in brass nailing distinguished the sets. Instead of the usual double row of nails, Rundlet's chairs feature a more fashionable swag pattern (96A).

The Ffrost and Rundlet chairs differ most obviously in the design of their backs. Here, an arched crest caps a square back filled with five tapered banisters, each carved to replicate the sinuous stem and crown of a water leaf. The pattern never became popular. Only one chair of the same design is known. It bears the brand of its original owner, Samuel Tripe, a Portsmouth sailmaker, and was part of a set of twelve that he possessed at his death in 1815.[3]

Though a rarity in Boardman's repertoire, the distinctive back of the Rundlet chairs has special significance. In plate 9 of *The Cabinet-Maker and Upholsterer's*

Guide, George Hepplewhite depicts a shield-back chair with five banisters ornamented with water-leaf carving (96B).[4] Boardman adapted the plan to a square back. Philadelphia craftsmen produced their own shield-back versions of the Hepplewhite plate, but Boardman is the only known American artisan to incorporate the motif into a square back.[5]

Boardman learned of neoclassical design through his training in the Salem area. Yet, this sophisticated armchair suggests that he also had direct access to English sources through Hepplewhite's *Guide.* Unfortunately, his ownership of this influential book cannot be documented. His probate inventory of 1833 only refers to one "Lot of Books $8," a time-saving accommodation by the appraisers that offers no clue of the contents of his library.[6]

D C E and B J

Structure and Condition: The construction of the chair matches that of cat. no. 94. Each arm support is tenoned into the arm and fastened with a sliding dovetail to the side seat rail. An original screw (driven from the seat rail into the arm support) reinforces the sliding dovetail joint. The arm fits into a notch in the stile and is secured from the back with a screw. The left stile consists of two pieces of wood joined diagonally between the arm and stay rail. The unusual splice joint appears to be original and may reflect the maker's effort to salvage a stile that was damaged during construction. Small chips mar the stay rail and legs.

When acquired by SPNEA in 1971, the chair was covered in a red striped fabric dating from the early twentieth century and the finished surfaces of the frame had a thick, darkened coating of varnish and polish. In 1982, SPNEA conservators removed the upholstery, discovering in the process a small fragment (½" by 1") of the original show cover of striped black horsehair and evidence of the original brass nailing pattern (96A). To protect the frame from further damage, conservators fashioned a rudimentary nail-less foundation, consisting of ½" plywood and a polystyrene block. The polystyrene was cut and shaped to simulate the contours of the original stuffing. An appropriate striped horsehair show cover was unavailable at the time, and a satin-woven horsehair was substituted. Conservators secured the fabric with a minimum of

96A.

Detail of the side seat rail showing a swag pattern of nail holes from
the original brass nails. When hammering the nails into place, the im
print of the ribbed weave of the original horsehair show cover was
transferred onto the seat rails.

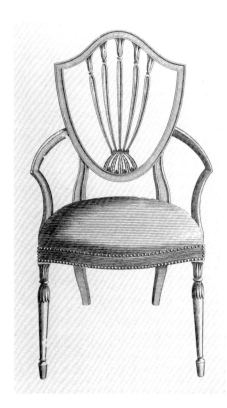

96B.

"Chair," plate 9 in George Hepplewhite's The Cabinet-Maker and Upholsterer's Guide *(third edition, 1794). Courtesy, Printed Book and Periodical Collection, The Winterthur Library, Winterthur Museum, Winterthur, Delaware.*

iron tacks and glued brass nailheads onto the fabric to create the surface appearance of the nailing pattern. The finish was cleaned with alcohol and waxed.

Materials: *Mahogany legs, crest rail, banisters, stay rail, arms, arm supports, and stretchers; mahogany veneer on rear seat rail; *soft maple seat rails; *basswood corner blocks. Reproduction black horsehair on seat.

Dimensions: H. 37; W. 22 1/16; SD. 18; SH. 16¾

Provenance: This chair shares a provenance with cat. no. 8.

Publications: Plain and Elegant 1979, no. 1; Mussey 1986, 644.

1. The similarities suggest the hand of a single upholsterer, probably William Sowersby (*see cat. no. 94*).

2. Though the Rundlet armchair was reupholstered at about the turn of this century, it retains evidence of its original treatment. Like the Ffrost set (*see cat. no. 94*), this armchair had two strips of webbing running from side to side and from front to back. Sackcloth followed, and in all likelihood linen rolls filled with marsh grass formed a firm edge along the sides and front of the seat. No traces of the original stuffing or outer layer of linen survive, but a fragment of the show cover was found during conservation of the chair (see *Structure and Condition*).

3. The Tripe chair is pictured in *Antiques* 114:5 (Nov. 1978): 969. An illustration of the brand appears in appendix B.

4. Hepplewhite mistakenly numbered two adjacent plates as 9; the source for Boardman's chair appears on the right side of the first plate.

5. For Philadelphia chairs, see Montgomery 1966, nos. 87, 88; Garvan 1987, 69–70. Two distinct groups of Massachusetts square-back chairs have arched crests and banisters with leaf

carving at the top, but neither is derived from a specific pattern book plate. The first group features four straight banisters which flare at the top into carved leaves (see Nutting 1928–33, nos. 2388, 2393). The second group has three straight leaf-carved banisters, each inlaid with two light-wood strips which simulate fluting (see Stoneman 1965, no. 60). In 1979, a set of eight of the latter type was attributed to the Portsmouth firm of Judkins and Senter on the basis of a bill from the makers to Jacob Wendell (see *Plain and Elegant* 1979, no. 8). However, the bill, which amounts to only $28, probably refers to fancy chairs rather than more costly carved chairs with upholstered seats; see cat. no. 100.

6. Langley Boardman, 1833 inventory, old series, docket 12564, Rockingham Co. (N.H.) Probate.

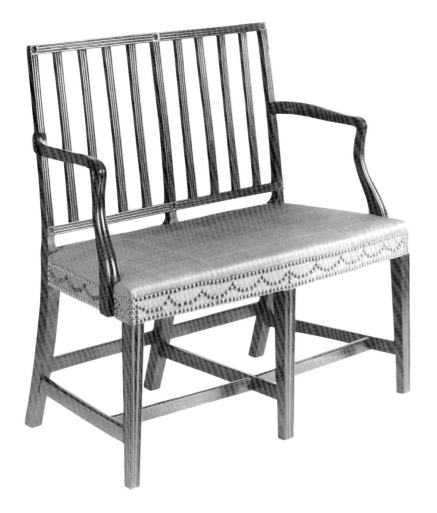

☙ 97

SETTEE

Attributed to Langley Boardman (1774–1833)
Portsmouth, New Hampshire
1805–13
The Henry Francis du Pont Winterthur Museum
Winterthur, Delaware
Gift of Henry Francis du Pont, 52.133.1

SQUARE-BACK SEATING FURNITURE filled the parlors of federal Portsmouth. Fashionable examples with arched crests and carved or veneered banisters (*cat. nos.* 94, 95, 96) were highly prized but made in limited numbers. A plainer, less costly version had more widespread appeal. Its essential elements are a square back with reeding on the crest rail, stiles, and stay rail; four straight reeded banisters; carved rosettes at the corners of the back; over-the-rail upholstery; and tapering molded legs. The pattern appears most frequently on chairs (97A) but in rare instances on settees. This striking example is one of a pair; only three others, all with Portsmouth-area provenances, are known.[1]

This settee retains a century-old label noting that the pair had "Belonged to Elizabeth Wentworth [,] wife of Joseph Haven—Grand mother Thachers uncle." The inscription refers to the daughter of Hugh Hall Wentworth and Penelope Jepson Wentworth, who married Joseph Haven (1757–1829), a successful Portsmouth merchant, in 1784. Elizabeth Haven died in 1813, and her husband married Sarah Appleton of Boston the next year. Neither marriage produced any children. Joseph Haven's will, written on August 7, 1824, and proved on August 12, 1829, states: "I give and bequeath to my niece Elizabeth Haven Thacher…all my household furniture in my dwelling house where I now live that may remain undisposed of by my wife at the time of her decease." Presumably the pair of settees did pass to Elizabeth Haven Thacher after Sarah Haven's death in 1838, thus explaining the reference to a Grandmother Thacher in the nineteenth-century label.[2]

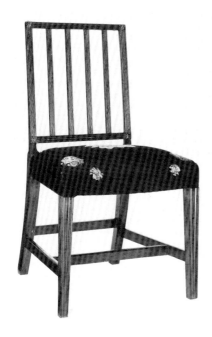

97A.

*Side chair. Attributed to Langley Boardman
(1774–1833). Portsmouth, New Hampshire,
1800–1815. Mahogany, maple, birch, and east-
ern white pine, H. 36¼; W. 20; SD. 17¾; SH.
17. Strawbery Banke Museum, Portsmouth,
New Hampshire, gift of Miss May Springfield,
1979.223. This chair descended in the Ports-
mouth area in the Springfield family. It retains
its original upholstery foundation, which matches
that of cat. no. 94.*

Remarkably, Joseph Haven's detailed probate inventory contains no clear ref-
erence to the settees. The inventory lists fancy chairs with both cane and straw bot-
toms, mahogany chairs (presumably with upholstered seats), an easy chair, a sofa, a
rocking chair, lolling chairs, and assorted foot stools or crickets, but not settees.
However, one reference offers a possible explanation. The contents of the north-
west parlor include "2 Mahogany arm Chairs" valued at $12. The sum far exceeds
that of any other piece of seating furniture except the sofa. By comparison, an easy
chair is appraised at $4, a lolling chair at $3, and most side chairs at $1 each. The
highly valued armchairs were clearly special in some way. Perhaps to the inventory-
takers, the special pair of Haven settees were simply armchairs.[3]

Joseph and Elizabeth Haven's house still stands on Pleasant Street in a neigh-
borhood of merchant's homes of the late eighteenth century.[4] Jacob Wendell lived
directly across the street (*fig.* 17), and Governor John Langdon and Captain Tho-
mas Thompson resided in adjacent houses next door. The Havens began to build
their large, three-story dwelling in 1799, just as John Peirce was finishing his man-
sion a few blocks away (*fig.* 18). During the next decade, these affluent families set
to work furnishing their grand houses with an array of stylish goods. Nearly all out-
fitted their parlors with square-back chairs. In addition to the settees owned by the
Havens, sets of square-back chairs of the same design belonged to John Peirce and
John Langdon, the ship captain John S. Davis, and undoubtedly many others, judg-
ing from the dozens of surviving examples.[5]

Despite the popularity of the form, no exact English precedent is known.
Both Hepplewhite's *Guide* and Sheraton's *Drawing Book* illustrate square-back
chair designs, but neither provides a perfect prototype. Perhaps an imported En-
glish chair served as the source, because similar chairs were made at about the same
time in other regional centers, notably Hartford, Philadelphia, and Baltimore.[6] An
English cabinetmaker, George Osborne (1755–1818), immigrated to Portsmouth
in 1795, but it is doubtful that he introduced the design there. Contemporary refer-
ences to his work suggest that he concentrated on case pieces and tables.[7]

A more likely candidate for developing the distinctive Portsmouth version of
the design is Langley Boardman. In 1937, Stephen Decatur attributed the pattern
to Boardman on the basis of a closely related set of chairs with carved oval rosettes
in the banisters that had descended in Boardman's family (97B).[8] Close inspection
of the Haven settees and the attributed Boardman chairs suggest that they were
made in the same shop. Furthermore, the same construction features appear on
documented Boardman chairs made for George Ffrost (*cat. no.* 94) and James
Rundlet (*cat. no.* 96). A plain square-back chair such as 97A became Boardman's ba-
sic model—his standard offering to clients who sought fashionable upholstered
seating at the most modest price.

R F T

Structure and Condition: The construction of the frame and arms of this settee matches that of cat. no. 96. The carved rosettes at the corners of the back are applied. The center legs are joined to the frame in a manner customary for chairs but not for settees and sofas. Typically, the front and rear seat rails of a settee extend across the entire frame, and the center legs are tenoned into the rails. Here, the center legs conform in plan to the corner legs, and the rails are tenoned into the center legs. A sway-backed medial brace, set into notches at the top of the center legs, provides additional support for the upholstered seat. The rear center leg is made of two vertical strips of mahogany. Though differing from the standard one-board technique used for the other legs, the pieced construction is original. The frame of the settee is in excellent condition; its only obvious flaw is a ¾" triangular chip at the base of the rear center leg. The upholstery has been renewed several times. During the mid-1960s, the Winterthur Museum staff had the settee recovered in green silk and decorated with brass nails. The upholsterer based the nailing pattern on a design in plate 4 of the 1794 edition of Hepplewhite's *Guide.* In 1984, conservators reglued a loose stretcher and cleaned and waxed the frame. Three years later, they applied the present green silk covering.

Inscriptions: "Two Settees. one in Brockton. / (Sheriton) / Belonged to Elizabeth Wentworth / wife of Joseph Haven—Grand mother / Thachers uncle" written in ink on a paper label glued to the inside of the front seat rail.

Materials: *Mahogany legs, crest rail, banisters, stay rail, arms, arm supports, and stretchers; *birch seat rails; *maple medial brace; *eastern white pine corner blocks. Eighteenth-century green silk on seat.

Dimensions: H. 35⅝; W. 36⅝; SD. 17⅛; SH. 16¼

Provenance: Joseph Haven (1757–1829) and his wife Elizabeth Wentworth Haven (ca. 1764–1813); to their niece Elizabeth Haven Thacher (1798–1879); presumably to a grandchild; purchased before 1937 by the Boston antiques dealer Hyman Kaufman and consigned to the New York gallery of Mrs. K. K. Tysen. After an unsuccessful attempt to sell the pair of settees, they were returned to Hyman Kaufman and eventually sold to Henry A. Hoffman; purchased from Hoffman's estate by Henry Francis du Pont in about 1952.

Publications: Comstock 1937, 102; Montgomery 1966, no. 29.

1. One settee matching cat. no. 97 appears in a photograph of a Portsmouth interior in 1896; see Elwell 1896, pl. 4. In 1931, another pair of settees was pictured in the Sarah Orne Jewett House in South Berwick, Me.; see views of the library and parlor in the SPNEA Archives. The pair may have belonged to Theodore Jewett (1782–1854) who moved from Portsmouth to South Berwick in 1812.

2. Wentworth 1878, 1:510–11; Appleton 1874, 22; Joseph Haven, 1829 will and inventory, old series, docket 11857, Rockingham County (N.H.) Probate.

3. Joseph Haven, 1829 inventory, old series, docket 11857, Rockingham County (N.H.) Probate.

4. For information about the Haven house, see Candee and Porter 1984, passim.

5. The Langdon chairs are divided between the Portsmouth Historical Society (PL5) and SPNEA's Governor John Langdon House (1966.281a-d, 1966.375). The Peirce and Davis chairs were sold as part of an assembled set at Sotheby's, sale 6051, June 28, 1990, lot 554. The four Davis chairs in the set bear the brand "J. S. DAVIS"; the pair of armchairs in the set belonged to Peirce. Other examples include five chairs at Strawbery Banke Museum (1974.43–44; 1984.51–53) that descended in the Goodwin and Storer families of Portsmouth.

6. For the most closely related design sources, see Hepplewhite 1794, pls. 9, 12, 13; and Sheraton 1793, pls. 24, 26. For examples made in areas other than Portsmouth, see Christie's, Oct. 21, 1989, lot 351; Lockwood 1926, 2: fig. 89; Christie's, Jan. 27, 1987, lot 271, previously attributed to Baltimore in Sotheby's, sale 5056, June 30-July 1, 1983, lot 345; Sotheby Parke Bernet, Los Angeles, sale 264, Nov. 5–8, 1979, 1: lot 303; Lockwood 1913, 2:fig. 605; *Great River* 1985, no. 149; Singleton 1900–1901, 2:429.

7. See, for example, George Osborne to Stephen Chase, bill, Nov. 13, 1797, Chase Papers, folder 11, box 3, Strawbery Banke Museum.

8. Decatur 1937, 5. For a similar version of the Boardman chair but with an arched crest, see Nutting 1928–33, no. 2394.

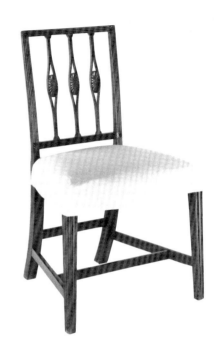

97B.

*Side chair. Attributed to Langley Boardman (1774–1833). Portsmouth, New Hampshire, 1800–1815. Mahogany, *white oak, and *soft maple, H. 35¾; W. 21; SH. 17; SD. 17⅝. Collection of Stephen Decatur. This chair, which descended in the Goodwin and Storer families of Portsmouth, is identical to a set that probably belonged to Langley Boardman.*

98

FANCY SIDE CHAIR

Portsmouth, New Hampshire,
or possibly New York or Philadelphia
ca. 1806
Rundlet-May House
Portsmouth, New Hampshire
Society for the Preservation of New England
Antiquities, gift of Ralph May, 1971.721.b

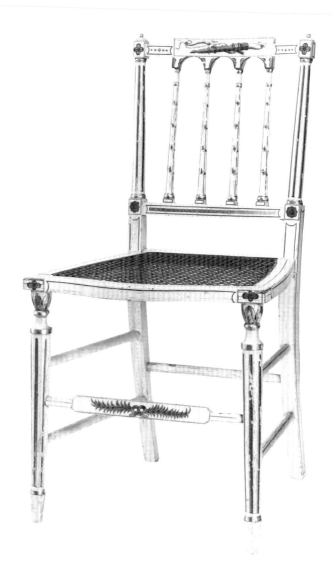

BY THE END OF THE EIGHTEENTH CENTURY, painting and veneering had replaced carving as the preferred surface treatments for furniture. The variety of color and pattern that could be achieved with these techniques appeared fresh and fashionable, capturing the spirit of the new neoclassical style. As George Hepplewhite noted in *The Cabinet-Maker and Upholsterer's Guide:*

> For chairs, a new and very elegant fashion has arisen within these few years, of finishing them
> with painted or japanned work, which gives a rich and splendid appearance to the minuter
> parts of the ornaments, which are generally thrown in by the painter.[1]

Craftsmen adopted the term "fancy chair" to describe painted examples with rush or cane seats. In Portsmouth, as early as 1798, the painter John Gray, Jr., provided customers with "window and bed Cornishes, Fancy Chairs, Fire buckets… [and] Ornamental Work of every description."[2] Over the next decade, three other painters also plied their skills in the town, transforming hundreds of unfinished turned frames into colorful seats nearly everyone could afford.[3] Though substantial, the work of Portsmouth decorators paled beside the output of the chair manufactories of Boston, New York, and Philadelphia. These large urban establishments shipped chairs throughout the world, providing keen competition for local workmen and sometimes forcing them out of business. In Portsmouth, patrons could choose either native or imported fancy furniture. Today, distinguishing between the two can be difficult, as cat. no. 98 illustrates. This handsome white and gold chair was acquired by the Portsmouth merchant James Rundlet, but the source of his acquisi-

tion remains an intriguing mystery. Conflicting evidence suggests a possible origin in Portsmouth, New York, or Philadelphia.

In 1806, Rundlet bought "6 fancy Chairs" from the Portsmouth chairmaker Josiah Folsom for $24. Born in Dover, New Hampshire, Folsom may have apprenticed in Boston, where he married Mary Perkins in 1786. Within two years, the chairmaker had returned to New Hampshire and begun a business in Portsmouth, offering "Windsor Chairs of every description... as cheap as can be purchased at BOSTON or elsewhere."[4] By 1806, the year of Rundlet's purchase, Folsom's typical product was a "bamboo" chair, a Windsor square-back chair with bamboo turnings on the legs and stiles. The price for his standard pattern amounted to $2.33, far less than the $4 he received from Rundlet.[5] Clearly the Rundlet chairs ranked among his most fashionable fare.

In the 1979 catalogue, *Plain & Elegant, Rich & Common: Documented New Hampshire Furniture,* this painted chair was linked to Rundlet's bill and attributed to Folsom.[6] The chair is one of five (from a set of six) that still remain in Rundlet's Portsmouth home. Though two other sets of painted chairs also belonged to Rundlet (70A *and* 99A), this is the only set of the correct size and date for the Folsom account. In addition, chairs from four closely related sets retain Portsmouth provenances (*see cat. no.* 99), lending further proof of a local origin for Rundlet's chairs. Like cat. no. 98, the related sets feature square backs with button finials, distinctive bowed seats made as separate units (see *Structure and Condition*), and front legs with cup-like turnings at the top and round spade feet. Finally, sets of white and gilt window cornices made for Rundlet's house as well as the Moffatt-Ladd House in Portsmouth strengthen the case for local manufacture of the chairs. The decoration of the chairs and cornices may represent the work of the same craftsman. If so, that craftsman probably lived in Portsmouth, since the custom fitting required for cornices was best done on site.

Yet, the possibility remains that all five sets were imported into Portsmouth from New York or Philadelphia. The reasons are threefold. First, the chairs contain an odd mixture of woods, including citrus wood, an unusual tropical hardwood, and sweet gum, a favored choice of cabinetmakers in New York and, to a lesser degree, in Philadelphia and Baltimore.[7] Except for the five related sets, no other furniture with Portsmouth histories is made of these woods. Second, splat-back chairs such as cat. no. 99 relate in design to examples tentatively attributed to Pennsylvania and New York.[8] Third, a pair of armchairs that nearly match Rundlet's white set stood in a Bristol, Rhode Island, residence during the late nineteenth century. Built by William deWolf in 1808, the house contained a rich assortment of furnishings that the family had inherited from South Carolina, New York, and Massachusetts.[9]

Today we labor to distinguish local fancy chairs from their imported competition. Yet, Rundlet probably concerned himself more with his set's appearance than with its origin. The graceful arcaded back of the chair, resembling plate 9 in Hepplewhite's *Guide,* must have appealed to him.[10] But when placing his order, his primary concern may well have been color. He sought white and gilt decorative surfaces, which at the time represented the height of neoclassical taste. Fashion deemed such ornamental furnishings appropriate for either the grandest parlors or bedchambers. Shortly after 1800, the Portsmouth merchant John Peirce outfitted a parlor with a set of "12 white painted Chairs, 2 of them Arms."[11] His neighbor Samuel Ham had a painted set of twelve chairs in his best chamber which probably matched the "painted & Gilt Bedstead" in the room.[12] The popularity of white bedchambers may have guided Rundlet in his own furnishing scheme.[13] The original cornices for his sitting-room chamber were white and gilt, suggesting that he once

had a bed to match, draped with white dimity. Within that setting, these white chairs would surely have affirmed the "rich and splendid appearance" of painted decoration.

D C E and B J

Structure and Condition: As on most fancy chairs, round mortise-and-tenon joints fasten the stretchers to the legs, and standard rectangular mortise-and-tenon joints secure the crest rail and stay rail to the stiles. The columnar banisters in the back are joined with round tenons to the crest and rectangular tenons to the stay rail. The seat is constructed as a unit—the side rails are tenoned through the front and rear rails—and then secured to the chair frame. The front legs are round-tenoned into the front corners of the seat. Screws are driven through the rear legs into the back corners of the seat. Wooden strips are added to the seat rails to increase their height. The button finials are glued to the top of the stiles.

This chair is in better condition than any other member of the set. The present decoration appears to be the second layer, probably applied soon after the chair was made. L-shaped angle irons reinforce the rear corners of the seat. The right seat rail split along the caning holes long ago, and a strip has been added. In 1982, SPNEA conservators cleaned the painted surface and coated it with a synthetic varnish (Acryloid B–72) to prevent further flaking.

Materials: *Soft maple legs, crest rail, stay rail, and stretchers; *cherry front and right seat rail; unidentified wood for banisters and left and rear seat rails; *red oak strip added to right seat rail. Replaced cane on seat.

Dimensions: H. 34⅝; W. 18³⁄₁₆; SD. 16; SH. 17¾

Provenance: This chair shares a provenance with cat. no. 8.

Publications: Plain and Elegant 1979, no. 5; Sander 1982, no. 61; Mussey 1986, 644.

1. Hepplewhite 1794, 2.

2. *Oracle of the Day,* Dec. 1. 1798.

3. The painters are Samuel Beck, Henry Bufford, and George Dame. For advertisements describing their work, see *New Hampshire Gazette,* Mar. 10, 1807; Sept. 17, 1811; Feb. 25, 1812.

4. James Rundlet, ledger B, 30, James Rundlet Papers, Archives, SPNEA; *New Hampshire Gazette,* Nov. 8, 1797; *Plain and Elegant* 1979, 145.

5. In 1807 Folsom billed Benjamin Lapish of Durham for four sets of bamboo chairs. The price for a "plain" set of six was $14. Josiah Folsom to Benjamin Lapish, bill, 1807, Benjamin Lapish Papers, folder 3, box 1, Durham Historical Society.

6. *Plain and Elegant* 1979, 30–31.

7. Charles Montgomery suggested a New York or Baltimore origin for a painted chair that closely relates to the Portsmouth group because of the presence of sweet gum in the splat; see Montgomery 1966, no. 462.

8. Ibid.; Parke-Bernet, sale 2604, Oct. 21, 1967, lot 122; *Maine Antique Digest,* Feb. 1987, 31; and a pair of chairs at Beauport, an SPNEA property in Gloucester, Mass. (see Curtis and Nylander 1990, 30). Regretably, none of these objects has a documented history. The authors are grateful to Nancy Goyne Evans for sharing her knowledge of related chairs; see letters to Brock Jobe, Sept. 16, 1991; and Oct. 17, 1991.

9. Northend 1914, 252–63, especially pl. 95. Another armchair of the same design is illustrated in Nutting 1928–33, no. 2420.

10. Hepplewhite 1794 mistakenly identifies two adjoining plates as plate 9. A design for a square back chair with an arcaded back and central tablet is shown at the left of the first plate.

11. The room is identified in Peirce's estate inventory as the "South West Room" and apparently served as a dining room and parlor; John Peirce, 1815 inventory, old series, docket 8909, Rockingham County (N.H.) Probate.

12. The value of the chairs—$2 each—suggests that they were fancy chairs rather than more expensive upholstered chairs made of mahogany; Samuel Ham, 1813 inventory, old series, docket 8702, Rockingham County (N.H.) Probate.

13. For more on the popularity of white bedchambers, see Garrett 1990, 116; Montgomery 1966, 56–57.

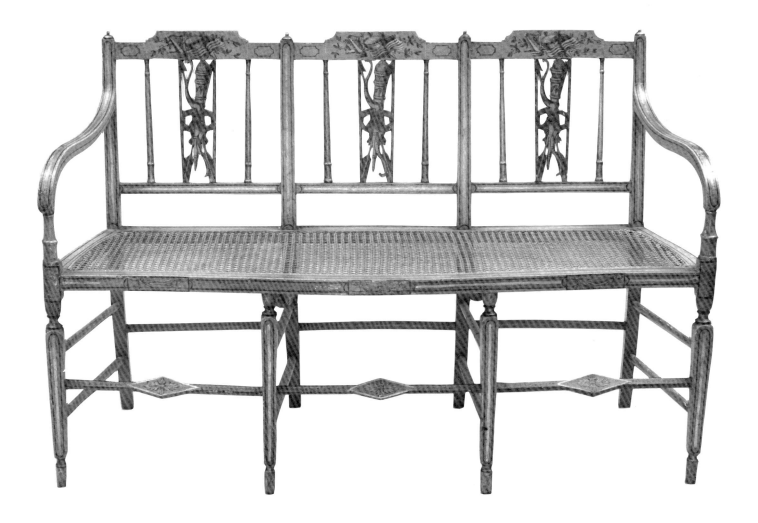

 99

FANCY SETTEE

Portsmouth, New Hampshire,
or possibly New York or Philadelphia
1805–15
Ackland Art Museum
The University of North Carolina at Chapel Hill
Chapel Hill, North Carolina
Knapp Collection, 58.3.74

LIKE THE PRECEDING FANCY CHAIR (*cat. no.* 98), this yellow painted settee has an impeccable Portsmouth provenance. It bears the brand of its original owner, the ship captain Lewis Barnes (1776–1856). Born Jacobi Ludwig Bäarnhielm in Gothenburg, Sweden, he accompanied his uncle on a voyage to America in 1790. Though only fourteen at the time, he jumped ship in Salem, Massachusetts, and was taken in by the celebrated merchant Elias Hasket Derby. While in Salem, the Reverend William Bentley convinced the boy to change his name to Lewis Barnes because, as one contemporary noted, "the Swedish name was not so easily pronounced by English tongues."[1] Barnes removed to Portsmouth in about 1800 and achieved a modest fortune through trade. He bought a commodious three-story house on Islington Street in Portsmouth and furnished it with a fashionable assortment of local goods and imports.[2] At his death, all of his possessions passed to his widow and two spinster daughters.[3]

Fortunately, his furnishings can be identified because he meticulously branded them with his name. He owned a serpentine-front secretary with a fall-front desk drawer resembling 28C, probably made by Langley Boardman. He also had a dressing table, lolling chair, and easy chair (104A) from other shops in town as well as an imported gilt neoclassical looking glass.[4] The settee is part of a large branded set, which includes a matching settee and eight chairs.[5]

Of all his surviving possessions, this suite of fancy furniture is the most intriguing. It retains its original painted finish of goldenrod yellow with red-brown

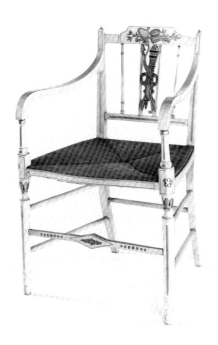

99A.

Fancy armchair. Portsmouth, New Hampshire, or possibly New York or Philadelphia, 1805–15.
**Soft maple, *cherry, *beech, *sweet gum, hickory,*
H. 34⅝; W. 22³⁄₁₆; SD. 18⅞; SH. 17⅝.
Rundlet-May House, Portsmouth, New Hampshire, Society for the Preservation of New England Antiquities, gift of Ralph May, 1971.477.f. This chair is one of nine from a set originally owned by James Rundlet of Portsmouth. It is now painted white but was originally red.

lining and bands of gilding. In design, the set relates in key details to the white and gold chairs owned by James Rundlet (*cat. no.* 98). Both sets feature square backs, button finials, and seats constructed as a separate element with open tenons (*see Structure and Condition*). Here, however, a central splat ornamented with a torch, bow, and arrow replaces the arched columns of the Rundlet chairs. Here also, the legs are faceted and the crest is stepped. Similar traits link three other sets of painted seating furniture, all with Portsmouth histories. One, which also belonged to James Rundlet (99A), matches the Barnes set in every detail but two: the set is rushed rather than caned, and the legs are turned in the standard manner rather than faceted. Two identical sets owned by Governor John Langdon (99B) and the Wendell family share sufficient features with the other chairs to suggest that all originated in the same shop.[6]

But, where was that shop located? The presence of so many related examples with a Portsmouth past points to a shop in the town. Yet, the use of unusual woods, including sweet gum and citrus wood, may indicate manufacture in New York or Philadelphia (*see cat. no.* 98).[7] Orders from Portsmouth merchants to agents in both of these cities document an established trading network. In 1793, John Langdon asked a Philadelphia firm to send him "1½ doz. of narrow dining Chairs 1 Inch higher than common, White or light Stone."[8] Two decades later, Jacob Wendell acquired a fashionable set of New York fancy chairs (*cat. no.* 100), and by the 1820s vast quantities were arriving regularly from New York and Boston.[9] Such evidence offers clues but no definitive answer to the question of where the Barnes set was made. For now, the origin of this impressive group of painted furniture remains frustratingly elusive.

D C E and B J

Structure and Condition: The construction of the settee matches that of cat. no. 98 with the following exceptions: the front legs at each corner continue upward to form the arm supports, which are round-tenoned into the arms; the arms butt against the stiles and are fastened with screws driven in from the back; the turned columns in the splat are round-tenoned into the crest and stay rail; and swayed-back braces are set between the front and rear medial legs. The settee is in excellent condition with nearly all of its original painted decoration intact. The turned columns in the back have been repainted, and the gilding on the stay rails has been retouched. The right medial brace is replaced. The bamboo-turned upper medial stretchers differ from the plain stretchers elsewhere on the settee but are probably original.

Inscriptions: "L • BARNES" branded three times on the underside of the rear seat rail.

Materials: Soft maple legs, crest rail, stay rail, arms, and applied strips on seat rails; *citrus wood seat rails; sweet gum splat; unidentified wood for columns in back; cherry medial brace. Replaced cane on seat.

Dimensions: H. 34⅞; W. 54; SH. 18; SD. 19¼

Provenance: Lewis Barnes (1776–1856); to his wife Abby Maria Walden Barnes; eventually to his daughter Esther Walden Barnes who outlived all of her siblings and died in East Orange, N.J., in 1903; acquired by Joseph C. Hart; bequeathed to Archibald Hart of Montclair, N.J., who sold it to the antiques dealer Charles Woolsey Lyon; purchased from Lyon by Mrs. Joseph Palmer Knapp in 1927 and given to the Ackland Art Museum in 1958.

1. Lewis Barnes, obituary, *Portsmouth Journal,* July 4, 1856; see also *Federal Fire Society* 1905, 38–39.

2. Nelson 1930–32, 20; Howells 1937, 100–107. Barnes, a ship captain and importer, eventually acquired two ships, the *Recovery* and the *Lewis.*

3. Lewis Barnes, 1856 will, old series, docket 17307, Rockingham County (N.H.) Probate. The estate was not inventoried. His daughter Esther W. Barnes, who died in East Orange, N.J., in 1903, outlived her sibling. She seems to have inherited many of the Barnes objects and passed them along to relations who lived in New York and New Jersey; see Esther W. Barnes, 1903 will, new series, docket 12092, Rockingham County (N.H.) Probate. One descendant moved from New York to Minnesota, where many items still remain. The Ackland Museum's portion of the painted set has a documented past in New Jersey as well as a spurious history of having belonged to the New York writer Washington Irving.

4. The secretary was sold with a later bookcase at Sotheby's, sale 5680, Jan. 28–30, 1988, lot 1888; the dressing table belongs to SPNEA (1966.1813), the lolling chair to the Baltimore Museum of Art (1990.10), and the easy chair to Strawbery Banke Museum (1980.779; see 104A). The looking glass is in a private collection in Minnesota. Other Barnes family pieces, including a Portsmouth chest of drawers with ovolo corners, are in a second private collection in Minneapolis, Minn.; see note 3.

5. The Ackland Art Museum also owns four matching side chairs (58.3.75–.78); Henry Ford Museum owns a pair of side chairs (73.74.1–2); and Old Sturbridge Village owns another pair (5.42.17). The second settee was formerly in the collection of the Baltimore Museum of Art (63.26) but was deaccessioned in 1972 and sold at auction by Weschler and Son, Oct. 6–8, 1972, lot 665.

6. Only one chair (99B) from the Langdon set is known. The Wendell set, now owned by Strawbery Banke Museum, includes a pair of double-chairback settees (1989.2.1–2), two armchairs (1989.2.3–4), and eight side chairs (1989.2.5–12). For illustrations of the Wendell set, see Lockwood 1913, 2:figs. 604, 635. The Langdon chair retains its original red decoration; the Wendell set has been repainted. Otherwise the chairs are identical, even in their varied assortment of woods. Possibly they were all part of one set originally.

7. The maker consistently used sweet gum for the splats and citrus wood (often in combination with other woods) for the seat rails. His remaining woods are typical New England materials: maple, cherry, and hickory. If the chairs were made in Portsmouth, the artisan may have obtained his chair splats and seats from New York or Philadelphia. Though no documentation for the export of selected parts is known, there is considerable evidence of the shipment of chairs in pieces from New York and Philadelphia to reduce freight charges; see Evans 1988b, 161–62, 166. If chairs were "knocked down" for shipboard storage, individual parts could be handled in the same way.

8. Quoted in Cleary 1978, 31.

9. Samuel Dockum and Edmund Brown advertised the importation of hundreds of New York chairs at a time; for example, see *New Hampshire Gazette,* Jan. 9, 1827; Feb. 27, 1827.

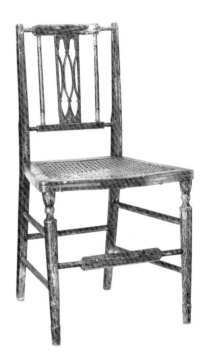

99B.

*Fancy side chair. Portsmouth, New Hampshire, or possibly New York or Philadelphia, 1805–15. *Soft maple, *sweet gum, *hickory, and probably citrus wood, H. 34⅝; W. 18¹³⁄₁₆; SD. 15¾; SH. 17¾. Society for the Preservation of New England Antiquities, Boston, Massachusetts, museum purchase, 1974.352. This chair supposedly belonged to Governor John Langdon of Portsmouth. Though well worn, its red painted decoration is original.*

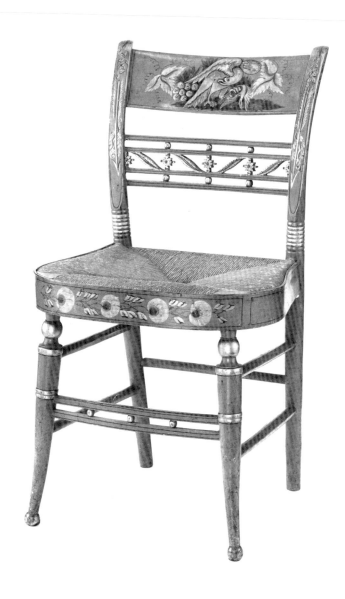

100

FANCY SIDE CHAIR

New York, New York
1815–16
Strawbery Banke Museum
Portsmouth, New Hampshire
Gift of Gerrit van der Woude, 1988.230.4

THIS FANCY CHAIR is part of an exceptional set of twelve side chairs, two armchairs, and one settee ordered by the merchant Jacob Wendell of Portsmouth. Rather than patronize a local chairmaker, Wendell opted to send away to New York City for his set. The mercantile partnership of Benjamin Bailey and Walter Willis charged Wendell $5.25 for each chair, $30 for the settee, and $2.50 to pack the set. The transaction concluded on January 18, 1816, when the merchandise was "shipd by Schooner Freindship [*sic*] Capt. Martin per your order for Portsmouth New Hampshire."[1] No record of the maker's name survives. Dozens of chair manufactories filled the commercial neighborhoods of New York. Their products dominated the coastal export trade, presenting stiff competition to local chairmakers from Portsmouth to Buenos Aires.[2]

When Jacob Wendell ordered this set in 1816, he was in the midst of furnishing a house on Pleasant Street that he had bought the year before. Within one month, he acquired thirty-four chairs and the settee—all fancy furniture but ranging considerably in price and source. He purchased two inexpensive sets of six chairs from the Boston firm of Gridley and Blake, a recently formed business specializing in the sale of fancy chairs and cabinet wares. The price per chair amounted to $2 for one set, $1.25 for the other.[3] The Portsmouth partnership of Judkins and Senter supplied six side chairs at $3 each and two matching armchairs at $5 each. Their bill was once thought to refer to mahogany chairs with upholstered seats, but the prices are too low. A later household inventory documents the actual appearance of the

Judkins and Senter set: "6 fancy chairs - 2 arm'd do. (dark colourd)."[4] The set provided by Bailey and Willis cost significantly more than the others and found a home in Wendell's "parlour," the most formal public space in his residence.[5]

The design of the New York set followed a popular formula.[6] But, its ornate gilt decoration was superior to most and accounted for its higher price. In this case, the painter covered the frames in a pale shade of yellow. He then stenciled the primary motif of an eagle and its prey onto the crest in gold powder. Additional "penning" or hand-lining in black and shading with a red pigment in a spirit varnish was applied over the stenciled area. Peripheral motifs, such as the bow and arrow on the stiles and the rosettes and feathers on the medial slat, were executed freehand.[7] The result is a product that is handsome, stylish, and functional. It is not surprising that Jacob Wendell would seek out such a set to outfit his fine home.

D C E

Structure and Condition: As on most fancy chairs, the cylindrical stretchers are round-tenoned to the legs, but the square front stretchers are square-tenoned to the legs. The crest rail and horizontal splat are tenoned to the stiles. The side rails are round-tenoned to the rear legs but joined with rectangular tenons to the exposed corners of the front seat rail. The legs are round-tenoned to the front corners of the seat. A wooden skirt is nailed to the edge of the seat. The original painted surface is in excellent condition, obscured only by dirt and minor wear. The right front leg is cracked just above the foot, and the right stile is split at the joint with the medial slat.

Materials: *Soft maple legs, crest rail, middle and bottom rungs of medial slat, upper rung of front stretcher, and all turned balls; *hickory side and rear stretchers; *ash seat rails, upper rung of medial slat, and bottom rung of front stretcher; *yellow-poplar applied skirt. Original yellow-painted rush on seat.

Dimensions: H. 33⅝; W. 18; SD. 16⅛; SH. 17⅜

Provenance: This chair shares a provenance with cat. no. 5. It remained part of the estate of Francis A. Wendell (1915–79) until Gerrit van der Woude gave it to Strawbery Banke Museum in 1988.

Publications: Ward 1989a, 1, 72; for an illustration of the settee, see Ward and Cullity 1992, pl. 11.

1. Bailey and Willis to Jacob Wendell, bill, Jan. 18, 1816, Wendell Collection, Jacob Wendell bills, case 13, Baker Library, Harvard Business School. Bailey and Willis are listed in various editions of the *New York Register* and the *New York City Directory* from 1810 through 1817, both as partners and individually.

2. See Evans 1988b, 166–67, for an illustration of Thomas Ash's trade card, which shows chairs from his chair factory being carted to a waiting vessel for shipment to a distant port. Ash is just one of the many manufacturers who could have made the set for Wendell. For information on imports into Portsmouth, see cat. no. 99, note 9; for more on local efforts to compete with the flood of imports, see cat. no. 110.

3. Gridley and Blake to Jacob Wendell, bill, Jan. 2, 1816, Wendell Collection, Jacob Wendell bills, case 13, Baker Library, Harvard Business School. For more on this partnership, see Talbott 1974, 66–67.

4. Judkins and Senter to Jacob Wendell, bill, June 29, 1816, Wendell Collection, Jacob Wendell bills, case 13, Baker Library, Harvard Business School; *Plain and Elegant* 1979, no. 8; Jacob Wendell, 1828 inventory, Wendell Collection, case 14, Baker Library, Harvard Business School. A pair of red painted fancy chairs recently acquired by Strawbery Banke Museum (1992.7.1–2) may be part of the Judkins and Senter set. The chairs descended in the Wendell family until sold at auction in Ipswich, Mass., by L. A. Landry Antiques on Nov. 14, 1991.

5. Jacob Wendell, ca. 1828 inventory, Wendell Collection, box 18, Portsmouth Athenaeum. In addition to the set of fancy chairs, the parlor contained a pair of card tables made by Judkins and Senter in 1816 (*cat. no.* 64).

6. For similar sets with New York histories, see *Sack Collection*, 4:954; and Blackburn 1976, 86. A closely related set erroneously attributed to New England was sold at Sotheby's, sale 5883, June 21, 1989, lot 346. For other related examples, see Lea 1960, 49, fig. 25; 50, figs. 28–30; 51, fig. 33; 52, figs. 34–35; *Antiques* 50:1 (July 1952): 16; *Antiques* 125:5 (May 1984): 1144; and *Antiques* 136:3 (Sept. 1989): 503. Another set, which is attributed to the chairmaker Henry Dean, is in the collection of Boscobel; see Tracy 1981, 46.

7. Marylou Davis, letter to the author, Sept. 11, 1991.

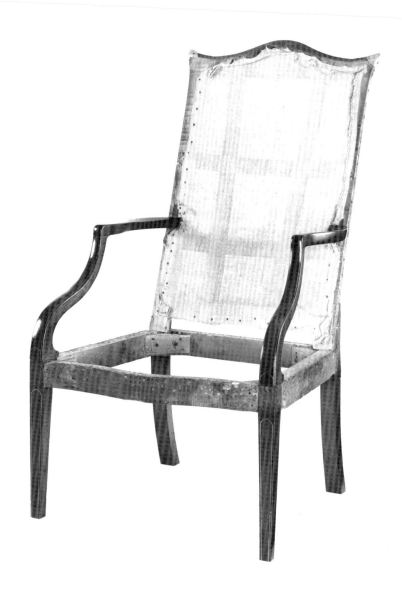

 IOI

LOLLING CHAIR

Langley Boardman (1774–1833)
Portsmouth, New Hampshire
1803
Rundlet-May House
Portsmouth, New Hampshire
Society for the Preservation of New England
Antiquities, gift of Ralph May, 1971.448

DURING THE 1790s, the upholstered armchair took on a different appearance as well as a new name. Its predecessor, sometimes called a French chair (*cat. no.* 91), closely followed English models in the rococo style. In Europe the form soon faded into obscurity, but in America it was adapted to suit federal taste and dubbed a lolling chair. It remained a fashionable form of seating for more than a quarter century, especially in New England.[1]

In Portsmouth, the earliest reference to the new term occurs in a 1799 advertisement by Langley Boardman. The Portsmouth cabinetmaker announced a full line of furniture, including "Lolling Chairs; Easy Chairs; and a variety of other articles."[2] Not surprisingly, the earliest surviving example of the form also comes from Boardman. On December 10, 1803 (*see* 8A), he supplied the Portsmouth merchant James Rundlet with this lolling chair for $8 and a related easy chair for $15 (101A). Though purchased on the same day and similar in appearance, the two chairs were almost certainly destined for different rooms. Rundlet probably placed the lolling chair in the parlor or sitting room and reserved the easy chair for a bed-chamber.[3]

Boardman's two upholstered chairs reflect the introduction of the new neo-classical style. The individual parts of their frames are more attenuated than on earlier examples (*cat. no.* 91), and smooth surfaces enlivened by inlay now replace carved or molded treatments. The high back and serpentine crest follow an established eastern Massachusetts formula that Boardman came to know through training in the Salem area. However, he modified the design by accentuating the curve

of the crest. Generally, Massachusetts lolling chairs have a more languid shape along the top.[4]

The construction of the frames confirms that these two chairs, as well as a second easy chair with a Portsmouth provenance, came from the same workshop.[5] All three objects are joined with mortises and tenons in the standard manner, but, with one exception, none of the joints are reinforced with pins.[6] The arms are tenoned through the stiles and wedged from the back. The front seat rails are bowed at the center, but the side rails are straight—much like Boardman's side chairs (*see cat. nos.* 94, 95, 96). At the corners of the seat, large triangular blocks are fastened with cut nails—again like Boardman's other work. Finally, the stiles are mounted to the rear legs with a characteristic splice joint (101B) employed by craftsmen in both eastern Massachusetts and coastal New Hampshire. For the joint, the upper edge of the leg is cut on the diagonal and secured to the back edge of the stile with glue and either nails or screws. The bottom of the stile fits into a notch in a side seat rail.

The frames merely hint at the grandeur that these chairs once had. Their upholstery added color and comfort as well as a fashionable note of luxury. The artisan responsible for the transformation was probably William Sowersby (*see cat. no.* 94). Unfortunately a few strips of webbing and sackcloth on the back of the lolling chair are all that remain from his upholstery. Rundlet's accounts offer no clues of Sowersby's treatment. But the frames themselves reveal a key piece of evidence: neither chair was decorated with brass nails, suggesting that they initially had slipcovers, or "cases" as they were frequently called, rather than fixed show covers. Hepplewhite commented upon the popularity of the practice when describing a design for an easy chair: "they may be covered with leather, horse-hair; or have a linen case to fit over the canvass stuffing as is most usual and convenient."[7] Such cases tended to be loose fitting (101C) and, for Rundlet's lolling chair, covered the front corners of the seat but not the mahogany arm supports or arms. Patrons preferred striped, checked, or printed cotton for the cases, frequently to match the window and bed curtains. In his "North West Chamber," the Portsmouth merchant John Peirce draped his high-post mahogany bedstead and easy chair in "copperplate," a printed cotton.[8] A surviving blue-and-white printed cover for a Portsmouth easy chair documents the treatment, and Rundlet's family preserved a fragment of copperplate which may have served the same purpose (101D).[9] On the latter, horses race to the finish while onlookers cheer from the "The Turf Inn," a festive scene that would have brightened any bedchamber.

D C E and B J

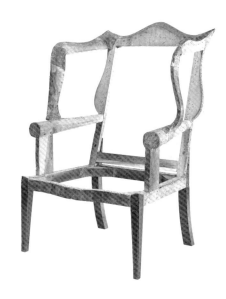

101A.

Easy chair. Langley Boardman (1774–1833). Portsmouth, New Hampshire, 1803. Mahogany, light-wood inlay, maple, birch, and eastern white pine; H. 45⅞; W. 31½; SD. 23⅜; SH. 14⅝. Rundlet-May House, Portsmouth, New Hampshire, Society for the Preservation of New England Antiquities, gift of Ralph May, 1971.673. The chair once had casters; the legs have been extended slightly.

101B.

Detail of rear leg and stile of cat. no. 101.

Structure and Condition: When acquired by SPNEA in 1971, the lolling chair had a spring seat, two layers of twentieth-century fabric on the seat and back, late nineteenth-century casters, and a dark, thick, linseed-oil finish that had become bleached on the arms. In addition, the position of the left arm had been lowered during an earlier repair. A screw had been driven through the left arm support into the leg and covered with a mahogany plug. The rear legs had lost about 2" in height. In 1984, SPNEA conservators Robert Mussey and Joseph Twichell removed the upholstery and found the original sackcloth and webbing intact on the back as well as evidence that the outer canvas of the underupholstery had extended around the front corners of the seat, covering the unfinished areas at the top of the legs. The conservators

disassembled the left arm and arm support, cleaned the joints of old glue, and resecured the parts in their original locations. The casters were removed, and the legs extended 3" at the back and 1" at the front. The bleached arms were refinished with shellac; the remaining mahogany portions of the frame (except the tops of the front legs) were cleaned with mineral spirits and a mild detergent, sprayed with shellac, and waxed. The chair has not been reupholstered.

Inscriptions: "R H Hall Portsmouth" in pencil on the front of the left stile.

Materials: *Mahogany legs, arms, and arm supports; light-wood inlay; *hard maple side and rear seat rails; *soft maple stiles, crest, and stay rail; *birch front seat rail; *basswood corner blocks. Original linen webbing and sackcloth on back.

IOIC.

January. *Engraved by R. Dighton, London, ca. 1780. Mezzotint engraving, H. 14; W. 10½. Colonial Williamsburg Foundation, Williamsburg, Virginia, 1977–177,1.*

IOID.

The Turf Inn. *England, 1790–1800. Copperplate printed cotton, H. 28; W. 21¼. Rundlet-May House, Portsmouth, New Hampshire, Society for the Preservation of New England Antiquities, gift of Ralph May, 1971.771. The printed surface of this faded fragment was originally a brilliant purple.*

Dimensions: H. 45¼; W. 24¾; SD. 22¼; SH. 14¾

Provenance: This chair shares a provenance with cat. no. 8.

Publications: Plain and Elegant 1979, no. 3.

1. Montgomery 1966, 155–56. The origin of the term is unclear, but Montgomery points out that *The Oxford English Dictionary* defines to loll as "to lean idly; to recline or rest in a relaxed attitude," indicating that the sitter's posture may have prompted the term. See also Flanigan 1986, 142.

2. *New Hampshire Gazette,* Apr. 23, 1799.

3. Garrett 1990, 70, 124–25, describes the customary placement of easy chairs and lolling chairs within the home.

4. For Massachusetts examples, see Montgomery 1966, nos. 109, 110, 111. Massachusetts makers (notably Lemuel Churchill) also offered a distinctive barrel-back version with a straight crest, which has no known Portsmouth counterpart; see Montgomery 1966, nos. 115, 116, 117.

5. The second easy chair, also owned by SPNEA (1971.484), is nearly identical to IOIA. It descended with the Rundlet-May House and is surely the work of Langley Boardman. Two undocumented lolling chairs can also be ascribed to Boardman. The first has tapering molded legs but is otherwise identical to cat. no. 101; see Montgomery 1966, no. 114. The second substitutes bellflower inlay on the legs for the simple arched stringing on the Rundlet example; see Christie's, Oct. 10, 1987, lot 235.

6. Wooden pins secure some of the mortise-and-tenon joints in the Rundlet easy chair (IOIA). Its other structural features, however, match those of the lolling chair, suggesting that both objects originated in the same shop.

7. Hepplewhite 1794, 3.

8. John Peirce, 1815 inventory, old series, docket 8909, Rockingham County (N.H.) Probate.

9. The blue-and-white cover was photographed during the late 1960s in Portsmouth; its present location is not known.

❦ *102*

LOLLING CHAIR

Portsmouth, New Hampshire
1810–20
Henry Ford Museum and Greenfield Village,
Dearborn, Michigan, 26.26.3

THIS CHAIR EXEMPLIFIES the second phase of neoclassical lolling chairs produced in Portsmouth workshops. Although similar in form to the version made for James Rundlet a decade earlier (*cat. no.* 101), this lolling chair features a number of fashionable innovations. Rundlet's chair has straight tapering legs enlivened by string inlay. Here, the legs also taper but were turned on a lathe rather than sawn and planed. Vigorous ball, reel, and ring motifs coupled with carved leaves ornament the turnings. The feet and rings on the legs are ebonized, though possibly at a later date.[1]

The arms and upholstery of the two chairs also display noticeable differences. The arm supports on Rundlet's chair sweep backward to meet the arms, a standard pattern reminiscent of earlier French chairs (*see cat. no.* 91). Here, reeded bulb-shaped arm supports align themselves vertically over the legs; the arms extend forward to meet the supports at gracefully curved handholds, termed "crane neck'd elbows" in one period price-book.[2] Sinuous and sculptural, these shapely elbows became a favored motif for sofas (*see cat. no.* 106) as well as lolling chairs.

The over-the-rail upholstery on Rundlet's chair follows a traditional treatment: the fabric wraps around the front legs, covering the joint between the legs and arm supports. On this lolling chair, each front leg and corresponding arm support are a single continuous element. The construction of the post varies significantly from customary joinery. On cat. no. 101, the seat rails are tenoned into the legs; here, the front corners of the seat rails are dovetailed and set into notches in the legs. A single screw, driven through the dovetail joint into the leg, binds the

seat rails and leg. In Portsmouth, the technique became the accepted procedure for fastening turned legs to straight rails. Craftsmen used it most often on lolling chairs, sofas (*see cat. no.* 106), and card tables (*see cat. no.* 63). Though practical and efficient, the joint is inherently weak and often loosens over time. In this case, a repairman had to add a screw through each leg to tighten the frame; the heads of the screws are covered with mahogany plugs.

Lolling chairs with turned arm supports and legs achieved considerable popularity in Portsmouth. This example is one of a pair that belonged to William Simes, a prominent Portsmouth silversmith. Its design ranks among the most ornate by any local maker and includes several unusual details, such as ball feet, carved leaves on the legs, and narrow reeding that halts half-way up the arm support.[3] A more typical version of the form was owned by Jacob Wendell (102A). It retains its original underupholstery as well as an old ink inscription on the rear seat rail, "$12.00," which probably refers to the initial price of the chair.[4] As on other similar chairs, figured birch veneer envelops the top of the front legs, and the legs and arm supports are fully reeded.[5]

Simes's pair of lolling chairs undoubtedly became fashionable accoutrements of his large house on Market Street, near the center of Portsmouth. No evidence survives that might indicate the placement of these chairs.[6] For clues to their use, we must turn to estate inventories of his contemporaries. The merchant Joseph Haven placed a pair in the front entry of his Pleasant Street mansion.[7] Haven's neighbor on State Street, Abraham Shaw, kept a pair of lolling chairs in a sitting room that seems to have doubled as a dining room.[8] In both cases, the chairs stood in spaces that served many purposes. Their location, however, was probably not fixed. Lightweight and sometimes fitted with casters, lolling chairs were easily moved to meet specific needs. By 1828 Jacob Wendell had put his lolling chair in a back bedchamber, but over the next century the chair's location within his house changed at least three times.[9]

D C E and B J

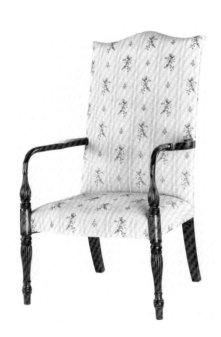

102A.

*Lolling chair. Portsmouth, New Hampshire, 1810–20. *Mahogany, *birch veneer, *soft maple, *beech, and *eastern white pine; H. 43¹³/₁₆; W. 25³/₁₆; SD. 19¾; SH. 15. Strawbery Banke Museum, Portsmouth, New Hampshire, gift of Gerrit van der Woude, 1989.11. This chair belonged to Jacob Wendell (1788–1865) of Portsmouth.*

Structure and Condition: The top of the arm support is round-tenoned into a curved handhold, which in turn is round-tenoned into the arm. The construction of the back probably matches that of the preceding chair (*cat. no.* 101) but could not be verified because of the upholstery. A large triangular block is nailed at each corner of the seat. Two cut nails originally secured each block. The chair is in excellent condition. In 1922, loose-fitting chintz upholstery with a deep dust ruffle covered the frame. Since its acquisition by the Henry Ford Museum, the chair has had three subsequent coverings, including the present striped brocade installed after 1964. A dark, crazed varnish now covers the exposed parts of the frame.

Materials: Mahogany legs, handholds, and arms; birch seat rails; eastern white pine corner blocks. Modern blue and peach striped silk brocade on seat and back.

Dimensions: H. 45¾; W. 25¼; SH. 15½; SD. 21

Provenance: Owned by William Simes (1773–1824) and descended in his family; sold at auction in Portsmouth in 1922; subsequently acquired by Israel Sack, then an antiques dealer in Boston, and sold in 1926 to Henry Ford Museum.

Publications: Antiques 2:2 (Aug. 1922): 50; Shelley 1958, 162; Comstock 1962, fig. 438; *Decorative Arts* 1964, 2; Davidson 1968, 60.

1. A layer of finish lies beneath the black paint, suggesting that the black was added after the chair was made. See cat. no. 64 for a card table with ebonized feet.

2. *London Chair-Makers' and Carvers' Book of Prices* 1802, pl. 6, no. 7; see Montgomery 1966, 303–4.

3. Another lolling chair, possibly from the same shop, has incised rings on the front legs and arm supports; see Warren 1975, no. 148. A Portsmouth sofa with similar reeding on the arm supports originally belonged to the merchant George McClean and bears his brand; see 106B. Another Portsmouth sofa with small ball feet similar to those on the Simes chair was made by Judkins and Senter for Jacob Wendell in 1816 (*fig.* 47). This sofa, now in the collection of the Strawbery Banke Museum (1988.227), provides a possible link between this cabinetmaking partnership and the Simes chair. More careful study of the two objects is needed to determine if they are the work of the same maker.

4. The extensive collection of Wendell family papers includes only one reference to the purchase of a lolling chair. On Oct. 2, 1813, Jacob

Wendell paid the auctioneer Samuel Larkin $5.62½ for a "Lolling Chair"; bill, Wendell Collection, case 13, miscellaneous bills 1813–17, Baker Library, Harvard Business School. The chair was among the household goods sold by Larkin for Charles Peirce, a Portsmouth merchant moving to Philadelphia; *New Hampshire Gazette,* Sept. 28, 1813. If 102A is the chair in the bill, it was relatively new when acquired by Wendell but still available at less than half its original price.

5. Three mates to the Wendell chair are known. One, first pictured in *Antiques* 63:1 (Jan. 1953): 46, is now in the collection of the White House (976.1253.1). The second was sold by Sotheby's, sale 5001, Jan. 27, 29, 1983, lot 423. The third originally belonged to Lewis Barnes, a Portsmouth ship captain, and was recently given to the Baltimore Museum of Art (1990.10). Chairs in the collections of the Metropolitan Museum of Art (10.125.313; see Montgomery and Kane 1976, 177–78, fig. 132), Milwaukee Art Museum (M1968.94; see Ward 1991a, no. 84), and George M. and Linda H. Kaufman (Flanigan 1986, no. 52) resemble the Wendell lolling chair and its mates in overall design but vary in several details. The front legs have square capitals with veneered panels instead of the round capitals wrapped with birch veneer on the Wendell chair. In addition, the swelled arm supports differ slightly in design from the reeded outline on the Wendell chair. At present, the origin of the Kaufman, Metropolitan, and Milwaukee chairs cannot be pinpointed. Portsmouth, Salem, and Boston all remain possibilities. None of the chairs have early histories.

6. Simes purchased a brick dwelling on Market Street in 1803 and established a store there. His silversmithing business flourished, judging from the substantial quantity of surviving silver that bears his mark. Late in his life, his financial affairs deteriorated. By 1821 he had converted his dwelling into a boarding house. He was sued for debt on several occasions and in 1823 defaulted on a mortgage that he had taken on his Market Street property. Apparently he declared bankruptcy soon afterwards and died suddenly on Apr. 15, 1824. He left no will and no inventory was taken. Throughout his career he is described as a silversmith, goldsmith, or gentleman. Though insolvent by the time of his death, he appears to have lived comfortably. See Storer to Lunt and Simes, 1803 deed, 165:428, Rockingham County (N.H.) Deeds; Portsmouth Bank v. Simes, 1815, series A, docket 46835, Rockingham County (N.H.) Court, State Archives; New Hampshire Bank v. Simes, 1823, series B, docket 4336, Rockingham County (N.H.) Court, State Archives; Sherburne v. Long, Apr. 1823, series B, docket 5242, Rockingham County (N.H.) Court, State

Archives; *Portsmouth Directory* for 1821; *New Hampshire Gazette,* Apr. 20, 1824; Parsons 1983, 24, 32–33, 35–36, 44, 122. Examples of Simes's silver are owned by Strawbery Banke Museum and the New Hampshire Historical Society.

7. Joseph Haven, 1829 inventory, old series, docket 11857, Rockingham County (N.H.) Probate.

8. Abraham Shaw, 1828 inventory, old series, docket 11702, Rockingham County (N.H.) Probate. Shaw's inventory does not designate rooms by name. Nevertheless, it is apparent that the appraisers described the items in one room before moving into the next. The lolling chairs are listed among what appears to be the contents of a combination sitting room and dining room:

1 Wilton Carpet with Hearth Rugg 42 yds	[$]31.50
10 yds Green bocking 1¾$. 1 Brass fire sett & fender	6.75
1 Pr Brass Lamps 2$. 2 Plated candlestick with 2 lamps $1	3.00
Plated Snuffer & Tray 75 1 Looking Glass 5	5.75
4 Window Curtains & pins 5 1 Willard time peice	12
6 Windsor Chairs & 2 Rocking Dᵒ	1.50
2 Lolling Chairs 3 1 Mahogʸ Side Board 5	8
1 Mahog'ʸ Book Case 8$. Lot of Books, 100 vols 3	11
1 Dᵒ. Liquor Case with the bottls in it 3	3

9. Jacob Wendell, ca. 1828 inventory, Wendell Collection, box 18, Portsmouth Athenaeum. Family photographs in the Strawbery Banke Museum depict the lolling chair in the south front chamber in 1902, back sitting room in 1912, and north parlor in 1940.

103

LOLLING CHAIR

Portsmouth, New Hampshire
1820–30
Rundlet-May House
Portsmouth, New Hampshire
Society for the Preservation of New England
Antiquities, gift of Ralph May, 1971.820

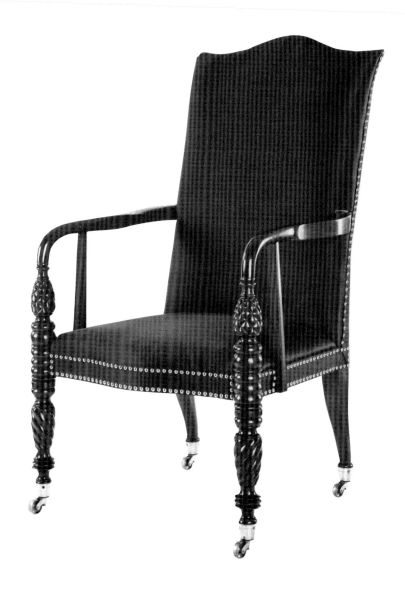

By the 1820s, the lolling chair was a well-established and popular form of seating furniture in Portsmouth. The design of this example, with a history in the Lord family, follows the traditional form in many respects; its high rectangular back and sinuous arms relate closely to lolling chairs and sofas made between 1805 and 1815 (*see cat. nos.* 101, 102, 105, 106). The details of this chair, however, especially the thick, spiral turning on the front legs, pineapple carving on the arms, and distinctive curved rear legs, vary from earlier patterns and indicate that this is a late expression of the form. Samuel Lord, its original owner, purchased the house now known as the John Paul Jones House in Portsmouth in 1826, which suggests an approximate date for the chair of the mid 1820s.

The Lord chair is closely related to two other examples. One is a lolling chair with a history in the family of Portsmouth merchant Jacob Wendell and now at Strawbery Banke Museum (103A). The other is privately owned and lacks an early provenance.[1] Of the three, the Lord chair is the most elaborately carved, its turnings are thickest and most integrated, and it has round, rather than square rear legs, all features that suggest it is a few years later in date than either of its counterparts. The Lord chair also has the unusual feature of vertical supports beneath the arms, a rare device found on only one other chair to date, a lolling chair that was once in the Moffatt-Ladd House and may have first belonged to Alexander Ladd and his wife Maria Tufton Haven Ladd (103B).[2] The Ladd family chair combines a curious assortment of details, including gooseneck handholds and three tiers of stylized

leaves on the legs. Yet, its overall design follows an established Portsmouth precedent, and the ring and vase turnings of the legs conform in general outline to those of the Simes family lolling chair (*cat. no.* 102). The Ladd chair, like the Wendell and Lord examples, represents a distinctive expression of late federal taste in Portsmouth.

All three chairs are also related in their upholstery. Although the frames of these chairs might have been made in any one of Portsmouth's leading cabinet shops, such as those operated by Langley Boardman, Judkins and Senter, or Ebenezer Lord, their original upholstery can be attributed with more confidence to William Sowersby, the only major upholsterer in Portsmouth during the first quarter of the nineteenth century.[3] The Wendell chair still has its original black horsehair upholstery decorated with cast brass nails; the Lord chair retains only its original underupholstery but has been carefully reupholstered to match its original appearance. The Ladd chair has been recovered.

Samuel Lord, the original owner of this chair, is largely forgotten today, although he was a well-known and nearly legendary local figure in his own time. He was born in South Berwick, Maine, and came to Portsmouth in 1803 to serve his apprenticeship in business. In 1823, he organized the Portsmouth Savings Bank and was its first treasurer, thus embarking on a long career in banking and insurance that would involve him in nearly every major business in Portsmouth for half a century. At his death in 1871, his total estate was valued at more than $90,000; no itemized inventory of his possessions was recorded by the probate court.[4]

The chair descended in the Lord family and by the late nineteenth century was regarded as a prize heirloom. Lord's daughter, Mary Elizabeth Lord Morrison, chose to be portrayed sitting in the chair when she commissioned U. D. Tenney (1826–1908) to paint her portrait in 1874. Earlier, in 1847, Mrs. Alexander Ladd, the owner of the Ladd family lolling chair, was painted in a rococo chair that had descended in her family (*see acknowledgments*), and as late as perhaps 1930, Mrs. Edith Greenough Wendell selected the Wendell lolling chair as her seat for a formal portrait photograph. The use of these antique Portsmouth chairs as props in formal portraits of Portsmouth women of distinguished ancestry may have been a conscious means of evoking the glories and prosperity of Portsmouth in the eighteenth and early nineteenth centuries, an era that had faded quickly after the Panic of 1837.[5]

G W R W

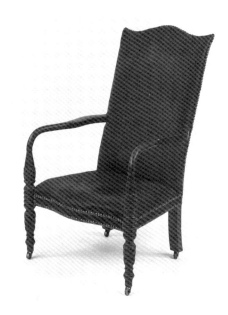

103A.
*Lolling chair. Portsmouth, New Hampshire, 1815–25. *Mahogany, *soft maple, and *eastern white pine; H. 44; W. 26⅜; SD. 21⅜; SH. 13¼. Strawbery Banke Museum, Portsmouth, New Hampshire, gift of Gerrit van der Woude, 1989.12. This chair belonged to Jacob Wendell (1788–1865) of Portsmouth. The black horsehair upholstery and decorative brass nails are original.*

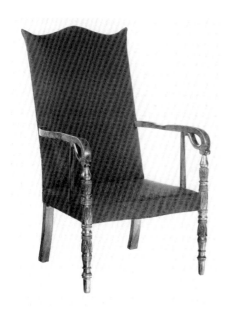

103B.

Lolling chair. Portsmouth, New Hampshire, 1810–20. Mahogany, maple, and eastern white pine; H. 44³⁄₈; W. 25⁷⁄₈; SD. 21¹⁄₈; SH. 14¹⁄₂. Henry Ford Museum and Greenfield Village, Dearborn, Michigan, 64.143.1. This chair probably belonged to Alexander Ladd (1784–1855) of Portsmouth.

Structure and Condition: The construction duplicates that of the two previous chairs: the back matches that of cat. no. 101 while the seat rails conform to those of cat. no. 102. The bowed front seat rail is formed of two pieces: a straight maple rail faced with a curved pine strip. A large triangular block is fastened with two original cut nails at each corner of the seat. The vertical supports beneath the arms are round-tenoned into the arms and glued into slots in the seat rails. The chair has survived in excellent condition. It was conserved and reupholstered by the SPNEA Conservation Center in 1984.

Materials: *Mahogany legs, handholds, arms, and medial arm supports; *soft maple seat rails; *eastern white pine corner blocks and applied strip on front seat rail. Original brass socket casters; reproduction black horsehair on seat.

Dimensions: H. 45⁵⁄₈; W. 25³⁄₄; SD. 21³⁄₈; SH. 15³⁄₄

Provenance: Originally owned by Samuel Lord (1788–1871) of Portsmouth; descended to his daughter Elizabeth Lord Morrison (1817–1903) and afterwards shares a provenance with cat. no. 11. In an account of Sept. 11, 1936, Ralph May noted that this chair "was given to Samuel Lord by his mother, that is, my mother's great grand-mother gave it to my mother's grandfather." Lord's mother was Mehitable Perkins Lord (d. 1831), the wife of General John Lord of South Berwick, Me. It has not been possible to substantiate Ralph May's claim. In all likelihood, Samuel Lord acquired the chair at about the time he moved into the John Paul Jones House (as it is now known) in 1826.

1. *Antiques* 125:3 (Mar. 1984): 511. The chair differs from the Lord chair chiefly in its carving. Instead of the spiral reeding and pineapple carving of the Lord chair, a spiral pattern of carved leaves ornaments the front legs and arm supports.

2. A paper label on the front seat rail of the Ladd chair bears the ink inscription: "Property of Mrs. J. L. Ward." The name refers to Ann Parry Ladd (1842–1925) who married John Langdon Ward (1841–1915) in 1871. Ann's grandparents, Alexander and Maria Tufton Haven Ladd, lived in the Moffatt-Ladd House from 1819 until 1861. When the contents of the house were divided among Ladd family descen-

dants in 1911, many objects went to Ann Parry Ladd Ward (*see cat. no. 62*). The label may date from the time of the dispersal. Subsequent family members preserved a record of the chair's history, which they gave to the antique dealer William Samaha when he purchased the chair in the early 1960s. The Henry Ford Museum acquired the chair from Samaha in 1964.

Another lolling chair with vertical supports beneath the arms may be of Portsmouth origin. Now in the White House collection (962.380.1), the chair conforms to documented Portsmouth examples in such details as its high, narrow back, deeply serpentine crest, sinuous arms with curved handholds, bowed front seat rail, and veneered panels at the corners of the seat (here curly maple rather than the more customary figured birch). However, the design of its legs varies from usual patterns. The swelled and reeded front legs are capped by a cup-like turning with carved leaves; an inverted version of the motif appears at the base of the reeded vase on the arm supports. The medial supports beneath the arms are turned and reeded, rather than sawn and planed like those on the Lord and Ladd chairs. The chair at the White House lacks an early history. If it did originate in Portsmouth, it ranks among the finest examples made there.

3. See cat. nos. 94, 96, and 101.

4. Obituary, *Portsmouth Gazette*, Mar. 25, 1871; Samuel Lord, 1871 inventory, new series, docket 379, Rockingham County (N.H.) Probate. See also Brighton n.d., portrait facing p. 8, and Prince 1975.

5. The portrait of Mrs. May is in the Rundlet-May House (1971.589); the portrait of Mrs. Ladd is in the Moffatt-Ladd House; and the picture of Mrs. Wendell is in the Strawbery Banke Museum collection. I am grateful to Brock Jobe for seeing the connections between, and possible symbolism of, these three portraits.

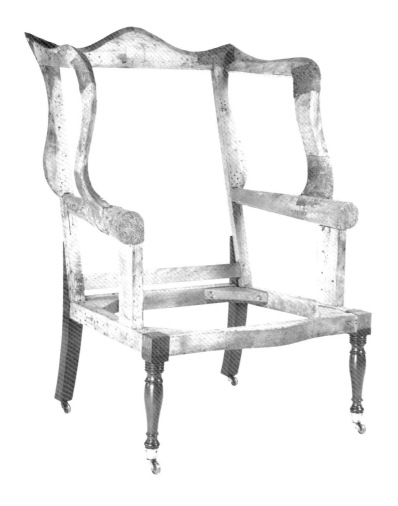

104

EASY CHAIR

Portsmouth, New Hampshire
1810–20
Rundlet-May House
Portsmouth, New Hampshire
Society for the Preservation of New England
Antiquities, gift of Ralph May, 1971.732

EASY CHAIRS OF THIS TYPE, derived (except for the legs) from a design in George Hepplewhite's *Cabinet-Maker and Upholsterer's Guide,* have often been attributed to northeastern Massachusetts.[1] This example, however, has a history in the Rundlet-May House on Middle Street in Portsmouth and is part of a group of easy chairs with similar characteristics that can now be assigned to the Portsmouth area.[2] Another related chair is in the collection at the John Paul Jones House in Portsmouth, and one member of the group was owned originally by Capt. Peter Pray of the town's South End and descended in his family. Two additional chairs, nearly identical to these chairs except for the presence of straight-tapered legs with inlaid stringing and some minor variances in construction, also have a history in the Rundlet-May House. One of them is thought to have been purchased by James Rundlet from Langley Boardman in 1803 for $15 (101A).[3]

Features shared by the members of this group include serpentine crest rails with sharp peaks at the centers, vertically oriented serpentine wings, scrolled arms, and bowed front seat rails. The short turned legs, however, are even more typical of Portsmouth work. Their profile—consisting of four ring turnings, a reel, and a thicker ring turning above the vase-shaped leg, with a cuffed ring, a reel, and a larger, flattened ring above the caster—is similar to that used, for example, on the Wendell family sideboard (*cat. no.* 37) and sofa by Judkins and Senter now at Strawbery Banke Museum (*fig.* 47). Some chairs in the group have the added embellishment of several grooves running around the thickest part of the leg, creating

in essence ring turnings that do not project beyond the body of the leg.[4]

A related chair (104A) has a distinctive feature characteristic of a subgroup of Portsmouth easy chairs: exposed knob-like handholds above the front legs. These chairs have broader proportions and thicker turnings than cat. no. 104, suggesting they were made from five to fifteen years later. This example, fitted with a commode seat, bears the brand of its original owner, Lewis Barnes, a Portsmouth merchant (*see cat. no. 99*). He married Abby Walden on October 2, 1803, and resided in Portsmouth until his death in 1856. The easy chair was acquired for the Thomas Bailey Aldrich Memorial in 1907 or 1908.[5]

G W R W

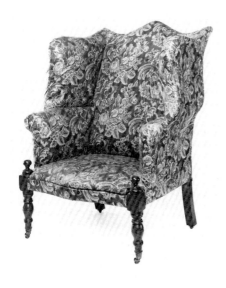

104A.

Easy chair. Portsmouth, New Hampshire, 1820–25. Mahogany, birch, maple, and eastern white pine, H. 45¼; W. 33⅞; SD. 25¼; SH. 14¼. Strawbery Banke Museum, Portsmouth, New Hampshire, gift of the Thomas Bailey Aldrich Memorial Association, 1980.779. This chair belonged to Lewis Barnes (1776–1856) of Portsmouth.

Structure and Condition: The seat rails are tenoned to the legs, and the arm supports are tenoned into the seat rails and into the arms. The arms are composed of two boards glued one on top of the other, and each arm is tenoned through its respective stile and wedged from the back. The wing supports are set into sliding dovetails in the arms and tenoned into the wings; the top rail of each wing is set into a notch in the stile and secured with two cut nails. The crest rail and stay rail are tenoned to the stiles. The bowed front rail is made of a single board rather than the two boards used on the preceding lolling chair (*cat. no. 103*). A large triangular block is nailed to each corner of the seat frame with four original cut nails. Each rear leg is joined to the rear stile with a characteristic splice joint reinforced with a single nail (*matching that described in cat. no. 101; see 101B*).

When acquired by SPNEA in 1971, the chair had a spring seat, yellow printed upholstery, a shattered right front leg that had been poorly reattached to the seat rails, and a darkened varnish over an early linseed oil finish. In 1984, SPNEA conservators Robert Mussey and Joseph Twichell removed the spring seat and later upholstery, rebuilt the upper portion of the right front leg, and cleaned and waxed the legs.

The chair frame has only been upholstered twice. Though none of its original upholstery survives, the chair retains evidence of the placement of the original webbing: it had two vertical and two horizontal strips on the back, three front-to-back strips and two side-to-side strips on the seat. Brass nails never ornamented the rails, suggesting that the chair may have been fitted with a slip cover originally (*see cat. no. 101*). To strengthen the frame, the maker or upholsterer of the chair wrapped strips of linen, soaked in glue, around the joints binding each wing to the back and the arm.

Materials: *Mahogany legs; *birch crest rail, seat rails, arm supports, stiles, wing supports and wings, and stay rail; *eastern white pine arms and corner blocks. Original brass casters.

Dimensions: H. 45¹⁵⁄₁₆; W. 34⅝; SD. 23³⁄₁₆; SH. 13¹³⁄₁₆

Provenance: The chair was part of the contents of the Rundlet-May House given to SPNEA by Ralph May (1882–1973). Due to some ambiguity in the family records, the first owner and early history of the chair are unknown, although the chair undoubtedly descended in the Rundlet family or the Lord family.

1. Hepplewhite 1794, pl. 15. The design calls for tapered legs and spade feet. See Montgomery 1966, no. 126; *Sack Collection*, 3:813.

2. Stokes 1985, no. 29.

3. The chair at the John Paul Jones House is owned by the Portsmouth Historical Society (PL31). The Pray family chair was sold at auction at the Seaboard Auction Gallery in Eliot, Me., May 6, 1989, and again at Northeast Auctions, Manchester, N.H., Mar. 15, 1992, lot 482; it is now in a private collection. The Rundlet-May chairs are discussed in Stokes 1985, nos. 27, 28. One of them (101A) is currently without upholstery. Its construction is very similar to the chair in this entry, although the maker used pins to secure the mortise-and-tenon joints in the frame and the arms are made of a single piece.

4. For example, see fig. 47, and Warren 1975, no. 148.

5. Silver flatware owned by Barnes is in the collection of Strawbery Banke Museum, and other objects associated with him came on the market in the mid 1970s from a descendant in the Midwest. Chairs bearing his brand are also in various collections (*see cat. no. 99*). Information on Barnes is derived from the Strawbery Banke Museum accession files. Related chairs with handholds include examples published in *Antiques* 48:3 (Sept. 1945): 128, and 51:4 (Apr. 1947): 233, and several examples in private collections.

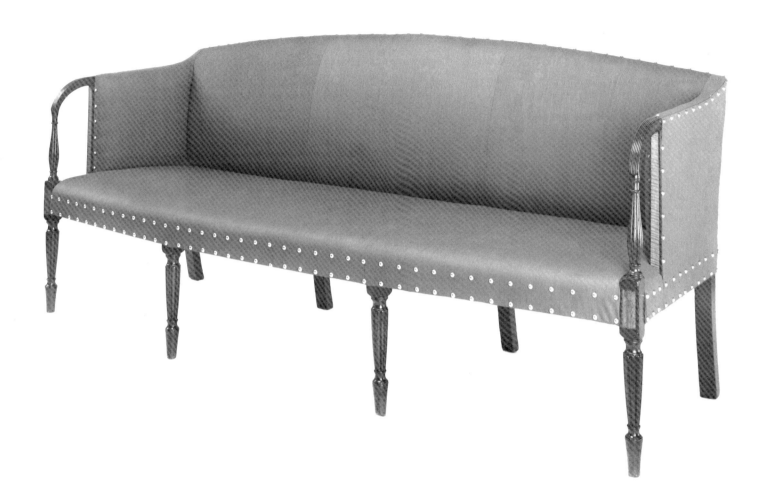

DURING THE FEDERAL ERA, sofas became an indispensable part of fashionable Portsmouth households. The merchant Samuel Ham kept "1 sopha covered with Scarlet" and a matching "Suite of Scarlet curtins & trimmings" in his best parlor.[1] John Peirce filled his southwest room with a pair of small sofas as well as a larger one, all covered in black horsehair.[2] His neighbor, James Rundlet, acquired this striking example and its mate for his new home on Middle Street, completed in the fall of 1808. Although located in the front entry by the early twentieth century, Rundlet's sofas probably first stood in the best parlor or adjacent front sitting room.[3] There, they would have complemented an assortment of elegant furnishings, including a set of fancy chairs (*cat. no.* 98), matched girandole looking glasses (*cat. no.* 117), and a pair of mahogany card tables made by the same craftsman who constructed the sofas (*cat. no.* 63).

The sofa's arched crest rail, curved handholds, and reeded front posts (105A) adhere to a standard formula, also adapted for use on Portsmouth lolling chairs. Instead of leaving the space beneath the arms open, as on William Simes's chair (*cat. no.* 102), the maker of this sofa elected to fill it with abbreviated wings, which offer more support and protect the sitter from drafts. To ornament the front edge of the wings, he applied veneered panels of curly maple. Many similarly designed sofas survive, but only a few relate closely to this well-documented Portsmouth interpretation.[4] Among its Portsmouth counterparts, most have a veneered band of figured birch on the crest rail (*see cat. no.* 106) instead of the cloth-covered crest seen here.

105

SOFA

Portsmouth, New Hampshire
1808–15
Rundlet-May House
Portsmouth, New Hampshire
Society for the Preservation of New England
Antiquities, gift of Ralph May, 1971.576a

When acquired by SPNEA in 1971, this sofa was covered in a striped red fabric probably installed in 1898. Conservators removed the upholstery in 1983, discovering the original webbing, linen sackcloth, and some of the stuffing still intact on the back and wings as well as linen rolls filled with straw on the front and side seat rails. Yet they found no clear evidence of the original show cover.[5] SPNEA curators chose as a replacement a scarlet worsted moreen, perhaps similar to the material used on Samuel Ham's sofas and related in color to the fabric that had covered Rundlet's sofas for most of the twentieth century. A row of widely spaced brass nails, placed 2" apart, was mounted along the crest rail and wings, while double rows were installed on the seat rails. Although unusual in its spacing, the pattern replicates the original. Loose cushions arranged along the back of the sofa would have embellished the design and enhanced the level of comfort. In *The Cabinet-Maker and Upholsterer's Drawing Book,* Thomas Sheraton recommended that four loose cushions used at the back of a sofa should "generally [be] made to fill the whole length."[6] Such an elegantly trimmed and comfortable pair of sofas surely impressed all who visited James Rundlet's mansion.

A R H and B J

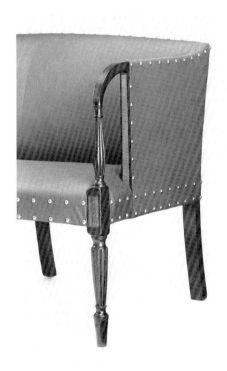

105A.

Front leg and arm support.

Structure and Condition: Standard rectangular mortise-and-tenon joints fasten all parts with four exceptions. The top rail of each wing is glued into an open notch in the rear stile. The top of the arm support is round-tenoned into the curved handhold. Large triangular blocks are nailed at each corner of the seat. Three sway-backed seat braces fit into dovetail-shaped slots in the front and rear seat rails. As on most federal sofas, double-tenons secure the medial legs to the seat rails. The joint provides a much stronger bond between the leg and rail than a standard single tenon. The leg and stile at each rear corner are of one piece; the leg and arm support at each front corner are of one piece. The support is not centered above the leg block but set to one side. Original strips of linen, soaked in glue, are wrapped around the joints at the upper corners of the crest rail and wings.

The frame is in excellent condition; the only notable replacement is the lower half of the rectangular veneered panel on the left front leg. The present cover is probably the fourth. In 1990 SPNEA conservators reupholstered the sofa us-ing a nail-less method which prevents further damage to the frame (*see also cat. no.* 84). The original stuffing on the back and wings had condensed and sagged. Conservators added a thin skimmer of curled hair, a thin modern linen undercover, and a layer of polyester batting to recreate the original contours of the back and wings. They shaped a 2" thick slab of high-density ethafoam and mounted it onto the top of the seat rails. A layer of polyester batting and a new linen undercover followed. All of the upholstery was then covered with reproduction red moreen backed with red cotton. Brass nail heads conforming to the original pattern were glued to the moreen.

Inscriptions: "R Covered 1898 by Currs [?]" in pencil on the back of the crest rail.

Materials: *Mahogany legs and handholds; mahogany and curly maple veneer on front edge of wing stiles; birch veneered panel on front legs; *soft maple crest rail, stay rails, medial back stiles, front seat rail, and seat braces; *birch top rails and stiles of wings and side and rear seat rails; eastern white pine corner blocks. Reproduction red worsted moreen on seat, back, and wings.

Dimensions: H. 35 1/16; W. 79 3/8; SD. 26 1/8; SH. 14 3/4

Provenance: This pair of sofas shares a provenance with cat. no. 8.

1. Samuel Ham, 1813 inventory, old series, docket 8702, Rockingham County (N.H.) Probate.

2. John Peirce, 1815 inventory, old series, docket 8908, Rockingham County (N.H.) Probate.

3. Unfortunately, no nineteenth-century inventories for James Rundlet's house survive. An early twentieth-century photograph depicts the sofas in the front entry; a detailed description of the contents of the house prepared by Mary Ann Morrison May in 1936 also refers to the sofas in the entry. Both the photo and description are in the SPNEA Archives.

4. The list of sofas of the same form is lengthy. They were probably made in coastal communities from Portland, Me, to Boston, Mass. The most similar examples to Rundlet's are one at Strawbery Banke Museum (1975.3941) and another advertised in *Antiques* 90:1 (July 1966): 13. Others include: Anderson Galleries, sale 2192, Nov. 11–12, 1927, lots 64, 244; Anderson Galleries, sale 2287, Jan. 9–10, 1928, lot 54; Anderson Galleries, sale 2300, Dec. 7–8, 1928, lot 36; American Art Association, sale 3787, Nov. 7–9, 1929, lot 273; American Art Association, sale 4018, Jan. 24–28, 1933, lot 929; American Art Association, sale 4252, Apr. 18, 1936, lot 150; Parke-Bernet, sale 32, Apr. 23, 1938, lot 105; Parke-Bernet, sale 629, Jan. 26–27, 1945, lot 134; Parke-Bernet, sale 706, Nov. 16–17, 1945, lot 339; Parke-Bernet, sale 1526, May 27–28, 1954, lot 168; *Antiques* 100:1 (July 1971): 23; *Antiques* 129:4 (Apr. 1986): 804; Skinner, Inc., sale 1274, Oct. 27–28, 1989, lot 356. Three related sofas with Maine histories are known: one at the York Institute (Sprague 1987a, no. 55), another at the Portland Museum of Art that descended in the Waite family of Portland, and a pair at the Winterthur Museum that originally belonged to William Bond of Portland but may have been made in Boston (Montgomery 1966, no. 273; see also Flanigan 1986, no. 55, for a similar version without a history that has been attributed to Boston).

5. When examining the frame, conservator Elizabeth Lahikainen found a few threads from an earlier horsehair covering but could not determine whether the horsehair was from the first or a subsequent upholstery.

6. Sheraton 1802, 388, pl. 35.

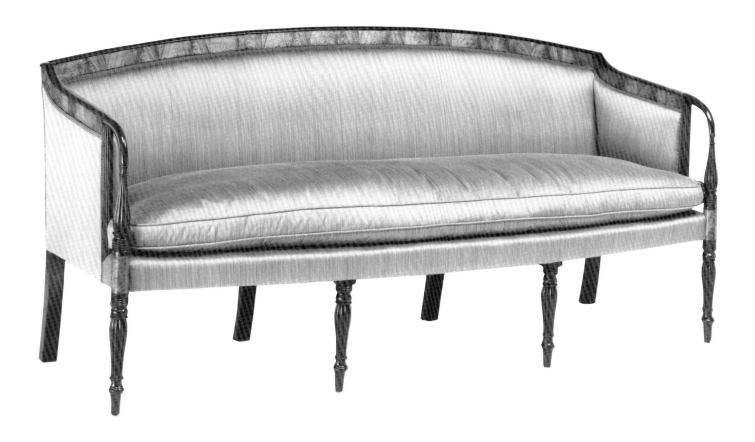

106

SOFA

Portsmouth, New Hampshire
1810–20
Collection of Clarence Zimmerman

THIS SOFA, which descended in the Tredick and Brewster families of Portsmouth, is the best documented example of a form traditionally associated with the town. Henry Tredick, a sea captain from neighboring New Castle, moved to Portsmouth in 1794. The captain and his wife, Margaret Tarlton Tredick, appear to have owned several fine examples of locally made furniture, including an inlaid card table that bears his brand.[1] The sofa remained in the family until the mid twentieth century.

The Tredick sofa closely resembles the lolling chair owned by his fellow townsman, Jacob Wendell (102A). Both examples feature short cylindrical feet, reeded legs with baluster and ring detailing, birch veneer at the terminus of the upper leg, and reeded bulb-shaped arm supports with curved handholds (106A). What sets the Tredick sofa apart, and others like it, are the bands of vertically arranged flame-birch veneer that delineate the wings and arched crest rail. This striking detail provides upholstered sofas with the same contrasts of color and pattern more commonly seen on case furniture (*see cat. nos.* 10 *and* 37). Like the drop-panel chest of drawers (*cat. no.* 11), the veneer-crested sofa has become a signature of Portsmouth federal furniture.

The cost of these large decorative sofas was considerable. In 1810, Langley Boardman charged the ship captain Reuben S. Randall $35 for a standard model. Three years later, he billed another customer $46 for a more elegant example. In 1816, Jacob Wendell paid approximately $40 for a plainer version without veneer on the crest (*fig.* 47).[2] Sofas compared in price with an ornate sideboard or secretary

and bookcase but far exceeded other forms of seating furniture. A mahogany side chair with horsehair cover and brass nails cost about $9; an easy chair sold for $15.[3]

Despite their expense, sofas became increasingly popular. Fashion prescribed their placement along the walls of the best parlor. As the centerpiece of these ceremonial interiors, sofas took on special significance. They soon became valued family heirlooms, and many have survived as a result. Six with veneered crests retain histories of ownership in the Portsmouth area.[4] Another twenty sofas without provenances can be attributed to the town.[5] The members of this sizable group share numerous similarities. All have eight legs and, with one exception, measure from six to seven feet in width.[6] The construction of their frames is remarkably consistent. Most resemble one originally owned by George McClean, a Portsmouth ship captain (106B). Though none in the group retains its original upholstery, all appear to have had a stuffed back and seat, perhaps a series of pillows along the back or against the wings (see cat. no. 105) but not a separate seat cushion. Two of the sofas nearly match the Tredick family version in design.[7] The rest vary slightly in three areas: the choice of wood for the crest, the shape of the outer front legs where they join the seat rails, and the ornament on the legs and arms supports.

All of the sofas have a band of veneer along the crest and wings, but the type and embellishment of that veneer differs. Most customers preferred figured birch, but some selected curly maple, bird's-eye maple, or she-oak instead. On the most elaborate sofas, craftsmen enhanced the crest with a central panel, sometimes fitted with an inlaid oval.

The corner legs of both the McClean and Tredick sofas have a cylindrical turning at the juncture with the seat rails. On the latter, birch veneer wraps around the turning—a popular detail that appears on almost half of the sofas in the group. On the rest, the leg terminates in a block ornamented with a rectangular panel of light-wood veneer, like that on James Rundlet's sofa (cat. no. 105). The block permits a stronger joint between the leg and seat rails but interrupts the graceful continuity of the turned leg and arm support.

On the Tredick sofa, the decoration of the legs and arm supports is limited to reeding and ring and baluster turning. Craftsmen offered other, more expensive options, including carved leaves and scribed lines on the legs and arm supports. Usually the leaves are long and narrow with little definition or relief, as on the Simes lolling chair (cat. no. 102). On one rare exception, the leaves display much more detail, and on another, deeply carved oak leaves ring the upper portion of the leg.[8]

The Tredick sofa and its many relations document the wide appeal of this classic Portsmouth form. A statement of luxury and opulence, it offered its owners comfort as well as status. Like the parlor for which it was intended, it possessed "all the elegance embellishments can give."[9]

D C E and B J

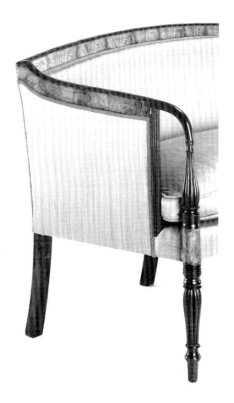

106A.
Front leg and arm support.

Structure and Condition: The construction of this sofa matches that of James Rundlet's sofa (*cat. no.* 105) with three exceptions. The seat rails are dovetailed at each front corner and screwed to the legs, as on cat. no. 102. On the front edge of the wing, a half-round reeded pilaster takes the place of the veneered panel on the Rundlet sofa. Two medial braces, rather than three, are set into dovetail-shaped slots in the front and side seat rails. The construction of the back could not be examined because of the upholstery, but it probably conforms to that of the Rundlet and McClean sofas (106B).

When acquired by Israel Sack in 1958, the sofa retained an old darkened finish and early twentieth-century leather upholstery. Since then, it has been cleaned and reupholstered twice, most recently by Andrew Passeri for the present owner. L-shaped angle irons once reinforced the front corners of the seat but have now been removed. The corner blocks are replaced. The rear legs have been painted with dark brown graining. Several shrinkage cracks in the mahogany cap along the crest rail have been filled with splines.

Materials: Mahogany front legs, handholds, reeded pilasters on front edge of wings, and cap on crest rail of back and wings; birch veneer on crest rail; *birch rear legs and medial braces; *elm front seat rail; elm or maple for side and rear seat rails. Modern green striped silk upholstery on seat, back, and wings.

Dimensions: H. 36½; W. 80½; SD. 25½; SH. 14¼

Provenance: Probably first owned by Henry Tredick (1769–1815) and his wife, Margaret Tarlton Tredick (1776–1843); descended to their son Thomas T. Tredick (1799–1888); to their grandson Charles Tredick (1846–95); to Charles's wife, Abbie Rowell Tredick (1843–1927); to her daughter Martha Tredick Brewster (1879–1958), who sold it to Israel Sack in 1958. Sack sold it to a succession of collectors, beginning with Emily Post in 1959 and ending with the present owner, who acquired it in 1987.

Publications: Antiques 75:1 (Jan. 1959): inside cover; Buckley 1963, fig. 8; *Antiques* 90:3 (Sept. 1966): inside cover; *Sack Collection,* 1:53; and *Sack Collection,* 2:357.

106B.

Sofa. Portsmouth, New Hampshire, 1810–20. Mahogany and birch veneer; H. 34; W. 72; SD. 24. Private collection, courtesy Israel Sack, Inc. This sofa belonged to George McClean (d. 1820), a Portsmouth ship captain, and bears his brand. The construction of this frame is nearly identical to that of cat. no. 106.

1. A card table bearing the brand "H. TREDICK" and resembling cat. no. 61 sold at the American Art Association, sale 4085, Feb. 9–10, 1934, lot 367. It is not known if the sofa is branded; the frame could not be examined because of the upholstery. Since its initial publication in 1959, this sofa has been known as the Brewster sofa. The authors would like to thank the Rev. Charles Brewster for clarifying the original ownership of the sofa in the Tredick family. Letter to the authors, Apr. 7, 1992.

2. Langley Boardman to Reuben S. Randall, bill, Jan. 26, 1813, Wendell Collection, case 3, Reuben S. Randall bills, Baker Library, Harvard Business School; Boardman v. Wentworth, 1813, series A, docket 38657, Rockingham County (N.H.) Court, State Archives; Judkins and Senter to Jacob Wendell, bill, June 29, 1816, Wendell Collection, case 13, folder 4, Baker Library, Harvard Business School. The Wendell bill refers to the purchase of a sofa and pair of card tables for $70. At the time, the standard price for a pair of card tables was $30, suggesting a price of $40 for the sofa.

3. The price of the mahogany chair is based on Langley Boardman's bill to George Ffrost for a set of fashionable square-back chairs; see cat. no. 94. The charge for an easy chair is based on accounts between Boardman and both James Rundlet and John Wendell; see 8A and Langley Boardman to "Mʳ Wendell Esqʳ.," bill, Aug. 4, 1802, Wendell Collection, case 13, Jacob Wendell bills, Baker Library, Harvard Business School.

4. Four of the six can be linked to specific residents of Portsmouth: Henry Tredick (*cat. no.* 106), Captain George McClean (106B), the silversmith William Simes (*Antiques* 2:2 [Aug. 1922]: 50), and the lawyer and statesman Daniel Webster. The Webster sofa passed to Webster's nephew, Benjamin Webster of Epsom, N.H., and descended in his family until the early 1960s. It subsequently was bought by the antiques dealer John Walton and sold to the White House (961.24.1); see *The White House* 1969, 106.

One of the remaining sofas was located in the Wentworth-Coolidge Mansion on the outskirts of Portsmouth during the early twentieth century and perhaps for much of the nineteenth century as well; see Randall 1965, no. 192. The final sofa descended in the Thaxter family of Kittery, Me.; see Skinner, Inc., sale 1362, Jan. 12, 1991, no. 177.

5. These twenty sofas include five in the following public collections: Currier Gallery of Art (*Antiques* 83:3 [Mar. 1963]: 259); Henry Ford Museum (28.1.31); Metropolitan Museum of Art (10.125.176); Winterthur Museum (Montgomery 1966, nos. 271, 272; the latter was deaccessioned and sold at Christie's, Jan. 26, 1991, lot 360). Privately owned examples are illustrated in American Art Association, sale 4193, Oct. 25–26, 1935, lot 187 (later pictured in *Antiques* 116:1 [July 1979]: 4); American Art Association, sale 4267, Oct. 9–10, 1936, lot 176; American Art Association, sale 4366, Jan. 21–22, 1938, lot 66; Parke-Bernet, sale 204, May 18, 1940, lot 239; *Antiques* 54:4 (Oct. 1948): 221; *Antiques* 58:2 (Aug. 1950): 75; *Antiques* 100:4 (Oct. 1971): 534; *Antiques* 116:6 (Dec. 1979): 1214; Christie's, Oct. 13, 1984, lot 444; Christie's, Jan. 23, 1988, lot 387; Phillips, sale 621, Apr. 19, 1989, lot 293; Christie's, Jan. 17–18, 1992, lot 493; *Sack Collection*, 6:1506; *Sack Collection*, 8:2258 (this sofa, which varies from others in the group in the extreme boldness of its turnings, may have originated in another community, perhaps in southern Maine or northeastern Massachusetts). Finally, a rare version of the form with oak leaf carving on the legs instead of the standard reeding or narrow stylized leaves is privately owned and unpublished.

6. The exception is an enormous sofa, measuring nine feet in length, that supposedly belonged to General Henry Knox, a man also known for his great size. The Massachusetts native weighed nearly three hundred pounds and, according to a friend, lived in lavish grandeur "in the style of an English nobleman." Knox built an imposing federal mansion in Thomaston, Me., during the late 1790s. See *Antiques* 58:2 (Aug. 1950): 75. For information on Knox and his home, see Kirker 1969, 93–100, Roy 1988, 62–82, and Taylor 1990, 37–47.

7. The related sofas are in the collections of the Metropolitan Museum of Art and Winterthur Museum; see note 5. Both differ slightly from the Tredick sofa. The latter has the addition of an inlaid oval panel at the center of the crest rail, and the former has arrow inlay on the front edge of the wing stiles.

8. *Sack Collection*, 6:1506; the sofa with oak leaf carving is privately owned.

9. Hepplewhite 1794, 24.

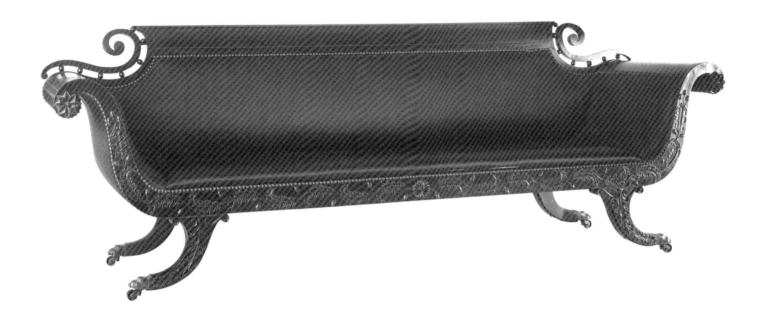

 107

Sofa

Attributed to Langley Boardman (1774–1833)
Portsmouth, New Hampshire
1815–25
Moffatt-Ladd House
Portsmouth, New Hampshire
In care of The National Society of The Colonial
Dames of America in the State of New Hampshire
Gift of Mrs. Archer E. King, Jr., 1977.14

In 1900, THIS IMPOSING SOFA stood prominently in the front entry of the Portsmouth home built for Langley Boardman nearly a century earlier.[1] By this time, the house had descended to Boardman's grandchildren, who decided to sell it to William E. Marvin, the mayor of Portsmouth. Years later, the antiquarian Stephen Decatur talked to the Marvin family about this transaction:

> It developed that when the house was sold the purchaser stipulated that certain pieces of furniture should remain in it. This was agreed to and, as a matter of interest, they are still there. Among them was a sofa and a sideboard which the Boardman family said had always been in the house.[2]

Decatur went on to explain that the Marvins wanted to retain these pieces because they were "exceptionally large, [and] had been constructed to fit the particular places they occupied…"[3] The sofa is indeed large. It measures eight and one-half feet in length and weighs far more than earlier federal examples, such as cat. no. 106. Yet, its position was not fixed. Its feet have always had casters, and the sofa was moved about to accommodate particular needs.

During Langley Boardman's day, the sofa adorned the parlor, not the entry hall. His estate inventory of 1833 describes it with characteristic brevity as "1 Sofa $20." It formed part of a standard array of parlor furnishings that included two looking glasses, a girandole mirror, a pair of card tables, sixteen rush-seated fancy chairs, a pair of "Crickets" or stools, and carpeting.[4] When not in use, the sofa, chairs, and card tables probably lined the walls; but for conversation or card playing,

they were drawn closer to the fireplace or arranged into a more casual grouping.

The appraisers of Boardman's inventory used the term Grecian to describe the card tables in the parlor as well a Pembroke table in the dining room. Though lacking the Grecian label, this sofa and the family sideboard are also in the new style. English design books such as Thomas Hope's *Household Furniture and Interior Decoration* of 1807 or George Smith's *A Collection of Designs for Household Furniture and Interior Decoration* of 1808 popularized this later phase of neoclassicism, which also became known as the Empire style. Creators of the fashion sought to interpret ancient Greek and Roman sources with greater fidelity. They also looked to other exotic locales like Egypt for inspiration. Their work is more substantial than earlier Adamesque furniture and places a greater emphasis on broad expanses of dark, figured mahogany with occasional accents of brass. A new vocabulary of ornament defined the style. Saber legs, scrolled arms, tablet backs, paw feet, and such details as the anthemion and rosette became familiar trademarks.[5]

The new style had appeared in Portsmouth by 1821, when Jacob Wendell bought a Grecian card table at auction (*cat. no. 65*). Boardman readily adopted the style, offering customers numerous forms in the Grecian mode.[6] This sofa, however, far exceeds other documented Portsmouth products of the era in its sophistication (*compare with cat. no. 68*). Its shape follows a popular pattern but in this case exhibits unusual grace.[7] Numerous decorative details relieve the severe outline of the form. Bold scrolls flank the corners of the crest, floral rosettes cap the ends of the arms, sweeping acanthus leaves cover the front saber legs, and, most noticeable of all, a chain of oak leaves and acorns meanders across the front rail (107A). The quality of the carving is exceptional, and the craftsmanship throughout the frame is executed with skill. The present black horsehair upholstery is not original but probably corresponds to the sofa's original treatment. Small cylindrical bolsters and larger square pillows may have been placed against each arm.

Boardman's sofa has no exact counterparts. It is reminiscent of some Salem furniture of the same period but differs in its carved details, especially the oak leaves on the rails.[8] Boardman apparently designed it to meet his own specifications rather than those of the marketplace. He employed specialists to carve and upholster the frame and may well have turned over much of the cabinetwork and finishing to others within his shop. Yet he must have overseen the production of this striking sofa, because it was destined for his own home. There, it surely made a memorable impression, its striking design and lavish ornament reminding all of the stature of Langley Boardman, Portsmouth's most successful artisan and entrepreneur.
D C E

107A.
Front leg and scrolled arm.

Structure and Condition: Both the legs and side seat rails are tenoned into the front and rear rails. The seat frame never had corner blocks. Two medial braces are glued into sliding dovetails in the front and rear seat rails. The veneered panel on the crest consists of two matched flitches that meet at the center. Each scroll at the corner of the back is made of two pieces of solid mahogany glued together along a lengthy lap joint. The decorative balls are fastened with round tenons. All of the carved decoration on the sofa is applied. The construction of the back and arms could not be determined because of the upholstery.

The sofa retains virtually all of its original elements except upholstery. The legs have sustained considerable damage because of their design and the amount of weight they support. All but the right leg have broken. The left front and rear legs have been resecured with glue. The break in the right rear leg is more severe and has been bound with string. Angle irons have also been screwed to the underside of the legs. The scrolls at the corners of the back are reinforced by angle irons as well. The veneer on the tops of the arms has minor cracks, and there are minor chips on the legs. A thick, darkened varnish covers the exposed parts of the frame.

Materials: *Mahogany legs, applied carving, and scrolls at corners of back; mahogany veneer on front rail, front legs, arms, arm supports, and crest rail; *hard maple right seat rail; *birch for all other secondary work. Original brass feet and casters with traces of old gilding; replaced black horsehair on seat, back, and arms.

Dimensions: H. 37⅞; W. 102⁵⁄₁₆; SD.13¾; SH. 14

Provenance: Originally owned by Langley Boardman (1774–1833); descended as part of the contents of the Boardman house to Langley's son, Dr. John H. Boardman (1804–74); to his grandchildren who sold it with the house to William E. Marvin (1872–1938) in 1900; lent to the Society of Colonial Dames by Mrs. William E. Marvin and later given by Mrs. Archer E. King, Jr., daughter of Mr. and Mrs. Marvin.

Publications: Decatur 1937, 5; Howells 1937, 209; Giffen (Nylander)1970a, 122.

1. An early twentieth-century photograph in the SPNEA Archives shows the sofa in the front entry of the Boardman house. Decatur 1937, 5, and Howells 1937, 209, depict the sofa in the same location.

2. Decatur 1937, 5. The sideboard, now owned by Strawbery Banke Museum (1974.653), is pictured in Howells 1937, 209 and Ward and Cullity 1992, pl. 20.

3. Decatur 1937, 5.

4. Langley Boardman, 1833 inventory, old series, docket 12564, Rockingham County (N.H.) Probate.

5. Talbott 1991, 960.

6. Among the shop contents listed in Boardman's estate inventory of 1833 are center tables, bureaus with square "pillows," and "pillowed" worktables and Pembroke tables—all in the Grecian style.

7. The form had appeared in England by 1800 and soon became a popular alternative to more delicate Adamesque examples. Thomas Sheraton published a design for a Grecian sofa with scrolled arms and a tablet crest as early as 1803, and the *Supplement to the London Chair-Makers' and Carvers' Book of Prices* of 1808 discusses the construction of the form in detail. See Sheraton 1803, 2: pl. 75; *Supplement* 1808, 95–107; Montgomery 1966, 117–18.

8. Salem couches with carving reminiscent of that on the sofa are in the collections of the Winterthur Museum and Henry Ford Museum. See Montgomery 1966, no. 281.

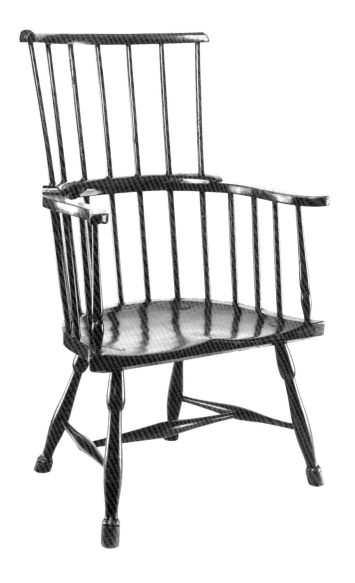

❧ *108*

HIGH-BACK WINDSOR
ARMCHAIR

Portsmouth, New Hampshire, or Rhode Island
1750–80
Strawbery Banke Museum
Portsmouth, New Hampshire
Gift of Mr. and Mrs. Thomas L. Sanborn
1975.26

THIS CHAIR, ONE OF A PAIR, is thought to have been owned originally by the Reverend Samuel McClintock, for more than half a century a well-known and beloved minister in Greenland, New Hampshire. McClintock's father, William, emigrated from Scotland to America in the late seventeenth century. He was a farmer, and Samuel was one of his nineteen children borne by four wives. Samuel was educated at Princeton and accepted the charge from the Congregational Church at Greenland in 1756. During the Revolution, McClintock was the chaplain of the 2nd New Hampshire regiment at the Battle of Bunker Hill, and he is pictured in John Trumbull's portrait of the death of Major Warren at that clash.[1]

In his will, McClintock left "six green sitting chairs & the house furniture of every kind which was her mother's" to his daughter Elizabeth, and his inventory also included numerous chairs, including six green chairs. However, no traces of paint can be found on the Windsors that have come to us today, and it is impossible to know if any of the other inventory listings of chairs refer to the chairs in hand.[2]

The McClintock chairs are closely related in style to several other examples with New Hampshire histories, including a chair in the Woodman Institute in Dover, New Hampshire, and another example bearing the brand of the Salter family of Portsmouth. The use of yellow birch for the McClintock chairs also suggests a New Hampshire or northern New England origin for them. Windsor chairs were made in Portsmouth before the Revolution, as suggested by a bill from the local turner

Richard Mills to William Barrell on September 1, 1766, for two Windsor chairs costing £1.16.0 for the pair.[3]

However, the extensive research by Nancy Goyne Evans, the preeminent scholar of American Windsor furniture, indicates that this cluster of chairs with New Hampshire histories may actually be part of a group of related chairs made in Rhode Island in an early style very much in the English tradition.[4] Several features of the McClintock chairs, including the flaring seat corners and the leg design, with a long baluster-shaped section terminating in an extended cylinder (some of which has been worn away), place the chairs within an identifiable sequence of Rhode Island and eastern Connecticut designs.[5] The McClintock chairs and the others like them with New Hampshire histories could well have been imported into the Piscataqua region.

G W R W

Structure and Condition: The chair is made with a two-piece seat, three-piece arm, and a crest rail of a single piece. Seven spindles project through the arms and into the crest. The center spindles and the outermost spindles on each side are held in place with pins; the outermost spindles on the lower level are turned. The legs are tenoned through the seat.

The chair has seen hard use. A spline has been added at the joint of the two boards in the seat, and a large bolt has been screwed through the back edge of the seat into the front board to secure the two boards together. The outer tip of each arm is missing, and the seat was once upholstered. There are other minor breaks and repairs, and the feet have been cut down about 2".

Inscriptions: A typewritten note, an extract possibly from the donor's grandmother's will, was taped to the underside of the chair seat. It reads: "Seventh: To Mary M. Gookin, I give and bequeath, the sum of $100.00 (one hundred dollars), also my necklace with brass pendant, also my little cluster diamond ring and the t[wo] chairs which belonged to her great great great grandfather, Rev. Samuel McClintock."

Materials: *Yellow birch.

Dimensions: H. 38¾; W. 24¾; SD. 14⅞; SH. 14½

Provenance: According to a history provided by the donor of the chairs, the pair was owned originally by the Reverend Samuel McClintock (1732–1804) and his first wife, Mary (Montgomery) McClintock (ca. 1737–1785) of Greenland, N.H. They passed (according to the donor) to his daughter, Mary (b. 1760), who married William Stoodley; next to their daughter, Mary Stoodley, said to have married the Rev. Nathaniel Gookin III of Greenland; to their son, Capt. John Gookin; to his son, Capt. George Gookin and his wife, Mary (Leavitt) Gookin; and, finally, to their granddaughter, Sara Gookin (Mrs. Thomas L.) Sanborn (b. 1893) of Norwalk, Conn., who gave the chairs to Strawbery Banke Museum in 1975.

Recent research into genealogical and probate records has been unable to confirm this traditional history in detail; the trail becomes especially confused in the third generation of ownership in the mid nineteenth century. However, the chairs were clearly highly regarded family

heirlooms, and there seems no reason to doubt the general outline of descent through the McClintock, Stoodley, and Gookin families of Portsmouth and Greenland to the eventual donor.[6]

1. For McClintock, see Brewster 1869, 160–66. Three volumes of McClintock's manuscript sermons are in the Strawbery Banke Museum Library, and the museum also owns a leather billfold and a pair of spectacles said to have belonged to him.

2. Samuel McClintock, 1804 inventory, old series, docket 17259, Rockingham County (N.H.) Probate.

3. The Woodman Institute and Salter chairs were brought to Strawbery Banke's attention by Nancy Goyne Evans; see her 1975 correspondence in the museum's object files (1975.26–27). For another related chair, see Neumann 1984, fig. 496. At SPNEA's Hamilton House, there is a related chair that is missing its highback (1949.224). The Mills bill is in the waste book of William Barrell, then residing in Portsmouth, in the Stephen Collins Collection, 149:110, Library of Congress; this document was kindly brought to the project's attention by Richard M. Candee.

4. Letter from Nancy Goyne Evans to the author, Apr. 20, 1992, Strawbery Banke Museum object files, contains references to related Rhode Island and Connecticut chairs. I am grateful to Evans for sharing her analysis of these chairs. For related English chairs, see Kirk 1982, figs. 1097–99, 1114, 1131; and Sotheby Parke Bernet, sale 342, July 12–14, 1982, lot 143.

5. The McClintock chairs have a late form of the so-called "Colt" foot; see Kirk 1982, 294.

6. I am grateful to Rodney Rowland for his assistance in attempting to confirm the history of these chairs.

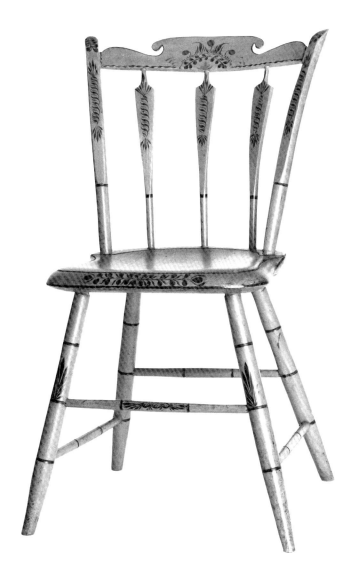

WINDSOR SIDE CHAIR

Portsmouth, New Hampshire, area
1815–30
Private collection

LARGE WINDSOR ARMCHAIRS, like the previous example, were produced in small numbers to be sold separately or in pairs for use in the best rooms of affluent households. By the late eighteenth century, craftsmen offered vast quantities of low-back Windsor chairs, and patrons purchased them in large sets as a less expensive alternative to upholstered seating. Federal-era artisans dramatically altered the Windsor through the introduction of bamboo-like turnings on the legs and stretchers, tablet crests, and arrow spindles (called flat sticks in the period).[1] Portsmouth artisans quickly adopted the form but added their own distinctive treatment of the crest. New York and Boston makers favored a rectangular or stepped crest, but their Portsmouth counterparts fashioned a shaped crest with volutes at the upper corners of the tablet.[2] The outline resembles splash boards on dressing tables.

This chair, one of a set of six, is the best preserved example of the Portsmouth arrow-back Windsor. It belonged to Hopley Demeritt (1792–1834) of Madbury, a rural community twelve miles northwest of Portsmouth, and may have been acquired at the time of his marriage to Abigail Snell (1794–1885) in 1820. Hopley placed the chairs in the family homestead that he inherited from his grandfather, John Demeritt (*see cat. no.* 20). After Hopley's death, his widow Abigail remained there for nearly a half-century. Her granddaughter, Jennie DeMerritt had vivid recollections of Abigail's bedroom in the house:

> In this room has stood for three generations at least a set of inlaid Sheraton containing a field
> bed, bureau, dressing table in yellow, table and light-stand. The chairs in this room are of

rather unique design of arrow-back Windsor, rose in color, and stencilled. All these things have been the special pride of the last generation.[3]

Jennie DeMerritt was incorrect in identifying these chairs as having stenciled decoration; rather, they have been painted freehand in much the same way that tinware of the era was decorated. The buds, leaves, striping, and anthemion-like clusters were executed in a quick and systematic manner by using specific brushes to achieve particular effects.[4] These details were painted in shades of red, yellow, and blue-green on a salmon pink ground. This shade of pink could be the "blossom" or "flesh" color that appears in references from the 1810s and 1820s.[5] Jennie DeMerritt's account of where these chairs were used and how much the family valued them explains why they survive in such remarkable condition. By seeing duty in the best chamber of the house, they avoided the mistreatment that regularly befell chairs situated in the kitchen, hall, or front porch.

DCE

Structure and Condition: The crest is tenoned through the stiles; the stiles are round-tenoned through the seat and wedged from beneath. The spindles are round-tenoned into the seat and crest; the tenons in the crest are reinforced with nails. The stretchers and legs are secured with round tenons in the standard manner. The original paint survives in excellent condition with only slight wear on the seat and legs.

Inscriptions: "HD" in chalk beneath the seats of all six chairs.

Materials: Maple legs and stretchers, eastern white pine seat, and undetermined woods for the spindles, stiles, and crest.

Dimensions: H. 33¾; W. 19⅛; SD. 16⅛; SH. 18

Provenance: Originally owned by Hopley Demeritt (1792–1834) and his wife Abigail (Snell) Demeritt (1794–1885); descended to their grandchildren, John DeMerritt (1856–1934), and Jennie DeMerritt (1863–1936), who sold the family house and its contents to the parents of the present owners (*see cat. no.* 20).

1. Evans 1988a, 1128–43.

2. A closely related Windsor chair in the New Hampshire Historical Society (1959.55.1) descended in the Bartlett family of Kingston. A set of three chairs at Strawbery Banke Museum (1974.583) descended in a Portsmouth family. The latter set is marked "TJP" in the same florid hand as that on the Demeritt family chairs. Another related set without any history sold at Parke-Bernet, sale 900, Nov. 12–15, 1947, lot 160. For stylish Salem objects with this crest, see Clunie 1980, nos. 38 and 40. See also Kenney 1971, 158–59.

3. DeMerritt 1929, n.p.

4. Marylou Davis, letter to the author, Sept. 11, 1991.

5. Nancy Goyne Evans, letter to the author, Sept. 16, 1991. Drawn from her chart of "Painted Seating Colors." For a similarly hued chair, see Churchill 1983, no. 23.

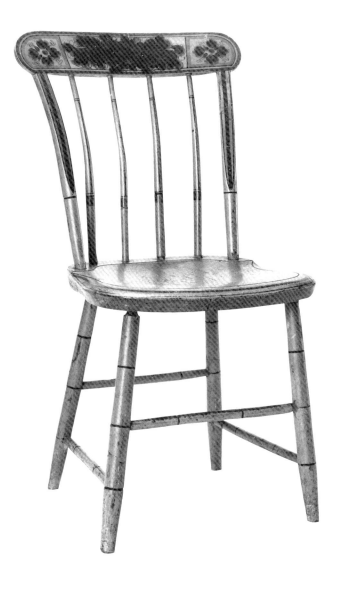

110

FANCY SIDE CHAIR

Thomas Brown (1796–1866)
Newmarket, New Hampshire
1831–35
Private collection

NEWMARKET, NEW HAMPSHIRE, originally a farming community at the southern tip of the Great Bay, is strategically situated on the Lamprey River with access to the Piscataqua and beyond. Because of the accessible waterway and potential for water power, Newmarket developed into a small manufacturing center in the 1820s and 1830s. Cotton mills and machinery manufactories were erected along the banks of the river. By the 1850s, one booster remarked, "Newmarket is a very busy town. Mechanical labor, in its various departments, is quite extensively pursued."[1]

Thomas Brown selected Newmarket as the site of his "chair factory," possibly as early as 1829.[2] This fancy chair is one example of the type of furniture that he manufactured and marketed at his shop on Main Street.[3] Although no evidence survives, his shop may have relied in part on water power.[4] The chairmaker Abraham Folsom, in nearby Somersworth, advertised that "The superior advantage of Water Power in the above [chair manufactory] business will enable the subscriber to sell as *cheap as can be bought in Boston*, and warranted equally as good."[5] Brown's label (110A) refers to the establishment of a factory in 1831, enabling him to sell chairs at extremely competitive prices. It also reveals that Brown, like Folsom, sought to compete with Boston-made furniture. He hired a workman from that city not only to manufacture the parts but also to ensure that they are "painted in the best style."

Brown's merchandise appealed to residents of Newmarket as well as to clients throughout the region. Jacob Meserve, a cordwainer from Newmarket, purchased the following on March 11, 1833:

CHAIR FACTORY.

THE subscriber having established a CHAIR FACTORY in connexion with his Cabinet Shop, at Lamprey River, is now enabled to sell CHAIRS as cheap as can be purchased in the State, and probably cheaper. They are made in a substantial and workmanlike manner, and painted in the best style, by an experienced workman from Boston. He also manufactures *DRESS TABLES & WASH-STANDS*, superior, it is believed, to any which can be found elsewhere.

—ALSO—

CABINET FURNITURE

of all kinds. Those wishing to purchase are invited to call and see for themselves

THOMAS BROWN.

Newmarket, (Lamprey River) 1831

110A.

Label on the bottom of the seat of cat. no. 110.

	[$]19.25
1 bureau 14.. - 1 Pem.[broke] table 5.25	[$]19.25
1 Pem. table 3.50 - 1 work stand 2.75	6.25
2 bedsteads 4.00 - 6 Im.[?] chairs 8.50	12.50
1 Rocking chair 2. - 1 cradle 4.50	6.50

Mr. Meserve attempted to settle his account by payments of cash as well as shoes, boots, and labor.[6]

Like many of his fellow cabinetmakers, Brown was affected by the difficult economic times of the mid 1830s. In 1835 Brown advertised in the *Exeter Newsletter*, "The Subscriber, beinging [*sic*] desirous of settling up his business, offers for sale his whole stock of Cabinet Furniture and CHAIRS at a large discount from former prices for Cash."[7] Not only did Brown have 400 chairs in stock, but he also carried tables, beds, and cabinet furniture. A wood engraving of a six-drawer chest headed the advertisement, and the typeface gave primary emphasis to "bureaus," indicating that Brown had increased his investment in case furniture. Despite his economic set-back, Thomas Brown stayed in business until his death in 1866. The inventory of his estate lists 170 pieces of furniture in his shop, including chairs, tables, stands, bedsteads, and looking glasses, totalling nearly $300 in value. His costliest products, however, were coffins. His shop contains 68 examples in pine, walnut, or "white wood," worth $381.[8] Although coffins did not become a significant part of his business until late in his career, Thomas Brown was chiefly remembered by posterity as a coffin dealer rather than a furniture maker or retailer.[9]

Thomas Brown's career reflects the change in furniture production from a small shop operation to one that concerned itself with the economics of scale within a modest manufactory setting. By the 1820s, many furniture makers in the Piscataqua area and throughout northern New England were adopting production methods that relied on simple designs with interchangeable parts. The unassuming patterns of such furniture, including this side chair, were hidden by colorfully painted surfaces. Furniture operations employing this method of production generally had a number of workers on hand, including a turner, an assembler, and a finish specialist. In 1836, Brown had four "hands" in his employ, though he certainly remained the chief cabinetmaker and merchandiser.[10] Factories such as Brown's were commonly located in smaller communities that offered ready access to wood, labor, water power, and easy transportation to markets in the area and beyond the region. *D C E*

Structure and Condition: The stiles are tenoned through the seat. The crest is fastened to the stiles with screws driven from the back. The legs, stretchers, and spindles are secured with round tenons. The original decoration consists of a yellow ground enhanced by green and black stringing; a stencilled cluster of grapes and flanking rosettes ornament the crest. The painted surface survives in good condition but is worn on the seat and stretchers as well as the stiles and spindles.

Inscriptions: "CHAIR FACTORY. / The subscriber having / established a Chair / Factory in connexion with / his Cabinet Shop, at Lamp- / rey River, is now enabled / to sell CHAIRS as cheap / as can be purchased in the / State, and probably cheap- / er. They are made in a / substantial and workmanlike manner, and / painted in the best style, by an experien- / ced workman from Boston. He also man- / ufactures DRESS TABLES & WASH- / STANDS, superior, it is believed, to / any which can be found else- where,— / -ALSO- / CABINET FURNI- TURE / of all kinds. Those wishing to purchase / are invited to call and see for themselves. / THOMAS BROWN. / Newmarket, (Lamprey River) 1831" printed on a paper label affixed to the bottom of the seat.

Materials: *Birch legs, stretchers, and spindles; *soft maple crest and stiles; *eastern white pine seat.

Dimensions: H. 33⅜; W. 17⅝; SD. 15⅜; SH. 16⅞

Provenance: This chair shares a provenance with cat. no. 109 but is still owned by the twentieth-century purchaser of the Demeritt house and its contents.

1. Charlton 1857, 327.

2. Brown v. Kittridge, June 3, 1837, series B, docket 17449, Rockingham County (N.H.) Court, State Archives. He varnished a sulkey for Dr. George W. Kittridge of Newmarket in 1829.

3. Another example is a painted dressing table with the identical label in the collection of the New Hampshire Historical Society (1984.48).

4. Brown does not appear in the 1850 U.S. Census of Manufactures for Newmarket, nor do the deeds relating to his purchase of land on Main Street refer to access to water power. Jewett to Brown, Jan. 3, 1839, 294:28, Rockingham County (N.H.) Deeds.

5. *Dover Gazette and Strafford Advertiser*, Apr. 14, 1835.

6. Brown v. Meserve, May 2, 1836, series B, docket 16509, Rockingham County (N.H.) Court, State Archives.

7. *Exeter Newsletter*, Mar. 10, 1835.

8. Thomas Brown, 1866 inventory, old series, docket 19983, Rockingham County (N.H.) Probate.

9. George 1932, 85. Stephan Toppan, a contemporary of Thomas Brown and a furniture maker, also began selling coffins later in his career. His advertisement in the 1843 *Dover Directory* states that he stocks "every item ever used from the cradle to the coffin." Moreover, in his advertisement in the 1865 *Dover Directory*, Toppan claims to "keep ready-made, and furnishes to order, coffins and caskets of every description."

10. Meserve v. Brown, Sept. 27, 1836, series B, docket 16974, Rockingham County (N.H.) Court, State Archives. Jacob Meserve counter sued Brown for an unpaid obligation of $64.03 for shoes for the Brown family and "hands" Fowler, Emery, Nutter, and Bay. These individuals probably worked as journeymen or apprentices.

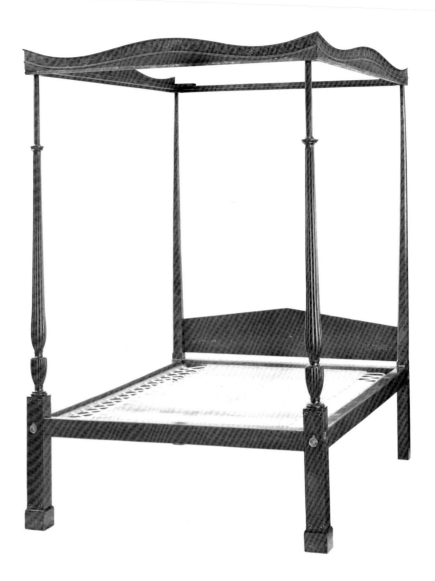

III

HIGH-POST BEDSTEAD

Attributed to Langley Boardman (1774–1833)
Portsmouth, New Hampshire
1800–1810
Society for the Preservation of New England
Antiquities, Boston, Massachusetts, museum
purchase, 1969.573

THIS HANDSOME BEDSTEAD survives in pristine condition because of its historical associations. For nearly half a century, it stood in the best chamber of William Hale's Dover, New Hampshire, mansion. A prominent federal merchant, state senator, and United States congressman, Hale hosted dignitaries from across the country. Daniel Webster, President James Monroe, and the marquis de Lafayette enjoyed Hale's generous hospitality. Of all his guests, none was more celebrated than Lafayette. His tour of the United States in 1825 included a triumphal procession along the New Hampshire coast. Early in the morning of June 23, a huge crowd gathered in Dover to greet the hero of the American Revolution. The leading citizenry met Lafayette's entourage at the Durham town line and paraded to Dover. As Lafayette approached the town, thirteen cannons fired, churchbells rang, and cheering throngs surrounded the column. "It was a memorable day for Dover," noted one eyewitness. After a busy schedule of celebrations, addresses, and a sumptuous dinner followed by sixteen toasts (three more than the customary thirteen), Lafayette retired to Hale's home for the evening. According to Hale's housekeeper, "Lafeyette's room was ready for days, The great room with canopied bed." In one night, the renowned guest transformed a piece of family furniture into a family heirloom. It became the "Lafayette Bed," a title that Hale descendants have proudly continued to use to the present.[1]

Though preserved for its history, the bed has special significance because of its condition and design. It retains both its original sacking bottom and painted

cornice—two elements that later generations usually discarded.[2] The sacking supported a firm hair mattress and a soft rotund feather tick that could weigh up to sixty pounds. On the Hale bedstead, the bottom—a large panel of canvas with eyelets spaced 4" apart—fits into a groove in the headrail and is held tight with a wooden wedge. Narrow strips of canvas, also with eyelets, are attached to the foot and side rails in the same manner, and the sacking bottom is laced to them with cord. Two other Portsmouth beds display the same unusual technique, all undoubtedly the work of sailmakers adept at working with canvas.[3]

The decorative cornices on the Hale bed probably matched window cornices in the room. Such "cornishes" are listed in Portsmouth estate inventories of the early nineteenth century and today survive in greater numbers from Portsmouth than any other New England community.[4] In this case, the cornice is painted with flowers on a dark background and is accented by thin gilded moldings at the top and bottom (111A). Its serpentine shape may well have been a favorite of Portsmouth patrons; a cloth-covered cornice with the same outline originally capped one of James Rundlet's beds.[5] The pattern follows an established English formula, shown in grander form in plate 108, "Cornices for Beds or Windows," in George Hepplewhite's *The Cabinet-Maker and Upholsterer's Guide.*[6]

Even with its decorative cornice and canvas bottom, the bedstead conveys little of its original opulence. Yards of material draped the frame in rich, luxurious color and pattern. When closed, the curtains completely encased the bed, offering its occupants warmth and seclusion. As one Salem contemporary noted, a bed became "a room in itself, with four carved posts, flowered curtains for walls, a chintz tester for ceiling, and steps conducting one into an acre of billowy bolstered bliss!"[7]

Remarkably, a nineteenth-century stereograph depicts the Hale bed with its lavish glazed chintz hangings still in place.[8] The curtains hung from wooden rods secured to the posts by means of iron hooks. Deep pleated valances were tacked directly to the lower edge of the cornice. At the center of the foot and sides, the valances were drawn up and gathered around fabric rosettes. Atop the bed, the tester cloth originally formed a shallow dome ornamented with a central rosette.[9] A counterpane, made of the same chintz used for the curtains, probably covered the bedding and may have extended to the floor, much like that on a surviving example with a New Hampshire history.[10]

The design of the bedstead conforms to a classic model. The three-part plan of each footpost—straight Marlborough leg, turned urn, and tapering upper shaft—had become a favored pattern by the mid eighteenth century and continued well into the federal era, with only minor refinements such as inlay and reeding to update the form. At first glance, such a standard arrangement would seem to deter attribution to a specific town or maker. However, the history and secondary woods (birch and eastern white pine) of Hale's bed suggest an origin in the Portsmouth area. Furthermore, the stringing and quarter-fan inlays on the footposts (111B) corre-

spond to those on the drawer fronts of the serpentine chest of drawers made by Langley Boardman for James Rundlet (*cat. no. 8*).

William Hale built his imposing three-story Dover mansion in 1806, a year before James Rundlet undertook a dwelling of similar scale in Portsmouth. To perform the work, both men sought out the best craftsmen in the region.[11] Surely, they commissioned the best cabinetmakers as well. Rundlet's accounts document his patronage of Boardman. Though Hale's choice is not known, Boardman seems most likely.[12] His reputation was unparalleled. During the first decade of the nineteenth century, he became the leading purveyor of fashionable neoclassical furniture to a new generation of Piscataqua merchants. Conscious of fine craftsmanship and desirous of elegant design, William Hale would have appreciated and probably demanded an artisan of Boardman's skill.

R C N

Structure and Condition: The rails are tenoned into the posts and secured by bed bolts that are screwed into nuts set in the rails; the bed bolts are concealed by brass caps. The applied cuffs on the footposts are butt-jointed at the corners. The square headposts lack cuffs and have chamfered edges above the rails. The headboard fits into slots in the posts. The joined tester frame rests on iron pins driven into the top of each post. The painted cornice is glued to the tester frame. Screws originally fastened the medial brace for the domed tester cloth to the center of the side tester rails. The footposts were refinished long ago; the rails, headboard, and headposts retain their original red stain but have been varnished at a later time. The tester frame has been reglued. The hooks at the top of the posts that once held the curtain rods have been cut off.

Inscriptions: Chisel-cut Roman numerals at the joints of the posts and rails.

Materials: Mahogany footposts; *birch headposts and head rail; *soft maple side and foot rails; *eastern white pine headboard, cornice, and tester. Replaced brass bed bolt covers; original canvas bottom.

Dimensions: H. 91½; W. 58⁵⁄₁₆; D. 77¹¹⁄₁₆

Provenance: This bedstead shares a provenance with cat. no. 56 until acquired by Elizabeth Hale Smith (1868–1956), daughter of Jeremiah Smith II (1837–1921); given to her second cousin, Julian Street (1879–1947), who presented it to his daughter Rosemary Hale Street Lewis (1908–92), a fifth-generation descendant of William Hale; purchased by SPNEA from Rosemary Lewis in 1969.

IIIA.

Detail of painted cornice.

Publications: Country Life, Oct. 1927, 59; *Three Centuries of Connecticut Furniture* 1935, no. 206; Nylander 1975, 1141, fig. 10.

1. The bed is probably the "mahogy bedstead" valued at $4 in William Hale's northeast chamber in 1849; see William Hale, 1849 inventory, docket 271, Strafford County (N.H.) Probate. Hale's career is discussed in Smith 1902, 12–13; Scales 1914, 393–95. For information on Lafayette's visit, see Wadleigh 1913, 215–22; Swett 1903, especially 14. Correspondence from Hale descendants in the SPNEA object files for 1969.573 describes "the Lafayette bed" and its history in detail. In 1935, a descendant living in Connecticut lent the bed to the Connecticut Tercentenary Exhibition in Hartford because of William Hale's relationship to the Connecticut patriot Nathan Hale. The two were first cousins. See *Three Centuries of Connecticut Furniture* 1935, no. 206.

2. Many high-post beds were updated for comfort; the sacking bottom was replaced with coil springs. The cornice was removed along with the bed hangings, which came to be considered unhealthy.

3. Cat. nos. 112 and 113B originally had bed bottoms secured in the same manner. Two Portsmouth sailmakers, Samuel Tripe and Joseph Walker, made bed bottoms for the cabinetmaker Langley Boardman.

4. For example, see Samuel Ham's estate inventory of 1813. His best chamber included "1 Suit dimity Bed & window Curtins Cornish & trimmings." The "Cornish" were probably painted to match the "painted & Gilt Bedstead" in the room. Samuel Ham, 1813 inventory, old series, docket 8702, Rockingham County (N.H.) Probate. Most surviving painted cornices from Portsmouth are for windows rather than beds. They include three sets at the Rundlet-May House and individual sets from the Warner, Moffatt-Ladd, Governor John Langdon, and Langley Boardman houses.

5. Jobe and Kaye 1984, no. 141. Matching window cornices are in the Rundlet-May House.

6. Hepplewhite 1794, pl. 108, especially the cornice pattern in the center.

7. Quoted in Garrett 1990, 109.

8. In 1940, Julian Street mounted the stereograph into a frame covered with a woven floral fabric. He believed the fabric to be a fragment of the bed's original drapery, but it probably came from a later set of hangings. The stereograph remains in the possession of the Street family; SPNEA has a photostatic copy.

9. A medial brace spanning the tester frame from side to side documents the presence of the domed tester. The lower edge of the brace is arched to accommodate the dome; the center of the brace retains a circular disk for the rosette. The brace is not visible in the photograph of the bedstead.

10. The counterpane is part of a set of printed hangings owned by SPNEA (1960.92) that served as the model for the reproduction hangings now on the Hale bed; see Nylander 1975, 1141, fig. 10.

11. Garvin 1983, 457, 458–62. Hale based the design on the Edward Cutts house in Portsmouth and commissioned the Exeter architect Bradbury Johnson to draw the plan. He employed a crew of joiners from Madbury and Dover to build the frame, then brought in another crew from Kensington, nearly twenty miles to the south, to finish the entry of the house. Clearly Hale sought out talented tradesmen, many from a considerable distance away.

12. Though detailed building accounts for Hale's house survive among his papers at the New Hampshire Historical Society, comparable information on his household purchases has not been found in family papers at the Historical Society or the Portsmouth Athenaeum.

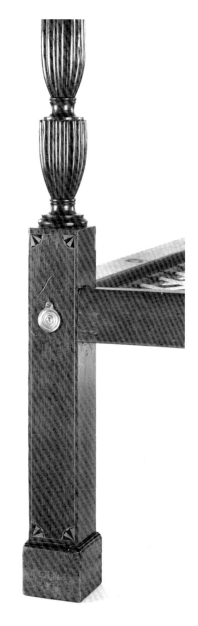

113B.
Footpost.

112

High-post bedstead

Attributed to Langley Boardman (1774–1833)
Portsmouth, New Hampshire
1805–10
Private collection

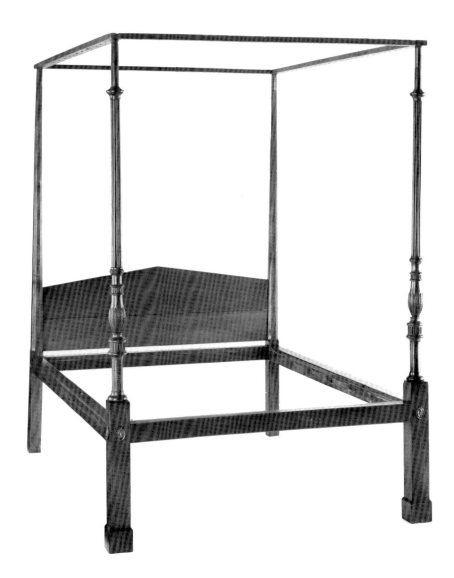

When draped with a full set of hangings, this mahogany bedstead bespoke luxury and wealth. Typically, a bed was the single most valuable household furnishing, its worth based not on the wooden frame that we appreciate today but in the yards of fabric required for the hangings and the pounds of feathers that filled the ticking and pillows.[1] The feather bedding alone equaled or exceeded the bedstead in value. The estate inventory of Thomas Thompson, a wealthy Portsmouth ship captain who died in 1809, illustrates the pronounced discrepancy in cost. It first lists the feather "beds," a period term for the tick, bolster, and pillows. They range in weight from 72 to 92 pounds per bed and in value from $24 to $28. The "Curtins" come next—60 yards of "patch," a glazed chintz, for a canopy-top field bedstead and an equal amount for a high-post bedstead. Each set of curtains is appraised at $20, but the bedsteads have a value of only $6 and $12 respectively.[2]

Inventories also corroborate the high value of textiles in relation to the other furnishings chosen for a room. The best chamber of Samuel Ham's three-story federal mansion contained dimity bed and window curtains, a counterpane, and a carpet appraised at $108, a bedstead and bedding at $77, and seventeen remaining items—a mahogany bureau, dressing glass, twelve chairs, and washstand—all at only $57.[3]

Samuel Ham's choice of dimity for the matching bed and window curtains reflected prevailing fashion. Writing in 1788, George Hepplewhite noted that "White dimity, plain or corded, is peculiarly applicable for the furniture [i.e., bed

hangings], which, with a fringe with a gymp head, produces an effect of elegance and neatness truly agreeable."[4] Printed fabrics offered an appealing alternative. Thomas Thompson's "patch" curtains document one common type. An 1816 auction notice describes another Portsmouth favorite: "for sale at public vendue…mahogany 4 post Bedsteads with suits of copperplate Curtains; Window Curtains & Chair Covers to match."[5] Such ensembles of matching color, whether in white dimity or brilliant prints, came to characterize the fashionable federal interior.

This bed belonged to the Portsmouth merchant, Abraham Wendell. He probably acquired it shortly before his marriage to Susan Gardner in 1809 and later moved it into the brick mansion that they built on Pleasant Street in about 1820.[6] Unlike the purchases of his brother Jacob Wendell, which survive in quantity and are frequently recorded in family papers (*see cat. no. 113*), few of Abraham's possessions are known (*see cat. no. 24*), and none are documented. Nevertheless, some information about the bed can be discerned through related sources. Its original cost probably ranged between $22 and $25. On January 12, 1802, James Rundlet acquired a high-post bedstead from Langley Boardman for $21 (*see* 8A). Six months later, Boardman supplied sixteen pieces of furniture, including a bedstead for $23, to "M[r] Wendell Esq[r]."[7] The tantalizing reference to Mr. Wendell is too early for Abraham, who was only seventeen at the time. Instead, the furniture was probably ordered by Abraham's father, John Wendell, as a dowry for his daughter Dorothy who married Reuben S. Randall on August 7, 1802. Though the bill is not directly linked to Abraham, it does document the family's patronage of Langley Boardman. Abraham Wendell may well have continued the tradition.

The most striking feature of Wendell's bed is the design of its footposts. Here we find an unconventional plan derived from a pattern-book source—plate 105 of Hepplewhite's *Guide* (112A). Instead of the standard arrangement of a straight leg capped by an urn and tapered shaft (*as in cat. no. 111*), there is a thin colonnette crowned by a fluted band, which divides the urn from the leg (112B). The arrangement of parts is nearly the same as in Hepplewhite's design, but the maker has substituted inlay for the leaf carving on the colonnette in the plate. The maker must have had access to this influential volume. At least two Portsmouth craftsmen possessed the book; one was Langley Boardman, who used it when designing a particular pattern of chairs (*see cat. no. 96*).[8]

Aside from the distinctive footposts, the Wendell bed nearly matches that owned by William Hale (*cat. no. 111*). Both have slender chamfered headposts and triangular headboards (a later strip was added along the lower edge of the Wendell headboard). The original sacking bottoms were secured in the same manner, and the Marlborough legs relate closely in dimension and detailing (112C). The legs are exactly the same height—24¼"—and vary by only ¼" in width. They have identical cuffs and display the same outline of stringing. Such similarities suggest that the beds share a common origin, probably in the shop of Langley Boardman.

R C N

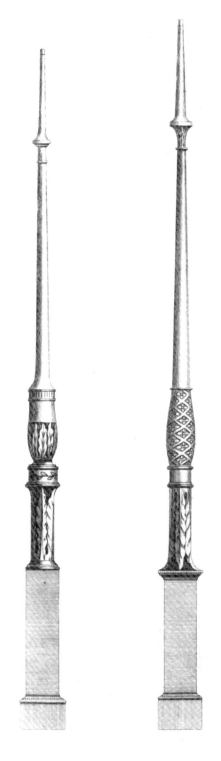

Structure and Condition: The construction of the bedstead matches that of cat. no. 111. The turned capitals at the top of the footposts are separate pieces that slide onto the posts. The bedstead has been refinished; traces of a red stain remain under a recent varnish on the headposts, rails, and headboard. The present owner reduced the posts by 3¾" to fit the bed into a smaller room but saved the pieces, which were reattached for the photograph. The base of the leaf-carved urn on the right footpost was broken and poorly repaired long ago. Fragments of the canvas strips for the bed bottom still remain in place in the rails (*see cat. no. 111 for an original bottom of the same design*). The tester frame has considerable age but may not be original.

Inscriptions: Chisel-cut Roman numerals at the joints of the posts and rails.

Materials: *Mahogany footposts; *soft maple headposts and rails; *eastern white pine headboard, tester, and wedge securing canvas in right side rail; *white oak wedge securing canvas in foot rail. Replaced brass bed bolt covers; once had casters.

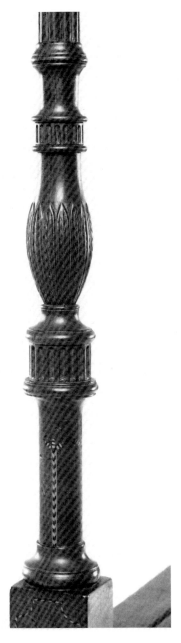

112B.

Middle of footpost.

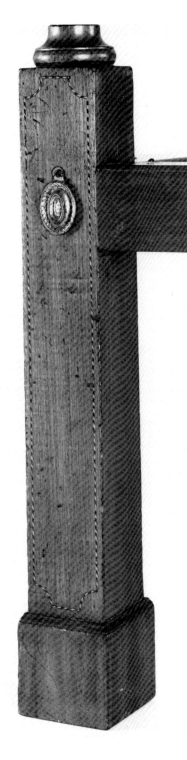

112C.

Marlborough leg of footpost.

Dimensions: H. 83⅞; W. 57; D. 78⅜

Provenance: Abraham Wendell (1785–1865); to his daughter Susan (ca. 1810–1903); purchased by Andrew Peterson Wendell (1844–1926) for his daughter Frances Wendell Lamson (1875–1962) upon her marriage in Sept. 1903; descended to the present owner.

1. The values of beds and their components are based on a survey of thirty-nine Portsmouth estate inventories recorded between 1773 and 1849.

2. Thomas Thompson, 1809 inventory, old series, docket 8080, Rockingham County (N.H.) Probate. Thompson resided on Pleasant Street, next door to Governor John Langdon. For a description of "patch," see Montgomery 1984, 318.

3. Samuel Ham, 1813 inventory, old series, docket 8702, Rockingham County (N.H.) Probate.

4. Hepplewhite 1794, 18.

5. Sale of William Boyd's household goods, *New Hampshire Gazette,* Aug. 6, 1816. For a definition of copperplate, see Montgomery 1984, 203–5.

6. Wendell's brick house of 1820 is pictured in Howells 1937, figs. 250–51.

7. Langley Boardman to Mr. Wendell, bill, Aug. 4, 1802, Wendell Collection, case 13, Jacob Wendell bills, Baker Library, Harvard Business School.

8. Portsmouth examples based on Hepplewhite's designs include cat. nos. 61, 93, 96, and 112. Of these, the federal side chair (*cat. no.* 96) is documented to Boardman and the bedstead (*cat. no.* 112) can be attributed to him. The card table (*cat. no.* 61) may represent the work of another shop. The origin of the unusual curved settee (*cat. no.* 93) remains an intriguing mystery. Its diagonal-striped stringing on the splats, arm supports, and front legs is similar to that on the Marlborough legs of the bedstead (*cat. no.* 112), raising the possibility that the settee may also be the work of Boardman.

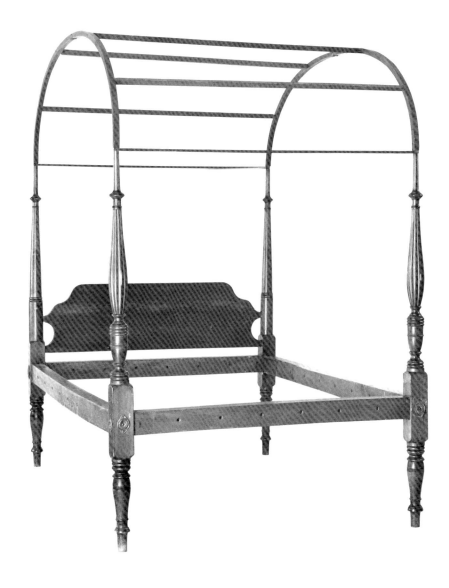

🌿 *113*

Field bedstead

Judkins and Senter (w. 1808–26)
Portsmouth, New Hampshire
1816
Private collection

Of camp or field bedsteads there are a great variety…These may be considered for domestic
use, and suit for low rooms, either for servants or children to sleep upon; and they receive this
name on account of their being similar in size and shape to those really used in camps.[1]

Thomas Sheraton's remarks of 1803 describe a form that enjoyed widespread
popularity during the first half of the nineteenth century in Portsmouth. Typically
such beds had an arched top that could be easily disassembled for movement or
storage. When fully outfitted, the bed was draped in yards of dimity or printed fab-
ric, often gathered into swags or festoons (*fig.* 113A).

 This birch field bed illustrates a popular Portsmouth version of the form. Its
turned legs scratched with three tightly spaced lines and capped with two thick
rings follow a characteristic pattern.[2] Similar thick rings ornament the urns. The
pronounced arch of the canopy enhances the graceful outline of the bed. Here, a
full half-circle replaces the usual bowed top that crowns most field beds. Its con-
struction, however, conforms to standard practice. The arched ends of the canopy
are hinged at the center, and the slats are tenoned through the ends. The bed rails
are pierced with holes for rope that was either strung like that on cat. no. 114 or
laced to a canvas panel like that on cat. no. 111. The original red stain covers the
posts, rails, and canopy. This common practice transformed the natural color of na-
tive birch into a rich reddish-brown, simulating mahogany.

Detailed documentation accompanies the bed. It is the "Bedstead" sold by Judkins and Senter to Jacob Wendell on May 10, 1816. Six weeks later the firm supplied the canopy.[3] On July 31, 1816, Wendell identified the items as "1 Field Bed Stead my chamber" and "Bed Top for field Bedstead" in his own account of furniture acquired for his house.[4] At the time, the bed stood in the chamber over the back sitting room, a small room that Wendell may have used as his own chamber until his marriage to Mehetable Rogers on August 15, 1816. Apparently, after their wedding, the couple moved into a larger bedchamber at the front of the house. This ornate, sunlit room contained a grander high-post bed, also probably made by Judkins and Senter (113B).

Wendell family accounts and reminiscences offer a remarkably complete picture of the variety and arrangement of beds in Jacob Wendell's house. By the late 1820s, Wendell had filled the second-floor chambers with eight beds to accommodate the needs of a growing family that would eventually include eight children, six of whom lived to maturity.[5] He and his wife continued to reside in the front room over the south parlor or dining room. Their bed (113B) was probably one purchased in 1816 and outfitted with a gilded cornice made by Judkins and Senter. A "Suit India Curtains" adorned the bed, while dimity curtains hung at the windows.[6] When the room was photographed in the late nineteenth century, the bed still retained its original cornice and curtains (113C); both were later transferred to another bed in the house and are now in the collection of Strawbery Banke Museum.[7] The Wendells also kept a mahogany cradle in their bedchamber, which they had purchased from Judkins and Senter on June 10, 1817, just one week before the birth of their first child.[8] Like many mothers of the era, Mehetable wanted her youngest child close at hand.

The matron of the family—Jacob's mother, Dorothy Wendell—resided across the hall, in the other large front chamber. After her husband died in 1808, she lived with her children, moving into Jacob's house sometime after 1816. In the late nineteenth century, one of Jacob's nieces, recalling many earlier visits to the house, provided a rare glimpse of Dorothy's chamber:

> grandmother's room…contained a high-post bedstead curtained with very old-fashioned India Chintz; the pattern, a cottage with trees, fences, dogs, men with guns hunting, etc; the color, purple & white & was the delight of my childish eyes when I slept with her…There was one old-fashioned dressing table with a place in top decayed almost through. It had belonged to some of the family who died & the friends closed the room for so long a time, just as it was, that some water which had been spilled there decayed the hard Walnut; there was another dressing table between the windows very black Mahogany. It had besides drawers a small closet in the middle where grandmother loved to have Mehetable & Caroline play baby house. There was an old black looking portrait of grandmother's Uncle Eyre hanging by the door.[9]

To a young visitor in the 1820s, the room's array of family heirlooms sparked her interest and imagination. The bed curtains, in particular, seemed an exotic delight. Though she describes them as an "India Chintz," they were an English copperplate print of the late eighteenth century, perhaps related to a set owned by James Rundlet (101D).

In the back chambers of the house, Jacob Wendell crowded numerous beds. The kitchen chamber had three: one, a mahogany field bed with a serpentine canopy; the second, probably a high-post bed that Jacob purchased second-hand in 1825; and the third, a "Bedstead with Truckels"—a trundle bed on wheels—purchased from Judkins and Senter in 1818. Both the field and high-post bedsteads survive, though no trace remains of their hangings. They are fashionable mahogany examples made between 1810 and 1815. The field bed probably originated in

113A.

Doll's field bedstead with original hangings. America, 1800–1825. Probably walnut and pine. Henry Ford Museum and Greenfield Village, Dearborn, Michigan, 1965.66.1.

Portsmouth, the high-post bed in Boston. The latter resembles the example attributed to Judkins and Senter (113B); surely the Boston bed or one like it served as a source for the Portsmouth cabinetmakers.[10]

The chamber over the back sitting room housed cat. no. 113 as well as a "Rocking Crib" bought in 1821. The field bed still remained in the room in 1891, its canopy adorned with "dimity hangings, fringed."[11] Surprisingly, except for the trundle bed, Wendell kept no low-post beds in his second-floor bedchambers.[12] Most households, even those of affluent merchants, had less expensive beds in back chambers for children or servants. In Wendell's case, he established a tasteful ambience throughout the house, which his descendants maintained well into the twentieth century. Today his legacy of furnishings and supporting documentation constitute an extraordinary resource in the study of Portsmouth furniture.

R C N and B J

Structure and Condition: The rails are joined to the posts in the same manner as cat. no. 111. The shaped headboard is made of two boards fastened with nails and glue and secured with a double-tenon to the headposts. The corners of the canopy fit over metal pins projecting from the tops of the posts. The bottom slats of the canopy are separate parts; the other slats are tenoned through the arched ends. The bed is in excellent condition except for minor chips and routine wear. In 1991, SPNEA conservators repaired a broken slat in the canopy. The headboard has been varnished.

Inscriptions: Chisel-cut Roman numerals at the joints of the posts and rails.

Materials: *Birch posts and arched ends of the canopy; *poplar rails; *eastern white pine headboard and canopy slats. Probably replaced bed bolt covers.

Dimensions: H. 88¼; W. 56¼; D. 79¾

Provenance: Jacob Wendell (1788–1865); afterwards followed the same descent as cat. no. 5; purchased by the present owner at auction in 1989.

Publications: Sotheby's, sale 5810, Jan. 26–28, 1989, lot 1448.

1. Sheraton 1803, 1:123–24.

2. Jonathan Sayward Barrell of York, Me., owned a high-post bed with the same turnings that may also be the work of Judkins and Senter. Barrell's bed is in the collection of SPNEA (1977.496) and on view at the Sayward-Wheeler House in York. See Nylander 1979, 574, pl. 7.

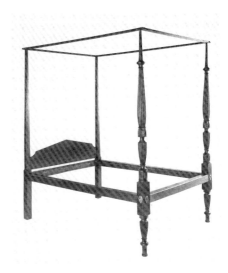

113B.

Bedstead. Attributed to Judkins and Senter (w. 1808–26). Portsmouth, New Hampshire, 1810–15. Mahogany, birch, and eastern white pine; H. 89½; W. 56¾; D. 80⅜. Private collection. This bed belonged to Jacob Wendell (1788–1865) of Portsmouth.

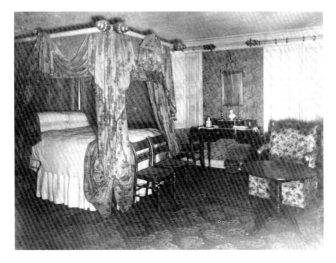

113C.

View of the bedstead shown in 113B while in the north front bedchamber of the Wendell House. Photograph, 1890–1902. Strawbery Banke Museum, Portsmouth, New Hampshire. The bed retains its original hangings of block-printed English cotton and a white-and-gold cornice made for the bed by Judkins and Senter in 1816. The bed originally stood in Jacob and Mehetable Wendell's room, the south front bedchamber. Matching cornices hung above the windows.

3. The sale of the bedstead and canopy (identi-fied as a "Bed top") are recorded in Judkins and Senter to Jacob Wendell, bill, June 29, 1816, Wendell Collection, folder 4, case 13, Baker Library, Harvard Business School [hereafter Judkins and Senter bill].

4. Jacob Wendell, "Account of Cash p^d for Sundries for furnish^g my House," July 31, 1816, ledger 2, 1814–27, 63, Wendell Collection, Baker Library, Harvard Business School [here-after "Account for furnish^g my House"]. Judkins and Senter's bill (see note 3) lists the bedstead at $19; Wendell's own account puts it at $26. The discrepancy may result from the addition of dimity curtains in Wendell's account. The price of the canopy is $2 on both documents.

5. In about 1828, Jacob Wendell made an in-ventory of the contents of house. He was facing bankruptcy because of the failure of nearby tex-tile mills in which he had invested heavily. The inventory became the basis for a later mortgage of his property. It lists all major rooms except the north front parlor chamber, then occupied by his mother, Dorothy Wendell. The distribu-tion of beds within his house is carefully noted. Jacob Wendell, ca. 1828 inventory, Wendell Collection, box 18, Portsmouth Athenaeum [hereafter 1828 inventory]. Stanwood 1882, 30–31, provides the vital statistics for Wendell's children.

6. Wendell noted the purchase of a "Bedstead & Curtains" for $30 on Jan. 7, 1816; see "Ac-count for furnish^g my House." The account does not indicate who supplied the bedstead. Nor do any tradesmen's bills in the Wendell Papers at the Baker Library refer to the bed. In all likeli-hood, Wendell bought the "Bedstead & Cur-tains" second-hand at a local auction and later updated the bed with a cornice supplied by Judkins and Senter on June 27, 1816, for $13. At the same time, the firm also made matching window cornices for $7.50; see Judkins and Senter bill. In July 1816, in preparation for Wendell's marriage the next month, the bed was apparently rehung with new curtains, which Wendell's "Account for furnish^g my House" de-scribes as "Patch" while his 1828 inventory calls a "Suit India Curtains." Both terms refer to a printed fabric; in this case, they describe an En-glish block-printed floral cotton, which still dressed the bed when it was photographed in the late nineteenth century (113C). By this time, the bed had been moved across the hall, from Jacob and Mehetable Wendell's bedchamber into the large chamber formerly occupied by Jacob's mother, Dorothy Wendell; see note 9.

7. The curtains are 1990.209 and the cornice is 1989.139 in the Strawbery Banke Museum col-lection. Only a portion of the bed hangings sur-vives. Sometime prior to 1902, the Wendell family transferred the cornice from the bed in 113B to a closely related Boston bed that may have been acquired at auction in 1825; see note 10. This bed apparently stood in the kitchen chamber in 1828 but by 1891 had been moved into the bedchamber formerly occupied by Jacob and Mehetable Wendell. For illustrations of the Judkins and Senter bed cornice on the Boston bed and a portion of the block-printed hang-ings, see Roy 1992, 112–13. The inset black-and-white photograph on p. 112, reused here as 113C, shows the hangings on the bedstead attrib-uted to Judkins and Senter (113B).

8. Judkins and Senter to Jacob Wendell, bill, Aug. 16, 1817, Wendell Collection, case 13, miscellaneous bills 1813–17, Baker Library, Harvard Business School. The Wendells' first child, Mark Rogers Wendell, was born on June 18, 1817.

9. A typescript of this remarkable account is titled "John, Dorothy & Jacob's Home" and pre-served among the Wendell Collection at the Portsmouth Athenaeum. The location of the original account is not known.

10. By 1891, the field bed—then described as "1 small canopy-top bedstead mahogany posts, in white dimity"—had been moved into a small middle front chamber between the larger north chamber (Dorothy Wendell's room) and south chamber (Jacob and Mehetable Wendell's room); see Caroline Q. Wendell, 1891 inven-tory, new series, docket 6696, Rockingham County (N.H.) Probate. For an illustration of the bed, see Sotheby's, sale 5810, Jan. 26–28, 1989, lot 1446.

On Mar. 10, 1825, Jacob Wendell noted in his "Account for furnish^g my House" an expen-diture for "Cash p^d S Larkin for Bedstead high post Shapley [$]6.60." On Mar. 5, the Ports-mouth auctioneer Samuel Larkin had sold the household furniture of the late Reuben Shapley, Esq. Among the goods were "Feather Beds; high-post and canopy Bed-steads"; *New Hamp-shire Gazette*, Mar. 1, 1825. The Shapley bed ac-quired by Wendell may have been the Boston bedstead now owned by Strawbery Banke Mu-seum(1989.14) and illustrated in Roy 1992, 112. This is one of two surviving high-post bedsteads that descended in the Wendell family. The other (113B) seems to have served as Jacob and Mehetable's bed and was originally outfitted with the Judkins and Senter cornice; see notes 6 and 7.

On Jan. 27, 1818, Judkins and Senter sold a "Bedstead with Truckels" to Jacob Wendell for $4; bill, Jan. 28, 1819, Wendell Collection, case 13, Jacob Wendell bills, miscellaneous 1802–35, Baker Library, Harvard Business School.

11. "Account for furnish^g my House," Aug. 17, 1821. Wendell also purchased a "Crib with rails & bed & Pillows of M^r Draper" for $4 on Aug. 16, 1825, but his 1828 inventory does not iden-tify its location. Perhaps it stood in Dorothy Wendell's chamber, which is omitted from the inventory.

12. Wendell probably had at least one plain bed in the attic. On June 1, 1813, he bought a bed-stead at a local auction for only $.95, a price too inexpensive for a field or high-post bed. This bed may have been the "cross bedstead" in the attic store room in 1891; see Caroline Q. Wendell, 1891 inventory, new series, docket 6696, Rockingham County (N.H.) Probate. For an illustration of a cross bed, see 114B.

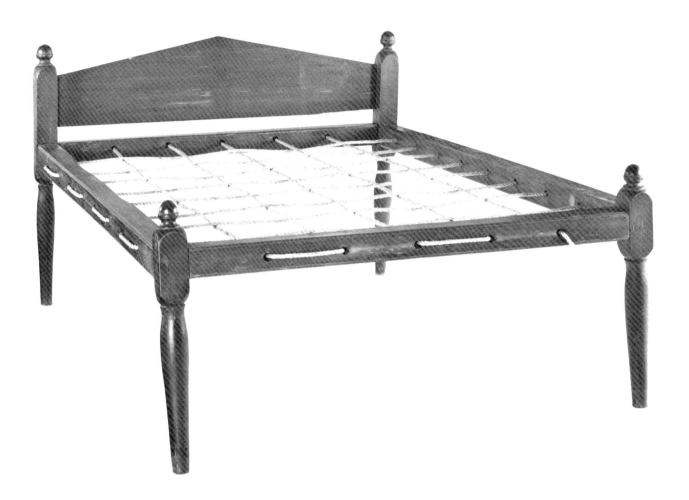

EARLY NEW HAMPSHIRE HOUSEHOLDS, whether rich or poor, invariably included low-post bedsteads. Though common in their day, they now survive in fewer numbers than their high-post counterparts, which have always been cherished as family heirlooms. Today collectors frequently refer to the form as a "hired man's bed" and associate it with farmhouses in rural areas. But plain utilitarian beds were just as plentiful in urban settings. Portsmouth inventories of the federal era describe them as "common," "Short-Post," or "Low-Post"; or list them simply as bedsteads, with little value.[1] Their cost lay far below that of more ambitious field and high-post beds. According to a typical bill of 1807, one Portsmouth cabinetmaker charged $20 for a mahogany high-post bedstead and only $3 for a "common" low-post version.[2] Many local craftsmen offered the form. Yet occasionally wealthy clients sought even these ordinary objects from abroad. In 1766 the Portsmouth merchant Woodbury Langdon sent a lengthy order to London that included "4 Good strong cheap Beds, Bedding & Bedsteads without Posts [i.e., without high posts] or Curtains for Servant Men & Maids."[3] The bedding for such pieces, whether British or American, usually consisted of a feather or straw tick, pillows, and a blanket, quilt, or bed rug.

 This turned and painted bedstead characterizes the low-post form in coastal New Hampshire. Both the headposts and footposts have swelled and tapered legs capped with acorn-shaped finials. The headposts project above the footposts and are fitted with a plain, pointed headboard. The rails are tenoned into the posts but

§ II4

LOW-POST BEDSTEAD

Coastal New Hampshire
ca. 1824
Woodman Institute, Dover, New Hampshire
Gift of Mrs. Ellen Rounds, T 1057

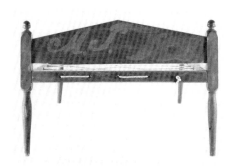

114A.

114A.

Inscription on back of headboard.

not fastened with bed bolts. Instead, the cord that supports the mattress unites the frame into a stable, secure unit.[4]

The vast majority of turned low-post beds are unassuming products of anonymous artisans. This standard example is distinguished from its counterparts by its documentation. It bears the inscription "M. T. 1824" (114A) on the back of the headboard in the same original gray paint that covers the posts and rails. The date probably refers to its year of manufacture. The initials are surely those of the artisan who painted the bed, and possibly made it.

The practice of painting bedsteads made of inexpensive local woods was commonplace throughout the colonial period. In 1764 Portsmouth painter Joseph Simes charged Nathaniel Barrell £16 for "Painting two Bed Steads Green."[5] Four years later, the bankruptcy proceedings for Samuel Moffatt of Portsmouth refered to two "Cedar Painted" bedsteads, one of which was hung with a set of green check hangings.[6] During the federal era, green remained a popular choice for inexpensive bedsteads, while white and gold became a fashionable combination for grander high-post beds.[7] Frequently too, birch or maple beds were stained reddish-brown to simulate mahogany. John Peirce outfitted the southwest chamber of his imposing federal mansion with a "stained Wood field Bed Stead."[8]

John Peirce also owned a form identified as a "horse" bedstead in his inventory of 1815. The term refers to a folding bedstead that could be easily moved from room to room. Peirce had one set up in an upper chamber and two stored in the back entry. Jacob Sheafe's inventory of 1829 describes the same form as a "cross leg Bedstead."[9] In the kitchen chamber on the fourth floor of his large house, he kept "two cross legg'd bed steads (one double & one single)" valued at just $2.50. These inexpensive beds resembled portable cots with detachable headboards. A surviving example once owned by James Rundlet is typical of the form (114B). Its canvas bottom is nailed to rails (a leather strip reinforces the nails), which in turn are supported by cross braces at each end. Each pair of braces pivots on a central pin, allowing the bed to fold up for storage. Stretchers are tenoned into the braces. A headboard (now missing) originally fit into holes at one end of the rails.

Piscataqua homes, like those throughout America, contained varied accommodations for sleeping. A straw tick and blanket on the floor satisfied the most basic need, but most residents sought grander settings. Cross, low-post, field, and high-post beds became steps in the domestic hierarchy of bedchamber furnishings. Each represented a greater level of comfort, expense, and status. At the pinnacle, during the colonial and federal periods, stood the carved high-post bedstead replete with sacking bottom, soft feather tick, and flowing yards of decorative hangings. Yet no Portsmouth house had only high-post bedsteads. Best beds were reserved for the best bedchambers, and lesser rooms contained plainer bedsteads with less expensive hangings or, in the case of cross or low-post beds, no hangings at all.

RCN and BJ

Structure and Condition: The headboard fits into mortises in the head posts. Beaded edges are cut on the outer corners of the rails. The bedstead is in excellent condition with only one minor repair. The right side rail is cracked at one end and refastened with five large nails. An old chip, probably from the removal of bark, extends 42" along the inner top corner of the left rail. The rope bottom is new.

Inscriptions: "M. T. 1824" in gray paint on back of headboard; chisel-cut Roman numerals at the joints of the posts and rails.

Materials: *Soft maple posts and rails; *eastern white pine headboard.

Dimensions: H. 36¹¹⁄₁₆; W. 53¾; D. 78

Provenance: The bed descended in the Drew family of Dover, who owned the Dam Garrison in the nineteenth century; inherited with the Garrison by Mrs. Ellen Rounds in the 1880s and given to the Woodman Institute in 1915.

1. John Wardrobe, 1804 inventory, old series, docket 7315, Rockingham County (N.H.) Probate; Thomas Thompson, 1809 inventory, old series, docket 8080, Rockingham County (N.H.) Probate; Samuel Brewster, 1834 inventory, old series, docket 12612, Rockingham County (N.H.) Probate.

2. Samuel Wyatt to Benjamin Lapish, bill, 1807, Benjamin Lapish Papers, box 1, folder 2, Durham Historical Society.

3. "Memorandum of Sundry Furniture for Sherburne & Langdon to be Ship'd P[er] first Opportunity," April 1766, Langdon Papers, Strawbery Banke Museum.

4. See *Antiques* 141:1 (Jan. 1992):69.

5. Joseph Simes to Nathaniel Barrell, bill, May 30, 1764, private collection.

6. Moffatt v. Moffatt, Mar. 2, 1768, docket 25135, N.H. Provincial Court, State Archives.

7. The color of painted bedsteads is rarely cited in estate inventories, but when it does appear, it is usually green; the 1809 inventory of Thomas Thompson lists an old "Green" high-post bedstead valued at $3, old series, docket 8080, Rockingham County (N.H.) Probate; the 1820 inventory of Richard Hart includes a "Green Bedstead" valued at $1 in the kitchen chamber, old series, docket 10092, Rockingham County (N.H.) Probate. The popularity of white and gilt furniture in fashionable Portsmouth interiors is discussed in cat. no. 98.

8. John Peirce, 1815 inventory, old series, docket 8909, Rockingham County (N.H.) Probate.

9. Jacob Sheafe, 1829 inventory, old series, docket 11774, Rockingham County (N.H.) Probate.

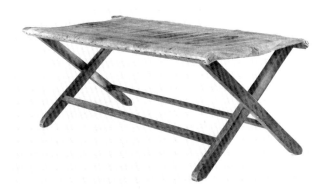

114B.

Cross bedstead. Portsmouth, New Hampshire, 1800–1825. Birch; H. 27½; W. 35; D. 75. Rundlet-May House, Portsmouth, New Hampshire, Society for the Preservation of New England Antiquities, gift of Ralph May, 1971.1891. This bedstead belonged to James Rundlet (1772–1852) of Portsmouth.

⚜ 115

Picture frame

Probably Boston, Massachusetts
ca. 1751
With a portrait of Capt. John Moffatt
(1691–1786), attributed to
John Greenwood (1727–92)
Moffatt-Ladd House
Portsmouth, New Hampshire
In care of The National Society of
The Colonial Dames of America
in the State of New Hampshire
Gift of Mrs. W. E. S. Griswold, Sr.
1977.92.

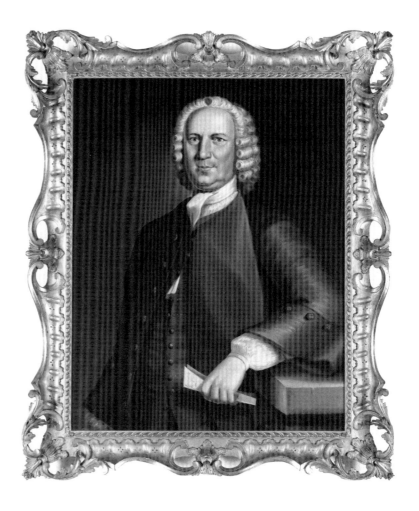

THE MAST TRADE brought Capt. John Moffatt, portrayed here, to the Piscataqua River area from his home in Somerset, England.[1] He commanded one of the King's ships bound for Kittery Point, Maine, with orders to obtain masts for the navy.[2] Portsmouth must have impressed the visitor, because he elected to stay, marrying Katharine Cutt (1700–1769) of Kittery in 1723.[3] He amassed a great fortune as a merchant and soon joined the ranks of Portsmouth's most elite citizenry. In 1746 he became a Masonian Proprietor, one of a select group of men who claimed the exclusive right to establish township grants in New Hampshire's unsettled lands.

In 1751, Moffatt hired the painter John Greenwood, who was visiting Portsmouth, to execute an impressive series of half-length portraits of his immediate family, including himself, his wife, three daughters, a son, and possibly a son-in-law.[4] These portraits survive in their original matching frames, which are carved and gilded in the newest rococo style.[5] Such large-scale commissions were unusual at the time and could have cost Moffatt as much as £20 per painting, roughly equivalent to the cost of a fine high chest or a silver teapot.[6] The pictures adorned the walls of Moffatt's best public rooms, conveying an image of social status and wealth to those who visited his home on Buck Street. Some of the portraits later hung in the grand Market Street mansion that Moffatt built for his son Samuel in 1763. The elder Moffatt moved into this house after his son fled town as a debtor in 1768.[7] The inventory of John Moffatt's estate includes "6 pictures" worth 24s. in the "Front Parlour Chamber."[8]

Moffatt spared no expense when it came to frames for his family portraits. The entire group of frames is nearly identical in design, with gadrooned inner molding; *rocaille,* the protean rock-like watery motif, on the cove molding; and sculptural acanthus leaves, ribbed shells, and C-scrolls trimming the midpoints and corners of the outer edge. Yet, slight variations within the group do appear. The frame on Capt. John Moffatt's portrait features ribbed shells of stylized design and cove moldings with fourteen oblong indentations per side, while the frame on the portrait of his daughter (115A), Katharine Moffatt Whipple (1734–1821), has more naturalistically rendered shells and only twelve indentations on each side. Moreover, the wood used on the latter's frame is *pinus sylvestris* (red pine), while that on the elder Moffatt's is *pinus strobus* (eastern white pine). Although indigenous to New England and Great Britain, it seems likely that the frame made from *sylvestris* pine was an English import and served as a model for the white pine versions in the group.[9]

The rococo style, with its emphasis on asymmetry and naturalistic ornament, became popular in England by the 1740s. London master carver Matthias Lock published *Six Sconces* in 1744, which provided designs for frames as well as sconces in the new French mode.[10] These forms were ideally suited for the excesses of the rococo. Frames and looking glasses in this style were sent to New England where the public admired them and local carvers used them as inspirations for their own work. Either the patron or the artist could have selected the frames, but it seems more likely that, in this instance, Greenwood approached a local Boston carver such as John Welch (w. 1732–89) to make the suite based on an English prototype. In the 1760s and early 1770s, the painter John Singleton Copley sold carved and gilded frames by Welch for as much as £9, representing a substantial investment beyond the price of the portrait.[11] Thus, this group of family portraits with their original frames not only records the visages of the Moffatts but also their conspicuous wealth and their fashionable taste.

D C E

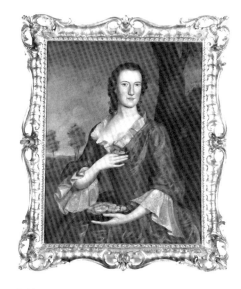

115A.

Picture frame. Probably England, ca. 1750. With a portrait of Katharine Moffatt Whipple, attributed to John Greenwood (1727–92), ca. 1751. Oil on canvas, H. 44¼; W. 36⅜; D. 2⅞. Moffatt-Ladd House, Portsmouth, New Hampshire, in care of The National Society of The Colonial Dames of America in the State of New Hampshire, on loan from a Moffatt descendant.

Structure and Condition: The stiles and rails of
the frame are each made of two boards glued
one on top of the other. The corners of the
frame are mitered and glued. Each miter is rein-
forced by a spline; no nails are used. A thin layer
of gesso and bole was applied to the primary
surface. It was then water gilded. A yellow wash
was brushed on the back of the frame. The
frame is in excellent condition, marred only by a
chip at the lower left corner and the loss of the
lower third of the central shell on bottom rail.
Paint now covers the original gilded decoration.

Materials: *Eastern white pine.

Dimensions: H. 44½; W. 36⅜; D. 2⅞

Provenance: Acquired by Capt. John Moffatt
(1691–1786); descended to his granddaughter
Mary Tufton Moffatt Haven (1768–1842); to
her daughter Maria Tufton Haven Ladd (1787–
1861); to Maria's son Alexander Hamilton Ladd
(1815–1900); to Alexander's daughter Maria
Haven Ladd Emery (b. 1848); to Maria Emery's
daughter Ruth Emery Griswold (b. 1880), the
donor.

Publications: Giffen (Nylander)1970a, 114 and 118.

1. Goss 1991, 1–3.

2. Howells 1937, 31.

3. Goss 1991, 1–3.

4. The surviving portraits in the group are all
attributed to John Greenwood, Boston, 1751,
and they include: *Capt. John Moffatt, Katharine
Cutt Moffatt* (Giffen [Nylander] 1970a, 116),
Katharine Moffatt Whipple (1734–1821), and
Samuel Moffatt (1738–80) (Giffen [Nylander]
1970a, 113) owned by or on loan to The Society
of The Colonial Dames, Moffatt-Ladd House,
Portsmouth; and *Elizabeth Moffatt Sherburne*
(1730–62) in the collection of Yale University
Art Gallery (1983.18). A third daughter,
Mehitable Moffatt Knight (1736–83), was
probably painted at this time, but the where-
abouts of her portrait is unknown. Greenwood's
presence in Portsmouth can be verified by his
letter sent from Boston to Richard Waldron
dated Dec. 16, 1751: "This will only inform you
I have had my health ever since I left Portsmᵒ
and that I have again Engaged in Business but
my tho'ts have not yet left their roving Ideas."
*Documents and Papers,*18:405–6. For more on
Greenwood and the Moffatt portraits, see
Burroughs 1943, 34, 42, and 68–69. The author
would like to thank Charlotte Emans Moore
and Sandra Armentrout for their help in re-
searching Greenwood.

5. Seven nearly identical and seemingly con-
temporary frames survive; five are on the afore-
mentioned portraits. A sixth frame is now on a
later portrait of William Whipple (1730–85),
son-in-law of Capt. John Moffatt, but may have
originally contained Mehitable Moffatt Knight's
portrait, while a seventh frame stands empty in
storage at the Moffatt-Ladd House. The sev-
enth sitter could have been a son-in-law of the
Moffatts, probably John Sherburne who married
into the family in the early 1750s. The author
would like to thank Nancy D. Goss for her help
with the Moffatt family genealogy.

6. Saunders and Miles 1987, 19.

7. For more on the Moffatt's financial prob-
lems, see Giffen (Nylander) 1970a, 113–20.

8. John Moffatt, 1786 inventory, old series,
docket 5173, Rockingham County (N.H.) Pro-
bate. Moffat's inventory also lists two pictures in
the front parlor and two more in the back parlor
chamber, valued at 6*s.* and 3*s.* respectively. Por-
traits seldom appear on estate inventories be-
cause appraisers thought they had little resale
value; this may explain the low estimate ascribed
to Moffatt's pictures. They could also have been
prints. Most, if not all, of the Moffatt family
portraits still resided in the Market Street man-
sion (now the Moffatt-Ladd House) in 1849
and were among the fifteen "Gilt Framed Fam-
ily Portraits" owned by John Moffatt's great-
granddaughter, Maria Tufton Haven Ladd, and
her husband, Alexander Ladd. The pictures
were divided into groups and hung in the grand
entry, drawing room, front parlor, north front
chamber, and dining room. See Alexander
Ladd, 1849 mortgage, 5:184–89, Mortgages of
Personal Property, Portsmouth City Hall.

9. Both woods were identified by Prof. Bruce
Hoadley, University of Massachusetts, Amherst,
using microscopic analysis. Three of the seven
frames in the group were analyzed by Hoadley.

10. *Rococo* 1984, 157, 166.

11. Beckerdite 1987, 147–58. The design of the
frames attributed to Welch relates to that of the
Moffatt suite; however, Welch's frames are
nailed at the corners while the Moffatt examples
have splines. The author would like to thank
Luke Beckerdite for his advice on the relation-
ship between these groups of frames and the
probable date of the Moffatt frames.

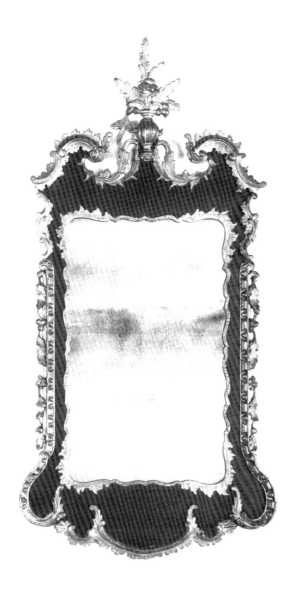

LOOKING GLASS

London
ca. 1766
Portsmouth Historical Society,
John Paul Jones House
Portsmouth, New Hampshire
Gift from the Mrs. Albert Rice Collection, H3

LOOKING GLASSES constituted a costly and essential accessory in a well-furnished Portsmouth home of the eighteenth century. Because large silvered glass plates were produced only in England and on the Continent, colonial Americans with aspirations toward fashionable living were forced to purchase imported looking glasses, which usually arrived framed.[1] Dry-goods merchants, upholsterers, and even silversmiths sold looking glasses, which were available in a wide variety of sizes and forms to suit all but the smallest purse.[2] The wealthiest individuals, such as Woodbury Langdon, the original owner of this rococo style looking glass (*see Inscriptions*), commissioned agents to purchase looking glasses and other luxury items directly from vendors in London.

Those who owned only one looking glass usually put it on view in the parlor where it served as the decorative focal point. Often hung between windows or above a mantel, the looking glass enhanced the amount of natural and artificial light in the room. Because of the cost involved in buying a looking glass, it provided a sure means of judging a family's wealth.[3] In 1785 the Reverend Stephen Chase owned "1 Looking Glass 20/. D° larger 35/ .[£] 2..15..0."[4] Only the bedding was valued more highly in this household. The home of the mariner Nathaniel Sherburne contained a grand looking glass valued at £3.12.0 as well as three other glasses ranging in value from £0.6.0. to 2.8.0. In addition, he owned two pairs of small looking glasses valued at only a few shillings.[5] The best account of looking glasses in an eighteenth-century Portsmouth house can be found in the 1794 estate inventory of Madame

Elizabeth Wentworth. It includes an impressive group of nine looking glasses, which were used in the public rooms as well as the bedchambers of her mansion. The most costly example was a "Large Looking Glass" worth £9 paired with a "Chimney Glass" over the mantel worth £3 in the "South West Parlour."[6]

By 1770, when only thirty-two years old, the merchant Woodbury Langdon had become one of the richest men in Portsmouth.[7] His dramatic rise from modest circumstances and his acerbic personality brought him many detractors, but one candid friend recalled:

> He was diligent and persevering—pursued his object with constant unremitted attention. He was naturally inclined to be arbitrary and haughty, but his sense of what was right prevented him from doing intentional evil. To his friends he was attentive, and to his personal enemies, and he had many, he was unyielding. It was his maxim that when he was obliged to quarrel with a man, *never to quarrel at the halves*.[8]

Langdon began his career in the counting room of Henry Sherburne. He then furthered his fortunes by serving as a ship captain, and later as a merchant in partnership with Sherburne and as a judge. He married Sarah Sherburne, his partner's daughter, in 1765.[9] A short time later he set about outfitting their home on Broad Street in a style suitable to the couple's eminent standing.[10]

Among Langdon's earliest purchases was a pair of marriage portraits by John Singleton Copley, the finest artist in the colonies.[11] In 1766 Langdon compiled a detailed list of furnishings to be acquired in London by his brother John. It included carved bedsteads outfitted with luxurious bedding and hangings; window curtains and seat cushions *en suite* with the hangings; table linens; pewter and monogrammed silver tablewares; brass cooking utensils; wallpaper; a "Marble Slabb or Side Board supported in the newest Fashion;" and:

> 2 Looking Glasses, Large, Handsome newest Fashion- - -@ 80/ or 90/ cash
>
> 2 - Dº - @ 60/ or 70/
>
> 2 - Dº - @ 55/ or 60/
>
> 4 - Dº - from 30/ to 45/. [12]

It is possible that some of these looking glasses were destined for other households, but it seems more likely that Langdon intended to keep them all for use in his own richly appointed home. This looking glass is probably one of those requested in this remarkable tally.

The overall form of the looking glass is based on classical architectural elements first popularized by the Palladian style in England early in the eighteenth century. Most evident among these elements are the scrolled pediment, pendant foliage, and the egg-and-dart molding.[13] By midcentury, carvers had begun to overlay naturalistic rococo details, such as shell work, sinuous floral and foliated trim, and curvilinear inner moldings, onto traditional frames. Langdon's looking glass is a fine example of this somewhat tentative interpretation of the rococo style.[14] At the same time, the merchant also owned more flamboyant rococo frames that housed

his Copley portraits. Such a combination of stylish articles documents his position as one of Portsmouth's most fashionable citizens.

D C E

Structure and Condition: The stiles and rails of the frame are lap-jointed and glued. The pediment, skirt, and swelled corners of the sides are glued to the frame and supported with blocks (one vertical and two horizontal blocks for both the crest and the skirt, one block for each corner). The figured mahogany veneer covering the façade is mitered at the corners. The gilt finial and carved ornament along the outer border of the frame are glued to the mahogany veneer. The carving on the inner border is cut into the spruce core of the frame. Strips of carved and gilt leaves are glued and nailed to the sides of the frame. The original mirrored glass is held in place with small wedge-shaped blocks glued to the inner edge of the frame. The back—three horizontal boards—is secured with nails.

The looking glass has had minimal repair. Two new support blocks reinforce the pediment. New screws attach the original vertical blocks to the back of the pediment and skirt. The frame is missing three elements: the gilt leaf to the right of the finial vase, the largest lower leaf on the left scroll of the pediment, and the bottom backboard. The other two backboards may be early replacements. A dark varnish covers the veneered surface of the frame.

Inscriptions: "This mi... / My great great gr... / Woodbury Lang... / Born at Portsmouth 1738 / Died 1805 / The above was written by Anna Parker Pruyn / The Mirror became her daughter's (Harriet Langdon Pruyn Rice) / at her death Octr 1909" written in ink on paper label on upper backboard. "This mirror belonged to Woodbury Langdon / of Portsmouth N.H. / 1738–1805" in ink on the middle backboard.

Materials: Mahogany veneer on façade; *spruce support blocks, rails, and stiles; *eastern white pine backboards. Original mirrored glass.

Dimensions: H. 57¾; W. 27¾; D. 2½

Provenance: Originally owned by Woodbury Langdon (1738–1805) and his wife Sarah Sherburne Langdon (1748–1827); probably descended to his daughter, Sarah Sherburne Langdon Harris (1771–1860); to his granddaughter, Mary Ann Harris Dana (d. 1867); to Mary's daughter Julia Van Ness Dana Whipple; to Julia's son Napoleon Dana Whipple. The latter sold it to his cousin Anna Fenn Parker

Pruyn (1840–1909); descended to her daughter Harriet Langdon Pruyn Rice (1868–ca. 1937), who gave it to the Portsmouth Historical Society.

1. Barquist 1991, 1108.

2. Ibid., 1108–9.

3. Garrett 1990, 46.

4. Rev. Stephen Chase, 1785 inventory, old series, docket 5093, Rockingham County (N.H.) Probate.

5. Nathaniel Sherburne, 1795 inventory, old series, docket 6036, Rockingham County (N.H.) Probate.

6. Elizabeth Wentworth, 1794 inventory, Larkin Papers, box 1, folder B, Portsmouth Athenaeum. She was the widow of Mark Hunking Wentworth, the second highest taxpayer in town in 1770. Brewster 1859, 165.

7. Brewster 1859, 165. Langdon was taxed £24 in 1770. Those who paid more in taxes include: George Boyd, £67; Mark Hunking Wentworth, £30; Jonathan Warner, £27; and James McMaster £27.

8. As quoted in Mayo 1937, 262.

9. Ibid., 10.

10. Garvin 1983, 292–304. Langdon's home burned in March 1781. He replaced it with a three-story brick dwelling, in about 1785. It introduced the Adamesque style of neoclassical architecture to New England, nearly a decade before the architect Charles Bulfinch began working in Boston. Presumably, this looking glass was rescued from the 1781 fire.

11. Prown 1966, 1:109, 221, pls. 169 and 170.

12. Memorandum, Apr. 1766, Langdon Papers, Strawbery Banke Museum.

13. Barquist 1991, 1112.

14. A closely related example still in England is in the collection of the Victoria and Albert Museum (w. 85–1910), see *Georgian Furniture* 1958, no. 78; for two variations on this type of rococo looking glass, see Conger 1979, pl. 24, and Barquist 1991, 1115, pl. 10.

117

GIRANDOLE LOOKING GLASS

Probably London
1808–15
Rundlet-May House
Portsmouth, New Hampshire
Society for the Preservation of New England
Antiquities, gift of Ralph May, 1971.507a

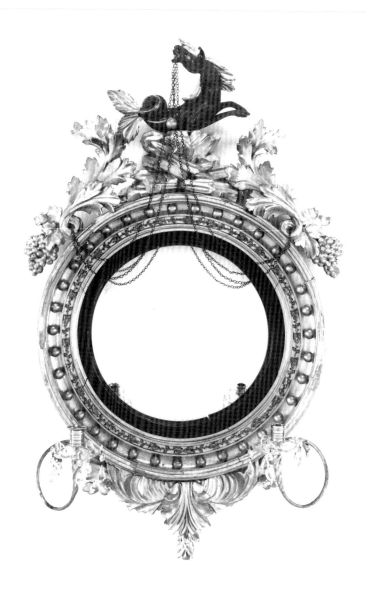

IN THE EARLY NINETEENTH CENTURY, girandoles—wall-mounted branched supports for candles—were paired with looking glasses to offer a stylish solution to the vexing problem of insufficient light within the home. By attaching the girandoles directly onto the frame of a looking glass, craftsmen offered an innovative design in the latest fashion and amplified the amount of light a candle could produce. Most girandole looking glasses are circular in shape and feature a convex glass. According to Thomas Sheraton, this form was technically called a mirror, but the term looking glass continued to be more commonly used in America.[1] In 1803 Sheraton stated:

> a mirror is a circular convex glass in a gilt frame, silvered on the concave side, by which the reflection of the rays of light are produced. The properties of such mirrors consist in their collecting the reflected rays into a point, by which the perspective of the room in which they are suspended, presents itself on the surface of the mirror, and produces an agreeable effect. On this account, as well as for the convenience of holding lights, they are now become universally in fashion, and are considered both as a useful and ornamental piece of furniture.[2]

The new form was well-adapted to serve as a base for the plethora of neoclassical decorative elements popular at the time. This looking glass features acanthus leaves, grapes, balls, oak-and-acorn clusters, and a sea-green hippocampus.[3] Gilding covers most of the decoration except for the hippocampus and oak clusters. The former has a mottled painted finish alluding to fishscales, while the clusters were coated with a dark gold-colored metallic powder creating a matte effect against the otherwise highly burnished surface. The ebonized reeded inner molding provides a

dramatic buffer between the reflective surfaces of the glass and gilded frame. The Portsmouth merchant James Rundlet purchased this looking glass and a matching one soon after moving into his new home on Middle Street in 1808. The pair was destined for the best parlor. In September 1809, Rundlet paid Henry Bufford to paint and paper the room with "Peach Damask" wallpaper and a "Paris Flock Border."[4] Rundlet then proceeded to fill this grand space with sofas (*cat. no.* 105), card tables (*cat. no.* 63), a set of chairs, and the girandole looking glasses. The glasses were mounted on opposite walls (117A), strategically situated to reflect light from the windows and fireplace. Although subsequent generations rearranged the furniture to suit their taste, the looking glasses and the wallpaper remained just as the patriarch intended.

Record of Rundlet's acquisition of the looking glasses has not survived. The stylish design and excellent craftsmanship of the glasses suggest an origin in London.[5] Rundlet may have commissioned an agent to send them directly from there, just as Woodbury Langdon had done nearly fifty years earlier (*see cat. no.* 116). Rundlet routinely imported shipments of textiles and other goods from London to sell in his Portsmouth store. Indeed, the peach damask wallpaper was manufactured in London and shipped by Mann and Barnard in 1807.[6] It is also possible that Rundlet acquired the glasses from a Portsmouth vendor who imported ornate examples from abroad. A matching looking glass (*see* 95A) belonged to the Hayes family of South Berwick, Maine.[7]

D C E

Structure and Condition: The outer molding of the frame consists of two sections of laminated boards that are face-turned and glued together. The surface has been gessoed, coated in a gray bole, and water-gilded. The reeded inner molding also consists of two sections that are face-turned and glued together. It has been painted black. The mirrored glass probably rests in a rabbet cut into the molding. The backboard is held in place by a series of glue blocks that are affixed to the back of the frame and the board. The board has never been removed. The overlaying crest and lower bracket are nailed to braces that are tenoned, glued, and nailed into the outer molding. The acanthus, grape clusters, rockery, and balls are all carved wood that has been finished in the same manner as the outer molding. The hippocampus is carved wood; the body has been painted a blue-green color and the mane and tail fin have been water-gilded. The oak-and-acorn cluster is cast composition on a string; the chain has been glued to the outer molding and then coated with a gold-colored metallic powder and a gold-colored lacquer. The candle arms are made from wire that has been wrapped with fabric and then covered in composition. Each arm is attached to the frame by means of a bracket and two screws.

During its lengthy history in the Rundlet-May House, the looking glass has sustained only modest damage. By 1992, shrinkage cracks had developed in the frame, which disrupted the gilded surface; a piece of the backboard was missing; the bottom decorative pendant was missing as were some of the oak clusters; and there were a number of other splits in the foliage and hippocampus. There were numerous losses of gesso and gilding; bronze paint used

previously to hide some of the losses had discolored; and the burnished gold surface was obscured by dirt and soot. The chain and candle cups were exceedingly tarnished.

In preparation for this publication, SPNEA conservators Susan L. Buck and Christine Thomson stabilized the numerous areas of loose gesso and cleaving gold, cleaned the accumulations of dirt and dust as well as grime, filled the losses to the composition and gesso, glued pine blocks and wedges to the back of the frame and the crest and lower bracket, and cleaned all of the brass and glass elements.

Materials: *Sylvestris pine frame and backboard; *eastern white pine support braces for the upper and lower decorative elements; original mirrored glass and glass bobeche and drops; original brass chain and cups; wire arms.

Dimensions: H.41; W. 25½; D. 3⅛

Provenance: This looking glass shares a provenance with cat. no. 8.

1. Barquist 1992a, 330, note 21.

2. Sheraton 1803, 2:271.

3. Taken from Greek mythology, the hippocampus is a sea-monster with head and fore quarters of a horse and the tail of a dolphin. Neptune harnessed them to draw his sea-borne chariot. For other examples with hippocampi, see Christie's, sale 6416, June 5–6, 1987, lot 327; and Skinner, Inc., sale 1305, Jan. 13, 1990, lot 120.

4. Nylander, Redmond, and Sander 1986, 113.

5. See Barquist 1992a, 322. The presence of a native American wood—eastern white pine—in the frame does not necessarily substantiate an American origin for the looking glass. American wood was imported to England for use in the production of frames.

6. Nylander, Redmond, and Sander 1986, 113–14.

7. The looking glass pictured in 95A probably belonged to Judge William Allen Hayes and his wife Susan Lord Hayes of South Berwick; see cat no. 95. It is listed in the 1906 estate inventory of their son, Augustus Lord Hayes, as an "Old convex mirror with two light sconce and crystal pendants" valued at $75. Typescript, Old Berwick Historical Society.

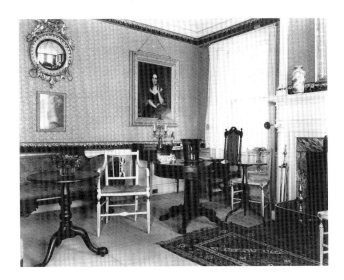

117A.
Parlor, Rundlet–May House, Portsmouth, New Hampshire. Photograph ca. 1935. Archives, Society for the Preservation of New England Antiquities, Boston, Massachusetts.

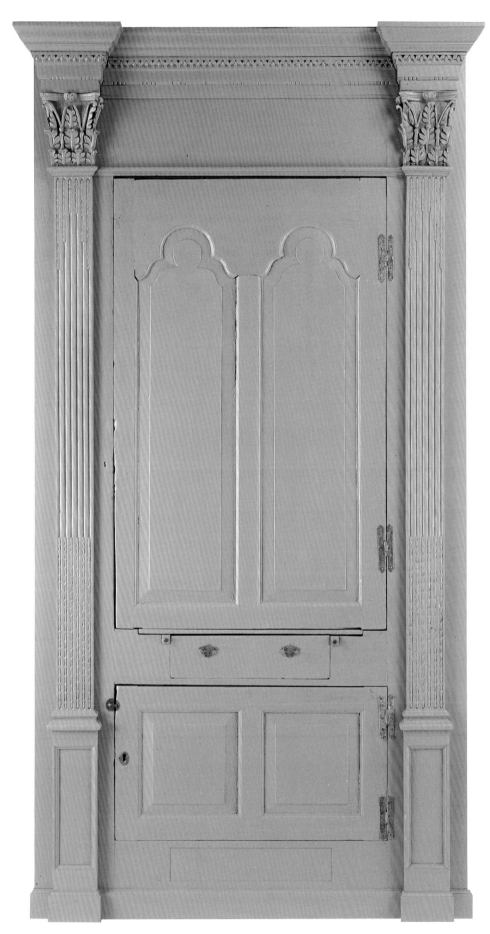

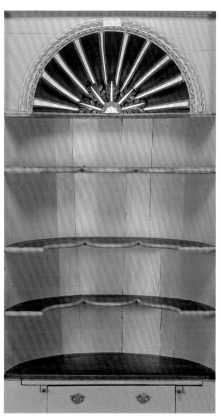

❧ *Plate 1*

CUPBOARD & INTERIOR

Cat. no. 4
Portsmouth, New Hampshire
1720–30
Museum of Fine Arts, Boston, Massachusetts,
purchased from the Henry Lillie Pierce Residu-
ary Fund, the Fund for Colonial Art, and with
contributions from Charles H. Tyler and
Templeman Coolidge, 20.602
Courtesy, Museum of Fine Arts

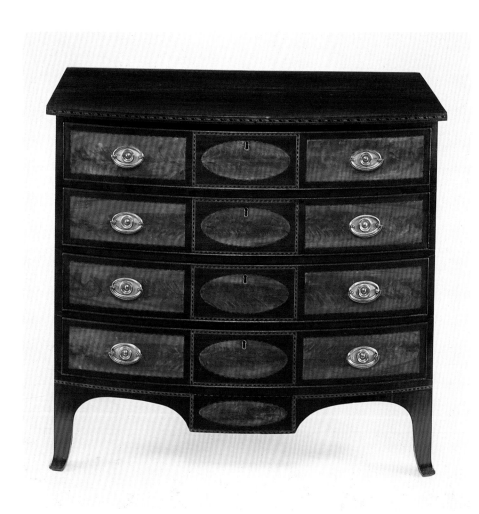

❧ *Plate 2*

CHEST OF DRAWERS

Cat. no. 12
Probably Portsmouth, New Hampshire
1800–15
Private collection

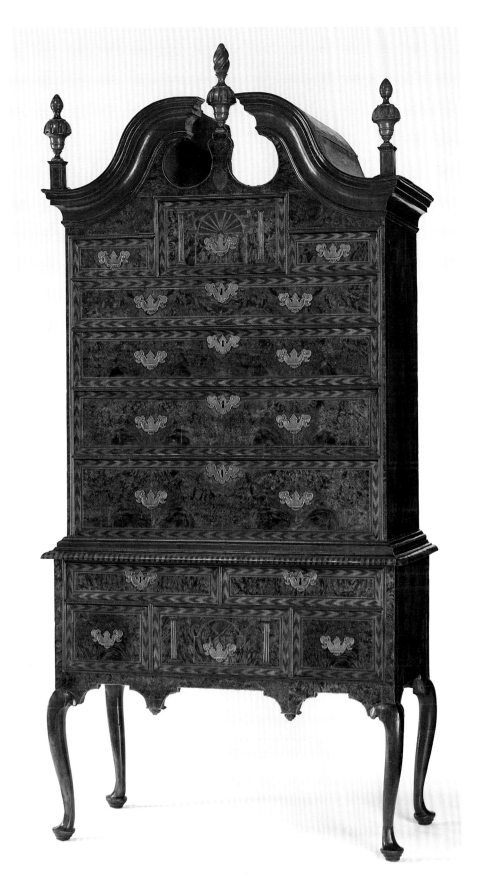

❧ *Plate 3*

HIGH CHEST OF DRAWERS

Cat. no. 15
Portsmouth, New Hampshire
1733
Private collection

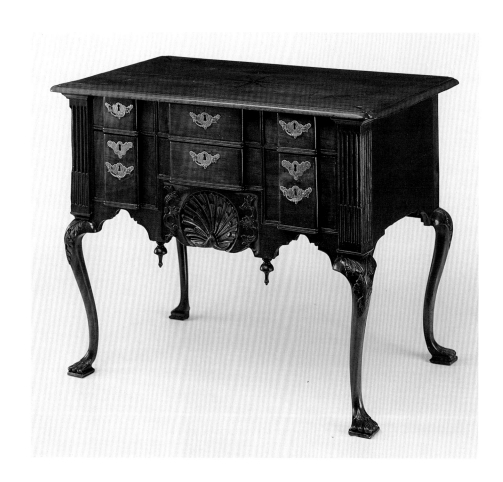

❧ *Plate 4*

Dressing table

Cat. no. 17
Attributed to Joseph Davis
(working 1726–62)
Portsmouth, New Hampshire
1735–50
Private collection

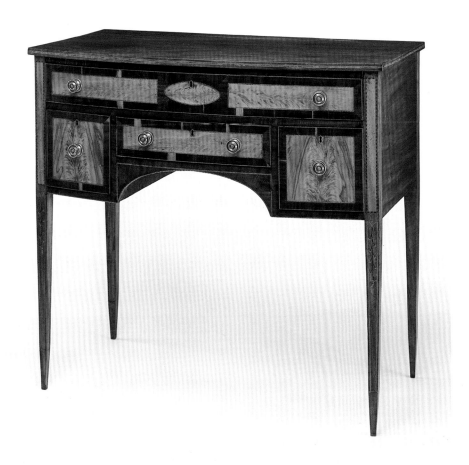

❧ *Plate 5*

DRESSING TABLE

Cat. no. 21
Portsmouth, New Hampshire
1805–15
Rundlet–May House
Portsmouth, New Hampshire
SPNEA, gift of Ralph May, 1971.985

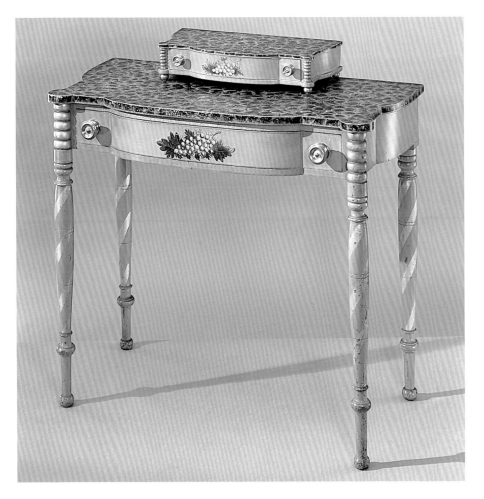

❧ *Plate 6*

DRESSING TABLE

Cat. no. 24
Portsmouth, New Hampshire
1815–25
Abby Aldrich Rockefeller Folk Art Center
Williamsburg, Virginia, 74.2000.2

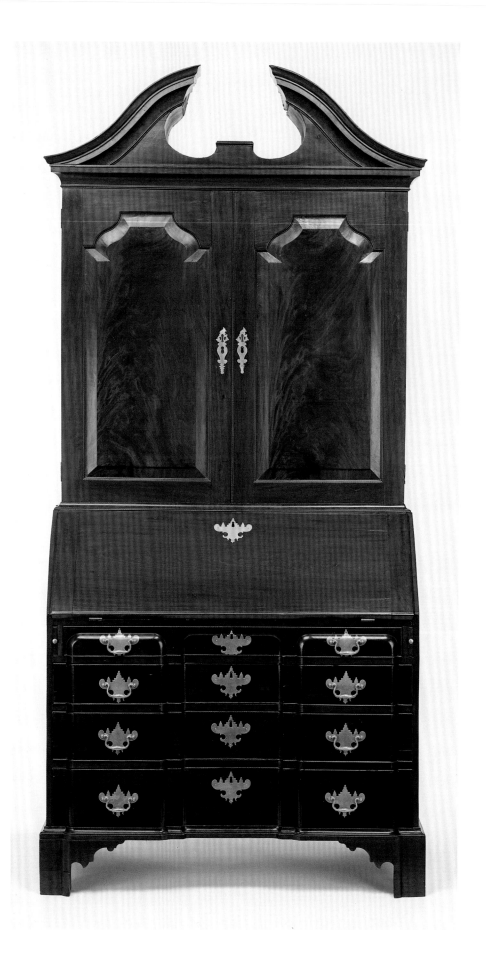

Plate 7

DESK AND BOOKCASE

Cat. no. 26
Portsmouth, New Hampshire
1755–70
SPNEA, 1983.114

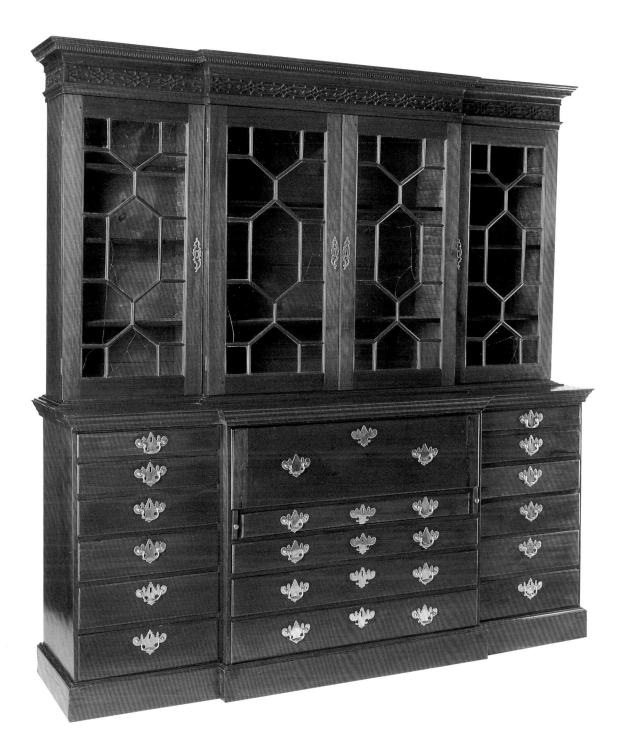

❧ *Plate 8*

LIBRARY BOOKCASE

Cat. no. 27
Attributed to Robert Harrold
(working 1765–92)
Portsmouth, New Hampshire
1765–75
Warner House Association
Portsmouth, New Hampshire
Gift of Mrs. John Curtis, 1980.1

Plate 9

SECRETARY AND BOOKCASE

Cat. no. 33
Judkins and Senter (working 1808–26)
Portsmouth, New Hampshire
1813
William E. Gilmore, Jr.
and Terri C. Beyer,
on loan to The Currier Gallery of Art,
Manchester, New Hampshire

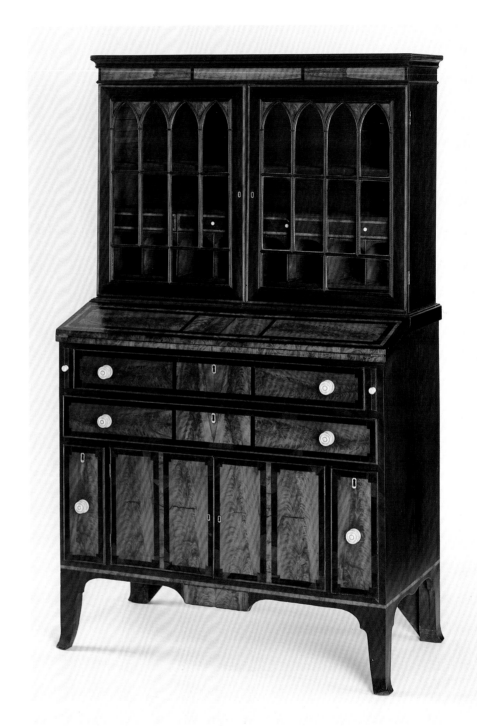

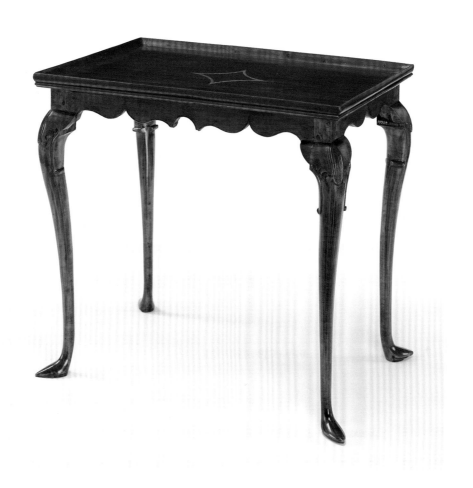

❧ *Plate 10*

Tea table

Cat. no. 47
Portsmouth, New Hampshire
1740–75
SPNEA, 1991.114

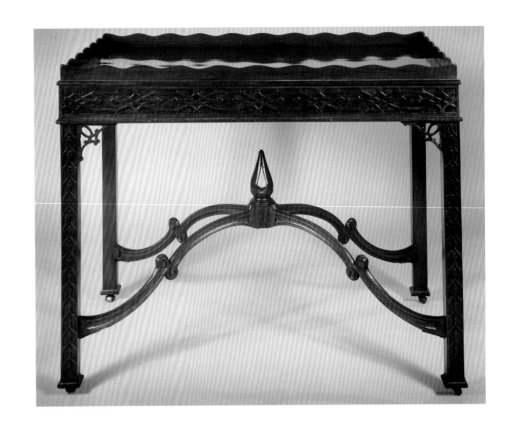

✤ *Plate 11*

CHINA TABLE

Cat. no. 48
Attributed to Robert Harrold
(working 1765–92)
Portsmouth, New Hampshire
1765-75
The Carnegie Museum of Art
Pittsburgh, Pennsylvania, museum purchase:
Richard King Mellon Foundation grant,
72.55.2

✤ *Plate 12*

PEMBROKE TABLE

Cat. no. 56
Portsmouth, New Hampshire
1760-90
Private collection

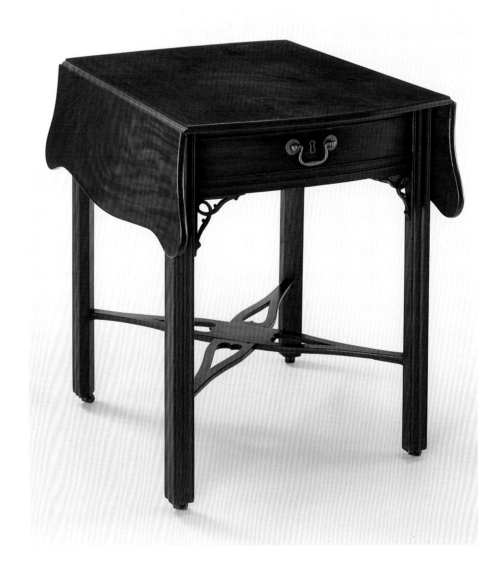

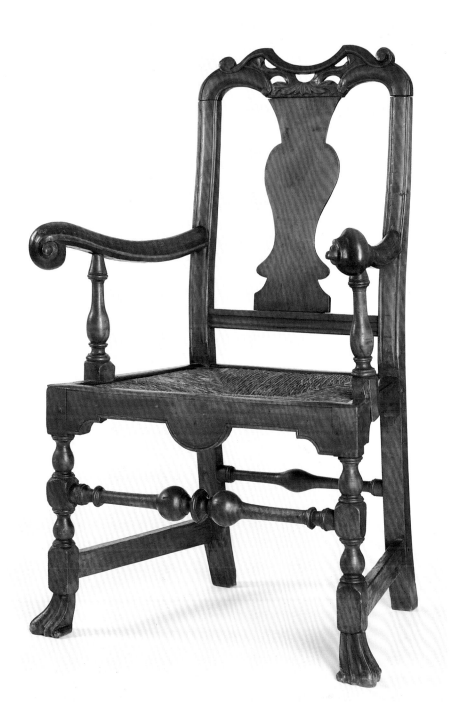

ARMCHAIR

Cat. no. 77
Attributed to John Gaines III (1704–43)
Portsmouth, New Hampshire
1735–43
Collection of Peter Elliot

❧ *Plate 14*

ARMCHAIR

Cat. no. 88
Portsmouth, New Hampshire
1765–80
Governor John Langdon House
Portsmouth, New Hampshire
SPNEA, bequest of Elizabeth Elwyn Langdon,
1966.286

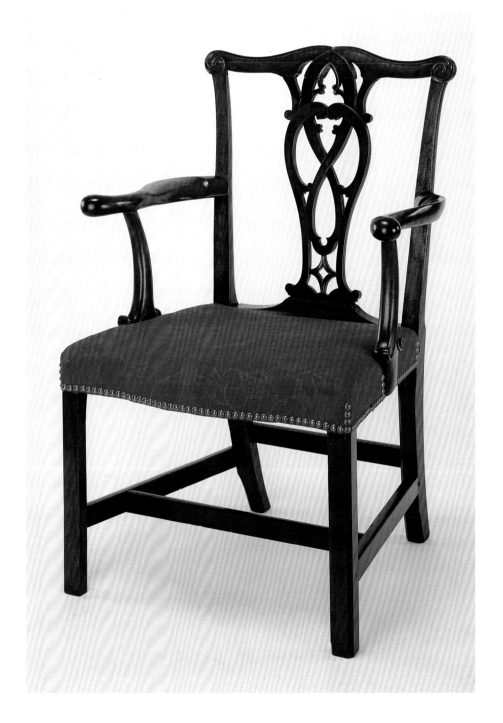

Appendix A: Furniture Makers and Allied Craftsmen

Kevin Shupe

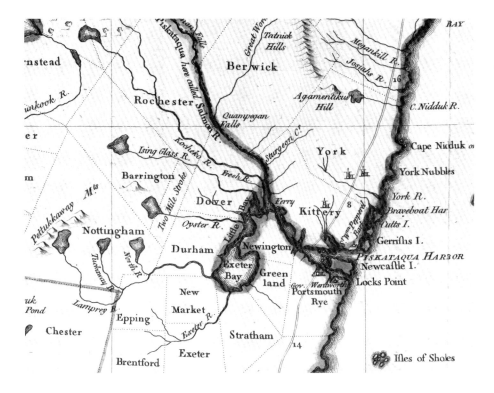

Furniture making has traditionally been an anonymous craft. Artisans seldom signed their work, and written documentation rarely accompanies surviving examples of furniture. Nonetheless, the names of artisans have been preserved in city directories, financial and tax records, and legal documents. The following checklist records the names of more than 250 craftsmen engaged in furniture making in Portsmouth and the surrounding Piscataqua-area townships between the years 1700 and 1840.

In compiling the list, we excluded house joiners and carpenters, unless they also participated in the furniture trade, and restricted working dates to documented years. Craftsmen's files are maintained at SPNEA.

Sources used to compile this checklist include Burroughs 1937; Churchill 1991b; Giffen (Nylander) 1968; Jobe 1993; McBrien 1993; and *Plain and Elegant* 1979. In addition, researchers consulted the following primary sources: probate records, deeds, court records, and vital statistics from Rockingham, Strafford, and York counties; city directories; city tax lists; and the archives of the Portsmouth Athenaeum and Strawbery Banke Museum. Diane Carlberg Ehrenpreis, James L. Garvin, and Johanna McBrien helped compile and edit the information. The production of this list was made possible by a gift from the Elizabeth Carter Fund of the Greater Portsmouth Community Foundation.

CHAIR MANUFACTORY.

THE subscriber respectfully informs the public that he has recently commenced the manufacturing of *Common Dining* and *Parlour* **CHAIRS** which he will sell Wholesale or Retail, on reasonable terms, for cash or approved credit.

☞Chair Dealers are invited to call and examine before they purchase elsewhere. The superior advantage of Water Power in the above business will enable the subscriber to sell as *cheap as can be bought in Boston*, and warranted equally as good.

ABRAHAM FOLSOM.

Somersworth, G. F. Oct. 28, 1834. 6m

Advertisement in Dover Gazette and Strafford Advertiser, *April 14, 1835. Portsmouth Athenaeum, Portsmouth, New Hampshire.*

Name	Occupation	Birth / Death	Working Location	Relationships
Adams, Benjamin	joiner		Portsmouth, 1795–1805	Partner with James Nutter
Adams, James	joiner		Portsmouth, 1805–10	
Adams, John	cabinetmaker	d. 1821	Portsmouth, 1810–15	wife: Sally Hodgdon
Adams, Joseph	cabinetmaker		Exeter, 1780–84	wife: Mary
Adams, Mark, Jr.	cabinetmaker		Portsmouth, 1824–34	
Aris, Samuel	clockmaker, watchmaker	d. 1781	Portsmouth, 1758	
Babb, Peter	joiner	ca. 1724–1800	Portsmouth, 1750–70	father: Philip; daughter: Sarah, married George Osborne; apprenticed to Joseph Hall
Babb, Peter, Jr.	joiner	ca. 1755–1810	Portsmouth, 1797–99	wife: Hannah Ham
Badger, William	cabinetmaker		Portsmouth, 1834 New Market, 1839	wife: Mary?; apprenticed to Ebenezer Lord (1828)
Banfield, George	turner, chairmaker	d. 1760	Portsmouth, 1725–60	sister: Abigail, married Thomas More; wife: (1) Miriam Shortridge, (2) Mary Locke
Bass, Joseph	upholsterer	1744–1822	Portsmouth, 1764–98	wife: (1) Abigail Griffith, (2) Sarah; apprenticed in Boston, probably to his brother, Moses Belcher Bass
Beck, George	cabinetmaker	d. 1820	Portsmouth, 1806–20	wife: Polly White?
Beck, Henry	chairmaker, painter	1787–1837	Portsmouth, 1805–34	wife: Fanny Simpson; guardian of Joseph Simpson (1808); probably apprenticed to Josiah Folsom; partner with Nathaniel Frost (1810)
Beck, Samuel	painter, gilder		Portsmouth, 1812–19	partner with Andrew Hall, Jr. (1810–11)
Belcher, John	joiner	1661–1731?	Kittery, 1690–1731?	
Blunt, John S.	painter	1798–1835	Portsmouth, 1821–31	did work for Ebenezer Lord
Boardman, Langley	cabinetmaker	1774–1833	Portsmouth, 1798–1833	wife: Rachael Annable; apprentices and workers: Edward Sherburne, Andrew Lewis, Alfred T. Joy, George Clifford, and Ebenezer Lord
Bowles, William	painter, glazier	d. 1815	Portsmouth, 1802–15	
Brackett, Samuel	turner	ca. 1672–1752	Berwick, 1694–1752	wife: Elizabeth Botts
Brown, Edmund M.	cabinetmaker	1803–83	Portsmouth, 1825–64	wife: Mary Ann Treadwell; sons Washington and James C. were cabinetmakers; partner with Samuel M. Dockum (1827–29), Albert Joy (1836–43), Samuel P. Treadwell (1851)
Brown, Thomas	chairmaker, cabinetmaker	d. 1866?	New Market, 1831–66	wife: Olive Ann; workers: Fowler, Emery, Nutter, and Bay (1836)
Bufford, Henry	painter, gilder	ca. 1780–1854	Portsmouth, 1801–51	wife: Mary Gall; son: Marcellus (1818–94), painter; apprenticed to George Doig (1800)
Burleigh, Josiah	cabinetmaker	1759–1817?	Durham, 1796–1810	
Burley, Charles	cabinetmaker?		Exeter, 1820	
Burley, James	cabinetmaker	ca. 1756–1812	Exeter, 1809–10	wife: Susanna; son: James Burley Jr.
Burley, James, Jr.	cabinetmaker		Exeter, 1809–15	father: James Burley
Buss, Joseph	joiner	before 1700–1756	Portsmouth, 1714–41	wife: Lydia Davis, daughter of Timothy I; son: Joseph Buss, Jr.
Buss, Joseph, Jr.	joiner	d. 1762	Portsmouth, 1737–62	wife: Mary; father: Joseph Buss
Calfe, Jeremiah	joiner		Portsmouth, 1711	apprenticed to Timothy Davis II
Cermenati, Barnard	carver, gilder, looking-glass maker	ca. 1783–1818	Newburyport, 1807–9 Salem, 1810 Boston, 1811, 1813–18 Portsmouth, 1812	wife: Mary Rose Francis
Chapel, John	cabinetmaker		Exeter, 1809	
Clark, George	joiner, chairmaker	d. 1747	Stratham, 1718–27	wife: Elizabeth Jewett
Clarke, Joseph	cabinetmaker	1767–1857	Greenland, 1791–1816 Wolfeborough, 1817–51	wife: Comfort Weeks; son and apprentice: Enoch Clarke

Name	Occupation	Birth / Death	Working Location	Relationships
Clifford, Ebenezer	joiner, cabinetmaker	1746–1821	Kensington, 1770–93 Exeter, 1793–1821	wife: Anna; son: George Clifford
Clifford, George	cabinetmaker	1783–1805	Portsmouth, 1799, 1801–4	father: Ebenezer; apprenticed to Langley Boardman
Colcord, Charles	cabinetmaker	1814–72	Portsmouth, 1836–43	wife: Susan B. Lord, daughter of Ebenezer Lord, with whom he apprenticed; partner with Woodbury Gerrish (1837–38)
Cole, James Charles	clockmaker, watchmaker	1791–1867	Rochester, 1813–27	wife: Betsey Nutter; apprenticed to Edward S. Moulton; Charles Dennett made his clock cases
Coleman, Eleazer	joiner	b. 1719?	Portsmouth, 1754	
Cotton, Solomon	joiner, cabinetmaker	1745–1805	Portsmouth, 1767–1803	wife: Mary (Tucker?); worked for Mark Langdon (1766) and possibly Robert Harrold
Cutts, John S.	joiner, chairmaker?		Portsmouth?, 1815	
Cutts, Thomas	turner	1700–1795	Kittery, 1724–95	
Dam, William	joiner, chairmaker	1729–55	Portsmouth	wife: Bridget Ayer; brother: Theophilus
Dame, George	painter, gilder		Portsmouth, 1801–11	
Davis, Joseph	cabinetmaker		Portsmouth, 1726–62	wife: Christian Green; apprenticed to Job Coit of Boston
Davis, Thomas	joiner, cabinetmaker		Portsmouth, 1730–43	worked with Timothy Davis (II?) and Hugh Montgomery (1731)
Davis, Timothy, I	joiner	d. 1718	Portsmouth, 1688–1718	wife: (1) Joanna Moses, (2) Constant; sons: Timothy and John; daughter: Lydia, married Joseph Buss; daughter: Hannah, married John Paine, father of John Paine
Davis, Timothy, II	joiner	ca. 1680–ca. 1758	Portsmouth, 1711–33	wife: Elizabeth Badger; father: Timothy I; son: Timothy III; apprentices: Jeremiah Calfe, William Locke, Dominick Donnelly
Davis, Timothy, III	joiner	1715–72	Portsmouth, Berwick 1729–72	wife: Olive Gookin; father: Timothy II
Dearborn, Daniel	cabinetmaker		Portsmouth, 1826–43	worked for Samuel M. Dockum (1827–34)
Dearborn, William	laborer		Portsmouth, 1833–34	worked for Samuel M. Dockum (1833–34)
Dearing, Ebenezer	carver	1730–91	Portsmouth, 1764–91	wife: (1) Mary Frost, (2) Sarah Colender; father: William; son: William
Dearing, William	carver	b. 1759	Portsmouth, 1785–1810	father: Ebenezer
Dearing, William	carver	b. 1706	Kittery, 1729–62	wife: (1) Dorothy Mendum, (2) Eunice Gunnison; son: Ebenezer
Demeritt, John	joiner	1728–1826	Dover, 1760–1811	wife: (1) Elizabeth Cate, (2) Elizabeth Davis
Dennett, Charles	cabinetmaker	1788–1867	Gilmanton, 1802–9 Rochester, 1812–30	wife: Abigail Ham; made clockcases for James C. Cole
Dennett, Mark, Jr.	cabinetmaker		Portsmouth	apprenticed to Samuel M. Dockum
Deverson, John	joiner	d. 1751	Portsmouth, 1724–48	wife: Deborah Cotton; father: Thomas
Dockum, Mark R.	cabinetmaker	1798–1843	Portsmouth, 1823 Wolfeborough	wife: Betsey Seavey; brother: Samuel
Dockum, Samuel M.	cabinetmaker, carver	1792–1872	Northwood, 1814 Portsmouth, 1816–32	wife: Lucy Norton; apprenticed to Mark Durgin (?); partner with Isaac Pinkham (1815–16), Edmund M. Brown (1827–29), Hanson Adams, nephew (1855); apprentices and workers: Mark Dennett, Jr., Eldridge Remick, Ezra Robinson, Alfred T. Joy, Asa Libby, William G. Nowell, Daniel and William Dearborn, George W. Jenness, John and Joseph C. Somerby, John Stickney, and Moses Yeaton(?)
Doe, Samuel, Jr.	joiner, cabinetmaker		New Market, 1762 Durham, 1762–64 Portsmouth, 1764–1809	wife: Elizabeth Pickering
Doig, George	painter, gilder	1756–1817	Portsmouth, 1791–1817	apprentice: Henry Bufford (1800)

Name	Occupation	Birth / Death	Working Location	Relationships
Donnelly, Dominick	joiner		Portsmouth, 1733	apprenticed to Timothy Davis I
Drew, Francis	joiner	d. 1746	Portsmouth, 1723–43	wife: Sarah Hunking; apprenticed to John Drew
Drew, Hopley	chairmaker		Durham, 1825–26	
Drew, John	joiner	ca. 1675–1738	Boston, 1714 Portsmouth, 1716–34	daughter: Anna, married Michael Whidden II; apprentices and workers: John Seaward, Samuel Waters, Michael Whidden II, Mark Haddon, Francis Drew, Hugh Montgomery, John Martin, Thomas Sherburne, and Joshua Thomas
Durgin, Mark	cabinetmaker		Portsmouth, 1809–13 Georgetown, D.C., 1820–23	wife: Maria Beck
Ellery, Benjamin	cabinetmaker		Portsmouth, 1804–5	
Evans, William	joiner	d. 1830	Portsmouth, 1812–27	
Fellows, Jeremiah	clockmaker	1749–1837	Kensington	
Fernald, Thomas	joiner	1716–68?	Portsmouth, 1731–32 Kittery, 1738–68?	apprenticed to Michael Whidden II
Fitz, William	clockmaker	1770–1827	Portsmouth, 1791–98	
Folsom, Abraham	cabinetmaker	1805–86	Dover, 1829–46	wife: Abigail S. Pierce
Folsom, James	cabinetmaker, painter	1764–1849	Exeter, 1793	
Folsom, Josiah	chairmaker	1763–1837	Portsmouth, 1788–1812	wife: (1) Polly Perkins, (2) Sarah Hull
Foster, Benjamin Call	cabinetmaker		Portsmouth, 1815–24	wife: Wilmont Griffith
French, Andrew	cabinetmaker		Dover, 1814–17	
Frost, John	joiner	b. 1716	Berwick, 1740–51? Nova Scotia, ca. 1751	
Frost, Nathaniel	joiner, chairmaker		Portsmouth, 1810–18	partner with Henry Beck
Gaines, George	joiner, cabinetmaker, housewright	1736–1809	Portsmouth, 1762–82	wife: (1) Mary Dam, daughter of Theophilus, (2) Sarah Pickering; father: John Gaines; son: John Gaines
Gaines, John, III	turner, chairmaker	1704–43	Portsmouth, 1727–43	wife: Ruth Waterhouse; father, John, was a chairmaker in Ipswich, Mass.; son: George; daughter: Mary, married David Brewster
Gaines, John	clockmaker, watchmaker	1775–1854	Portsmouth, 1797–1839	father: George Gaines
Gerrish, Woodbury	cabinetmaker	ca. 1812–98	Portsmouth, 1833–77 Cambridge, 1877	apprenticed to Ebenezer Lord (1833); partner with C. J. Colcord (1837–38); journeyman at Lord's (1839)
Gilman, Benjamin Clark	clockmaker	1763–1835	Exeter, 1795–1830	
Gilman, John	cabinetmaker		Epping, 1796	
Gilman, John K.	painter		Portsmouth, 1816	partner with John Smith (1816)
Golden, Henry	upholsterer		Portsmouth, 1763	
Grant, John, Jr.	chairmaker		Portsmouth, 1818–27	wife: Eliza Ann Vaughan
Gray, John, Jr.	painter, gilder		Portsmouth, 1798–1801	probably apprenticed to William Gray of Salem; partner with William Gray (1800)
Gray, William	painter	1750–1819	Salem, 1774–99 Portsmouth, 1800–3	partner with John Gray, Jr. (1800)
Green, Joseph	carver, gilder		Portsmouth, 1827	
Greenough, Epps	joiner	b. 1711?	Kittery, ca. 1730–36 Newbury, 1737	
Griffith, Nathaniel S.	clockmaker, watchmaker	ca. 1743–1821 or 1827	Hampton, 1767 Portsmouth, 1769–1808	
Haddon [Hayden], Mark	joiner	d. 1741?	Portsmouth, 1717–27 Kittery, 1728–41	worked for John Drew
Hall, Joseph	joiner		Portsmouth, 1750	trained Peter Babb
Ham, Daniel	clockmaker	ca. 1804–37	Portsmouth, 1825–34	wife: Elizabeth A. Trefethen; father: George

Name	Occupation	Birth / Death	Working Location	Relationships
Ham, George	clockmaker, watchmaker	1767–1832	Portsmouth, 1791–1825	wife: Joanna Beck; sons: Daniel and Nathaniel
Ham, Mark	joiner, cabinetmaker	d. 1798?	Portsmouth, 1794–97	wife: Lois
Ham, Nathaniel J.	watchmaker		Portsmouth, 1818–24	father: George
Ham, Supply	clockmaker, watchmaker	1788–1862	Portsmouth, 1809–61	wife: (1) Elizabeth Osborne, (2) Esther Marston, (3) Elizabeth Ham?; son: Francis, a clock and watchmaker
Ham, Timothy	joiner, housewright	ca. 1745–1824	Portsmouth, 1767–1818	wife: Mary; sons: Timothy and Supply; daughter: Mary, married Samuel Brewster
Hanson, Humphrey	cabinetmaker		Rochester, 1802 Durham, 1810–11	
Hardy, Francis W.	chaisemaker		Portsmouth, 1812	
Harris, Joseph	joiner	d. 1725?	Portsmouth, 1709–14 York, 1714–25?	
Harrold, Robert	joiner, cabinetmaker	d. 1792	Portsmouth, 1765–74, 1784–92 Conway, 1775–83	wife: Lilly; son: Tobias; worked with Richard Shortridge (1765); worked for Mark Langdon (1766)
Harrold, Tobias	cabinetmaker	b. 1768	Portsmouth, 1792–1807	wife: Sally; father: Robert
Haskell, Andrew L.	furniture dealer		Dover, 1827	
Hatch, Samuel	cabinetmaker	b. 1774	Exeter, 1804–24	
Hearn, George	chairmaker		Dover, 1762	
Hill, Joseph	turner	1657–1712?	Dover, 1680–94 Kittery, 1696–1712?	
Hill, Joseph	turner, chairmaker	d. 1756	Stratham, 1740 Greenland, 1747	
Hill, Samuel	turner	1650–1723?	Oyster River, 1680–83 Kittery, 1686–88 Portsmouth, 1696–1700 Kittery, 1702–23?	
Hill, Samuel, Jr.	turner	b. 1696	Kittery, 1716–20? Newington, 1720 Kittery, 1724–40?	
Howe, Otis	watchmaker	ca. 1788–1825	Portsmouth, 1825	wife: Martha Rye
Howe, Thomas	chairmaker		Portsmouth, 1755–56	
Hubbard, Moses	joiner	1700–1757?	Berwick, 1692–97 Kittery, 1738–57?	
Hubbard, Phillip	joiner	d. 1713	Berwick, 1692–97? Kittery, 1703–13	
Hutchins, Benjamin	turner, chairmaker	bap. 1727–87?	Kittery	wife: Anna Cluff?
Hutchins, Thomas	cabinetmaker?		Durham, 1781–82	
Jackson, Samuel, Jr.	joiner	d. 1804	Portsmouth, 1738–69	wife: (1) Sarah Low, daughter of Jonathan, (2) Sarah; son: Samuel
Jackson, Thomas	clockmaker	ca. 1741–83	Portsmouth, 1767 Kittery, 1773–75	
James, Samuel	joiner, chairmaker	1773–1860	Hampton, 1829–36	
Jenness, George W.	cabinetmaker	ca. 1813–68	Portsmouth, 1834–43	wife: Mary W. Goodrich; apprenticed to Samuel Dockum (1830–31); worked for Dockum (1832–34); partner with Andrew Lewis (1837); and with William G. Nowell (1838–40)
Jewett, Benjamin	cabinetmaker		Durham, 1814–15	wife: Susan; made clock case for Winthrop Smith (1815)
Jones, Benjamin	looking-glass maker	d. 1842	Portsmouth, 1839–42	wife: Lucy; partner with John Trundy (1839–40)
Jones, Zacheus	cabinetmaker		Portsmouth, 1813	
Joy, Alfred T.	cabinetmaker	1808–88?	Portsmouth, 1837–64	wife: Sarah F. Gardner; son: William G. Joy, cabinetmaker/turner; apprenticed to Langley Boardman; worked for Samuel M. Dockum (1831–34); partner with Edmund M. Brown (1837–43)

Name	Occupation	Birth / Death	Working Location	Relationships
Judkins, Jonathan	cabinetmaker	1776–1844	Portsmouth, 1806–39	wife: Lucy Maria Vaughan; sons John, Samuel, Leonard, and Daniel, cabinetmakers; partner with William Senter (1808–26)
Kidd, Thomas	turner?		Exeter, 1743	
Kincade, Naphtali	joiner	1690–1745?	Portsmouth, 1710–16? Oyster River, 1716–34? Sheepscot, 1735–45	
Knight, George	joiner, chairmaker	bap. 1732–85	Portsmouth, 1769	wife: (1) Mary, (2) Susannah Chesley
Lane, John	cabinetmaker		Epping, 1818–53	
Langdon, Mark	cabinetmaker	1698–1776	Portsmouth, 1720–76?	wife: (1) Mehitable Jackson, (2) Mary Clarke; worked with Robert Harrold and Solomon Cotton (1766)
Lawrence, William F.	furniture dealer, upholsterer	b. 1804?	Portsmouth, 1824–33	wife: Mary Jane Lake
Leighton, Daniel	joiner, cabinetmaker		Portsmouth, 1743–63	
Leighton, Hatevil	joiner	d. 1800	Dover, 1785–1800	wife: Abigail Nock; son: John
Leighton, Mark	turner, blockmaker		Portsmouth, 1780–1830	
Lewis, Andrew	cabinetmaker		Portsmouth, 1820–21, 1824–43	wife: Nancy; partner with William Badger (1834), George W. Jenness (1837)
Lewis, Ebenezer	carver	ca. 1747–73	Portsmouth	son of William
Lewis, Joseph	chairmaker	b. 1747	Portsmouth, 1767	apprenticed to Richard Mills?
Lewis, William	carver	bap. 1722–64	Portsmouth	
Libby, Asa	cabinetmaker		Portsmouth, 1836	wife: Elizabeth Yeaton; apprenticed to Samuel M. Dockum (1829); worked for Dockum (1834)
Lock, William	joiner		Portsmouth, 1733–43	apprenticed to Timothy Davis
Lord, Ebenezer	cabinetmaker	1788–1877	Portsmouth, 1809–65?	wife: Susan Hickey; daughter: Susan, married Charles J. Colcord (Lord's apprentice); apprenticed to Langley Boardman (his cousin); son: Charles E. Lord, a cabinetmaker; apprentices: William Badger (1828); Thomas Bell (1828); Mark Lowd (1828); Woodbury Gerrish (1830?–34); David Chapman (1834+), Lord's nephew, married his daughter Lucy; Timothy Hanson (1835)
Main, Benjamin	turner		Portsmouth, 1765	
March, Benjamin	joiner	1690–1753?	Kittery, 1714–25? Berwick, 1727–53?	
March, George	joiner		Portsmouth, before 1719 Arundel, 1719–41?	
March, Nathaniel B.	saddler, trunkmaker	d. 1862	Portsmouth, 1809–19	wife: Lucy E.
Marshall, Nathaniel	cabinetmaker		Portsmouth, 1792	
Martin, John	joiner		Portsmouth, 1736–58	lived with John Gaines
Meloon, Nathaniel	cabinetmaker		Portsmouth, 1839	
Meservy, Clement, Jr.	joiner	d. 1746?	Portsmouth, 1702–26 Scarborough, 1719–46?	
Miller, John	joiner	d. 1813	Portsmouth, 1801–11	wife: Ruth Ham; brother: William
Miller, William	joiner		Portsmouth, 1808–15	brother: John
Mills, John	turner, joiner	ca. 1693–1780	Portsmouth, 1725–63	wife: Alice Main; son: Richard; apprentice: Nathaniel Morrel
Mills, Richard	joiner, turner, chairmaker	1730–1800	Portsmouth, 1757–63	father: John; apprentice: Benjamin Walton
Montgomery, Hugh	joiner		Portsmouth, 1718–46	worked with John Drew and Timothy Davis (1731)
More, Thomas	carver		Portsmouth, 1715 Boston, 1725	wife: Abigail Banfield, sister of George

Name	Occupation	Birth / Death	Working Location	Relationships
Moody, Edmund	joiner		Kittery, 1728–38?	
Moulton, Edward S.	clockmaker	1778–1855	Portsmouth, 1800–2 Dover, 1812 Saco, 1814–55	apprentice: James Cole
Mulenex, Joseph	turner		Portsmouth, 1741–42	
Newton, I. L.	clockmaker, watchmaker, gilder		Portsmouth, 1806	
Norton, John	joiner		Hampton, before 1717 Kittery, 1717–42	
Norton, John, Jr.	joiner		Kittery, 1742	
Norris, Nathaniel	cabinetmaker		Hampton Falls, 1814	
Nowell, William G.	cabinetmaker	ca. 1813–70	Portsmouth, 1838–43	wife: Mary Jane Robinson; worked for Samuel M. Dockum (1833–34); partner with G. W. Jenness (1838–40)
Nutter, Enoch H.	clockmaker	1801–80	Dover, 1826–28	wife: Minna L.; apprenticed to James Cole
Nutter, James	joiner		Portsmouth, 1801–27	apprenticed to Elisha Whidden
Nutter, Samuel	turner		Portsmouth, 1760	
Osborne, George	joiner, cabinetmaker	1755–1818	Portsmouth, 1795–98, 1803–18	wife: (1) Elizabeth Walton, (2) Sally Babb, daughter of Peter
Parker, William	joiner, cabinetmaker		Portsmouth, 1760–67	
Paul, Moses	carver	1676–1730	Portsmouth 1701–27? Boston, 1727	wife: Mary Cotton; apprenticed to Richard Knight
Payne, Thomas	joiner	1684–1742?	New Castle, 1705–8 York, 1720–42?	
Peavey, James	joiner	d. 1811	Newington, 1782–1810	wife: Mary Dame
Peirce, John	housewright, joiner	d. 1816	Portsmouth, 1805–7	wife: Mary
Philbrook, John	joiner, cabinetmaker	d. 1791	New Market, Epping, 1760–70 New Market, 1791	
Philbrook, Samuel	cabinetmaker		Greenland, 1794 Lancaster, 1814	wife: Mary
Philbrook, Walter	joiner, chairmaker, cabinetmaker	bap. 1724	Greenland, 1755–72	wife: Margaret Neal
Pickering, J. H. & W.	cabinetmakers		Portsmouth, 1837?	
Pike, Ebenezer	painter, glazier		Portsmouth, 1806–24	wife: Catherine
Pinkham, Isaac	cabinetmaker	c. 1787–1820	Portsmouth, 1812–20	wife: Polly Chesley; partner with Samuel M. Dockum (1815–16)
Place, Samuel	clockmaker	d. 1810	Portsmouth, 1778–89	wife: Christian
Pond, John	clockmaker, watchmaker		Portsmouth, 1809–12	wife: Hannah Willard; apprenticed to Simon Willard, Jr.
Price, William A., Jr.	gilder		Portsmouth, 1820–21	
Prince, George W.	clockmaker	d. 1825?	Dover, 1825	
Purinton, Jonathan B.	clockmaker	1732–1816	Kensington, 1750–88 Lynn, 1816	father: Elisha
Rand, John	turner		Rye, 1762	
Rand, Joshua	turner, chairmaker		Rye, 1771–1803	
Rand, Richard	turner		Rye, 1754–56	
Remick, Eldridge			Portsmouth, 1830–32	apprenticed to Samuel M. Dockum
Rhodes, Thomas	joiner	1642–1711?	Kittery, 1676–1711?	
Roberts, John	joiner, cabinetmaker		Portsmouth, 1713–19	
Robinson, Ezra	cabinetmaker		Portsmouth, 1833–34	apprenticed to Samuel M. Dockum
Sanborn, Andrew	chairmaker		Epsom, 1804	

Name	Occupation	Birth / Death	Working Location	Relationships
Sawyer, Moses	joiner		Dover, 1765–1803	son: Moses Sawyer, Jr.
Seaward, John	joiner		Portsmouth, 1728–29	worked for John Drew
Senter, Abraham	gilder		Portsmouth, 1768–69	
Senter, John T.	joiner, turner		Portsmouth, 1802–15	wife: Margaret L. Loud
Senter, William	joiner, cabinetmaker	ca. 1784–1827	Portsmouth, 1806–26	wife: Dolly Gerrish; partner with Jonathan Judkins (1808–26)
Sewall, Thomas	joiner		Kittery, 1743	
Shaw, Caleb	clockmaker	1717–91	Kensington, 1737–91	
Sheafe, Sampson	joiner		New Castle, 1783–95	
Sherburne, Edward	cabinetmaker	b. 1792?–1812	Portsmouth, 1811	apprenticed to Langley Boardman
Sherburne, James	chairmaker	ca. 1688–1760	Portsmouth, 1744–46	wife: Margaret Rowe
Sherburne, James, Jr.	chairmaker	b. 1714	Portsmouth, 1744–55	wife: (1) Sarah Anoy, (2) Anna Hamblett
Sherburne, John	joiner	bap. 1711–67?	Portsmouth, 1733–39 Kensington, 1767	wife: (1) Elizabeth Sherburne, (2) Deborah Batchelder; son: John Sherburne, Jr.
Sherburne, John	joiner, cabinetmaker		Portsmouth, 1768–1808	worked with Richard Shortridge
Sherburne, John, Jr.	joiner	d. 1774	Kensington, 1767–74	wife: Deborah; father: John
Sherburne, Thomas	cabinetmaker	1713–84	Portsmouth, 1730–32 Boston, 1733–34, 1736–84	apprenticed to John Drew
Shorey, Stephen	chairmaker	1808?–79	East Rochester, 1845–62	wife: Louisa Corson
Shortridge, Richard	joiner, turner, cabinetmaker	1734–76	Portsmouth, 1763–70	wife: Mary Pitman; worked with John Sherburne and Robert Harrold (1765)
Simpson, Joseph	chairmaker	1794–1882	Portsmouth, 1821–27	wife: Elizabeth Tilton; Henry Beck appointed guardian (1808)
Smith, William	turner		Portsmouth, 1758	
Somerby, John	saddler, upholster	1786–1876	Portsmouth, 1821–64	wife: (1) Elizabeth Perkins, (2) Patricia Dunyon; worked for Samuel M. Dockum (1834); business with son Joseph C. Somerby, cabinetmaker (1839)
Somerby, Joseph C.	cabinetmaker		Portsmouth, 1834–43 Boston, 1876	wife: Ann E. Trague; worked for Samuel M. Dockum (1834–39)
Sowersby, William	saddler, upholsterer, chaise trimmer	ca. 1762–1837	Portsmouth, 1784–1834	wife: Sally Ayres
Stickney, John	upholsterer		Portsmouth, 1834	wife: Elizabeth T. Stokell; worked for Samuel M. Dockum (1834+)
Stickney, Samuel, Jr.	upholsterer		Portsmouth, 1827	
Stillings, Peter	joiner, turner, cabinetmaker		Boston, 1725-33, Somersworth, 1735–37, 1745; Portsmouth, 1738–44, 1764–66	
Swain, Richard	turner, chairmaker	b. 1703	Portsmouth, 1726–28 Durham, 1747	
Sweazy, Nathanial	cabinetmaker	d. 1803	Dover, 1802	wife: Sarah
Sweetser, Benjamin	trunkmaker, saddler	ca. 1778–1834	Portsmouth, 1803–33	wife: Abigail Palfrey; partner with John Sweetser (1804)
Sweetser, John	trunkmaker, saddler		Portsmouth, 1804	partner with Benjamin Sweetser
Swett, Samuel	joiner?		Kingston, 1771–74	
Taylor, William	cabinetmaker		Dover, 1809–13	
Thomas, Joshua	joiner		Portsmouth, 1728–32, 1737–51 Marblehead, 1733	worked for John Drew
Thomas, M. C.	upholsterer		Portsmouth, 1817	
Toppan, Stephen	cabinetmaker	1803–75	Dover, 1826–49	wife: (1) Lucy Bardan, (2) Emma Smith; apprentices and workers: Daniel F. Berry, Parkman Burley, James P. Sleeper, and Daniel E. True

Name	Occupation	Birth / Death	Working Location	Relationships
Towle, Amos	cabinetmaker?		Hampton, 1816–21	
Towle, Simon	cabinetmaker		Hampton, 1811–40	
Treadwell, Samuel P.	cabinetmaker		Portsmouth, 1839–64	wife: Hannah; worked for Brown and Joy (1839); partner with Edmund Brown (1851)
Treadwell, William	cabinetmaker		Portsmouth, 1834–39	
Triggs, Thomas	turner		Portsmouth, 1762 66	
True, Israel	joiner	ca. 1710–93	Portsmouth, 1752	wife: Abigail Jackson; daughter: Mary, married Jeremiah Hill; daughter: Comfort, married Elisha Hill
Trundy, Elihu	painter, glazier		Portsmouth, 1816	
Trundy, John	looking-glass maker	1800–73	Portsmouth, 1822–51	wife: Lucy; partner with Benjamin Jones (1834–46)
Tufts, Samuel	chairmaker		Portsmouth, 1799	
Varney, James	chairmaker		Dover, 1807–14	
Walker, George	cabinetmaker		Portsmouth, 1814–27	wife: Elizabeth Jenkins?
Walton, Benjamin	chairmaker	b. 1749?	Portsmouth, 1767	apprenticed to Richard Mills
Waters, Samuel	joiner	ca. 1703–85	Portsmouth, 1721–64	worked for John Drew
Whidden, Michael, II	joiner, gunsmith	ca. 1695–1773	Portsmouth, 1720–62	wife: Anna Drew, daughter of John; son: Michael; worked for John Drew; apprentices: Isaac Wincott, Thomas Fernald
Whidden, Michael, III	joiner, cabinetmaker	1731–1818	Portsmouth, 1752–1816	father: Michael II
Wiggin, Henry, Jr.	joiner	1767–1828	New Market, 1803–12	
Wille, Thomas	clockmaker		Durham, 1757	
Wilson, Joseph	joiner		Portsmouth, 1823–29	
Wincall, Isaac	joiner		Portsmouth, 1724 Kittery, 1744	
Wincott, Isaac	joiner		Portsmouth, 1731	apprenticed to Michael Whidden
Winkley, John	clockmaker	1768–1813	Durham, 1803–13	wife: Lydia
Wittum, Daniel	turner		Kittery, 1719–30 York, 1738–42	
Wittum, James	turner		Kittery, 1719–37	
Wittum, John	turner		Kittery, 1703–26 York, 1726–36 Arundel, 1736	
Wittum, Peter	turner	b. 1656	Kittery, 1679–1730	
Wittum, Peter, Jr.	turner	b. 1684?	Kittery, 1713–61?	
Wyatt, Samuel	cabinetmaker	1776–1863	Portsmouth, 1799–1813 Dover, 1814 Georgetown, 1857–63	wife: (1) Elizabeth, (2) Sophia Hayes
Yeaton, Benjamin	joiner	ca. 1734–86	Portsmouth, 1754–64	

APPENDIX B: PORTSMOUTH BRANDED FURNITURE

Kevin Nicholson

Bottom of a trunk branded "JB.WENDELL" to-gether with the Wendell branding iron. Trunk, courtesy of the Portsmouth Athenaeum. Branding iron, private collection.

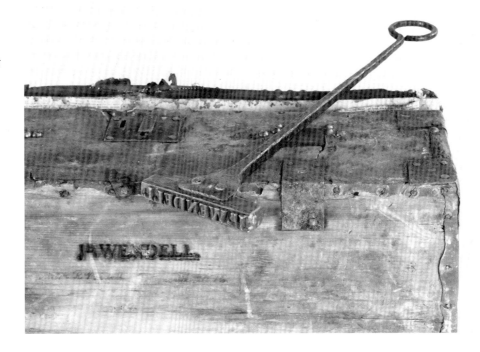

BRANDING PIECES OF FURNITURE with the owner's name occurred frequently in Portsmouth during the late eighteenth and early nineteenth centuries. Marks approximately ½" in height appear discreetly on the underside of tabletops, inside drawers, and underneath chair rails. It is likely that branding was done for identification purposes rather than as a display of ownership. Although some incidents of branding by owners are found in New York state, Boston, and Salem, nowhere was there so concentrated an appearance of this practice during the federal period as in Portsmouth.[1]

The fear of war, fire, and theft offers a plausible explanation for the branding of property. The British blockaded Portsmouth from 1774 through 1775. Anxious to protect their belongings from the British, many wealthy residents sent possessions to distant towns for safekeeping. In 1814, during the War of 1812, rumors swirled around Britain's impending invasion of the seaport; this may have prompted citizens to brand their furniture to ensure a swift recovery in the event of another exodus.[2]

Sporadic fires in the eighteenth century motivated citizens to form fire societies and appoint firewards charged with devising plans to combat future conflagrations. Members of the Friendly Fire Society were required to "keep a number of trunks with strong handles, and the owner's name on them" in order to whisk "the most valuable moveables" to safety.[3] In addition, they were to keep fire bags and buckets marked with the owner's first initial and surname. The firewards also orga-

nized for the storage of property until it was claimed by the owner. Their vigilance saved furnishings from thieves as well as flames during the disastrous fires in 1802, 1806, and 1813.

In addition, fire insurance companies were established in 1799, 1803, and 1808, producing policies to cover ships, freight, goods, houses, and household furniture. Although neither fire societies nor insurance companies required the branding of furniture with the owner's name, it is clear that this practice expedited the recovery of property.

The following list records the names of forty-eight individuals who have been identified as Portsmouth-area residents with branded furniture or branding irons. These owners were largely men of means (although several left insolvent estates at their deaths). Merchants and ship captains constituted more than half of the group, craftsmen a third. The rest represent a diverse cross section of prominent occupations: lawyer, minister, doctor, teacher, bookseller, and grocer. In addition, two spinsters may have been among the group (see PURCELL).

The majority of the objects listed below have been catalogued and photographed by SPNEA project staff, and the photographs are part of a pictorial archive. (In some cases, photographs of the brands were not available.) Files on each owner are also maintained by SPNEA. Sources used to compile this list include: genealogical information at the Portsmouth Athenaeum and the New England Historic Genealogical Society; city directories, first published in 1821; city tax lists; probate records; fire society histories; and vital statistics. This list involved the efforts of many individuals. The author is grateful to the following people for their assistance: Tara Hingston Cederholm, Diane Carlberg Ehrenpreis, Anne Rogers Haley, Brock Jobe, Helen Nicholson, Kevin Shupe, and Linda Woolford.

1. For New York examples, see Blackburn 1981, 1130–45. For Boston examples, see Jobe and Kaye 1984, no. 109, and Conger and Rollins 1991, no. 73.

2. Kaye 1978, 1102.

3. As quoted in Kaye 1978, 1102. Broadside, Friendly Fire Society, 1795, New Hampshire Historical Society. Broadside, 1789, *Federal Fire Society*, 1905.

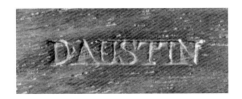

D • AUSTIN

Daniel Austin (1753–1819). Successful Portsmouth merchant and member of the New Hampshire legislature; town fireward; member of the Friendly Fire Society. "Between the North Church and the new Custom House site stands the first building of *three stories* which was erected for a store in Portsmouth…At the time of its erection by Daniel Austin, in 1800, there were only fifteen three storied houses in Portsmouth" (Brewster 1873, 286).

1. Pair of side chairs. Possibly Portsmouth, 1760–80. Yale University Art Gallery, 1950.715A and B. *Antiques* 113:5 (May 1978): 1100, fig. 2.
2. Side chair. Portsmouth, 1775–1800. Private collection. *Antiques* 113:5 (May 1978): 1099, fig. 1.
3. Side chair with original leather upholstery, matching no. 2. Private collection.

I B

Rev. Jeremy Belknap (1744–98). Son of John Joseph and Sarah; graduated from Harvard College in 1762; moved to Portsmouth in 1764 and studied theology under Samuel Haven. Ordained minister of the First Congregational Church of Dover, N.H., in 1767; married Ruth Eliot of Boston June 15, 1768; elected to the American Philosophical Society in 1784 and to the American Academy of Arts and Sciences in 1786; author of *The History of New Hampshire*, published in three volumes between 1784 and 1792.

1. Drop-leaf table. Dover or Portsmouth, 1765–80. Woodman Institute, Dover, N.H.

L • BARNES

Lewis Barnes (1776–1856). Born Jacobi Ludwig Bäarnhielm in Sweden, migrated to Salem, Mass., at the age of fourteen; moved to Portsmouth by 1800. Successful merchant and ship captain; owned all or part of the *Recovery* and *Lewis*. Lived on Islington St. Admitted to the Federal Fire Society in 1810. Bequeathed his household possessions to his two daughters, Abby Maria Barnes and Esther Walden Barnes (old series, docket 17307, Rockingham County [N.H.] Probate).

1. Chest of drawers. Portsmouth, 1810–20. Private collection.
2. Dressing table. Portsmouth, 1805–20. Gov. John Langdon House, SPNEA, 1966.1813.
3. Secretary. Portsmouth, 1800–1810. Private collection. Sold with later bookcase, Sotheby's, sale 5680, Jan. 28–30, 1988, lot 1888.
4. Fancy settee (*cat. no.* 99). Portsmouth, 1805–15. Ackland Art Museum, University of North Carolina, Chapel Hill, N.C., 1958.3.74.
5. Fancy settee matching no. 4. Formerly owned by the Baltimore Museum of Art; sold at auction in Washington, D.C., Weschler, Oct. 6–8, 1972, lot 665.
6. Set of four fancy chairs made to accompany no. 4. Ackland Art Museum, 1958.3.75–.78.
7. Pair of fancy chairs made to accompany no. 4. Old Sturbridge Village, 5.42.17. *Antiques* 106:4 (Oct. 1979): 863.
8. Pair of fancy chairs made to accompany no. 4. The Henry Ford Museum and Greenfield Village, 1973.74.1.
9. Easy chair (104A). Portsmouth, 1815–25. Strawbery Banke Museum, 1980.779.
10. Lolling chair. Portsmouth, 1810–20. Baltimore Museum of Art, 1990.10.
11. Gilt looking glass. England or America, 1810–20. Private collection.

C BLUNT.

Charles Blunt (1768–1823). Son of Capt. John Blunt. Prominent ship captain and shipowner; lived on Pleasant St.; member of the Friendly Fire Society; fireward in 1817. History portrays him as a heroic figure; he died during a voyage in the West Indies—stabbed to death and thrown overboard by pirates *(New Hampshire Gazette,* April 15, 1823). The inventory of his estate was valued at the substantial sum of $11,210.88 and included "1 birch Table [$]2.50," "1 light Stand & toilet Stand 3.50," and "1 blind for fire place 0.50" (old series, docket 10643, Rockingham County [N.H.] Probate).

1. Drop-leaf table. Portsmouth, 1790–1810. Warner House Association, 1992.2.
2. Stand *(cat. no. 71).* Portsmouth, 1770–1800. New Hampshire Historical Society, 1977.34.10.
3. Firescreen. Portsmouth, 1800–1810. Warner House Association, 1992.1.

S. BOWLES

Samuel Bowles (ca. 1770–1840). Cooper by trade; deacon of Middle Street Baptist Church. Owned a house on Daniel St. in 1800 but apparently resided on Ladd St. in 1839. His estate inventory totaled only $342.51. Among his possessions was "1 Portable Desk" valued at $2.50 (old series, docket 14045, Rockingham County [N.H.] Probate).

1. Portable desk. Portsmouth, 1800–1815. Strawbery Banke Museum, 1990.125.

O. BRIARD

Oliver Briard (b. before 1780). Operated a dry-goods store on Market St.; lived on Middle St.; married Sally Noble in 1800; long-time member and secretary of the Humane Fire Society; fireward in 1817; director of the Portsmouth Bank in 1821; and a justice of the peace in 1834. May have moved to Boston during the mid 1830s.

1. Side chair. Portsmouth, 1760–80. New Hampshire Historical Society, 1978.81.
2. Card table. Portsmouth, 1800–1810. Private collection. Sotheby's, sale 5680, Jan. 30, 1988, lot 1825.
3. Desk. Probably York, Maine, 1750–85. Collection of Robert Foley.
4. Dressing table *(cat. no. 23).* Portsmouth, 1805–20. Collection of Carl and Brenda Stinson. Northeast Auctions, Aug. 4, 1991, lot 588.

H. CATE

Henry Cate (1779–1817). Blacksmith; his account book survives at the Portsmouth Athenaeum. Entries include various repairs and sales of Rumford Roasters and branding irons. Wife, Salome (1781–1845). His estate inventory, which totaled $1,883.77, included: "1 Desk 5$ 1 pembroke Table @ 2$" and "six Winsor Chairs 3$," a house on Cross St., and a shop in an undisclosed location. His estate was insolvent (old series, docket 9477, Rockingham County [N.H.] Probate).

1. Desk. Portsmouth, 1795–1810. Private collection.
2. Pembroke table. Portsmouth, 1795–1810. Private collection. DAPC, Winterthur Museum, 1975.1011.

3. Set of five Windsor side chairs. Portsmouth, 1800–1820. Old Sturbridge Village, 5.1.682–86.

E • M • CLARK.
Enoch M. Clark (1764–1815). "Portsmouth gent^m," deacon, and teacher; married Mary Woodward, Nov. 19, 1805. Estate inventory of 1815 includes "1 Secretary $20," but the entire legacy only totaled $408.12 1/2 (old series, docket 9162, Rockingham County [N.H.] Probate).

1. Secretary and bookcase. Portsmouth, 1805–20. Private collection.

L. COTTON.
Leonard Cotton (1800–1872). Trained as a cooper and plied his trade in Trinidad for eight years; returned to Portsmouth in 1826; owned real estate along Puddle Dock and operated a ship's store; married Martha Clarkson (1805–42) in 1825; purchased the Blunt house on Washington St. in 1826; admitted to the Mechanic Fire Society in 1831; town fireward 1839; two fire buckets survive in a private collection. For portraits of Leonard and Martha Cotton, attributed to John S. Blunt, see *Antiques* 112:5 (Nov. 1977): 968.

1. Card table. Portsmouth, 1805–20. Private collection. *Antiques* 113:5 (May 1978): 1102, 1104.
2. Drop-leaf table. Portsmouth, 1795–1815. Strawbery Banke Museum, 1989.134.
3. Card table. Portsmouth, 1805–20. Strawbery Banke Museum, 1992.2. Christie's, sale 7398, Jan. 17–18, 1992, lot 474.

J. S. DAVIS
John Stavers Davis (1775–1843). Ship captain and shipowner; his log book for the ship *Shaw* is owned by the Old Berwick Historical Society. Wife Mary (1770–1851); Davis lived on South St.; town fireward and police officer in 1817. Davis owned "18 Chairs @ 20——$3.60," which comprised a small portion of his $1,421 estate (old series, docket 14628, Rockingham County [N.H.] Probate).

1. Set of four side chairs. Portsmouth, 1805–20. Private collection. Sotheby's, sale 6051, June 28, 1990, lot 554.

Dr • DWIGHT.
Dr. Josiah Dwight (d. 1855). One of eight practicing physicians in Portsmouth in 1821; overseer of the poor in 1817; first lived on Court St.; later moved to the house built by his father-in-law, Capt. Thomas Thompson, which is next door to the Gov. John Langdon House on Pleasant St.; member of the Humane Fire Society. Inherited a piano and possibly a secretary and bookcase from Capt. Thompson. SPNEA owns a portrait of Dr. Dwight (28D).

1. Secretary and bookcase (*cat. no.* 28). Portsmouth, 1805–20. Rundlet-May House, SPNEA, 1971.615.
2. Piano. London case and Portsmouth base, 1800–1815. Moffatt-Ladd House, 1977.10.

T • ELWYN.

Thomas Elwyn (1775–1816). Born in Canterbury, England; educated at Oxford University; immigrated to Philadelphia in 1796, where he married Elizabeth Langdon, daughter of John Langdon; adopted Langdon as a middle name. Moved to Portsmouth in 1810; practiced law and served in state legislature; resided in the Woodbury Langdon house on Broad St. (gift to his wife from her father), but also retained a house in Philadelphia. Estate valued at $83,438.75 (old series, docket 9270, Rockingham County [N.H.] Probate).

1. Lady's cabinet and writing table (*cat. no.* 30). Made by John Sailor, Philadelphia, 1809. Gov. John Langdon House, SPNEA, 1966.368.
2. Dining table. Portsmouth, 1805–15. Private collection.

W. EVANS

Probably William Evans (d. 1830). A joiner with a house and workshop on South St.; working from 1812–27; owned one dressing table valued at $.84; total estate valued at $899.77 (old series, docket 12084, Rockingham County [N.H.] Probate.) Also, a William Evans of Portland, Me. owned a house on Cabot St. in Portsmouth, 1817.

1. Painted dressing table. Portsmouth, 1805–20. Strawbery Banke Museum, 1992.5.
2. Drop-leaf table. Possibly Portsmouth, 1745–75. Private collection. Pennington 1979, no. 123.

O. FALL

Otis Fall (1785–1846). Ship captain; house and shop on Fore St. in 1821; owned a house on State St. occupied by Capt. Muir, 1823–24 tax list; wife Frances Tredick Fall (1785–1837), daughter of Capt. Henry Tredick, Sr.; Otis Fall served as an administrator of his father-in-law's estate; last name also spelled "Falls."

1. Card table. Portsmouth, 1805–20. Private collection. Sotheby's, sale 5968, Jan. 24–27, 1990, lot 1079.

W. FLAGG

William Flagg (1770–1844). Ship captain, shipowner, and privateer. Shortly after 1810, moved to Dover, N.H., where he worked with his brother John Flagg. Elected to the New Hampshire State Legislature in 1813.

1. Work table. Portsmouth, 1805–20. Collection of Mr. and Mrs. E. G. Nicholson.

I. FOLSOM

Probably Jonathan, Josiah, or Josiah Gilman Folsom. Jonathan Folsom (1785–1825); born in Exeter, N.H.; joiner, apprenticed to Ebenezer Clifford; owned a house on Islington St.; owned one-quarter of the schooner *Mary Ann*; member of the Friendly Fire Society; total estate valued at $1,673.19 (old series, docket 11091, Rockingham County [N.H.] Probate).

Josiah Folsom (1763–1837); chairmaker, born in Dover, N.H.; married Mary Perkins of Ipswich, Mass. in 1786, and Sarah Hull of Durham, N.H., in 1803; moved to Portsmouth in 1788; a founding member of the Associated Mechanics and Manufacturers in 1803; chair manufactory located on Broad St. in 1805; bought land with a wharf and water privileges in 1812 and began to deal in West India goods; in 1821 owned a house near the mill-dam bridge, a store for his own use, and shops on Water St.

Josiah Gilman Folsom (1806–35); grocer dealing in West India goods; Josiah Folsom's son-in-law, married his daughter Sarah; owned half of a house near the South Mills; insolvent at his death (old series, docket 12994, Rockingham County [N.H.] Probate).

1. Card table. Portsmouth, 1805–20. Moffatt-Ladd House, 1977.83.

N B FOLSOM
Nathan B. Folsom (1781–1863). Merchant, later operated a commission store. In 1823, resided in a house on Islington St., owned a house and store on Parade St., claimed $400 worth of stock in trade, and $3,000 in cash or in public funds; moved to Bangor, Me. ca. 1840, and then to Illinois, where he died at the home of his son, Nathan B. Folsom, Jr.

1. Washstand. Possibly Portsmouth, 1805–20. Private collection. DAPC, Winterthur Museum, 1981.1030.
2. Card table. Portsmouth, 1805–20. Private collection. Northeast Auctions, Nov. 8, 1992, lot 443.

S. HALE
Samuel Hale (1758–1828). Merchant, shipowner, operated a lumber business and tannery; born and educated in Portsmouth; moved to Barrington, N.H. as a young man, later joined by his brother and partner, William Hale (1765–1848). Married Mary Rollins in 1791; became a state senator, a state judge, and a presidential elector; president of the Piscataqua Bank in 1827.

1. Handle of a bed warmer. Portsmouth area, 1770–1815. Private collection.

E. HALL
Elijah Hall (1743–1830). Naval lieutenant, who served under John Paul Jones, and shipowner; subsequently a state representative and senator; director of the New Hampshire Union Bank at Portsmouth and president of the Portsmouth Marine Society. Married Elizabeth Stoodly; owned a mansion on Daniel St. One of original members of the Friendly Fire Society, he resigned in 1808; fireward in 1809. Hall's estate totaled $4,904, but was not dispersed until 1911 because of long-standing claims against the Danish government for illegally seizing his ship *Aurora* and the government of France for doing the same to his ship *Fame*. Caroline Hall White, his daughter, inherited all of the household furnishings (old series, docket 12029, Rockingham County [N.H.] Probate).

1. Dining table. Probably Portsmouth, 1785–1805. Private collection. *Antiques* 132:5 (Nov. 1987): 1036.

S • HAM.

Either Samuel, Supply, or Samuel Ham, Jr. Samuel Ham (1770–1813); merchant, ship captain, and shipowner; married Abigail Boyd; built a mansion, later known as the Levi Woodbury house; admitted as a member of the Federal Fire Society in 1801. Left an estate valued at $20,468.66, which included "1Mah^y Secretary $12," but no tall-case clock (old series, docket 8702, Rockingham County [N.H.] Probate). Supply Ham (1788–1862); watchmaker; shop on Congress St. and house on Broad St. in 1821; later owned a house on Islington St. and a store and house on Congress St.; acquired the Jaffrey family clock (*cat. no.* 38). The inventory of his estate included: "1 Secretary 7.00," "1 Clock 12.00," "1 8dy Clock formerly Jaffreys 20.00," and "1 8 day Clock 5.00." All of the furnishings were bequeathed to the widow Elizabeth, except the Jaffrey clock, which his sons inherited (old series, docket 18843, Rockingham County [N.H.] Probate).

The 1821 *City Directory* lists one Samuel Ham, a farmer, residing on North Rd., and Samuel Ham, Jr., a mason, living on North St. Only a Samuel, Jr. appears on the 1817 city tax list; he paid $1.80.

1. Secretary and bookcase. Portsmouth, 1805–20. Private collection. *Antiques* 92:5 (Dec. 1967): front inside cover.
2. Tall-case clock (*cat. no.* 40). Portsmouth, 1791–98. Collection of Christopher and Kathleen Roper.

W. R. HARDY

William Reed Hardy (1773–1841). Son of Stephen Hardy. Tailor and draper; shop located on High St. in 1801; kept a shop on Ladd St. and lived on Jaffrey St. in 1821; owned a brick shop on Ladd St. and two tenements in 1823; kept a shop at 27 Daniel St. and lived at 14 Hanover St. in 1839.

1. Card table. Portsmouth, 1805–20. Private collection. *Antiques* 136:5 (Nov. 1989): 937.
2. Windsor side chair. Portsmouth, 1810–25. Private collection.

R HART

Richard Hart (1733–1820). Merchant; married to Mercy Collings; lived on Russell St. in a house built in 1737 by his father-in-law, Capt. John Collings; owned a wharf in the North End and a store on Fore St.; admitted as a member of the Federal Fire Society in 1792. The detailed inventory of his estate totaled $34,639.77 and included: two Pembroke tables, "10 hair bottomed Chairs [$] 25-," "1 doz Windsor Chairs 6-," "1 Easy Chair & Covg 2-," and a number of desks (old series, docket 10092, Rockingham County [N.H.] Probate).

1. Two Pembroke tables. Portsmouth, 1760–90. Private collections. *Antiques* 54:5 (Dec. 1948): 407.
2. Side chair. Portsmouth, 1760–90. Private collection. *Sack Collection* 7:2001.
3. Side chair, mate to no. 2. Portsmouth, 1760–90. Strawbery Banke Museum, 1992.18.1.
4. Side chair. Portsmouth, 1760–90. Strawbery Banke Museum, 1992.18.2.
5. Side chair. Portsmouth, 1790–1805. Collection of Gregory H. Laing.
6. Tilt-top table. Portsmouth, 1760–95. Private collection. See Benes 1986, 10–11.
7. Worktable. Portsmouth, 1805–20. Private collection. See Benes 1986, 10–11.

8. Desk. Portsmouth or Northeastern, Mass., 1780–1810. Private collection. See Benes 1986, 10–11.
9. Easy chair. Portsmouth, 1785–1805. SPNEA, 1992.50. *Sack Collection* 3: 749 (not branded, but inscribed in chalk).
10. Tall-case clock. Private collection.
11. Set of four Windsor side chairs. Portsmouth, 1805–20. Private collection. *Maine Antique Digest* (March 1990): 34C.
12. Drop-leaf table. Portsmouth, 1770–95. Private collection. *Maine Antique Digest* (Aug. 1988): 36–37F.

D. HASELTON

Daniel Haselton (w. ca. 1820–30). Son of James Haselton, a Portsmouth mason. Also worked as a mason; lived on Sudbury St.; member of the Mechanic Fire Society; listed as a Portsmouth resident in the 1830 census; surname also spelled "Hazeltine."

1. Worktable. Portsmouth, 1805–20. Private collection. Parke-Bernet, sale 1669, April 13–14, 1956, lot 364.

J • HAVEN.

Either Joseph, John, or Joshua Haven, brothers who lived in Portsmouth during the early nineteenth century. Joseph (1757–1829); a successful merchant; married first Eliza Wentworth and second, Sarah Appleton; lived in a mansion on Pleasant St.; member of the Federal Fire Society. He left a handsome estate that totaled $51,210.01 (old series, docket 11857, Rockingham County [N.H.] Probate).

John Haven (1766–1845); ship captain, shipowner, merchant, and president of Rockingham Bank; in 1817 he was the fifth highest taxpayer, after James Sheafe, Thomas Elwyn, John Langdon, and James Rundlet. Married Ann Woodward; resided on Islington St.; member of the Federal Fire Society. His estate was not inventoried (old series, docket 15023, Rockingham County [N.H.] Probate).

Joshua Haven (1779–1830); merchant; married Mary Cunningham; purchased a brick house on Islington St. in 1815; member of the Humane Fire Society; fireward and overseer of the poor in 1817, but no record of his whereabouts after that date.

1. Desk (*cat. no. 29*). Portsmouth, 1805–15. Museum of Fine Arts, Boston, 1941.576. *Antiques* 113:5 (May 1978): 1102.
2. Sideboard (*cat. no. 37*). Portsmouth, 1815. Strawbery Banke Museum, 1988.228.
3. Table (*cat. no. 45*). Portsmouth, 1750–85. Strawbery Banke Museum, 1986.606

E. HILL 3ᵈ

Elisha Hill III (1777–1853). Merchant; married Phoebe Jenkins in 1798; in 1821 he lived on Islington St. and kept a store with his partner, William Clark II, on Market St.; still in business on Market St. in 1839, but without a partner. Later owned a house on Court St. Willed the house and furnishings to his wife, and upon her death, they were to be equally divided between his spinster daughter Olive Hill and son Aaron H. Hill (old series, docket 16591, Rockingham County [N.H.] Probate).

1. Secretary and bookcase. Portsmouth, 1805–20. Strawbery Banke Museum, 1991.155.

I. HILL

In the 1821 city directory seven J. Hills and one I. Hill are listed. Of these individuals the mostly likely owners include: John Hill (1772–1843), joiner and later an agent for a distiller, lived on Deer St.; John Burley Hill, a blacksmith who lived on Vaughan St.; James Hill, a businessman who lived on Deer St.; and Joseph Hill, a goldsmith and jeweller with a shop on Fore St. A second Joseph Hill operated a fancy-goods store from his house on Market St. as late as 1839; married Clarissa Jones of Portsmouth in 1826; admitted to the Mechanic Fire Society in 1827, served as its clerk in 1830, and was honorably dismissed in 1856. Other I. Hills also resided across the Piscataqua River in Berwick, Me.; see *Antiques* 97:6 (June 1970): 902.

Courtesy, The Henry Francis du Pont Winterthur Museum

1. Side table. Portsmouth, 1735–60. Winterthur Museum, 1965.3093. Downs 1952, no. 353.

J: LANGDON

John Langdon (1741–1819). Son of John and Mary (Hall). Merchant and statesman; married Elizabeth Sherburne in 1777; lived in a mansion on Pleasant St. Signer of the Declaration of Independence; agent for Continental prizes in New Hampshire in 1776; delegate to Congress 1783; state senator in 1784; president of New Hampshire from 1785–89; United States senator 1789–1801; United States representative 1801–5; governor of New Hampshire 1805–11, except when defeated in 1809; retired from political life in 1812.

Courtesy, Old Sturbridge Village. Photograph by Henry E. Peach

1. Side chair (79B). Boston, 1740–60. Old Sturbridge Village, 5.1.756. *Antiques* 113:5 (May 1978): 1098.
2. Side chair. Boston, 1740–70. Old Sturbridge Village, 5.1.758. *Antiques* 113:5 (May 1978): 1098.

G • LONG

George Long (1762–1849). Son of Col. Pierse Long (1739–89), a famous Revolutionary War veteran and statesman. Married Mercy Hart in 1788; shipmaster until 1789, then pursued a successful career as a merchant; auditor of accounts for the town of Portsmouth in 1821; resided on the corner Joshua and Middle streets. in 1827. The inventory of his estate totaled $30,389.16 and included "2 Mahogany Card Tables $7" (old series, docket 15768, Rockingham County [N.H.] Probate).

1. Card table. Portsmouth, 1800–1815. Larkin House, Monterey State Park, Monterey, Cal., 455–2–42 L.H.

G • McCLEAN

George McClean (d. 1820). Ship captain and later a merchant; married Anna Frye in 1806; resided on Islington St.; later owned a house on Congress St. Surname also spelled "McClane." Upon his death the house was sold to Supply Ham for $1,425, while the contents of the house were valued at $824.97 and included: "one Sopha [$] 15" in the parlor and "one Sopha $8 one pembroke Table $4" in the front sitting room (old series, docket 10175, Rockingham County [N.H.] Probate).

Courtesy, Israel Sack, Inc.

1. Pembroke table. Portsmouth, 1805–20. Private collection. *Sack Collection* 8:2219.
2. Sofa. Portsmouth, 1810–20. Private collection. *Sack Collection* 8:2218.

M. S. MARSH

Matthew Sheafe Marsh (1773–1814). Successful merchant and shipowner; helped plan the construction of St. John's Church. His tombstone reads: "As a husband and father he was affectionate and beloved. As a merchant highly esteemed. His faithful services were liberally afforded in the building of this church." His estate totaled $31,177.50 and included a variety of chairs valued at $2 and $3.50 each (old series, docket 8908, Rockingham County [N.H.] Probate).

1. Pair of side chairs. Portsmouth, 1760–85. U. S. Department of State, 1973.46.1 and .2. Conger and Rollins 1991, no. 37.

W MORTON •

William Morton (ca. 1785–1865). A joiner who owned a house on Joshua St. in 1821.

1. Secretary and bookcase (*cat. no.* 34). Portsmouth, 1813. Strawbery Banke Museum, 1983.6.

T. G. MOSES

Thomas G. Moses (1787–1825). Tailor; he had a home and shop on Congress St. in 1821; moved his shop to Market St. in 1823; admitted to the Mechanic Fire Society in 1811; served as its clerk from 1815–17; honorably dismissed at his request in 1819, but later readmitted. Moses's personal estate amounted to a modest $240.48, while the house and land on Rock St. that he owned were valued at $650, but his debts exceeded his net worth, leaving his estate insolvent. Listed amongst his furnishings were "1 Secretary & Book Case 54/ 16 knifes & forkes 6/ [$] 10" (old series, docket 10938, Rockingham Co. [N.H.] Probate).

1. Secretary and bookcase. Portsmouth, 1805–20. Private collection. *Girl Scouts Exhibition*, no. 695.

N. T. MOULTON

Nathaniel T. Moulton (1787–1870). Tailor; married Lydia D. Holbrook in 1809; lived on Joshua St. and worked out of a shop on Ladd St.; operated a clothing warehouse on Market St. in 1834; in 1839 he lived on Auburn St.; member of the Association of Mechanics and Manufacturers; admitted to the Mechanic Fire Society in 1813, served as a warden in 1814, and was honorably dismissed in 1818. Two of his leather fire buckets survive in a private collection.

1. Secretary and bookcase. Portsmouth, 1805–15. Private collection. *Antiques and the Arts Weekly* (Aug. 3, 1990): 113.

N PIERCE

Probably Nathaniel Pierce (1779–1833). Printer and druggist; married Sally Gunnison Greenough in 1805; lived on Washington St. in 1827; published the *New Hampshire Gazette* 1802–5; member of the Association of Mechanics and Manufacturers, a Mason and member of St. John's Lodge No. 1; admitted to the Mechanic Fire Society in 1811, president in 1813, and active member until 1826.

There were several other Nathaniels in Portsmouth who used the alternate spelling, "Peirce": Nathaniel S. Peirce, a druggist, lived and worked on Daniel St. in 1821; and Nathaniel J. Peirce, a customs inspector, lived on Partridge St. in 1821.

1. Washstand. Portsmouth, 1805–20. Private collection. Christie's, sale 6622, June 4, 1988, lot 199.

PURCELL

The only brand without an initial before the surname. Because there were no male Purcells residing in early nineteenth-century Portsmouth, it may be the mark of Misses Nancy (1767–1843, a.k.a. Ann) and Susan (ca. 1777–1861) Purcell, spinster daughters of Capt. Gregory Purcell (d. ca. 1777) and his wife Sarah Wentworth (1741–89). Lived at the home of their brother-in-law William Gardner, in the Wentworth-Gardner House on Mechanic St.

1. Pembroke table (*cat. no.* 57). Portsmouth, 1795–1810. Collection of Mr. and Mrs. E. G. Nicholson. Sotheby's, sale 5810, Jan. 26–28, 1989, lot 1452.

W. RICE

William Rice (1767–1851). Ship captain, shipowner, privateer, and merchant; owned much Portsmouth real estate; imported goods from Europe and the Caribbean; wife Abby (1773–1812); second wife Emily P. Rice, who outlived him; owned a house on Deer St.; member of the Friendly Fire Society and the Portsmouth Athenaeum. Hosted a "Calico Party" in 1814, where ladies were invited to cut dress patterns from bales of fabric that Capt. Rice captured from the British. He left a substantial estate valued at $20,937.42 (old series, docket 16103, Rockingham County [N.H.] Probate).

1. Side chair. Portsmouth, 1765–90. Private collection. Decatur 1938, 7.
2. Sea chest. Portsmouth, 1790–1810. Strawbery Banke Museum, 1984.58.

J. RUNDLET

James Rundlet (1772–1852). Born in Exeter, moved to Portsmouth in 1794; married Jane Hill in 1795; successful commission merchant; built a mansion and outbuildings on Middle St., 1807–8; the fourth highest taxpayer in the year 1817, after James Sheafe, Thomas Elwyn, and John Langdon; fireward and selectman in 1817; owned a Rumford Roaster and a branding iron, which he may have purchased from Henry Cate (see above). Rundlet's estate was never inventoried, nor does any branded furniture survive with his mark.

1. Branding irons. Portsmouth, 1800–1820. Rundlet-May House, SPNEA, 1971.1023A and B.

I • SALTER

John Salter (1740–1814). Successful ship captain and merchant; married Dorothy Bickford (1740–76) in 1762, Elizabeth March (1745–81) in 1777, and Jane Ffrost (1757–1837) in 1781; had nine children, including John Salter, II (1788–1858), who may also have used the brand. Owned a house and store on Washington St.; member of the Masons, St. John's Lodge No. 1; estate valued at $42,306.13 (old series, docket 8948, Rockingham County [N.H.] Probate).

1. Chest of drawers (*cat. no. 7*). Portsmouth, 1760–90. Private collection. Sotheby's, sale 5810, Jan. 26–28, 1989, lot 1454.
2. Armchair. Portsmouth, 1775–1800. Private collection. *Antiques* 113:5 (May 1978): 1103.
3. Windsor armchair. Portsmouth or Rhode Island, 1760–95. Private collection.

G.W. SEAWARD

Possibly refers to Giles Seaward (d. 1798). Portsmouth resident who died insolvent, with possessions totaling $71.24. His will mentions a son and grandson also named Giles, but they do not appear in any city records (old series, docket 6423, Rockingham County [N.H.] Probate).

It is possible that the initials on the brand were transposed, in which case William G. Seaward (d. 1826) may have been the owner. A sailmaker or mariner; wife Mary Elizabeth Seaward. The total value of his inventory was $216.10 and included "1 Work Table 15 / 9 Windsor Chairs 5 / [$] 10.00." Administrative accounts for the estate list $17.50 in cash received from the cabinetmakers Judkins and Senter (old series, docket 11144, Rockingham County [N.H.] Probate).

1. Worktable. Portsmouth, 1805–20. Private collection. Sotheby's, sale 5622, Oct. 24, 1987, lot 423.

J SHAPLEY

James Shapley (1765–1837). Merchant and shipowner; owned a mansion and outbuildings on Jaffrey St., as well as four acres of mowing fields in 1823; his widow Sarah lived at 3 Court St. in 1839; his son James E. Shapley (1815–39) may also have used the brand. The elder James's estate totaled $3,638.95 and included two mahogany armchairs with "hair" valued at $4.50 and eight mahogany side chairs with "hair" worth $14. Shapley also owned numerous tables including a mahogany Pembroke table worth $1.50 and "2 Mahogany Dining Tables 6.00." Moreover, his workshop contained "1 Branding iron" along with other odd tools and nails valued at $1.50 (old series, docket 13377, Rockingham County [N.H.] Probate).

1. Drop-leaf table. Portsmouth, 1765–90. Private collection.
2. Set of chairs. Portsmouth, 1765–90. Private collection. Skinner, sale 1120, Nov. 1, 1986, lot 240.

J. B. SHEAFE, JR.

Jacob Sheafe, Jr. (1745–1829). Merchant; son of Jacob Sheafe who died in 1791; lived on Buck St. until 1813, when his house burned in the great fire of 1813; moved to a house on the corner of Market and Daniel streets. Also owned a farm in Rye, N.H. and a variety of other commercial properties in Portsmouth; member of the Federal Fire Society. Sheafe's entire estate was valued at the handsome sum of

$47,199.29½ and included "One birch Bureau 15/" in Mr. E. L. Sheafe's chamber (old series, docket 11774, Rockingham County [N.H.] Probate).

1. Chest of drawers. Portsmouth, 1805–20. Private collection. Sotheby Parke Bernet, sale 3422, Oct. 21, 1972, lot 39.

J. F • SHORES

James F. Shores (1792–1871). Bookseller and stationer; police officer in 1817; notary public in 1834; lived on State St., but kept a store on Daniel St. in 1821; later moved to Islington St. Late in life resided at 1 Richards Ave. Bequeathed his household goods to his daughter, Elizabeth P. S. Pray (new series, docket 534, Rockingham County [N.H.] Probate).

1. Chest of drawers (11B). Portsmouth, 1805–15. Private collection.

C. STORER

Clement Storer (1760–1830). Congressman, selectman, and high sheriff of Rockingham County; office and house on Congress St. in 1821. Also owned a store and lot on Market St.; married Dolly Cutter in 1786; member of the Friendly Fire Society and the Portsmouth Athenaeum. His estate totaled $7,067.90 and included "14 Hair bottom Chairs [$] 10.50" and "6 Entry do 2.00," which his wife inherited (old series, docket 12121, Rockingham County [N.H.] Probate).

1. Set of six side chairs. Boston, 1765–90. Gov. John Langdon House, SPNEA, 1966.294a–f. Jobe and Kaye 1984, no. 114.
2. Corner chair. Boston, 1765–90. Gov. John Langdon House, SPNEA, 1966.293. Jobe and Kaye 1984, no. 115.

H. TREDICK

Henry Tredick, Jr. (1769–1815). Ship captain; nephew of Henry Tredick, Sr.; married to Margaret Tarlton (1776–1843); their house on Buck St. burned in the fire of 1813; member of the Friendly Fire Society; later owned a mansion house and outbuildings on Washington St. The total value of his estate was $8,926.80 and included "1 pair Mahogany Card tables [$]12-" (old series, docket 9106, Rockingham County [N.H.] Probate).

1. Card table. Portsmouth, 1805–15. Private collection. American Art Association, sale 4085, Feb. 9–10, 1934, lot 367.

S. TRIPE

Samuel Tripe (1750–1815). Sailmaker; born in Bristol, England; son of Major Seth Tripe; lived on Buck St. until his house burned in the fire of 1813; a lot of land situated on the corner of State and Chapel streets worth $700 comprised the bulk of his estate in 1818; the remainder of his estate totaled $133.56 and featured: "10 Mahogany Chairs including 2 Arm Do. [$]20." Nevertheless, Tripe died insolvent (old series, docket 9175, Rockingham County [N.H.] Probate).

1. Side chair. Portsmouth, 1805–20. Private collection. *Antiques* 114:5 (Nov. 1978): 969.

D. WEBSTER

Daniel Webster (1782–1852). Statesman, orator, and jurist; served in the U. S. House of Representatives and Senate; Secretary of State; moved to Portsmouth in 1807; married Grace Fletcher in 1808, the same year he was admitted to Humane Fire Society. Resided in a house on Vaughan St., then moved to Pleasant St., where they suffered losses in the fire of 1813, and then to High St.; office on Market St.; moved to Boston in 1816.

1. Stand. Portsmouth, 1805–20. Private collection.
2. Desk. Portsmouth, 1780–1810. Private collection. *Antiques and the Arts Weekly* (May 25, 1990): 120–K.

J^B. WENDELL

Jacob Wendell (1788–1865). Merchant and shipowner; married Mehetable Rindge Rogers, 1816; owned a house on Pleasant St.; president of the Commercial Bank in 1817; member of the Friendly Fire Society; town fireward in 1817; four fire buckets survive in a private collection. Suffered severe losses in the depression of 1827–28; later worked in the office of Ichabod Goodwin, former state governor and close friend.

1. Trunk. Portsmouth, 1800–1825. Portsmouth Athenaeum.
2. Branding iron. Portsmouth, 1800–1820. Private collection.

J. WIGGIN

Probably Joseph Wiggin (d. 1861). Grocer; taxed $16.85 for a store and stock in trade in 1817; store and house situated on North St. in 1821; owned a house on Christian Shore, various commercial properties, and stock in trade in 1823; served as a fireward in 1817 and selectman in 1824; became a farmer in 1857. He willed his household furnishings, valued at $122.33, to his wife Rhoda Wiggin. The estate also included $2,118.97 worth of bonds, notes, and other investments as well as $122.33 in household furnishings, including two bureaus worth $8 (old series, docket 18513, Rockingham County [N.H.] Probate).

1. Chest of drawers. Portsmouth, 1805–20. *Antiques* 131:6 (June 1987): 1209.

INSTITUTIONS CONSULTED

The Ackland Art Museum, The University of North Carolina at Chapel Hill, Chapel Hill, North Carolina

American Antiquarian Society, Worcester, Massachusetts

The Antiquarian and Landmarks Society, Inc., Hartford, Connecticut

The Art Institute of Chicago, Chicago, Illinois

Atlanta Historical Society, Atlanta, Georgia

Baker Library, Graduate School of Business Administration, Harvard University, Cambridge, Massachusetts

The Baltimore Museum of Art, Baltimore, Maryland

The Bayou Bend Collection, The Museum of Fine Arts, Houston, Texas

Berwick Academy, South Berwick, Maine

Boston Athenaeum, Boston, Massachusetts

Boston Public Library, Boston, Massachusetts

The British Library, British Museum, London

The Brooklyn Museum, Brooklyn, New York

The Carnegie Museum of Art, Pittsburgh, Pennsylvania

Chesterwood, Stockbridge, Massachusetts

The Colonial Williamsburg Foundation, Williamsburg, Virginia

Conway Historical Society, Conway, New Hampshire

Corbit-Sharp House, Odessa, Delaware

The Currier Gallery of Art, Manchester, New Hampshire

DAPC, Decorative Arts Photographic Collection, Winterthur Museum, Winterthur, Delaware

The Detroit Institute of Arts, Detroit, Michigan

Dey Mansion, Wayne, New Jersey

The Dietrich American Foundation, Chester Springs, Pennsylvania

Diplomatic Reception Rooms, U.S. Department of State, Washington, D.C.

Durham Historic Association Museum, Durham, New Hampshire

Eliot Historical Society at the Fogg Library, Eliot, Maine

Essex County Court House, Salem, Massachusetts

Exeter Historical Society, Exeter, New Hampshire

The Fogg Library, Eliot, Maine

Gore Place Society, Waltham, Massachusetts

Greenland Historical Society, Greenland, New Hampshire

The Hagley Museum and Library, Wilmington, Delaware

Hammond-Harwood House Association, Annapolis, Maryland

The Henry Ford Museum and Greenfield Village, Dearborn, Michigan

Historic Deerfield, Inc., Deerfield, Massachusetts

Historical Society of Old Newbury, Cushing House Museum, Newburyport, Massachusetts

Hood Museum of Art, Dartmouth College, Hanover, New Hampshire

House of Seven Gables, Salem, Massachusetts

Hurd Library, North Berwick, Maine

Ipswich Historical Society, Ipswich, Massachusetts

James E. Whalley Museum and Library, Masonic Temple, Portsmouth, New Hampshire

Kittery Historical and Naval Museum, Kittery, Maine

Kittery Historical Society, Kittery, Maine

Kittery Public Library, Kittery, Maine

Larkin House, Monterey State Historic Park, Monterey, California

Leeds City Art Galleries, Leeds, Yorkshire

Library of Congress, Washington, D.C.

Los Angeles County Museum of Art, Los Angeles, California

Madbury Historical Society, Madbury, New Hampshire

Maine Historical Society, Portland, Maine

Maine State Library, Augusta, Maine

Maine State Museum, Augusta, Maine

Marblehead Historical Society, Marblehead, Massachusetts

Massachusetts Historical Society, Boston, Massachusetts

The Metropolitan Museum of Art, New York, New York

Milwaukee Art Museum, Milwaukee, Wisconsin

Moffatt-Ladd House, property of The National Society of The Colonial Dames of America in the State of New Hampshire, Portsmouth, New Hampshire

Monmouth County Historical Association, Freehold, New Jersey

Museum of Early Southern Decorative Arts, Winston-Salem, North Carolina

Museum of Fine Arts, Boston, Boston, Massachusetts

National Archives, Washington, D.C.

New Castle Town Hall, New Castle, New Hampshire

New England Historic Genealogical Society, Boston, Massachusetts

New Hampshire Antiquarian Society, Hopkinton, New Hampshire

New Hampshire Division of Historical Resources, Concord, New Hampshire

New Hampshire Historical Society, Concord, New Hampshire

New Hampshire State Archives, New Hampshire Division of Records Management and Archives, Concord, New Hampshire

New Hampshire State House, Concord, New Hampshire

Newington Historical Society, Newington, New Hampshire

Newmarket Historical Society, Newmarket, New Hampshire

The New-York Historical Society, New York, New York

North Berwick Library, North Berwick, Maine

North Hampton Historical Society, North Hampton, New Hampshire

Old Berwick Historical Society, South Berwick, Maine

Old Sturbridge Village, Sturbridge, Massachusetts

Old York Historical Society, York, Maine

Peabody and Essex Museum, Salem, Massachusetts

Philadelphia Museum of Art, Philadelphia, Pennsylvania

Phillips Exeter Academy, Exeter, New Hampshire

Portland Museum of Art, Portland, Maine

Portsmouth Athenaeum, Portsmouth, New Hampshire

Portsmouth City Hall, Portsmouth, New Hampshire

Portsmouth Historical Society, John Paul Jones House, Portsmouth, New Hampshire

Portsmouth Naval Shipyard Library, Portsmouth, New Hampshire

Portsmouth Public Library, Portsmouth, New Hampshire

Rhode Island School of Design, Museum of Art, Providence, Rhode Island

Rochester Public Library, Rochester, New Hampshire

Rockingham County Court House, Exeter, New Hampshire

Rye Historical Society at the Rye Public Library, Rye, New Hampshire

Rye Public Library, Rye, New Hampshire

Saint John's Church, Portsmouth, New Hampshire

Shelburne Museum, Shelburne, Vermont

Society for the Preservation of New England Antiquities, Boston, Massachusetts

Somersworth Historical Society, Somersworth, New Hampshire

South Berwick Public Library, South Berwick, Maine

Stevens-Coolidge Place, North Andover, Massachusetts

Strafford County Court House, Dover, New Hampshire

Strawbery Banke Museum and Library, Portsmouth, New Hampshire

Tate House, property of The National Society of Colonial Dames of America in the State of Maine, Portland, Maine

Tuck Memorial Museum, Hampton, New Hampshire

University of New Hampshire Library, Durham, New Hampshire

Virginia Museum of Fine Arts, Richmond, Virginia

Wadsworth Atheneum, Hartford, Connecticut

Warner House Association, Portsmouth, New Hampshire

Wentworth-Coolidge Mansion, Portsmouth, New Hampshire

Wentworth-Gardner and Tobias Lear Houses Association, Portsmouth, New Hampshire

Western Reserve Historical Society, Cleveland, Ohio

The White House, Washington, D.C.

Winterthur Museum and Library, Winterthur, Delaware

Wolfeboro Historical Society, Wolfeboro, New Hampshire

Woodman Institute, Dover, New Hampshire

Yale University Art Gallery, New Haven, Connecticut

York County Court House, Alfred, Maine

York Institute Museum and Dyer Library, Saco, Maine

York Public Library, York, Maine

Bibliography

Adams 1825 Nathaniel Adams. *Annals of Portsmouth*. 1825. Reprint. Hampton, N.H.: Peter E. Randall, 1971.

Albee 1884 John Albee. *New Castle: Historic and Picturesque*. Boston: Rand Avery Supply Co., 1884.

Albion 1926 Robert G. Albion. *Forests and Sea Power: The Timber Problem of the Royal Navy, 1652–1862*. 1926. Reprint. Hamden, Conn.: Archon Books, 1965.

Alden 1808 Timothy Alden, Jr. *An Account of the Several Religious Societies in Portsmouth, New-Hampshire*. Boston: Munroe, Francis, and Parker, 1808.

Aldrich 1893 Thomas Bailey Aldrich. *An Old Town by the Sea*. Boston and New York: Houghton Mifflin and Co., 1893.

Andrews 1916 Charles M. Andrews, ed. *Some Cursory Remarks Made by James Birket in his Voyage to North America 1750–1751*. New Haven: Yale University Press, 1916.

Appleton 1874 William Sumner Appleton. *A Genealogy of the Appleton Family*. Boston: Press of T. R. Marvin and Son, 1874.

Appleton 1920 William Sumner Appleton. "George Jaffrey House Portsmouth, N.H. About 1725." *Old-Time New England* 11:1 (July 1920): 33–34.

Arfwedson 1834 Carl David Arfwedson. *The United States and Canada in 1832, 1833, and 1834*. 1834. Reprint. New York and London: Johnson Reprint Corp., 1969.

Avery 1987 Amos G. Avery. *Clockmakers and Craftsmen of the Avery Family in Connecticut*. Hartford: Connecticut Historical Society, 1987.

Baker 1979 Bill Baker. "Brewster Portraits Sell at Record $58,000." *Maine Antique Digest* (Oct. 1979): 4d.

Barquist 1991 David L. Barquist. "Imported Looking Glasses in Colonial America." *Antiques* 139:6 (June 1991): 1108–17.

Barquist 1992a ———. "American Looking Glasses in the Neoclassical Style, 1780–1815." *Antiques* 141:2 (Feb. 1992): 320–31.

Barquist 1992b ———. *American Tables and Looking Glasses in the Mabel Brady Garvan and Other Collections at Yale University*. New Haven: Yale University Art Gallery, 1992.

Barry 1971 Peter Ralph Barry. "The New Hampshire Merchant Interest, 1609–1725." Ph.D. diss., University of Wisconsin, 1971.

Bartlett ca. 1940 Agnes P. Bartlett. "Early Portsmouth Families." New Hampshire Historical Society. Manuscript, ca. 1940.

Bartlett 1911 J. Gardner Bartlett. *Robert Coe, Puritan, His Ancestors and Descendants 1640–1910 with Notices of other Coe Families*. Boston: published privately, 1911.

Bass 1940 Charissa Taylor Bass, comp. *Descendants of Deacon Samuel and Ann Bass*. Freeport, Ill.: published privately, 1940.

Beckerdite 1987 Luke Beckerdite. "Carving Practices in Eighteenth-Century Boston." In *Old-Time New England, New England Furniture: Essays in Memory of Benno M. Forman*, ed. by Brock W. Jobe, 123–62. Boston: Society for the Preservation of New England Antiquities, 1987.

Belknap 1792 Jeremy Belknap. *The History of New Hampshire*. 1784–92. Reprint. Dover, N.H.: S. C. Stevens, Ela, and Wadleigh, 1831.

Benes 1986 Peter Benes. *Old-Town and the Waterside*. Newburyport, Mass.: Historical Society of Old Newbury, 1986.

Biddle 1963 James Biddle. *American Art from American Collections*. New York: Metropolitan Museum of Art, 1963.

Bishop 1972 Robert Bishop. *Centuries and Styles of the American Chair, 1640–1970*. New York: E. P. Dutton and Co., Inc., 1972.

Bivins and Alexander 1991 John Bivins, and Forsyth Alexander. *The Regional Arts of the Early South: A Sampling from the Collection of the Museum of Early Southern Decorative Arts*. Winston-Salem, N.C.: Museum of Early Southern Decorative Arts, 1991.

Blackburn 1976 Roderic H. Blackburn. *Cherry Hill*. Bethlehem, N.Y.: Historic Cherry Hill, 1976.

Blackburn 1981 ———. "Branded and Stamped New York Furniture." *Antiques* 119:5 (May 1981): 1130–45.

Boston Directory 1831 *The Boston Directory*. Boston: Stimpson and Clapp, 1831.

Boston Directory 1834 *The Boston Directory*. Boston: Stimpson and Clapp, 1834.

Brewster 1859 Charles W. Brewster. *Rambles About Portsmouth. First Series*. Portsmouth: Lewis W. Brewster, 1859.

Brewster 1869 ———. *Rambles About Portsmouth. Second Series*. Portsmouth: Lewis W. Brewster, 1869.

Brewster 1908 Lewis W. Brewster, comp. *Elder William Brewster and the Brewster Family of Portsmouth, New Hampshire*. Portsmouth: Arthur G. Brewster, 1908.

Brighton n.d. Ray Brighton. *The Portsmouth Savings Bank, 1823–1958*. Portsmouth: published privately, n.d.

Brighton 1985 ———. *Clippers of the Port of Portsmouth and the Men Who Built Them*. Portsmouth: Peter E. Randall for the Portsmouth Marine Society, 1985.

Brighton 1986 ———. *Port of Portsmouth Ships and the Cotton Trade, 1783–1829* Portsmouth: Peter E. Randall for the Portsmouth Marine Society, 1986.

Brighton 1989 ———. *Tall Ships of the Piscataqua, 1830–1877*. Portsmouth: Peter E. Randall for the Portsmouth Marine Society, 1989.

Brissot de Warville 1797 J. P. Brissot de Warville. *New Travels in the United States of America Performed in 1788*. Boston: Joseph Bumstead, 1797.

Brongniart 1986 *Alexandre-Theodore Brongniart, 1739–1813*. Paris: Musée Carnavalet, 1986.

Buckley 1963 Charles E. Buckley. "Fine Federal Furniture Attributed to Portsmouth." *Antiques* 83:2 (Feb. 1963): 196–200.

Buckley 1964 ———. "The Furniture of New Hampshire." *Antiques* 86:1 (July 1964): 56–61.

Burroughs 1943 Alan Burroughs. *John Greenwood in America, 1745–1752*. Andover, Mass.: Addison Gallery of American Art, Phillips Academy, 1943.

Burroughs 1937 Paul H. Burroughs. "Furniture Widely Made in New Hampshire." *American Collector* 6:2 (June 1937): 6–7, 14–15.

Butterfield 1961 L. H. Butterfield, ed. *Diary and Autobiography of John Adams*. Vol. 1. Cambridge: Harvard University Press, 1961.

Cabinet-Makers' London Book of Prices 1793 *The Cabinet-Makers' London Book of Prices*. 1793. Reprint. London: Furniture History Society, 1982.

Candee 1970 Richard M. Candee. "Merchant and Millwright: The Water-Powered Sawmills of the Piscataqua." *Old-Time New England* 60 (Apr.-June 1970): 131–49.

Candee 1976 ———. "Wooden Buildings in Early Maine and New Hampshire: A Technological and Cultural History, 1600–1720." Ph.D. diss., University of Pennsylvania, 1976.

Candee and Porter 1984 ———, and Jane Porter. "Nomination Form, Joseph Haven House, National Register of Historic Places Inventory." United States Department of the Interior, National Park Service. Typescript, 1984.

Candee 1987 ———. "'The Appearance of Enterprise and Improvement': Architecture and the Coastal Elite of Southern Maine." In *Agreeable Situations: Society, Commerce, and Art in Southern Maine, 1780–1830*, ed. by Laura Fecych Sprague, 67–87. Kennebunk, Me.: The Brick Store Museum, 1987.

Candee 1992 ———. *Building Portsmouth: The Neighborhoods and Architecture of New Hampshire's Oldest City*. Portsmouth: Portsmouth Advocates, 1992.

Catalfo 1973 Alfred Catalfo, Jr. *The History of the Town of Rollinsford, New Hampshire, 1623–1973*. Somersworth, N.H.: New Hampshire Printers, Inc., 1973.

Cescinsky and Hunter 1929 Herbert Cescinsky, and George Leland Hunter. *English and American Furniture*. Garden City, N.Y.: Garden City Publishing Co., 1929.

Cescinsky and Webster 1913 ———, and Malcolm R. Webster. *English Domestic Clocks*. 1913. Re-

print. New York: Bonanza Books, 1968.

Chamberlain 1940 Samuel Chamberlain. *Portsmouth, New Hampshire, A Camera Impression.* New York: Hastings House, 1940.

Charlton 1857 Edwin A. Charlton. *New Hampshire As It Is.* Claremont, N.H.: A. Kenney and Co., 1857.

Chase 1935 Ada R. Chase. "Old Clocks in Norwich, Connecticut." *Antiques* 27:3 (Mar. 1935): 99–101.

Chase 1963 Theodore Chase. "The Attack on Fort William and Mary." *Historical New Hampshire* 18:1 (Apr. 1963): 20–34.

Chase and Chamberlain 1928 John Carroll Chase, and George Walter Chamberlain. *Seven Generations of the Descendants of Aquila and Thomas Chase.* 1928. Reprint. Somersworth, N.H.: New England History Press, 1983.

Chesley 1982 W. Dennis Chesley. "The New Hampshire Turnpike, 1796–1825." Typescript, 1982.

Chesley 1984 ———. "A History of the Piscataqua Bridge, 1793–1855." Master's thesis, University of New Hampshire, 1984.

Chippendale 1754 Thomas Chippendale. *The Gentleman and Cabinet-Maker's Director.* London: Thomas Chippendale, 1754.

Chippendale 1762 ———. *The Gentleman and Cabinet-Maker's Director.* 3d ed. 1762. Reprint. New York: Dover Publications, Inc., 1966.

Churchill 1983 Edwin A. Churchill. *Simple Forms and Vivid Colors: An Exhibition of Maine Painted Furniture, 1800–1850.* Augusta: Maine State Museum, 1983.

Churchill 1991a ———. "Thomas Jackson, Clockmaker — Now There Are Two." *Maine Antique Digest* (Apr. 1991): 12b–13b.

Churchill 1991b ———. "Early Southern Maine Furniture Makers." Typescript checklist, 1991.

Clark and Eastman 1974 Charles E. Clark, and Charles W. Eastman, Jr., eds. and comps. *The Portsmouth Project.* Somersworth, N.H.: New Hampshire Publishing Co., 1974.

Clarke 1902 George Kuhn Clarke. *Nathaniel Clarke and His Descendants.* Boston: published privately, 1902.

Cleary 1978 Barbara Ann Cleary. "The Governor John Langdon Mansion Memorial: New Perspectives in Interpretation." *Old-Time New England* 69:1–2 (Summer-Fall 1978): 22–36.

Clunie 1976 Margaret Burke Clunie. "Salem Federal Furniture." Master's thesis, University of Delaware, 1976.

Clunie 1977 ———. "Joseph True and the Piecework System in Salem." *Antiques* 111:5 (May 1977): 1006–13.

Clunie 1980 ———, et al. *Furniture at the Essex Institute.* Salem, Mass.: Essex Institute, 1980.

Clutton 1982 Cecil Clutton, ed. *Britten's Old Clocks and Watches and Their Makers.* 9th ed. London: Bloomsbury Books, 1982.

Comstock 1937 Helen Comstock. "The Connoisseur in America." *Connoisseur* 99 (1937): 98–104.

Comstock 1954 ———. "An Ipswich Account Book, 1707–1762." *Antiques* 66:3 (Sept. 1954): 188–92.

Comstock 1962 ———. *American Furniture: Seventeenth, Eighteenth, and Nineteenth Century Styles.* New York: Viking Press, 1962.

Comstock 1966 ———. "A Salem Secretary Attributed to William Appleton." *Antiques* 89:4 (Apr. 1966): 553–55.

Conger 1979 Clement E. Conger. "Decorative Arts at the White House." *Antiques* 116:1 (July 1979): 112–34.

Conger and Rollins 1991 Clement E. Conger, and Alexandra W. Rollins. *Treasures of State, Fine and Decorative Arts in the Diplomatic Reception Rooms of the U. S. Department of State.* New York: Harry N. Abrams, 1991.

Conlon 1968 James E. Conlon. "The Clockmakers of Newburyport and Vicinity." In *Proceedings of the Boston Club, 1934–1940, Bulletins & Special Papers*, 96–100. Typescript, 1968.

Cooper 1980 Wendy A. Cooper. *In Praise of America: American Decorative Arts, 1650–1830, Fifty Years of Discovery Since the 1929 Girl Scout Loan Exhibition.* New York: Alfred A. Knopf, 1980.

Corning 1897 Charles R. Corning. "John Langdon." *New England Magazine,* new series 16:5 (July 1897): 616–30.

Cummings 1979 Abbott Lowell Cummings. "Massachusetts and Its First Period Houses: A Statistical Survey." In *Architecture in Colonial Massachusetts*, 113–221. Boston: Colonial Society of Massachusetts, 1979.

Curtis and Nylander 1990 Nancy Curtis, Richard C. Nylander, et al. *Beauport, The Sleeper-McCann House.* Boston: David R. Godine in association with the Society for the Preservation of New England Antiquities, 1990.

Cutter and Loring 1900 William R. Cutter, and Arthur G. Loring. "Descendants of Nahum Parker, of Kittery, Maine." *New England Historical and Genealogical Register* 54 (Oct. 1900): 216, 388.

Dame 1957 Clarence E. Dame. "Descendants of Deacon John Dam of Dover, N.H." *New England Historical and Genealogical Register* 111 (Jan. 1957): 45–55.

Daniell 1970 Jere R. Daniell. *Experiment in Republicanism: New Hampshire Politics and the American Revolution, 1741–1794.* Cambridge: Harvard University Press, 1970.

Daniell 1981 ———. *Colonial New Hampshire, A History.* Millwood, N.Y.: KTO Press, 1981.

Davidson 1967 Marshall B. Davidson. *American Heritage History of Colonial Antiques.* New York: American Heritage Publishing, 1967.

Davidson 1968 ———. *The American Heritage History of American Antiques from the Revolution to the Civil War.* New York: American Heritage Publishing, 1968.

Davidson 1980 ———. *The Bantam Illustrated Guide to Early American Furniture.* New York: Bantam Books, 1980.

Davidson and Stillinger 1985 ———, and Elizabeth Stillinger. *The American Wing at the Metropolitan Museum of Art.* New York: Metropolitan Museum of Art and Alfred A. Knopf, 1985.

Davies 1874 Thomas F. Davies. "Memoir Joshua Winslow Peirce." *New England Historical and Genealogical Register* 28 (Oct. 1874): 367–72.

Davis 1894 Franklin Ware Davis. "Old St. John's Parish, Portsmouth." *New England Magazine,* new series 11:3 (Nov. 1894): 321–37.

Decatur 1937 Stephen Decatur. "Langley Boardman, Portsmouth Cabinetmaker." *American Collector* 6 (May 1937): 4–5.

Decatur 1938 ———. "George and John Gaines of Portsmouth, New Hampshire." *American Collector* 7 (Nov. 1938): 6–7.

Decorative Arts 1964 *The Decorative Arts of New Hampshire, 1725–1825.* Manchester, N.H.: The Currier Gallery of Art, 1964.

Decorative Arts 1973 *The Decorative Arts of New Hampshire, A Sesquicentennial Exhibition.* Concord: New Hampshire Historical Society, 1973.

DeMerritt 1929 Jennie Mabelle DeMerritt. *The Story of the Old House.* Madbury, N.H.: published privately, 1929.

Dempsey 1980 Claire Dempsey. "Rundlet-May House Binder." Society for the Preservation of New England Antiquities. Typescript, 1980.

Denker 1985 Ellen Paul Denker. *After the Chinese Taste: Chinese Influence in America, 1730–1930.* Salem, Mass.: Peabody Museum of Salem, 1985.

Distin and Bishop 1976 William H. Distin, and Robert Bishop. *The American Clock.* New York: E. P. Dutton and Co., 1976.

Documents and Papers Nathaniel Bouton et al. eds. *Documents and Papers Relating to the Province of New Hampshire, 1623–1800.* 40 vols. Concord: State of New Hampshire, 1867–1943.

Documents Relative to Manufactures Louis McLane, ed. *Documents Relative to the Manufactures in the United States, Returns from the State of New Hampshire.* 1833. Reprint. New York: Augustus McKellens, 1969.

Doty 1989 Robert M. Doty. *By Good Hands: New Hampshire Folk Art.* Manchester, N.H.: The Currier Gallery of Art, 1989.

Dow 1927 George Francis Dow. *The Arts and Crafts in New England, 1704–1775.* Topsfield, Mass.: Wayside Press, 1927.

Dow 1893 Joseph Dow. *History of the Town of Hampton, New Hampshire, from its Settlement in 1638, to the Autumn of 1892.* Salem, Mass.: Salem Press, 1893.

Downs 1952 Joseph Downs. *American Furniture, Queen Anne and Chippendale Periods in the Henry Francis du Pont Winterthur Museum.* New York: Macmillan Co., 1952.

Dreppard 1947 Carl W. Dreppard. *American Clocks and Clockmakers.* New York: Doubleday, 1947.

Duboy 1986 Phillippe Duboy. *Lequeu—An Architectural Enigma.* London: Thames and Hudson, 1986.

Ducoff-Barone 1991 Deborah Ducoff-Barone. "Checklist of Cabinetmakers and Chairmakers of Philadelphia, 1800–1815." *Antiques* 139:5 (May 1991): 982–95.

The Dunlaps 1970 *The Dunlaps & Their Furniture.* Manchester, N.H.: The Currier Gallery of Art, 1970.

Durand 1984 *Jean-Nicholas-Louis Durand, 1760–1834.* Paris: Picard, 1984.

Dyer 1930 Walter A. Dyer. "The Iconography of the Banister-Back Chair." *Antiquarian* 15:2 (Aug. 1930): 30–32, 56.

Edwards 1954 Ralph Edwards. *The Dictionary of English Furniture.* 3 vols. 1954. Reprint. London: Barra Books, 1983.

Ellis Memorial 1971 *Ellis Memorial Antique Show Catalogue.* Boston: Ellis Memorial Antique Show, 1971.

Ellis Memorial 1978 *Ellis Memorial Antique Show Catalogue.* Boston: Ellis Memorial Antique Show, 1978.

Ellis Memorial 1983 *Ellis Memorial Antique Show Catalogue.* Boston: Ellis Memorial Antique Show, 1983.

Ellsworth 1971 R. H. Ellsworth. *Chinese Furniture, Hardwood Examples of the Ming and Early Ch'ing Dynasties.* New York: Random House, 1971.

Elwell 1896 Newton W. Elwell. *Colonial Furni-*

ture and Interiors. Boston: George H. Polley and Co., 1896.

Emery 1936 William M. Emery. *The Salters of Portsmouth, New Hampshire.* New Bedford, Mass., 1936.

Evans 1974 Nancy Goyne Evans. "The Genealogy of a Bookcase Desk." *Winterthur Portfolio* 9 (1974): 213–22.

Evans 1988a ———. "Design Sources for Windsor Furniture, Part II: The Early Nineteenth Century." *Antiques* 133:5 (May 1988): 1128–43.

Evans 1988b ———. "American Painted Seating Furniture: Marketing the Product, 1750–1840." In *Perspectives on American Furniture,* ed. by Gerald W. R. Ward, 153–68. New York: W. W. Norton and Co. for the Winterthur Museum, 1988.

Ezell 1963 John S. Ezell, ed. *The New Democracy in America: Travels of Francisco de Miranda in the United States, 1783–84.* Norman: University of Oklahoma Press, 1963.

Fairbanks 1976 Jonathan L. Fairbanks. "Queen Anne and Chippendale Furniture: Department of State Diplomatic Reception Rooms, Washington, D.C." *Connoisseur* 191 (May 1976): 48–55.

Fairbanks and Bates 1981 ———, and Elizabeth Bidwell Bates. *American Furniture 1620 to the Present.* New York: Richard Marek, 1981.

Fairbanks and Trent 1982 ———, and Robert F. Trent. *New England Begins: The Seventeenth Century.* 3 vols. Boston: Museum of Fine Arts, 1982.

Fairchild 1976 Byron Fairchild. "Sir William Pepperrell: New England's Pre-Revolutionary Hero." *New England Historical and Genealogical Register* 130 (Apr. 1976): 83–106.

Fales 1965 Dean A. Fales, Jr. *Essex County Furniture: Documented Treasures from Local Collections, 1660–1860.* Salem: Essex Institute, 1965.

Fales 1972 ———. *American Painted Furniture 1660–1880.* 1972. Reprint. New York: Bonanza Books, 1986.

Fales 1976 ———. *The Furniture of Historic Deerfield.* New York: E. P. Dutton and Co., 1976.

Federal Fire Society 1905 *Federal Fire Society of Portsmouth, N.H.* Portsmouth: Federal Fire Society, 1905.

Fennimore 1991 Donald L. Fennimore. "Brass Hardware on American Furniture, Part II: Stamped Hardware, 1750–1850." *Antiques* 140:1 (July 1991): 80–91.

Fischer 1987 Julian D. Fischer. "Shipbuilding in Colonial Portsmouth: The *Raleigh.*" *Historical New Hampshire* 42 (Spring 1987): 1–35.

Flanagan 1972 John H. Flanagan. "Trying Times: Economic Depression in New Hampshire, 1781–1789." Ph.D. diss., Georgetown University, 1972.

Flanigan 1986 J. Michael Flanigan. *American Furniture from the Kaufman Collection.* Washington, D.C.: National Gallery of Art, 1986.

Forman 1988 Benno M. Forman. *American Seating Furniture, 1630–1730.* New York: W. W. Norton and Co., 1988.

Foss 1972 Gerald D. Foss. *Three Centuries of Freemasonry in New Hampshire.* Concord, N.H.: Grand Lodge of New Hampshire Free and Accepted Masons, 1972.

Foss 1986 ———. "St. John's Lodge No. 1, Samuel M. Dockum, Cabinetmaker." *St. John's Lodge No. 1 Brochure* (Apr. 1986): n.p.

Foster 1896 Sarah H. Foster. *The Portsmouth Guide Book.* Portsmouth: Portsmouth Journal Job Print, 1896.

Fraser 1930 Esther S. Fraser. "Pioneer Furniture from Hampton, New Hampshire." *Antiques* 17:4 (Apr. 1930): 312–16.

Frost 1943 John Eldridge Frost. *The Nicholas Frost Family.* Milford, N.H.: The Cabinet Press, 1943.

Frost 1945 ———, comp. "Portsmouth Record Book." 2 vols. Portsmouth Athenaeum. Typescript, 1945.

Frost 1948 ———. *Colonial Village.* Kittery, Me.: The Gundalow Club, 1948.

Garrett 1990 Elisabeth Donaghy Garrett. *At Home: The American Family, 1750–1870.* New York: Harry N. Abrams, 1990.

Garvan 1987 Beatrice B. Garvan. *Federal Philadelphia, 1785–1825: The Athens of the Western World.* Philadelphia: Philadelphia Museum of Art, 1987.

Garvin 1988 Donna-Belle Garvin. "A Neat and Lively Aspect." *Historical New Hampshire* 43:3 (Fall 1988): 202–24.

Garvin 1971 James L. Garvin. "Portsmouth and the Piscataqua: Social History and Material Culture." *Historical New Hampshire* 26 (Summer 1971): 3–48.

Garvin 1973 ———. "St. John's Church in Portsmouth: An Architectural Study." *Historical New Hampshire* 28 (Fall 1973): 153–75.

Garvin 1974 ———. *Historic Portsmouth.* Somersworth, N.H.: New Hampshire Publishing Co., 1974.

Garvin 1980 ———. "The Range Township in Eighteenth-Century New Hampshire." In *New England Prospect: Maps, Place Names, and the Historical Landscape,* Dublin Seminar for New England Folklife Annual Proceedings, ed. by Peter Benes, 47–68. Boston: Boston University, 1980.

Garvin 1983 ———. "Academic Architecture and the Building Trades in the Piscataqua Region of New Hampshire and Maine, 1715–1815." Ph.D. diss., Boston University, 1983.

Garvin and Garvin 1985 ———, and Donna-Belle N. Garvin. *Instruments of Change: New Hampshire Hand Tools and Their Makers, 1800–1900.* Concord: New Hampshire Historical Society, 1985.

Garvin 1987 ———. "Old State House, Portsmouth, New Hampshire." Historic Structure Report, New Hampshire Division of Historical Resources. Typescript, 1987.

Garvin 1989 ———. "Wentworth House: Design, Construction, and Furnishings." *New Hampshire Archeologist* 30 (1989): 27–38.

Garvin 1991 ———. "The Old New Hampshire State House." *Historical New Hampshire* 46 (Winter 1991): 202–29.

Gazatteer 1849 ———. *A Gazetteer of New Hampshire.* Boston: John P. Jewett, 1849.

George 1932 Nellie Palmer George. *Old Newmarket, New Hampshire.* Exeter, N.H.: The News-Letter Press, 1932.

Georgia Collects 1989 *Georgia Collects.* Atlanta: High Museum of Art, 1989.

Georgian Furniture 1958 *Georgian Furniture.* London: Victoria and Albert Museum, 1958.

Getchell 1989 Silvia Fitts Getchell. *Fitts Families, Fitts, -Fitz, -Fittz.* Concord, N.H.: Capital Offset Co., Inc., 1989.

Giffen (Nylander) 1968 Jane C. Giffen (Nylander). "New Hampshire Cabinetmakers and Allied Craftsmen, 1790–1850." *Antiques* 94:1 (July 1968): 78–87.

Giffen (Nylander) 1970a ———. "The Moffatt-

Ladd House, Part I." *Connoisseur* 175:704 (Oct. 1970): 113–22.

Giffen (Nylander) 1970b ———. "The Moffatt-Ladd House, Part II." *Connoisseur* 175:705 (Nov. 1970): 201–7.

Gilbert 1978 Christopher Gilbert. *The Life and Work of Thomas Chippendale.* 2 vols. London: Studio Vista and Christie's, 1978.

Gilman 1869 Arthur Gilman. *The Gilman Family.* Albany, N Y · Joel Munsell, 1869.

Girl Scouts Exhibition 1929 *Loan Exhibition of Eighteenth and Nineteenth Century Furniture and Glass...for the Benefit of the National Council of Girl Scouts, Inc.* New York: American Art Galleries, 1929.

Gloag 1958 John Gloag et al. *English Furniture.* Cambridge, Mass.: Published for the Metropolitan Museum of Art by Harvard University Press, 1958.

Goss 1990 Nancy D. Goss. "And a Portsmouth Kettle Stand." *Antiques* 37:3 (Mar. 1990): 636, 646.

Goss 1991 ——— et al. "Names and Dates of Residents and Persons Important to the Moffatt-Ladd House." Report of genealogical work in progress, Moffatt-Ladd House. Typescript, 1991.

Goyne 1967 Nancy A. Goyne. "The Bureau Table in America." *Winterthur Portfolio* 3 (1967): 24–36.

Great River 1985 *The Great River: Art and Society of the Connecticut Valley, 1635–1820.* Hartford: Wadsworth Atheneum, 1985.

Greenlaw 1974 Barry A. Greenlaw. *New England Furniture at Williamsburg.* Williamsburg, Va.: Colonial Williamsburg Foundation, 1974.

Greenslet 1908 Ferris Greenslet. *The Life of Thomas Bailey Aldrich.* Boston and New York: Houghton Mifflin, 1908.

Gurney 1902 C. S. Gurney. *Portsmouth Historic and Picturesque.* Portsmouth: C. S. Gurney, 1902.

Gusler 1979 Wallace B. Gusler. *Furniture of Williamsburg and Eastern Virginia, 1710–1790.* Richmond, Va.: Virginia Museum, 1979.

Guyol 1958 P. N. Guyol. "The Prentis Collection." *Historical New Hampshire* 14 (Dec. 1958): 9–16.

Hall 1901 Charles Carroll Hall. *Some Historical Notes Relating to St. John's Church of Portsmouth, N.H.* Portsmouth: St. John's Church, 1901.

Hardon n.d. Henry Winthrop Hardon, comp. "Newington Families." Portsmouth Athenaeum. Typescript, n.d.

Harris 1977 Cyril M. Harris, ed. *Illustrated Dictionary of Historic Architecture.* New York: Dover Publications, Inc., 1977.

Hayward 1969 Helena Hayward. "The Drawings of John Linnell in the Victoria and Albert Museum." *Furniture History* 5 (1969): 1–115.

Heckscher 1985 Morrison H. Heckscher. *American Furniture in the Metropolitan Museum of Art.* Vol. 2. *Late Colonial Period: The Queen Anne and Chippendale Styles.* New York: Metropolitan Museum of Art and Random House, 1985.

Heckscher and Bowman 1992 ———, and Leslie Greene Bowman. *American Rococo, 1750–1775: Elegance in Ornament.* New York: Metropolitan Museum of Art and Los Angeles County Museum of Art, 1992.

Hendrick 1964 Robert E. P. Hendrick. "John Gaines II and Thomas Gaines I, 'Turners' of Ipswich, Massachusetts." Master's thesis, University of Delaware, 1964.

Hepplewhite 1794 George Hepplewhite. *The Cabinet-Maker and Upholsterer's Guide.* 3d ed.

London, 1794. Reprint. New York: Dover Publications, Inc., 1969.

Hewett 1991 David Hewett. "Bourgeault Records $1.75 Million Sale." *Maine Antique Digest* (Sept. 1991): 12a–13a.

Hewitt 1982 Benjamin A. Hewitt et al. *The Work of Many Hands: Card Tables in Federal America, 1790–1820.* New Haven: Yale University Art Gallery, 1982.

Hinckley 1971 Lewis Hinckley. *A Directory of Queen Anne, Early Georgian and Chippendale Furniture.* New York: Crown Publishers, 1971.

Hipkiss 1941 Edwin J. Hipkiss. *Eighteenth-Century American Arts: The M. and M. Karolik Collection.* Cambridge: Harvard University Press for the Museum of Fine Arts, Boston, 1941.

Hofer 1991 Margaret K. Hofer. "The Tory Joiner of Middleborough, Massachusetts: Simeon Doggett and his Community, 1762–1792." Master's thesis, University of Delaware, 1991.

Hood 1991 Graham Hood. *The Governor's Palace in Williamsburg, A Cultural Study.* Williamsburg, Va.: Colonial Williamsburg Foundation, 1991.

Hoopes 1931 Penrose R. Hoopes. "Osborne and Wilson, Dialmakers." *Antiques* 20:3 (Sept. 1931): 166–68.

Howells 1931 John Mead Howells. *Lost Examples of Colonial Architecture.* 1931. Reprint. New York: Dover Publications, Inc., 1963.

Howells 1937 ———. *The Architectural Heritage of the Piscataqua.* 1937. Reprint. New York: Architectural Book Publishing Co., 1965.

Hummel 1970 Charles F. Hummel. "Queen Anne and Chippendale Furniture in the Henry Francis du Pont Winterthur Museum, Part II." *Antiques* 98:6 (Dec. 1970): 900–909.

Hurst and Priddy 1990 Ronald L. Hurst, and Sumpter Priddy III. "The Neoclassical Furniture of Norfolk, Virginia, 1770–1820." *Antiques* 137:5 (May 1990): 1140–53.

Hutchinson 1884–86 Peter Orlando Hutchinson, ed. *The Diary and Letters of His Excellency Thomas Hutchinson.* 2 vols. Boston: Houghton Mifflin, 1884–86.

Hyde 1971 Bryden B. Hyde. *Bermuda's Antique Furniture and Silver.* Hamilton: Bermuda National Trust, 1971.

Illustrated Memories *Illustrated Memories of Portsmouth, Isles of Shoals, New Castle, York Harbor, York Beach and Rye, New Hampshire.* Portland, Me.: G. W. Morris, n.d.

Ince and Mayhew 1762 William Ince, and John Mayhew. *The Universal System of Household Furniture.* 1762. Reprint. Chicago: Quadrangle Books, 1960.

Jobe 1974 Brock Jobe. "The Boston Furniture Industry 1720–1740." In *Boston Furniture of the Eighteenth Century,* ed. by Walter Muir Whitehill, 3–48. Boston: Colonial Society of Massachusetts, 1974.

Jobe and Kaye 1984 ———, and Myrna Kaye. *New England Furniture, The Colonial Era.* Boston: Society for the Preservation of New England Antiquities, 1984.

Jobe and Moulton 1986 ———, and Marianne Moulton. "Governor John Langdon Mansion Memorial, Portsmouth, New Hampshire." *Antiques* 129:3 (Mar. 1986): 638–41.

Jobe 1987 ———. "An Introduction to Portsmouth Furniture of the Mid-Eighteenth Century." In *Old-Time New England, New England Furniture: Essays in Memory of Benno M. Forman,* ed. by Brock W. Jobe, 163–95. Boston: Society for the Preservation of New England Antiquities, 1987.

Jobe 1991a ———. "A Boston Desk-and-Bookcase at the Milwaukee Art Museum." *Antiques* 140:3 (Sept. 1991): 412–19.

Jobe 1991b ———. "The Late Baroque in Colonial America: The Queen Anne Style." In *American Furniture with Related Decorative Arts, 1660–1830, The Milwaukee Art Museum and the Layton Art Collection,* ed. by Gerald W. R. Ward, 105–114. New York: Hudson Hills Press, 1991.

Jobe 1993 ———. "Portsmouth Furniture, 1725–1800." Ph.D. diss., Boston University, 1993.

John Brown House Exhibition 1965 *The John Brown House Loan Exhibition of Rhode Island Furniture.* Providence, R.I.: Rhode Island Historical Society, 1965.

Kane 1976 Patricia E. Kane. *300 Years of American Seating Furniture.* Boston: New York Graphic Society, 1976.

Katra 1989 Joseph R. Katra, Jr. "Clockmakers and Clockmaking in Southern Maine, 1770–1870." In *National Association of Watch and Clock Collectors Bulletin Supplement 17* (Summer 1989): 3–80.

Kaye 1978 Myrna Kaye. "Marked Portsmouth Furniture." *Antiques* 113:5 (May 1978): 1098–1104.

Kaye 1985 ———. "The Furniture of Samuel Sewall." *Antiques* 128:2 (Aug. 1985): 276–84.

Kaye 1987 ———. *Fake, Fraud, or Genuine? Identifying Authentic American Antique Furniture.* Boston: Little, Brown and Co. for the New York Graphic Society, 1987.

Kenney 1971 John Tarrant Kenney. *The Hitchcock Chair.* New York: Clarkson N. Potter, Inc., 1971.

Kent 1727 William Kent. *The Designs of Inigo Jones.* London: William Kent, 1727.

Kettell 1959 Russell Hawes Kettell. *Pine Furniture of Early New England.* 1929. Reprint. New York: Dover Publications, Inc., 1959.

Kidder 1960 Robert Wilson Kidder. "The Contribution of Daniel Fowle to New Hampshire Printing, 1756–1787." Ph.D. diss., University of Illinois, 1960.

Kimball 1933 Fiske Kimball. "Salem Furniture Makers II, Nehemiah Adams." *Antiques* 24:6 (Dec. 1933): 218–20.

Kirk 1972 John T. Kirk. *American Chairs, Queen Anne and Chippendale.* New York: Alfred A. Knopf, 1972.

Kirk 1982 ———. *American Furniture and the British Tradition to 1830.* New York: Alfred A. Knopf, 1982.

Kirker 1969 Harold Kirker. *The Architecture of Charles Bulfinch.* Cambridge: Harvard University Press, 1969.

Kirkham 1988 Pat Kirkham. "The London Furniture Trade, 1700–1870." *Furniture History* 24 (1988): 1–195.

Komanecky 1990 Michael K. Komanecky, ed. *The Currier Gallery of Art Handbook of the Collection.* Manchester, N.H.: The Currier Gallery of Art, 1990.

LaBranche 1983 John LaBranche. "Strawbery Banke: A Historic Neighborhood." In *Ellis Memorial Antiques Show Catalogue,* 34–35. Boston: Ellis Memorial Antiques Show, 1983.

Lacy 1975 Harriet S. Lacy. "Samuel Swett's Diary, 1772–1774." *Historical New Hampshire* 30:4 (Winter 1975): 221–30.

Lea 1960 Zilla Rider Lea, ed. *The Ornamented Chair, Its Development in America (1700–1890).* Rutland, Vt.: Esther Brazer Guild of the Historical Society of Early American Decoration, 1960.

Levy Catalogue Bernard and S. Dean Levy, Inc. *Sales Catalogues.* 7 vols. New York: Bernard and S. Dean Levy, 1975–92.

Little 1980 Nina Fletcher Little. *Neat and Tidy: Boxes and Their Contents Used in Early American Households.* New York: E. P. Dutton and Co., Inc., 1980.

Little 1984 ———. *Little By Little: Six Decades of Collecting American Decorative Arts.* New York: E. P. Dutton and Co., Inc., 1984.

Lockwood 1901 Luke Vincent Lockwood. *Colonial Furniture in America.* New York: Charles Scribner's Sons, 1901.

Lockwood 1913 ———. *Colonial Furniture in America.* 2d ed., 2 vols. New York: Charles Scribner's Sons, 1913.

Lockwood 1926 ———. *Colonial Furniture in America.* 3d ed., 2 vols. New York: Charles Scribner's Sons, 1926.

Looney 1968 John F. Looney. "Benning Wentworth's Land Grant Policy: A Reappraisal." *Historical New Hampshire* 23 (Spring 1968): 3–13.

Lovell 1974 Margaretta Markle Lovell. "Boston Blockfront Furniture." In *Boston Furniture of the Eighteenth Century,* ed. by Walter Muir Whitehill, 77–135. Boston: Colonial Society of Massachusetts, 1974.

Lovett 1959 Robert W. Lovett. "A Tidewater Merchant in New Hampshire." *Business History Review* 33:1 (Spring 1959): 60–72.

Macquoid 1904–5 Percy Macquoid. *A History of English Furniture.* 1904–5. Reprint. London: Bracken Books, 1988.

Malone 1964 Joseph J. Malone. *Pine Trees and Politics: The Naval Stores and Forest Policy in Colonial New England, 1691–1775.* Seattle: University of Washington Press, 1964.

Manwaring 1765 Robert Manwaring. *The Cabinet and Chair-Maker's Real Friend and Companion; or, The Whole System of Chair-Making Made Plain and Easy.* London: Henry Webley, 1765.

Mayo 1921 Lawrence Shaw Mayo. *John Wentworth, Governor of New Hampshire, 1767–1775.* Cambridge: Harvard University Press, 1921.

Mayo 1937 ———. *John Langdon of New Hampshire.* Concord, N.H.: The Rumford Press, 1937.

McBrien 1993 Johanna McBrien. "The Portsmouth, New Hampshire, Furniture Industry, 1798–1840." Master's thesis, University of Delaware, 1993.

McDuffee 1892 Franklin A. McDuffee. *History of the Town of Rochester, New Hampshire, from 1722–1890.* 2 vols. Manchester, N.H.: John B. Clarke Co., 1892.

McKinley 1931 Samuel Justus McKinley. "The Economic History of Portsmouth, New Hampshire, From its First Settlement to 1830." Ph.D. diss., Harvard University, 1931.

McLaughlin 1982 Robert E. McLaughlin. *On Church Hill: A Layman's History of St. John's Parish, Portsmouth, N.H.* Portsmouth: St. John's Church, 1982.

Meigs 1975 Peveril Meigs. "John G. Hales, Boston Geographer and Surveyor, 1785–1832." *New England Historical and Genealogical Register* 129 (Jan. 1975): 23–29.

"Memoirs of Prince's Subscribers" 1861 "Memoirs of Prince's Subscribers." *New England Historical and Genealogical Register* 15 (1861): 16–17.

Merrill and Merrill 1817 Eliphalet Merrill, and

Phinehas Merrill. *A Gazetteer of the State of New-Hampshire*. Exeter, N.H.: C. Norris and Co., 1817.

Merrill 1889 Georgia Drew Merrill, ed. *History of Carroll County, New Hampshire*. Boston: W. A. Ferguson and Co., 1889.

Michael 1972 George Michael. "A Study in Identity: Drop-panel Furniture." *National Antiques Review* (Mar. 1972): 16–33.

Michael 1976 ———. "Drop Panel Furniture." *Antiques Gazette* (June 1976): 1, 6–7

Michael 1989 ———. "Drop Panel Furniture." *Maine Antique Digest* (Sept. 1989): 34d–35d.

Miller 1937 Edgar G. Miller, Jr. *American Antique Furniture*. 2 vols. New York: M. Barrows and Co., 1937.

Monkhouse and Michie 1986 Christopher P. Monkhouse, and Thomas S. Michie. *American Furniture in Pendleton House*. Providence: Museum of Art, Rhode Island School of Design, 1986.

Montgomery 1966 Charles F. Montgomery. *American Furniture, The Federal Period, in the Henry Francis du Pont Winterthur Museum*. New York: Viking Press, 1966.

Montgomery and Kane 1976 ———, and Patricia E. Kane, eds. *American Art: 1750–1800, Towards Independence*. Boston: New York Graphic Society, 1976.

Montgomery 1984 Florence Montgomery. *Textiles in America, 1650–1870*. New York: W. W. Norton and Co., 1984.

Morse 1902 Frances Clary Morse. *Furniture of the Olden Time*. New York: The Macmillan Co., 1902.

Morse 1917 ———. *Furniture of the Olden Time*. 2d ed. New York: The Macmillan Co., 1917.

Moses 1984 Michael Moses. *Master Craftsmen of Newport, The Townsends and Goddards*. Tenafly, N.J.: MMI Americana Press, 1984.

Moulton 1873 Thomas Moulton. *A Genealogical Register of Some of the Descendants of John Moulton of Hampton, and of Joseph Moulton, of Portsmouth*. Portland, Me.: B. Thurston and Co., 1873.

Mussey 1986 Robert D. Mussey, Jr. "Rundlet-May House, Portsmouth, New Hampshire." *Antiques* 129:3 (Mar. 1986): 642–44.

Mussey 1987 ———. "Transparent Furniture Finishes in New England, 1700–1825." In *Old-Time New England, New England Furniture: Essays in Memory of Benno M. Forman* , ed. by Brock Jobe, 287–311. Boston: Society for the Preservation of New England Antiquities, 1987.

Myers and Mayhew 1974 Minor Myers, Jr., and Edgar deN. Mayhew. *New London County Furniture, 1640–1840*. New London, Conn.: Lyman Allyn Museum, 1974.

Naeve 1971 Milo M. Naeve. "English Furniture in Colonial America." *Antiques* 99:4 (Apr. 1971): 551–55.

Naeve 1978 ———. *The Classical Presence in American Art*. Chicago: Art Institute of Chicago, 1978.

Nelson 1930–32 George A. Nelson, comp. "Early U.S. Customs Records and History, Portsmouth, N.H." Vols. 1–3. Portsmouth Athenaeum. Typescript, 1930–32.

Neumann 1984 George Neumann. *Early American Antique Country Furnishings, Northeastern America, 1650–1800*. New York: American Legacy Press, 1984.

Nineteenth-Century America 1970 *Nineteenth-Century America, Furniture and Other Decorative Arts.*

New York: Metropolitan Museum of Art, 1970.

Northend 1914 Mary H. Northend. *Historic Homes of New England*. Boston: Little, Brown and Co., 1914.

Noyes, Libby, and Davis 1928–39 Sybil Noyes, Charles Thornton Libby, and Walter Goodwin Davis. *Genealogical Dictionary of Maine and New Hampshire*. 1928–39. Reprint. Baltimore: Genealogical Publishing Company, 1972.

Nutting 1924 Wallace Nutting. *Furniture of the Pilgrim Century*. Framingham, Mass.: Old America Co., 1924.

Nutting 1928–33 ———. *Furniture Treasury (Mostly of American Origin), All Periods of American Furniture with Some Foreign Examples in America, also American Hardware and Household Utensils*. 3 vols. Framingham, Mass.: Old America Co., 1928–33.

Nye 1895 Alvan Crocker Nye. *A Collection of Scale-drawings, Details, and Sketches of What is Commonly Known as Colonial Furniture*. New York: William Helburn, 1895.

Nylander 1975 Richard C. Nylander. "The First Harrison Gray Otis House." *Antiques* 107:6 (June 1975): 1130–41.

Nylander 1979 ———. "The Jonathan Sayward House, York, Maine." *Antiques* 116:3 (Sept. 1979): 567–77.

Nylander, Redmond, and Sander 1986 ———, Elizabeth Redmond, and Penny J. Sander. *Wallpaper in New England*. Boston: Society for the Preservation of New England Antiquities, 1986.

Orcutt 1935 Phillip Dana Orcutt. *The Moffatt-Ladd House*. Norwood, Mass.: The Plimpton Press for The Society of The Colonial Dames of America in the State of New Hampshire, 1935.

Owsley 1973 David T. Owsley. "American Furniture." *Carnegie Magazine* 47:1 (Jan. 1973): 9.

Owsley 1976 ———. "The American Furniture Collection." *Carnegie Magazine* 50:6 (June 1976): 266–67.

Page 1979 John F. Page. "Documented New Hampshire Furniture, 1750–1850." *Antiques* 115:5 (May 1979): 1004–15.

Palmer 1948 Brooks Palmer. "The First New Hampshire Clockmakers." *Antiques* 54:1 (July 1948): 36–37.

Parker 1901 Benjamin Franklin Parker. *History of Wolfeborough*. Wolfeborough, N.H.: City of Wolfeborough, 1901.

Parsons 1988 Carolyn S. Parsons. "'Bordering on Magnificence': Urban Domestic Planning in the Maine Woods." In *Maine in the Early Republic, From Revolution to Statehood,* ed. by Charles E. Clark, James S. Leamon, and Karen Bowden, 62–82. Hanover, N.H.: Maine Historical Society and Maine Humanities Council, 1988.

Parsons 1968 Charles S. Parsons. "William Fitz — Clocks to Fish." *National Association of Watch and Clock Collectors Bulletin* 13 (Feb. 1968): 129-38.

Parsons 1976 ———. *New Hampshire Clocks and Clockmakers*. Exeter, N.H.: Adams Brown Co., 1976.

Parsons 1983 ———. *New Hampshire Silver*. Warner, N.H.: R. C. Brayshaw and Co., Inc., 1983.

Parsons 1855 Usher Parsons. *The Life of Sir William Pepperrell, Bart*. Boston: Little, Brown and Co., 1855.

Peabody 1852 Andrew P. Peabody, ed. *Memorial of John W. Foster*. Portsmouth: James F. Shores, 1852.

Pennington, Voss, and Solis-Cohen 1979 Samuel

Pennington, Thomas M. Voss, and Lita Solis-Cohen. *Americana at Auction*. New York: E. P. Dutton, 1979.

Peterson 1971 Harold L. Peterson. *Americans at Home, From the Colonists to the Late Victorians*. New York: Charles Scribner's Sons, 1971.

Petraglia 1992 Patricia Petraglia. *American Antique Furniture, Styles and Origins*. New York: Smithmark Publishers, Inc., 1992.

Pickering 1884 R. H. E. Pickering. *Genealogical Data Respecting John Pickering of Portsmouth, New Hampshire, and His Descendants*. Boston: published privately, 1884.

Plain and Elegant 1979 *Plain and Elegant, Rich and Common: Documented New Hampshire Furniture, 1750–1850*. Concord: New Hampshire Historical Society, 1979.

Plunket 1987 Donna Breshears Plunket. "The Spanish Foot Tavern Table at the Bayou Bend Collection." Bayou Bend Collection, Museum of Fine Arts, Houston. Typescript, 1987.

Praz 1971 Mario Praz. *Conversation Pieces: A Survey of the Informal Group Portrait in Europe and America*. London: Methuen and Co., 1971.

Prime 1929 Alfred Coxe Prime, comp. *The Arts and Crafts in Philadelphia, Maryland, and South Carolina, 1721–1785: Gleanings from Newspapers*. Topsfield, Mass.: Wayside Press for the Walpole Society, 1929.

Prince 1744 Thomas Prince, Jr. *The Christian History, Containing Accounts of the Revival and Propagation of Religion in Great Britain and America for the Year 1743*. Boston: S. Kneeland and T. Green, 1744.

Prince 1975 Thomas M. Prince. "A History of the First Bank of Portsmouth, 1824–1975." Portsmouth Athenaeum. Typescript, 1975.

Prown 1966 Jules David Prown. *John Singleton Copley in America, 1738–1774*. 2 vols. Washington, D.C.: National Gallery of Art, 1966.

Quiney 1979 Anthony Quiney. "Thomas Lucas, Bricklayer, 1662–1736." *Archaeological Journal* 136 (1979): 269–80.

Quiney 1990 ———. *The Traditional Buildings of England*. New York: Thames and Hudson, 1990.

Randall 1965 Richard Randall. *American Furniture in the Museum of Fine Arts, Boston*. Boston: Museum of Fine Arts, 1965.

Rauschenberg 1980 Bradford L. Rauschenberg. "The Royal Governor's Chair: Evidence of the Furnishing of South Carolina's First State House." *Journal of Early Southern Decorative Arts* 6:2 (Nov. 1980): 1–32.

"Record Books of the First Church" 1918 "Record Books of the First Church of Christ in Portsmouth, N.H.: North Congregational Church." New Hampshire Historical Society. Typescript, 1918.

Rhoades 1972 Elizabeth Rhoades. "Household Furnishings in Portsmouth, New Hampshire, 1750–1775." Master's thesis, University of Delaware, 1972.

Rice 1974 Arthur Rice. "Langley Boardman, Master Craftsman." *New Hampshire Profiles* 23:6 (June 1974): 42–45.

Rice 1963 Howard Rice, ed. *Travels in North America in the Years 1780, 1781 and 1782 by the Marquis de Chastellux*. Williamsburg, Va.: Institute of Early American History and Culture, 1963.

Richmond 1936 Katharine R. Richmond. *John Hayes of Dover, New Hampshire, A Book of His Family*. 2 vols. Tyngsboro, Mass.: K. R. Rich-

mond, 1936.

Rococo 1984 *Rococo: Art and Design in Hogarth's England*. London: Victoria and Albert Museum, 1984.

Rodriquez Roque 1984 Oswaldo Rodriquez Roque. *American Furniture at Chipstone*. Madison: University of Wisconsin Press, 1984.

Rogers 1983 Pat Rogers, ed. *Jonathan Swift, The Complete Poems*. New Haven: Yale University Press, 1983.

Roth 1961 Rodris Roth. "Tea Drinking in 18th-Century America: Its Etiquette and Equipage." *United States National Museum Bulletin* 225 (1961): 61–91.

Rowell 1943 Hugh Grant Rowell. "A Unique Willard Clock." *American Collector* 12:7 (Aug. 1943): 5–12.

Roy 1992 Carolyn Parsons Roy. "Strawbery Banke Museum: Textiles and Clothing." *Antiques* 142:1 (July 1992): 110–15.

Sack 1950 Albert Sack. *Fine Points of Furniture: Early American*. New York: Crown Publishers, Inc., 1950.

Sack Collection *American Antiques from Israel Sack Collection*. 10 vols. Washington, D.C.: Highland House, 1969–92.

Safford 1923 Edward S. Safford. "The Saffords in America." Essex Institute. Typescript, 1923.

St. George 1979 Robert Blair St. George. "Have a Little Faith Guys…" *Maine Antique Digest* (Apr. 1979): 1c–3c.

Salmon Falls 1974 *Salmon Falls: The Mill Village, Historic District Study for the Town of Rollinsford, New Hampshire*. Dover, N.H.: Strafford Regional Planning Commission, 1974.

Saltonstall 1941 William G. Saltonstall. *Ports of the Piscataqua*. Cambridge: Harvard University Press, 1941.

Sander 1982 Penny J. Sander, ed. *Elegant Embellishments: Furnishings from New England Homes, 1660–1860*. Boston: Society for the Preservation of New England Antiquities, 1982.

Saunders and Miles 1987 Richard H. Saunders, and Ellen G. Miles. *American Colonial Portraits: 1700–1776*. Washington, D.C.: Smithsonian Institution Press for the National Portrait Gallery, 1987.

Scales 1914 John Scales. *History of Strafford County, New Hampshire, and Representative Citizens*. Chicago: Richmond-Arnold Publishing Co., 1914.

Schwenke 1980 Thomas Schwenke. *American Furniture of Investment Quality*. New York: Thomas Schwenke, Inc., 1980.

Scott 1946 Kenneth Scott. "Price Control in New England During the Revolution." *New England Quarterly* 19 (1946): 453–73.

Shelley 1958 Donald A. Shelley. "Henry Ford Museum: The Furniture." *Antiques* 72:2 (Feb. 1958): 151–63.

Sheraton 1793 Thomas Sheraton. *The Cabinet-Maker and Upholsterer's Drawing Book*. London: T. Bensley, 1793.

Sheraton 1802 ———. *The Cabinet-Maker and Upholsterer's Drawing Book*. 3d ed. London, 1802. Reprint. New York: Dover Publications, Inc., 1972.

Sheraton 1803 ———. *The Cabinet Dictionary*. 2 vols. London, 1803. Reprint. New York: Praeger Publishers, 1970.

Sherburne 1904 Edward Raymond Sherburne, comp. "Henry Sherburne of Portsmouth, New Hampshire, and Some of his Descendants." *New England Historical and Genealogical Register* 58

Sherburne 1905 ———. "John Sherburne of Portsmouth, N.H., and Some of his Descendants." *New England Historical and Genealogical Register* 59 (Jan. 1905): 56–59, 61.

Sibley's Harvard Graduates John L. Sibley, and Clifford K. Shipton. *Sibley's Harvard Graduates, Biographical Sketches of Those Who Attended Harvard College*. 17 vols. Cambridge and Boston: Massachusetts Historical Society, 1873– .

Silsbee 1888 M[arianne] C. D. Silsbee. *A Half Century in Salem*. 4th ed. Boston and New York: Houghton, Mifflin and Co., 1888.

Singleton 1900–1901 Esther Singleton. *The Furniture of Our Forefathers*. 2 vols. New York: Doubleday, Page and Co., 1900–1901.

Skemer 1987 Don Skemer. "David Alling's Chair Manufactory: Craft Industrialization in Newark, New Jersey, 1801–1854." *Winterthur Portfolio* 22:1 (Spring 1987): 1–21.

Smith 1902 Elizabeth Hale Smith. *Descendants of Major Samuel Hale*. Cambridge: The Riverside Press, 1902.

Smith 1970 Robert C. Smith. "Masterpieces of Early American Furniture at the United States Department of State." *Antiques* 98:5 (Nov. 1970): 766–72.

Solis-Cohen 1990 Lita Solis-Cohen. "Christie's Scores Six Records for American Furniture." *Maine Antique Digest* (Mar. 1990): 10c–13c.

Spinney 1943 Frank O. Spinney. "An Ingenious Yankee Craftsman." *Antiques* 44:3 (Sept. 1943): 116–19.

Sprague 1987a Laura Fecych Sprague, ed. *Agreeable Situations: Society, Commerce, and Art in Southern Maine, 1780–1830*. Kennebunk, Me.: The Brick Store Museum, 1987.

Sprague 1987b ———. " 'Fit for a Noble Man': Interiors and the Style of Living in Coastal Maine." In *Agreeable Situations: Society, Commerce, and Art in Southern Maine, 1780–1830,* ed. by Laura Fecych Sprague, 107–21. Kennebunk, Me.: The Brick Store Museum, 1987.

Sprague 1987c ———. "Patterns of Patronage in York and Cumberland Counties, 1784–1830." In *Agreeable Situations: Society, Commerce, and Art in Southern Maine, 1780–1830*, ed. by Laurel Fecych Sprague, 163–72. Kennebunk, Me.: The Brick Store Museum, 1987.

Sprague 1987d ———. "John Seymour in Portland, Maine." *Antiques* 131:2 (Feb. 1987): 444-49.

Stackpole 1903 Everett S. Stackpole. *Old Kittery and Its Families*. Lewiston, Me.: Lewiston Journal Co., 1903.

Stackpole and Thompson 1913 ———, and Lucien Thompson. *History of the Town of Durham, New Hampshire*. 2 vols. Durham: The Town of Durham, 1913.

Stanwood 1882 James Rindge Stanwood. *The Direct Ancestry of the Late Jacob Wendell of Portsmouth, New Hampshire*. Boston: David Clapp and Son, 1882.

Starbuck 1989 David R. Starbuck, ed. "America's First Summer Resort: John Wentworth's 18th Century Plantation in Wolfeboro, New Hampshire." *New Hampshire Archeologist* 30 (1989): 1–129.

Stokes 1985 Jayne E. Stokes. "Federal Furniture in the Rundlet-May House: Regional Characteristics of Furniture in Portsmouth, New Hampshire, 1795–1815." Research paper, Cooperstown Graduate Program, 1985.

Stoneman 1959 Vernon C. Stoneman. *John and Thomas Seymour, Cabinetmakers in Boston, 1794–1816*. Boston: Special Publications, 1959.

Stoneman 1965 ———. *A Supplement to John and Thomas Seymour, Cabinetmakers in Boston, 1794–1816*. Boston: Special Publications, 1965.

Strachan and Comstock 1965 Ruth Strachan, and Helen Comstock. "Renewed Study of Salem Secretaries." *Antiques* 88:4 (Oct. 1965): 502–5.

Strawbery Banke 1968 *Strawbery Banke in Portsmouth, New Hampshire: Official Guidebook and Map*. Portsmouth: Strawbery Banke Museum, 1968.

Streeter 1973 Donald Streeter. "Early American Wrought Iron Hardware: H and HL Hinges, Together with Mention of Dovetails and Cast Iron Butt Hinges." *Association for Preservation Technology* 5:1 (1973): 22–29.

Supplement 1808 *Supplement to the London Chair-Makers' and Carvers' Book of Prices, for Workmanship*. London: T. Sorrell, 1808.

Swan 1945 Mabel M. Swan. "Newburyport Furnituremakers." *Antiques* 47:4 (Apr. 1945): 222–25.

Swan 1949 ———. "Coastwise Cargoes of Venture Furniture." *Antiques* 55:4 (Apr. 1949): 278–80.

Swett 1903 Lucia Gray Swett. *The Visit of Lafayette, The Old Housekeeper's Story*. Boston: Lee and Shepard, 1903.

Symonds and Ormsbee 1947 R. W. Symonds, and T. H. Ormsbee. *Antique Furniture of the Walnut Period*. New York: Robert McBride and Co., 1947.

Talbott 1974 E. Page Talbott. "The Furniture Industry in Boston, 1810–1835." Master's thesis, University of Delaware, 1974.

Talbott 1991 ———. "Seating Furniture in Boston, 1810–1835." *Antiques* 139:5 (May 1991): 956–69.

Tallman 1982 L. H. Tallman. "Portsmouth Families." Portsmouth Athenaeum. Typescript, 1982.

Taylor 1990 Alan Taylor. *Liberty Men and Great Proprietors: The Revolutionary Settlement on the Maine Frontier, 1760–1820*. Chapel Hill and London: University of North Carolina Press, 1990.

Three Centuries of Connecticut Furniture 1935 *Three Centuries of Connecticut Furniture, 1635–1935: An Exhibition at the Morgan Memorial, Hartford, as a Part of the Celebration of the Tercentenary of Connecticut, June 15 – October 15, 1935*. Hartford: Tercentenary Commission of the State of Connecticut, 1935.

Tolles 1984 Bryant F. Tolles, Jr., ed. "Journal of a Tour to the White Hills: An 1842 Chronicle by Samuel Johnson." *Essex Institute Historical Collections* 120:1 (Jan. 1984): 4–5.

Tracy 1981 Berry B. Tracy. *Federal Furniture and Decorative Arts at Boscobel*. New York: Boscobel Restoration, Inc., and Harry N. Abrams, Inc., 1981.

Trent 1984 Robert F. Trent. "The Spencer Chairs and Regional Chair Making in the Connecticut River Valley, 1639–1863." *Connecticut Historical Society Bulletin* 49:4 (Fall 1984): 175–94.

Trent 1991 ———. "The Wendell Couch." *Maine Antique Digest* (Feb. 1991): 34d–37d.

"Two Hundreth Anniversary" 1850 "Two Hundredth Anniversary of the Settlement of New-Hampshire." *Collections of the New-Hampshire Historical Society* 6 (1850): 245–77.

Usher 1912 Ellis Baker Usher II. *Captain Daniel Lane*. Milwaukee: Ellis Baker Usher II, 1912.

Van Deventer 1976 David E. Van Deventer. *The Emergence of Provincial New Hampshire, 1623–1741*. Baltimore: Johns Hopkins University Press, 1976.

Venable 1989 Charles L. Venable. *American Furniture in the Bybee Collection*. Austin: University of Texas Press, Austin, in association with the Dallas Museum of Art, 1989.

Vital Records of Ipswich 1910 *Vital Records of Ipswich, Massachusetts, to the End of the Year 1849*. Salem, Mass.: Essex Institute, 1910.

Wadleigh 1913 George Wadleigh. *Notable Events in the History of Dover, New Hampshire, from the First Settlement in 1623 to 1865*. Dover, N.H.: Tufts College Press, 1913.

Wallace 1984 R. Stuart Wallace. "The Scotch-Irish of Provincial New Hampshire." Ph.D. diss., University of New Hampshire, 1984.

Walton 1973 Karin M. Walton. *English Furniture Upholstery, 1660–1840*. Leeds, Yorkshire: Temple Newsam House, 1973.

Ward 1986 Barbara McLean Ward, ed. *A Place for Everything: Chests and Boxes in Early Colonial America*. Winterthur, Del.: Henry Francis du Pont Winterthur Museum, 1986.

Ward 1982 Gerald W. R. Ward. "Avarice and Conviviality: Card Playing in Federal America." In *The Work of Many Hands: Card Tables in Federal America, 1790–1820*, by Benjamin Hewitt et al., 15–38. New Haven: Yale University Art Gallery, 1982.

Ward 1988 ———. *American Case Furniture in the Mabel Brady Garvan and Other Collections at Yale University*. New Haven: Yale University Art Gallery, 1988.

Ward 1989a ———. "Portsmouth Treasures: The Wendell Collection at Strawbery Banke Museum." *Antiques and the Arts Weekly* (June 30, 1989): 1, 70–72.

Ward 1989b ———. "Furnishings of the Jacob Wendell House." *Antiques Journal* (Sept. 1989): 124, 128, 131.

Ward 1991a ———, ed. *American Furniture with Related Decorative Arts, 1660–1830: The Milwaukee Art Museum and the Layton Art Collection*. New York: Hudson Hills Press, 1991.

Ward 1991b ———. "An American Tavern Table." *Regional Furniture* 5 (1991): 108–9.

Ward and Cullity 1992 ———, and Karin E. Cullity. "Strawbery Banke Museum: The Furniture." *Antiques* 142:1 (July 1992): 94–103.

Warren 1975 David B. Warren. *Bayou Bend: American Furniture, Paintings, and Silver from the Bayou Bend Collection*. Houston: Museum of Fine Arts, 1975.

Webb 1967 Charles T. Webb. *St. John's Church, Portsmouth, New Hampshire, A Visitor's Guidebook*. Portsmouth: n.p., 1967.

Weidman 1984 Gregory R. Weidman. *Furniture in Maryland, 1740–1940: The Collection of the Maryland Historical Society*. Baltimore: Maryland Historical Society, 1984.

Wells-Cole and Walton 1976 Anthony Wells-Cole, and Karin Walton. *Oak Furniture from Gloucestershire and Somerset*. Leeds, Yorkshire: Temple Newsam House, 1976.

Wendell 1912 William Greenough Wendell. "Inventory of the Jacob Wendell House." Strawbery Banke Museum. Typescript, 1912.

Wendell 1940 ———. "The Jacob Wendell House As It Looked in 1940." Strawbery Banke Museum. Typescript with photographs, 1940.

Wentworth 1878 John Wentworth. *The Wentworth Genealogy: English and American*. 3 vols. Boston: Little, Brown and Co., 1878.

Wetherell 1991 Charles Wetherell, ed. "The Letterbook of George Boyd, Portsmouth, New Hampshire, Merchant-Shipbuilder, 1773–1775." *Historical New Hampshire* 46 (Spring, Summer, Fall 1991): 3–53; 92–125; 176–97.

The White House 1969 *The White House, An Historic Guide*. 9th ed. Washington, D.C.: White House Historic Association in Cooperation with the National Geographic Society, 1969.

Williams 1963 H. Lionel Williams. *Country Furniture of Early America*. New York: A. S. Barnes, 1963.

Winslow 1988 Richard E. Winslow III. *"Wealth and Honour": Portsmouth During the Golden Age of Privateering, 1775–1815*. Portsmouth: Portsmouth Marine Society, 1988.

Zea 1984 Philip Zea. "Rural Craftsmen and Design." In *New England Furniture: The Colonial Era*, Brock Jobe and Myrna Kaye, 47–72. Boston: Society for the Preservation of New England Antiquities, 1984.

Zea and Cheney 1992 ———, and Robert C. Cheney. *Clockmaking in New England, 1725–1825: An Interpretation of the Old Sturbridge Village Collection*. Sturbridge, Mass.: Old Sturbridge Village, 1992.

Index

Jackson, Thomas, 203n.7; estate of, 199; tall clock, 197–200, 200nn.1,13
Jackson, Thomas (Preston, Connecticut), 198, 200n.8
Jacobs, Robert, 285
Jaffrey, George, I, 193–4, 196, 252, 292
Jaffrey, George, II, 19, 194–95, 196; cupboard, 94–97; estate of, 95, 97n.4
Jaffrey, George, III, 97, 195, 196, 244n.13
James, Kingsley, 38
Jefferson Embargo, 29, 201
Jeffries, Walter Lloyd, 196
Jeffry, Cyprian, 128
Jenkins, Hands and, 147
Jenkins, Phoebe, 432
Jenkins, William, 113, 172–73
Jewett, Sarah Orne, 324n.4
John Paul Jones House, 370, 373
Johnson, Bradbury, 33, 395n.11
Johnson, Josiah, 200n.13
Jones, Clarissa, 433
Jones, Jacob, 200n.13
Jones, John, Jr., 200n.13
Jones, Levi, 214, 215; chest of drawers, 110
Jones, Nathaniel, 118n.3
Jones, Sarah. *see* Randall, Sarah Jones
Jones, Sarah Dodge, 118n.3
Journal of a Modern Lady, The. see Swift, Jonathan
Joy, Alfred T., 68, 71n.1
Judkins, Jonathan, 69, 71n.1, 145, 172, 176, 179, 265; card table, 70
Judkins, Jonathan, *see also* Judkins and Senter
Judkins and Senter, 59–61, 64, 67, 71n.8, 146, 269, 280, 368n.3, 373; basin stand, 279–80; bedstead, 401; card table, 264n.7, 265–6; desk, 60; dressing table, 61, 143–44, 145–46; field bedstead, 399–; 402; secretary, 183; secretary and bookcase, 177, 178–81, 191; secretary, lady's, 176–77; sideboard, 176–77, 190–92; side chair, 362–63, 363n.4; sofa, 60; table, 263

Kelly, Mary, 294n.5
Kelly, William, 292, 294n.5
Kensington, New Hampshire, 194, 198
Kent, J. H., 206
Kent, William, *Designs of Inigo Jones, The,* 23
kettle stand. *see* stand, kettle
Kimball family, card table, 258; dressing table, 146
Kimball, Fiske, 259
King, Caroline, 281
Kingston, New Hampshire, 37, 39, 198; card table, 262, 264n.1
Kittery, Maine, 197, 219, 289, 290, 297n.3, 312n.1, 406
Kittery Point, Maine, 187
Knibb, Joseph, 196n.7
Knight, John, 139
Knight, Mehitable Moffatt, 408n.4
Knight, Temperance Pickering, 137
Knight, William, 225n.2
Knox, Henry, 381n.6

Ladd, Abigail Hill, 230, 231
Ladd, Alexander, 259, 261, 309, 317, 370, 372n.2, 372
Ladd, Alexander H., 154, 261, 309, 408
Ladd, Ann Parry. *see* Ward, Ann Parry Lord
Ladd, Eliphalet, 229–30, 231
Ladd, Elizabeth, 154
Ladd, Maria Tufton Haven, 259, 261, 370, 372n.2, 408
Ladd, Mrs. Alexander, 7, 371
Ladd, William J., 309

Lafayette, marquis de, 392
Lane, Isaac, 116–17, 118nn.4, 5, 6; chest of drawers of, 116–17
Lane, Jane Maria. *see* Bradley, Jane Maria Lane
Lane, Samuel, 92
Lane, Thomas, 118n.6
Langdon, Caroline Eustis, 231
Langdon, Charlotte Ladd, 230, 231
Langdon, Elizabeth. *see* Elwyn, Elizabeth Langdon
Langdon, Elizabeth Sherburne, 433
Langdon, Harriet Olivia, 231
Langdon, Jacob, 58
Langdon, John, 26–28, 49, 58, 65, 169, 170n.5, 232–33, 242, 302, 306, 336, 354, 360, 410, 433
Langdon, Mark, 37, 56n.12, 225, 321n.3, 323, 324n.6
Langdon, Mary Hall, 433
Langdon, Mary Ladd, 231
Langdon, Mrs. Woodbury, 241
Langdon, Sarah Sherburne, 49, 411
Langdon, Woodbury, 28, 49, 50, 58, 169, 325, 403, 409, 410, 411
Langley, Batty, 27
Lapish, Benjamin, 248, 358n.5
Larkin, Samuel, 34, 62, 63, 167n.5, 267, 369n.4
Lawrence, John Livingston, 206
Lawrence, Lucy Cutts, 206
Lawrence, William, 67
Lear, Tobias, 333
Lee, New Hampshire, 222
Lewis, William, 41, 299
library bookcase: Boardman, Langley, 60; Harrold, Robert, 54, 159–62, 224; nineteenth-century, 64; Salem, Massachusetts, 64; *see also* bookcase; desk and bookcase; secretary and bookcase
Little Harbor, New Hampshire, 23, 24
Locke, William, 290, 297n.9
Lock, Matthias, *Six Sconces,* 407
London, England, armchair, 306–9
Long, George, 433
Longman and Broderup, piano, 165n.9
Long, Mercy Hart, 433
Long, Pierse, 433
looking glass, 409–11; girandole, 412–14; Walker, Samuel, 50
Lord, Ebenezer, 65, 69, 70, 71n.1, 172–73, 263, 275n.1; and Langley Boardman, secretary and bookcase, 182–85; card table, 267; secretary, 172; worktable, 273–75
Lord, John, 347, 349, 372
Lord, Lucy Boardman, 172
Lord, Mehitable Perkins, 372
Lord, Nathaniel, 182
Lord, Samuel, 144, 148, 334n.12, 370, 371, 372; lolling chair, 274
Lord, Susan. *see* Hayes, Susan Lord
Loundes, Anne, 225
Loudon, New Hampshire, chair, 288
Low, Martha Hale. *see* Ffrost, Martha Hale Low
Lucas, Thomas, 17

McClean, Anna Frye, 433
McClean, George, 249n.5, 281, 368n.3, 379, 380, 381n.4, 433
McClintock, Elizabeth, 385
McClintock, Mary Montgomery, 386
McClintock, Reverend Samuel, 385, 386
McClintock, William, 385
McMaster, James, 411n.7
Macpheadris, Archibald, 17, 20, 23, 131, 159, 252
Macpheadris, Mary. *see* Warner, Mary Macpheadris Osborne
Macpheadris-Warner House, 18

Madbury, New Hampshire, 136n.1, 140, 141
Magarth, Richard, 310
Main, Benjamin, 220n.7
Manwaring, Robert, 326; *Cabinet and Chair-Maker's Real Friend and Companion, The,* 308, 316, 317, 320, 321, 322
Marblehead, Massachusetts, 147
March, Elizabeth, 436
Marsh, John, 100n.8, 281, 324n.5; tea stand, 229
Marsh, Matthew S., 323, 324nn.3,5, 324, 434
Marston, Ann, 86
Marston, Jacob, 32
Marston, Mary, 86
Marston, Thomas, 86
Marston, William, 86–87, 88n.2
Martin, John, 297n.9
Marvin, Martha Bell Amazeen, 303
Marvin, William (1810–80), 303
Marvin, William (1840–1919), 303
Marvin, William E., 144n.2, 382, 384
Masonian Proprietors, 21, 26
Mason, John, 14, 15, 21
Mayhew, John, 108n.5, 223, *see also* Ince, William
May, James Rundlet, 107, 144, 264
May, Louisa Rundlet, 107, 264
May, Mary Ann Morison, 107, 144, 377n.3
Mechanick Exercises. see Moxon, Joseph
Melcher, J., sideboard, 186–7
Melcher, John, 186
Melcher, Mehitable, 186
Members of the Friendly Fire Society, 424–25
Memorial of John W. Foster. see Shores, James F., Jr.
Mendum, Eleanor. *see* Sherburne, Eleanor Mendum
Meserve, Jacob, 389–90
Meserve, Nathaniel, 19
Middleborough, Massachusetts, 41
Miller, John, 341
Mills, John, 19, 23, 24, 37, 40, 220n.7, 285, 286n.1, 290, 301
Mills, Richard, 23, 24, 220n.7, 290, 301, 385–86
Milton, New Hampshire, 110, 214
Mitchell, John, 63
Moffatt, Jacob, 156
Moffatt, John, 24, 43, 158n.11, 286n.4, 290, 296, 336, 406–8; inventory, 408n.8
Moffatt, Katherine. *see* Whipple, Katherine Moffatt
Moffatt, Katherine Cutt, 406
Moffatt–Ladd House, 336
Moffatt, Samuel, 24, 306, 336, 404
Montgomery, Hugh, 17, 41
Montgomery, Mary. *see* McClintock, Mary Montgomery
Moodey, Joshua, 236n.1
More, Thomas, 290
Morrell, Nathaniel, 40
Morison, Elizabeth Lord, 115, 371, 372
Morison, Elizabeth W., 115, 144
Morison, Mary Ann. *see* May, Mary Ann Morison
Morison, Mary Elizabeth Lord, 115
Morton, Sarah, 183
Morton, William, 172, 183, 185, 434
Morton, William H., 183
Moses, Thomas G., 434
Moulton, Benjamin, 93
Moulton, Edward Sherbourne, tall clock, 210–12, 213
Moulton, Joseph, 210
Moulton, Lydia Bickford, 210
Moulton, Nathaniel T., 175n.1, 434
Moxon, Joseph, *Mechanick Exercises,* 38
Mulenex, Joseph, 220n.7, 297n.9
Mulliken, Jonathan, 203n.3
Mulliken, Nathaniel, Sr., 200n.3

Morton, William, 434; *see also* bookcase, secretary and
Seller, John, 15
Senter, William, 67, 145, 172, 176, 179, 265, *see also* Judkins and Senter
settee: Boardman, Langley, 353–55; eighteenth-century, 51; fancy, 359-61; neoclassical, 341–43
Sewall family, 115n.1
Sewall, Samuel, 42
Seymour, John, 144n.3, 171, 175n.1, 190, 272n.3
Seymour, Thomas, 175n.1, 190, 272n.3
Shapley, James, 436
Shapley, James E., 436
Shapley, Sarah, 436
Shapleigh, Maine, 218
Shaw, Abraham, 368; estate inventory, 369n.9
Shaw, Caleb, 37, 196n.9, 200n.13
Shaw, William, 179
Sheafe, Jacob, 58, 404
Sheafe, Jacob, Jr., 436
Shearer, Thomas, 163
Sheraton, Thomas, 150, 168, 171, 246, 269, 276, 384n.7, 399, 412; *Cabinet Dictionary, The,* 176, 279; *Cabinet-Maker and Upholsterer's Drawing-Book,* 168, 169, 170n.2, 250, 354, 376
Sherburne, Daniel, 98, 277, 278n.8, 327
Sherburne, Dorothy. *see* Wendell, Dorothy Sherburne
Sherburne, Edward, 41
Sherburne, Eleanor Mendum, 125, 127
Sherburne, Elizabeth Warner, 125, 127, 162
Sherburne, Elizabeth Warner Pitts. *see* Penhallow, Elizabeth Warner Pitts Sherbourne
Sherburne, Ephraim, 222
Sherburne, George, 281
Sherburne, Hannah Skilling, 222
Sherburne, Henry, 410
Sherburne, John, 53, 124–25, 127, 130n.4, 323, 408n.5
Sherburne, John N. 127, 162
Sherburne, Joseph, 14, 127n.3, 237, 292
Sherburne, Mrs. Nathaniel, 131
Sherburne, Nathaniel, 125, 127, 162, 409
Sherburne, Sarah, 222
Sherburne, Sarah. *see* Langdon, Sarah Sherburne
Sherburne, Thomas, 40
Shores, James F., 115, 437
Shores, James F., Jr., *Memorial of John W. Foster,* 251
Short, Joseph, 326
Shortridge, Harrold, 54
Shortridge, Richard, 37, 38, 52, 53, 225, 290, 321n.3
Shortridge, Robert, 323
Shute, Samuel, 17
sideboard, 122, 189n.1; Judkins and Senter, 176–77, 190–92; Melcher, J., 186–87; Nutter, George, 186–89
side chair, 290 ; Boardman, Langley, 344–46, 347–49, 354, 355; baroque, 301–3; Boston, 303; Boston model, 301–3; cane, Queen Anne, 292–94; eighteenth-century, 48, 55, 288, 291, 293, 305, 315, 324, 326, 328–31, 332–34; fancy, neoclassical, 280, 356–58, 361, 362–63, 389–91; Gaines, John, III, 48, 296, 298–300; Gaines, John, Jr., 297n.7; Gaines, Thomas, Sr., 297n.7; Harrold, Robert, 319–21, 322–24; London, 310–12, 334; nineteenth-century, 349, 356–68; parts, 83; Queen Anne, 298–300; rococo, 322–24; Salem, Massachusetts, 345; Walker, Samuel, 310; Windsor, 387–88; *see also* armchair; chair
Silsbee, Marianne, 269
Simes, Joseph, 404
Simes, William, 368, 381n.4
Simnet, John, 198, 200nn.1,11

Simpson, David, 119
Singleton, Esther, *Furniture of Our Forefathers, The,* 131, 132, 154
Six Sconces. see Lock, Matthias
Skilling, Hannah. *see* Sherburne, Hannah Skilling
Smith, Elizabeth Hale, 247, 394
Smith, George, *Collection of Designs for Household Furniture and Interior Decoration, A,* 383
Smith, Hannah Richardson, 133
Smith, Jeremiah, II, 247, 394
Smith, Jeremiah, 247
Smith, Joseph Edwin, 133
Smith, Margaret, 101
Smith, Miss, 93
Snell, Abigail. *see* Demeritt, Abigail Snell
sofa, 368n.3; Boardman, Langley, 382–84; federal, 382–84; Judkins and; Senter, 60; nineteenth-century, 375–7, 378–81; *see also* couch
Somerby, John P., 71n.1
Somersworth, New Hampshire, 69
South Berwick, Maine, 115, 244, 304, 347, 355n.1, 413
South Church, Portsmouth, New Hampshire, 188
Sowersby, William, 63, 71n.1, 315n.3, 346, 352n.1, 365, 371
Spalding, James A., 222
Spalding, Susan Parker Parrott, 222
Sparhawk, Nathaniel, 19
stand: basin, Chippendale design, 276; basin, Judkins and Senter, 279–80; basin, rococo, 276–68; Blunt, Charles, 427; eighteenth-century, 281–82, 427; kettle, Harrold, Robert, 53, 229–31; nineteenth-century, 283–84; urn, 232–33
Stanwood, James Rindge, 339
Stickney, John A., 340
Stickney, John H., 192
Stoddard, Margaret Whitton Raymond, 239
Stoodley, Mary Montgomery, 386
Stoodley, William, 386
Stoodley, Elizabeth, 430
stool, Chinese-style, 307
Storer, Clement, 437
Storer, Dolly Cutter, 437
Storrow, Charles Wentworth, 319
Story of a Bad Boy, The. see Aldrich, Thomas Bailey
Swan, Abraham, 27, 28; *British Architect, The,* 27; *Builder's Director, The,* 27; *Builder's Jewel, The,* 27; *Collection of Designs in Architecture, A,* 27
Sweat, Samuel, 39–40
Swift, Jonathan, *Journal of a Modern Lady, The,* 253

table: altar, Davis, Joseph, 234–36, 299; breakfast, Chippendale, 246, 247n.2; china, 52, 227–28, 233–36; dining, 218-20, 237–39, 240, 243–45, 432; night, 276; parts, 80–81; Pembroke 246–47, 248–49, 264nn.5,6, 435; stands, 270n.7; tavern, 216–7; tea, baroque, 240–42; tea, eighteenth century, 221–22; toilet, 276; writing, nineteenth century, 250–1; writing, lady's cabinet and, 168–70; *see also* bureau table; card table; dressing table
Tappan and Fisher, 250–51
Tappan, John, 250
Tarbell, Edward, card table, 264n.1
Temple, Robert, 16
Tenney, U. D., 371
Thatcher, Elizabeth Haven, 353, 355
Thomas Bailey Aldrich Memorial, 189
Thomlinson, John, 19, 21, 23
Thompson, Ebenezer (colonel), 348, 349
Thompson, Ebenezer (judge), 348
Thompson, Susannah. *see* Dwight, Susannah Thompson
Thompson, Thomas, 57n.62, 164, 165, 354, 396,

397, 405n.7
Tilton, Elizabeth Jane Rundlet, 165
Tobias, Morris, 204
Tobias, Morris and Company, tall clock, 204–6
Tolford, Joshua, 211, 212n.9
Toppan, Stephen, 69, 391n.4
Towle, Simon, 43–44, 57n.48
Treadwell, Charles, 43, 294n.5
Treadwell, Frances Richardson, 133
Treadwell, George, 292
Treadwell, Grace Williams, 89
Treadwell, Jacob, tea stand, 229
Tredick, Abbie Rowell, 380
Tredick, Charles, 380
Tredick, Henry, 258, 258n.1, 378, 380, 381n.4
Tredick, Henry, Jr., 437
Tredick, Margaret Tarlton, 378, 380, 437
Tredick, Thomas T., 380
Triggs, Thomas, 220n.7
Tripe, Samuel, 350, 395n.3, 437
turners, mid–eighteenth century, 220n.7

Universal System of Household Furniture, The. see Ince, William and John Mayhew
urn stand. *see* stand, urn
Usher, Ellis, 118n.6

Vaughn, George, 237, 292, 298, 300n.1

Walker, George, 70
Walker, Joseph, 63, 395n.3
Walker, Samuel, 312n.3; side chair, 310
Walsh, Keyran, 29
War of 1812, 34, 424
Ward, Ann Parry Ladd, 372n.2
Ward, John Langdon, 372n.2
Wardrobe, John, 156
Warner, Elizabeth. *see* Sherburne, Elizabeth Warner
Warner House, 131
Warner, Jonathan, 53, 54, 100n.10, 127n.1, 131, 159, 160, 162, 244, 411n.7; bureau table, 105n.4; estate, 159
Warner, Mary Macphaedris Osborne, 53, 131,159
Warner, Samuel, 127n.1
Warren, Joseph, 18
washstand, 276
Waterhouse, Ruth. *see* Gaines, Ruth Waterhouse
Watson-Wentworth, Charles, 51, 332
Webster, Benjamin, 381n.4
Webster, Daniel, 381n.4, 438
Webster, Gloria Fletcher, 438
Weeks, Comfort. *see* Clark, Comfort Weeks
Welch, John, 407
Welch, Mary Appleton, 251
Wells, Fletcher W., 288
Wells, Sarah Drake, 288
Wendell, Abraham, 58, 150, 280, 397, 398
Wendell, Andrew Peterson, 398
Wendell, Barrett, 100, 328, 331
Wendell, Caroline Quincy, 99, 100, 331, 338, 339
Wendell, Dorothy. *see* Randall, Dorothy Wendell
Wendell, Dorothy Sherburne, 98, 100, 100n.11, 179, 277, 327, 331, 401
Wendell, Edith Greenough, 371
Wendell, Frances A., 280
Wendell, Frederick Sleeper, 253
Wendell, George, 192
Wendell, Isaac, 327
Wendell, Jacob, 28, 58, 176, 217n.3, 315n.6, 345, 354, 378, 383, 397, 437; basin stand, 279–80; bureau table, 100n.11, 100; card table, 265–66, 267–68, 274; chest of drawers, 103–5, 107n.4; couch, 338, 340; dressing table, 61, 145–46; field

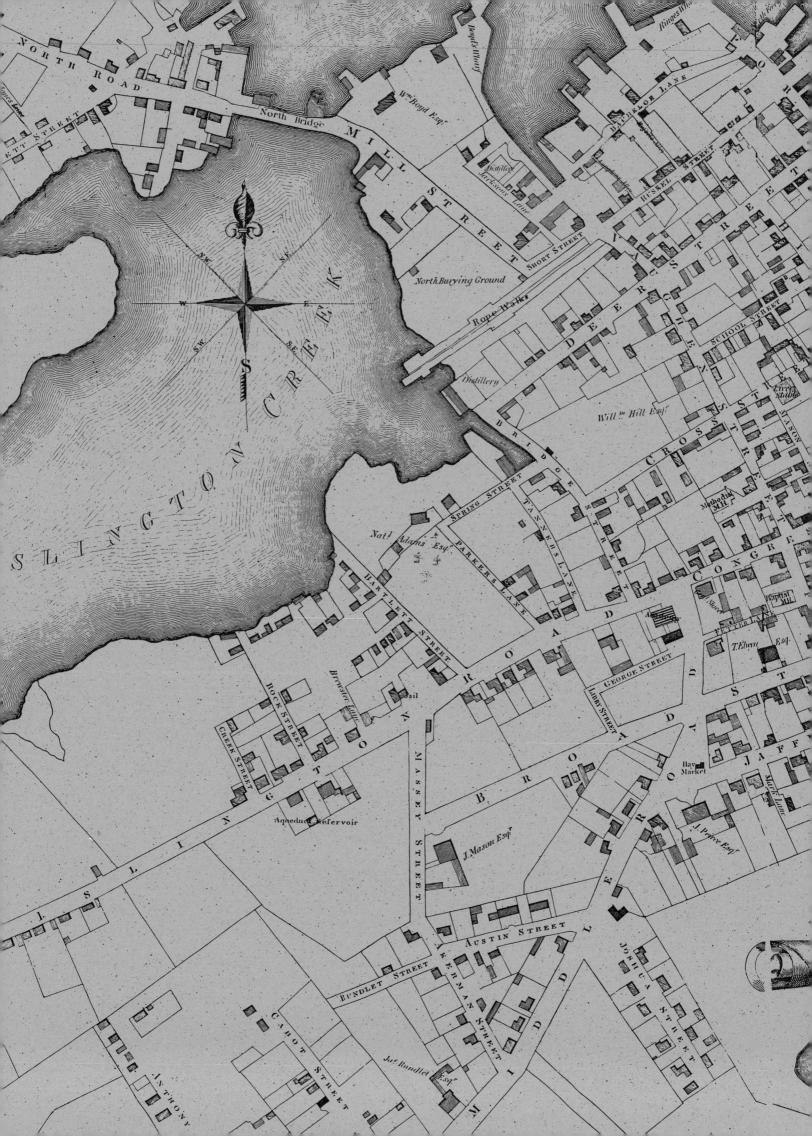

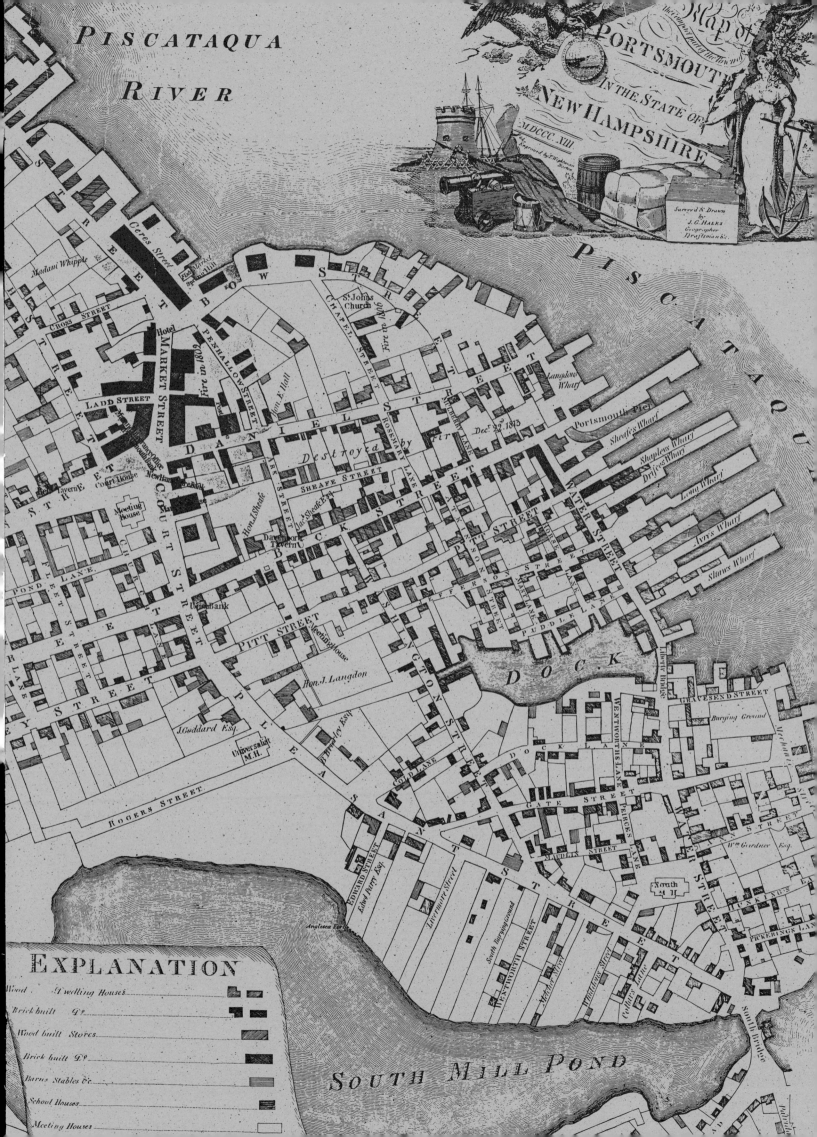